www.wadsworth.com

www.wadsworth.com is the World Wide Web site for Thomson Wadsworth and is your direct source to dozens of online resources.

At *www.wadsworth.com* you can find out about supplements, demonstration software, and student resources. You can also send email to many of our authors and preview new publications and exciting new technologies.

www.wadsworth.com
Changing the way the world learns®

Experiencing Art Around Us

Second Edition

Thomas Buser

University of Louisville

THOMSON

™

WADSWORTH

Australia • Canada • Mexico • Singapore • Spain
United Kingdom • United States

THOMSON
WADSWORTH

Experiencing Art Around Us, Second Edition
Thomas Buser

Publisher: Clark Baxter
Art Editor: John R. Swanson
Senior Development Editor: Sharon Adams Poore
Assistant Editor: Anne Gittinger
Editorial Assistant: Brianna Wilcox
Technology Project Manager: Melinda Newfarmer
Marketing Manager: Mark Orr
Marketing Assistant: Andrew Keay
Advertising Project Manager: Vicky Wan
Project Manager, Editorial Production: Trudy Brown

Executive Art Director: Maria Epes
Print Buyer: Judy Inouye
Permissions Editor: Stephanie Lee
Production: Mary Douglas Rogue Valley Publications
Text and Cover Designer: tani hasegawa
Photo Researcher: Lili Weiner
Copy Editor: Donald Pharr
Cover Images: Millennium Park, Chicago Anish Kapoor's bean-shaped *Cloud Gate* sculpture. Front Cover, © Todd Bannor/Alamy. Back cover © Scott Olson/Getty Images.
Text and Cover Printer: Courier Corporation/Kendallville
Compositor: Progressive Information Technologies

For more information about our products, contact us at:
Thomson Learning Academic Resource Center
1-800-423-0563
For permission to use material from this text or product, submit a request online at **http://www.thomsonrights.com.** Any additional questions about permissions can be submitted by email to **thomsonrights@thomson.com.**

Library of Congress Control Number: 2004115705

Student Edition: ISBN 0-534-64114-8

Instructor's Edition: ISBN 0-534-64113-X

Thomson Higher Education
10 Davis Drive
Belmont, CA 94002-3098
USA

Asia (including India)
Thomson Learning
5 Shenton Way
#01-01 UIC Building
Singapore 068808

Australia/New Zealand
Thomson Learning Australia
102 Dodds Street
Southbank, Victoria 3006
Australia

Canada
Thomson Nelson
1120 Birchmount Road
Toronto, Ontario M1K 5G4
Canada

UK/Europe/Middle East/Africa
Thomson Learning
High Holborn House
50–51 Bedford Row
London WC1R 4LR
United Kingdom

Latin America
Thomson Learning
Seneca, 53
Colonia Polanco
11560 Mexico
D.F. Mexico

Spain (including Portugal)
Thomson Paraninfo
Calle Magallanes, 25
28015 Madrid, Spain

About the Cover

Cloud Gate by British-based artist Anish Kapoor has become the centerpiece of Millennium Park in downtown Chicago. It is an enormous elliptical blob, inspired by the shape of liquid mercury and covered with a highly polished and highly reflective stainless steel skin. (The seams visible in the photographs will soon be made smooth and invisible.) Resting on two points, *Cloud Gate* forms a nine-foot high arch or gateway in the center. Under the arch, the skin curves up into a circular belly—the view shown on the cover.

From a distance, three-quarters of the surface of *Cloud Gate* reflects the sky and the clouds moving across the Chicago skyline. The piece becomes a film screen in broad daylight, an opening to a different view of time and space. Up close, the curved reflective surface distorts everyone's image like a funhouse mirror. Up close, the thirty-three-foot high piece of sculpture bulges out and looms overhead—some people have experienced vertigo and dizziness while looking at it.

Cloud Gate requires people to examine it from near and far, standing still and walking around and under it. Viewers must participate in the experience of the work. Like *Cloud Gate,* all art must be actively experienced. Art is not a static object—art looks back at us and calls for our involvement.

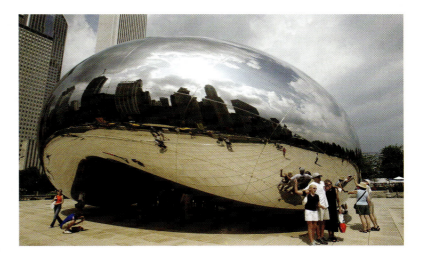

Millennium Park, Chicago, Anish Kapoor's bean-shaped *Cloud Gate* sculpture. © Scott Olson/Getty Images.

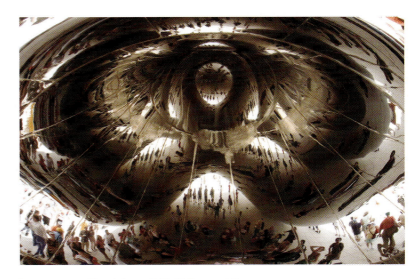

Interior view, *Cloud Gate.* © Todd Bannor/Alamy.

Brief Contents

Contents

4 Light and Color 82

5 Surface and Space 107

6 Principles of Design 124

III The Visual Arts

7 Drawing 143

Preface

Art is all around us. American museums and galleries display splendid works of art from all over the world. Outstanding sculpture stands in public places, and impressive architecture graces our cities and countryside. Good design and visual self-expression appear not only in traditional forms like painting but also in handcrafted pieces and commercial products and in advertising, photography, and film.

A textbook can only introduce students to the abundance of art around them. People have to discover it for themselves. Art that is actually seen is almost always better than a textbook illustration or classroom slide. Reproductions alter the size of every work of art or architecture. They distort color. They flatten brushwork and texture in two-dimensional art forms and obscure the feeling for masses and voids in three-dimensional forms. They give little or no feeling for scale. They allow only the camera's point of view.

Unless people learn to confront actual objects, art can remain merely theoretical or abstract—something to which they can remain indifferent. A work of art is incomplete without a viewer's active participation and reaction. For example, sculpture must be experienced in three dimensions, usually from different angles. Architecture must be walked through and lived in for a while. The experience of art is part of living, and a teacher's goal should be nothing less than to open minds to new modes of seeing and to enrich awareness and feeling. The goal of this book is to encourage the direct experience of art.

WHY STUDY ART?

People learn at least three important things from the study of art. First, they learn facts. Educated people should know something about the art of ancient Greece and what a Rembrandt painting looks like. They also ought to know the terminology, materials, and techniques that artists use.

Second, as with a foreign language, people not only acquire the vocabulary of art, they also learn its rules of grammar—the principles governing art. To experience art, people must see how shapes and lines and colors work and how they are put together by the artist to create meaningful communication. They ought to appreciate how paint is put on a surface, how solid materials are shaped into sculpture, and how space is enclosed for living. A knowledgeable viewer becomes sensitive to the range of possibilities within an art form and stays open to the experiments of artists who expand the art media.

Like mastering a new language, artistic awareness opens up new worlds of experience that were once incomprehensible. Understanding the language of art means comprehending other ways of seeing and other ways of looking that come from different places and different times. Moreover, training in the principles and practices of art sharpens our perceptions of the visible world. It enables us to form critical judgments about actual buildings, pictures, movies, and all other types of visual communication in addition to the examples studied in a classroom.

Third, every mature person ought to be able to enjoy art. The experience of art goes beyond the fun of learning something new and the satisfaction of accomplishment. For centuries people have felt that art offered a distinct kind of human experience, different from other forms of awareness. One of its essential characteristics was enjoyment—even when the subject matter was tragic or disturbing—because the insights and revelations of art can be emotionally exciting. In learning about art and how to experience art, it would be a shame to miss the joy that art has to offer.

THE STRUCTURE OF THIS BOOK

Experiencing Art Around Us is divided into five parts, each of which takes a different approach to the study of art. The approaches are theoretical (part I), formal (part II), technical (part III), historical (part IV), and institutional (part V). Constantly illustrated and demonstrated with actual works of art, the five parts establish five essential means to understand art.

Part I, "The Nature of Art," explores a number of fundamental conceptual issues. The first chapter answers the question "What is art?" by discussing the major theories of art, emphasizing the theory that art is a form of symbolic communication. The second chapter discusses the most common categories of subject matter and their significance to society.

Part II, "The Visual Elements," takes an in-depth look at essential formal elements such as line, light, color, and space because they play a key role in every form of art, from a small pencil sketch to the design of a large city. Awareness of the visual elements and the principles of design lay a foundation for a lifetime of appreciating art.

Part III, "The Visual Arts," examines the principles, materials, techniques, and expressive potential of a range of artistic media, including crafts and commercial design. Each chapter covers traditional methods of making art and also recent innovations made possible by film, video, and the computer.

Part IV, "History of World Art," shows how art expressed the culture of different peoples and times, in a survey of world art from the early cave paintings to contemporary performance pieces. These chapters have a global focus.

Part V, "The Art World," uses a new and timely approach to understanding art in the modern world. This part explores the business of art and the institutions that influence the creation of art. It investigates the role of the art market, museums, galleries, collectors, and critics in the production of art. It also discusses conservation and forgery.

Following each of the first four parts, the text analyzes the same work of art, *Summertime: Woman and Child in a Rowboat,* by the American painter Mary Cassatt. Each Critical Analysis examines the painting from the approach that has just been discussed in the preceding part. By the end of the text, students have a thorough analysis of a single work of art from four different points of view. Each analysis thus gives students a model to follow in applying the different approaches to other works of art.

Experiencing Art Around Us has as its goal the greatest possible diversity not only of art forms but of the people who make art. Women artists are well represented in this book, as are African American, Latino, and other minority artists. Non-Western art appears throughout the book, and it is integrated into the chapters devoted to the history of art in the conviction that the contemporary world has one history.

The works of art that illustrate the principles and media of art have been drawn primarily from art in American collections—the kind of art that students might actually see. In keeping with that approach, this text devotes a full chapter to the appreciation of film as a visual art.

In short, *Experiencing Art Around Us* is meant to be the first step in a lifetime of enjoying art.

FEATURES OF THE TEXT

Each chapter contains distinctive pedagogical features that enliven the presentation of the material and help foster student comprehension. These features include:

Extended captions to key works of art. These captions provide additional visual analysis or historic and cultural background. Through the extended captions these works become more than a mere illustration of a point in the text but works worthy of consideration for their own sake. These detailed descriptions also serve as a helpful student study and review tool.

Pronunciations for key artists' names and art terms are presented within the text when they appear for the first time.

Maps and timelines place discussions in their historical and geographical context, helping students to understand the genesis of artistic development.

Artist at Work boxes contain discussions of individual artists and their working methods—a celebration of the creativity of the individual artist. In addition to some internationally famous artists, the boxes profile many up-and-coming younger artists in the contemporary art world to provide a better idea of how art is actually made. The Artist at Work boxes relate not just biographical facts but explore the artists' training, how they go about making art, and their ideas and intentions—in short, an extensive examination of the creative process seen concretely through individual artists.

The **At a Glance boxes** in Chapters 2 through 14 summarize the material but are not a quick substitute for the text. They put into graphic form the fundamental concepts of the chapter to give students an overview of the material and to see relationships within that material.

Interactive Learning sections appear at the end of every chapter to direct students to the additional resources and learning tools at their fingertips. Here, students are led to features on the enclosed **ArtExperience CD-ROM** and the Internet.

STUDENT RESOURCES

ArtExperience CD-ROM, automatically packaged with every new copy of the text, is a new text-specific CD-ROM that gives students interactive, hands-on experience and access to a host of useful technology resources. Organized into six sections, the CD-ROM includes interactive exercises in foundations, video tours, and flashcards, along with expanded text features. The *Artist at Work* feature adds further context and additional resources, while the *Critical Analysis* section helps students develop their critical-thinking skills with interactive activities.

Student Test Packet features a practice test—including multiple choice, true/false, and short answer questions—for each chapter of the book. Complete answers and page references follow each chapter test, allowing students to check their understanding of concepts and practice for exams.

SlideGuide is a convenient student lecture companion that allows students to take notes alongside representations of the art images shown in class. It features reproductions of 170 images from the book also found on the **Instructor's Resource CD-ROM,** with full captions, page numbers, and space for note-taking. The *SlideGuide* can be bundled **free** with *Experiencing Art Around Us.*

ArtBasics: An Illustrated Glossary and Timeline provides a brief introduction to the basic terms, styles, and time periods. It is presented with full-color fine art images and high quality line art depicting the styles and techniques discussed. A four-color world map and fold-out timeline are also included. This supplement can be bundled **free** with the text.

The Museum Experience is a practical handbook that will enrich any student's museum visit, providing everything from a primer on museum etiquette to preparation tips on how to make the visit more constructive and enjoyable. It includes: end-of-chapter activities that apply the principles learned in each chapter to online examples of renowned artwork; useful checklists covering the essential notes students should take on a trip to the museum and revision "musts" for writing a research paper or review; and diagrams showing students how to create an effective sketch. Other features include an appendix listing museums across the United States and around the world; a directory of art, architecture, and world culture Internet sites; and a glossary of art terms students will encounter during a museum visit. This guide can also be bundled **Free** with the text.

Book Companion Website (http://art. wadsworth.com/buser02/) features chapter-by-chapter online tutorial quizzes, a final exam, chapter review, chapter-by-chapter weblinks, online study guide with links to images, artist pronunciation flash cards, and more!

INSTRUCTOR RESOURCES

WebTutor™ Toolbox forWebCT™ and Blackboard® provides preloaded content and is available via a free access code when packaged with your student's text. WebTutor ToolBox pairs all the content of this text's rich Book Companion Website with sophisticated course-management functionality. You can assign materials (including online quizzes) and have the results flow automatically to your grade book. WebTutor ToolBox is ready to use as soon as you log on—or you can customize its preloaded content by uploading images and other resources, adding weblinks, or creating your own practice materials. Students only have access to student resources on the website. Instructors can enter an access code for password-protected Instructor Resources.

The **Instructor's Resource CD-ROM** contains resources designed to streamline and maximize the effectiveness of your course preparation. The CD includes PowerPoint® lecture outlines and 170 digital images (maps, diagrams, and fine art images), as well as an electronic Instructor's Manual and Test Bank and image-specific JoinIn™ on TurningPoint® content for Student Response Systems (see below). Additionally, there is an electronic Resource Integration Guide that demonstrates how your curriculum can integrate our powerful learning and teaching tools with each chapter of the text.

JoinIn™ on TurningPoint® provides content for Response Systems that is tailored to *Experiencing Art Around Us,* allowing you to transform your classroom and assess your students' progress with instant in-class quizzes and polls. Our exclusive agreement to offer TurningPoint® software lets you pose book-specific questions and display students' answers seamlessly within the Microsoft® PowerPoint® slides of your own lecture, in conjunction with the "clicker" hardware of your choice. Enhance how your students interact with you, your lecture, and each other. For college and university adopters only. Contact your local Thomson representative to learn more.

The **Slide Set** includes 100 high quality slides of the text's images, maps, and line art to enhance lectures.

ACKNOWLEDGMENTS

For the development of this text, I have many people to thank, including Charles Grawemeyer, whose generous award encouraged my teaching this course many years ago. For their years of patience and help, my wife Sydney Schultze and my children Jack and Adrian have earned my constant thanks. I also thank Gail Gilbert, Kathy Moore, and the staff of the Bridwell Art Library for their help, my colleagues at the Allen R. Hite Art Institute for their suggestions about teaching art and their generous answers to my questions, and my students over the years, who have been my greatest inspiration and my best critics. I owe a big debt of gratitude to Robert Jucha, the indefatigable editor of the first edition and my kind but persuasive guide to writing a text.

I also thank the Thomson Wadsworth team who brought the second edition to light: John R. Swanson, Acquisitions Editor; Sharon Adams Poore, Senior Development Editor; Anne Gittinger, Assistant Editor; Brianna Wilcox, Editorial Assistant; Trudy Brown, Project Manager; Mary Douglas, Production Editor; Donald Pharr, Copyeditor; Lili Weiner, Photo Researcher; Melinda Newfarmer, Senior Technology Project Manager, and Mark Orr, Marketing Manager.

At many stages in the development of the text, professors in the front lines of art education all over the United States gave their advice. I was always stimulated by their insights, prodded by their criticism, and encouraged by their kind words. All showed themselves to be thoughtful, concerned, and provocative teachers of art. Everyone who reviewed the manuscript left a mark on the text. I am indebted to the following scholars and instructors: Fred C. Albertson, University of Memphis; Steve Arbury, Radford University; Randall Carlson, Bradley University; Heidi Endres, Northern Kentucky University; William Folkestad, Central Washington University; James Frakes, University of North Carolina–Charlotte; Martha Holmes, Fort Hays State University; Stephen Hunt, Radford University; Ralph Jacobs, Minnesota State University–Mankato; Lynn Mackenzie, College of DuPage; Aya Louisa McDonald, University of Nevada–Las Vegas; Helaine McLain, Northern Arizona University; Lynn Metcalf, St. Cloud State University; Kelly Ohl, Winona State University; Barbara Pogue, Essex County College; Lori Sears, Radford University; Susan Uhlig, Purdue University; Anke Van Wagenberg, Salisbury University; and Jessie Whitehead, University of Georgia.

Experiencing Art Around Us

Second Edition

1 What Is Art?

THE ATTRACTION OF ART

In the summer of 1888, Vincent van Gogh wrote to his brother Theo, "I'm painting with the enthusiasm of a Marseillais eating bouillabaisse, which won't surprise you when you know that I'm painting some big sunflowers." Living in southern France near the city of Marseilles, where the fish soup bouillabaisse was a popular specialty, the artist was busy painting a half dozen canvases of the flowers. They were intended to brighten up the room that he had set aside for the artist Paul Gauguin, who was coming to stay with him. Van Gogh asked his brother to imagine the effect of decorating the white walls of the room with large yellow sunflowers: "In the morning, when you open the window, you see the green of the gardens and the rising sun. . . . But you will see these great pictures of the sunflowers, 12 or 14 to the bunch, crammed into this tiny bedroom."[1] By means of the paintings, the sun-soaked garden would enter the room.

Each year, thousands of people stop to examine one of van Gogh's sunflower paintings (Figure 1-1) that is now hanging in the Philadelphia Museum of Art.

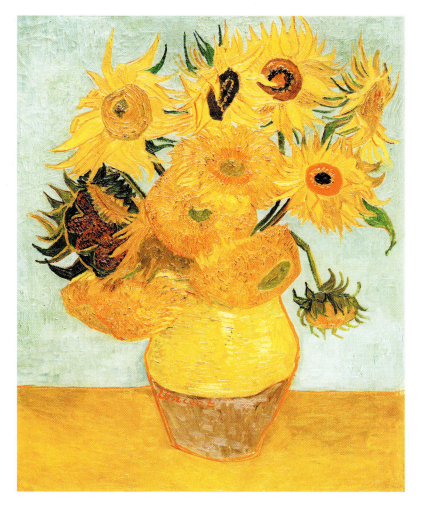

Figure 1-1 **Vincent van Gogh** [Dutch, 1853–1890], *Sunflowers*, 1888. Oil on canvas, 36 3/8 × 28 5/8 in. (92.4 × 72.7 cm). Philadelphia Museum of Art. Mr. and Mrs. Carroll S. Tyson Collection. © Philadelphia Museum of Art/Corbis.

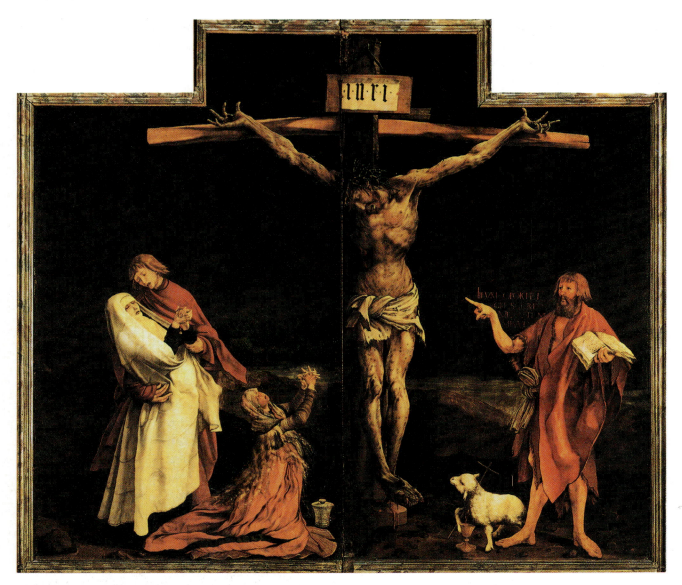

Figure 1-2 Grünewald (Matthias Neidhardt) [German, ca. 1480–1528], *The Isenheim Altarpiece* (closed), *Crucifixion*, ca. 1510–1515. Oil on wood, 117 1/2 × 134 in. (298.5 × 340.4 cm) Musée d'Unterlinden, Colmar, France.

Matthias Neidhardt, who has been called Grünewald since the seventeenth century, painted the crucifixion scene for the monastery hospital run by the Antonite monks in Isenheim in western Germany. The two halves of the painting swing back to reveal more paintings and sculpture behind the crucifixion scene. The large painting was placed above the altar in the church, which lay adjacent to the hospital wards. Many of the sick suffered from Saint Anthony's Fire, caused by eating contaminated rye grain. The disease ravaged and blackened their limbs, which sometimes were amputated as gangrene set in. When the painting is opened, Christ's arm is, in effect, amputated from his body.

The painting languished in relative obscurity until the twentieth century, when two world wars, genocide, and terror transformed it into one of the most sympathetic images of Christ and one of the great masterpieces of its period.

The vivid yellow colors, the tumbling round shapes, and the lush thick paint still elicit the same delight the artist intended. Indeed, whenever art truly engages someone, its images and shapes and colors treat the imagination to a complex tangle of feelings and associations.

The experience may even cancel out the humdrum of everyday existence and transport people outside themselves for a while. They perhaps see things in a new light and may be filled with wonder at the revelation. They may feel excited with new insights about themselves and the world around them. Art's revelation can treat people to a delightful surprise, like the joy they feel on the discovery of something or on meeting an old friend. Some have called the experience a natural high. Plainly, if these things happen, van Gogh's *Sunflowers* is no ordinary reproduction of a bouquet of flowers.

Not all artists set out to please their audience as did van Gogh when he painted *Sunflowers*. Some artists intend to disturb, provoke, and challenge their viewers. They make shocking and grotesque images that express their deep anxieties about life or about unspeakable atrocities and suffering. Five centuries ago the German artist Grünewald painted his large, gruesome *Crucifixion* (Figure 1-2) for the chapel of a hospital where most of the patients had little hope of recovery. Like the sick who suffered and died while praying before this image, Jesus Christ's body is also tormented and in agony. The painting shows that Christ had empathy for their anguish.

However, the provocation and challenge of such art deliver to most viewers a satisfactory experience beyond the immediate shock. Whatever the explicit subject matter, the experience of art can be like the stimulation of encountering another person. It is like the satisfaction people have when something works well, when the pieces all fit and everything comes out right.

The pleasurable stimulation of art is, simply, a good and valuable thing. Like love and friendship, art is an experience almost everybody would like to have. Many consider art to be one of the most important things in life—something that defines human nature. Like many of the best things in life, the pleasure of art is valuable in itself and needs no further justification.

AESTHETIC THEORIES

Despite the intrinsic value of the experience called art, some people have wanted to isolate and explain it. Unfortunately, no one has ever come up with an entirely satisfactory explanation, and people have proposed all kinds of answers to the question "What is art?" There is even a branch of philosophy, called **aesthetics,** that attempts to define what makes something art and to analyze the psychology of artists and the people experiencing art. With so many new definitions of art continually put forward and so many old ones rejected, artists themselves are often a bit reluctant to answer the question "What is art?"

Many of the older theories of art began by analyzing the characteristics of the objects made by artists. They then asserted that artists created a special class of objects that are inherently beautiful. These definitions usually stated that artists create a beautiful thing by combining a representation of something **real** and a conceptual **ideal.** In other words, artists make a special kind of object by depicting in it what they actually see (the real) and, at the same time, also depicting something they know or imagine (the ideal). For example, van Gogh painted actual sunflowers, but through the vigor of his brush and the vividness of his color he also depicted in them the idea that they were potent life forms bursting with the energy of the sun. By combining the real and the ideal, artists are capable of transforming something very specific into a universal truth, even though the words *real* and *ideal* can be philosophical opposites, if not contradictions.

The discussion of these two facets of art—the copying of reality joined to a conceptual or imaginative aspect—goes back in time at least as far as the ancient Greek philosophers Aristotle and Plato. The question that has plagued this tradition is "How can artists possibly get the two together?"

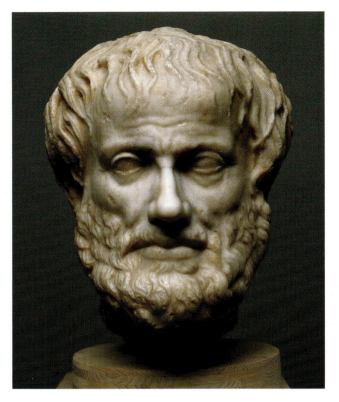

Figure 1-3 Roman copy after Greek original, *Aristotle*, fourth century BCE. Marble, 11 3/4 in. high (30 cm). Kunsthistorisches Institut, Vienna.

Aristotle

In the fourth century BCE, Aristotle (Figure 1-3) taught that the fundamental principle of art was the imitation of nature, or **mimesis** (pronounced mim-*eh*-sis), and his idea has been repeated whenever artists work from models of any kind and reproduce what they see before them. The school of mimesis asserts that creating a work of art is like holding a mirror up to nature because the artist reflects what he or she sees.

Belief in Aristotelian mimesis waned in the Middle Ages, when the concern for earthly reality diminished considerably, but returned in full force in the Renaissance. In art schools, such as the one depicted by Michel-Ange Houasse (Figure 1-4), Western art students perfected their skills in representation with years of training in copying the human model. It was only at the end of the nineteenth century that mimesis fell out of favor in the West when art became increasingly less representa-

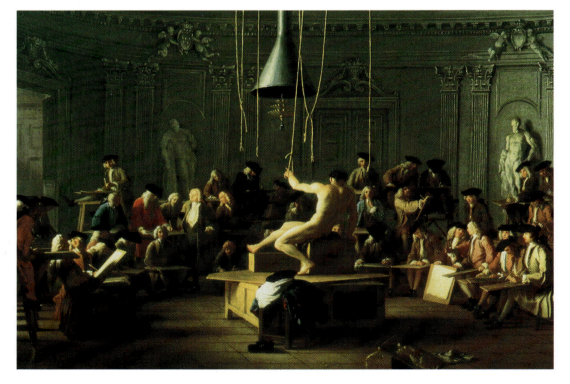

Figure 1-4 Michel-Ange Houasse [French], *The Academy of Drawing*. Oil on canvas, 20 1/2 × 28 1/2 in. (52 × 72.5 cm). Museo del Palacio Real, Madrid. Copyright © Patrimonio Nacional.

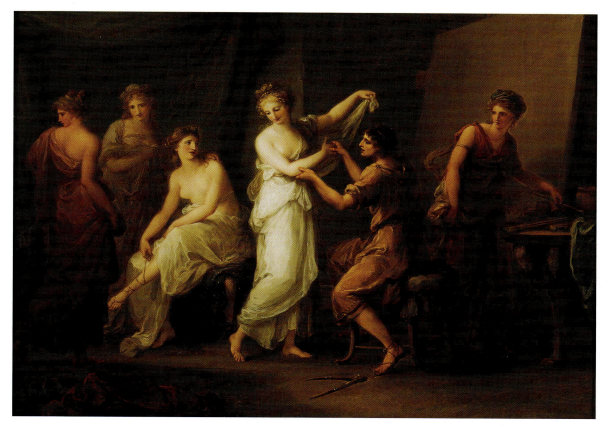

Figure 1-5 Angelica Kauffmann [Swiss, 1741–1807], *Zeuxis Selecting Models for His Picture of Helen of Troy*. Oil on canvas, 30 3/4 × 43 in. (78.1 × 109.2 cm). Annmary Brown Memorial Museum, Providence, Rhode Island.

tional. Mimesis lost its importance about the same time that photography began to preserve, with machine-like speed and precision, the external appearance of nature.

To be fair, Aristotle meant more than mere copying when he called art an imitation. For instance, in his treatise *Poetics* he does not hesitate to lay down rules that restrict mimesis. When it comes to writing a play, he insisted that the drama have just a few characters participating in a single action that takes place in about a day's time. Moreover, he stated that art is not supposed to reproduce ordinary people. Serious art is supposed to imitate men and women whose character is ethically superior to that of ordinary people and, by doing so, demonstrate goodness, beauty, and truth. Art, Aristotle said, is more philosophical and of graver import than history because art deals with such universal issues as beauty and goodness and truth.

Aristotle never made it clear how an artist, in practice, reconciles the imitation of reality with the reproduction of these philosophical ideals. However, to illustrate how an artist goes about depicting the idealized image of the perfectly beautiful woman while imitating reality, the ancients told a story. In the story an artist named Zeuxis searches to find the most beautiful legs, the most beautiful nose, the most beautiful arms on various women. As Angelica Kauffmann imagined in her painting *Zeuxis Selecting Models for His Picture of Helen of Troy* (Figure 1-5), the artist examines and chooses the parts before he puts them all together. In other words, beauty results from selecting certain parts of reality and then combining them. But how did Zeuxis know that a particular arm or leg was beautiful? How did he know how to put the pieces together? The story begs the question.

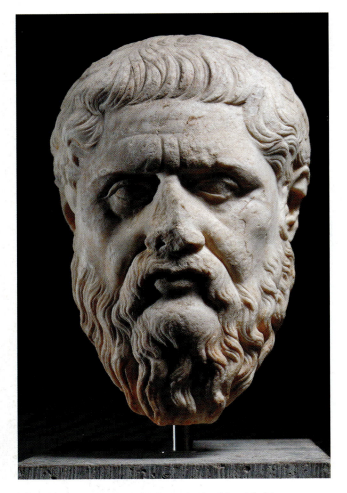

Figure 1-6 Roman copy after Silanion [Greek], *Plato*, original ca. 347 BCE. Marble. Museo Pio Clementino, Vatican Museums. © Archivo Iconografico, S.A./Corbis.

Plato

Even earlier, Plato (Figure 1-6) questioned the theory of imitation because he believed that all of nature is already an imitation of higher ideas and that if art only copies nature, it will not capture these higher ideas. According to Plato, an idea is an archetype that exists in a state of absolute perfection. For example, we recognize that a particular chair is a chair because there exists an idea of what constitutes perfect "chairness." Plato believed that such ideas are real and that material things exist because they participate in and imitate those universal ideas. If art is supposed to be an imitation of nature, then art is an imitation of what is already an imitation and thus twice removed from true reality. True reality—and true beauty—consists in the immutable ideas.

If Plato's theory is correct, who needs art? In fact, Plato banished art from his ideal republic.

But Plato also described art in more positive terms as a form of **inspiration.** According to him, artistic inspiration can change one's perception of reality just like inebriation or madness. (Unfortunately, alcohol and madness may debilitate a person, whereas artistic inspiration usually leads to the vigorous creation of something.) Plato compared the creation of art to madness because inspiration lifts artists out of themselves and takes possession of them. The inspired artist participates in a transcendent reality and is not governed by earthly rules. Plato's description of the inspired poet in his dialogue *Ion* has long been applied to every artist: "The poet is a light and winged and holy thing, and there is no invention in him until he has been inspired and is out of his senses. . . . These beautiful poems are not human, or the work of man, but divine and the work of God; the poets are only the interpreters of the gods by whom they are severally possessed."[2] Since the divine is acting through the artist, the divine becomes one with the artist; thus, the artist is able to combine the real and the ideal.

In the sixteenth century, Renaissance artists used Platonic theory to explain how they created beauty by constantly correcting and improving nature according to an image carried in the artist's mind. The Renaissance painter Raphael gave this explanation to a friend when he was asked where he found such a beautiful model for the nymph in the center of his painting *Galatea* (Figure 1-7): "In order to paint a beautiful woman, I should have to see many beautiful women . . .; but since there are so few beautiful women and so few sound judges, I make use of a certain idea that comes into my head."[3] Raphael admitted he was inspired, but the idea in his mind was probably formed by looking at many examples of Greek and Roman sculpture, which were increasingly attracting the attention of artists during the Renaissance.

Few Western artists living today talk about being possessed by the gods, but a lot of them speak about something happening inside them when their creative juices are really flowing. Time can stand still, and the world around them seems to go far away as their imagination takes hold.

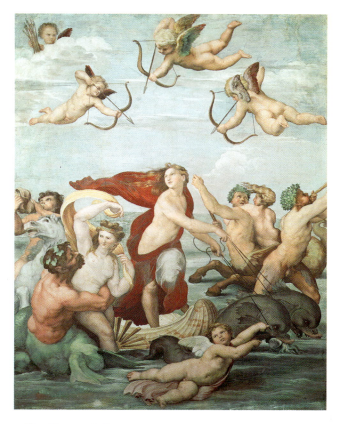

Figure 1-7 **Raphael** [Italian, 1483–1520], *Galatea*, 1513. Fresco. Palazzo della Farnesina, Rome. © Scala/Art Resource, NY.

Yoruban Aesthetics

Different cultures around the world explain the nature of their art in their own terms. For example, Yorubans, who live in Nigeria, would probably agree that the small *Twin Memorial Figures* (Figure 1-8) embody their concept of art. Yorubans believe that twins share the same soul, that they are spirit children and gifts from God; therefore, if one or both die, Yorubans treasure the memorial figures. Since Yoruban women give birth to more twins than any other group on earth, the practice of creating memorial figures is common.

Although the Yoruban sculptor of these figures clearly interpreted *imitation* differently than would a Greek or Renaissance artist, Yorubans believe that their carved figures resemble an individual subject—but in a moderate way. Too close a resemblance would not be art; neither would total abstraction. This moderation is perhaps the expression of a certain ideal of human personal behavior

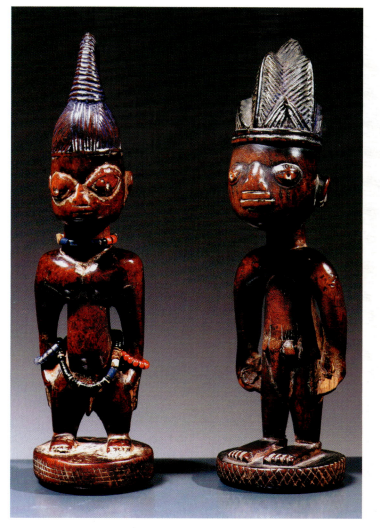

Figure 1-8 [Yoruban]. *Twin Memorial Figures (Ere Ibeji)*. Wood, 11 in. high (28 cm). Private collection of 19th century African art. © The Art Archive/Private Collection/Dagli Orti (A).

found in Yoruban society. Yorubans believe that someone should act in life with coolness, composure, even with a certain detachment. Consequently, Yoruban artists avoid emotions or violence in the facial expressions and gestures of their sculpture. Because of their desire for coolness and moderation, the Yorubans, like most African carvers, prefer symmetry—the clear delineation of parts arranged equally on either side of an upright central axis. They also find harmony in the contrived similarity of the body parts. In *Twin Memorial Figures,* the same elongated shape is repeated in the head, the breast, and the buttocks and knees—all of them arranged along parallel lines.

PSYCHOLOGICAL THEORIES

Modern psychobiology has demonstrated that Plato's description of an artist's feeling of being possessed and removed from the ordinary may have a basis in the operation of the brain. Research has shown that the two halves of the human brain operate differently. Although the functions of the two halves cannot be entirely separated, the left half of the brain normally controls language since it analyzes information logically, in a step-by-step fashion, over a period of time. The **right half of the brain,** on the other hand, "thinks" visually. It intuits things spatially—seeing how parts fit into place. It notices edges, intervals, relationships between parts, and relationships to the whole. Therefore, the right brain does not have much sense of the passage of time because time requires left-brain sequencing. Intuition and perception of the overall pattern of things take hold of a person.

When they shift to the right-brain modality, many people experience a pleasurable new form of awareness—an awareness perhaps similar to what Plato referred to as divine inspiration. Still, not all right-brain activity automatically becomes art. Nor does the biology of the brain fully explain how an artist actually creates a work of art that will capture her or his personal right-brain experience and communicate it to the viewer.

Modern psychologists have also attempted to explain art by dividing artists into personality types. They call those who tend to depict what they see before them **perceptual artists** and those who tend to depict what they have stored in their imagination **conceptual artists.** Perceptual artists have trained the hand to obey the mind's eye so that the hand can form the strokes to mimic what they see "out there." However, conceptual artists depict what is in their mind, what they know something to be. (This use of the term *conceptual* predates the Conceptual Art movement of the 1970s and is rather different in meaning.)

Creating images by visualizing concepts is a quite natural way of proceeding. If asked to draw an eye, for example, almost everyone would draw the concept of an eye. It would probably look like the old CBS logo, a more-or-less symmetrical or almond-shaped affair. Few would draw an eye in profile or from an odd angle, the way we typically see one.

In actual practice, artists often combine perceptually and conceptually derived images. They imitate nature, and at the same time they use their imagination either to make things up or to adjust and improve and transform what they see. The perceptual–conceptual distinction may not solve the ancient Greeks' problem of how to depict the beautiful human body, but it certainly confirms that we carry something like Plato's ideal forms in our minds, however they got there—whether we came by them instinctively or had to learn them. If we were to carve a statue or paint a picture of what a beautiful man or a beautiful woman should look like, the visual concepts that we have developed over years of lived experience would certainly help shape the result. For example, Yoruban artists operate with the concepts developed by the traditions of their own society; American artists have to work within a tradition that includes vast amounts of conditioning by movies and advertising.

THE THEORY OF THE ARTIST AS AN OUTSIDER

Since the early nineteenth century, many people have defined an artist as an inspired seer or prophet who saw things that ordinary people could not. This late form of Platonic inspiration gave to the artist a godlike power to penetrate reality, to see hidden meanings, and to unify matter and spirit through art. When an innovative or **avant garde** artist challenged commonly accepted forms of expression, the artist was treated as a rebel, an outcast who did not fit in society. Misunderstood and tormented, an inspired artist such as Vincent van Gogh made art that was disturbing, ahead of its times, and in violation of the rules. Until the work of these pathfinders was absorbed into the mainstream, the public often condemned it as primitive, raw, and brutal.

Since the 1970s, visionary art has been discovered among a distinct group called **outsider artists.** They are usually self-taught artists who through their cultural isolation stand apart from the institutions and standards of the art establishment. In theory, their work has not been influenced by the external art world. They seem instead to obey an inner voice and are seldom aware of art

outside their own; they may not even consider themselves artists or their own work as art. Some of them still practice **folk art**—traditional arts and crafts that were passed down within the confines of a minority culture. Some of them lack formal education; some are eccentric or even mentally unbalanced. Unspoiled by modern artistic culture, they are said to create innocently, spontaneously, and honestly. Outsider artist Bessie Harvey's only concern was to use art's magic power to release the spirit in the wood (Figure 1-9).

POPULAR THEORIES

Many people prefer that art be realistic and pretty. They expect art to look very much like the thing it represents, and they want art that is always pleasant and charming. But those requirements do not hold up under examination.

Realism

People often say about a painting things like "Those flowers look so real you can almost touch them!" Even back in ancient times, some critics set a high priority on a realism so convincing that it deceived the eye. The Greeks had another story about Zeuxis, that he painted fruit so realistically that birds flew into the wall to peck at it. Zeuxis's achievement exhibited great skill, not necessarily great art.

Even if a painting could actually deceive birds, art can never be truly real because all art is an illusion and make-believe. What many people demand of art is that it look like a photograph, even though photographs themselves capture only a portion of what the eye can perceive. Insisting on realism, many people demand that art not distort normal proportions and relationships. They require a certain accuracy. The more detail depicted, some people assume, the better the work of art. Since art lies in the artist's skill, according to these people, the more hard work that appears to have been applied, the better. All these strictures narrow the range of art and fail to grasp its essence.

Some people have assumed that an artist who works in a nonrealistic fashion, such as Picasso, must be incompetent—rather than having made a deliberate choice to work that way. Picasso's extraordinary ability to render reality at age fifteen

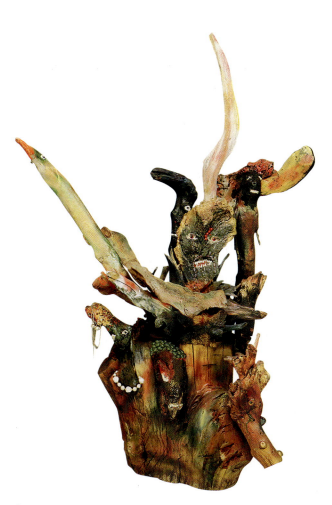

Figure 1-9 Bessie Harvey [American, 1928–1994], *Tribal Spirits*, 1988. Wood and mixed media, 45 × 26 × 20 in. (114.3 × 66 × 50.8 cm). Dallas Museum of Art. © Estate of Bessie Harvey.

Bessie Harvey, who lived in rural Tennessee, had visions of spirits living in trees. Deeply religious, Harvey felt that trees have souls that praise God, and in their wood she saw faces that pleaded to her to let their spirits come out. In *Tribal Spirits,* Harvey has attached around the main stem several pieces of wood that she has transformed with beads and shells into heads. The conflicting sizes and shapes of the heads and the antagonism of their expression are relieved by the smooth-necked bird that starts to soar above them. She decorated the whole with bright paint that operates like magic dust on her sculpture. Her ability to embody her vision of living wood and to make her vision present in the work defies conventions yet communicates its message with startling power.

(text continued on page 12)

Whatever Vincent van Gogh did throughout his life, he typically did it with passion, throwing his whole being into the pursuit. His intensity often made it difficult for him to get along with others. Yet, at the same time, he was able to articulate the state of his soul in extraordinarily revealing letters that he wrote to his younger brother Theo. Theo, who worked as an art dealer in Paris, supported Vincent through many years of poverty with a regular allowance and with additional money for expenses whenever Vincent pleaded for it in a letter.

In *Self-Portrait,* van Gogh distorted his own image, not because he had disturbed vision but because he wanted to make a statement. As an indication of his healthy mind when he painted, van Gogh wrote in quite explicit terms about the distortions that he made. In the painting he tried to make himself look Japanese at a time when a Japanese style was fashionable among young painters. He lucidly explained to his friend Paul Gauguin, to whom he dedicated this portrait, that he "aimed at the character of a simple Bonze [monk], worshipping the eternal Buddha."[1] To convey the idea that a painter was a seer and a visionary, van Gogh made it appear that he had shaved his head, as do Buddhist monks. The green brushstrokes circling around his head like a halo give him a spiritual look. The intensity of the painting builds out from his blue-and-green slanted eyes.

In 1886 Vincent van Gogh arrived at his brother's apartment in Paris after struggling to become a painter for five years. During his early years as an artist in Holland and Belgium, he had been especially attracted to landscape and to scenes of peasant life with somber figures in dark colors. In Paris he learned to brighten his palette with the light colors of the Impressionists, and he became friendly with the young painters around Georges Seurat who were experimenting with the expressive potential of color.

After two years in Paris, van Gogh moved to the warmer, sunnier south of France for his health. In Paris he had become very familiar with Japanese prints, and he hoped to find in the south a second Japan where he could investigate Japanese art from nature. In the few years he spent at Arles and then at Saint Rémy, both in southern France, van Gogh produced his most characteristic and most famous work. Attracted by the bright light and color of Arles, he painted ordinary people and ordinary things with extraordinary intensity. He painted the fruit trees flowering in the spring, bou-

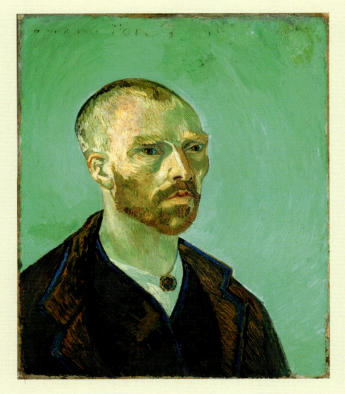

Vincent van Gogh [Dutch, 1853–1890], *Self-Portrait Dedicated to Paul Gauguin*, 1888. Oil on canvas, 19 1/4 × 23 1/2 in. (49.4 × 60.3 cm). Fogg Art Museum, Harvard University Art Museum, Cambridge. Bequest — collection of Maurice Wertheim, Class of 1906.

quets of sunflowers, and landscapes with reapers cutting grain under the hot sun of late summer. He called the reaper an image of death and suggested that humanity was the wheat he is reaping. But he thought there was nothing sad about the painting—it was "almost smiling" because of the bright yellow sunlight.

In the south of France, van Gogh soon realized that he could never be an exact realist because he saw nature too intently through the eyes of his own temperament. Since the contemplation of even ordinary things aroused nearly ecstatic feelings in him, he needed to give free scope to his imagination. Instead of trying to reproduce the exact color of what he had before his eyes like some "delusive realist," he wrote his brother in the summer of 1888 that he used "color suggesting some emotion of an ardent temperament."[2]

Vincent van Gogh [Dutch, 1853–1890], *Wheatfield Behind Saint Paul Hospital*, 1889. Oil on canvas, 28 1/4 × 36 1/4 in. (72 × 91.3 cm). Collection Kröller-Müller Museum, Otterlo, The Netherlands.

He often painted in a kind of passionate fury, at a fever pitch, and with a frenzy for thick paint. Sometimes, growing impatient with the tricks of painterly illusion, he squeezed paint straight from the tube onto the canvas to make his point. Painting became a release for his pent-up emotions, yet he stated that he wanted to paint pictures that would soothe people and make them happy, not disturb them. He wanted to produce something consoling in order to make life more bearable.

Doctors then and now disagree on a diagnosis of the illness that troubled van Gogh. He suffered frequent bouts of poor health, during which he could not paint and did not paint. When his health broke and he began experiencing prolonged seizures, van Gogh committed himself to an asylum in Saint Rémy, where he was allowed to paint between his attacks. In his confinement, when he regained his clarity of mind, he sometimes copied black-and-white prints of Rembrandt or Delacroix into full-colored paintings; some-

times he painted the fields visible through the bars of his window. Anxious about the ever-more-frequent recurrences of his illness, he made even bolder expressions of his feelings about nature. Each brushstroke became a broad, thick mosaic tile fitted into place. Every color is heightened, and every stroke and every shape twists with energy. Depressed by the increasingly frequent breakdown of his health, van Gogh finally shot himself.

It has been said that van Gogh risked his life for his art by devoting himself so totally to its creation. In actuality, he feared that his illness was destroying his creative powers. Painting helped keep him reasonably happy and sane. He wrote from the hospital in September 1889 that "I am working like one actually possessed, more than ever I am in a dumb fury of work. And I think that this will help cure me."[3] Although he sold only one painting in his lifetime, his paintings are now admired by millions of people who take great pleasure in seeing them.

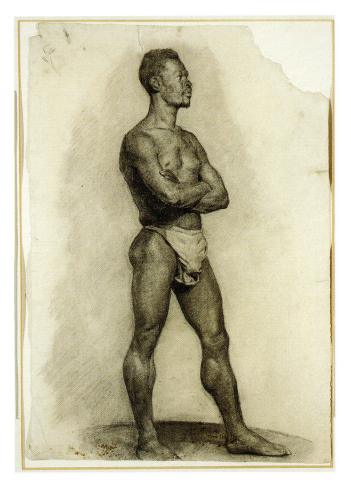

Figure 1-10 Pablo Picasso [Spanish, 1881–1973], *Standing Male Nude*, 1896–1897. Charcoal and crayon on light tan paper, 18 5/8 × 12 1/2 in. (47.3 × 31.8 cm). Museu Picasso, Barcelona. © 2006 Estate of Pablo Picasso/Artists Rights Society (ARS), New York.

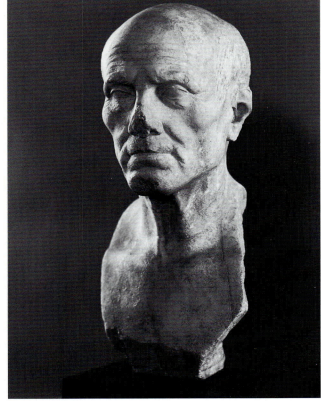

Figure 1-11 [Roman], *Portrait of a Man*, first century BCE. Marble, 18 in. (45.7 cm) high. Cincinnati Museum of Art. William Hayden Chatfield collection (1957.485).

or sixteen in his drawing of a studio model (Figure 1-10) refutes that assertion. Others contend that artists who distort their images in any way must need glasses or some other medical treatment or psychological help. Doctors often fall into this last logic trap when they try to diagnose the illnesses of artists such as Leonardo da Vinci or Vincent van Gogh in order to explain the way they paint. These doctors implicitly assume that if an artist were healthy, he or she would paint realistically.

We might also ask this question: What is this reality that artists should imitate? Is it the superficial appearance of things? Is it some spiritual or psycho-logical reality? Some investigators are sure that sense perceptions color reality—at least, the way things appear to one person may not be the way things appear to another. If perceptions vary, if our background and psychological life affect, if not control, everything we see, we have no way of knowing if our mind is giving us a true picture of objects "out there." What indeed is the reality that artists should reproduce?

Realism in History

Rarely in the history of art did artists try to be realistic and nothing else, but even their efforts call the notion of pure realism into question. Perhaps the ancient no-nonsense Romans, who had great veneration for their ancestors, strove to get as accurate a reproduction of the face as possible when they had their portraits carved (Figure 1-11). In some in-

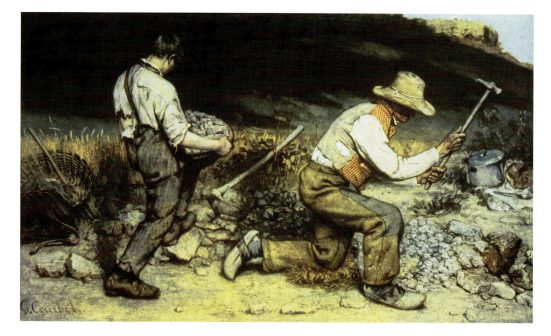

Figure 1-12 Gustave Courbet [French, 1819–1877], *The Stone Breakers*, 1849. Oil on canvas, 63 × 102 in. (160 × 259.1 cm). Destroyed 1945. Bridgeman Art Library.

Gustave Courbet actually saw the young boy and old man breaking rocks at the side of a road. Brought to his studio, they resumed their poses—a little awkwardly perhaps. His painting was meant as an indictment of such mind-numbing labor. The artist sympathized with the stone breakers as faceless members of the exploited working class. He bound them to the earth by raising the horizon far above their heads and hiding their faces from the viewer.

Viewers in 1849 complained about the socialist content of Courbet's painting; they also disliked its crudity, especially because the harsh dabs of paint on the surface pressed home to them the materialism of Courbet's Realist point of view.

stances they may have used death masks to achieve an unadulterated realism. Perhaps they also carved so many wrinkles and such gaunt cheeks into the face to impress people with their own ruggedness and stern character. The Roman head may be an exaggeration of reality, although no one can provide the original face for comparison. In either case, it was an artistic choice—not an artistic necessity—to produce such craggy portraits.

The French painter Gustave Courbet claimed that he painted only what he saw. He became the leader of a mid-nineteenth-century style that we now call Realism. He declared that he would paint only subjects that he could actually see and would celebrate their material existence in large paintings. However, his painting *The Stone Breakers* (Figure 1-12) was not very detailed or photographic looking. In fact, he sometimes applied the paint with a knife in a thick, pasty, rough texture. Many of his early viewers complained that his Realist paintings were not highly finished, that they were crudely painted. What *was* real in his painting was the thick texture and the material reality of the paint.

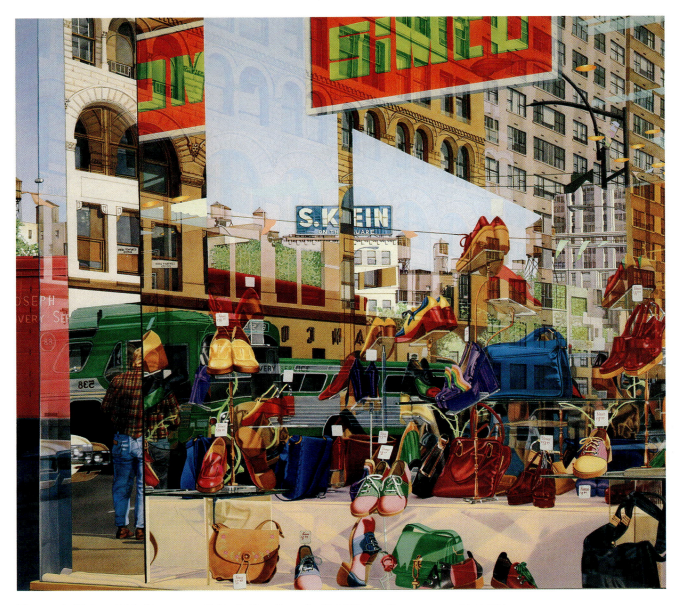

Figure 1-13 Don Eddy [American, 1944–], *New Shoes for H*, 1973. Acrylic on canvas, 44 × 48 in. (111.8 × 121.9 cm). Cleveland Museum of Art. © Nancy Hoffman Gallery.

A number of late-twentieth-century painters adopted a style called Photo-realism, which results in the precise realism of an ordinary photograph. Don Eddy adapted his painting *New Shoes for H* (Figure 1-13) from black-and-white photos that he took. As the name implies, these artists do not copy objects in the real world but instead copy the distinctive look of photographs, especially their uniformity and luminosity. Many Photo-realists go out of their way to depict highly reflective surfaces, such as a shop window. Eddy has put in sharp focus what is reflected in the window and what is displayed through and behind the window so that the difference between what is reality and what is illusion becomes blurred. The artist gives us far more than what is popularly meant by "realistic."

Prettiness

Some people prefer art to be pretty. These people usually want to look at only pleasant things and feel that there is already too much ugliness in

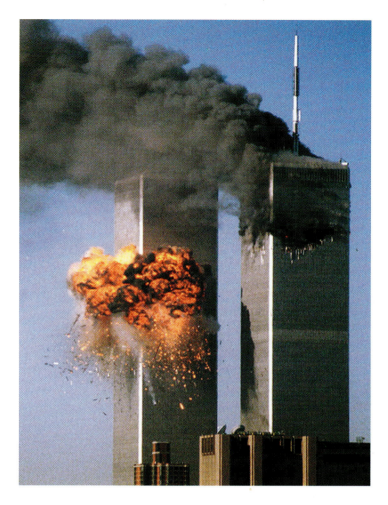

Figure 1-14 World Trade Center, September 11, 2001. © Reuters/Corbis.

this world. However, insisting that art be pretty limits art to one kind of expression. Because human experience is much richer, art should be free to reflect life in all its richness. It would be nice if everything in life were pleasant, but some of the most important things are not so nice. Birth and death can be rather painful; so can falling in and out of love. Grünewald's powerful painting (Figure 1-2) is not very pretty. News photos are often not very pretty either—photos of the terrorist attack on the World Trade Center (Figure 1-14) shocked the nation. Yet these awful images inspired moral indignation and the call for action. The overwhelming response to them demonstrates the potential for even horrid visual images to move us deeply.

THEORIES BASED ON THE FUNCTIONS OF ART

The liveliest debate about the nature of art in the last one hundred years or more has concerned not what makes something beautiful but whether art has a purpose. Since the late nineteenth century, many artists have claimed that their art does not serve a useful function outside art itself. They believe that to require art to serve a purpose would destroy an artist's freedom and creativity. Artists who feel that the essence of art lies in perfecting its purely formal properties rather than in serving a purpose are said to adhere to the doctrine of **art for art's sake.** This view was championed by James McNeill Whistler, who defended his painting *Nocturne in Black and*

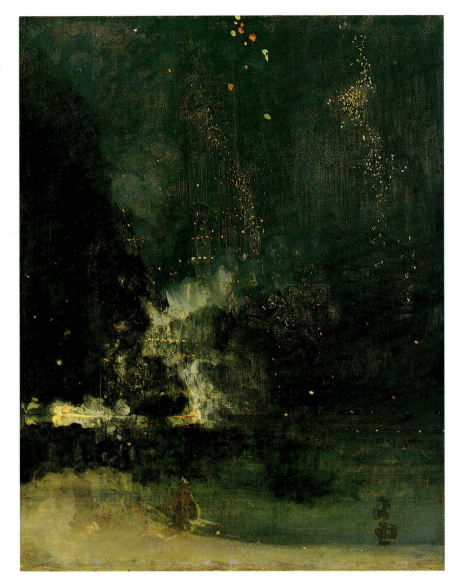

Figure 1-15 James McNeill Whistler [American, 1834–1903], *Nocturne in Black and Gold: The Falling Rocket*, ca. 1874. Oil on panel, 23 3/4 × 18 3/8 in. (60.2 × 46.8 cm). © The Detroit Institute of Arts.

The Victorian critic John Ruskin had this painting in mind when he denounced Whistler for "flinging a pot of paint in the public's face." Whistler sued him for libel. The artist won, but the judge awarded him only a penny in damages. At the trial and in his book *The Gentle Art of Making Enemies* (1890), Whistler defended his position: "Art should be independent of all clap-trap—should stand alone, and appeal to the artistic sense of eye or ear, without confounding this with emotions entirely foreign to it, as devotion, pity, love, patriotism, and the like."

Gold: The Falling Rocket (Figure 1-15) as primarily an arrangement of line, form, and color—divested of any outside interest.

Nevertheless, examples of the usefulness of art stretch way back into the past and continue in the present. The religions of the world have always used art to make unseen powers visible. Religious images have often expressed the gods' capabilities and have made their invisible spirit very tangible. It was also believed that gods, saints, and heroes on public display would teach lessons in moral virtue. Therefore, political authorities have often wanted art under state or church control so that only uplifting themes would be treated and so that vice would be exposed and the rewards of virtue demonstrated.

In the last several decades, many artists, rejecting art for art's sake, have devoted their work to contemporary causes such as equal rights or AIDS in order to change the moral behavior of their audience. Barbara Kruger (Figure 1-16) and other feminist artists have dedicated their art to exposing the signs and symbols that determine power and establish gender roles in contemporary society.

In ancient times, Aristotle thought that moral purpose is disclosed by whatever reveals character in art. Of course, painters and sculptors work not with speeches but with poses, gestures, and facial expressions—with body language—to disclose character. Plato used music to show how art has a moral

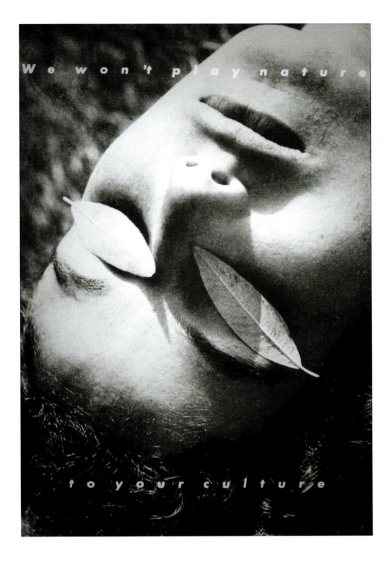

Figure 1-16 Barbara Kruger [American, 1945–], *Untitled (We Won't Play Nature to Your Culture)*, 1983. Black-and-white photograph, 73 × 49 in. (185.4 × 124.5 cm) (framed). Ydessa Hendeles Art Foundation, Toronto.

Barbara Kruger creates photomontages the size of small billboards, using old photographs and inscriptions printed in block letters across them. The cryptic, provocative statement "We Won't Play Nature to Your Culture" refers to the nature versus culture debate in the social sciences. She rejects the inferior role assigned to female *nature* compared to the high *culture* supposedly developed by males. In doing so, she also rejects the practice of the male-dominated art world to treat women in art as objects controlled by the male gaze. Ironically, the woman in the photograph covering her eyes with "nature"—two small leaves—refuses to look at anything but nature itself. Kruger's work is not an illustration with an explanatory text but, like a catchy advertising campaign, a visual totality of word and image that persuades.

effect. He believed that listening to music that had rhythm, grace, and harmony will bring those same good dispositions of grace and harmony into the soul and consequently educate young people in good moral behavior. In Plato's thinking, the moral nature of art lies in its formal properties. A harmonious style produces good behavior; a bad style produces bad behavior.

Morality in art continues to be debated in the present day along the lines devised by Aristotle and Plato. On the one hand, censors and moralists condemn a painting or a statue or a film if the actions of the characters do not meet the moral standards of the community. On the other hand, many modern artists and critics focus on the formal properties of the same work and declare that they are good for us

or good in themselves and not harmful to moral behavior. These issues of morality and censorship are not easy to resolve, and they are complicated by our strong tradition of freedom of expression. The issues would never be so hotly debated if everyone were to agree that art has no purpose.

THEORIES BASED ON COMPARISONS BETWEEN THE ARTS

For a long time, artists and critics defined art by comparing it to literature, specifically poetry. Following this idea, artists not only painted pictures or carved statues that told stories, but they

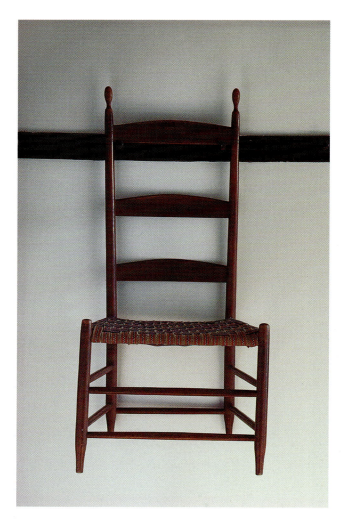

Figure 1-17 [American], side chair, ca. 1850. Courtesy Shaker Village of Pleasant Hill, Harrodsburg, Kentucky.

The United Society of Believers in Christ's Second Appearance, commonly called Shakers, established separatist religious communities throughout the northeastern United States, where they manufactured chairs and other household goods for their own use and for sale to the outside world. They did not invent the slat-backed chair with a woven seat but rather refined its design according to their religious beliefs of simplicity, practicality, and lack of worldliness. The only decoration on the chair is the egg-like pommels at the top. The slats have a gradual curve along the top and a straight edge along the bottom. The high back contrasts with the broad seat. The plain uprights of the chair, gracefully tapered at the ends, are as elegant and delicate as possible.

also tried to obey the rules laid down for epic, lyrical, or tragic poetry. Long ago, in the seventeenth and eighteenth centuries especially, critics tended to praise visual art that told a story with a moral message, as did literature, and to denigrate paintings such as landscapes that merely copied nature.

Just as our vocabulary distinguishes between the uncommon art of poetry and the everyday use of language, so too do many people distinguish between the **fine arts** as opposed to the **applied arts** or crafts. The English language defines the fine arts as those to be enjoyed for their own sake, whereas the applied arts perform some function. However, the distinction is difficult to maintain. Architecture almost always serves a practical function. Conversely, a craft object, such as a finely wrought Shaker chair (Figure 1-17), made for a useful purpose, may express as much formal and cultural significance as any painting or sculpture displayed in a museum of fine art.

Other artists and theorists, following Plato, have tried to understand the visual arts by comparing them to music. Wassily Kandinsky, for example, when he painted *Fragment 2 for Composition VII* (Figure 1-18), one of his earliest abstract paintings, believed he could produce a heightened spiritual effect by intensifying the musical elements in his painting. Just as music has the elements of rhythm, harmony, and melody, the visual arts have rhythmic lines, melodious forms, and harmonious colors. Both the visual elements and the corresponding musical elements would therefore elicit the same mental and physical responses in a person. But this comparison involved more than just these similarities. It was also believed that certain lines or shapes or colors correspond to certain musical sensations because of the phenomenon of **synaesthesia.** According to this theory, one sense organ in the body will respond to the stimulus of another. For example, a certain sound might cause a person to experience a certain color. Kandinsky believed that synaesthesia has a basis in human physiology and that individual sounds have an exact equivalent on the color scale. In the act of painting *Fragment 2 for Composition VII,* he made himself aware of these musical relationships.

Figure 1-18 **Wassily Kandinsky** [Russian, 1866–1944], *Fragment 2 for Composition VII*, 1913. Oil on canvas. 34 1/2 × 39 1/4 in. (87.6 × 99.7 cm). Albright-Knox Art Gallery, Buffalo. Room of Contemporary Art Fund, 1947. © 2006 Artists Rights Society (ARS), New York/ADAGP, Paris.

SYMBOLIC COMMUNICATION THEORY

Since ancient times, the discussion about art has focused on what kind of object qualifies for the category of art. In modern times, the discussion has shifted to what sort of experience the artist and viewer have when they create art or when they see art. Concentrating on the experience of art makes clear that, fundamentally, art is a form of communication. Artists, in making a work of art, create something for somebody else to see and share. The study of this communication between the artist and the viewer through the medium of the artist's signs and symbols has been called **semiotics.**

Since art is a sign written in its own distinctive, visual language, communication presupposes that both the sender and receiver of the message understand the same basic language. Very often the receiver has to learn the visual language of the sender for communication to take place. The culture of one may be very different from the culture of the other. Sometimes, contemporary artists revise the visual language of their culture and invent something new. In this case, the feeling often arises that the artist is ahead of the times.

In short, visual art, like any living language, does not have static, rigidly set signals that follow inviolable rules. Both the sender and receiver operate within a fluid context in which the significance of the visual signs is constantly changing. The language of art is not set in concrete; it is not universal. To a great extent, the vital context surrounding the visual language gives the art signs their meaning, just as

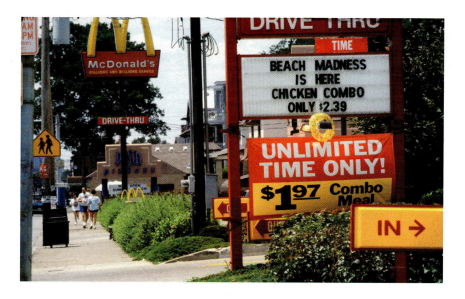

Figure 1-19 McDonald's road sign. Photo courtesy University of Louisville Art Department.

the meaning of a spoken language is derived from its immersion in the surrounding culture. If Thomas Jefferson traveled in a time machine to one of our streets, he would have a lot of difficulty understanding what he saw. If the third president saw the sign illustrated in Figure 1-19, how could he understand "beach madness" and "chicken combo"? Those words existed two hundred years ago, but their meaning is modern.

But art is also a **symbolic communication.** Art is not a mere sign substituting for something else, like an element of Morse code or an algebraic letter in an equation. A highway sign tells us unequivocally the distance that lies ahead; the picture of a rose in a botany textbook describes a certain kind of flower and no other. But the visual arts convey a different kind of information. The signs in art operate like symbols—understood here in a broad sense, as a sign that stands for a rich kind of meaning, textured with memories and colored with emotions. Art goes beyond traditional visual symbols such as a halo standing for sainthood or a skull for mortality. The symbols of art include lines, colors, textures, shapes—every means of visual expression.

To understand this interpretation of *symbolic,* let us take as an example a line of poetry by Robert Burns: "My love is like a red, red rose." The word *rose* is a symbol—a simile, to be exact—for the poet's girlfriend. The poet is not telling us that his loved one has a red face, has thorns, and smells; no, the poet means that his beloved is delicate, precious, lovely, and in possession of all the other good qualities we associate with roses. The personal experience we have of roses is transferred to the beloved.

Because poetry and the visual arts depend on each person's experience, communication through the symbols of art can be compared to the "knowledge" we have of other people in friendship. We may know some facts about a good friend, but mostly we have intuitions and feelings about her or him and memories of things we have lived through together. The most important "facts" we know about our friend—a smile, a walk, a turn of phrase—are always charged with emotions. The symbolism of art communicates this kind of lived experience in layers of meaning interwoven with emotional association.

The signs or visual symbols in Frida Kahlo's *Self-Portrait with Monkey* (Figure 1-20) communicate a great deal of emotionally charged information. We immediately focus on Kahlo's dark, penetrating eyes, hooded by thick V-shaped eyebrows, and her pursed red lips. She has turned her face to the side, but the eyes, brows, and lips seem to move forward and thus increase the intensity of her riveting expression. The unnatural length of her neck and her dark, pulled-back hair help to accentuate the face. A dark-haired monkey, wearing a leash, puts its arm around her neck. Kahlo also wears a collar—a strange piece of bent wood. A leafy background tends to push her face forward. The artist exaggerated the veins and hairy texture of the leaves, the hair-like growths on the white branches, the monkey's hair, and her own

Figure 1-20 **Frida Kahlo** [Mexican, 1907–1954], *Self-Portrait with Monkey*, 1938. Oil on masonite, 16 × 12 in. (40.6 × 30.5 cm). Albright-Knox Art Gallery, Buffalo. Bequest of A. Conger Goodyear, 1966.

Figure 1-21 **Marcel Duchamp** [French, 1887–1968], *Fountain*, (second version), 1950. Ready-made glazed sanitary china with black paint, 1 ft. (30.5 cm) high. Philadelphia Museum of Art, Philadelphia: Gift (by exchange) of Mrs. Herbert Cameron Morris. #1998-74-1 © Photo Graydon Wood, 1992 © 2006 Artists Rights Society (ARS), New York/ADAGP, Paris/Succession Marcel Duchamp.

facial hair. All these clues communicate a disturbing and forceful personality.

Different viewers may interpret Kahlo's self-portrait differently from one another and differently from what the artist herself may have intended. Interpretations differ because the life experience that the artist has and the life experience that the viewer has are never the same. Experience is personal. The differences among people are one of the reasons that art, which conjures up personal experience, could never be a direct, one-to-one form of communication like the highway sign. Art communicates something like personal knowledge; the depth of that communication depends on the amount and quality of experience that the artist and viewer have accumulated.

The experience of art does not require a particular class of objects. Almost any material in any size or shape can give us the experience of art, provided that we view it symbolically. Theorists were investigating the wrong thing when they searched for ob-

No work of the twentieth century seems to have caused more discussion about the nature of art than Marcel Duchamp's *Fountain*. In 1917 Duchamp challenged every accepted definition of art by submitting the piece as the work of an unknown artist, R. Mutt, to a New York City exhibition of independent artists which had advertised that it would accept every work submitted. The exhibition committee excluded Duchamp's work, however, not just because they thought it indecent but because they questioned whether it was art. Nevertheless, in *Fountain* Duchamp boldly asserted that art is whatever the artist says is art, even a ready-made object that he had found in the plumbing supply outlet of the J. L. Mott Iron Works company. Art, he declared, resides in the intention of the artist.

jects that combined the right amount of the real and the ideal, or the right amount of representation and imagination. Art lies not in the thing itself, but in the intention of the artist and viewer to see something as art, as Marcel Duchamp demonstrated radically in his *Fountain* (Figure 1-21) of 1917. Duchamp explained his work in a statement that defends his def-

inition of art: "Whether Mr. Mutt with his own hands made the fountain or not has no importance. He chose it. He took an ordinary article of life, placed it so that its useful significance disappeared under the new title and point of view—created a new thought for that object."[4]

But Duchamp's assertion of the supremacy of the artist's choice does not fully explain why *Fountain* is art. If a professional plumber had displayed a urinal in a nearby shop and called it art, few people would have taken note of it, and the historical results would not have been the same. Because Duchamp was an established artist and because *Fountain* was intended to be seen in an art gallery, the public was asked to experience *Fountain* as art. For better or for worse, the viewer was asked to appreciate its visual symbols (its lines, shapes, texture, and color) along with its subject matter—especially now that, turned on its side, signed, and labeled, *Fountain* was dissociated from its practical function.

In short, *Fountain* is art because the art establishment gave its stamp of approval to it—which it did not do to the urinal of the plumber. Some have called this the **institutional theory** of art. In other words, art is what the art world says is art. For un-less the art establishment recognizes someone as an artist (Duchamp went to art school and had an exhibition record as an artist), unless the artist displays the work in an exhibition or gallery, unless critics, museums, textbooks, or other artists give the work some form of acceptance, the work will never become art. The institutional theory has a ring of cynicism to it—as if any other definition of art is impossible—but it also has a note of practical truth.

Since artist and viewer can turn on the artistic faculty over any kind of object—as *Fountain* so strikingly demonstrated—perhaps we have been asking the wrong question. Perhaps we should be asking not "What is art?" but "When does art happen?" Art happens when the artist or viewer intends to see something as art, very often when the art world has signaled that it is to be experienced as art.

The experience of art can reveal our inner selves and disclose the hidden relationships among things in the world. It can treat us to some delightful surprises, amazing discoveries, stimulating feelings, and remarkable insights. Discoveries and insights inevitably tickle the soul—or sometimes make it cry. Art ranks alongside love and friendship as one of the nicest ways to get to know life.

AT A GLANCE

What Is Art?

Aesthetic Theories

Aristotle	Art is imitation or mimesis.
	An artist should imitate only ethically superior characters or demonstrate universal ideas.
Plato	Imitation is twice removed from true reality.
	Art is inspiration, or possession by the divine.
Yoruban	Art is moderate imitation.
	Art exhibits coolness, detachment.

Psychological Theories

Right-brain theory	The left brain controls language, logic, and sequencing; the right brain controls art and intuits spatially.
Perceptual process	Art represents what the eye sees.
Conceptual process	Art depicts what the mind knows.

The Artist as Outsider Theory

Avant garde artists	Artists are prophets who operate ahead of their times.
Outsider artists	These are self-taught artists who work apart from the art establishment.

Folk art	Folk art produces traditional arts and crafts that are passed down within a minority culture.

Popular Theories

Realism	Art is the same as reality.
	Artists who paint in a nonrealistic fashion must be incompetent or ill.
Prettiness	Art cannot be ugly.

Theories Based on the Functions of Art

Art for art's sake	Art has no function but to serve as art itself.
Religion	Art instructs, inspires, makes the invisible visible.
Morality	Art provides models for behavior (Aristotle).
	Art inspires by its good style (Plato).

Theories Based on Comparisons Between the Arts

Art as poetry	The rules of literature apply to art.
Fine arts	They are distinct from the applied arts, which serve a function.
Art as music	Art affects correspondences between the senses.

Symbolic Communication Theory

Semiotics	Art communicates by visual signs between artist and viewer.
Symbolic communication	Art is analogous to the multileveled experience of a person in friendship.
Institutional theory	The art world tells us when to experience art.

INTERACTIVE LEARNING

Flashcards

Artist at Work: Vincent van Gogh

Companion Site: http://art.wadsworth.com/buser02

Chapter 1 Quiz
InfoTrac® College Edition Readings
Talking Flashcards
Online Study Guide

2 Subjects and Their Uses in Art

Figure 2-1 [Seneca Iroquois, Native American], *Rim-Dweller*, 1920–1925. Basswood mask, 11 in. (27.9 cm) high. Allegheny Reservation, New York, private collection. Photo by Peter T. Furst.

ICONOGRAPHY

Who is *Rim-Dweller*? (See Figure 2-1.) Why is his face distorted? Viewers are always curious to know what a work of art represents and what is happening in it. In the jargon of art criticism, the subjects and symbols of art are called **iconography.** The Greek roots of the word mean "picture writing."

The face of *Rim-Dweller* strikes most viewers as unusual because of the way it was carved. The mouth, eyes, and nose are larger than those of normal human figures. The nose is twisted, and the eyes are askew. Deep ridges cut into the surface of the face. The way in which an artist renders a work of art is called **style.** It includes all the formal properties of art—lines, colors, shapes, masses, and texture. These visual elements will be discussed in Chapters 3–6.

If style takes in everything that answers the question *how* is it done?, iconography, then, includes everything that answers the ques- **Iconography** MODULE tions *who* is it? or *what* is it?

SIGNIFICANCE

The iconography of a work discloses only part of its meaning, or **significance.** To interpret the iconography properly, one needs to understand the culture that sustained it—the historical, social, economic, and psychological factors that conditioned it. The style in which a subject is rendered may also radically alter its significance. Style and iconography combine and transform each other. Together, they generate something more than, and different from, the mere addition of subject matter and form. In this instance, one plus one equals three.

The large twisted features and deep ridges of *Rim-Dweller* may seem puzzling, but when we

24

learn about the cultural context of the Iroquois mask, its distinct appearance starts to make sense. In fact, the artist has embodied the significance of the work in the carving of the mask. The mask represents Rim-Dweller, the grandfather of all the grandfathers, the great spirit who lives at the edge of the world. Rim-Dweller's face was twisted when it collided with a moving mountain—the collision transforming him into a beneficent spirit. Now we can not only see why the nose and mouth are twisted but also feel in the circular lines of the face the force of the impact and sense Rim-Dweller still staggering from the blow. The hair to one side of the face accentuates the feeling of being off balance. Perhaps the big curve of the smiling mouth hints at a kindly grandfather who helps cure disease and drives away misfortune. The subject, Rim-Dweller, comes alive in the context of Iroquois culture, and the style of the mask helps communicate that meaning.

We have tried to discover the significance that the mask *Rim-Dweller* had for the Iroquois artist and the Iroquois audience that first saw it. Through a discussion of its content and form we can perhaps open a window onto their culture at the time the piece was made. But since our culture is very likely quite different from theirs, the work will probably never have the same meaning for us, try as we might to experience it.

Figure 2-2 Clyfford Still [American, 1904–1980], *1948–C*. Oil on canvas, 80 7/8 × 68 3/4 in. (205.4 × 174.6 cm). Hirshhorn Museum and Sculpture Garden, Washington, D.C. Joseph H. Hirshhorn Purchase Fund 1992 (92.8).

KINDS OF SUBJECTS

Often, the titles given to many works of art do not provide a lot of information. Titles such as *Still Life* or *Landscape* or *Portrait* merely indicate the obvious. These labels refer to the general nature of the subject: still life (a grouping of small objects), landscape (a nature scene), portrait (a representation of a certain person). Other categories include the nude, religious art, personification and allegory, fantasy, and subjects drawn from everyday life, or genre (pronounced *zhahn-ruh*). All these subjects often performed certain functions, or to put it more accurately, the functions that these subjects served helped give them their meaning.

At times a traditional iconographic category acted only as a springboard for the artist's fantasy, and the artist produced something totally unexpected out of it. A picture titled *Landscape of My Mind* might look like a still life. In modern times, just to be provocative, an artist might choose an arbitrary title derived from a random place or person. Or the piece might be labeled simply *Untitled*. The American painter Clyfford Still (Figure 2-2) labeled his works with a simple code letter and the date of execution. These personal associations and unfathomable titles spur us to look a little harder and think more carefully about what we are seeing.

Figure 2-3 **Shelton Jackson "Spike" Lee** [American, 1957–], *Malcolm X*, 1992. Denzel Washington as Malcolm X. © Warner Brothers/The Kobal Collection.

Figure 2-4 **Emanuel Leutze** [German, 1816–1868], *Washington Crossing the Delaware*, 1851. Oil on canvas, 12 5/12 × 21 1/4 ft. (3.78 × 6.48 m). Metropolitan Museum of Art, New York. Gift of John Stewart Kennedy, 1897 (97.34). © Bettmann/Corbis.

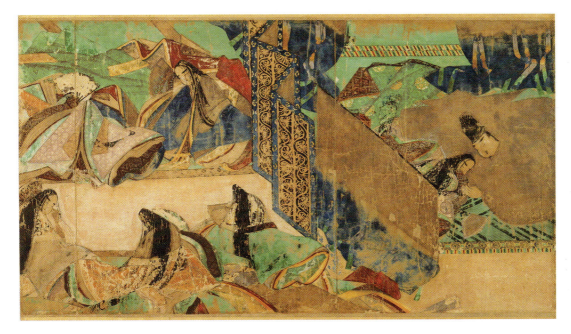

Figure 2-5 Attributed to Takayoshi [Japanese], illustration of the Yadorigi chapter of *The Tale of Genji (Genji Monogatari)*, late Heian period, twelfth century. Color on paper, 8 1/2 in. (21.6 cm) high. Tokugawa Museum, Nagoya, Japan.

The Tale of Genji describes Japanese court life and the intrigues of the aristocracy of Kyoto. Lady Shikibu Murasaki's long novel hints at subtle relationships at court, very often through nuanced descriptions of flowers and the costumes and the calculated adjustment of painted screens in a room. This illustration of *The Tale of Genji* shows just this sort of restrained and intimate narrative. It is early morning. The ladies-in-waiting, at the top and bottom on the left, are still asleep. On the right, in cramped space behind a folding screen and a blue silk curtain, a gentleman, returning from a rendezvous with another woman, tries to console his weeping lover. The mask-like heads of the figures, who wear mounds of heavy, starched clothing, do not express much personality or emotion because the decorum and etiquette of court life are more important. Instead, the awkward space at the right conveys the mood of the story.

NARRATIVE ART

Religious, mythological, and genre subjects often tell part of a story that in actuality has a beginning, middle, and end. Even though many events in religion and myth are legendary and not necessarily factual, critics since the Renaissance have called these storytelling pictures **history paintings**. Narratives also appear in drawings, prints, photographs, films, and sculpture, but no one has come up with another term for these dramatic images. History painting declined by the end of the nineteenth century; however, the tasks of history painting have blossomed in the movies, where filmmakers have frequently visualized biblical subjects and historical events, such as the life of Malcolm X (Figure 2-3).

Within the category of history painting, some artists try to re-create events in secular history, as in the popular icon of the American Revolutionary War, *Washington Crossing the Delaware* (Figure 2-4). Since the time of the ancient Sumerians, Assyrians, and Egyptians, societies have recorded victorious battles and other historical events in works of art, generally as propaganda to enhance the power of the state. Other narrative artists illustrated scenes from great works of literature such as Shakespeare's *Hamlet*, Milton's *Paradise Lost*, or Lady Shikibu Murasaki's eleventh-century Japanese novel *The Tale of Genji* (Figure 2-5). However, compared with the great number of religious and mythological history paintings, only a small percentage of them portrayed secular fact or literature.

Figure 2-6 **Thomas Eakins** [American, 1844–1916], *The Gross Clinic*, 1875. Oil on canvas, 96 × 78 in. (234.8 × 198.1 cm). Jefferson Medical College, Jefferson University, Philadelphia.

Dr. Samuel Gross has just made an incision along the underside of the young man's thigh. With blood coating his fingers and scalpel, he pauses to lecture to the students who surround him in the amphitheater of Jefferson Medical College, Philadelphia. The operation takes place shortly after the invention of anesthesia but a few years before the discovery that germs cause infection. A towering presence, Gross commands attention. The emotion of the patient's mother contrasts with the seriousness of the attendant doctors. Gross was renowned for making surgery a respected branch of the medical profession by turning it into a vehicle for healing in pioneering operations such as the one illustrated in the painting—removing dead bone from the patient's leg.

Eakins hoped that his ambitious and dramatic painting would make his reputation when he submitted it to an exhibition in celebration of the Centennial of the United States in 1876, but the squeamish exhibition committee rejected it. It hung instead in an out-of-the-way medical exhibit at the Centennial Exposition in Philadelphia.

The dramatic arrangement of human figures in history paintings sometimes appears in other categories as well. Small-scale mythological or biblical figures inhabiting a landscape may tell a story, producing a mixture of categories that might be called a historical landscape. Thomas Eakins, in his painting *The Gross Clinic* (Figure 2-6), transformed a group portrait of Dr. Samuel Gross and his colleagues into a history painting by depicting Gross in the midst of surgery on a man's leg while he lectures to his medical students. Although each face reproduces the likeness of an individual, the figures act out an intense drama.

As Eakins does so well in *The Gross Clinic*, history painters have to illustrate events with appropriate actions and expressions that will tell the story clearly and convincingly. Because of the difficulty of inventing these actions and expressions and because of the nobility of history painting's aims, European and American critics for many centuries considered history painting the highest kind of art. In effect, the nobility and difficulty of the subject matter determined whether one work of art was better than another. Few Western critics today would maintain that certain kinds of subject matter are essentially better than others. Because iconography constitutes only part of the art experience, employing one kind does not automatically result in a better work of art.

THE NUDE

The visual arts infrequently handle some subjects that are popular in other media—for example, boy meets girl, girl loses boy, and so forth. Although artists seldom tell love stories—except for scenes of the loves of the gods, as in Raphael's *Galatea* (Figure 1-7) and of course in films—they often dwell on the sensuous appeal of the male and female body. For centuries, Western art has considered the unclothed human figure—the **nude**—the prime example of how to do something "beautiful." The nude has almost become a stereotype of something artistic. Very often, artists call their nude figure Venus or Eve or Hercules or The Dance, but the main emphasis of the work is really the beauty, grace, sensuousness, and expressive potential of the human body. What other object in nature possesses the same range of emotional and psychological expression? How can artists show the body if it is covered up?

Figure 2-7 Polyclitus [Greek, fifth century BCE], *Spearbearer (Doryphoros)*. Roman copy after a bronze original, original ca. 440 BCE. Marble, 83 in. (210.8 cm) high. Museo Nazionale, Naples, Italy.

The ancient Greeks were the first to celebrate the nude figure in major works of art such as Polyclitus's *Spearbearer* (Figure 2-7). Certain aspects of Greek culture explain why many Greek statues are nude. Nudity was more common in ancient Greece than in modern society: Greek men exercised in the nude, and they competed in games such as

Figure 2-8 Style of Phidias [Greek, active ca. 490–430 BCE], *Three Goddesses*, 448–431 BCE. Marble, over-life-sized. From the east pediment of the Parthenon. British Museum, London. © Ancient Art & Architecture Collection Ltd.

The goddesses have been identified as Hestia and Aphrodite, who is reclining on the lap of her mother, Dione. The goddesses were part of a group of Olympian gods witnessing the birth of Athena, the patroness of Athens. The seated and reclining figures once fit into the triangular gable or pediment at the front end of the temple. Phidias enlarged the scale of the goddesses to make them more heroic and also to make them more visible; they were about thirty feet above the head of the viewer. He also devised a kind of clothing that clings to the figure in some places and reveals the body underneath.

the Olympics in the nude. Nudity was a sign of civilization, not a sign of shame; only barbarians (foreigners) wore pants. In Greek thought, man was the measure of all things, the focus of the universe, and the only subject truly worthy of study. By using reason, his highest faculty, man could discover the essential laws of nature. Even their gods were depicted in the image of man. (Women played little part in the thought and public life of ancient Greece.)

Polyclitus expressed these high ideals in his nude figure *Spearbearer*—a heroic and perfected athlete or warrior at the peak of his powers with his intellect fully in control of his body. No emotion disturbs his concentration; no individualized traits spoil the general perfection of his body. Polyclitus made the nude represent humankind's aspirations for a well-ordered existence—an ideal, not an actual reproduction of reality.

Although his statue resembles ordinary human appearance, Polyclitus achieved *Spearbearer*'s ideal perfection by means of numerical proportions. He determined the dimensions of the anatomy by whole-number ratios such as 2:1 or 3:1 so that, for example, the fingers were in proportion to the palm of the hand, the palm of the hand to the forearm, the forearm to the upper arm, and all parts to each other throughout the entire body. These numbers did not represent the average size of the hand, arm, or head in human beings; the interrelated numbers represented norms—what a head or chest or leg ought to be. Since numerical proportions remained constant and were thought to embody universal truths, they expressed an ideal beauty.

For a long time, the Greeks never depicted the female nude. For instance, *Three Goddesses* (Figure 2-8) from the Parthenon and other female statues during the golden age of ancient Greece, the fifth century BCE, were usually fully covered. Then, in the fourth century BCE, an Athenian sculptor named Praxiteles carved *Aphrodite of Knidos* (Figure 2-9), a statue of the nude goddess of love and passion, and placed it in her temple on the island of Knidos. Its beauty reportedly drove some men wild.

Modern standards of female beauty differ considerably from those portrayed in the Greek Knidian Aphrodite, who has broad shoulders and a powerful frame. The discrepancy exists in part because Praxiteles constructed his female figure according to a system of proportions. The distance between the nipples of the breasts is the same as the distance between a breast and the navel. The same measurement controls the distance between the navel and the groin. Since the breasts are so separated, they do not seem to be organic parts of the body. Furthermore, the sculptor conceived the goddess as heroic, imposing, and larger than life. In *Spearbearer, Aphrodite*, and countless other human figures, the ancient Greeks established in Western culture the possibility that male and female nudity in art stands for a heroic and ideal existence.

Some cultures around the world reserve nudity for certain undesirable types, such as prisoners, victims, or the inhabitants of hell. Other cultures accept nudity as a matter of course—without the connotations of Greek nudity. Alongside Buddhist art in India, there often appear very sensuous and appealing nude representations of popular gods of fertility—the male god Yaksha and the female god

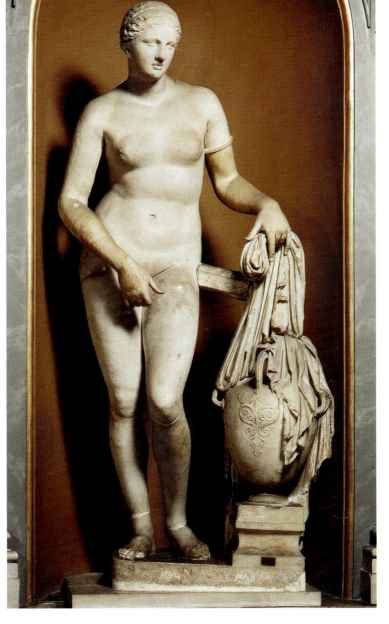

Figure 2-9 Praxiteles [Greek], *Aphrodite of Knidos.* Roman copy after a fourth-century BCE original. Marble, 80 in. (203.2 cm) high. Vatican Museums, Rome. © Scala/Art Resource, NY.

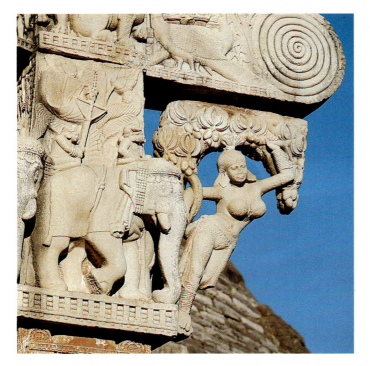

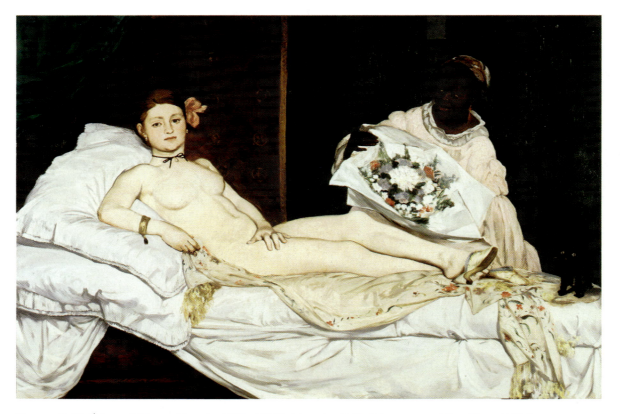

Yakshi. The famous *Yakshi* in Figure 2-10 serves as a carved stone bracket on the East Gate of the Great Stupa (Shrine) at Sanchi (see Figure 15-30). Her limbs are entwined in a fruit-filled tree, and she strikes the tree trunk with her left foot in the belief that the touch of a beautiful woman will cause the tree to blossom. Her whole body twists in voluptuous, sinuous S-curves. She welcomes the visitor to the austere Buddhist stupa with the promise of the pleasure of the senses. The frank sensuality of the Yakshi differs from the reserved and ideal sensuality of the Greek goddess Aphrodite.

The French painter Édouard Manet challenged, and revitalized, the Western tradition of the nude. When he exhibited his *Olympia* (Figure 2-11) in 1865, it provoked a torrent of abuse. The painting was considered indecent, vulgar, and ugly. For the next one hundred years, many art critics defended Manet's painting by praising its formal properties—its lines and brushstrokes—as harbingers of modern art. Recently, historians and critics have paid

Figure 2-10 [Indian], *Yakshi (Tree Goddess)*. Early Andhra period, first century BCE. From the East Gate of the Great Stupa at Sanchi, India. © Robert Harding Picture Library.

Figure 2-11 Édouard Manet [French, 1832–1883], *Olympia*, 1863. Oil on canvas, 51 × 75 in. (129.5 × 190.5 cm) Musée d'Orsay, Paris. © R.M.N./Art Resource, NY.

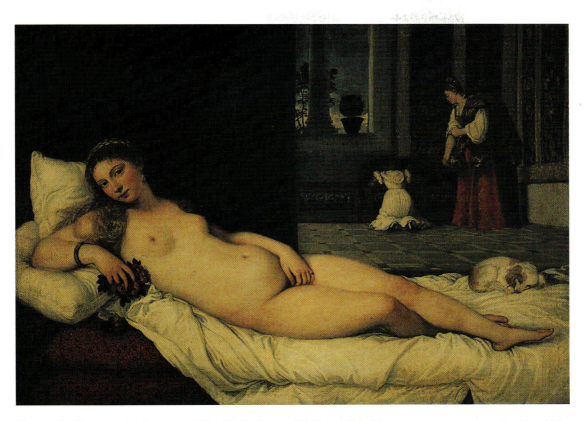

Figure 2-12 Titian [Italian, ca. 1490–1576], *Venus of Urbino*, 1538. Oil on canvas, approximately 48 × 66 in. (121.9 × 167.6 cm). Galleria degli Uffizi, Florence. ©Canali Photobank, Milan.

more attention to the iconography of *Olympia* and have come closer in their judgment to the public's initial shocked reaction in the nineteenth century. Manet's depiction of the nude was indeed new and different.

Manet modeled his painting on a famous work of Renaissance art, Titian's *Venus of Urbino* (Figure 2-12), which Manet himself had copied about ten years earlier. The pose and several other features are the same. But Manet's reclining nude is alert. Her head is erect; her hand clutches her thigh. No doubt she is coolly examining a male visitor, who alarms the cat and who may have sent the flowers the maid is unwrapping. Olympia wears an impertinent and unperturbed expression. More importantly, Olympia is a specific person with a young, thin, taut body—not the statuesque, smooth, and rounded Venus imagined by Titian. In Manet's time, an idealized image of a goddess was considered high art; a matter-of-fact depiction of an actual nude was an outrage.

RELIGIOUS ART

Works of **religious art** such as the Iroquois mask and the statues of Aphrodite and Yakshi make tangible the gods, goddesses, and spirits of a people, as well as their beliefs and hopes. This crucial role dates back to the very beginning of art, when Stone Age cave dwellers drew animals on the walls deep within the earth, as in *Hall of Bulls* (Figure 2-13), at Lascaux, France, to secure the well-being of the community by controlling, through art, the forces that were beyond human powers. Visual images, which can create a presence and stir emotions, have a natural magic that makes them the immediate ally of religion. Almost every civilization before the modern era was permeated with religion's sense of the mysterious, and many natural events received supernatural explanations. Since the arts have powerful resources to stimulate the imagination, from the start most societies seem to have used visual images to reach unseen forces to control their power or solicit their help.

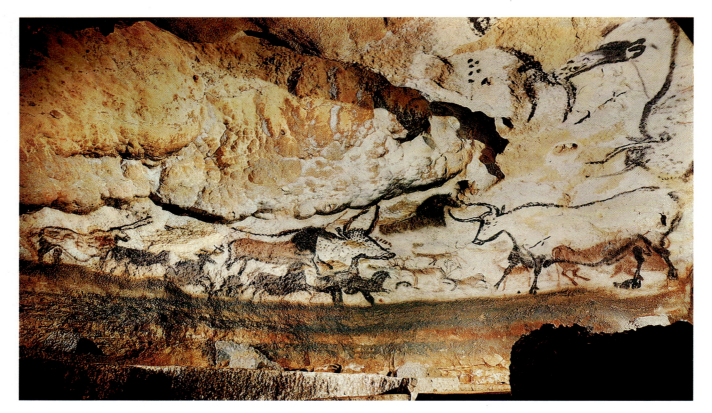

Figure 2-13 *Hall of Bulls*, ca. 13,000 BCE. From Lascaux cave, Dordogne, France. © Hans Hinz: Jean Vertut.

Investigators have put forward numerous proposals to give some meaning to the prehistoric cave paintings in northern Spain and southern France. One hypothesis claimed that the images, through a magic ritual in the cave, provided success in the hunt. Another hypothesis maintained that the images ensured fertility for the herds on which the tribe depended. However, bone evidence in the caves shows that the animals the people killed are not the same as the animals depicted—mostly horses and bison. Recent scholars have contended that the caves were covered with animals systematically, in carefully laid-out compositions, to illustrate a mythology or system of ideas. Shamans—interpreters of the spirit world—likely painted the caves to record and pass on to future generations the learning and mores of the people encoded in the images of the animals.

Many religious objects, now displayed for aesthetic pleasure, have been disconnected from the context where they once elicited spiritual forces. The mask *Rim-Dweller* (Figure 2-1), now in a private collection, once functioned in the living religious life of the Iroquois people. Such masks continue to be carved and worn by members of the Society of Faces in dances during the midwinter rites and other festivals, to cure disease and purify the Iroquois houses. The masks are respected by the Iroquois people for their spiritual power. The striking *Antelope Dance Headdresses* (Figure 2-14), made by the Bamana

people of Mali, Africa, and now on display in the Art Institute of Chicago, were actually worn in ritual dances to honor the heroic creator of agriculture, Chi Wara. Statues of the Virgin and Child, now in museums, once stood in churches, where they inspired mothers to pray for the health and safety of their children.

All these works lose something when they are isolated in private collections and museums and appreciated merely as pieces of art. In fact, groups of people have protested that their sacred objects do not belong in such displays and have demanded

Chi Wara dancers wearing antelope head-dresses. Photo by Pascal James Imperato.

Figure 2-14 [Bamana people], male and female antelope figures (Chi Wara dance headdresses), late nineteenth century. Wood, brass tacks, string, cowrie shells, iron, quills; male, 38 1/2 in. (97.8 cm) high; female, 31 1/2 (79.8 cm) high. From Mali, Africa. Art Institute of Chicago. Ada Turnbull Hertle Fund (1965.6-7).

The Chi Wara association teaches the cooperation of Bamanan men and women in food production. However, only the men participate in the initiation rite in which the male and female Antelope Dance headdresses are worn. Roy Sieber, an authority on African art, explains the meaning of the performance:

> The animals carved on the headdresses are composites of different species of antelopes. To the Bamana, these forest animals, with their grace and strength, embody the ideal qualities of champion farmers. The male is the sun, and the female is the earth; the fawn on her back symbolizes human beings. The fiber costumes worn with these headdresses represent water. As there must be a union of sun, earth, and water for plants to grow, there must be cooperation between men and women possessing the requisite physical and moral qualities to ensure that agricultural processes . . . take place on schedule to ensure a successful harvest.[1]

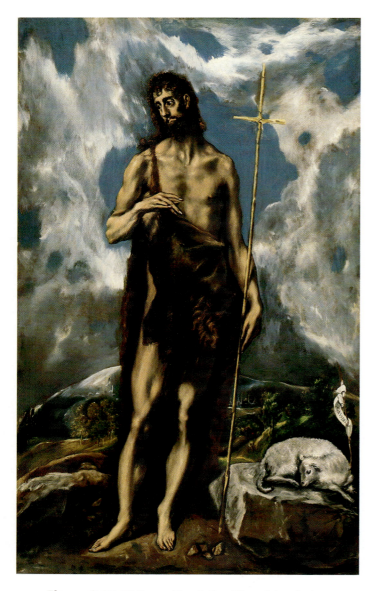

Figure 2-15 **El Greco** (Doménikos Theotokópoulos) [Spanish, 1541–1614], *Saint John the Baptist*, 1597–1603. Oil on canvas, 43 3/4 × 26 in. (111.1 × 66 cm). Fine Arts Museums of San Francisco. Funds from Various Donors, 46.7.

that they be returned. Some groups of Native Americans want objects housed in museum collections returned because of the sacred character of these objects—even though the museums may have received the items in good faith years ago. In recent years, some of their requests have been honored.

The interpretation of religious iconography is not always easy. In Christian religious art, saints frequently wear halos to indicate their heavenly status. They usually hold a symbol or an attribute to help identify who they are. In the painting *Saint John the Baptist* (Figure 2-15), by the Spanish artist El Greco, the saint is accompanied by a lamb because John identified Jesus Christ with the words "Behold the lamb of God." In medieval art, a young knight dressed in a suit of armor and lancing a dragon at his feet can be identified by these attributes as St. George, who rescued a princess by his heroic deed. At one time, biblical events and the saints and their attributes were familiar to most Westerners. That general knowledge of the Judeo-Christian tradition no longer exists.

Many people still know the story of Adam and Eve, the story of the Nativity (Christ's birth at Bethlehem), and the Crucifixion. Since the religious iconography of these events still forms part of the general culture, contemporary artists such as the photographer Andres Serrano can bank on the public's awareness of their meaning as he transforms them into a personal exploration called *Blood Cross* (Figure 2-16).

The main character of Raphael's painting *Galatea* (Figure 1-7) is a sea nymph, a goddess whose home is the ocean. As she sails across the water with her companions in her dolphin-drawn chariot, she turns sharply, attracted by the music of the one-eyed giant Polyphemus, who is depicted in an adjacent painting. Cupids up above get ready to shoot their arrows. However, Galatea is in love with Acis, whom jealous Polyphemus will eventu-

His attributes, winged hat and winged feet, identify the figure. Mercury sometimes carries the caduceus (pronounced kah-*doo*-see-us), a winged magic wand intertwined with snakes. The caduceus became a symbol of healing and is still used to identify the medical profession.

PERSONIFICATION AND ALLEGORY

Everyone knows that the giant statue in New York Harbor of a classically draped woman who holds up a torch stands for liberty (Figure 2-18). She is a **personification**—a human figure who represents a virtue or some other abstract concept. In another example, the blindfolded woman carrying a sword and a set of balanced scales personifies justice. She often stands as a reminder of justice in courtrooms and on courthouses. The gods of Greece and Rome often personify virtues or ideas. Venus means beauty or love; Mars is the god of war; Apollo, the sun god, represents culture and is the embodiment of male physical beauty.

Some modern advertising campaigns carry on the tradition of personification. Think of the Pillsbury Dough Boy, Colonel Sanders, or Mr. Clean (Figure 2-19). The Dough Boy may not stand for a virtue but merely identifies the product. The last two—the amiable colonel and the powerful Mr. Clean—might suggest qualities inherent in the product.

An allegory is very much like a personification in that it stands for an idea; in fact, figures involved in an allegory are often personifications. Strictly speaking, an **allegory** means two or more

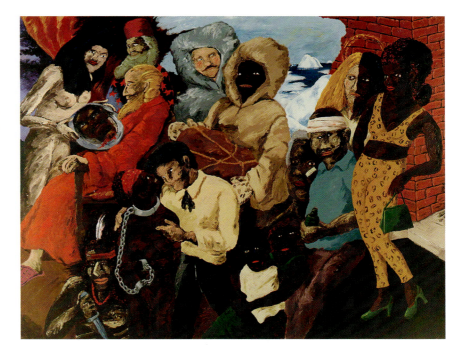

Figure 2-20 Robert Colescott [American, 1925–], *Knowledge of the Past Is the Key to the Future: Matthew Henson and the Quest for the North Pole*, 1986. Acrylic on canvas, 90 × 114 in. (228.6 × 289.6 cm). Phyllis Kind Gallery, New York and Chicago.

In his work, Robert Colescott does not paint traditional allegorical figures so much as historical characters who have become stereotypes in the West for virtue and achievement. The black Matthew Henson, who worked alongside the white Robert C. Peary to reach the North Pole in 1909, was all but forgotten when Peary received international fame and glory for his achievement. In this painting, Colescott depicts several other historical figures as blacks, thereby reversing racial stereotypes. In the upper left, Salome presents King Herod with the head of a black John the Baptist. In the lower foreground, an Elvis type embraces an enchained slave. Jesus Christ, in the upper right, is half black and half white. The painting provokes questions—What if Jesus were the product of an interracial marriage, as was Colescott himself? Colescott's exposure of racial bias in the writing of history opens the door to a different future.

personifications performing some action that has a conceptual or moral message. For example, two figures fighting each other might represent virtue overcoming vice. Allegory is an old method of narration that nearly disappeared in modern times. However, it has made a surprising comeback in contemporary works where artists such as Robert Colescott (Figure 2-20) use a very personal kind of allegorical figure to confront issues of public concern.

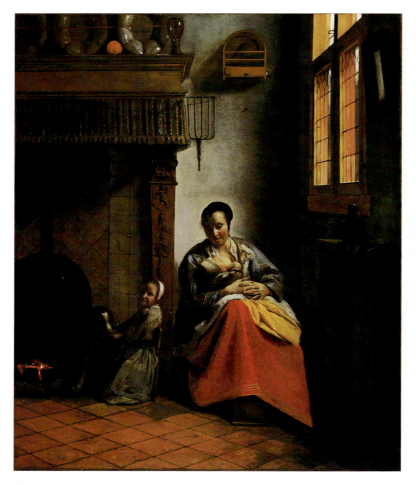

Figure 2-21 Pieter de Hooch [Dutch, 1629–1684], *Woman Nursing an Infant, with a Child Feeding a Dog*, ca. 1658–1660. Oil on canvas, 26 5/8 × 21 7/8 in. (67.6 × 55.6 cm). Fine Arts Museums of San Francisco. Gift of the Samuel H. Kress Foundation, no. 61.44.37.

In the well-lit corner of a tidy room, a woman breast-feeds the child on her lap. Her right foot rests on a foot warmer, a box containing a pan of hot coals. The older daughter feeds her dog in imitation of her mother feeding the child. The Dutch firmly believed that children received their most important lessons at home by following the example of their parents. In addition, contemporary moralists and doctors extolled breast feeding because the mother passed on moral and intellectual nourishment with her milk. On the wall above hangs a bird cage, which may allude to the role that mothers played in the home as captives of marital love, an idea reinforced by the cupids on the fireplace. De Hooch's genre painting celebrates the virtues of the good Dutch mother and housewife.

GENRE

Woman Nursing an Infant, with a Child Feeding a Dog (Figure 2-21), by the Dutch artist Pieter de Hooch, describes everyday activities in a middle-class home in seventeenth-century Holland. Artists like de Hooch deliberately avoid high-minded iconography taken from the Bible, mythology, or history and prefer to depict scenes of ordinary people in everyday life, or **genre**. Although it may look like a portrait of two people, their names were never known, and the artist intended each of them to be a type of person. The Dutch in seventeenth-century Holland were among the first to exploit this kind of subject by showing everyday domestic life and lively tavern scenes. The emergence of genre around 1600 in Europe probably indicates that the middle and lower classes were gaining in importance. Critics who believed in the superiority of history painting denigrated genre painting because it often reproduced down-to-earth and even lowlife characters. They thought it merely copied the real world and lacked imagination. But genre often creates a scene that has a moral message by illustrating symbols, proverbs, or other moral maxims.

In the eighteenth century, during the Age of Reason, genre became a vehicle for social satire. For example, the English artist William Hogarth published several series of satirical engravings, such as *The Rake's Progress* (Figure 2-22), genre subjects with a moral intent. In them, Hogarth exposed and ridiculed the vices of society so that they might be avoided and public morality might be improved—although it is unlikely that his engravings had the effect he desired.

Moralizing genre is still prevalent today, but it has primarily shifted from painting and printmaking to photography and television. Despite the great re-

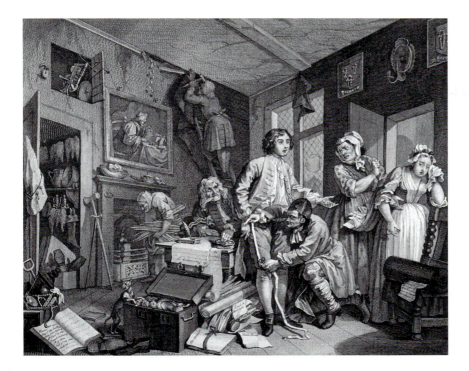

Figure 2-22 **William Hogarth** [English, 1697–1764], *He Takes Possession*, plate 1 from *The Rake's Progress*. Engraving. Metropolitan Museum of Art, New York. Harris Brisbane Dick Fund, 1932 (32.35 [28]). © Burstein Collection/Corbis.

The Rake's Progress, in eight separate scenes, tells the story of the misadventures of Tom Rakewell. In the first scene, plate 1, Tom drops out of college when he inherits a bundle of money from his miserly old father. While being measured for new clothes by a tailor, Tom spurns his pregnant sweetheart, Sarah Young, and sets out upon a life of lavish spending, carousing, and gambling.

laxation of the rules of public morality in modern times, many TV sitcoms have dealt with ordinary family life while developing an instructive moral. Photographers have often captured scenes of everyday life in their work. For example, the photographer Sophie Rivera has documented the life of the Puerto Rican minority in New York in a series of photographs taken on the subway. Her *Woman and Daughter in Subway* (Figure 2-23) captures not just the commonplace event of a subway ride but also the innocence of the child and the pride and fierce protectiveness of the mother.

In contrast to this interpretation of Rivera's photograph, many people have called Adolphe-William Bouguereau's (pronounced Boo-ger-oh's) *Indigent Family* (Figure 2-24) sentimental. **Sentimental** is the excessive or exaggerated use of

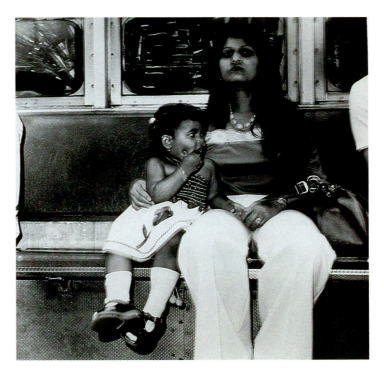

Figure 2-23 **Sophie Rivera** [American]. *Woman and Daughter in Subway*, ca. 1982. Silver gelatin print, 16 × 20 in. (40.6 × 50.8 cm). Courtesy of the artist.

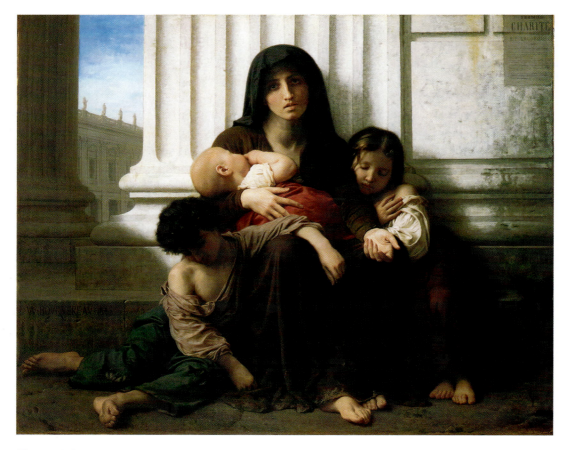

Figure 2-24 **Adolphe-William Bouguereau** [French, 1825–1905], *Indigent Family (Charity)*, 1865. Oil on canvas, 48 × 60 1/4 in. (122 × 153 cm). City Museum and Art Gallery, Birmingham, England.

In the nineteenth century, when there was no system of government welfare to support a mother with dependent children, the death of a husband often spelled disaster for a woman. William Bouguereau wanted the viewer to have sympathy with this mother, who was forced to beg for charity. However, he was afraid of upsetting his middle-class audience by showing a family that was genuinely starving and homeless. Instead, he made them appealing and attractive. Their full features are smooth and clean. Their clothes are clean and made of a silky material. In front of grand and noble architecture, he arranged them in a pyramid that resembles the classical composition of images of the Madonna and Child. Consequently, we are attracted to this lovely group for the wrong reasons, and the sympathetic emotions that the work arouses are false. A critic in 1865 rightly called it middle-class sentimentality.

emotion. Even after taking into account the different reactions of different individuals, it can be argued that the emotions which Bouguereau tried to arouse in his work do not represent a proportionate or justified response to the subject. Pathetic-looking children are sure to catch our sympathy, and Bouguereau used them to help make his indigent family very attractive. But his emotional reaction to the scene ignored the harsh realities of the problem the artist has depicted. Both Rivera's *Woman and Daughter* and Bouguereau's *Indigent Family* have appealing children, but the attitude of the mother on the subway undercuts the potential sentiment in the photographer's work.

PORTRAITURE

Just as Thomas Eakins captured the likeness of Dr. Gross performing surgery, Alice Neel referred to her profession while reproducing her own features in

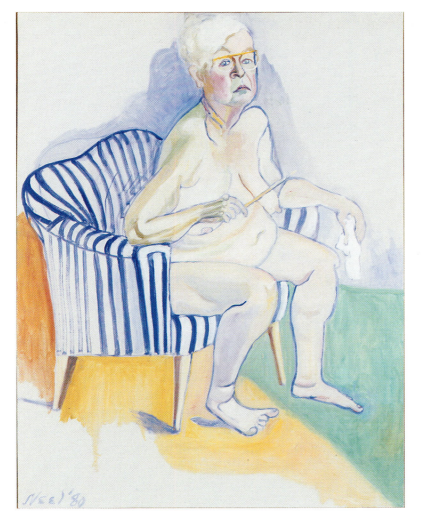

Figure 2-25 **Alice Neel** [American, 1900–1984], *Nude Self-Portrait*, 1980. Oil on canvas, 54 × 40 in. (138.5 × 102.6 cm). © National Portrait Gallery, Smithsonian Institution/Art Resource, NY.

Nude Self-Portrait (Figure 2-25). Sitting on the edge of a striped chair, she holds a paintbrush in her right hand and a cloth to wipe it in the left. In the nude, at the age of eighty, she hides nothing and does not spare us a sardonic view of her sagging flesh. Yet she holds her head, glasses on, upright and alert. Both paintings are **portraits**, or representations of a person.

Alice Neel painted portraits because she chose to. In the past, women artists often concentrated on making portraits because they lacked the training to do history painting, which required the ability to depict the human figure in a variety of poses and actions. On moral grounds, women were excluded from instruction in art schools and academies (see Figure 1-4), where, until the nineteenth century, most of the nude models were male. This meant that few women learned how to draw the human figure properly and were at a disadvantage when it came to ambitious religious and mythological iconography. Their lack of training in history painting, which the art world at one time considered to be the greatest artistic achievement, is a major reason why in the past so few women became famous artists.

Except for religious subjects, probably more portraits have been painted than any other kind of iconography. People like to examine their image and to preserve their appearance. Friends have used portraits to keep the memory of someone dear to them alive. Also, a portrait can expose or interpret the character of an individual, as in a propaganda portrait promoting someone as a courageous leader. However, we must remember that artists continue to express themselves even when they copy someone else's likeness. So it is not always easy to tell if the characterization in a portrait derives from the sitter's personality or is a reflection of the personality of the artist.

Artists have not always made exact likenesses of individuals. The ancient Egyptians made rather formal portraits of people—most of them at first seem very much alike. The ancient Greeks were generally satisfied with portraying only standard character types such as youth, wise old man, or aged woman even when they were representing an individual. Most sculptors in West Africa seem to have wanted only generalized representations of individuals. However, the ancient Romans specialized in distinctive, particularized portraiture (Figure 1-11) perhaps because, early on, the Romans prided themselves on being a society of rugged individuals. Roman culture also stressed the importance of a person's family and the family's distinguished ancestors. It was close to a religious duty for the Romans to keep in their home exact replicas of the faces of their ancestors. European artists in the subsequent Middle Ages sel-

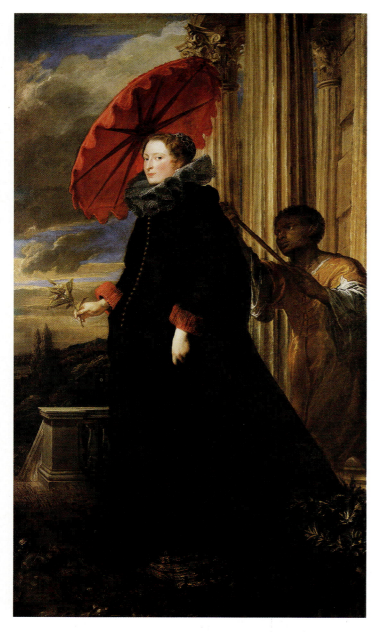

Figure 2-26 **Anthony van Dyck** [Flemish, 1599–1641], *Marchesa Elena Grimaldi*, ca. 1623. Oil on canvas, 97 × 68 in. (246.4 × 172.7 cm). Widener Collection 1942.9.92(688)/PA. Image © 2004 Board of Trustees, National Gallery of Art, Washington, D.C.

dom depicted the exact features of a person because spiritual reality was more important to them. Portraits again became popular a little over five hundred years ago in the Renaissance, when society once more prized an individual's achievement on earth.

Portrait artists are generally expected to flatter individuals or at least to portray them at their best.

We still expect as much when we hire a professional photographer to take our portrait. The Flemish artist Anthony van Dyck made his reputation by painting flattering portraits, such as his *Marchesa Elena Grimaldi* (Figure 2-26), which set the standards for portraying elegant and beautiful people. Carrying a flowering branch, the marchesa strides out of her palace onto the terrace of her garden. A servant rushes up to hold a parasol over her head lest a ray of the golden sun spoil her perfect complexion. The parasol makes a flare of bright red behind her face—the color is repeated in her cuffs. She appears to be seven feet tall; her body measures nine times the length of her head. From her elevation she looks down at mere mortals. Historians know almost nothing about Elena Grimaldi, and van Dyck gives us no clue about her personality—her face is expressionless. His main concern is her beauty and her position in society. Few artists in the distant past tried to depict what the modern age is most interested in—psychological character.

Portraits come in all shapes and sizes, and the type of portrait is one of the first decisions the artist has to make. A bust-length portrait, such as Kahlo's *Self-Portrait* (Figure 1-20), which includes the head and shoulders, obviously concentrates on the features of the face. Other types of portraits include half length, from the waist up; three-quarter length, from the knees up; and full length, as in van Dyck's *Marchesa Elena Grimaldi*. Occasionally, artists portray a profile view of the face, such as the relief portraits of presidents on coins, a tradition that goes back to the profile portraits of emperors on ancient Roman coins.

Full-length portraits are special and grand. For a long time they were reserved for royalty and the most important members of society because not only did the artist need a large piece of canvas or other material to produce one, but the owner needed a palatial residence to display the finished work. A little more than a hundred years ago it became fashionable for millionaires in America to commission full-length portraits for their grand estates, in imitation of Van Dyck's portraits of Baroque nobility. Commemorative portraits of national heroes and heroines in public places still tend to be full-length pieces.

Most portraits include the hands, which may be doing or holding something significant, and a good

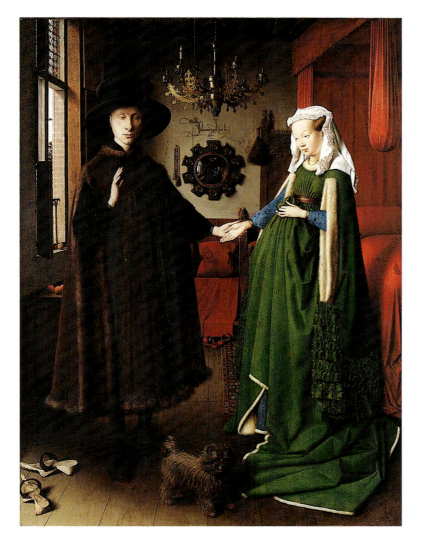

Marriages at that time did not have to take place in a church, and the prominent bed in the painting of course refers to the consummation of the marriage. Although it is unlikely that Giovanna Cenani was already pregnant at the time of her marriage, her large belly, a fashion of the day exaggerated by the folds of her dress, certainly was meant to forecast a fruitful union. A number of other, seemingly everyday items in the room are very likely symbols of the religious dimensions of marriage, one of the Seven Sacraments of the Church. The dog at the couple's feet represents fidelity. The figure of St. Margaret, the patron saint of childbirth, is carved into the bedpost. The convex mirror resembles the all-seeing eye of God. The single candle burning in the chandelier symbolizes the presence of Christ, the light of the world. The couple have removed their shoes as Moses did when he witnessed God's presence in the burning bush. The wealthy couple, dressed in furs and velvet, express no emotions, but they seem to believe firmly in the sanctity of their marriage.

amount of the clothing, or costume, that someone is wearing. Often the costume, which might indicate the person's status in society, counts for more than does the sitter's bland face. The setting and the objects in the room also help reveal character and the sitter's profession or position in society. Jan van Eyck's (pronounced *van Ike*) double portrait of Giovanni Arnolfini and his bride, Giovanna Cenani (Figure 2-27), is full of clues about the status of the couple. In fact, their portrait seems to document their marriage and, consequently, has been called *The Arnolfini Wedding*. The richly dressed couple hold hands in the interior of their bedroom and seem to be exchanging marriage vows—he raises his right hand as one might do when taking an oath. The artist, a witness to their vows, indicates his presence by signing his name on the back wall of the room and by including his own reflection in the mirror.

NATURE

Like the sense of individual worth needed for portraiture, a certain respect for nature is required to depict **landscapes**, or works in which the major focus is on nature.

In Roman times and in the Renaissance, landscape emerged in an urban culture as a vicarious escape to the countryside for rest and relaxation. In the nineteenth century, Romantic religious faith teamed up with the newborn science of geology to produce, especially in America, some spectacular landscapes such as Frederick Church's *Cotopaxi* (Figure 2-28). Church studied the Cotopaxi volcano on trips to the Andes, in South America. In his seven-foot painting, the pale, cone-shaped mountain rises above the horizon line of a high plateau. Smoke and ash jet hundreds of feet into the air, fall, and then drift across the sky—almost obscuring the setting sun,

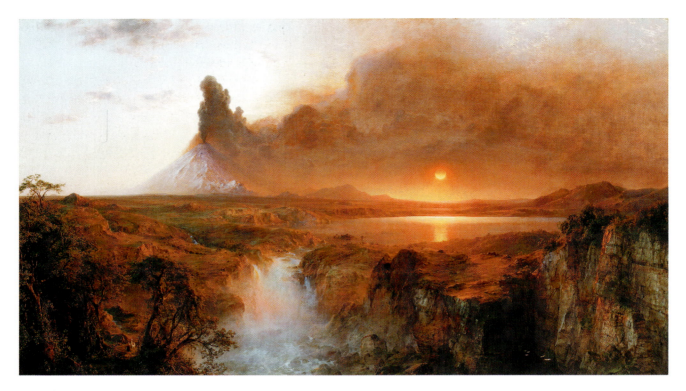

Figure 2-28 Frederick Edwin Church [American, 1826–1900], *Cotopaxi*, 1862. Oil on canvas, 48 × 85 in. (121.9 × 215.9 cm). Detroit Institute of Arts. Founders Society Purchase, Robert H. Tannahill Foundation Fund, Gibbe-Williams Fund, Dexter M. Ferry, Jr., Fund, Merrill Fund, Beatrice W. Rogers Fund, and Richard A. Manoogian Fund. Acc. #76.89. Photograph © The Detroit Institute of Arts.

which nevertheless bathes the earth in its aura. A river running from a mountain lake cuts a gorge through layers of sedimentary rock. Church recreated in a single panorama the basic processes of nature—volcanic upheavals and the sediment from steady erosion forming new lands for future generations. The beauty and harmony of the design manifest in the earth proved to the artist and his viewers that the Creator continued to guide the world for humanity's benefit.

For a long time, Asian cultures have appreciated views of nature in accord with their own history and beliefs. Western biblical religion places human beings at the head of nature. Chinese Taoist religion stresses attunement and identity with nature, and Chinese Ch'an Buddhism encourages the cultivation of quiet and openness to moments of illumination. In these Eastern religions, a man or a woman is not superior to nature but plays a small part in the scheme of creation. For centuries, Chinese artists strove to capture the spirit of nature through close study of each of its details. The forms of nature are boiled down to their essence and skillfully reproduced by the artist with a distinctive dash that animates everything. A Chinese landscape invites the mind to travel from place to place through nature and to find at each resting spot food for contemplation and con-

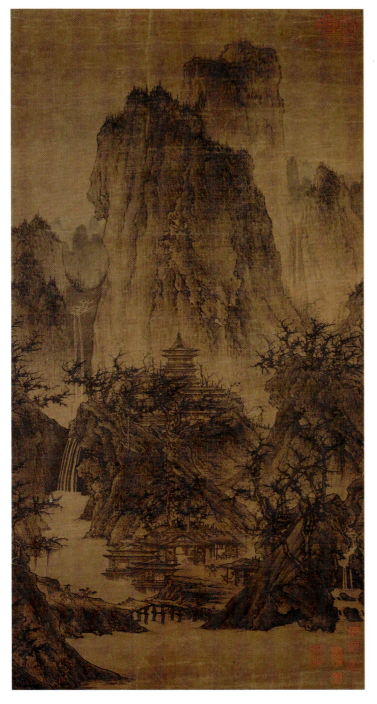

Figure 2-29 **Attributed to Li Ch'êng** [Chinese, 919–967], *A Solitary Temple Amid Clearing Peaks (Ch'ing-luan hsiaossu)*, Northern Sung dynasty (960–1127). Hanging scroll, ink and color on silk, 44 × 22 in. (111.8 × 56 cm). Nelson-Atkins Museum of Art, Kansas City. Purchase of Nelson Trust. 47–71. Photo: Robert Newcombe.

solation for the return to real life. The distinct Chinese culture gives life to a distinct kind of landscape painting.

The artist Li Ch'êng painted *A Solitary Temple Amid Clearing Peaks* (Figure 2-29) in the first half of the tenth century. In Li Ch'êng's landscape, the mind's journey begins with small figures emerging down the path and across the wooden bridge in the lower left. Another figure enters the gates of the monastery. Partially glimpsed steps lead up to the pagoda on the hill, from which one can contemplate the steep mountains across the mist-filled valley or contemplate the jagged silhouettes of dark trees against the light mist. The tall format of Li Ch'êng's landscape, painted on a silk hanging scroll, presupposes more space to the left and right, and the empty area above the mountains suggests limitless space beyond. The Chinese artist does not allow us to take in the whole scene at once. In fact, different parts of the landscape are seen from different points of view.

Until the nineteenth century, artists in Europe and America seldom painted landscapes directly from nature; they were almost always created in the artist's workshop from conceptions about nature or, at best, from sketches made outdoors. Furthermore, until the nineteenth century, landscapes were not generally held in high regard. People thought the landscape painter was merely copying nature and not doing anything very original. To justify the painting of landscapes, artists frequently made nature the setting for biblical or mythological events—often an idealized image of what nature should be like. But in the mid-nineteenth century, Impressionist artists such as Camille Pissarro attempted to reproduce nature just as it appeared to them. In *The Artist's Garden at Eragny* (Figure 2-30), Pissarro took his paints outdoors and tried to capture the color and light of this small corner of nature.

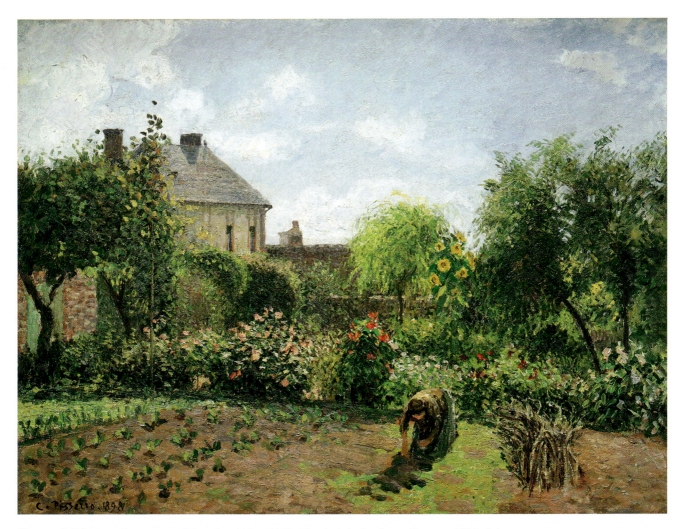

Figure 2-30 **Camille Pissarro** [French, 1830–1903], *The Artist's Garden at Eragny*, 1898. Oil on canvas, 28 7/8 × 36 1/4 in. (73.4 × 92.1 cm). Ailsa Mellon Bruce Collection, 1970.17.54.(2426)/PA. Image © 2004 Board of Trustees, National Gallery of Art, Washington, D.C.

Artists depicting landscape today may realize how fragile and imperiled the ecology is. Some contemporary artists such as Neil Jenny express concern about the environmental crisis and the threat of apocalypse. In *Meltdown Morning* (Figure 2-31), Jenny views a woodland, the symbol of the once great North American wilderness, through an enormous slit, as though from a bunker. The heavy dark frame with its bold lettering visually threatens the delicate light, the fragile leaves, and the pale blue sky.

STILL LIFE

In *Still Life* (Figure 2-32), the Dutch artist Pieter Claesz (pronounced *Clay*-zoon) depicted a table cov-

ered with what seems to be the remnants of a meal. A large glass goblet stands half empty on the left, and an ornate silver cup lies on its side behind it. An array of food—a cone of spice, a peeled lemon, oysters, nuts, and a roll with one big bite taken from it—seems scattered about the table. The meal in the painting appears to be partially eaten, as though diners had suddenly left the table in disarray. If this interpretation is correct, the abandoned meal suggests the passage of time, and the food may symbolize the transience of sensory pleasures such as taste. Claesz includes a skull among the objects in some of his paintings—a clear indication of the theme of *vanitas* (vanity)—a reminder that all things must pass away.

Like many seventeenth-century Dutch artists, Claesz specialized in the painting of **still lifes**, delib-

Figure 2-31 **Neil Jenny** [American, 1945–], *Meltdown Morning*, 1975. Oil on panel, 25 3/4 × 112 1/2 in. (65.4 × 285.8 cm). Philadelphia Museum of Art. Purchase of Samuel S. White III and Vera White Collection (by exchange) and funds contributed by Daniel W. Dietrich Foundation in honor of Mrs. H. Lloyd Gates.

erate groupings of small inanimate objects, which rarely include people. No doubt, the artist carefully arranged the objects in his painting to make them appear disordered, and, as we have seen, the objects may also symbolize or otherwise express some significance. Ever since Zeuxis painted grapes that supposedly deceived some birds, artists have used still lifes to display their skill at painting objects realistically enough to fool the eye.

The still-life iconography of food and musical instruments attracted Cubist artists in the early twentieth century, and in the 1960s Pop artists rejuvenated still life. Pop artists added a new twist to still life by depicting common modern objects and popular images from advertising and other mass media. For example, Andy Warhol made still lifes of soup cans, Coca-Cola bottles, and Brillo boxes (Figure 18-7).

PROTEST ART

As discussed above, Neil Jenny's 1975 painting *Meltdown Morning* (Figure 2-31) makes a statement about ecology and the threat of nuclear annihilation. Since the 1970s, many artists have rejected the cool and aloof detachment of Pop Art and Photorealism for a profound commitment to political and social problems. Their **protest art** has important things to say about issues such as racism, sexism, the environmental crisis, and the AIDS epidemic. Barbara Kruger's *Untitled (We Won't Play Nature to Your Culture)* (Figure 1-16) is another example of this type of art. Critics often debate whether art such as theirs can have a tangible effect on social behavior.

One example of a modern work of art that has succeeded in having a powerful effect is the AIDS

Figure 2-32 **Pieter Claesz** [Dutch, ca. 1597–1661], *Still Life*, 1633. Oil on wood, 15 × 21 in. (38 × 53 cm). Staatliche Kunstsammlungen, Kassel. © Francis G. Mayer/Corbis.

Figure 2-33 AIDS Memorial Quilt. © 1996, 2001 The NAMES Project Foundation. Photo by Paul Margolis.

Memorial Quilt (Figure 2-33). It was displayed for the first time in 1987 on the Mall in Washington, D.C., and covered a space larger than a football field. Its 1,920 panels commemorated an equal number of individuals who had died of AIDS. The following spring it toured around the nation, raising awareness about AIDS and raising funds for AIDS service organizations. The quilt continues to be on tour and has grown to more than 44,000 panels—each one of which is available on the Web. The last time the entire quilt was displayed in Washington, in 1996, it covered the entire Mall. As the largest community art project in the world, the AIDS quilt continues to bring people together to fight the disease.

FANTASY ART

Hieronymous Bosch's *Garden of Earthly Delights* (see "Artist at Work") contains a most vivid fantasy of paradise, earth, and hell, even though very little of the iconography of the painting can be found in the Bible. This fascinating piece is a **triptych,** three separate wooden panels hinged so that the left and right "wings" can fold over to conceal and protect the painting.

The triptych illustrates three stages in the religious history of humankind, which Bosch sees as a relentless journey into hell. The left panel depicts the creation of Eve in the Garden of Eden. The square central panel shows life on earth as a garden of lust in which men and women devote themselves only to the sinful pleasures of the flesh. However charming their activities may look to us today, the late Middle Ages considered deriving pleasure from sex sinful. Lust was the first sin of Adam and Eve after the Fall and was the cause of numerous other sins. It is apparent from the position of the fantastic hell scene on the right that as a result of their actions, all men and women will be eternally tormented in hell. There is no heaven in Bosch's last judgment.

Fantasy art is a rendition of something that exists only in the artist's imagination. In the past, the visual reenactment of mythological, religious, or historical events in history paintings came from the artist's imagination because the artists were not present when the events happened. In modern

Figure 2-34 **Meret Oppenheim** [Swiss, 1913–1985], *Object (Le Déjeuner en Fourrure)*, 1936. Fur-covered cup: 4 3/8 in. (11.1 cm) in diameter, saucer: 9 3/8 in. (23.8 cm) in diameter, spoon: 8 in. (20.3 cm). Museum of Modern Art, New York (purchase). © MOMA/Art Resource, NY. © 2006 Artists Rights Society (ARS), New York/ProLitteris, Zurich.

times, movies constantly create fantasies, not only in science fiction and thrillers, but also in images of supposedly real life showing violence without consequence to anyone, wealth without work, or sex without personal involvement.

Many modern artists like to work even more explicitly from their imagination and visualize their mental fantasies. They like to manipulate reality and recombine it illogically, if for no other reason than to stress how much our imagination creates what we call reality. The twentieth-century movement named Surrealism especially encouraged artists to depict the imagery of their dreams and the fantasies of their subconscious mind. In fact, the Surrealists believed that dreams capture the truth of things and the meaning of life better than the rational mind. They often explored the psyche by illustrating the absurd and chance juxtaposition of very different things, as in Meret Oppenheim's *Object* (Figure 2-34). The soft fur may appeal to the sense of touch, but when holding a liquid it would feel disgusting in the mouth. The irrational combination of the two awakens contradictory sensations and at the same time heightens awareness. The fur-lined teacup reconstructs a dream where these impossible juxtapositions can happen.

ABSTRACT AND NONOBJECTIVE ART

In 1952–1953 the American painter Willem de Kooning painted *Woman IV* (Figure 2-35), part of a series of brutally twisted and distorted women, in order to express himself through the dynamic act of painting. He seems to have attacked the canvas with broad, violent, jagged strokes of harsh color. It is an example of **abstract art,** which emphasizes the formal properties of art. Viewers can sometimes barely recognize people or things in abstract work because the subject is fragmented, distorted, or exaggerated. In other cases, abstract artists strip appearances bare and reduce things to their essence so that their underlying form stands out clearly. In still other instances, modern artists choose as their subject the actual creative process of art—as de Kooning did. He made the act of painting art explicit, often at the expense of a lucid iconography.

Even identifiable objects or fragments of objects in abstract art are not always reliable clues to the meaning of the work. Modern artists often confess that they merely use a subject as an initial impulse and that the iconography of the subject has little significance for them. Willem de Kooning maintained

(text continued on page 54)

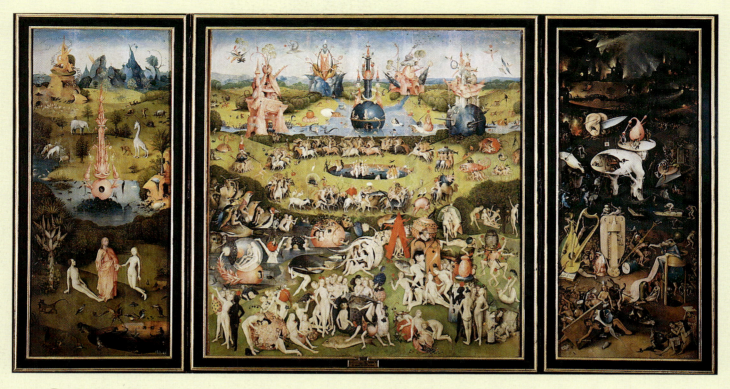

Hieronymous Bosch [Flemish, ca. 1450–1516], *The Garden of Earthly Delights*, ca. 1505. Oil on wood; central panel, 86 5/8 × 76 3/4 in. (220 × 194.9 cm); each wing, 86 5/8 × 38 1/4 in. (220 × 97.2 cm). Prado Museum, Madrid. Copyright © Museo del Prado.

The arrangement of the panels makes the thrust of the artist's message clear, but the details of his iconography have fascinated and puzzled observers from practically the day it was painted. In the panels, men and women engage in bizarre activities on earth and in hell. Strange animals and stranger monsters populate the landscapes. Animals transform themselves into human shapes or combine in endless mutations with insects. The land itself, whether paradise, earth, or hell, produces exotic vegetable-like rock formations. The punishments in hell are grotesque and nightmarish.

What sort of person produced these strange images? Was he a fanatic given to hallucinations?

Unfortunately, very little is known about Bosch, except that he led an unremarkable existence in the town of 'sHertogenbosch in the Netherlands. Although his family name was Van Aken, he has always been referred to by the abbreviated name of his hometown. Bosch learned the family trade: his grandfather, father, and uncles were all painters. Bosch belonged to the Brotherhood of Our Lady, a respected and orthodox religious group that maintained in the town's cathedral a richly decorated chapel with a miracle-working image of the Virgin. However, since *The Garden of Earthly Delights* belonged to the nobleman Hendrick III of Nassau, presumably this intricate painting was created for an audience of educated aristocrats rather than for public consumption in a church.

Bosch divided each of the panels into three sections—a foreground, a middle ground with a body of water, and a background with distant hills. In effect, he set the three events in the same terrain, as though the earth is gradually transformed from paradise into hell. Bosch also employed an unorthodox manner of painting for his day, laying down directly a layer or two of paint and then dabbing on a few highlights and finishing touches. Instead of building up an image out of carefully planned layers as his contemporaries would, Bosch worked as though he were in a hurry to get his fantasies down as quickly as possible.

Fascinating details cover every inch of the painting. In the foreground of the lush landscape on the left, Jesus Christ, the creative Word of God, introduces the newly created Eve to Adam, who awakes from sleep. Bosch hints that their sinful passions are first aroused even in Eden. Paradise teems with life, including some unusual animals such as a

giraffe, an elephant, a unicorn, and a three-headed bird. Bosch would have known about such animals from medieval bestiaries that listed the fabulous animals of far-off lands. The thin pink Fountain of Life, made of vegetable forms, rises in the center of the pond. Out of the circular base of the fountain peers an owl—the bird of evil magicians and of secular knowledge, and a bird of the night—a premonition of the evil to come.

The middle of the central panel contains a circular pool where women bathe. Around them dozens of men ride and cavort on a great variety of animals, which probably symbolize their base instincts. Through this merry-go-round of human beings, Bosch conveys the perpetual carnival of male-female sexual attraction. Among the foreground groups of men and women, some engage in obvious sexual activity; many more pick fruit, offer each other fruit, or eat fruit, especially oversized strawberries. In fact, one early commentator called The Garden of Earthly Delights The Strawberry Plant. Strawberries and other fruit symbolize short-lived sensual pleasures. Bosch seems to be illustrating, throughout the garden, figures of speech, plays on words, sayings, and proverbs that were popular in his day. For example, some men carry fish because the Netherlanders' word for fish was once slang for the male sex organ.

While the fires of hell explode with volcanic force in the background of the right wing, the nearer parts of hell are filled with exquisite torments tailored to an individual's sin. Most of the instruments of torture are common things enlarged to nightmarish proportions. People are impaled on or harassed by musical instruments—a lute, harp, hurdy-gurdy, woodwind, drum, or bagpipe—because the sensuous delights of music led to the sin of lust. A giant pair of ears emerges from the fires of hell like a battle tank ready to grind down its victims. Monsters attack gamblers and drinkers, in the lower left corner, for their sinfulness. In the center stands a white Tree Man, whose face seems to be a portrait. On his hat, sinners eternally parade to the music of the sexually symbolic bagpipe. His cracked-open egg body houses an infernal tavern scene. As if in an impossible dream, he stands on legs made from dead tree trunks that rest on boats perched on a frozen lake.

Even if a viewer does not understand all the allusions and symbolic references of Bosch's iconography, the incongruities in his imagery still express to every viewer a perversion of the laws of nature and a world turned upside down through evil.

Hieronymous Bosch [Flemish, ca. 1450–1516], *The Garden of Earthly Delights*, ca. 1505. Oil on wood; right panel. Prado Museum, Madrid. © Archivo Iconografico, S.A./Corbis.

Figure 2-35 **Willem de Kooning** [American, 1904–1997], *Woman IV*, 1952–1953. Oil, enamel, and charcoal on canvas, 59 × 46 1/4 in. (149.9 × 117.5 cm). Nelson-Atkins Museum of Art, Kansas City. (Gift of William Inge) 56–128. Photo: Jamison Miller. © 2006 The Willem de Kooning Foundation/ Artists Rights Society (ARS), New York.

that he was saying nothing derogatory about women in his art. Despite his assertion, we can scarcely look at his painting with the same indifference to the subject as he did. Clearly, our own visual and cultural background affects the way we see and understand an artist's iconography.

The term *abstract art* includes any work that fragments, simplifies, or distorts reality so that formal properties of lines, shapes, and colors come to the forefront of our consideration. Works that have no recognizable objects in them whatsoever, such as Wassily Kandinsky's *Fragment 2 for Composition VII* (Figure 1-18), could be designated **nonobjective.** We saw that the colors and lines in Kandinsky's art symbolize other sensations, especially the experience of music. The analogy between art and music has convinced numerous artists that shapes and colors, like

sounds and rhythms, have significance and that a completely abstract and nonobjective art is therefore possible.

Whether their work is merely abstract or totally nonobjective, many modern artists believe that the lines, the colors, or the arrangements of masses themselves are the subject of their work—that the painting or piece of sculpture is about itself or concerned with the process of making art. Their art depicts visual perception itself, or it expands visual experience. Their art concerns the experience of space, the experience of shape, or the experience of color, as in Victor Vasarely's *Orion* (Figure 2-36), where the alterations of light and color change our perception of three-dimensional space.

Visual experience is an eminently suitable subject for art because it is such an important part of

Figure 2-36 **Victor Vasarely** [Hungarian-French, 1908–1997], *Orion, 1956–1962.* Paper on paper mounted on wood, 82 1/2 × 78 3/4 in. (209.6 × 200 cm). Hirshhorn Museum and Sculpture Garden, Smithsonian Institution, Washington, D.C. © 2006 Artist's Rights Society (ARS), New York/ADAGP, Paris.

Victor Vasarely's work may appear only to be rows of circles and squares, but it really concerns the perception of color and space. Light-and-dark contrasts and color contrasts make some circles and squares come forward and others recede. Light and color, in short, create movement forward and backward in space. It is possible to spend a considerable amount of time examining the work to experience the variety of effects and to contemplate the activity of the human imagination.

our existence. Feelings and mental states do not have exact classifications, and an artist's representation of feelings may be very subjective. We can never know precisely what a particular color or line means to an individual artist. Still, we can use our own experience of these visual elements to understand this sort of visual "symbolism." Once we experience for ourselves that abstract or nonobjective art possesses a legitimate meaning, we can let our imagination and feelings run free, let the work speak on its own terms, and enjoy its insights into the psyche.

Abstract Art **MODULE**

AT A GLANCE

Categories of Iconography

Narrative art	Narrative art illustrates stories from religion, myth, literature, or history.
The nude	The nude emphasizes the sensuous attraction of the human body.
	The Greeks made nudity an ideal state of existence.
Religious art	Religious art was the early and fundamental embodiment of humankind's deepest concerns.
	It makes gods, goddesses, and spirits visible.
	It played a vital role in people's lives and in the community.
	It explains the nature of the world and the customs of a society.
	Mythological art depicts the gods and heroes of an ancient culture.

(continued on next page)

Personification and allegory	Personification and allegory use human beings to symbolize virtues and ideas.
Genre	Scenes of everyday life of ordinary people are called genre.
Portraits	Portraits reinforce the importance of the individual.
	The different types of portraits are bust, half length, three-quarter length, and full length.
	Portraits often provide an ambiguous expression of the sitter's character.
Landscapes	Landscapes grow out of a culture's attitude toward nature.
	Chinese landscape art is based on the harmony of human beings and nature.
	European landscapes were often idealized.
	Nineteenth-century artists discovered the beauty of the ordinary in nature.
Still lifes	A still life is the deliberate grouping of small inanimate objects. The objects themselves often have meaning.
Protest art	Protest art emphasizes political and social concerns.
Fantasy art	Fantasy art depicts an illusion or vision from the imagination.
	Surrealism creates fantasies with irrational juxtapositions.
Abstract and nonobjective art	Abstract and nonobjective art may express emotions, reduce forms to their essence, and reveal the process of art.
	This kind of art focuses on visual perception and may symbolize feelings or mental states.

INTERACTIVE LEARNING

Foundations Modules: Style, Form, and Content

Flashcards

Artist at Work: Hieronymous Bosch

Critical Analysis: The Nature of Art

Companion Site: http://art.wadsworth.com/buser02

Chapter 2 Quiz
InfoTrac® College Edition Readings
Talking Flashcards
Online Study Guide

Is It Art?

The woman and child in Mary Cassatt's *Summertime: Woman and Child in a Rowboat* seem to be ordinary people performing an inconsequential summertime activity. The artist did not particularly idealize their image or give them the proportions of Greek sculpture. Critics who subscribe to a Platonist view might complain that Cassatt merely imitated reality, something that a photographer could have done better. However, the piece is far from a realistic photograph in a number of ways: a brush sketched the image in obvious patches of paint, the color seems more varied and intense than in reality, and the surface of the water seems to tip up unnaturally, especially toward the top of the canvas.

Like other members of the Impressionist movement to which she belonged, Cassatt painted directly from objects that she could see before her. In fact, she wrote in 1894 in a letter to a friend that "going out in a boat to study the reflections of the water, on the bay here has made me seasick."[1] Nevertheless, it is unlikely that the two subjects (and the ducks!) held that precise pose in a boat on a sunny day for the hours that Cassatt must have taken to paint the canvas. Her realism was more likely assembled, like Zeuxis's idealism, from piecemeal observation.

Cassatt never published her aesthetic beliefs, and her many letters reveal little along those lines.

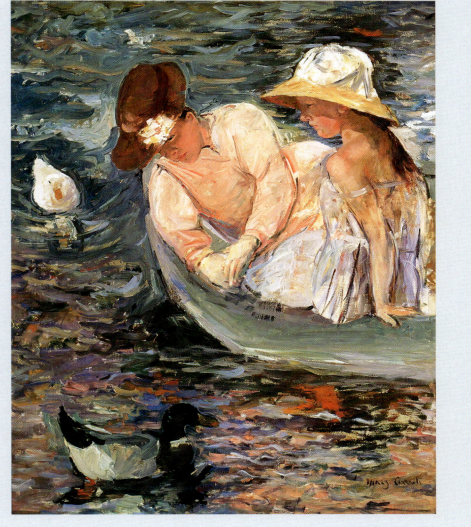

Mary Cassatt [American, 1845–1926], *Summertime: Woman and Child in a Rowboat*, 1894. Oil on canvas, 42 × 30 in. (106.7 × 76.2 cm). Terra Foundation for the Arts, Daniel J. Terra Collection, 1988.25. Photography courtesy of Terra Foundation for the Arts.

We might assume that her ideas about art were close to those of the other Impressionists. In one letter, in the midst of writing about her rose garden, Cassatt exclaimed, "There is nothing like making pictures with real things."[2] Like many of the Impressionists, she was challenged to make something beautiful out of the ordinary. To demonstrate the point, she once chose a decidedly homely ser-

vant girl and had her pose in an awkward position. The result was *Girl Arranging Her Hair,* in which Cassatt's skillful placement of the lines and shapes and the harmony of the colors transformed even something "ugly" into art.

If art is understood as communication of lived experience through visual symbolism, the painting *Summertime* without question succeeds as art. Most of us have been mesmerized by looking at water on a hot summer day and can share the experience of the two boaters. Cassatt vividly brings to our imagination the light and color that dance on the water. Cassatt arouses in us sensations we have experienced and opens our eyes to delightful perceptions of color, light, and space we might otherwise have missed in a casual glance at the scene. When we work at looking as intently as she did, so that the painting works its magic, it is art.

The Subject

The objects depicted in Cassatt's *Summertime* are easily listed: a woman, a young girl, a boat, two ducks, and water. The event depicted by Cassatt is easily surmised: the two figures are enjoying a relaxing boat ride in the summer sun. Perhaps they have fed the ducks to attract them. However, the woman and child seem to be staring into the water, captivated by the light dancing on the surface. Since the faces of the two figures are somewhat obscured, it is unlikely that the painting is a portrait. Much more likely, the painting should be understood as a genre subject, illustrating a commonplace event.

Equally interesting is what Cassatt did not depict: the sky, the shoreline, and any other landmark are omitted. She also left out the person at the oars, whose weight must be balancing the boat while the woman and child lean over the edge. The artist concentrated instead on the figures staring at the water. We may imagine that they are mother and daughter, but Cassatt's models were usually not related. Cassatt's painting is also devoid of emotion. Some of Cassatt's earliest critics praised the refreshing lack

Mary Cassatt [American, 1845–1926], *Girl Arranging Her Hair,* 1886. Oil on canvas, 29 5/8 × 24 5/8 in. (75 × 62.3 cm). National Gallery of Art, Washington, D.C. Chester Dale Collection, 1963.10.97.(1961)/PA. Image © 2004 Board of Trustees, National Gallery of Art, Washington, D.C.

of sentimentality in her many paintings of women and children.

The clothing of the woman—a long-sleeved dress and gloves—is the only part of the iconography that places the scene at a certain period of time, the mid-1890s. The awareness of time allows us to speculate on the significance of the activity of the woman and child in the society in which they lived. We know that women and children of the middle class, as these appear to be, in general led rather sheltered lives. Society permitted them only nonstrenuous leisure-time activities and recreations such as boating, although some were beginning to ride bicycles and play tennis. An awareness of the social context of *Summertime* may add a note of wistfulness to its depiction of the genteel activities allowed the two women.

3 Line, Shape, and Mass

LINE

When Henri Matisse (Figure 3-1) and Max Beckmann (Figure 3-2) reproduced their own features, the results look very different. The basic subject is the same—a human head—but the results vary. We see two distinct people because each artist chose different tools to make **lines**—marks that form the design on the surface—and those lines communicate different temperaments. Because the lines in each work have their own character, we have dissimilar feelings about their

Figure 3-1 Henri Matisse [French, 1869–1954], *Self-Portrait*, 1949. Lithograph, 9 × 7 1/4 in. (22.9 × 18.5 cm). Bibliothèque Nationale, Paris. © 2006 Succession H. Matisse, Paris/Artists Rights Society (ARS), New York.

Figure 3-2 Max Beckmann [German, 1884–1950], *Self-Portrait*, 1920. Drypoint, 7 11/16 × 5 3/4 in. (19.5 × 14.6 cm). Collection of the Grunewald Center for the Graphic Arts, UCLA. Hammer Museum, Los Angeles. Gift of Mr. and Mrs. Stanley I. Talpis. © 2006 Artists Rights Society (ARS), New York/VG Bild-Kunst, Bonn.

portraits. Matisse used continuous, curvy lines; Beckmann used short, jagged, broken lines. Matisse seems serene, almost jovial; Beckmann seems intense and troubled. The lines themselves speak to us and communicate thoughts and feelings beyond mere information about the shape of the eyes, mouth, or chin.

Line is the first of the traditional seven elements of design that actualize and express an artist's vision. The seven visual elements are line, shape, mass, value, color, texture, and space.

GENERAL CHARACTERISTICS
Quality

In Euclidean geometry, a line is an abstraction signifying a series of locations on a plane; it has no thickness or any other feature. In art, lines can be thick or thin, jagged or smooth, broken or continuous. Straight lines seem regular and assuring in contrast to broken and jagged lines, which create a tense feeling because of their unevenness. Because we sense these different qualities, they seem to express a personality or character. For instance, John Hancock expressed himself in the bold lines of his famous signature—in lines so resolute and determined that the name of the first person to sign the Declaration of Independence has become a synonym for *signature*. Lines can instinctively produce in us emotional effects. They might soothe the soul or excite our interest. We can read into lines some of the same kinds of feelings and attitudes we have toward different people.

John Hancock signature. From the National Archives.

Movement

The artist Paul Klee, who called line "the most primitive of elements," understood line essentially as **movement** because for him a line was "a point that sets itself in motion."[1] To Klee, a point was a dy-

Figure 3-3 **Edward Weston** [American. 1886–1958]. *Pepper No. 30*, 1930. Photograph by Edward Weston Collection Center for Creative Photography, The University of Arizona. © 1981 Arizona Board of Regents.

namic thing, full of potential and capable of generating lines of motion. A simple pencil moving across a sheet of paper makes a point move as it draws a line. Lines also have movement because they create paths that the eye can follow. Edward Weston's photograph of a common bell pepper, *Pepper No. 30* (Figure 3-3), accentuates the muscular curves of the unusually gnarled vegetable, which seems like a hand making a fist. He isolated the pepper against a dark background in a sharply lit, sharp-focused close-up that leaves us no choice but to follow the powerful lines.

Direction

If lines have movement, they also have direction: they can go up or down, move diagonally, or constantly change direction. These directions have sig-

Figure 3-4 **Edvard Munch** [Norwegian, 1863–1944]. *The Scream*, 1893. Oil on canvas, 33 × 26 1/2 in. (83.8 × 67.3 cm). Kommunes Kunstsamlinger, Munch-Museet, Oslo. © Scala/Art Resource, NY. © 2006 The Munch Museum/The Munch-Ellingsen Group/Artists Rights Society (ARS), New York.

The Scream has become one of the best-known expressions of the anxiety and desperation of modern life. Munch once elaborated on the event that he visualized so graphically: "I stopped and leaned against the balustrade, almost dead with fatigue. Above the blue-black fjord hung the clouds, red as blood and tongues of fire. My friends had left me, and alone, trembling with anguish, I became aware of the vast, infinite cry of nature."[2] The figure in the foreground, a portrait of the artist, raises his hands to his ears to shut out the cry of nature. But the writhing lines in the sky and the land already resonate in the twisted shape of his body. By contrast, the straight lines of the fence, keeping him from the abyss below, cut through his throbbing form. The steep perspective distances him from the ghost-like shapes on the left of the painting.

nificance because the mind's eye, moving along a line, projects emotional states onto the line's location. In general, horizontal lines feel calm and serene, like a solid floor or a flat horizon. Vertical lines are elevating because they mimic our feeling of standing up and the growth of trees and plants rising toward the sun. If horizontals symbolize the earth, verticals can also express our feeling of strength and resolution. Diagonal lines (think of mountain slopes and children's slides) seem more dynamic and exciting because they move in two directions at once—up or down and across. Curved lines seem to flow like water or like musical melody and visually express a feeling of constant change or gracefulness.

The interaction of two or more lines arouses feelings because of other physical associations. A combination of horizontal and vertical lines looks ordered and stable, like the steel framework of a building. Lines that meet at a ninety-degree angle give a sense of regularity. Lines may intersect and conflict with each other like crossed swords, or they may meet at obtuse angles and create blunt corners. Lines may come together and meet to form sharp angles that communicate a spiky feeling, as they do in Beckmann's *Self-Portrait*. Diagonal lines may clash with sinuous curved lines, as they do in *The Scream* (Figure 3-4) by Edvard Munch (pronounced moongk), where the discord helps express the anguish of the lonely, howling figure.

The emotions communicated by lines are subjective and relative to their context. Nevertheless, the artist Georges Seurat tried to establish guidelines for the feelings that the formal elements such as line convey and tried to embody his theory in a few of

Figure 3-5 Georges Seurat [French, 1859–1891], *Le Chahut*, 1889–1890. Oil on canvas, 66 1/8 × 55 1/2 in. (168 × 141 cm). Kroller-Muller Museum, Otterlo, The Netherlands.

Georges Seurat believed that an artist should achieve harmony in a work of art by expressing a dominant emotion through the use of the appropriate light, color, and lines. Seurat condensed and subsumed all possible emotions under three categories: gay, calm, and sad. Seurat then devised the dominant light, color, and lines that would produce one of these three emotions. To express gaiety, for example, an artist should use predominantly bright light, warm colors such as yellow, orange, or red, and lines that rise above the horizon. In a letter he wrote in August 1890, Seurat explained his formula in very terse language:

> Gaiety of value is the light dominant; of hue, the warm dominant; of line, lines above the horizon.

> Calmness of value is the equality of dark and light; of hue, of warm and cool; and the horizontal for line.

> Sadness of value is the dark dominant; of hue, the cool dominant; and of line, downward directions.[3]

his paintings. In *Le Chahut* (Figure 3-5), which illustrates a popular high-kicking dance of the same name in a French café music hall, Seurat wanted to express the dominant emotion of gaiety. To Seurat, horizontal lines expressed calmness, and lines that fell below the horizon expressed sadness. To express gaiety, according to Seurat, an artist should use lines that rise above the horizon. Rising diagonal lines dominate the composition of *Le Chahut:* the lines of the legs and skirts rise above the horizontal, and so do those of the lips, eyes, and mustaches of the dancers and musicians. Although Seurat's three categories of the emotional effects of line direction sound a bit simplistic, they capture some of the emotions we may feel in lines since they refer to basic physical experience.

The problem with a psychological interpretation of line direction is that, by definition, emotional associations have a subjective, nonrational element. Curved lines may look graceful and melodic to one person and sinister to another, as in *The Scream.* Furthermore, the effect of a line depends on the context in which the line appears and on its relationship to other lines. For instance, in Umberto Boccioni's painting *Dynamism of a Soccer Player* (Figure 3-6), several "dynamic" diagonal lines cross through the canvas. However, Boccioni communicates the energy of the athlete primarily by the repetition of numerous short, curved lines that tumble around the center of the composition—even though curved lines are usually characterized as graceful and melodic. Although it is hard to go much beyond

Figure 3-6 Umberto Boccioni [Italian, 1882–1916], *Dynamism of a Soccer Player*, 1913. Oil on canvas, 76 1/8 × 79 1/8 in. (193.4 × 201 cm). Museum of Modern Art, New York. Sidney and Harriet Janis Collection. © Art Resource, NY.

generalizations in discussing the emotional quality of line direction, interpreting art has always depended heavily on the psychological properties of lines.

SPECIALIZED LINES

Contour Lines

From the simple drawing of Henri Matisse's head (Figure 3-1) to the sophisticated representation of reality in Raphael's *The Alba Madonna* (Figure 3-7), artists' images depend on lines—especially contour lines—to create the appearance of a face, an apple, or an abstract shape. The red lines in the diagram accompanying Figure 3-7 indicate the contour lines around the body of Christ and along the robe of Mary in *The Alba Madonna.* A **contour line** surrounds the edge of a form, limiting the form and distinguishing one area from another. It indicates where the form breaks off and another form begins, and in this way implies some space or room until the eye comes to the next area. The lines in a child's coloring book usually consist of contour lines.

When Raphael began painting *The Alba Madonna,* he first drew the contour lines of the figures on the surface to be painted, then proceeded to fill in and cover these outlines with color. In a work such as Matisse's head, they are a **convention,** a device of representation that we all accept. In reality, there is no line under anyone's chin or along the tip of anyone's nose. We have learned to understand

Figure 3-7 Raphael [Italian, 1483–1520], *The Alba Madonna*, ca. 1509. Oil, transferred from wood to canvas, 37 1/4 in. (94.6 cm). National Gallery of Art, Washington, D.C. Andrew W. Mellon Collection 1937.1.24.(24)/PA. Image © 2004 Board of Trustees, National Gallery of Art, Washington, D.C.

contour lines as the limit of a form, even though contour lines themselves seldom exist in nature. These lines represent the edge of what one can see as those forms turn **Illusion** **MODULE** around through space. **of Roundness**

Architectural and Sculptural Lines

Solids and planes have distinct edges, of course, but not dark lines around them. Thus, by convention, one can also speak of the linear contours of the three-dimensional forms of sculpture or architecture—the line of a statue's back, the roofline of a building, or the curve of a chair leg.

Horizontal and vertical lines dominate in architecture because of our natural desire for a building's stability. The vertical lines of classical columns and the soaring lines of modern office towers lie perpendicular to the horizon. In many buildings, perpendicular window frames or curved arches create lines that express the character of the building. The intersection of walls at the corners of a building usually produces stable right angles, or they may be curved. Architecture also has rooflines—the angular pitch of gables, the jagged lines of medieval spires and pinnacles, the swelling curves of domes.

Drapery Folds

In sculpture and painting, the eye often follows the rhythmic lines of drapery folds. **Drapery** refers to the loose garments arranged on figures. Flowing garments are not common today, but in the past artists often arranged clothing around the human body. The folds of the drapery may hang loosely over

the mass, flow in a single direction, gather at specific points, or flutter free of the figure. Wavy, angular, or straight, the lines of drapery folds allow the artist to display motion in the body or simply express the excitement latent in the figure. The medieval sculptor of *The Ascension of Christ* (Figure 3-8) at Vézelay, France, carved drapery folds not as the bending of real cloth but as energetic patterns of lines that swirl about the figure and express the excitement of the event. The parallel lines curve and sway across and around the body of Christ. The lower edge of his robe, especially, ripples with movement. On the hip, knee, and arms the folds swirl like small whirlpools flinging out lines of energy. The pattern of lines transforms Christ into an ecstatic heavenly being.

Hatching

Artists also have conventions to indicate variations of light and dark. In his etching *Old Bearded Man Looking Down* (Figure 3-9), Rembrandt made a series of close, parallel lines to indicate the darker parts of forms—a technique called **hatching.** Two series of parallel lines crisscrossing on top of one another to create a particularly dark area is a technique called **cross-hatching.** In fact, Rembrandt depicted his old man with nothing but hatching and cross-hatching. By varying the density of the hatched lines, he suggested the degree of darkness and the quality of light in an area. The contour of the man's back nearly disappears in the dark, whereas the bright light obliterates the contour of his forehead and left arm. The absence of the contour intensifies the light on the old man, lost in his thoughts and dozing in the sun.

Calligraphic Lines

In Guercino's drawing *Mars and Cupid* (Figure 3-10), many of the lines do not define the precise contour of the form. Many of the curved lines are so animated and decorative that they create surface patterns and function merely as enhancements of the forms. Such lines are called **calligraphic** in the sense that they look like the elegant flourishes of a fancy handwriting such as that found in an eighteenth-century manual of beautiful writing styles (Figure 3-11)—a little something more than what is neces-

Figure 3-8 [French], *The Ascension of Christ*, 1120–1132. Detail from the tympanum over the central portal of the narthex of La Madeleine. Vézelay, France. © Gianni Dagli Orti/Corbis.

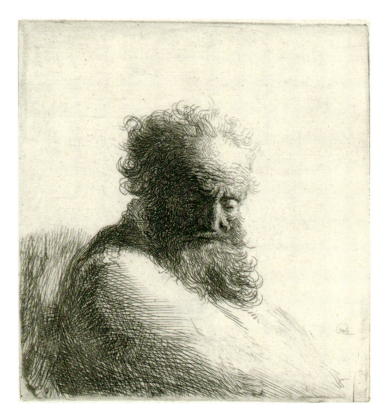

Figure 3-9 Rembrandt van Rijn [Dutch, 1606–1669], *Old Bearded Man Looking Down*. Etching. 4 5/8 × 4 1/8 in. (11.7 × 10.5 cm). Rijksprentenkabinet, Rijksmuseum, Amsterdam.

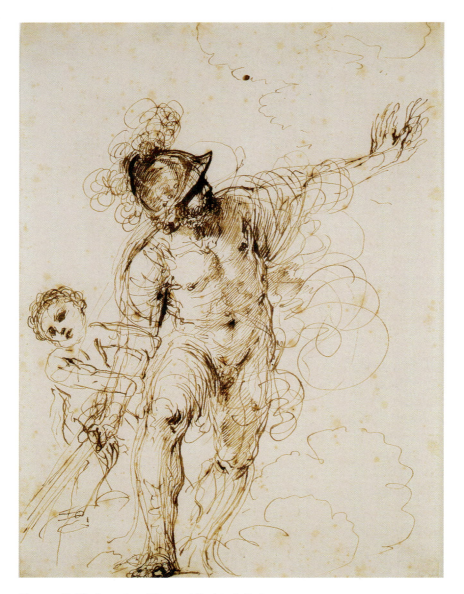

Figure 3-10 Guercino (Giovanni Barbieri) [Italian, 1591–1666], *Mars and Cupid*. Pen and ink, 10 1/16 × 7 3/16 in. (25.6 × 18.3 cm). Oberlin College, Ohio. Allen Memorial Art Museum. R. T. Miller, Jr. Fund, 1958.

sary to describe the form. We enjoy calligraphic lines for their decorative aspect, for their virtuosity and stylishness, and for the energy they generate.

In the East, to write the characters of their languages, the Chinese and Japanese have long employed a tradition of calligraphy, which has developed into an art form of its own. The landscape painter Chao Meng-fu employed a classic style of Chinese calligraphy in his *Pao-t'u Spring Poem* hand

Figure 3-11 "Elegance of Taste," in Thomas Tomkins, *The Beauties of Writing*, 1777. 11 × 17 1/2 in. (28 × 44.5 cm). Victoria and Albert Museum, London. © Art Resource.

Figure 3-12 Chao Meng-fu [Chinese, 1254–1322], running script, part of *Pao-t'u Spring Poem* hand scroll. Yüan dynasty. Ink on paper. National Palace Museum, Taipei, Taiwan, Republic of China.

The Chinese have a special reverence for calligraphy. As children, they are instilled with respect and appreciation for the art of writing. Using a brush for writing allows the Chinese calligrapher greater variety in the shape and personality of each character's lines; brushed lines easily swell and taper. As with any handwriting, Chinese calligraphy may express a person's character through the quality of the lines. However, Chinese characters have more meaning and associations connected with them than do the independent letters of the Western alphabet. Also, Chinese calligraphy has a history of styles, just like the history of styles in painting or sculpture, and the various styles of calligraphy may be appreciated as expressions of the historical culture that produced them.

scroll (Figure 3-12). He combined elegance of linear movement with the strength embodied in the angles and thickness of the lines.

Implied Lines

The human eye can also imagine lines in places where there might not be any lines. The arms and shoulders of the figure in *Archer* (Figure 3-13), a charcoal drawing by Tintoretto, form a diagonal line almost parallel to the arrow. Despite the numerous wavy contour lines that ripple around them, the torso and leg of Tintoretto's archer also form a curve very similar to the curve of the bow. His body takes on the very shape of his weapon.

But in reality the arms and shoulders of Tintoretto's archer have no straight lines, and the torso and leg do not have one continuous curve. The eye, always at work with the brain, likes to simplify many irregular forms and disjointed shapes and treat them as a line that moves in one direction. In spite of a very wiggly contour line, we can read the archer's whole arm as a single line. These **implied lines** appear in the figure because the mind's eye straightens out the twisty contour lines. It observes the general direction in which the undulations are moving. It also senses the central axis of the limb, as though it were an imaginary line running down the middle of the form. However we look at it, the mind's eye sees the body part as a single simple line.

Simplifying irregularities into comprehensible lines works not just with body parts. The outline of a hill in a landscape painting might be very irregular and disjointed yet seem to flow in a steady diagonal direction. We see these implicit lines because our mind prefers to see a unified whole before it experiences the individual parts. This principle was developed as part of **Gestalt psychology** in the early twentieth century. The German word *Gestalt* means "forms, pattern, or shape." Gestalt psychologists ob-

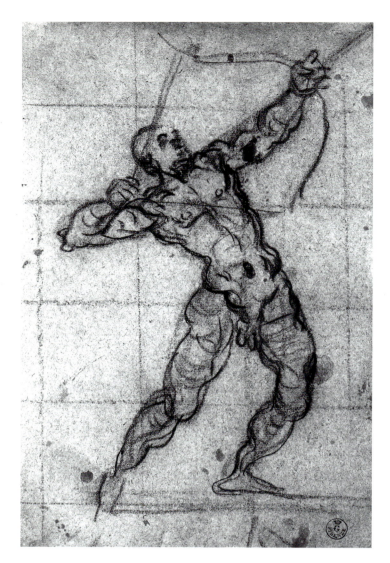

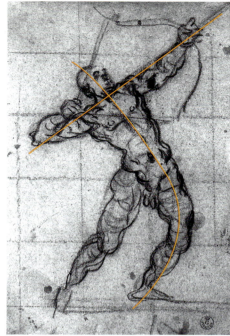

Figure 3-13 Tintoretto (Jacopo Robusti) [Italian, ca. 1518–1594], *Archer.* Charcoal, 12 11/16 × 8 1/8 in. (32.2 × 20.7 cm). Uffizi Gallery, Florence. © Art Resource.

Figural Movement Lines

The gestures and poses of the human body in a work of art make forceful linear roadways for our eyes to follow. It is only natural that we have strong sympathy for human movements. Some poses and gestures come to human beings naturally: laughing and crying seem to generate the same body movements in people all over the world. Other actions, such as shaking hands or waving good-bye, are developed as conventions in an individual society. Often we have to learn the body language of distant cultures in order to fully appreciate their lines. For example, understanding the body language of Hindu culture can give us a better feel for the strong lines of the sculpture of *Nataraja:*

serve that people are much more likely to see complete and unified patterns, such as single lines, rather than the fragments and parts. A broken circle will be seen as a circle before it will be perceived as a series of disconnected arcs.

The exchange of glances between John the Baptist and the Christ child and Mary in Raphael's *The Alba Madonna* (Figure 3-7) also creates a diagonal line parallel to the one formed by Mary's left leg and forearm. We call this imaginary line between an eye and the object of its glance an **eye-line.** Eye-lines create movement because they establish another kind of path for the viewer's eye. It is common experience that just as people tend to look in the direction that someone is pointing, the direction of someone's glance draws our attention along the imaginary line of the glance.

Actual and Implied Line **MODULE**

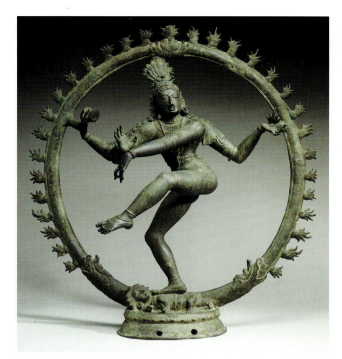

Figure 3-14 [Indian], *Nataraja: Shiva as King of Dance*, Chola period, eleventh century. Bronze, 43 7/8 in. (111.4 cm) high. © 2004 The Cleveland Museum of Art. Purchased from the J. H. Wade Fund (1930.331).

Nataraja is a manifestation of Shiva in Hindu religion. Shiva and Vishnu are the two important members of the Hindu trinity. In this sculpture, Shiva Nataraja is dancing within the circle of the sun, from whose rim flames shoot forth. The circle also represents the cosmos. Shiva tramples the demon of Ignorance under one foot. Hindus consider the universe to be the light reflected from the limbs of Shiva as he dances within the circumference of the sun. Shiva also periodically destroys the universe so that it might be created again.

Hindu sculptors add arms to Shiva whenever additional attributes are given to the god. In this example, while the forward hands perform the ritual of the dance, a third hand holds a small drum and the fourth a flame. The violence of the dance expresses the awesome power of the beautiful god, exquisitely poised and balanced within the circle.

Shiva as King of Dance (Figure 3-14). A god of creation and destruction, Shiva crosses his left leg over the other, parallel to the movement of the arms. The torso and right leg create a zigzag line similar to the W-configuration of the outstretched arms. Yet the violent dance is contained within the circle.

Whereas the dancing *Shiva* displays striking linear movement, the Greek bronze warrior from Riace, Italy, in Figure 3-15 displays movement in the

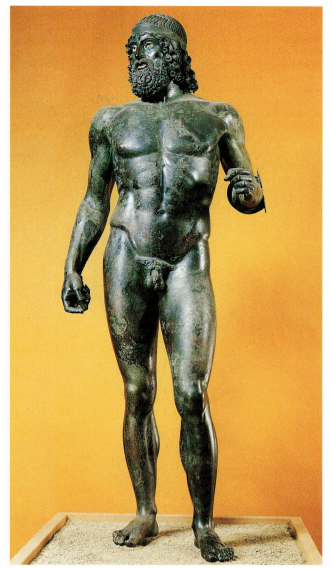

Figure 3-15 [Greek], *Riace Warrior*, 460–450 BCE. Bronze, silver teeth and eyelashes, copper lips and nipples, 71 in. (185.4 cm) high. Archeological Museum, Reggio Calabria, Italy. © Scala/Art Resource, NY.

The *Warrior* and another bronze companion sank to the bottom of the sea off the southern coast of Italy when the Romans were transporting the statues from Greece. There they remained for 2,000 years, until a diver accidentally discovered them in 1972.

Cast at a slightly earlier date than the bronze original of *Spearbearer* (Figure 2-7), the bearded *Warrior* was obviously meant to appear older than Polyclitus's youth. He once held a spear in one hand and a shield in the other. He also holds his head up and sharply to the right. He has opened his mouth and bared his silver teeth as though he is speaking in anger. The *Warrior* is as powerfully built as *Spearbearer,* but the original Greek bronze casting has more surface realism—inlaid eyes, veins, and sinews—than the Roman copy of Polyclitus's work.

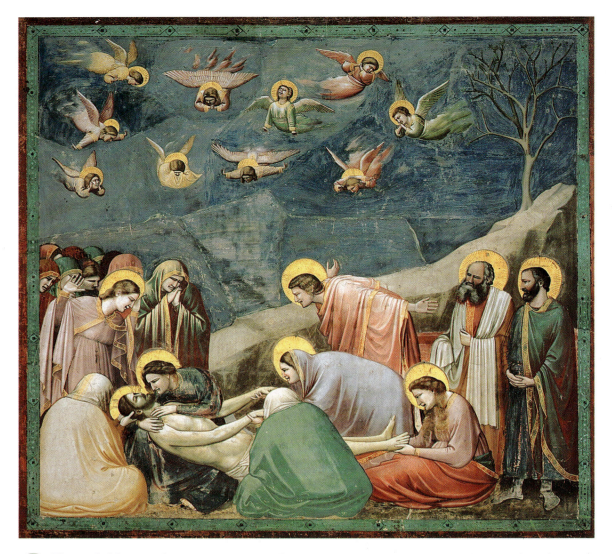

Figure 3-16 **Giotto** [Italian, ca. 1266–1337], *Lamentation*, ca. 1305. Fresco, 78 3/4 × 72 3/4 in. (200 × 184.8 cm). Arena Chapel, Padua, Italy. © Scala/Art Resource, NY.

human body by a subtle device called **contrapposto.** The Italian word means "counter-positioning." Contrapposto entails placing parts of the human body in contrast to each other by making them move in opposite directions. One part turns in one direction, and a related part turns in another, or one part is up while the other is down. The *Riace Warrior* has simply shifted his weight to one leg so that the one leg—the leg that supports the weight—is tensed; the other leg is relaxed. One leg moves forward; the other stays back. One arm is up, and the other is down. Shifting the weight to one leg throws the hip out and creates a slight spiraling curve throughout the entire body, from toe to head. The statue is a good illustration of how the body can move by alter-nately tensing and relaxing groups of muscles.

Implied Time and Motion **MODULE**

Compositional Lines

A network of lines often helps move the eye to reveal the essence of a scene. When Giotto dramatized *Lamentation* (Figure 3-16) in the Arena Chapel, Padua, he surrounded the dead body of Christ with mourners, all of whom direct our attention to Christ by their glances. The mourners focus also on Mary, his mother, who looks directly into her son's face. The tightly knit web of eye-lines created by the glances of the figures intensifies the drama. Giotto concentrated on human reactions, not the setting. In

Figure 3-17 Leonardo da Vinci [Italian, 1452–1519], *The Virgin of the Rocks*, ca. 1485. Oil on wood (transferred to canvas), 75 × 43 in. (199 × 122 cm). Louvre, Paris. © Scala/Art Resource, NY.

Lamentation the hill behind the figures forms an obvious diagonal line that leads our eye to the center of interest in the lower left corner—the embrace of Christ and Mary. St. John's out-flung arms parallel the same diagonal movement toward Christ. Except for these diagonals, most of the lines in the painting are stable and somber horizontals and verticals—especially the verticals at the left and right, framing the composition. The symbolic dead tree at the right lines up with the verticals of the disciples below, with both lines running parallel to the frame.

In *The Virgin of the Rocks* (Figure 3-17), Leonardo da Vinci arranged the four figures in his painting so that on the surface, they are in the shape of a triangle. Mary appears to encourage the infant John the Baptist to come forward by placing an arm around him. The slope of her arm and his back, as well as the eye-line of her glance, creates a diagonal on the left. The diagonal on the right runs down the back of the angel. John the Baptist stares at the Christ child, and the angel's pointing finger generates another implied line across the painting. Mary holds an outstretched hand above her child's head—part of a vertical line that runs up the Christ child's arm and through the angel's hand. Leonardo has choreographed the group into a stable triangular configuration filled, nonetheless, with complex interaction. As both Giotto and Leonardo have demonstrated, gestures and poses are one of the ways that lines move the eye to help discover the meaning of a work.

SHAPE AND MASS
Shape

In Georgia O'Keeffe's painting *Corn, No. 2* (Figure 3-18), some of the curves may be considered either thick lines or thin shapes. As lines swell to a certain

thickness, we become more aware of their two-dimensional character. This awareness transforms them into shapes. **Shapes** are areas of the surface of a work of art that have a distinct form. If a line is wide enough, we might easily call it a shape. Many of the sinuous lines that vibrate throughout the landscape in Edvard Munch's *The Scream* (Figure 3-4) seem to swell into snake-like shapes.

Sometimes we recognize an area of a work of art as a shape because it is bound by a contour line. In other words, a line that comes around and closes in on itself creates a shape out of the surface. Distinctions between light and dark can break a surface into separate shapes, such as the shape of a shadow cast on a wall. Finally, differences in color or differences in pattern or texture can also distinguish areas from one another and create shapes.

Mass

In three-dimensional art media, such as sculpture and architecture, distinguishable forms have solid, three-dimensional **mass** taking up real space, not simply an area of a surface. Although we can say that the lines and shapes of Tony Smith's *Cigarette* (Figure 3-19) twist and turn, the work is essentially a mass that meanders above and along the ground. In a drawing, a bent leg might be a curved shape; in the Greek sculpture *Three Goddesses* (Figure 2-8), it becomes a cylindrical mass protruding into space at

Figure 3-18 **Georgia O'Keeffe** [American, 1887–1986], *Corn, No. 2*, 1924. Oil on canvas, 27 1/4 × 10 in. (69 × 25 cm). Georgia O'Keeffe Museum, Santa Fe/Art Resource, NY.

When Georgia O'Keeffe painted flowers or plants, she came so close to them that their lines and shapes often extend beyond the edge of the canvas. By enlarging the corn leaves, O'Keeffe shows us a pattern of tall, tapering shapes and S-curves that we might never have seen ourselves. She once wrote that although everyone likes and admires flowers, "still—in a way—nobody sees a flower—really—it is so small—we haven't time—and to see it takes time like to have a friend takes time. . . . So I said to myself—I'll paint what I see—what the flower is to me but I'll paint it big and they will be surprised into taking time to look at it."[4]

Figure 3-19 **Tony Smith** [American, 1912–1982]. *Cigarette*, 1961. Painted steel. 15 ft. 1 in. × 25 ft. 6 in. × 18 ft. 7 in. (459.2 × 777.2 × 566.3 cm). Museum of Modern Art, New York. Digital Image © The Museum of Modern Art. Licensed by SCALA/Art Resource, NY. © 2006 Estate of Tony Smith/Artists Rights Society (ARS), New York.

the knee. In an architectural plan, the walls of an old stone building are black lines. In actuality, the walls and vertical columns of a building have thickness and substance and fill up space—they have mass.

Unlike the two-dimensional shapes of drawing and painting, the masses in sculpture and architecture bulge out, lie flat, or break at a sharp angle as in a cube or a pyramid. Curving gently or protruding to a point, the swelling of a mass expresses its character. The Indian sculptor who carved the two dancers (Figure 3-20) into the living rock in Karle, India, certainly understood sculptural form as mass. The dancers flank the doorway of an enormous pillared hall cut into the hillside. Their relaxed bodies still flush from their exercise and their chests raised to inhale the air, this prince and princess pause to welcome the worshipper. Their faces, his broad shoulders, her breasts and hips—everything the sculptor carved is conceived as a rounded mass, filling but not crowding the framework of the relief. The full masses of their bodies burst with vitality and health.

Kinds of Shapes and Masses

In Georgia O'Keeffe's painting (Figure 3-18) and in Tony Smith's abstract sculpture (Figure 3-19), the shapes and masses are easy to recognize because they are so distinct. But even in representational works we can distinguish simple shapes and masses. The two mourners in the foreground of

Giotto's *Lamentation* (Figure 3-16) form blunt triangular shapes. The Olmec sculptor who carved the seated figure holding a child in his lap (Figure 3-21) obviously understood the head, torso, and limbs as swollen cylindrical masses perpendicular to one another. These "hidden" shapes and masses within nature reveal that the artist sees relationships and imposes order.

Shapes and masses have some of the same characteristics as lines. Like lines, they have directions and make pathways for the eye. Except for circles and squares, spheres and cubes, most shapes and masses have a longitudinal axis that establishes a primary direction for the eye. The shapes of the curved leaves in O'Keeffe's *Corn, No. 2* (Figure 3-18) create a vertical movement.

Shapes and masses have direction.

Different shapes and masses have different emotional characteristics. Compare the shapes in O'Keeffe's painting with the shapes in Joan Miró's *Figure* (Figure 3-22). In O'Keeffe's piece, curved shapes flow through the canvas and beyond. They appear simple and full of life. In Miró's painting, col-

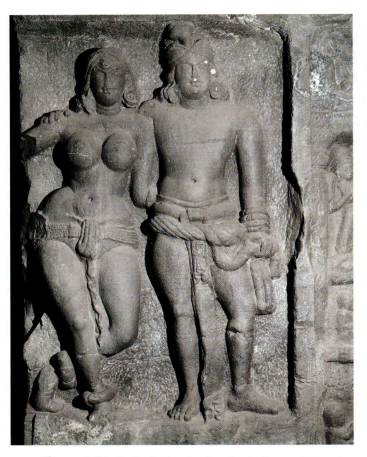

Figure 3-20 [Indian], Dancing Couple. Andhra period, early second century CE. Granite, over-life-sized. From the facade of the Chaitya Hall, Karle, India. © Borromeo/Art Resource, NY.

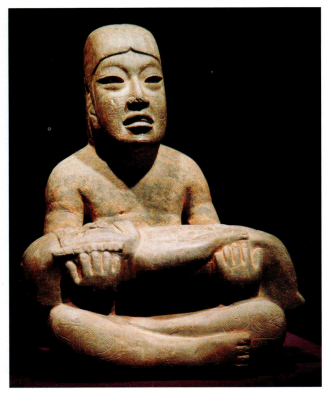

Figure 3-21 [Olmec], Las Limas sculpture, ca. 800 BCE. Greenstone, 21 5/8 in. (55 cm) high. Museo de Anthropologia, Xalapa, Veracruz, Mexico. © Gianni Dagli Orti/Corbis.

ored blobs float against a dark olive background. Many of the shapes resemble heads, arms, and legs. They seem absurd yet playful.

In a work of art, shapes and masses can be small or large, delicate or overpowering; they can be many or few, repetitious or isolated. When straight or curved shapes in modern art are bound by precise contours and resemble regular geometric forms such as the square, circle, or triangle, they are often called **hard edged.** This term is applied to shapes in works such as Ellsworth Kelly's *Red Blue Green* (Figure 3-23) to distinguish these shapes from the brushed-in and gestural forms in works such as de Kooning's *Woman IV* (Figure 2-35). Critics have called the shapes in Miró's painting **biomorphic** because they resemble the irregular

shapes of biological organisms such as a cell or tiny animal. The biomorphic shapes in Miró's *Figure* suggest a dramatic life of personal relationships in the biological world or, better still, a dramatic life of biological relationships in the personal world.

Types MODULE
of Shape

THE FORMAT

In Helen Frankenthaler's painting *Lush Spring* (see "Artist at Work"), most of the rugged shapes arrange themselves around the perimeter of the canvas. In other words, Frankenthaler's shapes repeat and reinforce the rectangular format of the canvas. Shapes often tend to run parallel to the canvas or paper. In fact, the shape of the working surface often influences the internal lines and shapes in a variety of ways.

Figure 3-22 Joan Miró [Spanish, 1893–1983], *Figure*, 1934. Gouache, ink, crayon, on paper. 41 3/4 × 28 in. (75 × 55.5 cm). Musee des Beaux-Arts, Lyon, France © Réunion des Musées Nationaux/Art Resource, NY © 2006 Successio Miró/Artists Rights Society (ARS), New York/ADAGP, Paris.

Since most canvases or pieces of paper for drawings, prints, or photographs are rectangular in shape, the lines and shapes within the typical rectangular format are in effect defined by their relationship to the edges. The edges, like x- and y-axes, act as the reference lines for the diagonals and curves in a composition. The lines and masses of sculpture and architecture also often conform to the overall configuration of the work. The rectangular shapes of windows usually align themselves with the main masses of the building. In a similar way, the shape of a block of stone sometimes influences the masses that a sculptor carves in the work. The consistency between the format and the internal forms of a composition appeals to both artists and viewers.

The painter Piet Mondrian once attempted to defy the influence of the format in a series of diamond-shaped canvases including *Tableau No. IV; Lozenge Composition with Red, Gray, Blue, Yellow and Black* (Figure 3-24). In most of Mondrian's other

paintings (Figure 17-28, for example), the lines, squares, and rectangular shapes run parallel to the edges of his canvas. Occasionally, as in *Tableau No. IV,* Mondrian tilted the canvas at a forty-five-degree angle to create a more dynamic, diagonally oriented format. As a result, the frame seems to be continually cutting the painted lines and the shapes, which implicitly go beyond the framework. We seem to be looking through a diamond-shaped porthole at a small part of a reality, unrelated to the frame and extending far beyond the frame.

Not all canvases are square or rectangular, however. Not all sculpture is carved from a rectangular block of stone. In painting and low-relief sculpture, circular shapes, or **tondos,** were once popular, especially in the Renaissance. Circular formats are inherently unstable and tend to roll since they do not have a dominant axis. To stabilize his tondo in *The Alba Madonna* (Figure 3-7), Raphael built a solid triangular configuration out of the three figures. Other artists may play with the very instability of the circular form and build a dynamic composition out of circular or radiating shapes. An Aztec sculptor carved the dismembered body of *Coyolxauhqui* (pronounced ko-yol-*show*-kee) (Figure 3-25) all over a large circular stone. The goddess seems to revolve around the circular format because of the repetition of forms and short diagonal lines.

The second half of the twentieth century saw a movement, led by the American artist Frank Stella, toward irregular formats, or **shaped canvases.** In *Empress of India* (Figure 3-26) and in many of Stella's other works, the shapes within the painting

seem to determine the shape of the work's format, instead of the format influencing the shapes as is traditional. The zigzag configuration of the canvas follows the internal lines and V-shaped stripes of the painting. Whenever the shape of the canvas calls attention to itself, a painting starts to take on a sculp-

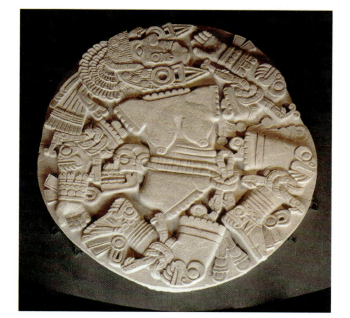

Figure 3-25 [Aztec], *Coyolxauhqui*, ca. 1400–1500. Stone, 132 in. (335.3 cm) in diameter. From the Great Temple of Tenochtitlán, Mexico City. © Gianni Dagali Orti/Corbis.

Discovered in 1978, this great circular relief lay at the foot of the twin pyramids that once stood in the heart of Tenochtitlán (Mexico City). In Aztec mythology, Coyolxauhqui, the moon goddess, was killed and dismembered by her brother Huitzilopochtli (pronounced weet-zeal-oh-*poch*-tlee), the god of the sun, because she had killed their earth mother. The enormous image of this macabre event confronted the thousands of sacrificial victims whose blood would spill down the steps of the Aztec pyramid.

tural quality. In this way, shaped canvases, especially as they grow more three-dimensional, frequently combine the arts of painting and sculpture into one work.

FIGURE–GROUND RELATIONSHIP

Some shapes psychologically appear to be more important than others in a work of art. In general, the figures or objects in the foreground tend to dominate the shapes in the background. For example, the figures in Giotto's painting *Lamentation* (Figure 3-16) attract our interest more than the pieces of earth and sky visible between them. This phenomenon of perception is called the **figure–ground relationship.** Gestalt psychology also investigated this tendency to perceive a form as a figure against a background. The popular Dutch printmaker M. C. Escher toyed with the figure–ground phenomenon in his woodcut *Day and Night* (Figure 3-27). At the top of his print a flock of dark birds flies over the daytime landscape on the left, and a flock of light birds flies over the nighttime landscape on the right. Toward the center we may perceive the shapes either way, depending on how we adjust the figure–ground

(text continued on page 80)

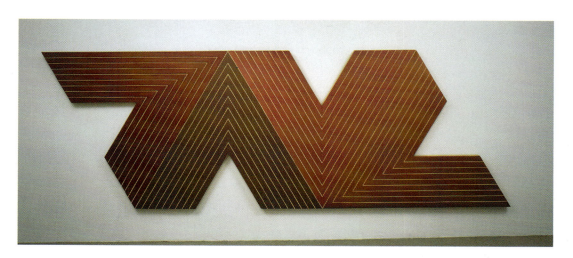

Figure 3-26 Frank Stella. *Empress of India*, 1965. Metallic powder in polymer emulsion paint on canvas. 6 ft. 5 in. × 18 ft. 8 in. (196 × 549 cm). Gift of S.I. Newhouse, Jr. (474.1978) The Museum of Modern Art, New York, NY, U.S.A. Digital Image © The Museum of Modern Art/Licensed by SCALA/Art Resource, NY © 2006 Frank Stella/Artists Rights Society (ARS), New York.

Helen Frankenthaler in her studio, 1969. Photo by Ernst Haas.

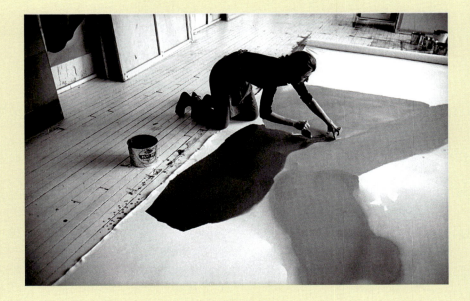

Helen Frankenthaler [American, 1928–], *Lush Spring*, 1975. Acrylic on canvas, 93 × 118 in. (236.2 × 299.7 cm). Phoenix Art Museum. Museum purchase with matching funds provided by COMPAS and the National Endowment for the Arts.

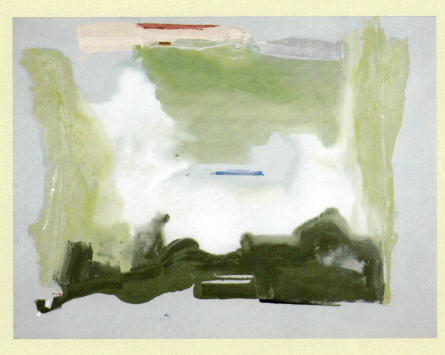

Helen Frankenthaler often stepped or crawled on her hands and knees inside her paintings. She painted on large pieces of canvas, spread on the floor, that she could work on from all four sides. By approaching her work this way, she identified no top or bottom to the canvas. Frankenthaler poured paint onto the canvas, moved it around with a sponge or her hands more often than with a brush, and let it soak in and stain the canvas. The flooding color grew dark and opaque as it pooled in spots, or the same color grew thin and transparent as it washed over another part of the canvas. By using this technique, she modulated light and dark, opaqueness and transparency. Sometimes, as in *Lush Spring,* Frankenthaler brushed on strokes of thick paint over the stained passages.

Frankenthaler saw an exhibition of Jackson Pollock's painting in 1951 (see Figure 18-1) and visited his studio on Long Island a number of times. His work struck her as a reve-

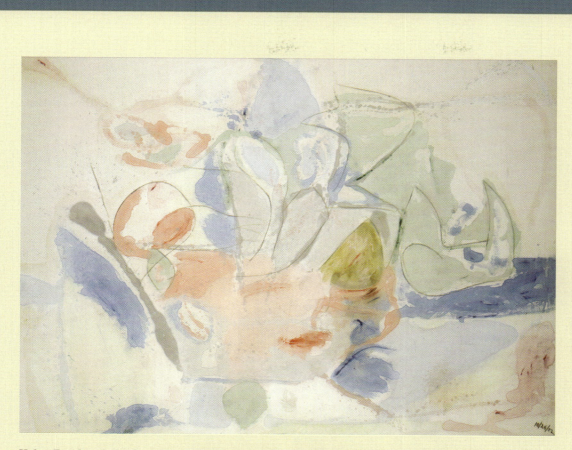

Helen Frankenthaler [American, 1928–], *Mountains and Sea*, 1952. Oil on canvas, 86 5/8 × 128 1/4 in. (220 × 325.8 cm). National Gallery of Art, Washington, D.C. On extended loan from the artist.

lation. She had grown up amid the art museums and galleries of Manhattan and had studied art at Bennington College, in Vermont, where she developed a late-Cubist style. It was not Pollock's technique of splashing and dripping paint that amazed her but the openness and boldness of his approach and the overall design floating in space that he achieved.

In October 1952, after weeks of sketching and of painting watercolor landscapes in Nova Scotia, Frankenthaler stained a canvas for the first time with shapes of oil color. The shapes of her painting *Mountains and Sea* preserved the feeling of wooded cliffs against the blue ocean. For years, her work reflected a landscape she had seen or an experience from life, although the titles were usually added after the painting was finished.

Frankenthaler's technical innovation was in transferring the methods of watercolor painting to oil painting on canvas. Because the canvas was raw and unprimed when she washed thinned oil paint across it, the paint soaked in and stained it. The light and the texture of the canvas material come through the transparent paint. The painted shapes become part of the surface so that they appear very flat and yet of mysterious

spatial ambiguity, like clouds in the sky. For example, the transparent, washed-in shapes of *Lush Spring* float around the rectangle, interlock, and frame a center of mysterious depth.

Frankenthaler painted spontaneously. She worked with the accidental flow of the paint, adjusting her next moves and allowing the shapes to grow and evolve. Although color usually defined a shape, colors often changed imperceptibly, one into another within the same shape, because of her flooding technique.

Around 1960, Frankenthaler began priming the canvas and switched to water-based acrylic paints to avoid the fading of oil paint and to achieve larger, more solid, and more defined shapes. In the early 1970s, she began adding the thick paint visible in *Lush Spring*. Her method was to try everything and experiment with new shapes, new color combinations, new textures. Nine times out of ten the experiment failed, she admits, and she threw away the canvas. She often cropped the canvas lying on the floor to achieve the final composition. Her shapes thus usually extend beyond the edge of the finished painting, unlike those in *Lush Spring,* which echo the rectangular framing edge.

relationship. As the ambiguous shapes transform themselves from ground into figure, day becomes night.

The figure–ground phenomenon of visual perception can mislead us about the relative importance of shapes. Although artists often characterize the left-over shapes in the background as **negative shapes,** they remain vital elements. Although they may seem subordinate, background shapes play an important role in the overall design of the work. Amateur photographers may discover this importance only when their prints are developed and they realize that there was a telephone pole in the background that now appears to be growing out of the subject's head.

To emphasize that every shape has a function in a design, some artists have tried to do away with the figure–ground relationship by treating all the shapes in the work equally. In Bridget Riley's *Nataraja* (Figure 3-28), the artist eliminated the figure–ground distinction completely. Each colored parallelogram asserts itself as a legitimate shape and rises to the surface. Without dominant figures or a ground, vertical bands appear to move in and out.

Positive and Negative Shape MODULE

Line

General Characteristics

Quality	Thick, thin, jagged, smooth, broken, and continuous lines express character.
Movement	Lines make the eye move.
Direction	Lines that go up, down, or across, move diagonally, or are curved convey feeling.

Specialized Lines

Contour lines	Contour lines surround the periphery of a form.
	Contour lines are an artistic convention.
Architectural and sculptural lines	Architectural and sculptural lines also have quality, movement, and direction.
Drapery folds	The folds and crevices of cloth create lines.
Hatching	Parallel lines indicate dark areas.
Calligraphic lines	Elegant flourishes, called calligraphic lines, are used to enhance forms.
Implied lines	The eye may imagine lines where none actually exist.
Figural movement lines	The eye has strong sympathy for the lines of the human body.
Contrapposto	Contrapposto is a device that uses contrasting directions of the body to portray movement.
Compositional lines	Compositional lines can guide the eye to the essence of the work.

Shape and Mass

Shape	A shape is a surface area with a distinct form.
Mass	A mass is a solid, three-dimensional form.
Kinds of shapes and masses	Shapes and masses also have quality, movement, and direction that can affect feeling.

The Format

	The format often influences the arrangement of the internal lines, shapes, and masses.

Figure–Ground Relationship

	Negative and positive shapes define the figure–ground relationship.

INTERACTIVE LEARNING

 Foundations Modules: Visual Elements

Flashcards

Artist at Work: Helen Frankenthaler

 Companion Site: **http://art.wadsworth.com/buser02**

Chapter 3 Quiz

InfoTrac® College Edition Readings

Talking Flashcards

Online Study Guide

4 Light and Color

LIGHT

In Joseph Mallord William Turner's painting *The Slave Ship* (Figure 4-1), the light of the sun becomes the leading actor in a tragic drama. The typhoon that threatens the ship swirls around the light and seems to emanate from it. The sun appears to operate as the agent of divine vengeance that causes the cataclysm and punishes evil. Throughout the painting, light cuts through, flings, and churns the blood-stained darkness. Turner's painting demonstrates that light itself can be much more than a mere source of illumination—that it can have meaning and be an active agent in a composition.

Turner first titled his painting *Slavers Throwing Overboard the Dead and Dying—Typhoon Coming On.* He had read about a slave ship called *Zong,* whose captain had ordered the sick and dying thrown overboard in order to collect insurance. An epidemic raged on board, but the ship had been insured for losses at sea, not for loss of life through disease. As Turner imagined the scene, the small, spindly ship struggles against crashing waves and is about to be engulfed by the storm. The captain has already thrown the diseased slaves into the water. In the foreground, fish that look like freshwater piranhas devour the slaves' manacled limbs. Although the light can be interpreted as divine vengeance, Turner himself, in a poem he wrote about the painting, emphasized the irony that the storm, which had prompted the captain's evil deed, would also dash the captain's hopes for high profits.

At times throughout history the sun has been worshipped as a god; it symbolizes divinity in religions around the world. The ultimate source of energy, heat, and light on earth, the sun makes life on earth possible. Light also makes seeing possible. The separation of light from dark was one of the first

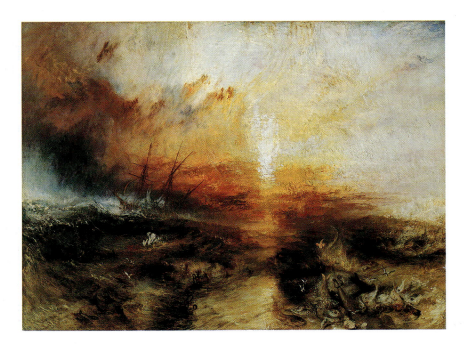

Figure 4-1 J. M. W. Turner [British, 1775–1851], *The Slave Ship (Slavers Throwing Overboard the Dead and Dying, Typhoon Coming On),* 1841. Oil on canvas, 35 3/4 × 48 1/4 in. (90.8 × 122.6 cm). Museum of Fine Arts, Boston. Henry Lillie Pierce Fund. © 2004 Museum of Fine Arts, Boston. All rights reserved.

acts of creation in the Hebrew Bible, and it can be the primary act of creation for the artist. Primitive feelings about light and dark lie deep inside us. In our culture, light can express goodness, clarity, intelligence, and fullness. Darkness can represent evil, mystery, ignorance, and emptiness. The contrast between light and dark not only creates forms and describes space in art; it generates feelings, energy, and drama as well.

Figure 4-2 *The Simpsons.* © UPPA/Tapham/The Image Works.

VALUE

Color is an integral part of light, but there is an important distinction between light and color. The difference can be easily demonstrated through black-and-white photography and television. Black-and-white film or video can translate the colors of nature into a seemingly infinite number of grays between black and white. For example, a black-and-white version of *The Simpsons* (Figure 4-2) remains legible without color. But an image cannot exist without distinctions between light and dark. An all-white, an all-black, or a solid-green surface without variations of light and dark would not signify very much.

The black-and-white image of *The Simpsons* demonstrates that light has two different properties: "lightness" and color. The first property involves the amount of light reflected from the surface of an object. The name for this relative lightness or darkness of some area is **value.** The color of an object, a property distinct from its value, is called **hue.** Hue is what we most often mean by the word *color*—that is to say, hue is what we mean by *red, green,* or *blue.* With value and hue, a surface can be dark or light and, at the same time, red or green.

Scientists describe light as belonging to a whole series of electromagnetic energy waves radiating through space such as radio waves, X-rays, and cosmic rays. The human eye can tune in to only a small number of these wavelengths. Technically speaking, a hue is a certain wavelength of light, a small part of the energy scale.

Value MODULE
Scale

LIGHT SOURCE

The variations of light and dark on an object in nature—its values—depend upon the location of a source or sources of light. The sun, a fire, and a light bulb are common **light sources.** Although rooms are often lit by a combination of natural and artificial light, artists have traditionally depicted what they see as if it were illuminated by a single light source. Two or more light sources are possible to render, but the simplicity and consistency of a single light source make the job of portraying light and dark surfaces easier.

The light in most pre-modern paintings and drawings usually comes from the upper left corner. Since most people are right-handed, artists usually sit with the light source at their left so that their right arm does not cast a shadow across their work. In portraits, this means that the sitter usually turns to the viewer's left to face the light coming from the left.

Sunlight most often comes into a painting from above. Occasionally, for special effects, an artist will use a more unusual light source, such as the light of dawn or sunset. Some landscape painters specialize in capturing the light of those rare times of day. In *The Slave Ship* (Figure 4-1), Turner looked directly into the low-lying sun and into its light blazing across the sky. Shadows caused by the waves in the ocean fall toward the viewer. A cloudy day presents

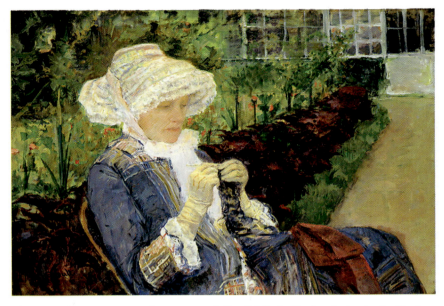

Figure 4-3 **Mary Cassatt** [American, 1845–1926], *Lydia Crocheting in the Garden at Marly*, 1880. Oil on canvas, 26 × 37 in. (66 × 94 cm). Metropolitan Museum of Art, New York. Gift of Mrs. Gardner Cassatt, 1965 (65.184). Photograph © 1984 The Metropolitan Museum of Art.

a special challenge to a landscape painter since the entire overcast sky becomes the light source and diffuses the light on things evenly from almost every direction. In Mary Cassatt's painting *Lydia Crocheting in the Garden at Marly* (Figure 4-3), objects cast almost no shadows, and almost every colored surface in the painting has the same middle value—except the slash of light in the bonnet and scarf that frame the face.

If the light source is placed behind the subject, the interruption of the light might turn the subject into a **silhouette,** or a likeness consisting only of an outline that has been darkened or filled in solid. (In the mid-eighteenth century, the French minister of finance, Étienne de Silhouette, began cutting profile portraits of people out of black paper, hence the term *silhouette.*) Apple Computer ran a successful advertising campaign for its iPod listening device using only silhouetted figures (Figure 4-4).

A strong light in many Surrealist paintings comes from the front or from the side and casts sharp shadows. The light source from the right front in Yves Tanguy's *Indefinite Divisibility* (Figure 4-5) puts every object in sharp focus and casts sharp shadows on the ground. By contrast, Tanguy's featureless landscape dissolves into the sky. The sharp light gives the strange creatures and machines, made from what looks like dried bones and weathered rock, an uncanny reality.

The source of illumination can even come from some artificial source visible within the picture. When the artist Artemisia Gentileschi painted *Judith and Maidservant with the Head of Holofernes* (Figure 4-6), she imagined the scene taking place at night and cleverly illuminated the two figures from the light of a candle. The source of light sets a mood of stealth and suspense. For symbolic reasons, the

Figure 4-4 iPod magazine advertisement. © Apple Computer, Inc. Used with permission. All rights reserved. Apple® and the Apple logo are registered trademarks of Apple Computer, Inc.

Figure 4-5 **Yves Tanguy** [American, 1900–1955], *Indefinite Divisibility*, 1942. Oil on canvas, 40 × 35 in. (101.6 × 88.9 cm). Albright-Knox Art Gallery, Buffalo. Room of Contemporary Art Fund, 1945. © 2006 Estate of Yves Tanguy/Artists Rights Society (ARS), New York.

Figure 4-6 **Artemisia Gentileschi** [Italian, 1593–1653], *Judith and Maidservant with the Head of Holofernes*, ca. 1625. Oil on canvas, 72 1/2 × 56 in. (184 × 142 cm). Gift of Mr. Leslie H. Green. Photograph © The Detroit Institute of Arts.

Unlike other women artists of her time, Artemisia Gentileschi developed the necessary skills to depict the human figure in action because her father, Orazio, also a prominent artist, gave her adequate training. Judith, an outstanding Old Testament heroine, cut off the head of Holofernes, the enemy of the Israelites. Artemisia Gentileschi, who painted the event several times, probably felt sympathetic toward the iconography of a heroic woman. In the Detroit painting, Judith and her servant seem startled by a noise they hear outside the tent. They both stop and look up. Judith raises her left hand to quiet her servant or to shield her eyes from the glare of the candlelight. Her hand casts a sinister patch of dark shadow across her face. The bright light and harsh shadows fill the air with menace and dramatic tension.

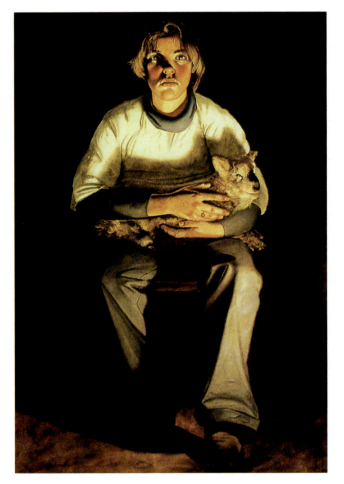

Figure 4-7 Alfred Leslie [American, 1927–], *Portrait of Donna Kaulenas*, 1976. Oil on canvas, 108 × 72 in. (274 × 183 cm). Courtesy of the artist.

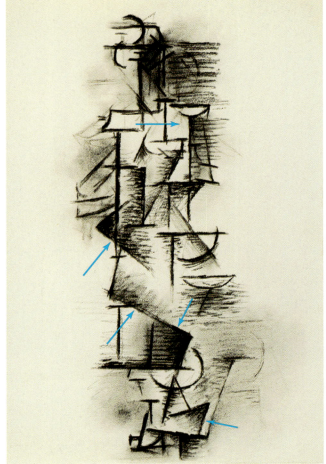

Figure 4-8 Pablo Picasso [Spanish, 1881–1973], *Nude*, 1910. Charcoal on paper, 19 1/16 × 12 5/16 in. (48.4 × 31.3 cm). Metropolitan Museum of Art, New York. Alfred Stieglitz Collection, 1949 (49.70.34). © 2006 Estate of Pablo Picasso/Artists Rights Society (ARS), New York.

The arrows indicate how the light comes from many different directions.

Christ child in a Nativity scene may be the light source, with the rest of the painting lit consistently from his direction. The light source in a painting or drawing might even be underneath an image. The American painter Alfred Leslie experimented with such an unusual light in his over-life-sized *Portrait of Donna Kaulenas* (Figure 4-7). Leslie's light source, located in the lower right, casts sharply defined shadows across the subject—including the shadowy outline of the sitter's pet. Coming from underneath, the light illuminates unusual places such as the neck, the chin, and the skin under the eyes and the eyebrows. The extraordinary light source reverses the conventional formulas for painting the human figure.

As soon as the modern movement in Western art abandoned the idea that a work of art had to be a reproduction of nature, many artists dropped the idea of a consistent light source coming from a single direction and felt free to light their forms in unorthodox ways. For example, Pablo Picasso, in the charcoal drawing *Nude* (Figure 4-8), made the geometrical facets he used appear to overlap and tilt in one direction or the other by means of contrasts of light and dark. However, he placed the lights and darks as though the light was coming from one light source in one place, then from another source in another place. Picasso seems to have changed the source of light with each observation of a shape in

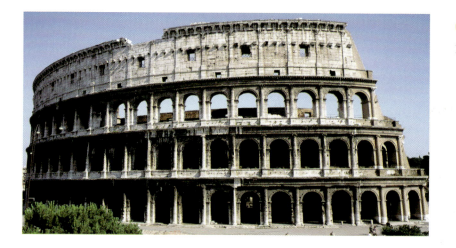

 Figure 4-9 [Roman]. Colosseum, 72–80 CE. Robert Harding Picture Library.

space. This treatment is typical of modern-art lighting, which is sometimes said to be irrational in the sense that the artist has not simplified, unified, or "rationalized" the light sources.

CHIAROSCURO

Images are formed in the eye by differences between light and dark. This text will call any contrast between light and dark **chiaroscuro** (the Italian word means "light dark" in literal translation), although many people reserve the term for pronounced contrasts.

Every change from light to dark—be it gradual or abrupt—suggests volume or spatial depth to our eye, so the term *chiaroscuro* often refers to the space-creating quality of light and dark in a work. Even in architecture and sculpture, changes in light and dark accentuate mass. The curving wall of the ancient Roman Colosseum (Figure 4-9) is penetrated by deep and dark tunnel-like openings whose shadowy depths accentuate the solidity of the building. Light and dark contrasts help define the roundness and weight of the concrete cylinders in Nancy Holt's *Sun Tunnels* (Figure **Chiaroscuro** **MODULE** 4-10).

Figure 4-10 Nancy Holt [American, 1938–], *Sun Tunnels*, 1973–1976. Concrete tunnels, 18 ft. (5.5 m) long, 9 ft. (2.75 m) diameter. Total length 86 ft. (26.2 m). Great Basin Desert, Utah. © Tony Smith/Corbis. Art © Nancy Holt/Licensed by VAGA, New York.

Fifty miles from the nearest town, the tunnels are aligned with the sunrise and sunset of the summer and winter solstices in the flat Utah desert. Dwarfed by the surrounding flatlands, they are nonetheless massive and easy to walk through. Their tops are punctured with holes that match the configuration of four constellations. Holt once stated that she wanted to bring the vast space of the desert back to human scale. Standing at the center of the four tunnels, the observer stands at a point that focuses both time and terrestrial and celestial space.

Figure 4-11 Georges Seurat [French, 1859–1991], *Seated Boy with Straw Hat*, study for *Bathers at Asnieres*, 1882. Conté crayon, 9 1/2 × 12 1/4 in. (24.1 × 31.1 cm). Yale University Art Gallery, New Haven. Everett V. Meeks Fund.

Cast Shadows

Do not confuse the darks on the underside of modeled arms and legs with **cast shadows.** Reserve the word *shadow* for the dark shapes projected onto another surface by an object that intercepts the light. In short, restrict it to mean a cast shadow such as the ominous ones caused by the objects in Yves Tanguy's *Indefinite Divisibility* (Figure 4-5). Cast shadows may reveal not only the direction of the light but also its quality. A fuzzy, faint shadow means a diffused, soft light; a sharp and distinct cast shadow results from a strong and focused light source—inexplicably too strong and too sharp in Tanguy's painting.

Modeling

A gradual change in light and dark across rounded surfaces such as a face, an arm, or a leg is called **modeling,** a common type of chiaroscuro. The painter Georges Seurat drew his *Seated Boy with Straw Hat* (Figure 4-11) with almost nothing but the technique of modeling. Modeling also suggests that the form turns through space because it shows that part of the form faces the light and part of it is turned away from the light. Seurat used light and dark like modeling clay to build a solid three-dimensional young boy.

Not every culture in the world or every period of Western art adopted the technique of modeling and the solid look that it produces. For example, when he depicted *Combing Hair* (Figure 4-12), the Japanese artist Kitagawa Utamaro did not employ modeling because he did not have Western concerns for the illusion of weightiness. Utamaro also did not want dark smudges to mar the perfect complexions of these women or detract from the elegance of the curved lines throughout the composition. He also accentuated the contrasting patterns of the two kimonos by keeping them flat.

Figure 4-12 Kitagawa Utamaro [Japanese, 1753–1806], *Combing Hair*, ca. 1800. Color woodcut, 15 × 9 5/8 in. (38.1 × 24.5 cm). Elvehjem Museum of Art, University of Wisconsin–Madison.

Tenebrism

Stimulated by the example of an Italian artist named Caravaggio (d. 1610), Baroque artists at the beginning of the seventeenth century developed a style of painting with such strong contrasts of light and dark that it has become known as **tenebrism** (the Latin word *tenebrae* means "gloomy darkness"). Artemisia Gentileschi, one of the finest tenebrist painters in Italy, made the chiaroscuro in her *Judith and Maidservant* (Figure 4-6) a source of exciting drama. Her tenebrism emphasizes the space-creating property of chiaroscuro that pushes the sharply illuminated parts of the painting out of the darkness into the light and seemingly into the viewer's presence.

Reflected Light

When modeling a form in light and dark, a painter will often have a touch of white in the light part to show where the light is most intense and where the light might be actually reflected from some surface. The area of the brightest light—like the light strokes down the thigh of Gentileschi's Judith (Figure 4-6)—is called the **highlight.** Highlights not only reveal the strength of the light source; they also reveal the nature of the surface that reflects the light, since different surfaces reflect light differently. The highlights of her dress suggest that Judith is wearing a silky material.

As a rounded form turns away from the light, it should get darker and darker until the deepest dark is met. But artists such as Philip Pearlstein in his *Female Nude Standing by Easel* (Figure 4-13) often observe in the dark area **reflected lights,** light bouncing off other surfaces, that retard the progressive darkening of modeled forms. The undersides of the nude's breasts in Pearlstein's painting appear luminous and transparent, rather than dark and opaque, because of the phenomenon. The reflected lights also keep the darks of a modeled form from merging with the darks of other surfaces and thereby obscuring the contours of the form.

COLOR

A color, or hue, is a wavelength of light that strikes the eye. Like value, hue is a property of light, not strictly speaking a property of an object. For instance, if a room contains only a red light source, the objects in the room will appear red. To be even more

Figure 4-13 Philip Pearlstein [American, 1924–], *Female Nude Standing by Easel*, 1974. Oil on canvas, 72 × 60 in. (182.9 × 152.4 cm) Sloan Fund Purchase, Brauer Museum of Art, 2001.28, Valparaiso University. Courtesy of the Artist & Robert Miller Gallery.

exact, hue is a perceptual response, in the visual cortex of the brain, to certain wavelength stimulation.

Color can get a bit technical because there exists a complex physics of light and an elaborate chemistry of **pigments,** or substances that impart color. Nevertheless, most artists try to keep the technicalities to a minimum because art—especially the art of color—is far from an exact science. Artists worry most about the relationship of one color to another—how one color acts upon another and how the colors work together as a whole.

THE SPECTRUM

White light is the presence of all colors, a fact that can be demonstrated by shining a pure white light through a prism. A triangular prism bends the different light waves at different angles into a **spectrum**—all the visible colors arranged by the size of their wavelengths. Some colors actually exist

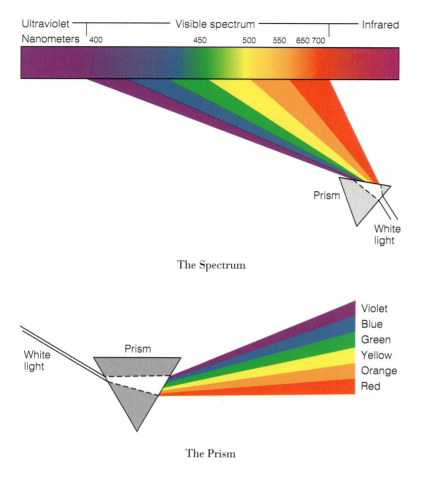

The Spectrum

Violet
Blue
Green
Yellow
Orange
Red

The Prism

THE COLOR WHEEL

Artists have found it helpful to bend the linear spectrum around into a circle called the **color wheel.** The British scientist Isaac Newton, who discovered the spectrum in the seventeenth century, also turned it into the color wheel. On the color wheel, instead of being at opposite extremes, red and violet lie next to each other. A circular spectrum better describes our perception of the continuous flow of hues, and it establishes oppositions across the diameters.

Placing two intersecting equilateral triangles, which form a six-pointed star, inside the color wheel helps to keep track of color relationships. On the tips of one triangle belong the **primary colors,** which are red, yellow, and blue. These are called *primary* because mixing other colors cannot form them and, theoretically, combining them can form all the other colors. On the three points of the second triangle reside the **secondary colors:** green, violet, and orange. These are called *secondary* because mixing two primaries can create them. Red and yellow make orange, which is located on the tip of the triangle between red and yellow. Blue and yellow make green, red and blue make violet, and they find their place accordingly. Artists seldom use all the primary and secondary colors of the color wheel in significant amounts in a single painting—unless they have some reason for the wealth of color. To make a case for pure, strong color, the American artist Ellsworth Kelly did a series of paintings in the 1960s reproducing the spectrum. In *Spectrum II* (Figure 4-14), he arranged thirteen separate panels, each nearly seven feet high, into a spectrum that is more than twenty-two feet long. Standing in front of the enormous painting, the viewer can experience nothing but color. Instead of starting the spectrum with red and ending with violet, he starts with yellow and ends with yellow—even though the color wheel has only twelve colors. Arranged this way, the spectrum tends to darken toward the center, and a certain symmetry is attained.

beyond the visible spectrum: infrared (the long waves at one end of the spectrum) and ultraviolet (the shorter waves at the other end of the spectrum).

Different pigments absorb, or subtract, different wavelengths of light. A white surface, such as the shell of an egg, looks white because it has no pigment and thus reflects all the wavelengths of white light, producing in the eye the sensation of white. An apple looks red because the pigments on its surface absorb all the other wavelengths of light and reflect only a red wavelength.

Reflected White Light

Figure 4-14 Ellsworth Kelly [American, 1923–], *Spectrum II*, 1966–1967. Oil on canvas, 80 × 273 in. (203.2 × 693.4 cm). The Saint Louis Museum of Art. Funds given by the Shoenberg Foundation, Inc. © Ellsworth Kelly.

On occasion, artists have achieved color harmony by using the three primaries. The Dutch artist Piet Mondrian (see Figure 3-24) painted with the triad of red, yellow, and blue as a matter of principle—because he wanted to use only the fundamental colors. He also employed the fundamental values, black and white. Mondrian wanted hue and value at their most basic so that their purity would speak universal truths. In his nonobjective paintings, areas of these colors, varying in size and devoid of contrasts of hue, were balanced to express, in his words, a "dynamic equilibrium."

Combinations of the secondary colors—violet, green, and orange—seem to be rather common and perhaps a little more sophisticated than a combination of primaries. For example, Michelangelo painted the figure of Mathan (Figure 4-15) on the Sistine Chapel ceiling in an arrangement of secondary colors. He painted the background lilac and colored Mathan's tights light green and a reddish violet. Mathan rests on an orange cushion—his hair is the same orange color—and a reddish orange cloak is draped around his arm and leg.

The color wheel can be filled with a great number of colors between the primaries and secondaries. If the gaps between the six points of the star are filled with just one more hue, created by the mixture of a primary and a secondary, **tertiary** or **intermediate colors** are created. For example, mix blue and green, and the result is blue-green.

A tertiary red-violet dominates Henri Matisse's *Destiny* (Figure 4-16), a plate from his series *Jazz*.

On the right, he overlapped a rectangle of red-violet on a rectangle of green, two colors in high contrast. On the left, the same red-violet intersects a rectangle of black. Behind them lies the same red-violet, lightened in value to a pink. The curved black shape on the left resembles the profile of an African mask, which appears to watch the white shape on the right, distilled from the image of a couple embracing. Matisse made the original illustrations for *Jazz* by cutting colored paper with a scissors. Cutting the paper reminded Matisse of the improvisation of jazz

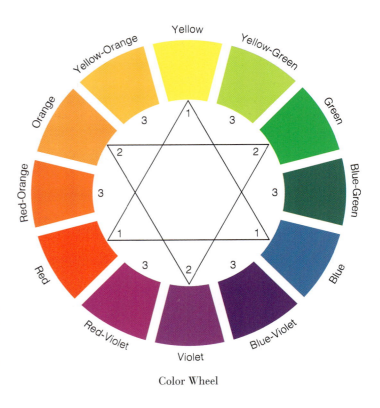

Color Wheel

Figure 4-15 **Michelangelo** [Italian, 1475–1564], *Mathan*, 1508–1512. Fresco. Sistine Chapel, Rome.

At the top of the wall above one of the windows of the Sistine Chapel, Michelangelo illustrated Mathan, an ancestor of Christ, sitting in a rather contrived pose. Michelangelo employed the triad of secondary colors among all the ancestor figures in the chapel, juxtaposing violet and yellow in one figure, orange and green in another. He also applied separate hues to model in light and dark. Mathan's pale green tights, for instance, turn red-violet, not dark green. As a consequence, shadows glow with color. The combination of these unmixable colors in his tights resembles the shot or iridescent colors of cloth woven with two colors of thread. Michelangelo's bold blocks of color build big masses and betray the hand of a sculptor.

Figure 4-16 **Henri Matisse** [French, 1869–1954], *Destiny (Le Destin)*, plate 16 from *Jazz* (Paris, Editions Tériade, 1947). Pochoir, printed in color, double sheet, 16 5/8 × 25 5/8 in. (42 × 65 cm). Museum of Modern Art, New York. The Louis E. Stern Collection. Digital Image © The Museum of Modern Art. Licensed by SCALA/Art Resource, NY. © 2006 Succession H. Matisse, Paris/Artists Rights Society (ARS), New York.

music—he felt like he was freely sketching with color because his scissors made shapes immediately in pure color.

COMPLEMENTARY COLORS

The color wheel enables us to see which colors are close to each other, such as red and violet, and also which colors are far apart. Colors that are directly opposite each other on the color wheel provide the greatest color contrast. They are called **complementary colors.** For example, the primary red is opposite the secondary green. If we use just the primaries and secondaries from the color wheel, the basic complementary pairs are red and green, yellow and violet, blue and orange. Placed near each other, one complementary color makes the other seem more vivid. But if a painter mixes equal portions of complementary colors, the result is usually a muddy gray.

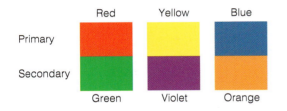

Complementary Pairs of Primary and Secondary Colors

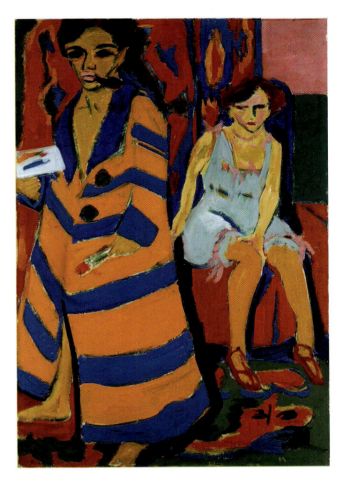

Figure 4-17 Ernst Ludwig Kirchner [German, 1880–1938], *Self-Portrait with Model*, 1910 or 1926. Oil on canvas, 58 5/8 × 39 in. (148.9 × 99.1 cm). Kunsthalle, Hamburg. Bildarchiv Preussischer Kulturbesitz/Art Resource, NY.

The German Expressionist painter Ernst Ludwig Kirchner sought the loudest possible color in his *Self-Portrait with Model* (Figure 4-17), with complementary contrasts. Carrying a brush dipped in deep red and wearing an orange robe with big bold blue stripes, the aggressive-looking artist turns from his model to confront the viewer. Another pair of complementary colors, red and green, decorates the background. Kirchner's favorite model, Dodo, sits sullenly behind him. The delicate pale blue of her dress clashes with, or is incompatible with, the intense complementary colors around her. Contrasting colors are often said to clash when they have different values.

A complementary pairing does not have to be exact. An artist may match one color to another that is not exactly its opposite, but with the two tertiaries adjacent to the opposite. A green placed next to some orange-red and some red-violet might produce a more sophisticated complementary contrast than simply a green with a red. This combination is called *split complementary colors.*

**Color MODULE
Relationships**

ANALOGOUS COLORS

Artists often paint with a combination of colors that are near one another on the color wheel. They are called **analogous colors** or adjacent colors. Red, red-orange, and orange constitute a sample of analogous colors. Since every other color on the color wheel is a tertiary, every group of analogous colors has to contain at least one tertiary.

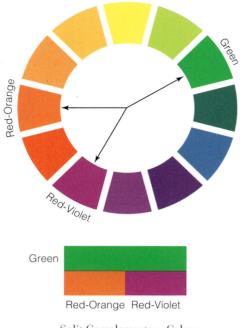

Green

Red-Orange Red-Violet

Split Complementary Colors

Examples of
analogous
colors

Examples of Analogous Colors

In his painting *Clear Cut Landscape* (Figure 4-18), Milton Avery employed a color scheme of green, blue, and blue-violet—close to a series of three analogous colors on the color wheel. Avery did not spoil the serenity of his simplified landscape with even the slightest touch of an opposite color. The lavender purple foreground and the green clump of trees in the middle offer the strongest color contrast, although the colors themselves are considerably muted.

VALUES OF COLOR

Value is the relative lightness or darkness of a color. Generally, yellow is the lightest color, followed by orange then red, for example. Because the hues of the spectrum have different values, Michelangelo could model his figure of Mathan from the Sistine Chapel (Figure 4-15) by using different colors.

Any individual color can be lightened or darkened—that is, changed in value—by the addition of

Figure 4-18 Milton Avery [American, 1893–1965], *Clear Cut Landscape*, 1951. Oil on canvas, 31 × 43 1/2 in. (78.7 × 110.5 cm). San Francisco Museum of Modern Art. Gift of Women's Board. Photo by Don Meyer. © 2006 Milton Avery Trust/Artists Rights Society (ARS), New York.

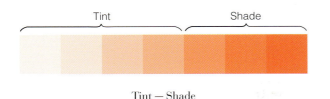

Tint Shade

Tint — Shade

white or black to the pigment. Theoretically, this does not change the wavelength of the hue and its position on the spectrum. Enough white added to red eventually makes us name the red *pink;* baby blue has a fair amount of white in it. Adding white to make a color lighter produces a **tint** of that color. Adding black to darken the same color produces a **shade** of that color.

Mixing some of the complement to any color will also produce a shade of that color. Brown can be a shade of orange (orange with some black in it), or the shade can be achieved by adding some dark blue to orange. Chocolate brown will have more dark red in it. Artists often prefer to create shades by adding the complement, rather than by adding black, because the complementary mixture results in a richer color of a darker value.

INTENSITY

Color has a third characteristic, in addition to hue and value. Colors can also vary in terms of *intensity* or *brilliance* or *saturation*—all these words have been used to describe this characteristic. **Intensity** refers to the quality or purity of the hue—the redness of a red, the blueness of a blue. An intense red is fully saturated with redness. A pigment color becomes more intense as it approaches the true spectrum color.

A spectrum hue of full intensity can be reduced in intensity by mixing it with its complement. For example, adding a touch of green to a puddle of red will make the red less intense. Add more green, and the red will become even less intense. Finally, add enough green, and the combination should become a very dark gray, a **neutral color** fully reduced in intensity. Theoretically, when mixed together in equal proportions, complements of full intensity should become black because one complementary color has totally absorbed or subtracted the wavelength of the other complementary color.

So-called **earth colors** result from the mixing of secondaries. A mixture of violet and orange pro-

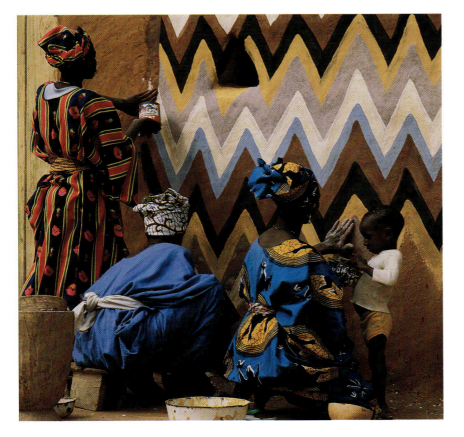

Figure 4-19 Diocounda, Assa, and Dianna Camara [Soninke], wall painting. ca. 1988–1989. Buanch, Mauritania, Africa. © Photo by Margaret Courtney-Clarke.

Wall painting in West Africa is a communal activity, often accomplished under the leadership of an expert in the art. The mothers of these women taught them to use the zigzag pattern for a festive occasion. The Soninke women of southwestern Mauritania paint with their fingers. They obtain their pigments from the earth near the Senegal River area and grind them into a powder themselves. Pigments are seldom mixed. In addition to using the traditional white, black, yellow ocher, and red earth colors, women in the twentieth century adopted imported washing blue as a native color. Green is conspicuously absent from most of the wall paintings of these arid regions.

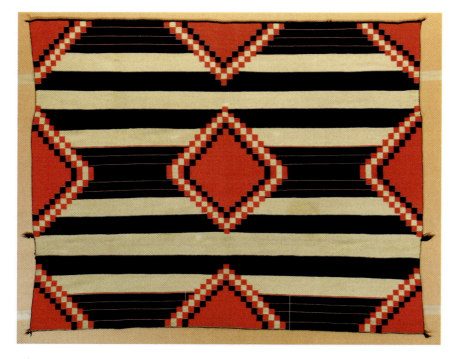

Figure 4-20 [Navajo Phase III], Chief's blanket, 1880-1890 (wool), American School, (19th century)/© Museum of Fine Arts, Houston, Texas, USA. Gift of Arthur T. MacDannald/ Bridgeman Art Library.

Navajo women wove this shawl in traditional colors of white, red, and black. The red came from the cochineal insect that lives on cactus in the Southwest. The creamy white is undyed wool. The weavers made an intriguing pattern of horizontal lines, contrasted with serrated diamonds and zigzags. When the serape is worn with the edges pulled around the shoulders, the zigzags come together to repeat the pattern of diamond shapes.

wove the serape in Figure 4-20 in the mid-nineteenth century used only natural dyes.

Dimensions of Color MODULE

CONTRASTS

Complementary colors placed side by side intensify each other because of a phenomenon known as simultaneous contrast. **Simultaneous contrast** is the ability of a color to induce in its neighbor the opposite in value and hue. It is simultaneous contrast that enhances the vivid combination of complemen-

duces a reddish earth. A mixture of orange and green produces yellow ocher. A mixture of green and violet produces olive green. These mixtures mimic the colors of minerals found naturally in the earth. Artists, ever since cavemen and cavewomen began to paint, have used the colors of nature with great success. When the Soninke women of sub-Saharan West Africa paint murals on the mud walls of their homes (Figure 4-19), they traditionally employ only the colors black, white, red, and yellow, since these colors are abundantly available in the earth in the region where they live. The Navajo women who

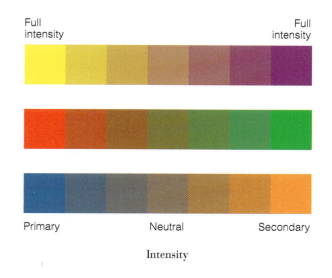

Full intensity Full intensity

Primary Neutral Secondary

Intensity

Gray Value Contrast

tary colors in Kirchner's *Self-Portrait with Model* (Figure 4-17).

Because of simultaneous contrast, a dark color next to a light color will make the light color seem lighter and the dark color seem darker. Any value will appear to change when first placed next to a dark area, then next to a light area. The central stripe in the diagram is the same value from one end to the other, but it appears to change against different backgrounds.

Simultaneous contrast also induces the complementary hue in the color next to it. Because

the opposite of red is green, red will induce the appearance of green in the color next to it. If the color next to the red is a neutral gray, the gray will look green-ish. Red next to a weak green will make it look more intensely green thanks to simultaneous contrast.

Artists frequently use a touch or an **accent** of a complement to enliven otherwise monotonous or even dull colors. The appropriate simultaneous contrast can push a tertiary color more toward one part of the hyphenated pair. A blue-green will look more bluish next to some orange; the same blue-green will look more greenish next to some red.

The artist Josef Albers demonstrated in his book *The Interaction of Color* (Figure 4-21) that simultaneous contrast can even make two different colors look like the same color. In plate VII-3 of his book the light yellow-green and darker red-violet colors are seen at first through diamond-shaped cutouts in a flap of paper hinged to the plate and covering the rest of it (Figure 4-21a). Lifting the flap reveals that each diamond-shaped color is actually surrounded by a large field of contrasting color (Figure 4-21b). The light-green background makes the diamonds at the bottom appear darker and less green, and the red background makes the diamonds at the top seem lighter and more green. Because of the interaction of colors, the diamonds now seem to be nearly the same color.

THE PSYCHOLOGY OF COLOR

Although the enjoyment of color may be universal, color remains a very emotional and subjective element. Color affects us intuitively and likely arouses primitive instincts,

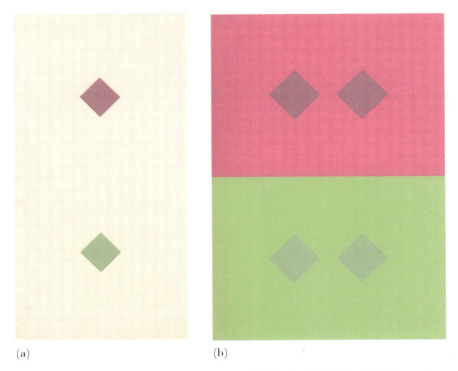

(a) (b)

Figure 4-21 Josef Albers [American, 1888–1976], plate VII-3 from *The Interaction of Color*, 1963, published by Yale University Press. © 2006 The Josef and Anni Albers Foundation/Artists Rights Society (ARS), New York.

(text continued on page 100)

Sitting at his worktable, Josef Albers painted on pieces of Masonite, not canvas. He preferred the hard surface of a panel because it did not stretch and move away from him as he applied the paint. In the series of paintings he began in 1949 titled *Homage to the Square,* he designed three or four squares nesting inside one another. He then filled in the spaces between the lines that he had measured and painted each square a different color. He deliberately chose an arrangement of simple rectangular shapes so that the relationships among the colors would stand out.

Albers did not, as a rule, mix his paints, but used colors straight from the tube. The arrangement of colors often suggested mixtures, or veils of color to our eye and mind. As he spread the paint with his small knife, he was careful not to let the knife strokes show. Albers applied the color thinly in one coat over a white underpainting so that the white underneath showed through and his colors appeared translucent and luminous.

Homage to the Square pays homage to the relationships among colors. In each work in the series, Albers generally painted the inner and outer squares in contrasting colors, whether the contrast was between values, between hues, or between both. The intervening square or squares form an ambiguous transition between the center and the periphery. The intervening color can be understood as the mixture of the two others on either side of it or as a third color veiling part of the inner square and part of the outer square. Thus, the colors can be seen as either opaque or transparent. Colors seem to change their character because of their interaction with an adjacent color. In short, we may perceive them in different ways. By means of his arrangement of colored squares, Albers causes us to participate in the creation of his art.

Albers used four different colors to paint *Homage to the Square: Departing in Yellow.* But we can also look at this painting in another way. We could imagine that he painted the inner square yellow and the outer square ocher and that he mixed yellow and ocher to paint the two intermediate squares. The painting offers us another possible interpretation—that the two inner squares were first painted yellow and the two outer squares were first painted ocher and that Albers then painted a transparent veil of color over part of each of them. Adjusting our perceptions, we can see in his painting two, three, or four colors.

Josef Albers at Black Mountain College, North Carolina, August 1944. Gelatin silver print, 24.2 × 19.8 cm. 93:001:021. © The Josef Breitenbach Trust, New York. © Collection Center for Creative Photography, The University of Arizona, Tucson.

Like many other artists in the twentieth century, Albers supported himself by teaching in art schools and in university art departments. Before coming to America, he taught at the Bauhaus, a famous progressive school of art in Germany in the 1920s and 1930s. He came to the United States when the Nazis declared modern art degenerate and closed the school.

Albers was a provocative teacher. He did not lecture his students and tell them what to think. Rather, he presented them with problems for which they were to find solutions. He showed them that human perceptions provided various explanations for ever-changing problems. He made them see for themselves by making them think for themselves. Albers also wrote an influential book, *The Interaction of Color,* published in 1963. Through teaching, writing, and the example of his own art, he made generations of artists see and learn how to use color.

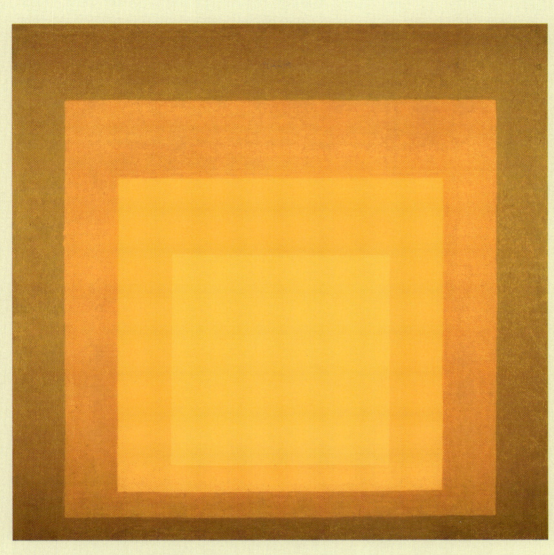

Josef Albers [American, 1888–1976], Study for *Homage to the Square: Departing in Yellow*, 1964. Oil on board, 30 × 30 in. (76.2 × 76.2 cm). Location: Tate Gallery, London. Great Britain © Tate Gallery, London/ Art Resource, NY. © 2006 The Josef and Anni Albers Foundation/Artists Rights Society (ARS), New York.

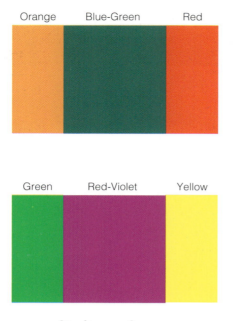

Orange | Blue-Green | Red

Green | Red-Violet | Yellow

Simultaneous Contrast

partly through subjective associations and partly through cultural conditioning. For example, black and white remind us intuitively of night and day, darkness and light; their association with evil and good is likely the result of culture. Red reminds us instinctively of fire and blood; it can also symbolize love, passion, martyrdom, danger, or revolution.

Statistically, most adults in the United States, Canada, and Western Europe prefer the color blue. People in Spain and some South American countries like red best. Children everywhere also tend to prefer red. The Japanese choose white as their favorite color, black as their second favorite, and yellow third. The Japanese are also more concerned about whether a given color is glossy or dull rather than whether it is yellow, red, or blue. Europeans in the Middle Ages saw only three colors in the rainbow—red, a yellow-green, and a dark color—although they could paint in all the colors of the rainbow. Many African languages do not distinguish among reds and browns and yellows, yet they are concerned with whether the color is wet or dry, hard or soft, rough or smooth, loud or quiet, happy or sad.

Vincent van Gogh often loaded the colors of his paintings with strong emotional and symbolic significance. Since the message of these colors is extremely subjective, not everyone will feel the same about them. Soon after van Gogh finished the paint-

Figure 4-22
Vincent van Gogh
[Dutch, 1853–1890], *The Night Café*, 1888. Oil on canvas, 28 1/2 × 36 1/4 in. (72.4 × 92.1 cm). Yale University Art Gallery, New Haven. Bequest of Stephen Carlton Clark, B.A., 1903.

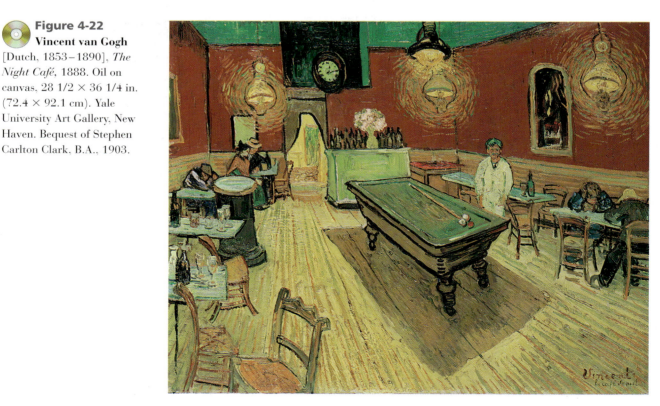

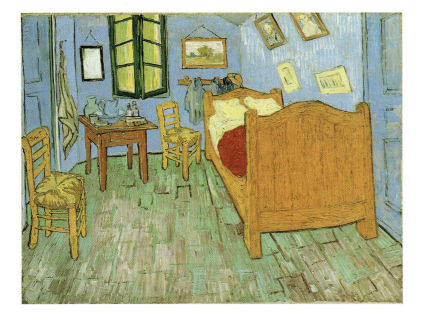

Figure 4-23 **Vincent van Gogh** [Dutch, 1853–1890], *The Bedroom*, 1888. Oil on canvas, 28 3/4 × 36 in. (73 × 91.4 cm). Art Institute of Chicago. Helen Birch Bartlett Memorial Collection (1926.417).

more relaxing. Scientists have demonstrated that exposure to red light increases the heartbeat and that exposure to blue light slows it down. For artists, the designation of warm and cool depends on the contrasting relationship between any two colors. A violet might be cooler than an orange because it has blue in it, but the same violet might be warmer than a green because it has red in it. The warm–cool distinction helps to create stimulating color contrasts because warm colors seem warmer next to cool colors and cool colors seem cooler next to warm colors.

Peter Paul Rubens frequently exploited warm–cool contrasts in his art. In his *Holy Family with Infant St. John and St. Elizabeth* (Figure 4-24), for example, Rubens enhanced

ing *Night Café* (Figure 4-22), he wrote in a letter to his brother that it was "one of the ugliest I have done." He revealed that he had tried to express by means of color "the terrible passions of humanity" and "to express the idea that the café is a place where one can ruin oneself, go mad or commit a crime."[1] He spoke of the complementary contrast of blood-red and green and the clash of analogous colors—blue-green, green, yellow-green, and sulfur yellow—probably because they also have contrasting values.

About a month later, van Gogh wrote that, in contrast to those in *Night Café*, the colors of his *Bedroom* (Figure 4-23) suggest rest or sleep. However, the bold combination of violet, red, yellow, lemon green, scarlet, green, orange, blue, and lilac in the painting of his bedroom does not necessarily transmit restfulness to the eye. Although we may be impressed with the depth of his feeling about color expressed in his letters, those associations remain, in the final analysis, personal.

However, there is a universal tendency to feel that some colors are warm whereas other colors are cool. Colors that are near red on the color wheel are considered **warm colors**—think of red-hot fire. Colors that are near blue on the color wheel are considered **cool colors**—think of cool, blue water. Warm colors seem more exciting; cool colors seem

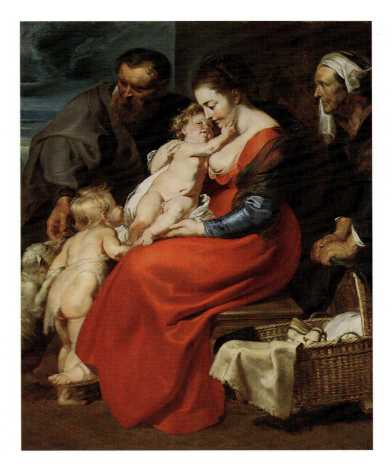

Figure 4-24 **Peter Paul Rubens** [Flemish, 1577–1640], *Holy Family with Infant St. John and St. Elizabeth*, ca. 1615. Oil on panel, 46 × 35 1/2 in. (116.8 × 90.2 cm). Art Institute of Chicago. Major Acquisitions Fund 1967.229.

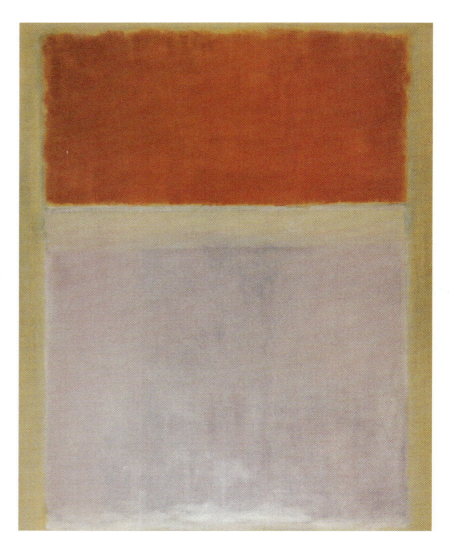

Figure 4-25 Mark Rothko [American, 1903–1970], *Orange and Lilac Over Ivory*, 1953. Oil on canvas, 117 1/2 × 91 1/2 in. (298.5 × 232.4 cm). Hood Museum of Art, Dartmouth College, Hanover, New Hampshire. Gift of William S. Rubin. © 2006 Kate Rothko Prizel & Christopher Rothko/Artists Rights Society (ARS), New York.

the dark-blue sleeve and a luminous red dress through contrasts of warm and cool colors. He also enlivened the sensuous appeal of his flesh areas with cool darks and warm lights. Rubens painted the bright, warm flesh tones of the figures with a thick layer of opaque paint; then he painted over that the shadows and the modeling in a thin veil of cool blue-gray. He painted his figures over a warm reddish-brown underpainting, most visible at the bottom of the panel. In many places—in the slate-blue robe of St. Joseph, for example—he applied over the underpainting a fluid layer of dark color, thin enough to let the lighter underpainting show through. Thus, throughout the painting, dark colors are transparent and light colors are opaque.

Rubens could use warm and cool colors to model the substantial forms of his figures because warm colors seem to project forward and cool colors seem to recede. Raphael enhances the spatial pro-

jection in the landscape of his *Alba Madonna* (Figure 3-7) by painting the distant hills and sky cool green and blue and the foreground a warm brown. In Mark Rothko's painting *Orange and Lilac Over Ivory* (Figure 4-25), the warm orange rectangle at the top seems to move forward, and the lilac square at the bottom seems to retreat, even though it is a much larger shape.

The French painter Nicolas Poussin, in contrast to Rubens, painted by using only **local color**—that is, the colors that he knew objects to be without any regard for temporary or accidental effects. Local color means that each hue of his painting *Madonna of the Steps* (Figure 4-26) is contained within the contour lines of the drawing. He ignored color reflections, transparent veils of one color over another, and warm and cool contrasts within a single area. Poussin did not necessarily use fewer or less intense colors than Rubens—his color harmony is the triad

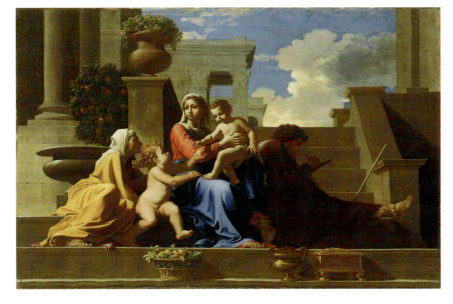

ored lighting, and simultaneous contrasts. Optical-color artists might paint an apple with touches of different red hues. They might use green for the modeling of the darks, a touch of blue reflected from the tablecloth, and a highlight of yellow reflecting the light of golden sun on the apple. When Rubens in his *Holy Family* captures the reflections of a red dress on the skin of a nearby child and when he uses blue for the shadows of flesh, he is employing optical color.

Local vs. Optical Color MODULE

Figure 4-26 Nicolas Poussin [French, 1594–1665], *Madonna of the Steps*, 1648. Oil on canvas, 28 1/2 × 44 in. (72.4 × 111.8 cm). Cleveland Museum of Art. Leonard C. Hanna, Jr. Fund. 1981.18.

of the three primary colors. He rejected Rubens's display of coloristic effects and instead took a rational approach to the color that he *knew* an object to be.

Rubens may be said to paint with what is known as **optical color**—color as the eye sees it, with all the subtleties of reflected colors, filtering atmosphere, col-

COLOR IN MODERN ART

At the end of the nineteenth century, the French Impressionists made painting with optical color extremely popular. Claude Monet, for example, observing the subtleties of color in nature, recorded his sensations in separate brushstrokes to produce *The Regatta at Argenteuil* (Figure 4-27). Monet left it to the eye of the viewer to mix the strokes of different

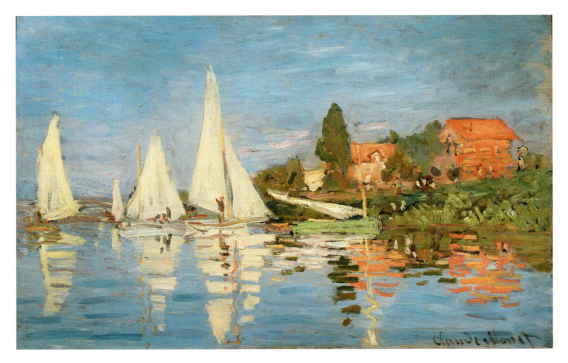

Figure 4-27 Claude Monet [French, 1840–1926], *The Regatta at Argenteuil*, ca. 1872. Oil on canvas, 19 × 21 1/2 in. (48 × 75 cm). Musée d'Orsay, Paris. © Edimédia/Corbis.

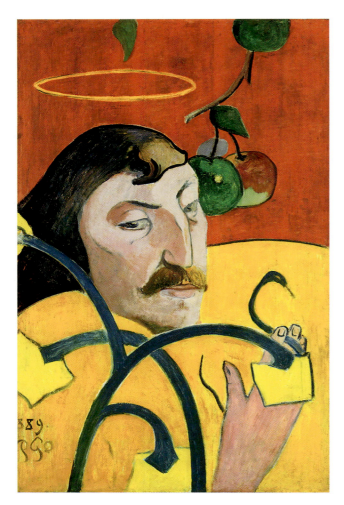

Figure 4-28 **Paul Gauguin** [French, 1848–1903]. *Self-Portrait*, 1889. Oil on wood, 31 1/4 × 20 1/4 in. Chester Dale Collection, 1963.10.150.(1814)/PA. Image © 2004 Board of Trustees, National Gallery of Art, Washington, D.C.

In his self-portrait, Paul Gauguin stares askew out of blue and green eyes. His head floats mysteriously between the red and orange planes and amid a series of curved lines that arc through the panel. The halo characterizes the artist as a saint; the snake and apples allude to Adam, the sinner. On more than one occasion, Gauguin himself brought attention to what he considered his dual nature of sinner and saint. In several other paintings, he used his own features in images of Jesus Christ—portraying himself as a messiah, suffering for his cause, but also as a prophet capable of seeing beyond the superficial appearances of things.

colors in any area. Monet and the other Impressionists began seeing nature as patches of color instead of a system of boundary lines around objects. Although the Impressionists devised their technique in order to be true to nature, their dabs of color took on an independent life. As in Monet's painting, color asserts itself.

The Impressionists tried to reproduce natural light by raising the values of all their colors. They painted in what has been called a *high key,* or a light range of values. They kept their color sensations unmixed on the canvas because mixing colors would muddy and darken them. Complementary colors appear side by side in their work so that simultaneous contrast could then go to work, intensify the colors, and help recreate the scintillation of natural sunlight. Some Impressionists rejected the use of black to darken colors because they found light and color even in shadows. They decided that because sunlight tends to color areas with tinges of yellow and orange, simultaneous contrasts should induce into the adjacent shadows tinges of violet and blue.

In *Night Café* (Figure 4-22), Vincent van Gogh transformed the colored brushstrokes of the Impressionists into a vehicle for personal expression. Van Gogh began to paint objects in colors that would mirror his feelings or symbolize his ideas, rather than capture the exact color in nature. Van Gogh's friend Paul Gauguin painted his *Self-Portrait* (Figure 4-28) with a background of intense red and orange, contrasted with a green apple, blue thistle stems, and their yellow blossoms. One of the first modern artists to discover synaesthesia, Gauguin painted color arrangements that are governed by the musical harmonies of the painting—in this instance, he harmonized primary and secondary colors. Large areas of flat color dominate the canvas. His example encouraged generations of younger artists to intensify color, to use it freely, and to explore its expressive potential.

As early as 1905, Henri Matisse asserted himself by using basic, bright color applied so boldly that critics called him a "wild beast" (*fauve* in French). Decades later, he still relished color, as his plate from *Jazz* (Figure 4-16) clearly indicates. For many in the twentieth century, he set an example of an artist dedicated to the enjoyment of rich color. Kirchner in Germany came under the spell of van Gogh, Gauguin, and Matisse and developed his own

manner of strident, brash complementary contrasts and colored heat. In his *Self-Portrait* (Figure 4-17), color transforms a traditional subject into subjective expressionism. Wassily Kandinsky (see Figure 1-18), likewise affirming the analogy between color and music, painted thoroughly abstract compositions containing patches of color, separated from and independent of the lines in the picture.

In the second half of the twentieth century, Josef Albers, as a painter, teacher, and author, impressed on artists the complexity of color relationships and made the perception of color the very theme of his work. He once remarked that his series *Homage to the Square* (see "Artist at Work") was actually a homage to color. In the 1960s, Color Field Painting, Hard-Edge Abstraction, and Minimal Art exploited areas of flat color in large-size abstractions. Mark Rothko, Ellsworth Kelly, and Helen Frankenthaler belonged to a group of so-called Color Field painters. In the sixties, Pop artists such as Andy Warhol often employed luminous and intense, almost fluorescent colors. Many contemporary artists delight in intense colors, strong complementary contrasts, and the emotional and spiritual significance of colors.

AT A GLANCE

Light

Value	The relative lightness or darkness of some area is its value.
Light source	Light sources may come from above, within, behind, or underneath the subject. They may be diffused or irrational.
Chiaroscuro	Chiaroscuro is any contrast between light and dark, produced by modeling, cast shadows, tenebrism, or reflected lights.

Color

Hue	A hue is a wavelength of light.

Color Relationships

Primary	The primary colors are red, yellow, and blue.
Secondary	The secondary colors are green, violet, and orange.
Tertiary	A tertiary color is a mix of a primary color and one of its adjacent secondary colors.
Complementary	Complementary colors are opposites on the color wheel.
Analogous	Analogous colors are adjacent to each other on the color wheel.

Values of Color

Tint	A lightened color is called a tint.
Shade	A darkened color is called a shade.

Intensity

Intensity	The saturation or purity of a hue is called its intensity.

Contrasts

Simultaneous contrast	Simultaneous contrast induces the opposite in value and hue.
Accent	An accent is a touch of a complementary color.
Warm–cool contrast	A warm–cool contrast has psychological effects: cool colors recede; warm colors project.

INTERACTIVE LEARNING

 Foundations Modules: Visual Elements

Flashcards

Artist at Work: Josef Albers

 Companion Site: **http://art.wadsworth.com/buser02**

Chapter 4 Quiz
InfoTrac® College Edition Readings
Talking Flashcards
Online Study Guide

5 Surface and Space

DIFFERENT REALITIES

Pablo Picasso's *Guitar* (Figure 5-1) contains several rectangular shapes made from pieces of paper, cut out and glued to the surface. The technique is known as **collage** (pronounced cole-*azh*), the French word for "pasting." The two curved shapes and the circle toward the left allude to a guitar, and the small boxes and circles in the lower right may represent a guitarist's fingers. More remarkably, the cut-out pieces are recognizable material: the front page of a Spanish newspaper, *El Diluvio;* sections of wallpaper with a floral pattern; and white pieces with a faded pattern of squares. Despite its incorporation into the work of art, the old newspaper still has the feel of old newspaper.

Someone could look at *Guitar* another way, observing that the abstract shapes lie one on top of the other. The newspaper page is both underneath and on top of several other shapes; part of it emerges to the right. The overlapping produces a feeling of three-dimensional space, however slight. *Guitar* thus demonstrates a polarity common to most works of two-dimensional art—a tangible surface that has physical reality to it plus an illusion of three-dimensional space.

TEXTURE

Texture refers to the real or apparent quality of the surface—whether a shape or mass is rough, smooth, or somewhere in between. A conspicuous texture, such as Picasso's newspaper page, calls attention to the surface and its material. We may enjoy the feel of the texture even though we never touch the surface—it may simply attract the eye.

In architecture, the walls in a building may be made of rough-cut stone, polished marble veneer,

Figure 5-1 Pablo Picasso [Spanish, 1881–1973], *Guitar*, 1913. Charcoal, wax crayon, ink, and pasted paper. 26 1/8 × 19 1/2 in. (66.6 × 49.5 cm). Museum of Modern Art, New York. Nelson A. Rockefeller bequest. Digital Image © The Museum of Modern Art. Licensed by Scala/Art Resource, NY. © 2006 Estate of Pablo Picasso/Artists Rights Society (ARS), New York.

red brick, or plate glass. The textures may be rich and warm like polished wood, or harsh and rough like poured concrete. Materials also may influence environmental systems, such as acoustics, ventilation, heating, and cooling. The flawlessly smooth machine-made panels on the walls of many modern structures are in sharp contrast to the adobe build-

Figure 5-2 [Pueblo], San Geronimo de Taos village, begun ca. 1000 CE. Taos, New Mexico. © Karl Weatherly/Corbis.

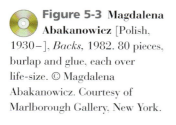
Figure 5-3 Magdalena Abakanowicz [Polish, 1930–], *Backs*, 1982. 80 pieces, burlap and glue, each over life-size. © Magdalena Abakanowicz. Courtesy of Marlborough Gallery, New York.

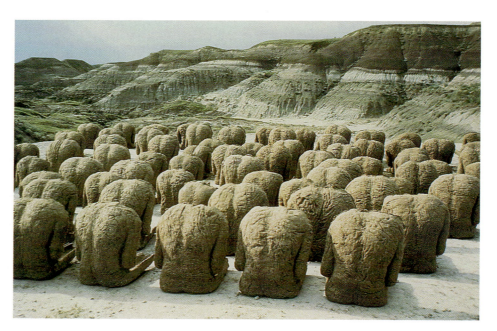

ings of the Pueblo people at Taos, New Mexico (Figure 5-2), which have a rugged texture, an appealing irregularity, and a human touch.

The textures of sculpture may vary from the smoothness of polished brass to the roughness of porous clay and rusty iron. Because we can seldom touch works of sculpture, texture often becomes the most important clue to the character of the sculp-

tor's material, its weight, and its solidity. Sculptors also control the play of light with variations in texture. Texture comes to the fore in any art form involving fibers. Magdalena Abakanowicz shaped the human figures in her work *Backs* (Figure 5-3) by squeezing organic fibrous material into a plaster mold. Arranged in rows and without heads and legs, the anonymous human figures bend sub-

missively. Variations in texture give them individuality and life.

In two-dimensional artworks, the artist may produce a rough or smooth surface in the very application of the medium. In Raphael's *The Alba Madonna* (Figure 3-7), for example, nothing breaks the smooth finish of the finely blended brushstrokes to call attention to the surface. In paintings by van Gogh, however, the rough surface draws attention to the way he applied the paint. We become aware of the paint and the artist's process of painting. We can enjoy the richness of the surface and, at the same time, see the illusions of people and objects that the brushstrokes create. Contrasting textures—like a contrast of colors, for example—can stimulate visual interest.

An artist can add thickeners or granular material to the paint to produce a textured surface. Paul Klee first constructed a textured surface out of roughly applied plaster before he began painting his *Coup de Foudre* (Figure 5-4). Picasso pasted actual materials on the surface of his collage *Guitar* (Figure 5-1), a work that takes delight in the contrast between what is real and what is not. For his drawing *Seated Boy with Straw Hat* (Figure 4-11), Georges Seurat deliberately chose a rough-textured paper so that his crayon would not easily fill in the pitted surface. The irregularity of the paper helps create a grainy soft light as his crayon hits the top of the hills and leaves the valleys empty.

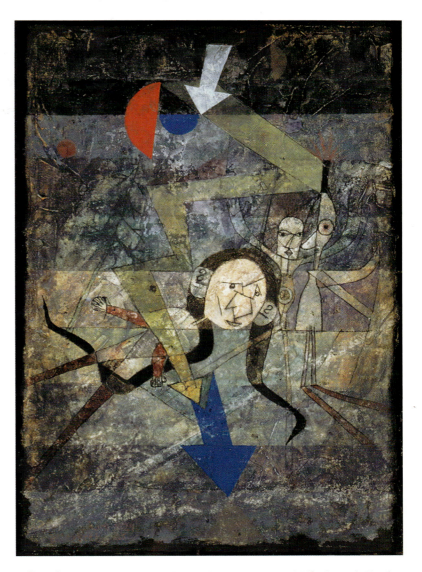

Figure 5-4 **Paul Klee** [Swiss-German, 1879–1940], *Coup de Foudre*, (Thunderclap), 1924. Paper and plaster, mounted on canvas. 16 3/4 × 11 5/8 in. (42.5 × 29.5 cm). Private collection © RMN/Art Resources © 2006 Artists Rights Society (ARS), New York/VG Bild-Kunst, Bonn.

Texture can also be merely implied through a purely visual illusion called **trompe l'oeil** (pronounced trohmp *loy*)—a French term that means "fool the eye." Viewers today, as in the nineteenth century, are often fascinated by the ability of the American artist William M. Harnett to capture believable reality in his painting *The Old Violin* (Figure 5-5). Harnett not only copies the objects in the painting exactly, but he also fools the eye into believing that the painted material has the same surface tex-ture as it does in nature. To fool the eye, an artist must observe how the surface reflects light. Light reflections, more than anything else, give the eye clues about the texture of a surface. Although the result is only an illusion, Harnett re-creates the texture of wood, metal, and paper with sensitive observations of how light reflects from those different materials.

The Surrealist artist Max Ernst invented a technique he called **frottage** (pronounced froh-*tazh*),

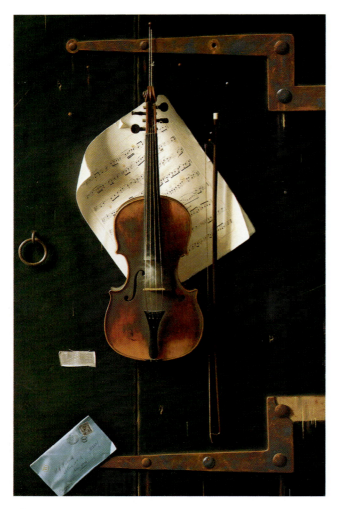

Figure 5-5 William M. Harnett [American, 1848–1892], *The Old Violin*, 1886. Oil. 38 × 23 5/8 in. (96.5 × 61 cm). Gift of Mr. and Mrs. Richard Mellon Scaife in honor of Paul Mellon. 1993.15.1./PA. Image © 2004 Board of Trustees, National Gallery of Art, Washington, D.C.

The American painter William M. Harnett specialized in still-life paintings with objects arranged on some vertical surface, such as an old door. More than the accuracy of his brushstrokes, it is the painting's light that convinces the eye about the material of any surface. The wood of the violin reflects more light than the wood of the door. Notice as well the soft transparent shadow cast by the fold of the sheet music, and notice the subtle modeling of the letter (addressed to the artist himself). Harnett's use of light attempts to trick the eye into believing that his painting is a real door in the wall. Be careful not to open the door; the bottom hinge is broken!

which means "rubbing," to let texture itself stimulate the imagination. In *Wheel of Light (Lichtrad)* (Figure 5-6), one of a series of illustrations in a book of Surreal science, he placed his paper on top of ordinary materials such as old floorboards, rough sackcloth, or tree leaves and rubbed the paper to produce textures. The textures then freed his imagination to create hallucinatory images. Frottage transforms ordinary material into a new reality. In *Wheel of Light* the veins of a leaf are transformed into the blood vessels of the eye to suggest a disturbing similarity between life-forms. **Texture** **MODULE**

THE ILLUSION OF SPACE

In his painting called *The Staircase Group: Raphaelle and Titian Ramsey Peale I* (Figure 5-7), Charles Willson Peale created another kind of illusion on the surface of the canvas when he depicted **space,** or the imagined third dimension that seems to extend back beyond the surface. From inside the painting, two of his sons, painted in the scale of life, look out and seem to beckon the viewer to climb the stairs with them. When *The Staircase Group* was first exhibited in the Statehouse in Philadelphia, Peale hung it in the frame of a doorway, as though the doorway led into the painted staircase. In addition, the artist placed a wooden step, built out into the room, at the base of

Figure 5-6 Max Ernst [German, 1891–1976], *Wheel of Light (Lichtrad)*. Collotype, after frottage, printed in black. Composition: 10 1/2 × 17 in. (26.6 × 43.2 cm). In *Histoire Naturelle* (Paris, Galerie Jeanne Bucher, 1926), plate 29. The New York Public Library/Art Resource, NY. © 2006 Artists Rights Society (ARS), New York/ADAGP, Paris.

the painting. The deception is reported to have fooled George Washington, who bowed politely to the painted figures as he passed by.

Many Western artists have attempted, like Peale, to create a three-dimensional illusion in their work. From the Renaissance to the modern period, Western artists have attempted to deny that the two-dimensional surface they work on is flat. Like magicians, they have created a three-dimensional world out of lines and layers of paint. They have treated the flat surface—the **picture plane**—as though it were a window through which viewers could see another world spread out before them. And if, like Alice in Wonderland, a viewer could eat the right amount of mushroom, he or she would become the right size to step over the frame and walk through this "window world." No painting can fool anyone for very long into thinking it is three-dimensional, but few paintings demonstrate so explicitly as Peale's *The Staircase Group* the idea that a painting is a window—or in this case a doorway—into a world lying behind the canvas.

SPACE AND TIME

Of course, we cannot enter into the painting and climb the stairs with the Peale brothers. We must view the painting from a fairly static point in front of it. However, there are types of art in which the viewer actually moves through space. If Peale had been an architect, we indeed could follow his sons' invitation to climb the stairs and move through the space of his building. If Peale had been a filmmaker, no doubt his camera would have moved through space to the room at the top of the stairs. If Peale had carved statues of his sons, we would likely move around the group to examine it on all sides. Since it normally takes movement to see these three types of art, it therefore takes a period of time for them to unfold—like a performance of music.

Architectural structures and sculptural masses take up space in the real world, and they sometimes seem to extend out and incorporate the surrounding space into the work. Centrifugal movement, like the extended limbs of a statue, can charge the viewer's space so that the work acquires a living presence. Standing beneath Rodin's *Thinker* (Figure 17-9), one can feel an emanation of the sculpture into the

Figure 5-7 **Charles Willson Peale** [American, 1741–1827], *The Staircase Group: Raphaelle and Titian Ramsey Peale I*, 1795. Oil on canvas, 89 × 39 1/2 in. (226.1 × 100.3 cm). Philadelphia Museum of Art. George W. Elkins Collection. E1945-1-1.

space around it as it looms overhead. Photographs of *The Thinker* cannot capture the sensation.

In *Constructed Head No. 2* (Figure 5-8), Naum Gabo created a work of almost pure space in which

Figure 5-8 **Naum Gabo** [American, 1890–1977], *Constructed Head No. 2*, 1916, reconstructed ca. 1923–1924. Celluloid, 17 × 12 1/4 × 12 1/4 in. (43.18 × 31.11 × 31.11 cm). Dallas Museum of Art. Edward S. Marcus Memorial Fund. The works of Naum Gabo © Nina Williams, England.

the surrounding space flows freely into the sculpture. Trained as an engineer, Gabo understood that the strength of an object is not to be identified with its massiveness. For example, a sturdy modern bridge can be constructed of an openwork steel structure rather than a solid mass of stone. In *Constructed Head No. 2* the intersecting thin planes segregate and define the space of a human bust. They open up and "measure" the space of the head. The cells of space become the primary element in the sculpture. Furthermore, the surrounding space easily invades the inner space—think of it as submerged in water—so that the two become one environment. The open structure of Gabo's head expresses the modern awareness of the continuity of all reality.

SPACE IN DIFFERENT CULTURES

Modern Western artists are very much aware that other cultures have represented reality in their art

without the illusion of a window. Inspired by their example, many Western artists closed the pictorial window through which they once viewed nature—think of the many examples of modern abstract art. For the most part, other cultures have avoided a three-dimensional appearance for their two-dimensional works of art. Rather than denying the flat surface, they affirm that they are working in two dimensions. Their flat images insist that they are decorating a surface. Often, these artists prefer to invest people and objects with a spiritual reality.

Ancient Egyptian artists typically tried to keep things as flat as possible (see Figure 5-9), for example, by arranging the human figure two-dimensionally so that it would not contradict the flat plane of the surface. Each feature of the body was depicted to its best advantage and in its most characteristic shape on the plane. The permanence of the form was important to the Egyptians, and they did not want to give the impression of a fleeting perception. Their civilization cherished regularity and stability. Just as most of their art that has survived comes from decorated tombs, so it was meant to last for eternity. To a great extent, the Egyptians kept to their conventions for the human figure for several thousand years.

An Egyptian artist always depicted the head in profile, but the eye frontally—the form of a typical eye or the concept of an eye. Their conventions also required that each human being display two shoulders frontally—even though the figures might be reaching across to hold something before them. The waist had to be in profile and the legs and feet in profile too. In fact, the figure had two left feet, because the arch and big toe appear the same on each foot.

Westerners in general used to think that other cultures such as the ancient Egyptians were undeveloped. In fact, except for classical Greek and Roman art, any art produced before about 1500 was once considered to be primitive. The word *primitive* often implied that these people were not intelligent enough to discover the secret of spatial projection for themselves. The irony of this attitude is that we have now come to realize that the West was out of step in the sense that it was the only culture in the world's history to denigrate the surface so blatantly and to treat it as a transparent window so insistently.

Figure 5-9 [Egyptian]. Offering Bearers. Eighteenth Dynasty, ca. 1300 BCE. Tempera on mud plaster, 27 5/8 × 21 in. (73.7 cm) across. From the tomb of Sebkhotep, Thebes, Egypt. The Metropolitan Museum of Art, Rogers Fund, 1930. (30.2.1). Photograph © 1983 The Metropolitan Museum of Art.

METHODS OF SPATIAL PROJECTION

Artists have a variety of ways to make a picture seem as if some space exists behind the surface. Overlapping shapes, positioning, diminishing the size of objects, linear perspective, foreshortening, chiaroscuro, atmospheric perspective, and warm–cool color contrasts can achieve a sense of three-dimensional space. Although these methods have all been used by cultures around the world, the following discussion will attempt to contrast, as often as possible, Western and non-Western methods of spatial projection.

Overlapping and Positioning

Overlapping is probably the fundamental method of spatial projection on a two-dimensional surface. If one object gets in the way of a second object and obscures part of it, then the second object must lie behind the first. When the violin obscures a part of the sheet music in William M. Harnett's painting *The Old Violin* (Figure 5-5), we judge that the sheet music is behind the violin. If a circle cuts off part of a triangle, we judge that the triangle is behind the circle. If, however, the circle and triangle intersect and both

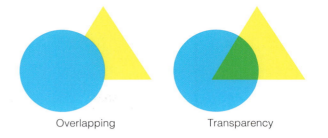

Overlapping Transparency

shapes remain complete, we have no way to judge which shape is behind which. The shapes seem to be transparent, and their spatial relationship is ambiguous.

Overlapping seems so natural that we might find it hard at first to imagine doing without it. But too much overlapping can often be confusing and runs the danger of obscuring significant persons or objects. Painters have often rearranged reality to avoid any obfuscation, and photographers likewise have found the right camera location or moved their subject into a better position, if possible. An important person must never be obscured by a subordinate; otherwise, she or he might not look so important. Try to imagine a White House photograph of the president of the United States with some unknown person standing in front of him.

The Greek painter Euthymides, who painted *Revelers* (Figure 5-10) before the classical period in

Figure 5-10 Euthymides [Greek, sixth to fifth century BCE], *Revelers*, ca. 510–500 BCE. Red figure vase painting, approximately 24 in. (61 cm) high. Staatliche Antikensammlungen, Munich. Photo: Hans Hinz.

Figure 5-11 'Abd Allah Mussawwir [Persian, Bukharam, Uzbekistan, active mid-sixteenth century], *The Meeting of the Theologians*, Uzbek Shaybanid dynasty, ca. 1540–1550. Watercolor on paper, 11 3/8 × 7 1/2 in. (28.9 × 19.1 cm). Nelson-Atkins Museum of Art, Kansas City. Purchase: Nelson Trust 43–5.

This small painting of a *madrasa,* or religious school, describes a considerable amount of deep space by the location of the people and things up and down the symmetrical design. At the bottom appears a street scene. As a theologian approaches the doorway, two beggars hold out their hands for alms. In the room behind the door, seven theologians sit on a floor that rises straight up the page. Behind them, in what appears to be another room or an alcove, a *mullah,* or teacher, instructs a young man. We may even imagine that the figures appearing in the "windows" above them reside in deeper space. Nevertheless, the figures toward the top of the page are the same size as the figures in the street at the bottom.

Greek art, made sure that his three tipsy dancers did not overlap one another, despite their wild movements. He keeps the lines of their high-stepping, twisting dance absolutely clear so that we can see, as we turn the curving surface of the vase, that the pose of the reveler on the right reverses the pose on the left and that the man in the middle twists 180 degrees from one to the other.

Some cultures avoided overlapping at all costs. Sixteenth-century Persian artists kept people and things from overlapping by placing them one above the other. Even the floor tiles in 'Abd Allah Mussawwir's small painting *The Meeting of the Theologians* (Figure 5-11) go straight up the surface. These Persian artists had a convention for indicating depth by an object's **position** on the surface. According to their convention, whatever was higher up in the picture was understood to be farther back. Looking at the image is like reading a road map. We can tell that the person wearing the blue and orange robes in *The Meeting of the Theologians* sits at the back because he is nearest the top of the picture.

Relative Size **MODULE**

Diminishing Size

It is part of our everyday experience that the farther away things get from us, the smaller they appear. By using the technique called **diminishing size,** or reducing the size of one form relative to the size of another, an artist can create the illusion of depth. For example, the columns in the painting *The Annunciation*

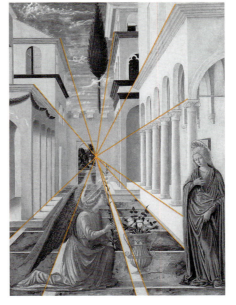

Figure 5-12 Master of the Barberini Panels (Fra Carnevale?) [Italian, active ca. 1445–1484], *The Annunciation*, ca. 1448. Tempera, and possibly oil, on panel, 34 1/2 × 24 3/4 in. (87.6 × 62.9 cm). National Gallery of Art, Washington, D.C.

(Figure 5-12), by the anonymous Master of the Barberini Panels, get progressively smaller as they move away from the observer. Notice, however, that the figures in *The Meeting of the Theologians* (Figure 5-11) do not diminish in size as they go up the surface—that is to say, back in space.

The amount that an object should diminish in relationship to its intended position in space can be determined by the rules for perspective. However, in many artworks diminishing size operates intuitively without the receding lines of a perspective scheme. For example, most landscapes do not use perspective to set out the receding space of irregular nature.

Linear Perspective

The artist who painted *The Annunciation* (Figure 5-12) gave a clear demonstration of the Italian Renaissance invention of **linear perspective**—a scheme for creating the illusion of three-dimensional space, in which parallel lines that move away from the viewer are drawn as diagonals that converge and meet at some point. If the lines that move away from the viewer, such as the pavement lines in *The Annunciation,* are genuinely perpendicular to the picture plane, they are called **orthogonals.** The picture plane is the imaginary window or surface perpendicular to the line of vision on which the image appears to be inscribed.

Linear perspective reproduces our everyday experience of parallel lines of highways or railroad tracks appearing to merge in the distance. It is most easily demonstrated in images, such as *The Annunciation,* that contain buildings and pavement, or roads or tabletops, because the regular parallel lines of these items make the perspective scheme clear.

Linear perspective was invented in the early fifteenth century by the Italian architect Filippo Brunelleschi, who wanted a method of rendering build-

Diminishing size

Position

Diminishing size and position

Figure 5-13 David Hockney [English, 1937–], *Mother I, Yorkshire Moors, August, 1985.* Photographic collage, 18 1/2 × 13 in. (47 × 33 cm). Courtesy of the artist.

three-dimensional graph paper, on which objects can be located in a rational way. For example, in *The Annunciation,* if the paving blocks are four feet square, then the building behind Mary is four blocks, or sixteen feet, long.

Because the parallel lines of *The Annunciation* are all perpendicular to the picture plane, the lines of the perspective all meet at a single spot called the **vanishing point.** This arrangement, called **single-point perspective** or one-point perspective, usually places the vanishing point in the center of the composition. To add visual interest to the composition, the artist positioned Mary and the angel to the right of the central axis and the vanishing point to the left of center, almost exactly underneath the white dove of the Holy Spirit.

Very few pictures use such a rigid system of perspective for creating the third dimension as does *The Annunciation.* Many artists might find its space contrived. Single-point linear perspective requires a special, almost an ideal, point of view. The artist and viewer must assume that everything in nature lines up precisely and rigidly so that all the lines fall into place.

In our actual experience, we observe objects in space from a constantly shifting point of view, as David Hockney cleverly illustrated in the assembled photographs of his mother, titled *Mother I, Yorkshire Moors, August, 1985* (Figure 5-13). His procedure of taking numerous shots of his subject and then assembling them imitates the actual experience we have of

ings in space. Renaissance artists such as the Barberini Master were immediately fascinated with the architect's invention because the perspective space within the painting operates something like

Figure 5-14 Edward Ruscha [American, 1937–], *Standard Station, Amarillo, Texas*, 1963. Oil on canvas, 64 7/8 × 121 3/4 in. (164.9 × 309.4 cm). Hood Museum of Art, Dartmouth College, Hanover, New Hampshire. Gift of James J. Meeker, class of 1958, in memory of Lee English. Courtesy of the artist.

Ruscha's *Standard Station, Amarillo, Texas* (Figure 5-14). If objects, such as the gas station, are turned at an angle to the picture plane, they have two vanishing points, one for each set of parallel lines visible on the sides of the object. The vanishing points may lie beyond the limits of the artist's composition. In practice, all vanishing points lie on the picture's horizon line, which is determined by the position of the eyes of the artist. The higher the artist's eye level, the higher the horizon line. Ruscha looked at the gas station from ground level.

reality. Confronted with reality, the eye moves rapidly back and forth across any subject and focuses on one aspect of it after another over a period of time. Our experience of a subject is a composite of a succession of rapid eye movements and shifting viewpoints. Through Hockney's composite photograph, his mother's expression seems to change as we take the time to move from one segment of her image to another, just as the camera did.

Instead of single-point perspective, many paintings and drawings employ an angular kind of perspective, called **two-point perspective,** like that in Edward

Even though Chinese painters liked to depict extensive landscapes, Far Eastern cultures never chose

Figure 5-15 **Xu Daoning** [Chinese, 970–1051/52], *Fisherman's Evening Song*, ca. 1049, Northern Song dynasty (960–1127). Hand scroll; ink and slight color on silk, 19 × 82 1/2 in. (48.3 × 209.55 cm). Nelson-Atkins Museum of Art, Kansas City. Purchase: Nelson Trust, 33–1559.

Figure 5-16 **James Montgomery Flagg** [American, 1877–1960], *I Want You*. Poster. Library of Congress, Washington, D.C. From the collections of the Library of Congress.

to pursue the same methods of perspective as employed in the West. In Xu Daoning's *Fisherman's Evening Song* (Figure 5-15), landscape features do not fall into places assigned by a single point of view, as dictated by the rules for linear perspective. In fact, we are not meant to take in all of nature at one glance. Our eye wanders through the landscape from one feature to another to "read" each part independently of the others. Chinese landscapes, such as this one, which is eighty-two inches long, were often painted on a scroll that allowed the viewer to see only one part at a time as the painting was gradually unrolled from one end at the same time that it was wound up on the other.

Linear Perspective MODULE

Foreshortening

When Uncle Sam points his finger out in space toward us in the famous World War I poster *I Want You* (Figure 5-16), by James Montgomery Flagg, most people would say that his arm is foreshortened. The same rules apply to **foreshortening** as to linear perspective, but the word *foreshortening* is usually reserved for parts of the body and other irregular ob-

jects that appear to go forward or back in space. Linear perspective suits the rendering of objects that have straight lines, such as buildings and tables. But it would be too cumbersome to use it for something as curvy as an extended arm. Instead, artists usually practice drawing the human figure for a long time in order to develop the knack of placing limbs intuitively in foreshortening.

Chiaroscuro

In *Seated Boy with Straw Hat* (Figure 4-11), Georges Seurat demonstrated that contrasts of light and dark could make the human figure seem rounded, solid, and three-dimensional. Chiaroscuro, discussed earlier, is any change between light and dark, and it can appear to us as the result of a change in the direction of the shape of an object, consequently suggesting a movement into depth. If one side of a box receives light, the other, darker side that does not receive light appears to go off in another direction. When the light gradually changes to dark in the modeling of the seated boy's leg, the limb appears three-dimensional.

Modeling and perspective transformed Western art in the Renaissance: they gave to images the appearance of solid bodies existing in space. Many modern artists have turned their back on that tradition by adopting the example of pre-Renaissance art

Figure 5-17 **Torii Kiyonaga** [Japanese, 1752–1815], *Interior of a Bathhouse*, 1785. Oban diptych; ink and color on paper as mounted, 15 1/4 × 20 in. (38.7 × 51 cm). Museum of Fine Arts, Boston. William Sturgis Bigelow Collection, 30.46 & 30.47.

Figure 5-18 Caspar David Friedrich [German, 1740–1840]. *Solitary Tree*, 1822. Oil on canvas, 21 5/8 × 28 in. (55 × 71 cm). Staatliches Lindenau Museum, Berlin. © Bildarchiv Preussischer Kulturbesitz/Art Resource, NY.

Caspar David Friedrich believed that God was revealed in nature, and he devoted his career to religious landscape painting to communicate the message. At work in his studio, he painted from the vision he had inside him and not from sketches or color studies. In some of his paintings the oak tree symbolizes the ancient traditions of Germany. In *Solitary Tree* it stands alone and battered in the center of an idyllic mountain valley. The contrasts throughout the painting—light and dark, near and far, old and new—hint at the presence of a divine plan, working within nature, and the promise of salvation.

or art from other cultures. For example, many late-nineteenth-century artists greatly admired Japanese wood-block prints, such as Torii Kiyonaga's *Interior of a Bathhouse* (Figure 5-17), which they imitated in their own art. They observed that the Japanese did not employ modeling or depict cast shadows, but instead they delighted in large areas of flat color. Western artists also noticed that in their prints Japanese artists employed an angular perspective in which parallel lines do not meet at a vanishing point. The lines of the floorboards remain parallel in what is known as **isometric projection.**

Atmospheric Perspective

The painting *Solitary Tree* (Figure 5-18), by Caspar David Friedrich, treats us to abundant three-dimen-sional space not by means of converging lines, but through our experience that distant objects change their appearance due to the intervening atmosphere. The effect is called **atmospheric perspective,** or aerial perspective, although it has little to do with linear perspective. In Friedrich's painting a massive, gnarled old oak tree stands in the middle of a meadow. A shepherd leaning against the tree affords a sense of scale. Far in the distance, beyond the sun-dappled fields, rise blue-purple mountains. The atmosphere gives the impression of a deep space because the mountains in the painting change in terms of color, distinctness, and chiaroscuro.

Color changes in atmospheric perspective happen because we live inside a gas called air, which normally has a bluish tint to it during the day. When enough air interposes itself between some distant

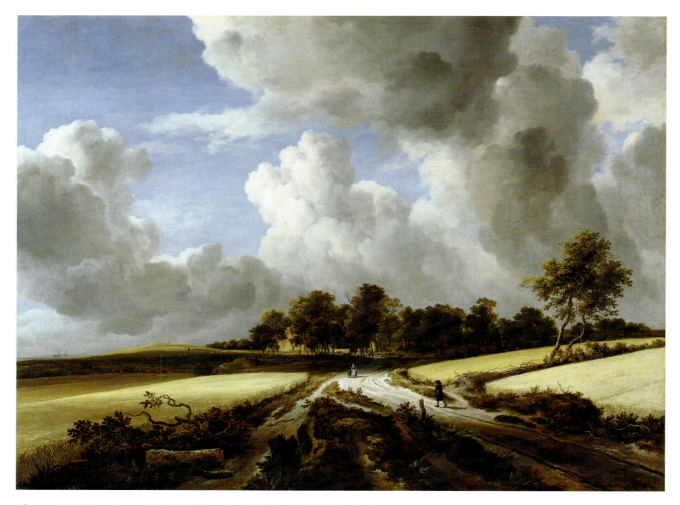

Figure 5-19 **Jacob van Ruisdael** [Dutch, 1628/29–1682], *Wheatfields*, ca. 1670. Oil on canvas, 39 3/8 × 51 1/4 in. (100 × 130.2 cm). Metropoliltan Museum of Art, New York. Bequest of Benjamin Altman, 1913 (14.40.623). Photograph © 1994 The Metropoliltan Museum of Art.

object and us, we see the object through a colored filter, as it were. As in Friedrich's painting, distant wooded mountains usually appear bluish.

Things at a distance also appear fuzzy and out of focus even to the sharpest eyes. Even on the clearest of days, the intervening air blurs things in the distance. We can distinguish few features on the mountainsides.

Finally, the contrast between light and dark becomes less pronounced on distant objects than on the objects in the foreground. In the foreground of a landscape, the lights are normally the lightest and the darks normally the darkest in value. In other words, chiaroscuro is strongest in the foreground. In the distance, the darks not only become lighter, but the lights also become a little darker. As both lights and darks move closer to each other, the contrast between them diminishes. Although the immediate foreground

in *Solitary Tree* is dark, the contrast between the silhouetted tree and the sunlit pond behind it is strong. But very little value contrast occurs in the mountains.

Atmospheric Perspective **MODULE**

Warm–Cool Color Contrasts

In Mark Rothko's *Orange and Lilac Over Ivory* (Figure 4-25), the red-orange rectangle at the top seems to move forward because Rothko painted it a warm color; the large lilac rectangle tends to recede because lilac is a cool color. The space in the painting pulsates. Any **warm–cool color contrast** can produce a spatial effect. The earth tones of a dirt road in a landscape painting can seem close at hand because of its warm colors; green hills and blue mountains recede. Paint a room red, and the walls seem to come closer and the room seems to get smaller.

SPACE IN MODERN ART

Artists, throughout history, have seldom wanted to create too much deep space in their work. Deep perspective tends to direct too much attention to the background. After the early Renaissance, deeply receding space was fashionable only during the Baroque period—the seventeenth and early eighteenth centuries in Europe. Jacob van Ruisdael's Baroque landscape *Wheatfields* (Figure 5-19) rushes the eye deep into space along a road and several rugged paths that converge on a clump of trees on the horizon. In the sky, which takes up two-thirds of the canvas, sodden clouds are foreshortened and seem to recede endlessly over the horizon. Unchecked in their horizontal movement, the wheatfields spread left and right beyond the frame—giving the impression that Ruisdael's painting is only a section of a panorama of the flat Dutch countryside. A man, a woman, and a child on the road suggest that the viewer too should "take a walk" through the landscape and enjoy the vastness of nature.

By the end of the nineteenth century, Western artists began to challenge the idea that a painting was a mirror of nature or a window behind which one could take a stroll. A French artist, Maurice Denis, told painters in 1890 to "remember that a picture before it is a war horse, a naked woman, or some anecdote, is essentially a flat surface covered with colors arranged in a certain order."[1] Even before that date, Western artists began to look to distant cultures to find out how others called attention to the arrangement on the surface by de-emphasizing the spatial projection. Many became fascinated with so-called primitive arts of Africa, Japan, and preclassical Greece. Rejecting the Western tradition they had been taught, they turned their back on linear perspective, modeling, and atmospheric perspective. A number of them felt that Western civilization was decaying, that it was corrupt and about to die. Pictorial practices such as perspective represented the exhausted values of an established society. These traditional practices produced mere illustration, not art, contended some artists who wanted to make a new beginning.

The rejection of deep space—one of the great revolutions in Western art—developed rapidly over

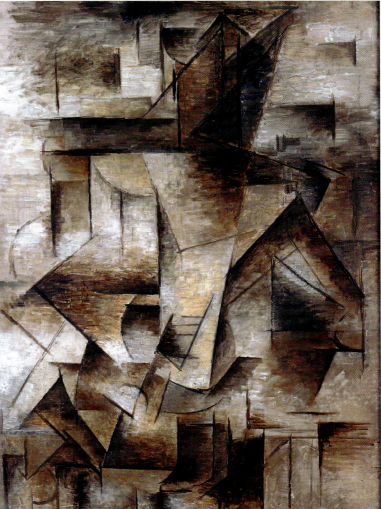

Figure 5-20 **Pablo Picasso** [Spanish, 1881–1973], *The Guitar Player*, 1910. Oil on canvas, 39 3/8 × 28 3/4 in. (100 × 73 cm). Musée Nationale d'Art Moderne, Centre Georges Pompidou, Paris. © CNAC/MNAM/Dist. Réunion des Musées Nationaux/Art Resource, NY. © 2006 Estate of Pablo Picasso/Artists Rights Society (ARS), New York.

a few generations at the end of the nineteenth and beginning of the twentieth centuries. By the opening years of the twentieth century, an artist such as Henri Matisse could insist that paintings were primarily decorations on a surface. Also at that time, in paintings such as *The Guitar Player* (Figure 5-20) and *Guitar* (Figure 5-1), Pablo Picasso and Georges Braque developed Cubism—an entirely new system for achieving a small amount of three-dimensional space seen from a changing rather than a fixed point of view. All these changes significantly altered the way an artist sees forms in space.

In his breakthrough painting *The Women of Avignon (Les Demoiselles d'Avignon)* (Figure 17-18), Picasso took up the challenge to reconcile the flatness of the canvas with the solid forms of nature. The expressive shapes of African art spurred Picasso's imagination in the new direction. The painting remained in his studio for years, shown only to a few friends, most of whom were stunned. The painting raced so far ahead of his previous work that he and his friend Georges Braque spent the next two years developing the implications of *Les Demoiselles d'Avignon* into the style of Cubism.

In his Cubist painting *The Guitar Player* (Figure 5-20), Picasso fragmented his subject into dozens of intersecting planes. He analyzed a guitar player from different points of view, excerpting fragments from this part, now that. Three-dimensional space still exists—created by the overlapping of the flat planes—but it is shallow, only a few inches deep, so to speak. Value contrasts contribute to a slight impression of three-dimensional space. It is often difficult to tell which shape is in front of which in *The Guitar Player.* Many of the intersecting planes penetrate one another, making the space ambiguous and relative to one's point of view. Seen from one point of view, a triangle appears to lie behind a rectangle. Seen from another, the same triangle might seem to overlap the rectangle. Light coming from different directions contributes to the ambiguity of the space created by the overlapping and intersecting facets.

Within a few years' time, some of the flat planes in Cubist works resulted from pasting cut-out material to the surface (see *Guitar,* Figure 5-1), or the area was painted to look like it was pasted. Picasso and Braque reduced the facets of Cubism to larger, simpler flat planes by means of collage. Picasso also introduced color into Cubism. The fewer shapes in *Guitar* seem to build a more monumental composition. Because of collage, the shapes do not recede behind the picture plane but come out from it so that the space in the painting seems to lie in front of the surface.

After World War I, Picasso worked in a representational and classical style at the same time that he was painting in a colorful Cubist vein. In the late 1920s, the Surrealists adopted Picasso as one of their own, and he himself turned Cubism into a vehicle of aggressive self-expression with deep-lying symbolism.

Pablo Picasso, 1913. © Hulton Archive/Getty Images.

Picasso worked constantly, preferably at night. He made little distinction between his working space and his living space—the rooms where he lived were cluttered with his equipment, his props, and his art. He often set the smaller canvases he painted on a tabletop. He began by laying out the essential armature of the painting with a few lines or shapes. He likely had in his imagination from the beginning a picture of the general design he wanted to achieve. He then painted over this basic structure a series of experiments, changes, and adjustments—repainting, erasing, and developing forms on the canvas. Picasso once said that when he painted he did not seek; he found. He meant that he was not groping in the dark for solutions but looking for the forms that were the equivalent of the vision he had from the start. Picasso's fertile imagination never stopped creating new means of expression.

Texture

Real texture

Real texture is the actual physical quality of a surface owing to the nature and treatment of the material.

Real texture can be rough, irregular, smooth.

Real texture calls attention to the surface; it adds richness and appeal.

Apparent texture

Apparent texture is imagined or implied texture, an illusion.

Apparent texture imitates the appearance of a natural material.

The effect of apparent texture depends on light reflections.

Space

Sculpture

In sculpture, masses take up space and move through space.

Some sculpture may charge the surrounding space.

Architecture

Space is an essential experience of architecture.

Architecture unfolds in time as the viewer moves in space.

Painting

Western two-dimensional art often creates an illusion of a three-dimensional world behind the window of the picture plane.

Art in other cultures usually respects and affirms the flat surface.

Methods of spatial projection include overlapping, positioning, diminishing size, linear perspective, foreshortening, chiaroscuro, atmospheric perspective, and warm–cool color contrasts.

Space in modern art is influenced by art from around the world.

Cubism reproduces space as seen from multiple points of view; it fragments space.

INTERACTIVE LEARNING

Foundations Modules: Visual Elements

Flashcards

Artist at Work: Pablo Picasso

Companion Site: http://art.wadsworth.com/buser02

Chapter 5 Quiz

InfoTrac® College Edition Readings

Talking Flashcards

Online Study Guide

Principles of Design

Figure 6-1 **Alvin Langdon Coburn** [American, 1882–1966], *The Octopus, New York*, 1912. Photograph. George Eastman House, Rochester, New York.

DESIGN

When we look at Alvin Langdon Coburn's photograph *The Octopus, New York* (Figure 6-1), the first thing we notice is the curved lines radiating from the circular "body" on the right. The awareness of what the photograph actually represents probably comes second to our attention. By taking this picture of a snow-covered city park from an unexpected angle—

from the top of a tall building—the photographer has transformed the subject into another reality so that the viewer sees the city in a new way. On first viewing, everyone very likely sees a pattern of lines, shapes, and value contrasts instead of walkways, trees, and snow-blanketed lawns. Coburn's unusual photograph emphasizes what every work of art contains: a unifying system among the visual elements—a **design** that imposes a coherence on the image and changes the subject so that it can be seen in a new way.

Principles, or methods, of design organize the forms of two-dimensional art as they appear on the picture plane, the surface on which an artist organizes the visual elements. Like the "octopus" in Coburn's photograph, this design holds the elements together and makes the visual elements in the work of art different from the masses, shapes, lines, light, color, texture, and space of everyday existence. The same design principles apply to three-dimensional art.

UNITY

A design brings everything together to form a **unity**—a wholeness, a completeness, a coherence. As a general rule, an organized design has the power to make a visual point more effective. And a coherent design gives shape to the artist's visual inspiration. Many artists would say that the design of the work *is* their vision.

Artists may have a master plan for their art object from the moment they start work, or they may work out a design as they go along. Before painting his *Last Supper* (Figure 16-16), Leonardo da Vinci made numerous preliminary drawings for the arrangement of elements and for individual figures. His early sketch (Figure 6-2)—he drew the left side of the table at the

Figure 6-2 Leonardo da Vinci [Italian, 1452–1519], *Study for the Composition of the Last Supper*, ca. 1495. Red chalk. 10 1/4 × 15 1/2 in. (26 × 39.4 cm). Accademia, Venice. Alinari/Art Resource, NY.

bottom—differs significantly from the finished painting. Most of the poses are changed, the figures are not symmetrically organized into four groups of three, and Judas sits on the near side of the table as Christ feeds him bread soaked with wine.

PRINCIPLES OF DESIGN

Artists strive to bring unity and focus to their vision by means of **principles of design.** These principles include dominance, consistency with variety, rhythm, proportions, scale, and balance. These six principles are not binding rules so much as rules of thumb. They are guidelines that artists absorb through their training and apply with sensitivity. Many good artists frequently challenge and break the rules. Principles of design only head the artist toward the intended effect.

DOMINANCE

Among the several ways to unify a design, one simple way is to use **dominance,** or to make some aspect of the composition the focus point. In Georges de La Tour's painting *Magdalen with the Smoking Flame* (Figure 6-3), the saint concentrates on the candle. Likewise, the artist concentrates on the saint's meditation and lets nothing in the painting distract from it. The object of her gaze is the only source of illumi-

Figure 6-3 Georges de La Tour [French, 1593–1652], *The Magdalen with the Smoking Flame*, ca. 1638–1640. Oil on canvas, 46 1/16 × 36 1/8 in. (117 × 91.76 cm). Los Angeles County Museum of Art. Gift of The Ahmanson Foundation. Photograph © 2004 Museum Associates/LACMA.

Figure 6-4 **Elizabeth Murray** [American, 1940–], *Pigeon*, 1991. Oil on canvas and laminated wood, 95 3/4 × 62 5/8 × 13 5/16 in. (243 × 159 × 33.8 cm). North Carolina Museum of Art, Raleigh. Purchased with funds from gifts by Mr. and Mrs. Samuel J. Levin and William R. Valentiner, by exchange. © Elizabeth Murray, courtesy PaceWildenstein Gallery, New York.

The work is an excellent example of a shaped canvas: not only does the canvas follow the contours of a long-armed woman, but the canvas also flips over at the bottom, protruding over twelve inches from the wall. The blobs painted on the flap may represent the footprints of the woman.

nation, and it lights up her rounded face and torso. After the death of Christ, according to legend, Mary Magdalen lived a life of prayer and penance. Her right hand touches a skull—a reminder of death and the vanity of earthly things. Her left hand supports her head—the traditional gesture of deep concentration. The Bible or other pious books rest on top of a bare wooden crucifix. Near them lies a scourge with which the saint will beat her bare back in punishment for her sins. Every object, every line, and

every light illustrates her deep meditation, which dominates the canvas.

As in La Tour's painting, the subject matter often determines what will be dominant, and it is up to the artist to control the visual elements so that the main subject is emphasized. In a portrait, it is almost always the sitter that will dominate the composition. The main motif in any work may be made dominant by receiving the brightest illumination, the main linear movements, the strongest color, the most detail, the most striking contrast, a prominent location in space—anything to draw attention to it. In abstract or nonobjective art, a certain line or shape, a certain light or color, a certain value contrast or color relationship may be the main goal of the work. If so, that particular visual element ought to dominate the design. Elizabeth Murray's *Pigeon* (Figure 6-4) consists of only curvilinear blob-like shapes, plus a twisted line that terminates in arrows like the hands of a clock. A single color contrast—bright red and dark blue—also dominates the painting.

CONSISTENCY WITH VARIETY

Another fundamental principle of design requires that a work of art possess **consistency with variety.** Line, shape, mass, value, color, texture, and space achieve unity in a work of art whenever there is some sort of consistency, or agreement. Consistency helps integrate the work when most of the lines or shapes resemble one another in some way, when the value contrasts are treated in a uniform way, or when the color contrasts establish homogeneous relationships. Perhaps the most common way to achieve consistency is through repetition. In Erich Heckel's *Two by the Sea* (Figure 6-5), for example, the artist employed the same bold line and triangular shape both in the woman and the man and in the setting—the shore of a mountain lake. The consistent use of this line and shape unifies both figure and ground into a coherent visual statement about a return of a modern Adam and Eve to a primitive nature. In another example, *Seated Boy with Straw Hat* (Figure 4-11), Georges Seurat modeled the fig-

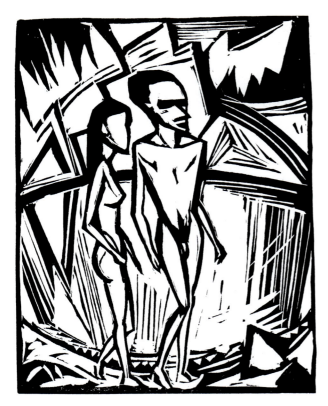

Figure 6-5 **Erich Heckel** [German, 1883–1970], *Two by the Sea (Zwei am Meer)*, 1920. Woodcut on heavy handmade paper, 7 × 5 5/16 in. (17.8 × 13.5 cm). Los Angeles County Museum of Art, the Robert Gore Rifkind Center for German Expressionist Studies. Photograph © 2004 Museum Associates/LACMA. © 2006 Artists Rights Society (ARS), New York/VG Bild-Kunst, Bonn.

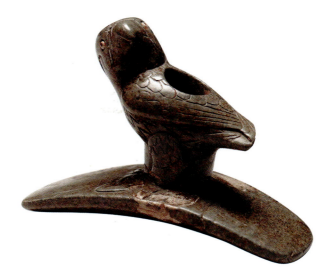

Figure 6-6 [Ohio Hopewell], falcon-effigy platform pipe, ca. 200 BCE–100 CE. Pipestone and river pearl, 2 1/8 × 3 1/4 in. (5.4 × 8.3 cm). Ohio Historical Society, Columbus. A–125–00019. Image # M00018.

ures consistently with the same sort of strong value contrasts throughout. Such consistency pulls together the separate parts of a work, creating explicit relationships among the elements. In contrast, inconsistencies such as a color that clashes unnecessarily or a mistake in perspective in a work that tries for correct perspective are disturbing or distracting.

Artists also usually strive to obtain consistency in the brushwork, the pencil stroke, the manner of carving, or in the general **handling,** or treatment, of their medium. The Hopewell Indians did so when they carved the stone pipe in Figure 6-6 in the form of an alert falcon. They consistently polished all parts of the bird into streamlined tubular masses on which they inscribed a regular pattern of lines for feathers. In painting, artists usually try to apply the paint in much the same way across the entire surface. On one extreme, an artist might try to hide his or her brushwork, whereas other artists may make a point of displaying their brushwork.

Consistency must be tempered with variety, or a work would look too static, dull, or monotonous. It must have a certain variety to attract the imagination and keep the eye interested. For the sake of variety and in contrast to his work's many straight lines and angles, Heckel introduced a few broad curves across his *Two by the Sea*. In contrast to the predominantly curved shapes of Coburn's *The Octopus* (Figure 6-1), the large vertical shape of the office tower's shadow cuts across the snowy park. In his nonobjective piece of sculpture *Cigarette* (Figure 3-19), Tony Smith consistently employed box-like masses, but for variety he occasionally sliced a massive member at an angle and freely twisted the whole piece up and around in contrast to the rigid geometry of the whole.

In traditional figural pieces, older critical theory liked to see the attitudes and movement of all the figures consistent with the theme of the work, and at the same time it liked to see a variety in the characterization of different people. For example, if an artist chose to illustrate a biblical event, such as the Last Supper, all the people the artist depicted were supposed to be doing something integrally connected with the event. However, the figures were expected to display variety—differences perhaps between young and old and differences of personality to show that the artist understood human nature and the moral implications of the event. In his *Last Supper* (Figure 16-16), Leonardo da Vinci imagined

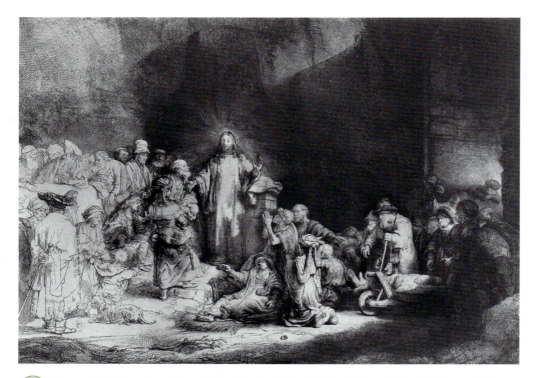

Figure 6-7 Rembrandt van Rijn [Dutch, 1606–1669], *Christ with the Sick Around Him,
Receiving the Children (The Hundred Guilder Print)*, ca. 1649. Etching, approximately 11 ×
15 1/4 in. (27.9 × 38.7 cm). © Pierpont Morgan Library/Art Resource, NY.

a different set of gestures and expressions for each
of the twelve Apostles and Christ so that the figures
represent thirteen distinct personalities.

Rembrandt's etching *The Hundred Guilder Print*
(Figure 6-7) is another classic example of consis-
tency with variety in this older sense. The work
received its peculiar name long ago when an
impression of the print sold for the high price of one
hundred guilders. In this scene of Christ preaching,
Rembrandt combined several incidents that take
place in the nineteenth chapter of the Gospel of
Matthew. Reading from left to right, we see the
Pharisees who cross-examine Jesus; the rich young
man, head in hand, who ponders his vocation to fol-
low Christ; the women who bring their little children
to Jesus; and the apostle who attempts to restrain
them. We see the poor, the sick, the lame, and fi-
nally, in the gateway on the right, the camel that, in
Christ's words, could pass through the eye of a nee-
dle easier than a rich man could enter heaven.

These dozens of people, who form a pyramid
with Christ at the apex, all focus on the preaching of
Christ, who stands out against the darkness. They
are all reacting to his words. Rembrandt not only

pulls together the entire chapter of Matthew's Gospel
into one dramatic moment, but the drama is also en-
acted by the widest variety of people—men and
women, young and old, rich and poor, high and low,
good and bad. The consistency and variety of
Rembrandt's design signify that Christ's preach-
ing embraces the whole of
humanity.

Unity and Variety MODULE

RHYTHM

When the visual elements in a work of art repeat
themselves in a steady flow across an image, they cre-
ate a **rhythm**—as repetitive beats do in music. As in
music, visual rhythm has a beat or an emphasis that
repeats itself at regular intervals. And the beat sug-
gests movement. The French artist Marcel Duchamp
painted *Nude Descending a Staircase* (Figure 6-8) in
imitation of a photograph that captures a person in
motion by means of multiple exposures. Inspired by
Cubism, he fragmented the nude into overlapping flat
planes. Duchamp then painted the fragments in regu-
lar groups organized in a descending rhythm as the
nude takes one step after the other down the stairs.

Italian artists in the early twentieth century, who called themselves Futurists, often repeated lines and fragments of a subject in a regular rhythm across the surface in order to visualize dynamic motion. The curved lines and shapes in Umberto Boccioni's *Dynamism of a Soccer Player* (Figure 3-6) create a forceful rhythm revolving around the center of the canvas. Architectural writers often suggest that the repetitive structure of a building sets up a steady rhythm that moves the eye through the building—for example, the rows of columns down the length of a Christian church move in a steady beat toward the altar.

Rhythm and Repetition **MODULE**

PROPORTIONS

Dominance, consistency with variety, and rhythm are appropriately vague and intuitive principles of design. To establish a more solid basis for good design, some theorists have devised more specific rules based on a system of **proportions,** or the relationships of parts to one another or to the whole. Their proportions usually involve mathematical relationships or ratios. An advantage of numerical ratios is that they generate, through a numerical progression or relationship, all the measurements in a work once an initial measurement is established. One shape—a room in a building, for example—might be a square (1:1), the next shape a rectangle (1:2), the next shape a longer rectangle (1:3), and so forth. When these ratios govern the intervals of the entire piece as well as the dimensions of individual parts, they produce a feeling of orderliness and serenity in the work.

The ancient Greeks believed in controlling through proportions the design of architecture, sculpture, and probably painting. They realized that numerical proportions governed musical harmony, and they believed that such mathematical ratios reflected the very principles by which the universe was constructed. In Chapter 2 we saw that the Greek sculptor Polyclitus employed a system of proportions involving whole-number relationships to create an ideal image of man, his *Spearbearer* (Figure 2-7). In the Renaissance, architects again used ratios to determine the proportions of their buildings. The Renaissance architect Leon Battista Alberti believed in the universal validity of proportions and employed them in his work (see the facade of Santa Maria Novella in Figure 6-9). In his famous treatise on architecture, *De re*

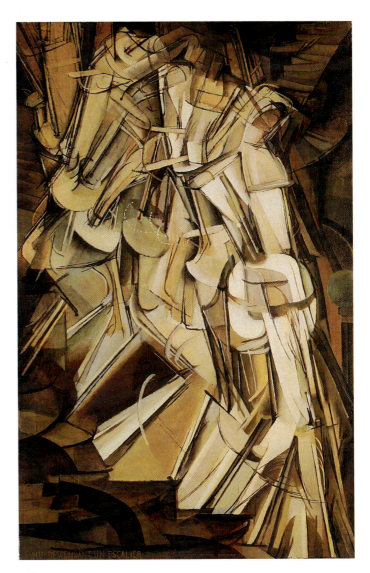

Figure 6-8 Marcel Duchamp [French, 1887–1968], *Nude Descending a Staircase (No. 2)*, 1912. Oil on canvas, 57 7/8 × 35 1/8 in. (147 × 89.2 cm). Philadelphia Museum of Art (Louise and Walter Arensberg Collection). © 2006 Artists Rights Society (ARS), New York/ADAGP, Paris/Succession Marcel Duchamp.

The notoriety of *Nude Descending a Staircase* made Duchamp's reputation when it was exhibited at the Armory show in New York in 1913. The show introduced European avant-garde art to America for the first time. President Theodore Roosevelt thought that Duchamp's painting looked like an explosion in a shingle factory. Meant as a put-down, his remark nevertheless caught the strong impression of movement in the painting.

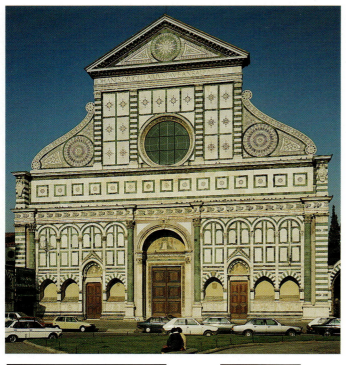

Figure 6-9 Leon Battista Alberti [Italian, 1404–1470], facade of Santa Maria Novella, Florence, completed 1470. © Ralph Lieberman.

Leon Battista Alberti's facade, covering the front of an older church with a new Renaissance design, employs a system of proportions governing the size and placement of every part of his arrangement. It is as tall as it is wide; in other words, the facade as a whole is in a ratio of 1:1. This basic square is divided in half by the cornice that runs horizontally underneath the circular window, giving two parts that are each in a ratio of 1:2. The lower part of the facade is of course formed by two squares, each exactly one quarter of the entire surface and therefore in the ratio of 1:2:4. The top story of the facade has the same dimensions as one of the two lower quadrants. The top story itself is divided in half at the horizontal line immediately above the capitals of the four vertical supports. The central part of the lower story—the door and its two flanking columns—is one-and-a-half times as high as it is wide and thus in the ratio of 3:2. The height of the intermediate zone between the first and second stories is half the width of the door, for a ratio of 3:2:1. Just as simple numerical proportions control the progression from one chord to another in music, Alberti's proportions harmonize the dimensions of one part of the building to another.

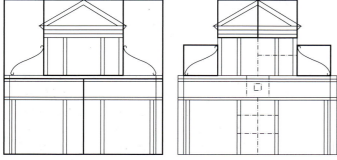

aedificatoria (1452), he coined a classic definition of beauty as "the harmony and concord of all the parts achieved in such a manner that nothing could be added, or taken away, or altered, except for the worse."[1] Many artists would still agree with Alberti's definition because to them one change in a successful composition would upset the whole work.

Proportion **MODULE**

GOLDEN SECTION RATIOS

Rather than using a set of proportional measurements involving whole numbers, some people have been fascinated by the idea of using the ratios of the golden section to determine the dimensions of elements and their relationships to one another. A shape whose sides are related according to the golden section can often be found in nature and can be very pleasing to the eye.

The **golden section** is the relationship between two unequal lines such that the smaller is to the larger as the larger is to the whole. In the diagram, the line AB is subdivided at C so that AC becomes the smaller segment and CB becomes the larger segment:

$$A \quad C \quad B$$

The golden section is created when the smaller line, AC, is related to the larger line, CB, just as the larger segment, CB, is related to the whole line, AB. In other words,

$$\frac{AC}{CB} = \frac{CB}{AB}$$

It is not difficult to draw two lines in the relationship of the golden section. First, draw a rectangle $ABDE$ whose long side is twice that of the short side ($AB = 2 \times AE$). Using the short side, AE, as the

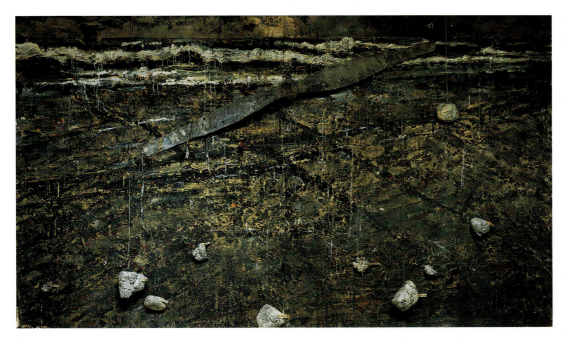

Figure 6-10 **Anselm Kiefer** [German, 1945–], *The Hierarchy of Angels*, 1985–1987. Oil, emulsion, shellac, acrylic, chalk, lead propeller, curdled lead, steel cables, band-iron, and cardboard on canvas, 134 × 220 1/2 × 21 1/2 in. (340.4 × 560.1 × 54.6 cm). Walker Art Center, Minneapolis.

radius of a circle whose midpoint is *E*, find the point of intersection *F* on the diagonal of the rectangle *EB*. Then use the rest of the diagonal *FB* as the radius of a circle whose midpoint is *B*. Where this circle intersects line *AB* at *C* will subdivide line *AB* into the golden section so that *AC* is to *CB* as *CB* is to *AB*.

In actuality, the ratio between short and long segments in the golden section is approximately 5:8, or more exactly .618. (The number .618 is only part of an irrational number—an unending decimal.) As a principle of design in art, the golden section can adjust the size of one element relative to another since it can generate a series of relationships approximating the number series 5, 8, 13, 21, 34. . . . For example, an architect could design a variety of windows for a building whose width and height are constantly in the relationship of the golden section.

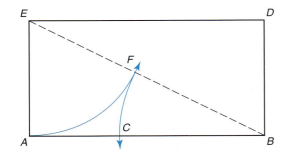

SCALE

Proportions apply to shapes a universal mathematical rule that is always valid. A **scale** is something different. Although a scale may use numerical ratios, the word *scale* refers primarily to the relationship between the artistic image and the real object that it imitates. For example, a drawing of a small building might use a mathematical scale in which one foot equals one inch or, in other words, a scale of 12:1. Such a scale is a convenient tool. Nothing is suggested about the universal validity of this scale for all drawings.

Artistic representations can vary in scale; for example, a miniature painting is on a small scale, and a mural is usually on a large scale. Consistency of scale is important because different scales often have a different style. Most small-scale works, such as a Leonardo drawing or the paintings of Paul Klee (see *Coup de Foudre*, Figure 5-4), are meant to be viewed up close in somewhat intimate circumstances. They tend to have intricate detail, small shapes, and/or delicate colors. Most large-scale works, such as a mural or Anselm Kiefer's *The Hierarchy of Angels* (Figure 6-10), are meant to be seen at a distance in a somewhat public setting. They tend to have large, simple shapes and/or bold colors. Only in the presence of Kiefer's

Figure 6-11 Chuck Close [American, 1940–], *Paul*, 1994. Oil on canvas, 102 × 84 in. (259 × 213.4 cm) Philadelphia Museum of Art. Purchased with funds (by exchange) from the gift of Mr. and Mrs. Cummins Catherwood, the Edith H. Bell Fund, and with funds contributed. 1994–166-1.

work, which is more than eighteen feet high, does the menace of the surface and the weight of the rocks strike home. Most works of art cannot be arbitrarily translated from one scale to another. A miniature cannot be easily made into a mural, and vice versa. The loss of scale is one of the greatest disadvantages of examining art in textbook illustrations.

Despite the importance of a consistent scale, many Pop artists distort the scale of everyday items to great effect. The sculptor Claes Oldenburg made a clothespin (see Figure 18-8), an electrical plug, and other household objects on a giant scale. The reversal of scale makes us appreciate the shapes of these common items as never before. The painter Chuck Close has specialized in enlarging photographs of heads into an enormous scale, as in his *Paul* (Figure 6-11), a painting more than eight feet high. On such a large scale, the heads of ordinary people become monstrous and perhaps a little frightening. However,

seen up close, the head in *Paul* dissolves into a grid of shapes and colors painted on a small scale.

Different scales are not easily mixed in the same work—unless the artist intends to produce a fantasy or a Surrealistic dream. The Surrealist painter René Magritte, in a painting titled cryptically *The Birthday* (Figure 6-12), filled an ordinary room with an enormous rock painted in a vastly different scale from the room. The discrepancy in scale conflicts with the realism of the painting, and reality becomes a nightmare. We can see no way out of the room and away from the oppressive rock, except through the window, which looks over an endless ocean.

Variations in scale can make other positive points of emphasis. The bronze plaque (Figure 6-13) from Benin, Nigeria, illustrates the principle of **hieratic representation,** in which the important people in a work of art, in order to symbolize their significance, are depicted in a larger scale than are subor-

Figure 6-12 René Magritte [Belgian, 1898–1967], *The Birthday (L'Anniversaire)*, 1959. Oil on canvas, 35 1/4 × 45 7/8 in. (89.1 × 116.2 cm). Art Gallery of Ontario, Toronto. Purchase, Corporations' Subscription Endowment, 1971 70/7. © 2006 C. Herscovici, Brussels/Artists Rights Society (ARS), New York.

dinate individuals. The *oba,* or king, in the center of the group is larger than the warriors standing at the far right and left and much larger than the musicians standing next to him.

Idealized figures, such as the three goddesses from the Parthenon (Figure 2-8), are often depicted in a larger-than-life-size scale. The exaggerated scale makes them look heroic and grand. The religious figures in Rubens's *Holy Family* (Figure 4-24) appear to be larger than life, especially the Christ child, who has the build of an infant Hercules. Rubens no doubt felt that the dignity of almighty God demanded the change in scale.

The relationship between the size of the shapes in a work and the format of the work in which they are placed seems also to affect the sense of scale. The figures in Rubens's painting fill up the rectangle of the panel. The tight relationship between the figures and the format makes them seem large in scale and of greater consequence. In Audrey Flack's still life *Wheel*

Figure 6-13 [Benin], *Warrior and Attendants Plaque,* seventeenth century. Brass, 14 3/4 × 15 1/2 in. (37.46 × 39.37 cm). Nelson-Atkins Museum of Art, Kansas City. Purchase: Nelson Trust 58–3.

Figure 6-14 **Audrey Flack** [American, 1941–], *Wheel of Fortune (Vanitas)*, 1977–1978. Oil over acrylic on canvas, 96 × 96 in. (243.8 × 243.8 cm). Photo courtesy Louis K. Meisel Gallery, New York.

A vanitas still life is a group of inanimate objects that symbolizes the transience of life and the vanity of frivolous and sensuous pursuits. This type of iconography has a long tradition, which Audrey Flack rejuvenated with popular contemporary imagery. The skull, hourglass, calendar page, and burning candle symbolize the passage of time. The jewelry, mirrors, lipstick, grapes, and wine represent ephemeral sense pleasures. The tarot card and the die allude to the fickleness of fortune. Poignantly, the portrait in the upper left corner is the artist's daughter.

To paint her large still-life composition, Flack first arranged the actual objects in a balanced, unified design in her studio. She then took photographs of her arrangements and painted from a slide that was projected onto a canvas mounted on a wall. Her procedure eliminated the need for a linear sketch but did not bypass the need for a design that organizes and balances her square canvas.

of Fortune (Vanitas) (Figure 6-14), the objects are fairly large shapes relative to the confines of the canvas. This relationship magnifies their scale and transforms them from common things Scale **MODULE** into something significant. of Art

Scale **MODULE** within Art

BALANCE

Most artists employ "rules" that are more general than mathematical proportions to unify their designs. To organize the elements and to achieve a satisfying unity, most artists simply consider whether the work before them is balanced. **Balance** is the stability that results when the visual elements on one side visually seem to "weigh" as much as those on the other. An artist might want an unbalanced work of art in order to convey a sense of tension or

Figure 6-15 [Bansoa, Cameroon, Bamileke], *Royal Beaded Throne*, nineteenth century. Wood, beads, shells, and fiber, 71 × 26 1/2 × 26 in. (180 × 67.3 × 66 cm). Nelson-Atkins Museum of Art, Kansas City. Purchase: The George H. and Elizabeth O. Davis Fund, 92–13.

of visual balance. The artist and the viewer must decide how much each element stimulates and also how much the elements stimulate in combination.

Visual balance has little to do with arranging equal *quantities* of elements. In other words, balance has little to do with placing the identical number of people or things on one side of the imaginary line and the same number on the other. Balancing has more to do with feeling than with numbers. Because "weighing" the various visual elements must always be a matter of intuition, no rules can ever exist to calculate the relative stimulation of things that are as different as colors and lines. The determination that so much light blue "weighs" as much as so many curved lines can be done only by intuition. Relationships among forms are important for establishing a balance. Visual elements that are farther from the imaginary central axis increase in visual weight, just as a child at the end of a seesaw can exert more weight than one sitting closer to the center. Any element near the edge pulls the eye farther to one side. Linear movements in directions relative to the central axis stimulate the eye to one side or the other. Contrasts of value or hue attract the eye as well, more than an equal patch of either value or either hue alone. The size of a color area affects its psychological stimulation. Textured shapes or complicated shapes attract attention more than plain and simple surfaces do.

Symmetrical Balance

The most obvious way to obtain a balance is, of course, to have the same kind of stimulation on one side of a work as on the other—in short, **symmetry.** Symmetry means that the formal elements on one side resemble the formal elements on the other side but reversed, as in a mirrored image. The facades of buildings are often quite symmetrical since symmetry reflects our desire for stability in architecture. And the human body is, in general, naturally symmetrical. In carving the human figure, many African sculptors, including the artist from western Cameroon who carved the royal beaded throne in Figure 6-15, adhere to bilateral symmetry in their work. Although it is not perfectly symmetrical, Michelangelo's *Pietà* (see "Artist at Work") is balanced because Mary and Christ form, in essence, a regular pyramidal mass. *(text continued on page 138)*

anxiety. We instinctively expect equilibrium, and imbalance frustrates our expectations.

As a general rule, to see if a work of art is balanced, artist and viewer can draw an imaginary line down the middle of the piece and try to judge if the visual stimulation on the left side "weighs" the same as the visual stimulation on the right side. "Weight," of course, is a metaphor for the total effect of the visual elements. The actual physical weight of the objects represented plays a negligible role in this kind

(text continued on page 138)

Michelangelo (1475–1564)

Michelangelo [Italian, 1475–1564], *Pietà*, 1498–1500. Marble, 68 1/2 in. (174 cm) high. St. Peter's, Rome. © Araldo de Luca/Corbis.

The contract that Michelangelo signed for the *Pietà* in 1498 specified that he was to finish the work in one year and was to be paid 450 ducats (perhaps the equivalent of several thousand dollars today). He was to be given another 150 ducats before he began. Michelangelo took about three years to finish it. When the contract was signed, the marble block for the *Pietà* had already been quarried, and Michelangelo must have had a rough idea of what he intended to do.

The *Pietà* is highly polished and refined. Its precision and perfection reveal Michelangelo's virtuosity in carving marble. However, it is one of the few pieces of sculpture that Michelangelo ever finished. Most of his work in stone he left

incomplete. In some cases he was distracted by new work that a powerful patron such as a pope insisted that he carve first. But the basic responsibility probably lay with Michelangelo himself. Again and again he agreed to undertake enormous projects, involving dozens of statues, which he contracted to complete in impossibly short periods of time.

Some of Michelangelo's statues, in their unfinished state, reveal his manner of carving. One example, *Awakening Slave,* was intended for an enormous tomb for Pope Julius II. Before carving any statue, Michelangelo often made rough models in wax or clay to work out his ideas. He also made preliminary drawings with hatch marks in pen or chalk that

Michelangelo [Italian, 1475–1564], *Awakening Slave*, 1520–1523. 8 ft 7 1/2 in. (2.63 m) high. Marble, Galleria dell'Accademia, Florence. © Scala/Art Resource, NY.

imitated the striation he would make with his chisel. Above all, he developed a powerful concept of the figure concealed within the block of stone. Michelangelo then made a full-scale drawing on the surface of the block before he began to carve. Even when he was carving a figure in the round, he worked on the block as though he were making a relief. Instead of first roughing out the major masses of the figure from all four sides, he carved the block from one side. A friend compared the way the figure emerged from the stone to pulling a body gradually up out of a tub of water. The forward parts emerged first, while the rest was still encased in the block.

In his incomplete *Awakening Slave*, after an assistant rough-cut the stone, Michelangelo himself used a chisel with teeth or claws that left parallel striations in the stone. We see in these marks the traces of his carving as he worked the stone and shaped the forms. We can still see part of the uncut block, the rough shaping of the stone, and certain parts brought to a degree of finish while other parts were ignored and left rough.

Michelangelo never intended that any of his works be seen in an unfinished state. Nevertheless, the figures still trapped in the stone that surrounds them seem to symbolize his belief that the spiritual soul is trapped in the material of the body. The figures seem to carry the weight of the stone.

During his lifetime, it became widely known that Michelangelo bent and broke the rules. He did not have much faith in systems of proportion that design by measurements. He once said, "It was necessary to have the compasses in the eyes and not in the hand, because the hands work and the eye judges."[1] He followed instead the voices of his own terrifying genius.

 Figure 6-16 James McNeill Whistler [American, 1834–1903], *Arrangement in Gray and Black, No. 1: The Artist's Mother*, 1871. Oil on canvas, 57 × 64 1/2 in. (144.8 × 163.8 cm). Louvre Museum, Paris. Copyright Edimedia.

Although this painting is popularly known as *Whistler's Mother,* James McNeill Whistler titled it *Arrangement in Gray and Black* because he wanted to stress the artistic aspect of his work. The organizing of colored shapes mattered more to him than the subject, although the colors themselves have been neutralized to an almost uniform gray. The lines of the floor barely recede; the entire image seems as flat as a Japanese print. Every part of the painting, even the figure, can be read as a rectangular shape.

Whistler's mother sits far to the right, her head positioned carefully between the two pictures. Whistler balanced her shape and the color of her head with the large rectangle of the decorated curtain on the left and the picture on the wall—most of which falls to the left of center. The direction of her glance stimulates movement to the left also. The design of the painting seems to freeze Whistler's mother in the formal world of art.

Symmetrical and **MODULE**
Asymmetrical Balance

Asymmetrical Balance

Western artists often take the risk of an asymmetrical form of balance, as James McNeill Whistler did in his *Arrangement in Gray and Black, No. 1: The Artist's Mother* (Figure 6-16). In an **asymmetrical balance,** although they weigh the same, the visual elements on one side are rather different from those on the other side. In Audrey Flack's *Wheel of Fortune (Vanitas)* (Figure 6-14), almost nothing on one side of the painting resembles the items on the other, although circular shapes are everywhere. The artist's sensitivity to line, value, shape, color, and space has to decide when totally different elements are equal. Because asymmetry is a bigger gamble, an asymmetrical balance usually has a bigger payoff and is a little more exciting to look at than a symmetrical work.

Landscape painters often create an asymmetrical composition with an attractive deep vista on one side balanced by foreground shapes on the other. Although Mary in Titian's so-called *Gypsy Madonna* (Figure 6-17) stands nearly in the center of the painting and the group of mother and child form a stable triangular shape, almost everything else is asymmetrically arranged. The Christ child stands on a small parapet to the right. The cloth of honor, a drapery that was traditionally spread behind royalty,

Figure 6-17 **Titian** [Italian, ca. 1488–1576], *The Gypsy Madonna*, ca. 1510. Oil on wood, 25 3/4 × 32 7/8 in. (65.5 × 83.5 cm). Kunsthistorisches Museum, Vienna. © Erich Lessing/Art Resource, NY.

has been shifted to the right. In the distance on the left lies a peaceful landscape with gently rolling hills. The spatial recession of the work, beginning with the parapet and the child Jesus on the right, moves diagonally back through the Mother to the light on the distant horizon to the left. Titian's new kind of balance, harmonizing nature and humankind, is one of the pleasant seductions of this lovely painting.

When artists apply the principles of design, they organize the visual elements into a design that becomes embedded in the work. Through the design, the artist takes the raw material of reality and makes clear its underlying structure or makes up a structure for it. Whether the artist is working with reality or with nonrepresentational shapes, colors, and masses, the design holds things together and helps achieve unity.

In the midst of creating art, artists are very unlikely to refer explicitly to a set of principles of design to determine their next step. Principles of design have, more likely, become so internalized that they seem instinctive. They have become part of an artist's creativity. Nevertheless, whether in the planning stage or in the middle of creation, artists are continually adjusting the elements in their work toward a coherent whole that expresses their vision.

AT A GLANCE

Principles of Design

Six principles of design are used to achieve unity or a wholeness:

Dominance	The main subject or main element is emphasized.
Consistency with variety	The visual elements resemble one another without monotony.
Rhythm	The repetition of elements creates a steady flow like a musical beat.
Proportion	Whole-number ratios or golden-section ratios organize forms.
Scale	The visual elements conform to a large or small scale.
Balance	The visual stimulation on the right "weighs" the same as the visual stimulation on the left.

INTERACTIVE LEARNING

Foundations Modules: Principles of Design

Flashcards

Artist at Work: Michelangelo

Critical Analysis: The Visual Elements

Companion Site: **http://art.wadsworth.com/buser02**

Chapter 6 Quiz

InfoTrac® College Edition Readings

Talking Flashcards

Online Study Guide

Line and Shape

The woman in Mary Cassatt's painting *Summertime: Woman and Child in a Rowboat* looks down at the water and establishes an imaginary vertical line between her eye and the duck. The vertical lines of the upright child parallel this eye-line. The child's eye-line parallels the diagonal tilt of the woman's shoulder. Contour lines are visible around the forms of the figures, but throughout most of the painting Cassatt does not so much fill in between the contours as create a network of short wavy lines by means of the large interwoven brushstrokes of color. The straight eye-lines conspicuously intersect the curves of the boat and of the woman's arms. The same sort of curve in the shape of the boat is repeated in the shapes of the hats and of the ducks.

Value and Color

Water is one of the favorite motifs of the Impressionist painters because its dancing ripples and reflections encourage the painter

Mary Cassatt [American, 1845–1926], *Summertime: Woman and Child in a Rowboat*, 1894. Oil on canvas, 42 × 30 in. (106.7 × 76.2 cm). Terra Foundation for the Arts, Daniel J. Terra Collection, 1988.25.

to separate colors into touches of unmixed paint. In the water that rises to the very top of the canvas, Cassatt set down reds and greens, oranges and blues—complementary combinations that would instantly turn muddy gray if they were mixed.

She also used dark colors—especially in the water under the boat—as a foil for the light clothes of the woman and child in order to help give some impression of the cloth's luminosity in bright sunlight. Light reflected from the water softens modeling and brightens shadows everywhere. Cassatt applied her colors in rather irregular brushstrokes. In contrast to other Impressionists who laid down paint more systematically, she seems to have enjoyed the expressionistic potential of her colors.

Texture and Space

The vigorous, visible brushwork throughout the painting creates a rich texture for the eyes. *Summertime* shows no linear perspective and very little modeling to indicate deep space and solid bodies residing in space. However, the forearm of the woman, the shoulders of the girl, and the white duck are foreshortened. The most remarkable feature of the spatial construction of *Summertime* is the two points of view from which the composition is seen. The water is observed from such a high vantage point above it that the horizon line lies beyond the frame at the top. The water can thus become a consistent background for the figures, and the placement of the figures and ducks comes close to the space-by-position scheme seen in the Persian *Meeting of Theologians* (Figure 5-11). However, the profile figures, the boat, and the ducks are observed from a point of view more or less perpendicular to them. The combination of separate viewpoints in one image, derived from the example of Japanese prints (see *Interior of a Bathhouse,* Figure 5-17), looks forward to the shifting points of view of Cubist space.

Principles of Design

Mary Cassatt took the risk of an asymmetrical balance by shifting the two main figures and the boat in her *Summertime* to the right. Still, the figure of the woman is nearly in the center of the composition. Although the contour line of the boat also directs the viewer's eye out of the picture toward the right, the vertical curve of the girl's back helps to curb that visual movement. The girl's glance to the left also counterbalances the visual stimulation of her form on the right. The value contrast between the little white duck and the dark blue-green water is an important counterweight to the larger shapes on the right. The very active color contrasts in the bottom half of the painting balance the human interest, value contrasts, and curving shapes of the top half. Although the balanced composition is carefully calculated, the asymmetry gives the impression of a casual glimpse of a fragment of reality.

7 Drawing

In preparation for his painting *The Alba Madonna* (see Figure 3-7), Raphael made a drawing (Figure 7-1) that captures his first ideas for the group: the mother sitting sideways on the ground, the child climbing on her lap, and the infant John the Baptist bringing them a lamb. The faint circle around them shows that Raphael planned to paint a tondo from the beginning. In the drawing, the artist explored the basic poses and the relationships among the three figures. With rapid, curved lines he sketched the essential forms of the Madonna, then more emphatically strengthened the shapes of the children with his drawing tool, a sharpened piece of red chalk. In the lower right corner, Raphael tried out another pose for the Christ child and filled the empty space at the top of the sheet of paper with ideas for two more Madonna and child compositions.

The drawing differs from the painting in a number of ways. The drawing is rough and sketchy—not refined and precise like the painting. Except for a few hills on the left, Raphael ignored the setting in the drawing. The drawing also disregards areas of color in exchange for contour lines that create shapes and some hatching that models the Christ child and darkens the area around him. But the drawing has attractions not present in the painting. It makes the artist's confidence and skill in depicting the contours of the figures more evident than in the painting. The sketchy lines record his creative impulses and his sensitive adjustments. The drawing documents the process of creation, whereas the finished paintings of an Old Master such as

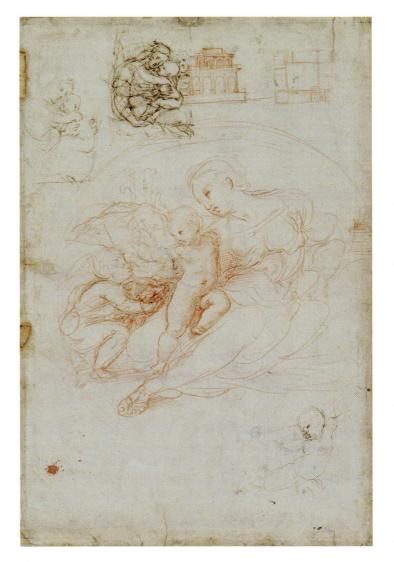

Figure 7-1 Raphael [Italian, 1483–1520], *Study for the Alba Madonna*, 1510–1511. Red chalk, pen, traces of black chalk (42.1 × 27.1 cm). Musée des Beaux-Arts, Lille. © Réunion des Musées Nationaux/Art Resource, NY.

Figure 7-2 [Hohokam], spiral at Spring Hill petroglyph site, northeast of Tucson, Arizona, ca. 1200 CE. Photo: © A. T. Willett, 1994.

Raphael obliterate all preliminary stages. Since the Renaissance, many collectors have felt that the artist's awe-inspiring power of creativity was often best preserved in drawings. Consequently, even preliminary working sketches such as Raphael's study have been avidly collected and admired.

THE BASIC ART

Raphael believed that drawing was fundamental for laying down the basic design of paintings such as *The Alba Madonna.* Many consider drawing *the* basic art. For one thing, drawing is the first art medium that most human beings practice. Sometime between the ages of eighteen months and twenty-four months, children realize that some shaky circles or wavy lines represent a person like Mommy or Daddy. Drawing is everyone's first experience of art—the first experience of a visual symbol standing for something else.

Drawings are also among the earliest sophisticated works of art that men and women produced in history, and they appear among the earliest types of art found in many cultures around the world. In addition to the famous drawings of animals in European caves, drawings by prehistoric peoples appear on rock walls in Australia and in America—especially in the Southwest. The abundant rock art

in the Southwest consists of paintings and, more commonly, **petroglyphs,** which are drawings made by pecking or cutting a design into the stone face of a natural rock or cliff. The spiral in Figure 7-2 symbolizes the beginning or origin of life for the now vanished Hohokam people.

For the last several hundred years, the Western art world has treated drawing as the basic art in another sense. Drawing has been the primary means by which the tradition of art is passed from generation to generation. It has been the chief means of instruction because learning to draw sharpens observation, increases perception, and releases self-expression. The low cost of drawing materials and the ease of making corrections and alterations encourage experimentation and creativity in the developing artist. In short, drawing has become the chief means for the education of the artistic imagination.

In many ways, drawing is the art form on which all others build. As in Raphael's example, the first creative impulses of a painter or sculptor are commonly expressed in drawings. Painters and sculptors are likely to work out their visual ideas, at least partway, in the less costly and less intractable medium of drawing before tackling their preferred medium. Architects and even photographers are commonly trained to draw if for no other reason than to train their perceptual skills and develop their creative potential. Compared with architecture and sculpture, drawing certainly is a more spontaneous medium, allowing architects and sculptors to visualize possibilities rapidly and to find their **Drawing** VIDEO way to solutions.

A DEFINITION

In most cases, to draw means to make marks on a surface in order to delineate something. It usually means to make lines and with those lines to make shapes. Drawings usually begin and often end with contour lines—those imaginary lines around the edges of forms in nature. As we saw in comparing Raphael's drawing and painting, lines and shapes in a drawing are usually more explicit. Through the lines of a drawing we are better able to sense the artist's state of mind and emotional attitude because we experience immediately whether the artist drew lines that are thick or thin, long or short, broken or smooth, harsh or delicate. Such differences can express char-

Artists may also rub the surface with their pencil, chalk, or charcoal to model a form in light and dark, or simply smear the contour line with their finger to achieve modeling. In the study *Triton Sounding a Conch Shell* (Figure 7-4), made in preparation for a mural, Annibale Carracci often blurred the chalk lines to model the dark undersides of ribs and muscles. Notice also how faint he left the contour line of the shoulder to indicate that it is exposed to the strongest light. We

Figure 7-3 Albrecht Dürer [German, 1471–1528], *Self-Portrait at Age Twenty-Two and Pillow Exercise*, 1493. Pen and ink, 11 15/16 × 7 15/16 in. Metropolitan Museum of Art, New York. Robert Lehman Collection, 1975 (1975.1.862). Photograph by Schecter Lee. Photograph © 1997 The Metropolitan Museum of Art.

Because Albrecht Dürer looked at himself in a mirror to make this self-portrait, his left hand—held closer to the mirror—is larger than his head. His pen lines are abrupt and turn in every direction. To reproduce dark areas and accentuate the roundness of forms, Dürer curved the hatching and cross-hatching and varied the thickness of the line and the frequency of the hatch marks.

Underneath his self-portrait on the front side of the sheet, or **recto**, Dürer practiced depicting the masses of a pillow with hatch marks. Then, on the reverse side, or **verso**, he tossed the pillow six different ways and repeated the drawing exercise six more times, curving the hatching along with the folds of the pillow. Art students today still practice Dürer's drawing exercise—usually by reproducing the dark values of a crumpled piece of paper.

acter. Drawn lines also have direction—up or down, left or right, in or out—and thus guide the eye. The movement of the eye along a line often repeats the very stroke made by the artist in the drawing.

In addition to lines, drawings can also depict values, and the art of drawing has established several conventions for the representation of values. In his *Self-Portrait* (Figure 7-3), the twenty-two-year-old Albrecht Dürer demonstrated that the parallel lines of hatching can darken a form and that the thickness of contour lines can also imply darker areas.

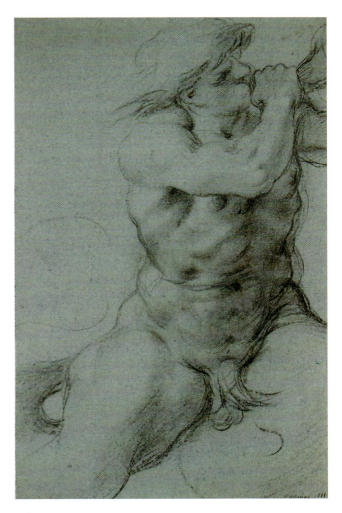

Figure 7-4 Annibale Carracci [Italian, 1560–1609], *Triton Sounding a Conch Shell*, ca. 1601. Black chalk on blue paper, 15 3/16 × 9 9/16 in. (38.6 × 24.3 cm). Metropolitan Museum of Art, New York. Rogers Fund, 1970. Photograph © 1987 The Metropolitan Museum of Art.

Figure 7-5 Giovanni Battista Tiepolo [Italian, 1696–1770], *Seated River God, Nymph with an Oar, and Putto.* Pen and ink, brush with pale (yellow) and dark brown wash, over black chalk, 9 5/16 × 12 5/16 in. (23.7 × 31.3 cm). Metropolitan Museum of Art, New York. Rogers Fund, 1937 (37.165.32). Photograph © 1982 The Metropolitan Museum of Art.

tends to cover the whole surface with paint. Most often the light of the paper is visible throughout a drawing, both in the figures and in the background. By convention, we do not hesitate to regard in a drawing one part of the paper as a human figure and another part of the same paper as the sky. In painting, however, artists normally fill up these different positive and negative shapes with areas of different colors.

The art of drawing is also defined by the tools that the artist employs. Traditionally, certain instruments such as a pencil, pen, chalk, or charcoal produce drawings only when they are the chief factors in a work of art. However, some tools produce several different kinds of art. For example, artists can also use brushes to make drawings as well as to make paintings. In many cases, it is only the artist who decides that his or her work is a drawing or a painting.

can still see in the drawing the first lines that Carracci made with the chalk as he searched for the right shape and adjusted the undulating contour to depict the anatomy of the sea creature. We can also feel in the lines a vibrancy that almost shakes the figure.

To achieve value contrasts in drawings, diluted ink may also be spread across the surface. After Giovanni Battista Tiepolo first made a faint sketch in black chalk and pen for *Seated River God, Nymph with an Oar, and Putto* (Figure 7-5), he then brushed on dark brown ink for the deepest shadows and flooded lighter diluted ink across patches of the drawing for softer contrasts. Whether the different values are created by lines, by rubbing the drawing medium, or even by brushing ink across the surface, the play of light and dark is an integral part of the art of drawing.

In most of these conventions for light and dark, the drawing medium is optically mixed with the lightness of the paper. In fact, a fundamental convention of drawing is that the artist usually leaves a considerable amount of the surface blank—unlike the technique of most forms of painting, which

FUNCTIONS OF DRAWING

Drawings are made for a variety of reasons. Many are created as completely finished artworks in themselves. Artists also might draw as an experiment aimed at increasing their general ability or as an experiment to complete a work in another medium, as Raphael did. Even though these drawings may seem to be lesser art forms, they are often appreciated as works of art in themselves. Outside the visual arts, preliminary studies are seldom so highly regarded. Scholars may be interested in the manuscripts of famous authors in order to explain their novels, but seldom is the reading public expected to appreciate the manuscript itself as art. Not so with a drawing. The incompleteness of its composition and its subordinate function do not detract from its quality as art.

Figure 7-6 **Leonardo da Vinci** [Italian, 1452–1519], *Sketch for the Madonna of the Cat*, ca. 1480. Pen and brown ink, stylus incised, 5 1/4 × 3 3/4 in. (13.2 × 9.6 cm). British Museum, London. 1856–6–21–1. © Scala/Art Resource, NY.

Drawings as Studies

Artists customarily make drawings to investigate different aspects of a work of art to be executed in another medium. As we saw in his *Study for the Alba Madonna* (Figure 7-1), Raphael made a drawing to visualize his preliminary idea or first thoughts for the composition. Artists often make **studies,** drawings used to stimulate their imagination, make concrete their intuitions, or solve the problems they set themselves. In fact, Leonardo da Vinci invented a technique in which he used drawings to brainstorm for new ideas, as illustrated in his drawing *Sketch for the Madonna of the Cat* (Figure 7-6). In the lower part of the design, his pen swirled in a tornado of possible positions for the Madonna's legs. Even the tail of the cat seems to wag because

Leonardo speculated about potential locations for it. He was not being hesitant and uncertain; on the contrary, he rapidly scribbled possibilities on top of each other to let the process itself create his image.

Once they settled on the overall design of a work, artists in the past usually made drawings from a model in order to determine the exact pose and correct anatomy of the figures in their final work. On the verso (reverse side) of the sheet on which he captured his first ideas for *The Alba Madonna* (Figure 7-1), Raphael studied the anatomy and foreshortening of the Madonna by posing a young man in her position (Figure 7-7). Artists have made separate drawings of the perspective to verify the spatial relationships and have made studies of the land-

Figure 7-7 **Raphael** [Italian, 1483–1520], *Life Study for the Alba Madonna*, 1510–1511. Red chalk, 16 5/8 × 10 11/16 in. (42.1 × 27.1 cm). Musée des Beaux-Arts, Lille. © Réunion des Musées Nationaux/Art Resource, NY.

Figure 7-8 **Peter Paul Rubens** [Flemish, 1577–1640], *Laocoön*, ca. 1607. Black and white chalk with bistre wash, approximately 19 × 19 in. (48 × 48 cm). Ambrosiana, Milan. © Biblioteca Ambrosiana/Auth. #168/04.

back as well. He used his drawings several years later to portray the anguish of Christ on the cross. Watteau always kept notebooks for drawing with him. The features of the little girl he captured in his *Two Studies of the Head and Shoulders of a Little Girl* (Figure 7-9) reappear in paintings he made about two years later.

Not only painters but also sculptors, architects, and theater designers make studies for their work in another medium. Some architects' drawings have an expressiveness to them that goes beyond the need to illustrate the dimensions of the building. Frank Gehry's sketch for Disney Hall (Figure 7-10) captures the energy of the building's curved walls, which seem to billow in the wind like the sails of boats on the water. Stage designers and costume designers often make drawings that express more than what is necessary for theatrical assistants to translate their conceptions into reality.

scape or the clothing. They have also made drawings of the entire composition to transfer the design to another medium, often by creating a grid across the surface—visible in Tintoretto's *Archer* (Figure 3-13)—to help with the copying of the drawing. A modern artist would more likely use a projector to transfer a drawing to a larger scale.

Artists can make studies at any time, with or without a specific work in mind. Since drawing is the fundamental tool for sharpening an artist's perception and for training the visual imagination, many artists draw constantly to study anatomy, foreshortening, or perspective. They draw to record people, places, and other visual motifs that the artist has experienced. Some artists, such as the Fleming Peter Paul Rubens or the Frenchman Antoine Watteau, drew continually, studying models in a great variety of poses, and when they wanted to make a painting, referred to their collection of drawings. In Italy, Rubens studied the Greek statue *Laocoön* (Figure 7-8), not only from the front but from the sides and

Drawings as Final Works

The intention of the artist, not the quality of the drawing, determines whether a drawing is a "final work." In the past, artists often made portrait drawings, not as studies for paintings, but as finished works of art. Portrait drawings, less expensive than paintings or sculpture, sometimes lend themselves to more intimacy and characterization than the formal portraits of the times. It was common, too, for artists to make drawings of interesting geographic features or of famous pieces of architecture as finished works. Before the age of photography, people were interested in such drawings as reproductions of far-away places or as records of their travels.

In modern times, artists are as likely as ever to produce independent finished drawings. Many artists make finished drawings because they prefer the scale of drawings, they like the directness of a drawing medium, or they want to experiment. Some modern artists specialize in drawing; other artists will devote themselves to the art of drawing exclusively for a long period of time. For example, Vija

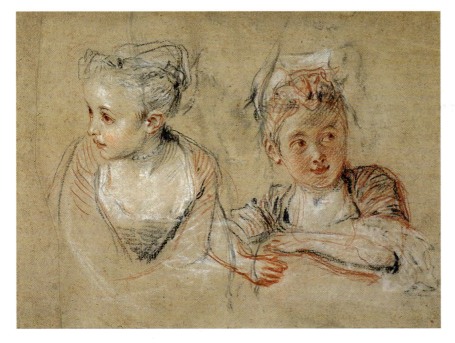

Figure 7-9 **Antoine Watteau** [French, 1684–1721], *Two Studies of the Head and Shoulders of a Little Girl*, ca. 1716–1717. Red, black, and white chalk on buff paper. 7 3/8 × 9 5/8 in. (18.7 × 24.4 cm). Pierpont Morgan Library, New York. © The Pierpont Morgan Library/Art Resource, NY.

Antoine Watteau has earned the reputation as one of the ablest draftspersons of all times, and he himself may have esteemed his drawings more than his paintings. Contemporaries praised the freedom of execution, the lightness of touch, and the delicacy of the contour lines in his drawings. To achieve his graceful style, Watteau drew mostly in red chalk, never in pen and ink, but he is most famous for drawings, such as this one, in three chalks—*à trois crayons,* in French.

In the pose on the left, where the girl looks into the light, white chalk renders the highlights on her forehead, cheek, and mouth. In the pose on the right, where the girl looks away from the light, red and black hatching covers her face in translucent shadow. The drawing gives the impression that the artist captured spontaneous and natural attitudes with ease and charm.

Figure 7-10 **Frank Gehry** [American, 1929–], *Disney Hall May '91,* 1991. Photo: Gehry Partners.

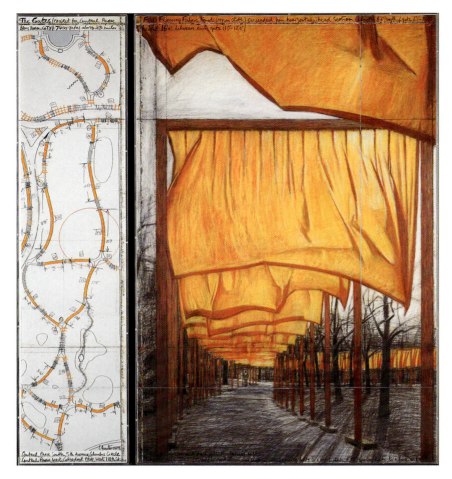

Figure 7-11 **Christo** [American, 1935–], *The Gates Project for Central Park, New York City*. Drawing 2002, in two parts, 65 × 15 in. (165 × 38 cm) and 65 × 42 in. (165 × 106.5 cm). Collection Jeanne-Claude and Christo, New York.

The environmental artists Christo and Jeanne-Claude are well-known around the world for wrapping in fabric famous landmarks, such as the Pont Neuf, a bridge in Paris, and tying them with rope into packages. They have also draped fabric across a landscape, as when they surrounded an island in Biscayne Bay, Florida, with fabric floating on the water. Their packages conceal and then reveal the land or structure in a new light. For *The Gates* project along the footpaths in Central Park in Manhattan, Christo and hundreds of workers erected 7,500 vertical and horizontal poles from which hung saffron-colored fabric panels that warmed the gray winter landscape like a golden river.

Over the months and years that it takes to devise and fund a project, Christo makes hundreds of drawings in preparation. Some of the projects are never realized and remain only on paper. Even the completed works are temporary since the building or landscape, once wrapped, is soon returned to its previous state. All that remains of his art are the excellent drawings, as well as photographs and models, that document the work. Christo's drawings and early works are the sole source of income financing his art.

Celmins concentrated for some time on making finished drawings, such as *Untitled (Ocean)* (see "Artist at Work"), which she exhibited and sold as finished works of art. In another example, before Christo and Jeanne-Claude complete a project, Christo creates preparatory drawings which show the evolution of the project through the years, for example, their large-scale projects such as *The Gates (Project for Central Park, New York City)* (Figure 7-11). Through the sale of their drawings, Christo and Jeanne-Claude are able to finance their projects. They accept no sponsors. For more information, see www.christojeanneclaude.net.

Drawings often appear as illustrations in books, magazines, and newspapers—especially cartoons and caricatures. Cartoon drawings range from comic to fantastic and come in a wide variety of styles. A **caricature** exaggerates prominent or characteristic features of well-known individuals or common types either for satirical effect or social commentary. Political cartoonists have created caricatures of presidents and prominent statesmen, exaggerating

Figure 7-12 Nick Anderson [American, 1966–], caricature of President George W. Bush, February 10, 2004. *The Courier-Journal*, Louisville, Kentucky. © 2004, Washington Post Writer's Group. Reprinted with permission.

Richard Nixon's nose and Jimmy Carter's teeth; Bill Clinton's full cheeks, hair, and nose; and George W. Bush's big ears and upper lip and small eyes (Figure 7-12). A caricature may also satirize a class of individuals such as an overstuffed capitalist, and caricature consequently runs the risk of reinforcing stereotypes. A good caricaturist has a keen eye for telling features and a knack for making the distortions in drawing plausible.

THE SUPPORT

Drawings have been made on wood, cloth, animal skin, the human body, clay, and rock, as well as on paper. In ancient Greece, painters such as Euthymides (see Figure 5-10) decorated the surface of red clay vases with human figures drawn with spare, continuous lines. In the West in ancient times and throughout the Middle Ages, artists drew on **parchment** made from the skin of animals such as sheep, goats, or calves, or on **vellum,** very fine lambskin, kidskin, or calfskin. Parchment and vellum must be *primed,* or rubbed with pumice, ground bone, or chalk, to smooth it and to prepare it for drawing. In the late Middle Ages and the early Renaissance, artists—especially young apprentices—drew on prepared wooden tablets that could be scraped and reused.

For over five centuries in the West, artists have drawn most frequently on paper. In fact, drawings might be defined as unique works of art made on paper. The word *unique* in this definition distinguishes drawing from almost all kinds of print-making, which normally produces multiple impressions on paper. The crucial element of the definition is "paper," for until the widespread availability of paper in the fifteenth century, drawing, understood as the basic art, scarcely existed. Drawing could not become the major vehicle for instruction, development, exploration, and creativity until there was an adequate supply of paper for the artist to work with.

Paper is made from the matted fibers of rags or of wood pulp, soaked in water and then pressed to varying degrees of smoothness or roughness. Rag paper lasts much longer than paper made from wood pulp because the longer and stronger rag fibers contain more stable cellulose. The Chinese invented paper by the second century CE, Islamic peoples in Samarkand learned the secret of papermaking in the eighth century, and the invention arrived in Europe through Islamic Spain in the twelfth century. Paper production exploded with the introduction of the printing press in the mid-fifteenth century.

For many centuries, artists' paper was dyed blue, beige, an earth red, or a green. Annibale Carracci drew *Triton Sounding a Conch Shell* (Figure 7-4) on blue paper. Antoine Watteau drew *Two Studies of the Head and Shoulders of a Little Girl* (Figure 7-9) on tan paper. Artists, like Watteau, often took advantage of the color of the paper, using it as a middle value while applying white chalk to the drawing for lighter values and black or red chalk for darker values.

DRAWING TOOLS

Different drawing tools determine to some extent what the finished product will look like. When making a drawing, most artists develop the potential latent in the medium; others, challenged by the restrictions of the tool, extend the range of the medium. In a rough chronological order of their appearance, some common drawing tools are metalpoint, pen and ink, chalk, pastels, brush and ink,

(text continued on page 154)

For about fifteen years, from the late 1960s to the early 1980s, Vija Celmins concentrated on making drawings. Her medium was the simple drawing pencil, in a variety of hard and soft leads. She usually covered the drawing paper with a ground of white acrylic paint to make the paper more sensitive to the pencil's touch and to make the luminous white of the paper more permanent. Celmins drew not with lines but with minute and subtle value contrasts.

During those years, Celmins focused on three main subjects: the ocean, the desert, and the night sky. Working from her own photographs, she expressed the infinity of the ocean and the vastness of the desert not by sweeping the horizon in a panorama but by looking down upon a segment of water or soil and painstakingly observing the myriad irregular forms. An infinite variety of shapes extends implicitly beyond the borders of the drawing.

What appears as a pattern, however, has no repeating elements—every ripple and every rock is different, a seemingly ordered chaos and an infinite series of variations. Nor does the texture that Celmins weaves across the surface have a dominant dramatic feature, a climax, a beginning, or an end. The same texture appears from one end of the paper to the other.

Even as a student, Vija Celmins possessed great technical ability and the diligence to reproduce nature with exactitude. She has the need to examine reality as closely as possible and to fix its image in her memory through her art. But trompe l'oeil (fooling the eye) has never been her goal. The aim of her drawing is thinking; she wants us to think about space and to think about the process of making art. Her space is exact and distinct, yet it has no precise location. Because it has no temporal or human references, this one specific area is timeless and universal. From a distance, the sameness and vastness stand out. Up close, each stroke of the pencil forming the illusion of reality is visible. The industrious pencil of the artist lovingly enriches the commonplace on earth.

The silvery gray of her light and dark pencil strokes is the perfect medium for capturing the enormous range of values in a black-and-white photograph. Just as the single eye of the camera can freeze thousands of waves or thousands of rocks in sharp focus, Celmins captured each shadow and each reflected light. In *Untitled (Ocean),* a low-lying light source rakes across the surface. Nevertheless, our awareness that she is reproducing a photograph keeps the image one step removed from reality. It keeps the desert or the ocean impersonal and checks us from projecting Romantic feelings of awe or sublimity upon nature.

Her drawings of the night sky, which celebrate the rich blackness of a soft pencil on paper, reproduced observatory photographs of the starry sky. She photographed the desert in Death Valley and the ocean from a pier in Venice, California, where she lived for nearly twenty years. In 1980 Celmins moved to New York, where she took up painting again, transferring her ocean, desert, and night sky to canvas. Although her motifs work well on canvas, we no longer feel the intimacy of drawing.

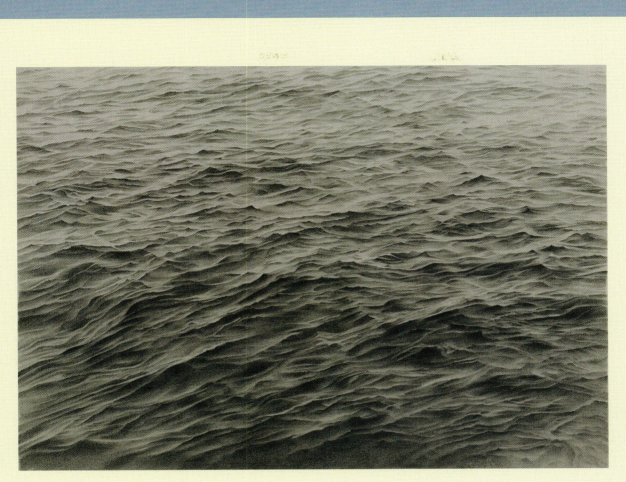

Vija Celmins [American, 1939–], *Untitled (Ocean)*, 1970. Pencil on paper, 14 1/8 × 18 7/8 in. (35.9 × 47.9 cm). Mrs. Florence M. Schoenborn Fund. The Museum of Modern Art, New York, Digital Image © The Museum of Modern Art/Licensed by SCALA/Art Resource, NY.

charcoal, pencils, and assorted modern inventions. Perhaps the essential drawing implement is the artist's hand. Popular wisdom believes that drawing skill lies in a person's ability to draw a straight line. But a ruler makes a straight line better than anyone can freehand. Instead, it is more important that the hand be able to vary a line by moving it around, by applying and releasing pressure, by turning and tilting the drawing implement.

Even the way the tool is held affects the character of the lines. In the West, we tend to hold all drawing implements the way we hold a pencil: on an angle between the first three fingers, with the heel of our hand resting on the surface. This method encourages downward strokes of the implement moved mainly by the fingers. Many artists hold the drawing tool with the shaft running under the hand and nearly parallel to the surface, especially when they want broader strokes to render values. In the East, a Chinese or Japanese artist holds the brush upright between the first two fingers and the back of the

third. The hand is poised free of the surface. This position allows movement in all directions and greater control in twisting and turning the brush to vary the line.

Metalpoint

In the early Renaissance, when Leonardo and Raphael were young, artists often made drawings with a sharpened piece of metal. They made **metalpoint** drawings using gold, copper, tin, lead, or, most commonly, silver. None of these metalpoints will leave marks on paper unless the surface is made hard and abrasive with a grit—traditionally bone dust.

All the metalpoints, including **silverpoint,** create thin, faint, gray lines that are impossible to erase. Pressure on the metalpoint scarcely increases the width or darkness of the lines. Some of the metallic lines tarnish with age—silver will turn faintly brown. Silverpoint drawings appear soft, subtle, and delicate; each line is calculated, isolated, and clean. A silverpoint drawing requires precision and restraint—the very opposite of what quick sketches demand.

One expert has called Leonardo's silverpoint drawing *Study of a Young Woman's Face* (Figure 7-13) "one of the most beautiful . . . in the world."[1] Turning her head on her profiled shoulders, she looks at us with a sideways glance out of heavy, enlarged eyelids. Leonardo sketched the torso, hair, and contours of her face with a few wavy lines. He then modeled her face with delicate parallel diagonal strokes, producing the smoky-soft transitions between light and dark for which Leonardo is so famous. Broader hatching casts a veil of half-light over the back of her head, neck, and shoulder. Long thought to be a study for the angel in the artist's *The Virgin of the Rocks* (Figure 3-17), this silverpoint portrait of a woman wears a puzzling expression.

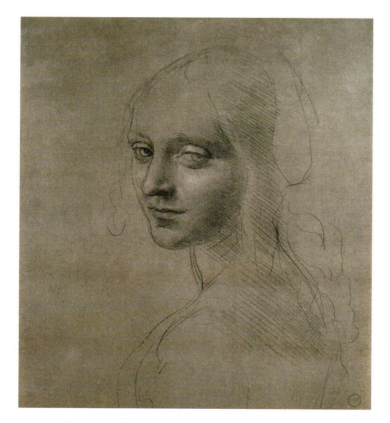

Figure 7-13 Leonardo da Vinci [Italian, 1452–1519], *Study of a Young Woman's Face*, late 1480s. Silverpoint, with traces of leadpoint, and white gouache, on very pale ocher prepared paper, 7 1/8 × 6 1/4 in. (18.1 × 15.9 cm). Biblioteca Reale, Turin. © Alinari Archives/Corbis.

Pen and Ink

All through his life Leonardo also employed **pen and ink** (see Figure 7-6), and its popularity as a drawing tool continues to this day. A pen filled with liquid ink held in the nib (point) produces decisive and clear lines. Ink lines cannot easily be erased. Guercino made the calligraphic lines in his drawing *Mars and Cupid* (Figure 3-10) with pen and ink. In Guercino's

Figure 7-14 Giovanni Battista Tiepolo [Italian, 1696–1770], *The Holy Family.* Pen and ink with wash over pencil, 12 3/8 × 9 in. (31.5 × 22.8 cm). Ashmolean Museum, Oxford.

hand, pen and ink produced lines of bold energy and fluid elegance. Whether the lines of an ink pen appear thick or thin depends on the size of the point, the angle at which the flattened nib is held, and the pressure applied by the hand.

Pens with steel tips were introduced only at the end of the eighteenth century. Guercino, living in the seventeenth century, used a **quill pen** made from the wing feathers of large birds such as geese or swans or from smaller birds such as ravens or crows. A quill pen fairly glides across the paper like a skater on ice. Soft, light, and pliable, quills respond readily to the touch to create smooth, fluid lines. Albrecht Dürer did not take advantage of the calligraphic freedom of the quill pen in his *Self-Portrait* (Figure 7-3), but Giovanni Battista Tiepolo created the quivering, energetic line in his drawing *The Holy Family* (Figure 7-14) with a quill. His wiggly line records his spontaneity, and we marvel at this magic mark that produces so much with so little, so quickly and so easily. Because it is soft, the tip of the quill needs frequent recutting to produce clear and fluent lines.

Pens cut from a hollow reed were common in the ancient world. A **reed pen** makes broad, bold lines that have considerable character. A stiff reed pen does not move easily over the surface, so it tends to create rather harsh, angular lines and does not permit the artist to show off in a fluent way. Because a reed pen releases its ink more rapidly than a quill, it also tends to make lines that are short and choppy. Van Gogh liked the challenge of the reed pen and revived its use to great advantage. In his drawing *Cypresses* (Figure 7-15), he copied one of his own paintings of cypress trees to send an image of it to his brother Theo in Paris. The lines of the drawing and the variety of textures they produce attempt to imitate the colors in the oil painting. With the reed pen, van Gogh was able to draw thick, powerful lines. Curved lines are everywhere, and they are constantly turning into patterns. But the knots and swirls of the trees give them an extra force as they surge above the horizon, into the sky, and beyond the top border.

Figure 7-15 Vincent van Gogh [Dutch, 1853–1890], *Cypresses*, 1889. Pencil, quill and reed pen, brown and black ink on white paper, 24 1/2 × 18 in. (62.2 × 45.7 cm). Brooklyn Museum of Art. Frank L. Babbott Fund and the A. Augustus Healy Fund. 38.123.

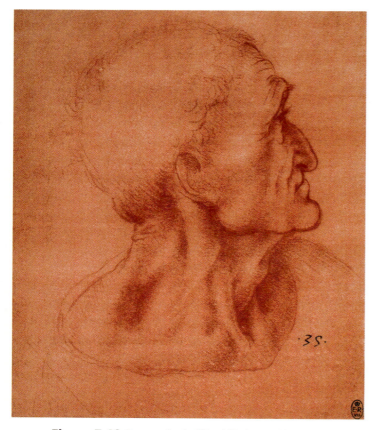

Figure 7-16 **Leonardo da Vinci** [Italian, 1452–1519], *Study for the Head of Judas*, 1497–1498. Red chalk on red prepared paper, 7 × 6 in. (18 × 15 cm). Royal Library, Windsor Castle, England. © Alinari Archives/Corbis.

Artists in the nineteenth and twentieth centuries have preferred to draw with black **India ink**—originally made from lampblack in China. In previous centuries the ink that filled an artist's pen tended to be brown or turned brown in time. Among the brown inks were **bistre,** made from wood soot, and **sepia,** made from secretions of cuttlefish or squid. The warm tones of sepia were popular in the late eighteenth and early nineteenth centuries.

Chalk

When Leonardo made studies for his mural painting *The Last Supper*—for example, his *Study for the Head of Judas* (Figure 7-16 and see Figure 6-2)—he drew them with red chalk. Following his example, generations of artists have picked up chalk to study the human figure. The modeling that Leonardo achieved in silverpoint (see *Study of a Young Woman's Face,* Figure 7-13) is more easily obtained

in **chalk,** a naturally occurring impure mineral. Unlike pen or silverpoint, chalk can be rubbed and blended. Chalk is very permanent, however, and cannot be easily erased. Natural chalks make soft, fuzzy lines that are not usually very dark, and a chalk line has a transparency to it that allows the light of the paper to show through.

In addition to red, artists since the fifteenth century have also drawn with black and white chalk, sometimes in combination, as Antoine Watteau did in his *Two Studies of the Head and Shoulders of a Little Girl* (Figure 7-9). Until the nineteenth century, these red, white, and black chalks were found in the earth, then cut into sticks. Warm red chalk—the French call it *sanguine,* or blood red—derives from hematite (iron ore); natural black chalk is a shale, a mixture of carbon and clay.

In the late eighteenth century, a French manufacturer, Nicholas-Jacques Conté, compounded fairly hard chalk with an oily material so that it would adhere to the surface even better. His chalks are known, confusingly, as **Conté crayons.** Seurat used a black Conté crayon to produce the smooth, rich value contrasts in his *Seated Boy with Straw Hat* (Figure 4-11). Most modern chalk is fabricated.

Pastels

In the Renaissance, Leonardo da Vinci wrote about pastels, and probably used them, but it was the Venetian artist Rosalba Carriera who first made them a popular medium, in the early eighteenth century. Her *Allegory of Painting* (Figure 7-17) illustrates her brilliant use of pastels. **Pastels** are almost pure pigments, lightly bound together by a gum into chalk-like sticks. They have a fine texture and are dry because they contain no oil. Thus, they preserve the brilliance of the pigment with no oil to darken them, but they require a grainy paper with some tooth to hold the pastel. The dry pigment on the surface of the paper is very fragile; therefore, it must be preserved carefully with a fixative that will not affect its matte (nonglossy) texture. Nevertheless, unlike oil paint, pastel is easy to handle and allows artists to express themselves directly in full color.

Pastels are sold in a wide variety of hues and in many tints and shades of those hues. With this considerable range of color, artists such as Carriera and Edgar Degas were induced to create works of art

Figure 7-17 Rosalba Carriera [Italian, 1675–1757], *Allegory of Painting*, ca. 1720. Pastel, 17 3/4 × 13 3/4 in. (45.1 × 34.9 cm). National Gallery of Art, Washington, D.C. Samuel H. Kress Collection.

Rosalba Carriera not only made the use of pastel fashionable in the eighteenth century; she also established in her work models of lightness and charm that became standards for the Rococo style. Antoine Watteau visited with Carriera twice when she made a much-publicized sojourn in Paris in 1720–1721. A glance at his *Two Studies of the Head and Shoulders of a Little Girl* (Figure 7-9) shows that their art has much in common.

Carriera was highly praised in her day for the liveliness of her figures, for their grace of expression, and for the beauty of her colors. The turn of the head, the poised fingers, the sidelong glance, and the luminous colors in this drawing confirm that praise. The features of the face seem too idealized to be a portrait of an individual. The soft modeling of the face, the blurred contours, and the delicate shadows around the upturned mouth remind us of Leonardo's *Mona Lisa* (Figure 16-17), which Carriera could have seen in Paris. The broader application of pastel on the girl's dress creates the illusion of a fluffy, transparent material. Deft touches of pastel as highlights make the hair silky, the earrings sparkly, and the lips moist.

Figure 7-18 **Edgar Degas** [French, 1834–1917]. *The Dancers*, ca. 1899. Pastel on paper, 24 1/2 × 25 1/2 in. (62.2 × 64.8 cm). Toledo Museum of Art. Purchased with funds from the Libbey Endowment, Gift of Edward Drummond Libbey, 1928.198.

ticipate the vivid color of early twentieth-century painting.

Brush and Ink

Lines drawn with **brush and ink** have a telltale swelling and tapering look. As the brush is lowered, the ink line begins to swell. When the brush is raised, the line thins and tapers. The Chinese and Japanese have preferred to use the brush above all other drawing tools and have developed a tradition of technical facility and visual sensitivity to brush drawing. In *Bamboo* (Figure 7-19), the Chinese artist Wu Chen used a brush to depict a few sprigs of bamboo, a plant that symbolizes for the Chinese the human ideal to remain steadfast and yet pliant to the winds of adversity. The brush is perfectly suited to reproducing the thin, tapering leaves of the plant. With deceptive ease, Wu Chen articulated the direction

that have the appearance of paintings, as in Degas's *The Dancers* (Figure 7-18). Compared with most oil paints, however, pastel colors appear more luminous, although frequently they are pale. (Deep darks are quite possible in the medium.) Pastels have a delicacy, a blurred, velvety quality, even when the artist is attempting a sharp definition of reality.

Despite their reputation for delicacy, the prominent Impressionist painter Edgar Degas made robust and exciting work with pastels. After 1885, Degas switched from oil paints to pastels to achieve a luminous, richly textured, and richly colored surface without the problems inherent in layers of oil paint. Pastels require no drying time, so Degas could change and rework his drawings immediately. Pastels allowed him to unite drawing and color. In his drawing *The Dancers*, he applied parallel strokes of pastel in layers, one color over another. The layering was made possible by spraying the preliminary colors with a fixative, whose secret Degas never divulged. In *The Dancers*, unmixed strokes of orange, violet, and some green—the secondary colors—an-

and location of each leaf and the natural growth of the plant, without falling into a stereotyped pattern. Diluted, paler ink creates the effect of atmospheric perspective. The expression-filled lines of the bamboo branch are matched by the expressionistic style of the calligraphy running down the left side of the page.

Western artists in the Renaissance sometimes used brush and ink to make line drawings, or they used a brush to apply white heightening to metalpoint or ink drawings on colored paper. Sometimes they added chiaroscuro to pen drawings by washing an area with light ink. A **wash** means that the ink is diluted with water and then flooded across the paper like watercolor. In the Baroque era, when artists could imagine objects solely in terms of light and dark, some artists made drawings almost entirely by means of wash. In *Seated River God, Nymph with an Oar, and Putto* (Figure 7-5), Giovanni Battista Tiepolo created his image of three characters lounging on a cloud mainly by washing in areas of dark and light. The white of the paper mixes with the diluted ink to

Figure 7-19 Wu Chen [Chinese, 1280–1354], *Bamboo*, 1350. 16 7/8 in. (42.9 cm) high. National Palace Museum, Taipei, Taiwan.

provide a diffused value contrast that is smoother than the textured appearance of hatching and cross-hatching. Wash renders clouds and atmosphere superbly. Tiepolo's brush and ink technique also suggests that the lights and darks flicker across the surface and may change at any moment.

Charcoal

Charred wood, or **charcoal,** has been an artist's medium for some time. Cave-dwelling men and women must have discovered it when they rubbed burnt sticks on the rock wall. Until modern times, its impermanence limited its use. However, art students now commonly use charcoal to make rapid sketches that quickly explore different points of view. The boldness of charcoal also makes it suitable for working on a large scale. Soft sticks of charcoal make a fairly thick, dark line; the side of the stick can create broad tonal passages that are rich and velvety. Charcoal is dry, coarse, and granular; it smudges easily. Consequently, it can be rubbed to create blurred lines and shading. Since charcoal can be erased and smudged, it must be secured with a spray of fixative to preserve the drawing.

Käthe Kollwitz demonstrated the freedom and range of charcoal lines and values in her *Self-Portrait* (Figure 7-20). When she drew this picture of herself—in profile, without a mirror—she was being persecuted by the Nazis because she had championed the poor and oppressed in her art. With a stick of charcoal she made a fairly sharp image of her profile, deep eyes, determined mouth, and poised hand. She easily blended the soft charcoal to produce variations of fuzzy gray. When doing a portrait study, it is common for an artist to make a precise face and then roughly sketch in the rest. Kollwitz did this; then, with the side of the charcoal stub, she made a thick black zigzag line, as strong as the coil spring of an automobile, between her head and her hand. Few lines so loudly shout defiance.

Pencils

Professional artists and amateurs alike draw with **pencils,** which commonly consist of graphite encased in wood. In *The Bathers* (Figure 7-21), Pablo Picasso made a virtue of the simplicity of an ordinary pencil line. Once committed to a contour line, Picasso seldom lifted the pencil from the page until the contour intersected with another line. He kept a steady pressure on the pencil and established each form with a single line. The economy of his line seems like a modern equivalent of the linear simplicity of classical Greek vase painting (see Figure 5-10). In contrast to the simplicity of Picasso's line draw-

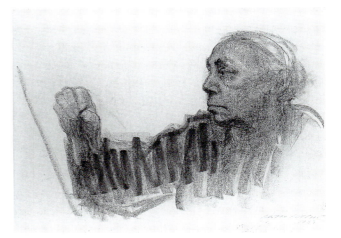

Figure 7-20 Käthe Kollwitz [German, 1867–1945]. *Self-Portrait Drawing,* 1933. Charcoal on brown laid Ingres paper, 18 3/4 × 25 in. (47.6 × 63.5 cm). National Gallery of Art, Washington, D.C. Rosenwald Collection. © 2006 Artists Rights Society (ARS), New York/VG Bild-Kunst, Bonn.

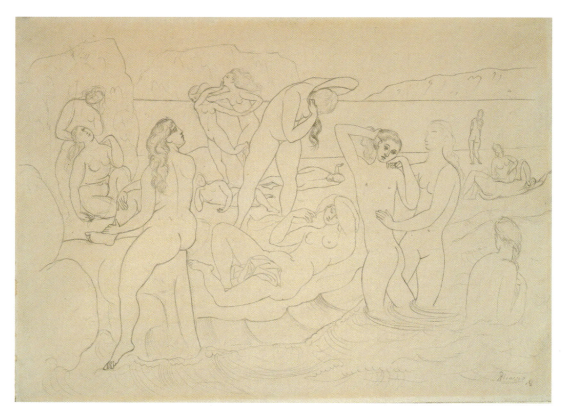

Figure 7-21 Pablo Picasso [Spanish, 1881–1973], *The Bathers*, 1918. Pencil on cream paper, 9 × 12 1/2 in. (23 × 31.9 cm). Fogg Art Museum, Harvard University Art Museums, Cambridge. Bequest of Paul J. Sachs. Image © President and Fellows of Harvard College. Photo by Allan Macintyre. © 2006 Estate of Pablo Picasso/Artists Rights Society (ARS), New York.

ing, Vija Celmins's drawing (see "Artist at Work") captures the complexity of the ocean's light and texture with a pencil.

All kinds of pencils are available, some of them hard (H-pencils) and some of them soft (B-pencils); well over a dozen degrees of hardness or softness are produced commercially. The common "lead" pencil is actually made of graphite mixed with clay to determine the degree of hardness. In the eighteenth century, first the British, then the French sheathed a thin shaft of graphite and clay in wood to invent the pencil as we know it. The thin tip of any pencil lends itself to an essentially linear style, although rubbing with the side of the pencil and the variations of pencil hardness can achieve values. The average pencil produces a gray color, somewhat shiny, although a wide variety of colored pencils are also available. The common pencil tends to be a reserved medium since it seldom lends itself to bold effects. Artists will frequently use pencil in the preliminary stage of a work and then go over the sketch with a stronger medium such as ink.

Modern Inventions

Felt-tipped pens come in every color, including fluorescent colors, although the colors may not be very permanent. They leave a transparent mark that seems to stain the paper. The lines of ball-point pens, of a consistent thickness and darkness, appear to be extremely continuous since the pens do not ordinarily run out of ink. More important than a few new tools is the urge that modern artists have to mix drawing media, as Picasso did when he combined charcoal, wax crayon, ink, and collage in his drawing *Guitar* (Figure 5-1). The Surrealists added new drawing techniques, such as frottage (see Max Ernst, *Wheel of Light,* Figure 5-6) and automatic drawing—letting a pencil wander over a piece of paper without conscious control. In 1959, Robert Rauschenberg gave new life to frottage and collage in a series of thirty-four drawings that illustrate Dante's *Inferno* (Figure 7-22). He transferred images from newspapers and magazines onto his drawing paper by dissolving their ink with lighter fluid and rubbing the

Figure 7-22 Robert Rauschenberg [American, 1925–], *Canto XXXI: The Central Pit of Malebolge, The Giants: Illustration for Dante's Inferno*, 1959–1960. Solvent transfer, pencil, gouache, and color pencil on paper, 14 3/8 × 11 3/8 in. (36.6 × 29 cm). Museum of Modern Art, New York. Digital Image © The Museum of Modern Art/licensed by Scala/Art Resource, NY. Art © Robert Rauschenberg/licensed by VAGA, New York.

Living in exile from his native Florence, Dante Alighieri (1265–1321) wrote the *Divine Comedy* to explore the meaning of life. Considered one of the greatest works of world literature, the poem is divided into three parts, *Inferno, Purgatorio,* and *Paradiso,* each of which is divided into thirty-three sections, or cantos.

Robert Rauschenberg made a separate drawing for each canto of the *Inferno.* In the upper left corner of Canto XXXI we see Dante and his guide, the Roman poet Virgil, who, at the sound of a horn, descend the stairs into the depths of hell. There they encounter enchained giants, whom Rauschenberg illustrated as prizewinning Olympic weightlifters. Finally, the giant Antaeus scoops up Dante and Virgil in his fist and deposits them in the lowest level of hell—the two tiny figures at the bottom. The modern imagery opens up the poem for new interpretations.

back of them with a pencil. The lines that his pencil made in rubbing seem to have brought the illusory images into existence. His transfer process allowed him to absorb photographic images into the act of drawing and thus open up new worlds of creativity.

Whatever the tool or technique, drawings are usually intimate works of art meant to be held in the hand or meant to be seen up close. Drawings allow us to examine their formal properties more explicitly than do most finished paintings or pieces of sculpture. The lines and values of a drawing express immediately the artist's personality and in many cases reveal the creative process.

AT A GLANCE

Drawing

The basic art	Drawing is the first art of children.
	Drawing was one of the earliest arts in prehistoric times.
	Drawing is a chief means of art instruction.
	Drawing is a chief means of visual study and creative stimulation.
Definition	To draw means to make lines and to render values.
Functions	Artists commonly make drawings as studies and as finished works.
Support	The widespread use of paper allowed drawing to become the major vehicle for instruction and exploration.
Tools	A drawing tool is anything that makes a mark. Some common tools are illustrated on page 162.

Pencil

Silverpoint

Charcoal

Chalk

Pastels

Brush and Ink

Pen and Ink

Felt-tipped Pens

Computer Graphics

Silverpoint drawing by Mary T. Walter. Computer Graphics by Tom Lochray. All other drawings by Tracy Turner.

INTERACTIVE LEARNING

In the Studio: Drawing

Flashcards

Artist at Work: Vija Celmins

Companion Site: http://art.wadsworth.com/buser02

Chapter 7 Quiz
InfoTrac® College Edition Readings
Talking Flashcards
Online Study Guide

8 Printmaking

Frank Stella's *Giufà e la berretta rosa (Giufà and the Pink Cap)* (Figure 8-1) illustrates the complex and creative nature of printmaking in the modern world. Traditionally, a **print** is any impression onto a piece of paper made by ink applied to a plate, a slab, a block, or a stencil that in some form holds an image. Frank Stella, who won fame as a painter of shaped canvases and as a maker of mixed media works, produced his print in collaboration with Tyler Graphics, one of several groups around the United States that offer their technical skill and their well-equipped workshops to painters and sculptors who want to make prints. Stella claims that he knows very little about printmaking! Unlike the relatively bare studios of most painters, a printmaking workshop is normally filled with worktables, machinery, tools, and chemicals necessary for the printmaking processes.

Giufà e la berretta rosa was printed on a custom-made piece of paper more than six feet high. To make the print, Stella and his collaborators used a variety of techniques. The grooves and ridges made on the metal plates to hold the ink were cut with tools or etched (cut) with acid. The plate itself was divided into pieces with a jigsaw so that parts of it could be inked separately; in fact, jigsawed pieces were reassembled and printed differently from the original design. Perhaps the most exciting part of the creative process was that Stella used a computer-aided design (CAD) system to develop a three-dimensional model of his image so that it could be turned, adjusted, and changed from a variety of angles on the screen. The computer printout was enlarged and transferred to the metal plate through a photographic process. Special skills, technology, collaboration, and the constant exploration of new possibilities are all vital parts of the current printmaking scene.

Figure 8-1 Frank Stella [American, 1936–], *Giufà e la berretta rosa*, 1989. Hand-drawn and computer-generated imagery; aquatint, engraving, and etching on white TGL handmade paper, 77 1/4 × 58 in. (197.5 × 147.3 cm). Printed and published by Tyler Graphics Ltd., Mount Kisco, New York. © 2006 Frank Stella/Artists Rights Society (ARS), New York.

Figure 8-2 **John James Audubon** [American, 1785–1851], *Cardinal*, from *The Birds of America*, 1827–1838. Engraving. © Academy of Natural Sciences of Philadelphia/Corbis.

THE NATURE OF PRINTMAKING

A clear-cut definition of printmaking is difficult because we also call photographs made on light-sensitive paper prints and speak of prints made by laser jets, xerography, and other new technologies. All of them are capable of producing multiple copies of the same image. Nevertheless, although Frank Stella's print exists in a number of copies, each one of them is considered an original work of art because each one is the result of the artist's hand and creativity.

Printmaking arose in the West chiefly to provide inexpensive devotional images for the generally illiterate masses. Many early prints simply reproduced paintings or statues—artists often used printed reproductions of their work as a form of advertising. Many other prints were produced for educational purposes. For example, John James Audubon's series *Birds of America* illustrates hundreds of birds,

including the *Cardinal* (Figure 8-2), in their natural setting. Albrecht Dürer's *Apocalypse* series, which includes *The Four Horsemen* (Figure 8-4—see page 166), interprets a fascinating book of the Bible. Some prints, whatever their subject, were produced as independent works of art from the beginning. Since the late 1800s, many of the functions of printmaking have been taken over by modern methods of photographic reproduction. In modern times, printmaking as an artist's medium has come to the fore.

Printmaking has traditionally been considered a graphic medium like drawing since it so often concentrates on delineating objects with lines. In the past, the results often looked a great deal like drawings. Unlike unique drawings, however, most fine art prints are produced in an **edition** (total number printed) of about twenty to a hundred **impressions** (single copies). When artists stop making impressions of their print, they usually cancel the plate by damaging the image so that no more impressions can be taken from it. The printmaker will then mark each impression in pencil with a number such as 15/40, meaning that this sheet is the fifteenth impression from an edition of forty.

However, some printmakers occasionally make **monotypes,** or single impressions, by simply pressing paper to a newly painted surface. Some monotypes are really a hybrid of printmaking and painting. To produce them, the artist paints or draws an image in paint or printer's ink on a smooth, nonabsorbent surface such as zinc, plastic, or glass. The single impression is transferred to paper by rubbing the back of the paper to the plate or sometimes by running the plate and paper through a press. The results are difficult to predict. The Impressionist painter Edgar Degas made hundreds of monotypes, including *Female Torso* (Figure 8-3). He reworked about eighty of them in pastel and probably intended to convert many more of his monotypes to pastel or another medium. Nevertheless, he signed several monotypes and gave them as finished works to friends. In *Female Torso,* Degas was able to model the figure without recourse to lines. His monotype technique produced a painterly kind of print in which the transfer to paper created a special luminosity not found in ordinary painting or other kinds of printmaking. The light seems to come from within.

Figure 8-3 **Edgar Degas** [French, 1834–1917], *Female Torso*, ca. 1885.
Brown ink on Japanese rice paper. 19 5/8 × 15 1/2 in. (50 × 39.3 cm).
Cabinet des Estampes, Bibliothèque Nationale, Paris.

RELIEF

The oldest method of printmaking is the **relief** process, in which the design to be printed is raised from the surrounding surface of a block. A relief can be made from the surface of different sorts of materials—wood, linoleum blocks, potatoes, or rubber, for example. After ink is applied to the raised part of a relief block with a roller, the impression is made with light pressure on the back of the paper that has been laid over the block. Printmakers usually press the paper into the ink with a **baren,** a smooth, rounded pad about five inches in diameter. Something like the back of a wooden spoon or a smooth doorknob can also be used. It is possible to run the block through the rollers of a press, although too much pressure could damage the relief.

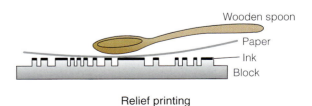

Relief printing

Woodcut

A common and very old type of relief printing is the **woodcut**, in which a design is drawn on a wooden block and the part of the block not to be printed is cut away with wood-carvers' tools such as knives, gouges, and chisels. The design is left raised in relief above the cut-away part.

The German artist Albrecht Dürer raised the woodcut to a medium of artistic expression that no one had previously imagined possible. Undoubtedly, Dürer first made a drawing of *The Four Horsemen* (Figure 8-4) on the wooden plank before he cut away the "white" parts, or negative areas. Dürer probably cut his own blocks since his demands from the medium were so high. For instance, his lines vary in length and width and density. In Dürer's new technique, contour lines and hatching lines are difficult to distinguish one from another. Many lines serve two functions at once—defining forms and defining values.

Soon after the woodcut reached an apogee in the art of Albrecht Dürer, other forms of printmaking supplanted the woodcut. In modern times, Paul Gauguin, Edvard Munch, and the members of the German Expressionist movement revived the woodcut by returning to its unsophisticated origins as a direct and forthright medium. They sometimes deliberately printed from rough, grainy, and knotted woods, which may supply their own texture to the print. Edvard Munch let the wood grain appear in his print *The Kiss* (Figure 8-5), its wavy lines veiling the lovers and also embedding them in nature—the growth of the tree. Erich Heckel, in his woodcut *Two by the Sea* (Figure 6-5), expressed his feelings by slashing and gouging the woodblock in a deliberately crude way. His return to a primitive technique reflects the return of the two nude figures to a primitive state.

Colored Woodcuts

Colored inks are available for relief printing, but to produce a multicolored print, separate blocks must be used to print each color. At the time of printing, each new block must be carefully aligned or registered with the colored areas of the preceding impression on the paper. Edvard Munch jigsawed the shape of the two lovers from one block and derived the wood grain from a second, uncut block. He inked

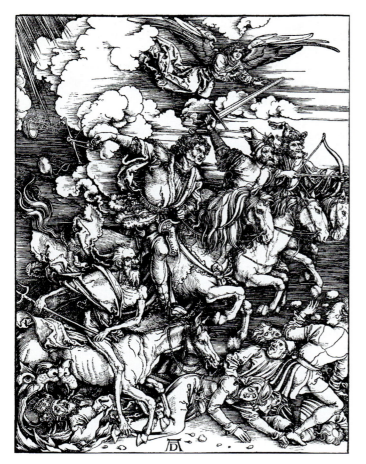

Figure 8-4 Albrecht Dürer [German, 1471–1528], *The Four Horsemen, from Apocalypse*, 1498. Woodcut, 15 7/8 × 11 in. (40.3 × 27.9 cm). Metropolitan Museum of Art, New York (gift of Junius S. Morgan, 1919). © Saskia.

This famous print comes from a series of fifteen that Dürer published illustrating St. John's Book of Revelation, or Apocalypse. In it, Dürer depicted St. John's vision in the Bible when the Lamb broke the first of the seven seals (Revelation 6:1–8). Death, riding a sickly pale horse, tramples a bishop, who soon will be swallowed by the jaws of hell. Next to him the dominant, burly Famine, swinging an empty pair of scales, rides a black horse. War wields a great sword. Pestilence gets ready to shoot his bow. Three of the horses fly in rank over the earth, knocking down all before them. Then the pale horse of Death stumbles over the fallen mass of men and women and sweeps them away.

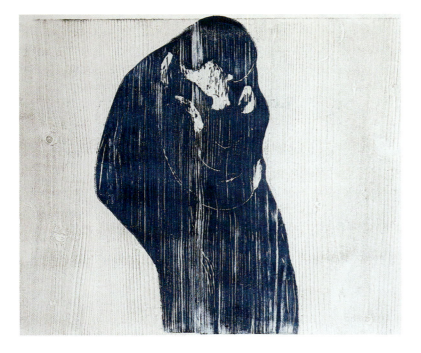

Figure 8-6 Helen Frankenthaler [American, 1928–], *Essence Mulberry*, 1977. Woodcut, 39 1/2 × 18 1/2 in. (100.3 × 47 cm). Tyler Graphics Ltd.

and printed the blocks separately—one in black, the other in gray. Helen Frankenthaler's woodcut *Essence Mulberry* (Figure 8-6) was printed with eight different colors on blocks cut from four different kinds of wood. Like Munch, she brought out the distinctive grain of the woods as she layered one color on the other. Without the usual border, the colors reach to the ragged edges of the paper, except at the bottom, where a large area of the untouched, beige-colored paper stands out. In her prints Frankenthaler radically changed the essence of the woodcut from line to color.

The colored woodcuts that were popular in sixteenth-century Europe became known as **chiaroscuro woodcuts** because the several colors

Figure 8-7 **Ugo da Carpi** [Italian, ca. 1480–1532], *Diogenes* (after a design by Parmigianino), ca. 1527–1530. Chiaroscuro woodcut, 18 13/16 × 13 1/2 in. (47.8 × 34.3 cm). Albertina, Vienna.

where, including the barrel behind Diogenes, where the austere philosopher lived.

In the East, Japanese woodblock printmakers employed a range of colors in their prints. In the eighteenth and nineteenth centuries in Japan, relief prints were considered popular rather than high art. The Japanese called them **ukiyo-e,** or "pictures of the floating world." "The floating world" referred to the entertainment district of Edo (modern Tokyo) with its famous courtesans and actors, who were often the subject of these prints. *The Great Wave Off Kanagawa* (Figure 8-8), filled with surging curved lines, is perhaps the most famous print by Katsushika Hokusai, a creative and energetic artist who made tens of thousands of designs for woodcuts.

Japanese artists such as Hokusai seldom cut their own woodblocks, which were made of cherry. Instead, craftsmen who had years of training cut the wood, usually in separate blocks for the printing of each color, as done in the West. Very likely, a third set of specialists printed the blocks. Instead of rolling on the ink, they brushed onto the block a water-based ink that would soak into the tough rice paper used for the finished print. With a brush, they might blend colors right on the wood relief of the block. For example, while the printers used three separate shades of blue for the water of *The Great Wave,* the ink for the sky was brushed and blended on the block to reproduce indistinct clouds and the dark horizon.

Linocut

In the late 1950s and early 1960s, Pablo Picasso cultivated a method of color relief printing called **linocut.** For his multicolored linocut *Still Life with Cherries and Watermelon* (Figure 8-9) he cut the

printed on them imitate different values. In other words, the inks of chiaroscuro woodcuts tend to be different values of the same color instead of strongly contrasting hues. In *Diogenes* (Figure 8-7), probably the most famous chiaroscuro print of the period, Ugo da Carpi printed four blocks, each with a different value. The result looks more like a wash drawing than a woodcut. The bearded Greek philosopher Diogenes, here posed like a nude by Michelangelo, ridiculed Plato's definition of human beings as featherless bipeds. In the print, curved lines flow every-

Figure 8-8 Katsushika Hokusai [Japanese, 1760–1849], *The Great Wave Off Kanagawa*, from *The Thirty-Six Views of Fuji*, 1823–1829. Woodblock print, 10 1/8 × 15 in. (25.7 × 38.1 cm). Photograph © 2004 Museum of Fine Arts, Boston (Bigelow Collection).

Figure 8-9 Pablo Picasso [Spanish, 1881–1973], *Still Life with Cherries and Watermelon*, 1962. Linocut, three blocks printed in black, green, blue, red, yellow, brown, and gray. Sheet 24 1/2 × 29 5/16 in. (50.4 × 72.9 cm). Metropolitan Museum of Art, New York. The Mr. and Mrs. Charles Kramer Collection. Gift of Mr. and Mrs. Charles Kramer, 1979 (1979.620.87). Photograph © 1983 The Metropolitan Museum of Art. © 2006 Estate of Pablo Picasso/Artists Rights Society (ARS), New York.

Pablo Picasso, an avid printmaker who made more than 2,500 prints in his lifetime, constantly experimented with new techniques to expand their range. *Still Life with Cherries and Watermelon* was printed from three linoleum blocks, or linoblocks, in eight colors. Picasso first printed almost the entire sheet in yellow from a block in which only the white of the lightbulb has been cut away. On a second block, which Picasso printed in brown, he cut away the lightbulb and the lines that in the final print appear yellow. Picasso then, in stages, continued to eliminate areas of relief from this second block so that areas of the colors that had already been printed would show. In short, he created his print by progressively destroying his linoblock.

Figure 8-10 Thomas Bewick [English, 1753–1828], "Duck," from *History of British Birds.* Newcastle: Beilby & Bewick, 1797–1804. Wood engraving.

relief printing, called **wood engraving,** was widely used in the nineteenth century for book, magazine, and newspaper illustrations because the blocks could hold up under the pounding of a mechanical printing press, where thousands of impressions are possible.

A prolific illustrator of books, Thomas Bewick popularized the technique of wood engraving at the very end of the eighteenth century. He illustrated his most famous work, *History of British Birds,* with many small profiles of birds in a rustic setting. To depict the duck in this series (Figure 8-10), Bewick started from the "black" surface of the woodblock and then gouged out "white" lines to create the image. He seldom developed contour lines with his method, but rather his white lines produced an amazing variety of light and shade to build form and to re-create textures.

Unfortunately for us, printmakers started calling Bewick's process wood engraving, even though it is a form of relief printing, not engraving. Perhaps the confusion arose because the wood engraver often uses a pointed tool called a graver. A wood engraver normally works directly at creating the image by cutting white lines into the block. The wood engraver can thus draw the image as he or she engraves, instead of merely eliminating unwanted wood from a line drawing.

images out of linoleum instead of wood. The soft linoleum, without any grain, is easily cut with a knife or other tool in any direction. After Picasso printed an entire linoleum block with one color, he cut away a portion of the block before he printed this block a second time in another color, covering over parts of the first color. He then cut away another portion of the same block before he printed a third color, and so on, until a very small portion of the relief was left to print the final color on top of all the others. He practiced what can be called a reduction method of color relief printing.

Wood Engraving

The grain in planks of wood, such as those available at a lumber store, usually runs along their length. However, small blocks for printmaking can be made by cutting across the grain of the wood, preferably boxwood—especially Turkish boxwood—or maple. A number of such cross-grain or end-grain blocks can be glued or clamped together to form a larger block.

The printmaker can cut into these end-grain blocks more easily in all directions. The relief carved out of end-grain blocks is also stronger and can withstand more pressure. This method of

Boxwood cut across the grain (end grain)

INTAGLIO

Another major form of printmaking goes by the Italian name **intaglio** (pronounced in-*tal*-yo). The word *intaglio* means "carving or indentation." In intaglio, the printmaker puts grooves into the surface of a printing plate where he or she wants black lines to appear, instead of cutting away the white spaces, as in the relief process. Deeper incisions make thicker, darker lines.

When the plate is to be printed, ink the consistency of mayonnaise is smeared on it and forced into the cuts in the metal. The surface of the plate is then carefully wiped clean, leaving the ink in the incisions, before it is placed on the bed of an intaglio press. Dampened paper is laid over the plate, and both are covered with felt blankets. Several hundred pounds of pressure supplied by the rollers of the press force the paper into the troughs and into contact with the ink. In a genuine intaglio print, the lines of the print are raised slightly above the surface of the paper because the rollers have pressed the paper into the troughs. Because of the pressure applied during printing, intaglio plates are made of metal. Usually, they are made of copper or zinc, or possibly plastic.

There are two major forms of intaglio: engraving, which includes drypoint, and etching, which includes aquatint. Although they both achieve the same basic result—a metal plate with grooves in it for ink—the two processes are really quite different.

Engraving

Engraving, the older printmaking process, began in the fifteenth century. Albrecht Dürer, as is evident in his *Adam and Eve* (Figure 8-11), became a brilliant exponent of the engraving technique also. Dürer's *Adam and Eve* illustrates the ideal man and woman according to the classical canon of proportions devised in antiquity. The figures both stand frontally like statues in classical contrapposto and are placed symmetrically to the left and right of the Tree of Life, represented as a mountain ash. Dürer cut incredibly delicate lines into the intaglio plate. His lines not only model the forms but also reproduce the appearance of textures—skin, bark, foliage, fur. Values range from the stippling that subtly models the flesh to the deep, dark hatching of the forest.

Intaglio Printing

This is an illustration of a seventeenth-century intaglio printmaking workshop by Abraham Bosse, who wrote the first book about engraving and etching, in 1645. In his illustration, one workman, using both hands and a foot, turns the rollers of an intaglio press. The rollers pull the plate through the press, squeezing the paper into the cuts in the plate filled with ink. The man on the left is wiping a plate that he has inked, first with a cloth and then with his hand. In the back of the room, prints hang on the line to dry.

 Bosse, Intaglio printmaking workshop. Victoria & Albert Museum, London/Art Resource, NY.

Figure 8-11 **Albrecht Dürer** [German, 1471–1528], *Adam and Eve*, 1504. Engraving, 9 3/4 × 7 9/16 in. (24.8 × 19.2 cm). The Metropolitan Museum of Art, New York. Fletcher Fund, 1919 (19.93.1). All rights reserved. The Metropolitan Museum of Art, New York.

Engravings are made by directly cutting the grooves into the plate by hand with a tool called a **burin**. A burin is about the size of a small screwdriver, with a steel tip that has a diamond-shaped profile at a forty-five-degree angle. Acting like a plow, the burin cuts the plate with the sharp tip of the lower point of the diamond.

The hard part of engraving is to apply just the right pressure in just the right direction so that the engraved line is of the desired thickness, length, and location. In general, one arm, holding the burin, applies the desired pressure, while the other arm of the printmaker turns the plate to achieve the desired direction in the line. Engraving results in a precise line that tends to swell as the burin cuts deeper into the metal.

Engraving scarcely tolerates mistakes and corrections. The only recourse is to scrape away part of the surface of the plate to remove an unwanted line and then rub or burnish the area smooth again.

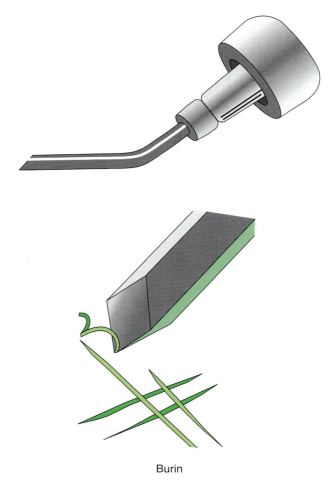

Burin

Because of the strength of the V-shaped engraved trough, engravings can be published in large editions. Yet the training necessary to be a competent engraver is so arduous that few modern printmakers practice engraving, except in combination with other techniques.

Drypoint

An artist can make lines on a metal plate just by scratching the surface directly with a sharp diamond-tipped or carbide steel needle. This simple method is called **drypoint.** Mary Cassatt used drypoint exclusively for her print *Baby's Back* (Figure 8-12), where the unforgiving metal plate put her drawing skills to the test. The metal removed by the drypoint needle forms a burr at the side of the trough. Because the burr catches most of the ink, drypoint lines tend to be soft and fuzzy. However, drypoint scratches are usually rather shallow, and the burr does not hold up well after only a few dozen impressions under heavy pressure.

Figure 8-12 Mary Cassatt [American, 1845–1926], *Baby's Back*, 1889–1890. Drypoint. 9 3/16 × 6 7/16 in. (23.3 × 16.4 cm). Library of Congress, Washington, D.C.

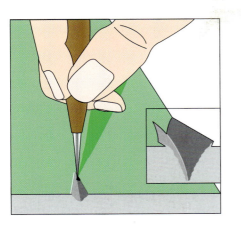

Drypoint

Close cross-hatching in drypoint can produce velvety blacks, as Rembrandt did in parts of his *Hundred Guilder Print* (Figure 6-7). By itself, drypoint tends toward short, jagged, spontaneous lines, an effect that Max Beckmann exploited in his *Self-Portrait* (Figure 3-2). Mary Cassatt's drypoint has the spontaneity of a pencil sketch. But drawing in drypoint takes more time, effort, and confidence than drawing with a pencil because of the resistance of the metal plate. Cassatt's needle made very sparse, short lines even in the hatching. The delicate drypoint lines suggest that she captured a fleeting impression.

Etching

Etching is a more versatile process than engraving or drypoint. Physical pressure does not cut the lines. Instead, acid—usually nitric acid—does the cutting. To make an etching, a copper or zinc plate is first coated with a black tar-like "paint," an acid-resistant liquid called **asphaltum.** Rosin and other acid-proof coatings may also provide the resistive coating, or ground. After the ground dries, a drawing can be made in the asphaltum by scratching the surface with a stylus or other sharp tool. The marks in the asphaltum lay bare the metal underneath. Making marks in the asphaltum for an etching is a lot easier than gouging out the actual metal with a burin for an engraving. Etched lines tend to be long and fluent since the asphaltum offers the etching needle little resistance. If the printmaker makes a mistake, the unwanted line can be removed simply by covering it over with more asphaltum.

Acid bites into the plate where the metal plate beneath the asphaltum has been exposed. A short immersion time will produce thin, faint lines; a longer time will produce thicker, deeper lines. Some of the lines can also be covered over with an acid-proof varnish or with more asphaltum after the initial acid bath. When the plate is returned to the acid, the lines that remain exposed will be etched deeper, and the lines that have been covered will remain relatively thin.

James McNeill Whistler's etching *Nocturne* (Figure 8-13) illustrates the freedom, delicacy, sketchiness, and atmosphere that are possible with etching. Whistler drew this image of the city of

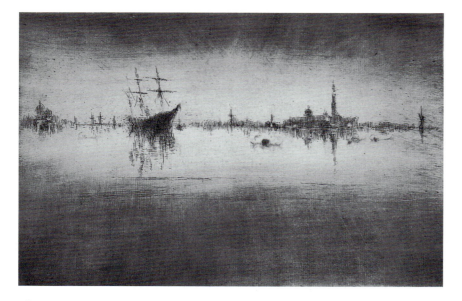

Figure 8-13 James McNeill Whistler [American, 1834–1903], *Nocturne,* 1879–1880. Etching with drypoint (fourth state or stage), 7 7/8 × 11 5/8 in. (20.2 × 29.6 cm). National Gallery of Art, Washington, D.C.

Venice directly onto the plate as though he were positioned on an island across the lagoon. Confident in his art, he was unconcerned that the city appeared in reverse when printed—as does every impression pressed to a printing plate. He envisioned Venice as a thin line floating between the water and sky. His etching needle made small, delicate lines that keep the image as simple as the nearly empty space above and below.

Whistler did not immerse his plate in an acid solution but applied the acid and moved it around with a feather in order to control the biting of the plate more carefully. Sometimes Whistler did not wipe the surface of his plates thoroughly clean of ink before printing so that a thin film of ink left on the plate would print as a glowing atmosphere. To create the moodiness in this impression of *Nocturne,* he left ink at the top and bottom of the plate.

A plate to be etched may also be covered with a **soft ground,** which is asphaltum mixed with petro-

leum jelly so that it will remain soft and sticky. A variety of textured materials can be pressed into the soft ground in order to expose the metal plate under the ground. Fabrics, cork, or lace can be pressed into the ground to make a textured impression. The acid will then bite these patterns into the plate. Käthe Kollwitz pressed a piece of fabric into the soft ground of her plate *Breaking Away* (Figure 8-14), illustrating a scene from the Peasants' Revolt of 1524–1525. The texture etched into the plate became a tone that unifies the entire image. It is also possible to reproduce the fuzzy quality of a pencil line in soft-ground etching by placing a sheet of tracing paper over the plate. Drawing on the paper with a pencil will remove the sticky soft ground from the plate where the pencil has touched the paper.

Aquatint

Within the etching process, printmakers can also achieve a gray tone—instead of using hatching for darker values—by means of a process called **aquatint.** To produce aquatint, printmakers dust or spray an area of the plate with fine, acid-resistant particles. If the printmaker dusts the plate with rosin powder, the plate must be heated to attach the rosin to it. The acid then etches the metal plate around each particle of rosin, which will print as a nearly microscopic white dot.

After Francisco Goya etched the copper plate for his *Hunting for Teeth* (Figure 8-15), he added aquatint. Goya applied aquatint of varying values to all parts of the plate except where the light of the moon hits the dead man's arm, the woman's hands and handkerchief, and parts of her dress. After he covered the clouds and several other lighter parts, Goya let the acid bite the aquatint still more to get a darker night sky. He then burnished (or smoothed out) some of the aquatint—on the woman's face, the man's

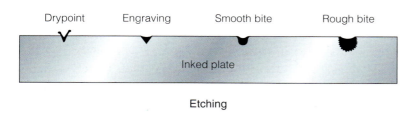

Figure 8-14 Käthe Kollwitz [German, 1867–1945], *Breaking Away*, 1903. Plate 5 of *The Peasants' Revolt*. Etching and soft-ground etching with cloth texture, aquatint, and engraving. 19 15/16 × 23 1/2 in. (50.64 × 59.69 cm). Los Angeles County Museum of Art. The Robert Gore Rifkind Center for German Expressionist Studies. Photograph © 2004 Museum Associates/LACMA. © 2006 Artists Rights Society (ARS), New York/VG Bild-Kunst, Bonn.

Peasants throughout Germany in 1524 and 1525 rebelled against the harsh taxes and service imposed by the nobility. The peasants stormed their castles to force their demands. Kollwitz depicts Black Anna inciting the enraged mob to attack as they swarm down the hillside as one mass. The artist no doubt saw the event as a foreshadowing of social unrest and workers' rebellion in her own time.

body, the patch under her feet. The subtle manipulation of aquatint recreates a spooky predawn darkness, perfectly suited for the woman's grotesque folly.

Many printmakers, always experimenting for new effects, like to combine techniques, mixing line etching, soft ground, aquatint, and/or drypoint on a single plate. The Mexican printmaker José Guadalupe Posada made prints in an unusual relief etching process. As a printmaker, Posada published thousands of illustrations for popular songs, games, storybooks, and broadsides—cheap single sheets such as *Skeleton of the Fashionable Lady (La Calavera catrina)* (Figure 8-16) that were sold to the general public. To make a relief etching, Posada used acid to cut away areas of a zinc plate but then inked the raised areas of the plate—as one normally would for a relief, not an intaglio. By this method he could draw directly and rapidly on a zinc plate with a greasy ink that, together with some rosin, would resist the deep biting of the acid. The simple and robust lines he drew transferred directly into the print. Furthermore, a metal relief plate, unlike a woodcut, could withstand the printing of hundreds of impressions.

Figure 8-15 **Francisco Goya** [Spanish, 1746–1828], *A caza de dientes (Hunting for Teeth)*, plate 12 from *Los Caprichos*, 1799. Etching, burnished aquatint, and burin, 8 9/16 × 5 15/16 in. (21.7 × 15.1 cm) (plate). Art Institute of Chicago. Clarence Buckingham Collection (1948.110/12).

In his *Los Caprichos* series, Francisco Goya satirized the ignorance and folly of Spanish society. In *Hunting for Teeth*, Goya ridiculed the superstition of a woman who believes that she needs the tooth of a hanged man for a witch's love potion. The well-dressed woman stands on her tiptoes at the top of a high wall in the dark of night to yank the teeth from the corpse. She holds a handkerchief to her face to avoid the sight of the dead man. Like William Hogarth (see *The Rake's Progress,* Figure 2-22), Goya shared the Enlightenment's belief that the mere exposure and ridicule of vice would improve society.

Figure 8-16 **José Guadalupe Posada** [Mexican, 1851–1913], *Skeleton of the Fashionable Lady (La Calavera catrina)*, twentieth century. Relief etching on zinc, 4 5/16 × 6 1/8 in. (11 × 15.6 cm). Harry Ransom Humanities Research Center, University of Texas at Austin.

Skeleton of the Fashionable Lady (La Calavera catrina) is one of a series of prints depicting the skeletons of various public characters published for sale on November 2, the Day of the Dead. (*Calavera* means "skull" and, by extension, "skeleton.") Mexicans remember the souls of the dead on that day, but they also use the occasion for witty and macabre comments about death. In this piece by Posada, the grinning skeleton wears a very fashionable broad-brimmed hat bordered with a dangling fringe and festooned with feathers and flowers. The ludicrous image makes fun of both life and death.

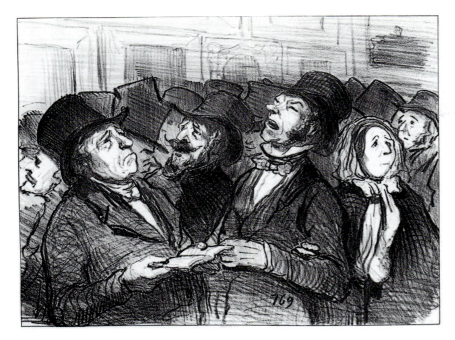

Figure 8-17 **Honoré Daumier** [French, 1808–1879], "This Mr. Courbet paints such coarse people," plate 12, second state, from "L'Exposition Universelle," published in *Le Charivari*, April–September 1855. Lithograph, 7 3/8 × 9 5/8 in. (18.73 × 24.45 cm). Cabinet des Estampes, Bibliothèque Nationale, Paris.

LITHOGRAPHY

Lithography was invented in 1798 in Germany by Alois Senefelder. Lithography is called a *planographic* process because the design stays on the flat surface. It is neither raised in relief above the surface plane nor cut below the plane as in intaglio. Instead, lithography involves a chemical reaction based on the principle that oil and water do not mix. The chemical reaction makes the smooth surface of a block of limestone accept ink in places where the artist wants ink and reject ink in places where the artist wants empty white spaces. Not every kind of limestone works. In fact, only stone from certain quarries in Bavaria works well, and those quarries have been nearly exhausted. Sheets of zinc or aluminum may now be substituted, but most artists prefer working on the old stones.

The French caricaturist Honoré Daumier produced over four thousand lithographs in his career—most of them satires of French society and wry comments on the human condition. Like many of his lithographs, "This Mr. Courbet paints such coarse people" (Figure 8-17) shows how strangers in modern urban society become a community as they react in unison to art, music, or the theater. It also shows how the middle-class viewers of 1855 sneered at Gustave Courbet's Realist paintings such as *The Stone Breakers* (Figure 1-12).

To make a lithograph, artists usually begin by drawing on the stone with a greasy lithographers' crayon or with **tusche,** which comes in solid or liquid form and may be brushed on like ink or applied with a pen. Lithography thus appeals to artists in media other than printmaking because they can draw or paint freely on the stone. Lithography will capture subtle value changes and the freshness of sketched lines. By means of lithography, the bold strokes of Daumier's drawing were reproduced directly in the print. No other printing technique is so immediate.

Lithographers' crayons and tusche contain grease, which will repel water during the lithographic process. After the artist's work is completed on the stone, the stone is chemically treated with gum arabic and very diluted nitric acid so that the image is securely bound to the stone and so that the *unmarked* surface of the stone will absorb water. Finally, the whole stone is cleaned with a solvent. At this point the visible image has disappeared from the surface of the stone. Before ink is rolled over the surface, the printmaker wipes the stone with a wet sponge. The part that has absorbed water will repel

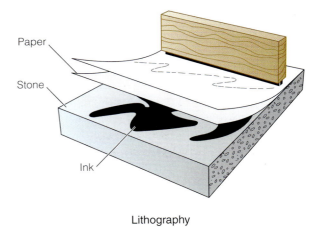

Paper

Stone

Ink

Lithography

the printer's ink; the part that has been marked with greasy crayon or tusche has repelled the water and so will now accept and retain ink. In a lithographic press, a scraper forces the paper against the ink. The process of wetting and inking the stone can be repeated numerous times.

Lithography has always been used for commercial illustration. But in the late nineteenth century, some painters, such as Henri Toulouse-Lautrec (see Figure 13-36), gravitated toward color lithography, which requires separate blocks for each color. In the United States in the 1960s, the printmaking workshops founded by Tatyana Grosman (U.L.A.E.) outside New York and June Wayne (Tamarind) in Los Angeles revived lithography as an artist's medium. Their collaboration with Jasper Johns (see "Artist at Work") and other leading artists of the period ushered in a printmaking Lithography **VIDEO** boom.

SCREEN PRINTING

Prints can also be made from stencils. For centuries, cloth and wallpapers have been decorated with stenciled designs. Stencils can be attached to a screen of porous material such as silk that is stretched across a rigid frame. The screen stabilizes all parts of the design and lets the ink or paint flow through the open areas. The process is then called **silk screening** or **screen printing**.

Modern artists developed the technique of screen printing into a major activity. Andy Warhol and other Pop artists in the 1960s rejuvenated screen printing and transformed it from a commercial medium to an art medium. In *Marilyn Monroe* (Figure 8-18), one of a series of ten similar prints, Warhol took a publicity photo from Marilyn Monroe's film *Niagara* and made a high-contrast photo-emulsion stencil from it. He printed her image on top of flat areas of bright color that are different in each print in the series. By using someone else's photo of the actress, the artist attempted to stand aloof from personal expression. Yet the garish colors proclaim that Warhol depicted the dream fantasy of her created by Hollywood.

In the late 1930s, artists coined the word **serigraphy** to distinguish fine art printing through a screen of silk from commercial activity. (*Seri*, in Latin, means "silk.") Nevertheless, polyester and several fabrics other than silk are now commonly used in the art of screen printing. Stencils can be

Figure 8-18 Andy Warhol [American, 1930–1987], *Marilyn Monroe*, from *Ten Marilyns*, 1967. Color screenprint, 36 × 36 in. (91.3 × 91.3 cm). Elvehjem Museum of Art, University of Wisconsin–Madison. © 2006 Andy Warhol Foundation for the Visual Arts/Artists Rights Society (ARS), New York.

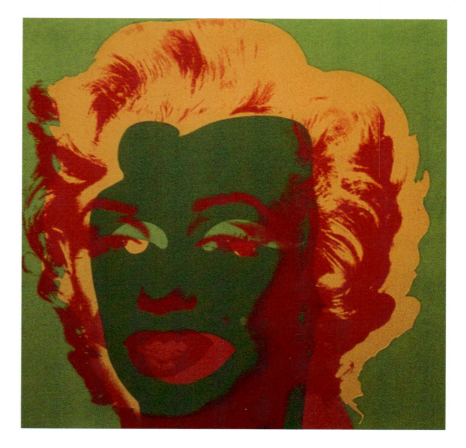

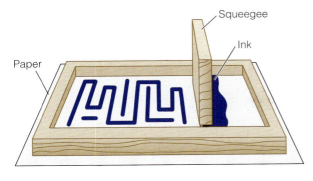

Screen printing

painted directly onto the screen with a variety of materials. As Warhol did in *Marilyn*, photographic images can be printed onto a screen coated with a photo emulsion. The ink is pushed through the stencil onto the paper with a squeegee. Creamy screen inks are usually opaque, although they can be made transparent, and they come in a full line of colors.

Screen printing is basically a simple process, with relatively inexpensive equipment. Yet it lends itself to multicolor printing, is open to a variety of approaches, and therefore is the printmaking process most like painting.

CONTEMPORARY PRINTMAKING

Printmaking as an art form is flourishing in modern times. Artists such as Frank Stella are quite likely to combine techniques in a single print, as in *Giufà e la berretta rosa* (Figure 8-1). Artists experiment constantly to push the limits of the printmaking

(text continued on page 182)

Figure 8-19 **Frank Stella** [American, 1936–] painting with stop-out varnish on etched magnesium plates for *Giufà e la berretta rosa* (see Figure 8-1), with assistance from Kenneth Tyler. Photo by Marabeth Cohen-Tyler.

Collecting Prints

The print buyer ought to be aware that an original print, produced by hand as a work of art, is quite different from a photomechanical reproduction of an artist's painting or drawing—a reproduction of Leonardo da Vinci's *Mona Lisa,* for instance. True, many modern artists incorporate photography into their paintings, drawings, and prints, and photographers themselves normally print copies of their work. Yet most responsible artists are reluctant to have someone simply take a photograph of their work, reproduce it in a high-speed, motorized press, and call the reproduction an original.

A photomechanical process can turn out thousands of copies of the original artwork so that the volume of the reproduction dilutes considerably whatever value the copies might have had. Even if few in number and signed by the artist, they remain photographic copies of the original. The artist or museum keeps the original. Hand-printed works like those discussed in this chapter are much superior in quality to a photo reproduction of the *Mona Lisa* not only because they are harder to make but because, above all, they are products of the artist's creativity, not of a machine's efficiency. Each print is an original, not a copy of an original. Because the printmaker's plates are really the printmaker's tools, the plates are not the original work of art—the print itself is.

Jasper Johns (1930–)

Jasper Johns's career took off in the late 1950s, when he made paintings out of iconic images such as flags and targets—emblems that were abstract and very flat and at the same time very real. Soon after, he began making prints with similar imagery and continued to make prints for the next several decades.

Johns was enticed to make prints by Tatyana Grosman, the founder of U.L.A.E. (Universal Limited Art Editions). She established a printmaking workshop in the garage of her home on the south shore of Long Island, an hour's drive from New York City. In 1960 she left lithographers' stones at Johns's doorstep in Manhattan to coax him to try printmaking. His friend Robert Rauschenberg helped carry them up to his studio.

Johns first drew a zero on the stone with lithographers' tusche. Like a target or flag, a number is flat and abstract yet also familiar and real. Johns knew nothing about printmaking, except that the image on the stone could be changed. He proceeded to print and rework the same stone, partially erasing the first image, then drawing another number in its place until he had made prints of the whole series from 0 to

Jasper Johns [American, 1930–], *0–9*, *1963*. Portfolio of ten lithographs, each 20 1/2 × 15 1/2 in. (52.1 × 39.4 cm). Courtesy of Universal Limited Art Editions (ULAE). Art © Jasper Johns/ licensed by VAGA, New York.

Jasper Johns [American, 1930–], *Pinion*, 1966. Color lithograph, 40 1/8 × 28 1/16 in. (101.9 × 71.3 cm). Courtesy of Universal Limited Art Editions (ULAE). © Christie's Images © Jasper Johns/Licensed by VAGA, New York, NY.

9. Traces of his earlier work on the stone carried over into the subsequent number. He realized that printmaking, especially lithography, was the perfect medium for illustrating change. Three years later he created thirty portfolios containing prints of all ten numbers.

Print collectors and critics were at first dismayed that Johns's prints repeated the same imagery he used in his paintings and drawings. They failed to see that an essential factor in his art was the constant reworking of familiar motifs. Nevertheless, the criticism sparked a controversy over what was an original print. Critics soon recognized that the transmutations recorded in *0–9* could be nothing but a print.

Johns's work in lithography throughout the 1960s helped establish that medium as a creative art form. *Pinion,* a large color lithograph published by U.L.A.E., also combines imagery reproduced elsewhere by Johns. In fact, Johns made impressions of his own hands, feet, and knee poised on the block in the starting position of a running race. Superimposed on it in a rainbow of color is a photographic reproduction of his painting *Eddingsville*. The different colors had to be applied very carefully to the large roller that inked the block. The photo includes a ruler reproduced in exact scale. A wire from a coat hanger seems to dangle across the print.

Johns went on to experiment with etchings, monotypes, and other forms of printmaking. His trend-setting work over several decades has led many authors to consider him the most challenging, skilled, and creative printmaker of modern times.

medium. Printmaking can be extremely technical, yet despite its technicalities, many artists enjoy the challenge of mastering the craft and working through the difficulties.

At the same time, collaboration between artists from other media and printmaking technicians commonly occurs, since it frees the artist from technical concerns and often expands the medium further. Many famous painters and sculptors have taken advantage of the extensive equipment and expert technical assistance of craftspeople working at fine art publishing companies so that they can turn their creative ideas into prints. With such printmaking expertise behind them, prints designed by famous painters such as Andy Warhol, Frank Stella (see Figure 8-19), Helen Frankenthaler, and Jasper Johns can reproduce and extend the style and imagery of their painted work with great success.

AT A GLANCE

Relief

Woodcut	Woodcut is the earliest relief process. In this type of printing, the design drawn on wood is left standing and the rest is cut away.
Chiaroscuro woodcut	Several woodblocks are used to produce value contrasts in a chiaroscuro woodcut.
Linocut	For a linocut, linoleum is used instead of a woodblock.
Wood engraving	For a wood engraving, a cross-section block of wood is cut with engraving tools instead of a knife.

Intaglio

Engraving	For an engraving, a burin is used to cut lines into a plate.
Drypoint	A drypoint is produced when a needle is used to scratch lines on a plate.
Etching	For an etching, the design is drawn into an acid-resistant ground and then cut by acid.
Aquatint	An aquatint results when the etching process is used to achieve varying tone qualities.

Lithography

For a lithograph, the design is drawn on the smooth face of a stone; it prints because the oil in the drawing medium does not mix with water.

Screen Printing

To produce a screen print, ink is forced through a stencil attached to a screen.

INTERACTIVE LEARNING

In the Studio: Lithography

Flashcards

Artist at Work: Jasper Johns

Companion Site: http://art.wadsworth.com/buser02

Chapter 8 Quiz

InfoTrac® College Edition Readings

Talking Flashcards

Online Study Guide

9 Painting

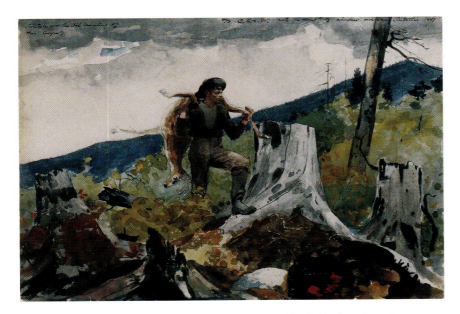

Figure 9-1 Winslow Homer [American, 1836–1910], *Guide Carrying a Deer,*
1891. Watercolor on paper, 14 × 20 1/8 in. (35.6 × 50.8 cm). Portland (Maine)
Museum of Art. Bequest of Charles Shipman Payson. Photo by Melville McLean.

addition of the dogs, but the painting medium changes the appearance of the scene even more. The sky is a more ominous steely gray; the woodlands are dark and opaque and much more somber even with a few touches of autumn foliage. At the loss of spontaneity, the mood is intensified.

Artists paint in a number of different ways, depending on the kind of paint used. Oil, watercolor, and other paints have special characteristics and are applied differently. Not every artistic effect is possible from any one painting medium. And an artist might paint a subject in a different manner when a different kind of paint is employed.

The American artist Winslow Homer painted the same Adirondack mountain scene, first in a watercolor called *Guide Carrying a Deer* (Figure 9-1) and then in an oil painting titled *Huntsman and Dogs* (Figure 9-2). Only in watercolor could Homer have brushed the paper rapidly enough to nail down a creative impulse before the moment passed. In watercolor he could dab the brush across the paper to achieve soft, grainy texture; transparent light; and a luminous sky. By means of watercolor the brilliant autumn foliage around the feet of the guide becomes dancing pools of transparent and opaque color. The oil painting on canvas is more than twice the size of the watercolor on paper and for that reason alone perhaps more imposing. The composition is somewhat different, especially owing to the

Artists usually choose a medium because they want to paint in a manner suitable for that medium. Some artists, challenged by the limitations of a medium, extend its possibilities beyond the ordinary. **Painting** **VIDEO**

VEHICLES AND SUPPORTS

Paints do not necessarily differ from one another because of the **pigments**—the dry, powdery substances that produce the different colors. They differ because of the **vehicle,** the liquid that suspends the pigments. Some vehicles, because of their chemistry, limit the kind and number of pigments that can be used. As fluids, vehicles allow brushing of dry pigments; they also cause the pigments to dry and

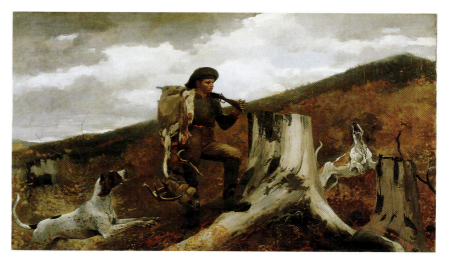

Figure 9-2 **Winslow Homer** [American, 1836–1910], *Huntsman and Dogs,* 1891. Oil on canvas, 28 × 48 in. (71.1 × 121.9 cm). Philadelphia Museum of Art. William L. Elkins Collection, 1924.

The deer carcass slung across his shoulders, the young hunter sets his foot triumphantly on the stump. His heroic stance makes an ironic contrast with the deforested and burned land around him. The dead animal is the final victim of human intrusion into the wilderness, and the hunter has probably killed the deer for the few dollars that the skin and antlers will bring.

Contemporary critics commented on the look of brutality on the young man's face. Winslow Homer perhaps underscored his savagery with the addition of the leaping and barking dogs. Modern critics have related Homer's painting to the late nineteenth century's interpretation of Darwin's *The Descent of Man,* touting the survival of the fittest. Homer's painting suggests that with his cruelty, destruction, and irresponsible pursuit of prey, the huntsman belongs to a lower, savage state of human development and that modern humankind has not yet evolved to a very high state of civilization.

adhere to a surface. They range from water to oil, from wax to eggs and to plastics. Some vehicles change the color of pigments, if only slightly. In short, vehicles act and handle differently and have different possibilities.

Artists most often paint on canvas, but wood has always been a favorite **support**—the surface to which the paint adheres. Wood feels solid beneath the brush, whereas canvas on a stretcher flexes to the touch of a brush. The weave of a canvas also has a texture that painters may or may not want to exploit in their work. Artists also paint on plaster walls and on copper plates, slate, or paper.

On most common supports, an artist might have to seal the raw surface—to render it less absorbent—and then apply a preliminary coating, called a **ground.** The ordinary ground for wood or canvas is **gesso**—plaster of paris or white chalk and glue—or a white paint. The white ground increases the luminosity of colors applied to it. In the nineteenth century the French Impressionists painted on canvases with a white ground because they wanted light-filled colors. In the preceding two or three centuries, when artists were more concerned with chiaroscuro, artists such as Rubens or Rembrandt preferred to paint on a colored ground, usually a gray or a reddish-brown.

ENCAUSTIC

In ancient Greece and Rome, artists frequently painted in a medium called **encaustic.** The vehicle

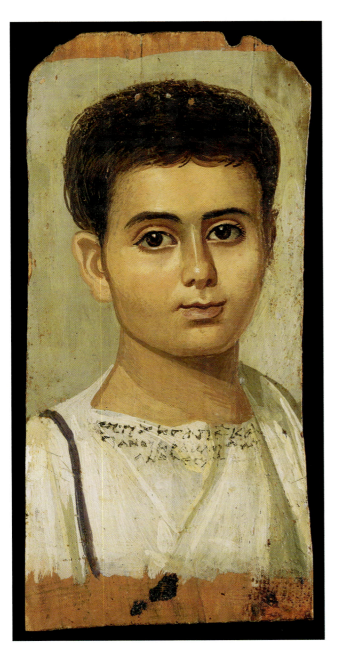

Figure 9-3 [Roman], *Portrait of a Boy*, second century CE. Encaustic on wood, 15 3/8 in. (39 cm) high, 7 1/2 in. (19 cm) wide. Metropolitan Museum of Art, New York. Gift of Edward S. Harkness, 1918 (18.9.2). Photograph © 1998 The Metropolitan Museum of Art.

This remarkably well-preserved Roman portrait was placed over the face of the mummified body and secured to it by the outermost wrappings. Centuries after Egypt had been conquered by Greece and Rome, people living there still mummified the dead. The boy wears Roman-style clothing, but the inscription below the neck of his tunic is written in Greek, the language most commonly spoken in the eastern Roman Empire. Part of the inscription gives us the boy's name, "Eutyches, freedman of Kasanios." In other words, Eutyches, which means "lucky" in Greek, was once a slave.

in encaustic painting is hot beeswax. Most of the surviving examples of this type of painting are panels from a region of Egypt called Faiyum, where the dry desert climate has preserved them remarkably well. All these panels, including *Portrait of a Boy* (Figure 9-3), are portraits that were buried with mummies. Living in the Roman province of Egypt, the artist who painted *Portrait of a Boy* achieved remarkably lifelike results in the medium. Light seems to come from our left, modeling the face with smooth transitions. Highlights on his forehead and

cheek and the glint in his dark brown eyes make the portrait come alive.

Encaustic painting requires that the artist keep both the paint and the panel hot so that the wax can be brushed. The artist can rework the paint once it has been applied if the surface is kept warm, or if the artist allows the wax to cool, she or he can soon add a new layer of paint. Traditionally, a heat source was passed over the completed panel to fuse and smooth the colors—hence the Greek word *encaustic*, which means "burned in." In the twentieth cen-

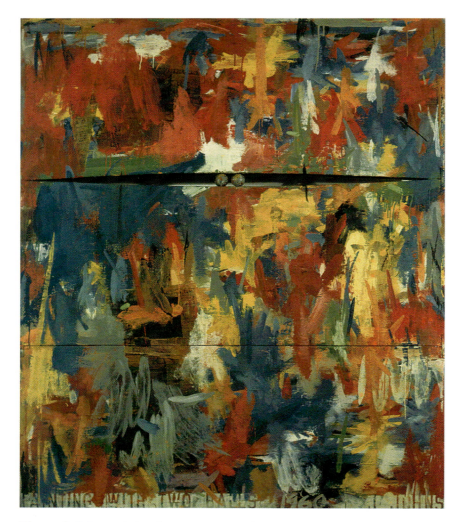

Figure 9-4 **Jasper Johns** [American, 1930–], *Painting with Two Balls*, 1960. Encaustic and collage on canvas with objects, 65 × 54 in. (165.1 × 137.2 cm). Collection of the artist. Photo courtesy Leo Castelli photo archives. Art © Jasper Johns/Licensed by Vaga, New York, NY.

Jasper Johns once explained why he resurrected the encaustic technique. "It was very simple," he said. "I wanted to show what had gone before in a picture, and what was done after. But if you put on a heavy brushstroke in paint, and then add another stroke, the second stroke smears the first unless the paint is dry. And paint takes too long to dry. I didn't know what to do. Then someone suggested wax. It worked very well; as soon as the wax was cool I could put on another stroke and it would not alter the first."[1]

Johns's *Painting with Two Balls* appears at first to be a repetition of Willem de Kooning's style of Abstract Expressionism (see Figure 2-35). However, Johns undercuts the emotional self-expression embodied in the slashes of paint by the deliberate gap in the painting, held apart by two actual balls (a pun for masculinity) and by the matter-of-fact stenciled lettering at the bottom. Johns seems to have merely displayed the primary colors and ridicules using them to exploit personal psychology.

tury, American artist Jasper Johns revived the encaustic medium—for example, in *Painting with Two Balls* (Figure 9-4)—precisely because it kept colors from mixing on the canvas.

MURAL AND FRESCO

The ancient Greeks and Romans also painted **murals**—in other words, pictures on walls or ceilings that became part of the architectural decoration. Some ancient Roman mural paintings, especially from Pompeii and Herculaneum, cities that were buried by an eruption of Mount Vesuvius in 79 CE, have been excavated and moved to safer locations. Wall paintings from a *cubiculum* (bedroom) in a *villa* (country house) (Figure 9-5), uncovered from the ashes of Mount Vesuvius in 1900, were brought to the Metropolitan Museum in New York three years later. In the mural the Roman artist, in effect, converted the bedroom into a porch open to the outside. But instead of a single panorama sweeping around the room, a separate view appears between each pair of columns—first a garden, then a temple, the rooftops of a city, and so on.

During the Renaissance, some of the most famous paintings of Western art were murals—for example, Michelangelo's Sistine Chapel ceiling. Diego Rivera and other painters in Mexico in the first half of the twentieth century revived mural painting with great success (see *Orgy—Night of the Rich*, Figure 17-32). In the United States during the Great Depression of the 1930s, the Works Progress Administration's Federal Art Pro-

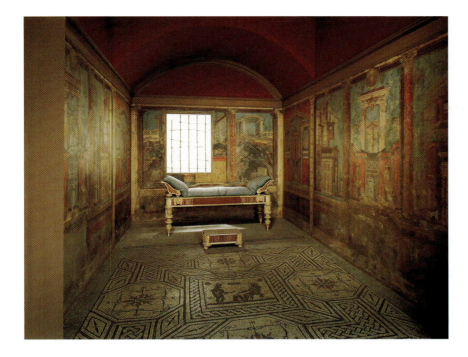

Figure 9-5 [Roman], cubiculum (bedroom) from the villa of P. Fannuis Synistor, at Boscoreale, ca. 40–30 BCE. Fresco, about 96 in. (243.8 cm) high. Metropolitan Museum of Art, New York. Rogers Fund, 1903 (03.14.13a–g). Photograph © 1986 The Metropolitan Museum of Art.

ject and the Treasury Department's Section of Painting and Sculpture put artists to work painting thousands of murals in post offices, courthouses, and other government buildings in Washington and throughout the country. Ethel Magafan's *Threshing* (Figure 9-6), in a rural Nebraska post office, illustrates the kind of popular imagery that the government encouraged artists to employ in a mural project. Regional iconography and a simple style lent dignity to common people while the murals extolled the value of hard work in a time of economic hardship.

More recently, mural painting has come back to life in urban America. Artists in many cities, especially Los Angeles, El Paso, and Philadelphia, have covered the sides of tall buildings and embankments with gigantic murals. These murals often embody the political messages of individuals and groups in ethnic neighborhoods. Richard Haas's mural *Cincinnatus*

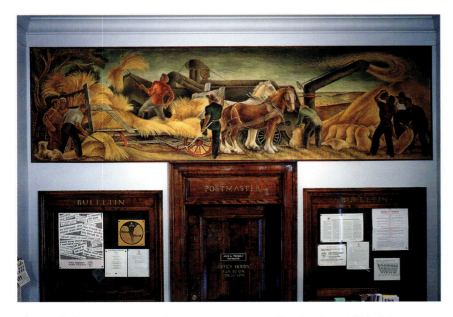

Figure 9-6 Ethel Magafan [American, 1916–1993], *Threshing*, 1938. Oil on canvas. Auburn, Nebraska. Photograph: Jeffrey Bebee Photography.

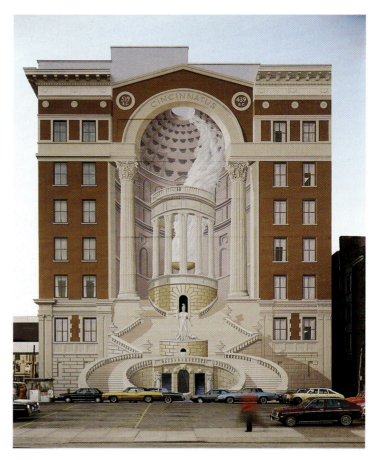

Figure 9-7 Richard Haas [American, 1936–], *Cincinnatus*, 1983.
Brotherhood Building, Central Parkway, Cincinnati, Ohio. Photo by
Peter Mauss.

(Figure 9-7) pays tribute to the Roman hero whose name is connected with one of America's large cities.

Unfortunately, outdoor painting of any kind has little chance of surviving the elements for very long—in twenty years Haas's mural has faded considerably. Indoors, where walls can be kept dry, murals have traditionally fared much better when they were painted in **fresco.** Michelangelo's Sistine Chapel ceiling is a perfect example of fresco painting. The Italian word *fresco* means "fresh." In true fresco, water-based paints are applied to fresh, wet plaster so that the pigment soaks into the plaster. The paint actually becomes part of the wall. The lime of the plaster, changing to calcium carbonate when it dries, binds the pigments permanently in the wall. The colors are matte, not glossy. They stay bright for hundreds of years, and as long as the wall lasts, the fresco lasts.

Paint applied to the wall when it is dry (*secco* in Italian) is not very permanent. Since some pigments will not combine properly in fresco, they have to be applied. The blue pigment that Giotto used in *The Nativity* (Figure 9-8) would not mix with the lime in plaster, so he had to paint it on the dry plaster. As a consequence, the blue of the sky and the blue of Mary's robe have almost all flaked off. Since true fresco must be painted on wet plaster, an artist can work on only a small portion of the wall where the plaster was freshly applied beforehand. A normal area for a day's work might be about one or two square yards, although the size depends on the complexity of the painting. Some days a frescoist might complete only a head. In Giotto's fresco *The Nativity,* the breaks between one day's work and the next are visible on close inspection.

Fresco painting takes a lot of preparation because artists have to have the entire composition worked out before they get started on an individual patch of plaster. In addition to the usual preliminary drawings, a frescoist also makes **cartoons**—drawings on paper in

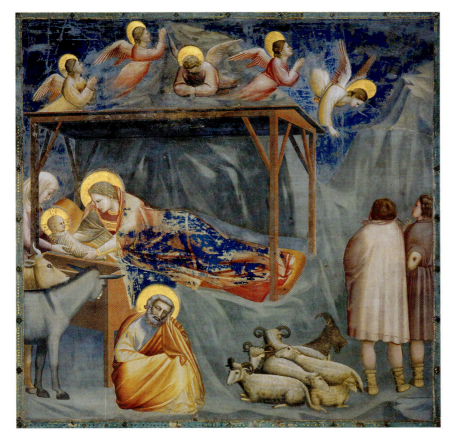

 Work patches over Giotto's *Nativity*

Figure 9-8 **Giotto** [Italian, ca. 1266–1337], *The Nativity*, ca. 1305. Fresco. Scrovegni Chapel, Padua, Italy. © Alinari/Art Resource, NY.

the same scale as the mural—so that the essential lines of the composition can be traced and transferred to the wall. (*Carta* in Italian means "paper.")

EGG TEMPERA

Distinct from murals, most artists produce **easel paintings**—works intended to be hung on a wall, whether they were painted on an actual easel or not. Bernardo Daddi painted the **triptych,** or three-part, *Madonna and Child* (Figure 9-9) for someone's private prayers. Originally, it may have rested on a table. After their devotions, the owners of the triptych could have folded the wings together to store it or carry it to another location.

When Daddi and other European artists in the fourteenth century wanted to create an easel painting, they usually worked on carefully prepared wooden panels. Wooden panels assembled from several planks and as large as ten to twelve feet high were common in that era. The wood had to be dried, aged, sealed, and primed with many coats of gesso so that it would become an acceptable painting surface as smooth as polished marble. Daddi mixed his pigments with egg yolk—sometimes the whole egg—a medium that is called **egg tempera.** If the panel received decent treatment over the years, a 650-year-old egg tempera painting such as *Madonna and Child* will have colors that are still well preserved and fresh. Egg tempera is quite a permanent medium.

Egg tempera paint dries as fast as a film of egg yolk dries on a breakfast plate and is just as stubborn to remove. An artist applies it in short strokes because of the rapid drying time, and by the time the artist comes back to the panel with the next brushstroke, the preceding one has already dried. Little blending is possible, and the only way to remove a mistake is by scraping it off. Every stroke has to be deliberately placed with small brushes.

Egg tempera is also transparent, since it does not cover well and what is underneath shows through. Therefore, the paint has to be built up in

Fresco Restoration

In the 1980s and 1990s, conservators cleaned Michelangelo's Sistine Chapel frescoes and discovered surprisingly bright color once again under the accumulated dirt. The cleaning of the Sistine ceiling caused outrage among some art historians, who could not believe that Michelangelo wanted such unmodulated color. They complained that in removing the centuries of grime, the restorers had also removed veils of paint that Michelangelo had applied to the dry fresco. However, the technical evidence weighs in favor of the result produced by the restorers of the Sistine frescoes.

Restorations of any kind continually arouse controversy because they involve fundamental aesthetic issues such as these: What were the original intentions of the artist? Should every work be stripped of every touch that is not by the artist's hands? Can conservators ever possibly restore a work without imposing their own point of view on it?

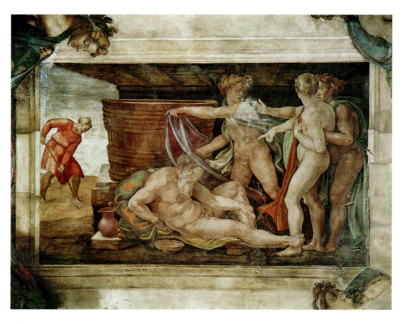

 Michelangelo's frescoes before restoration: *The Drunkenness of Noah.*
© Scala/Art Resource, NY.

 Michelangelo's frescoes after restoration: *The Drunkenness of Noah.*
© Art Resource, NY.

layers. Very often, artists first painted the modeling in a cool-green preliminary layer and then covered the layer with the appropriate local colors. Daddi sometimes applied gold leaf to the background of his painting and with leather-working tools embossed designs into the surface.

One contemporary artist, Andrew Wyeth, revived the use of egg tempera and made quite a reputation for himself in the medium. To paint the portrait *Braids* (Figure 9-10), Wyeth used a traditional egg tempera technique. He normally paints on panels layered with gesso. Wyeth deliberately chose

(text continued on page 194)

Figure 9-9 **Bernardo Daddi** [Italian, active ca. 1290–1349], *Madonna and Child*, 1339. Tempera and gold ground on poplar panel, triptych, 23 3/8 × 19 15/16 in. (59.42 × 50.64 cm). Minneapolis Institute of Arts. The Ethel Morrison Van Derlip Fund. Acc #34.20.

Figure 9-10 **Andrew Wyeth** [American, 1917–], *Braids*, 1979. Tempera, 16 1/2 × 20 1/2 in. (41.9 × 52 cm). © AM Art, Inc.

In 1986 the public learned that for the previous fifteen years, the prominent American artist Andrew Wyeth had painted and drawn a large series of pictures of Helga Testorf, the artist's neighbor in Chadds Ford, Pennsylvania. Not even his wife knew that Helga had been his model all those years. Posing indoors or out, clothed or nude, and in different times and places, Helga is always a striking individual with strong features. The emphatic light and dark contrast of *Braids* accentuates the hyperrealism conveyed by Wyeth's precise brushwork.

Susan Rothenberg (1945–)

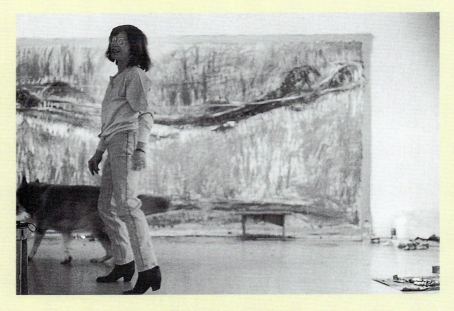

Susan Rothenberg in her studio. Photo by Brigitte Lacombe.

When Susan Rothenberg paints, she tacks a large canvas on the wall of her studio, dips a paintbrush in a can of paint-stained water or turpentine, and begins by drawing an outline of a figure on the canvas. At times the images in her painting result from random studies she made in drawings; at times the images result from "doodling" directly on canvas. She then starts to stab and stroke the canvas with a controlled and assertive freedom. The surface becomes layered with countless, energetic brushstrokes that often "correct" the initial drawing. In the process of painting, the image becomes embedded in the rough texture of her brushwork.

Like many painters who express themselves in a direct and vigorous application of paint, Rothenberg frequently steps back from the canvas to reflect on what is happening. Sometimes her paintings relate to things she has seen or experiences she has felt; sometimes they go off in an unknown direction and become mysterious to the artist herself. Rothenberg has compared her pictures to prayers asking to fulfill the wants of daily life. Through painting she can sublimate and exorcise her demons and put the world together the way she wants.

For five years, from 1974 to 1979, Rothenberg painted horses almost exclusively. She produced her first horse impulsively, as a "doodle" that immediately seemed right for her. In her mind she had the vague desire to paint something simple, magical, and universal like the prehistoric cave paintings of animals. Despite the serendipitous beginning, Rothenberg soon realized that her horse was a surrogate for the human figure. But her life-sized, powerful animals represent living spirits without the specifics of age, sex, or personality that accompany nearly every depiction of human beings.

Rothenberg first painted horses in profile, then posed frontally, and then dismembered parts of the horse as she pulled away from her fascination with the animal. In *For the Light,* the horse gallops toward the viewer, but its motion is stopped by the bone in its way. The horse's outline has grown to such thick and rugged dimensions that it can be read as the silhouette of another ghost-like horse looming behind it. Rothenberg likes to think of such forms as "bands," halfway between lines and shapes.

Rothenberg painted in water-based acrylic paints in the 1970s, then switched to oil paints in the 1980s. She

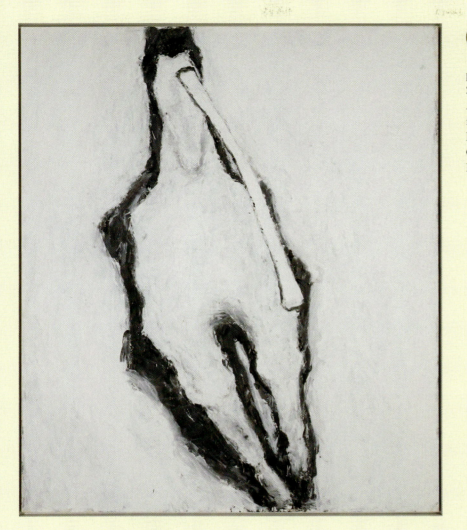

Susan Rothenberg [American, 1945–], *For the Light*, 1978–1979. Synthetic polymer and vinyl paint on canvas, 105 × 87 in. (266.7 × 221 cm). Whitney Museum of American Art, New York. Purchase, with funds from Peggy and Richard Danziger 79.23. Photography by Charles W. Crist, L.A., CA. © 2006 Susan Rothenberg/Artists Rights Society (ARS), New York.

switched to oil just to shake up her procedures and to see what it was like to work with oil. She liked the way the brush moved in oil paint and compared the consistency of acrylic paint to yogurt and oil paint to stiff butter. With oil paint, she found herself using smaller, shorter, denser, and choppier brushstrokes.

When Rothenberg was growing up in Buffalo, she had firsthand familiarity with modern painters in the splendid collection of the Albright-Knox Art Gallery. Perhaps the most

vital influence on her work came through her participation in dance and performance art in New York City. She began to understand art as an activity and a process. Her horse paintings attracted favorable critical attention and the interest of collectors and dealers in the mid-1970s. In the early 1980s, she became one of the few female painters associated with the male-dominated Neo-Expressionist movement. Rothenberg now lives in New Mexico, where she has finally learned to ride a horse.

egg tempera because the patience demanded by the medium puts a brake, he says, on his inherent messiness. The time it takes to paint a panel like *Braids* also allows him to whittle his composition down to its essence.

OIL PAINTING

Around the year 1500, Leonardo da Vinci (see *Mona Lisa,* Figure 16-17) and other Italian artists started using oil as the vehicle for painting, and they soon started using canvas as the support. Actually, the Netherlandish artist Jan van Eyck (see *The Arnolfini Wedding,* Figure 2-27) had worked with an oil vehicle several generations earlier. **Oil**—usually linseed oil—has the advantage that it can combine with a great range of pigments taken from all sorts of elements. Oil-based paint offers a greater variety of colors than fresco or egg tempera. And unlike other media, oil paint dries slowly so that its colors can easily be blended with one another right on the canvas. The best feature about painting with oil is its great flexibility. Oil paint can be laid on thick or thin. It can be made opaque or transparent.

The flexibility of the medium also allowed artists to sketch in oil paint with the freedom of a drawing medium. Peter Paul Rubens painted the oil sketch *St. Jerome* (Figure 9-11) for a panel that once decorated the ceiling of the Jesuit Church in Antwerp, Belgium. Rubens drew the saint, seen from below in steep foreshortening. St. Jerome appears to have been startled from his reading when a small angel blows the trumpet of the Last Judgment. The saint's red robes swirl around his legs. Over a colored underpainting Rubens let thin oil paint flow freely in some places, dabbed thicker patches of paint in others, and drew highlights and shadows with his brush. The vigor of his oil sketch more obviously illustrates Rubens's active imagination and his dexterous hand than the finished painting would have.

Artists can apply oil paint to the canvas opaquely, or they can apply it in thin, transparent layers called **glazes.** In glazing, the paint underneath, usually lighter in value, shines through the translucent glaze and gives the color a luminous quality. Van Eyck regularly employed glazes to make his colors especially brilliant and shiny like enamel. Light penetrates his paintings and is reflected back from the white ground through the colored glazes.

Figure 9-11 Peter Paul Rubens [Flemish, 1577–1640], *St. Jerome,* 1620–1621. Oil on wood, 12 1/4 × 17 3/4 in. (31 × 45 cm). Academy [Akademie der Bildenden Kunst, Gemäldegalerie], Vienna.

Susan Rothenberg, who painted *For the Light* (see "Artist at Work"), likes to work directly on the support, without glazing. The technique of direct painting is sometimes called **alla prima,** which in Italian means "at the first." In other words, the artist achieves the desired effect right away in the first layers of paint instead of gradually working toward an image by applying transparent layer after layer of paint. For centuries, artists had employed the *alla prima* technique for oil sketches. By the end of the nineteenth century, they were using *alla prima* for finished paintings. For example, the Impressionists worked *alla prima* in order to respond immediately to the light and color they saw in nature.

When paint on the surface of a canvas appears thick and somewhat three-dimensional, it is called **impasto.** Van Gogh often applied paint in an im-

Figure 9-13 **Joan Mitchell** [American, 1926–1992], *Marlin*, 1960. Oil on canvas, 95 × 71 in. (241.3 × 180.3 cm). Smithsonian American Art Museum, Washington, DC, U.S.A. Photo Credit: Smithsonian American Art Museum, Washington, DC/Art Resource, NY.

Figure 9-12 **Vincent van Gogh** [Dutch, 1853–1890], *Starry Night*, [detail of Figure 17-7], 1889. Museum of Modern Art, New York. Acquired through the Lillie P. Bliss Bequest. © The Museum of Modern Art, New York/Art Resource, NY.

pasto manner in order to express his intense feelings directly on the canvas (see the detail of *Starry Night* in Figure 9-12). In his impatience, he sometimes used paint squeezed directly from the tube. Artists have also used their palette knife to spread thick paint on the support for an impasto effect.

Another oil painting technique involving thickish paint is called **scumbling.** In scumbling, the artist drags brushstrokes of paint over the dry layer of paint underneath, as Joan Mitchell did on her canvas *Marlin* (Figure 9-13). Scumbling creates an open-textured brushstroke of opaque paint that still lets the color underneath appear. Usually, a light color is scumbled over a dark one underneath.

Opaque, transparent, *alla prima,* impasto, and scumbling are some of the many ways that an artist can apply oil paint. With the openness and freedom of these techniques, artists readily leave the marks of their personality in applying oil paint. Oil can be a very expressive medium.

ACRYLIC

When Kenneth Noland painted *No. One* (Figure 9-14), in 1958, he was among the earliest artists to use **acrylic** paints, a modern vehicle that seems to have solved several problems associated with oil paint. Oil paints dry too slowly to suit some artists. Oil paints can also crack, especially if the vehicle contains too much oil. Oil pigments can yellow or darken or undergo chemical changes because of the slow drying time. Acrylic paints do not yellow or become brittle. They seem to have many of the advantages of oil paint and some appealing characteristics of their own.

Artists have experimented with other synthetic media that had been developed for industrial use, but acrylics have superseded them all. Acrylic paint is a liquid form of plastic—chemically, a synthetic resin. The vehicle for acrylic paint is the plastic resin mixed with water. When the water dries, the plastic hardens, and more water cannot remove it.

Acrylic paints seem to be quite permanent, although they have survived only a half century so far.

Figure 9-14 Kenneth Noland [American, 1924–], *No. One*, 1958. Acrylic on canvas, 33 1/4 × 33 1/4 in. (84.5 × 84.5 cm). Portland (Oregon) Art Museum. The Clement Greenberg Collection; Museum Purchase with Funds Provided by Tom and Gretchen Holce. Art © Kenneth Noland/Licensed by VAGA, New York.

They dry about as fast as a brushstroke of water, which is slow enough for the artist to blend the paints on the canvas and fast enough for the artist to paint another layer on top without much waiting. Oil paints are still probably superior for subtle value gradations and extensive blending on the canvas. Acrylic paints, applied directly without additives, tend to be matte, opaque, and even in texture. Opaque or transparent, acrylic paints can be glazed or scumbled, and modeling paste can be added to them to achieve a thick impasto. Modern painters also like the brilliant, intense colors available in acrylics.

Acrylic paints have also suited artists who like to experiment with new ways of applying paint. They have especially attracted contemporary artists such as Noland who work with areas of flat color. Because acrylics can be painted on all kinds of unprimed surfaces, some contemporary Americans—Helen Frankenthaler and Sam Gilliam, for example—are able to stain the canvas and let the paint soak into the unprimed material. Staining in oil would eventually rot the unprimed canvas. One of the many artists who manipulate the shape of their canvas, Gilliam stained his large canvas *Carousel Form II* (Figure 9-15) and then draped it across the wall like a curtain.

WATERCOLOR

Watercolor is a transparent medium whose vehicle is water, of course, and gum arabic, a thickener derived from the acacia tree in Africa. It has been popular with landscapists and topographical artists because the equipment is easy to carry and watercolors dry quickly for transport. In the late 1800s, Winslow Homer took his watercolor kit to the Adirondack woods, where he painted *Guide Carrying a Deer* (Figure 9-1) in the summer and fall, and to Florida and the West Indies in the winter, where he painted *Shark Fishing* (Figure 9-16). His images of isolated woodsmen and boatmen vying with nature may be considered his masterpieces. Watercolor let Homer capture the immediacy, the movement, and the luminous color of sky and water. The medium lends itself to capturing spontaneous impressions of fleeting outdoor light.

Watercolor, painted on good-quality rag paper, is usually "washed" on rather than brushed on, al-

Figure 9-15 **Sam Gilliam** [American, 1933–], *Carousel Form II*, 1969. Acrylic on canvas, 19 × 75 ft. (5.8 × 22.9 m). Washington, D.C. Collection of the artist.

Sam Gilliam experimented with new techniques of applying paint by spreading unprimed, unstretched canvas on the floor and pouring paint directly onto it. The paint soaked in and stained the canvas as he tipped and folded it. It seemed natural to him that canvases that had been so manipulated in the act of painting should not be stretched flat and placed against a wall. Instead, enormous pieces of canvas were gathered and draped from the ceiling of the gallery. The swooping columns of cloth affect the viewer standing in the room in a much more dynamic way than if they were on the wall, out of the way. The expressionism of the paint plays hide-and-seek with the folds of the cloth while the boldly sweeping graceful folds assert themselves over the richness of color and paint.

Figure 9-16 **Winslow Homer** [American, 1836–1910], *Shark Fishing*, 1885. Watercolor, 13 5/8 × 20 in. (34.6 × 50.8 cm). Private collection. © Francis G. Mayer/Corbis.

though "dry," nearly opaque strokes of color are possible. The watercolor artist works from the light of the paper, adjusting the fluidity of the color to render values. With light shining through transparent colors, watercolors are naturally luminous. The watercolor medium demands spontaneity and tolerates few mistakes, although it is possible to blot or sponge or even scrape away errors. It takes a lot of practice not to let the washes run into one another and turn everything muddy.

GOUACHE

Jacob Lawrence painted the flat patchwork of colors in *The Migration Series, 1* (Figure 9-17) by using another water-based medium known as **gouache.** The colors of gouache are opaque and nonstaining because white pigment or white chalk has been added to them. Confusingly, gouache has sometimes been called tempera, although the vehicle is water, not egg, and sometimes called **body color** because it has substance, or body, to it.

Gouache also has more gum arabic or glue in it as a binder than does watercolor. Because gouache is opaque, glazing is impossible. And because brushstrokes of gouache dry fast, colors in gouache do not blend well. Without modeling, the flattened figures in Lawrence's painting seem to be pressing toward the gates, where trains are leaving for northern cities.

Artists often do sketches and other small-scale work in gouache. Since gouache readily builds solid forms, sketches in gouache can mimic the appearance of a finished oil or acrylic painting. The ancient Egyptians used opaque water-based paint to decorate the walls of their tombs (see Figures 5-9 and 15-9). The paint that Raphael used for his large-scale tapestry cartoon, *The Miraculous Draft of Fishes* (Figure 9-18), fits the description of gouache. Artists rediscovered gouache in the eighteenth century and have combined its opaque colors with transparent watercolor ever since. Illustrators and designers in modern times like to use it because of its convenience and simplicity.

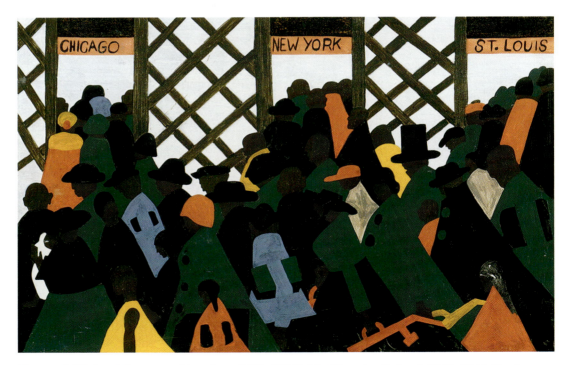

Figure 9-17 Jacob Lawrence [American, 1917–2000], *The Migration Series*, *1*, 1940–1941. Casein tempera on hardboard, 12 × 18 in. (30.5 × 45.7 cm). Acquired 1942. The Phillips Collection, Washington, DC © 2006 Gwendolyn Knight Lawrence/Artists Rights Society (ARS), New York.

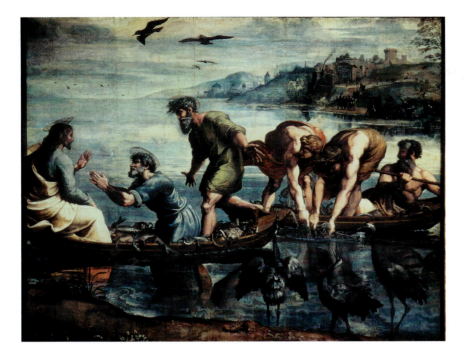

Figure 9-18 Raphael [Italian, 1483–1520], *The Miraculous Draft of Fishes*, 1515. Gouache on paper, 125 1/2 × 157 in. (319 × 399 cm). Victoria and Albert Museum, London. Victoria & Albert Museum, London/Art Resource, NY.

COLLAGE

When Georges Braque pasted paper and cardboard to the support of his *Musical Shapes (Guitar and Clarinet)* (Figure 9-19), he was practicing **collage**— one of the most stimulating new techniques of "painting" in the twentieth century. Picasso and Braque developed the collage technique in 1912 and 1913 as a stage in the evolution of Cubism. (Collage derives from the French word *coller,* meaning "to paste.") By attaching to the surface pieces of newspaper, colored paper, printed wallpapers, and other materials, Picasso and Braque admitted into the imagined space of the painting objects from the real world and allusions to everyday life, without breaking away from the style's flat relief.

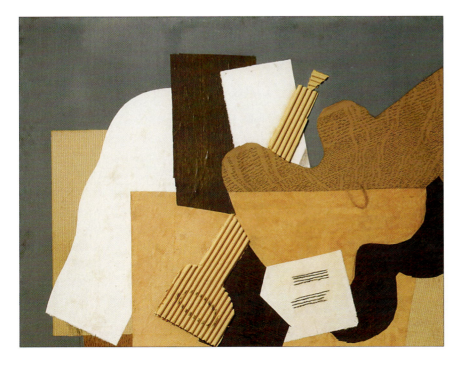

Figure 9-19 Georges Braque [French, 1882–1963], *Musical Shapes (Guitar and Clarinet)*, 1918. Charcoal and gouache, wood-pattern paper, colored paper, and corrugated cardboard pasted on grayish-blue cardboard, 30 × 37 in. (77 × 95 cm). Philadelphia Museum of Art. Louise and Walter Arensberg Collection, 1950. © 2006 Artists Rights Society (ARS), New York/ADAGP, Paris.

The two artists were also protesting against the pretensions of so-called high art, on the one hand, and on the other, they were declaring that ordinary "vulgar" materials could be transformed into art. In a collage the new materials introduce color and texture and sometimes poetic associations. The combination of painting and drawing with pasted "real" materials in a collage confronts the viewer with many fundamental questions about reality and illusion, such as these: are the shapes of the pasted material more real than the painted shapes, and where do they exist in space?

MIXED MEDIA

The combination of actual materials with paint in a collage is one example of **mixed media.** The com-

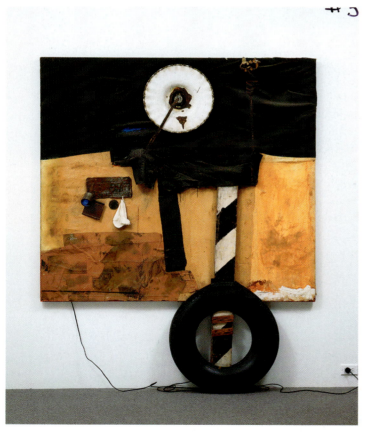

Figure 9-20 Robert Rauschenberg [American, 1925–], *First Landing Jump,* 1961. Combine painting — cloth, metal, leather, electric fixture cable, and oil paint on composition board. Overall, including automobile tire and wooden plank on floor, 89 1/2 × 72 × 8 7/8 in. (227.3 × 182.9 × 22.5 cm). Museum of Modern Art, New York. Digital Image © The Museum of Modern Art/licensed by Scala/Art Resource, NY. Art © Robert Rauschenberg/licensed by VAGA, New York.

bining of tempera and oil paint in a single work is another. Many modern artists practice mixed media when they put together not only different painting media but two different art media in one work. Sometimes it is impossible to say whether a work such as Elizabeth Murray's *Pigeon* (Figure 6-4) is a painting or a piece of relief sculpture. The categories of art media are by no means sacred, and their combination can open new avenues of expression for artists.

The artist Robert Rauschenberg pioneered mixing painted canvas with solid objects, as in his *First Landing Jump* (Figure 9-20). He called such works "combines." In *First Landing Jump,* Rauschenberg combined with oil paint a metal lampshade, a license plate, a tin can, rags, a highway barrier, a tire, and an electric cord. He probably found these items on the streets and alleys where he lived—in other words, they were things that he encountered in life. Since Rauschenberg felt at the time the need to incorporate real life into his art, his combine method allowed him to introduce reality into abstract painting.

Rauschenberg did not attempt to express his feelings about these objects, satirize them, or make some moral comment about them. They simply become part of his composition. They create a rich texture and make shapes and lines and value contrasts as well as any painted form. They also create space. Much more than a traditional relief sculpture, his combine painting comes out into the viewer's space. These objects from the real world assert their presence in the real world alongside the viewer.

VIDEO ART

In 1965 the Sony Corporation introduced the Portapak, an affordable videotape recorder. Artists immediately turned the technology into a lively new art form, **video art.** Because mass communications had influenced almost every aspect of daily life by then, the first impulse that most artists had was to do something very different from Hollywood productions and commercial television. Many early video artists, such as Vito Acconci in *Theme Song* (Figure 9-21), turned the camera on themselves. Instead of a traditional self-portrait, the camera recorded the artist performing some personal

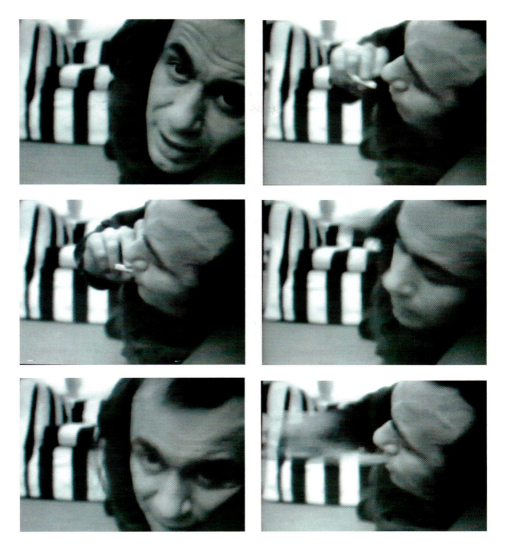

Figure 9-21 Vito Acconci [American, 1940–], *Theme Song*, 1973. Videotape. By permission of the artist.

activity. This focus on the artist's body in the art of the last several decades has been called **body art.**

In *Theme Song,* Acconci lies on the floor in front of a striped sofa. The camera is held very close to his face. He talks directly into it, begging the viewer to "Come in close to me. . . . Come on. . . . I'm all alone. . . . I'll be honest with you . . . really . . . come on." His video mocks the false intimacy of the television medium, which in the privacy of the home pretends to talk to individuals and to become their close friend. Works of video art such as Acconci's have sometimes been shown on public access television channels, but for the most part they have been exhibited in art galleries and museums, on ordinary monitors, or in elaborate settings, or **installations,** specifically created for them.

Another kind of video art corresponds more closely to traditional principles of painting. In the 1960s, Woody and Steina Vasulka, Nam June Paik, and other pioneers of video art discovered that they could manipulate the video image electronically in a free and creative manner that is nearly impossible with ordinary film. The magnetic images on videotape can be colored, distorted, fragmented,

Figure 9-22 **Steina Vasulka** [American, 1940–], *Voice Windows*, 1986. Voice pattern of Joan LaBarbara. In Steina Vasulka, *Voice Windows*. Videotape, 1987.

DIGITAL ART

In 1997 the Sony Corporation introduced the first digital video recorder sold in the United States, and video art began to merge with, and perhaps disappear into, the computer. Computers and other digitized means of producing visual images are the newest and most exciting technique for "painting." The vehicle in **computer art** is not a liquid but hundreds of thousands of electronic impulses. Computerized imaging has already conquered graphic design and the advertising industry. Computer-aided design and drafting (CADD) has also become fundamental to architectural planning. Digitized processes are now overwhelming photography, television, and filmmaking. Painting may be next—many young artists feel equally at home with a canvas or a computer screen. Computer artists can exhibit their digitized images on a CD, in a full-color printout, or over the Internet.

As when photography was first invented in the nineteenth century, it is perhaps too early to tell what direction computer art will take and whether it will develop its own style. The computer allows artists to thoroughly manipulate images supplied by a scanner, a video camera, a CD-ROM, or the Internet. Aside from its capabilities in photography and video, the computer may be employed simply as a painting tool. A computer program can translate commands into lines, colors, values, textures, perspective, and most every other feature of two-dimensional design. The computer can offer rapid solutions to complicated design problems. The algorithms of the computer can replicate subtle light reflections or the texture of tree bark with a keystroke or the click of a mouse. Software can imitate traditional painting techniques, but a

combined, and abstracted as freely and imaginatively as a painter applies paint to canvas. In *Voice Windows* (Figure 9-22), Steina Vasulka illustrated on the screen, with fragments of memories and pieces of words, a song declaimed in Old Norse dialect. The video images can be appreciated as abstract painting, with the exception that the screen generates light, rather than reflects light, and with the added element of elapsed time as the image evolves.

Figure 9-23 **Maureen Nappi** [American, 1951–], *Laconic Ethers*, 2002. Virtual Painting, variable sizes and media. © 2002, Maureen Nappi.

question remains: what new or unique results— other than speed—does the computer contribute to the art of painting?

Some imaginative possibilities for computer art have already emerged. With computer technology, artists can more readily transform reality into surrealistic fantasies. Manipulated images can float into one another as in a dream. Abstract images can come alive, as it were, and move through computer animation, exploring changing relationships. Maureen Nappi created *Laconic Ethers* (Figure 9-23) using an animation process. Animation allows her to explore abstract relationships not only in two dimensions but also in three. She considers animation a hybrid process of painting and sculpture, free from the constraints of surface, paint, gravity, and substance.

Another stimulating possibility for the computer is interaction. Every work of art has always demanded the viewer's reaction for the art experience to work, but the computer allows the viewer to physically alter the image or at least make selections from seemingly endless, programmed choices. The viewer may be invited to change the features of a portrait or to replace them with the viewer's own. Interaction allows the viewer to explore new avenues of perception. All in all, it is simply great fun for an artist to be alive in a time of such challenging creative change.

Painting

Medium	Vehicle	Characteristics
Encaustic	Beeswax	Is applied hot; cools and sets rapidly.
Fresco	Water	Is applied to wet lime plaster; is permanent; has matte colors.
Egg tempera	Egg yolk	Dries at once; allows no blending; is transparent; is permanent.
Oil	Linseed oil	Offers flexibility of application; provides a wide range of color and value; is opaque or transparent; dries slowly.
Acrylic	Water and plastic resin	Is versatile; dries as fast as water; becomes permanent.
Watercolor	Water and gum arabic	Is usually washed on; is transparent.
Gouache	Water and gum arabic	Is like watercolor but opaque.
Collage		Consists of materials pasted to a support.
Mixed media		Comes in two types: a combination of two or more painting media and a combination of two or more art media.
Video art		Results in a videotaped performance or documentary as well as manipulated video images that evolve through time.
Computer art		Displays an image that is recorded electronically; offers rapid flexibility, the transformation of one image into another, animation, interaction.

INTERACTIVE LEARNING

In the Studio: Painting

Flashcards

Artist at Work: Susan Rothenberg

Companion Site: **http://art.wadsworth.com/buser02**

Chapter 9 Quiz

InfoTrac® College Edition Readings

Talking Flashcards

Online Study Guide

10 Photography

Georgia O'Keeffe (Figure 10-1) is one of five hundred photographs Alfred Stieglitz took of O'Keeffe, the painter who eventually became his wife. Stieglitz believed that to make a portrait of a person, the photographer should take a series of photos that show various aspects of the individual throughout life. In this one, the thirty-five-year-old O'Keeffe, wearing coat and hat, leans her head against a rustic door frame. Her wide-eyed stare into the light toward the left is balanced on the right by the weathered texture of the vertical piece of wood and one or two lonely nails. The contrast somehow communicates layers of personal feelings. The closeness of the shot and the strong light and dark contrast keep out any distractions, and a grid of horizontal and vertical lines locks everything in place. Stieglitz's sensitive imagination and trained hand were responsible for making this meaningful image, as surely as the imagination and hand of every creative artist make art.

Figure 10-1 Alfred Stieglitz [American, 1864–1946], *Georgia O'Keeffe*, 1922. Platinum print, 8 × 10 in. (20.1 × 25.0 cm). Part purchase and part gift of An American Place, ex-collection Georgia O'Keeffe. George Eastman House, Rochester, New York.

Alfred Stieglitz believed in the principle of **straight photography.** He strove to make only "perfect" negatives. He felt that photographers who physically manipulated the photo in order to imitate art produced something fake. "Pure photography," as Stieglitz called it, meant seeing exactly what he wanted through the viewfinder of the camera. Above all, he had to choose the moment when to push the button and take the picture. Some photographers wait for hours in front of their subject until this photographic moment arrives. Stieglitz is said to have once waited three hours in a blinding snowstorm before he pressed the button. It takes a sensitive eye to see that privileged point in time.

In the darkroom, with few exceptions, Stieglitz made only contact prints, in which the light-sensitive paper came in direct contact with the negative. In short, the print is the same size as the negative. Only the contact print, which allows little manipulation, comes close to preserving the range of values of the negative. Straight photographers frowned upon cropping, or cutting down, the image in order to improve the composition because the photograph was

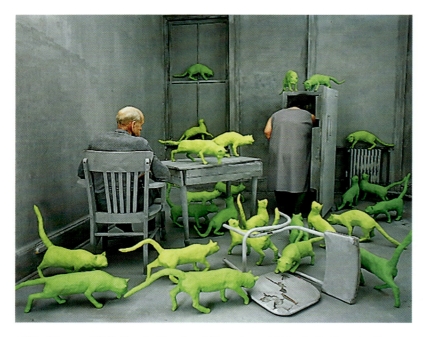

Figure 10-2 **Sandy Skoglund** [American, 1946–], *Radioactive Cats,* 1980. Cibachrome, 30 × 40 in. (76.2 × 101.6 cm). Collection of the artist.

practice. In *Radioactive Cats* (Figure 10-2), Sandy Skoglund photographed a subject that she obviously fabricated. Plaster cats, painted an electric yellow green, invade a room painted entirely gray—except for the vivid flesh tones of the man and woman. Like a Surrealist hallucination, the fantasy that she photographed stimulates the imagination with the endless questions it raises: Who are those people? What are they doing? What are the cats doing? Why those colors?

In addition to the **fabrication** of objects in front of the camera as in *Radioactive Cats,* contemporary photographers engage in the **manipulation** or control of photographic techniques of every kind. Manipulating the camera and embellishing the print has always been a possibility. But now that photography is becoming a digital process integrated with computer software, photographers are capable of rearranging, retouching, distorting, and adjusting images that can pose as flawless reality or can be as far from reality as a Cubist collage. The photo-artists of today, abandoning the documentary style of straight photography, contend that photographs are "made," not taken. In fabricating the subject or manipulating the photographic process, their work approaches the appearance of painting not only in their freedom of expression but also in their large size—*Radioactive Cats* is 30 by 40 inches. Many in this new generation who "make" photographs dislike being called photographers. They consider themselves primarily artists.

The modern world has seen two very different approaches to the art of photography. Nevertheless, straight photography as well as fabrication and manipulation have their roots back in the very beginning of photography in the mid-nineteenth century. They are two parallel stories.

supposed to represent exactly what the photographer saw through the camera lens. The photographer was supposed to get it right the first time. Straight photographers preferred black-and-white photos that documented reality and looked like photographs, not paintings. Stieglitz and other straight photographers in the twentieth century believed that the essence of photography as an art lies in its differences with painting, not in its similarities.

More than anyone else, Alfred Stieglitz championed the art of pure photography in America in the early decades of the twentieth century. He led the Photo Secession, an organization of photographers who were committed to the highest standards of art. From 1903 to 1917 he published the journal *Camera Work,* in which the best photographs of the time were reproduced in high-quality prints. He ran the gallery "291" in New York at 291 Fifth Avenue, where not only new photographers but also Picasso, Matisse, and other modern painters were first introduced to the American public. He also championed the cause of photography with the example of his own strong work.

Most photographers throughout the twentieth century followed his example and adhered religiously to the doctrine of straight photography. But in the last few decades photographers have rebelled against straight photography and completely transformed the art of photography in both theory and

REALISM IN THE NINETEENTH CENTURY

Photography was invented by several people at the same time in different places. In January 1839, the French painter L. J. M. Daguerre (pronounced

da-gair) announced his photographic process to the enthusiastic French public in Paris. He gave credit to Joseph Niépce (pronounced nee-eps) for a major part of his discovery. In England, when W. H. Fox Talbot heard of Daguerre's announcement, he contacted the Royal Society in London to discuss his own experiments. The public in London and Paris eagerly anticipated demonstrations of the new techniques. The enthusiasm of the public indicates that photography was an invention whose time had come. A middle-class society—founded on hard facts and mass production—had risen to economic and political power. Photography suited its taste for straightforward reality perfectly.

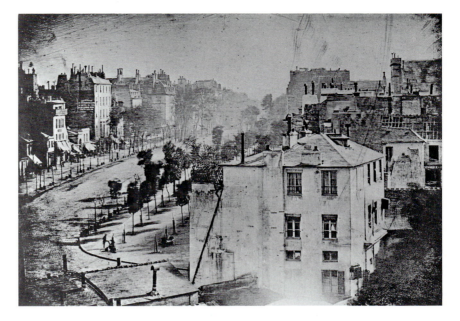

Figure 10-3 **Louis Daguerre** [French, 1789–1851], *Parisian Boulevard*, ca. 1838. Bayerische Nationalmuseum, Munich.

Neither Daguerre nor Niépce nor Fox Talbot invented the camera. For centuries it had been known that light coming through a small hole in a dark room or a dark box would project an upside-down image of the outside world on the wall of the box opposite the hole. The term *camera* derives from the Italian words for a dark room, **camera obscura.** Artists had often used a portable camera obscura, which projected the image onto a ground glass plate on the top of the box, to trace the essential lines of an image that they were copying from nature.

It had also been known for some time that certain chemicals, especially silver salts, react to light and that they can record contrasts of light and dark in a camera obscura. The problem that faced Daguerre and the other inventors of photography was how to stop the chemical reaction on the treated surface. They somehow had to remove the unaffected material. Obviously, without fixing the image, exposing a photograph again to light in order to look at it would ruin it.

Daguerre called his invention the **daguerreotype.** It produced a finely detailed image on a metallic surface. Each picture was a unique positive. Daguerre originally needed twenty to thirty minutes for an exposure. If anything moved during that time,

the image was blurred. In one of Daguerre's earliest photographs, *Parisian Boulevard* (Figure 10-3), a great variety of texture and detail was recorded. But only one man having his shoes shined is visible on the city street because he was standing still. Nevertheless, the public was amazed at how much fine detail the camera could reproduce. It was possible to see every paving stone in the sidewalk or the texture of every brick in a building. Photography could also record a seemingly infinite range of values—more than any artist ever attempted. Some artists declared, prematurely, that painting was dead. They soon realized that the lengthy exposure times meant that the camera could not record action—clouds in the sky, for example. Nor could it record color.

With new chemicals and improved equipment, the exposure time was soon shortened to about a half minute. Photographic portraits finally could be made, and photography soon became big business. All over the world photography studios sprang up to take inexpensive portraits of mostly middle-class patrons. The United States adopted the daguerreotype and led the world in its production.

Because the subjects had to collect themselves and take up sedate poses and sit as though mesmerized through the long exposure, early photo

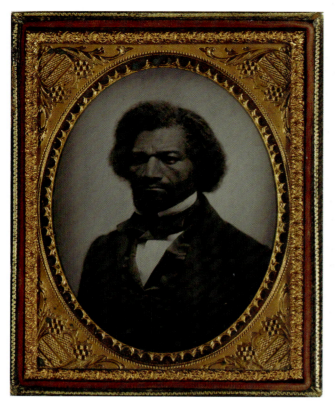

Figure 10-4 [American], *Frederick Douglass*, 1856. Daguerreotype. © National Portrait Gallery, Smithsonian Institution/Art Resource, NY.

portraits have a distinctive, haunting quality about them. At the time that Frederick Douglass's portrait was taken in 1856 (Figure 10-4), he was speaking and writing against slavery. To sit for the exposure, Douglass had to hold himself rigid, relax his mouth, and remove any momentary expression from his face. Most of all, without blinking, he had to stare intently at the camera. The technical necessities of the daguerreotype gave him an expression of serious determination. Furthermore, nothing in the plain background of this daguerreotype distracts from the bare revelation of his personality. An early daguerreotype could not capture a fleeting instant, but it could create a striking presence.

Parallel with Daguerre in France, Fox Talbot in England invented the Talbotype or **calotype** process. The calotype made a negative from which copies could be printed. The future of photography, of course, belonged to a process that could make reproductions from itself. However, Talbot's negatives were made on paper, and because of their texture, fine detail was lacking. In the 1850s both the daguerreotype and the calotype were supplanted by a wet glass-plate **(collodian)** process because it was faster.

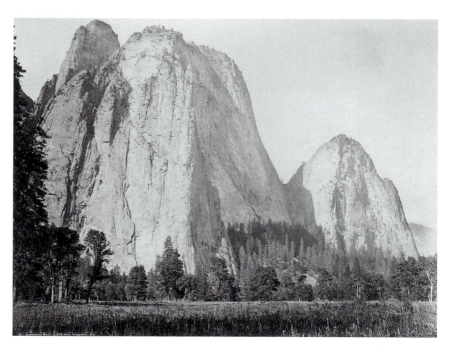

Figure 10-5 Carleton E. Watkins [American, 1829–1916], *Yosemite, No. 21*, 1866. Albumen print. Metropolitan Museum of Art, New York. The Elisha Whittelsey Fund, 1922.

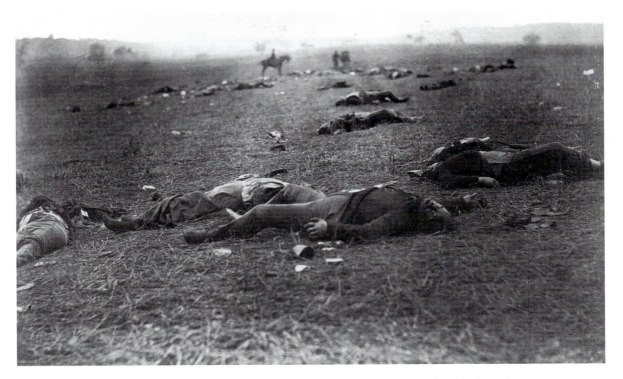

Figure 10-6 Timothy O'Sullivan [American, ca. 1840–1882], *A Harvest of Death, Gettysburg, Pennsylvania*, 1863. Albumen print. © New York Public Library/Art Resource, NY.

Despite the difficulties connected with early photography, photographers traveled all over the world and brought back to the eager public detailed images of hard-to-access places such as the Holy Land and the Far West. Carleton E. Watkins photographed *Yosemite, No. 21* (Figure 10-5) while on an expedition to survey and document Yosemite. His photographs revealed the vastness and grandeur of the West to an American nation eager for expansion. He also captured the cataclysmic forces that thrust the rock over two thousand feet in the air above the valley floor, revealing to the Bible-reading public the hand of God that controls the awesome forces of nature.

Adventuresome traveling photographers such as Watkins had to carry all their equipment—cameras, lenses, glass plates, chemicals, developing tents—across mountains and deserts and onto battlefields. Artists had often made sketches of far-away places, but their work lacked the credibility of photography. Current events were for the first time realistically documented by photographers. Under the supervision of Mathew Brady, Timothy O'Sullivan and over a dozen other men photographed the Civil War from start to finish. Despite

the long exposure time, they gave a detailed report of all aspects of the war, including the horrible carnage of the battlefield. In *A Harvest of Death, Gettysburg, Pennsylvania* (Figure 10-6), twisted, bloated men are scattered like refuse in the trodden-down grass as far as the camera could see. Death is the crop of this field. Loss of focus in the distance where a horse and rider watch creates a mood of sorrow and desolation. Published in *Gardner's Photographic Sketchbook of the War*, these photographs brought the reality of war into ordinary homes. The starkness of their images persuaded viewers that, through the photographer's eye, they too were there at that time. This realization of actuality added a poignancy that no other kind of image could have produced.

Because of their compelling immediacy, photographs have stirred patriotism, instilled concern for the poor, or persuaded the public for or against some cause. In the late 1880s, Jacob Riis, himself an immigrant to America, set out to expose the squalid conditions of the poor of New York City in penetrating photos, many of which were taken with the new technique of flash powder. Following a police search of a tenement, Riis photographed a room he labeled

Figure 10-7 Jacob A. Riis [American, 1849–1914], *Five Cents a Spot* (Lodgers in a Bayard Street Tenement), 1889. © Hulton-Deutsch Collection/Corbis.

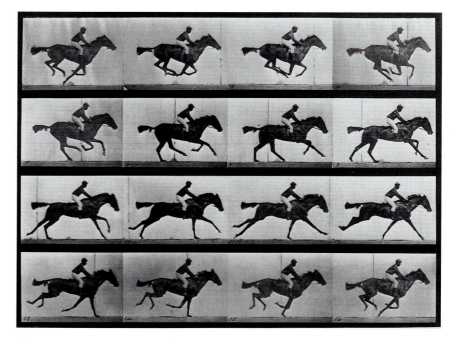

Figure 10-8 Eadweard Muybridge [American, 1830–1904], *The Horse in Motion*, 1878. © Corbis.

Leland Stanford asked Eadweard Muybridge to photograph a horse in order to demonstrate that the horse lifted all four hooves at one point in her gait. Behind the racecourse Muybridge set up a backdrop painted with twenty-seven-inch-wide boxes numbered 1 through 18. The moving horse tripped the electronically operated shutters of twelve cameras opening at a speed of one-thousandth of a second. The sensational pictures revealed facts that the human eye had never observed. They also revealed the fluid grace present in the single stride of a galloping horse. In 1883 Muybridge went to the University of Pennsylvania, where he continued to study human and animal motion in photographs.

Five Cents a Spot (Figure 10-7). Twelve men and women, each of whom had paid a slumlord five cents, slept in the single room—some on the floor and some in the bunks in a small alcove. He caught the overcrowding and squalor even before most of the residents stirred from their sleep. Published in books such as his *How the Other Half Lives* (1890) or illustrating his lectures as lantern slides, Riis's crusading photographs aroused public sentiment and did achieve housing reforms.

About 1880, dry plates became available, and most photographic materials were mass produced. By then, the technology of photography had advanced to the point that exposures could be made in short fractions of a second, and for the first time photography could stop action. Instant photographs by Eadweard Muybridge, such as *The Horse in Motion* (Figure 10-8), treated the world to images of humans and animals in poses that had truly never been seen before. Also in those years, George Eastman first applied photosensitive chemicals to a flexible material that could be wound on a spool. Cameras could thus be loaded with a roll of film and the film processed in factories. Eastman marketed his first Kodak camera in 1888. Everyone was encouraged to take photographs by the company's slogan: "You press the button, we do the rest."

DOCUMENTARY REALISM IN THE TWENTIETH CENTURY

Unvarnished **realism** is the basis of Stieglitz's straight photography, and in the twentieth century, many serious photographers concluded that realism is the chief characteristic of the medium. The ability of photographic film to record a precise moment in time makes it the perfect instrument for making an authentic record of the way things are. If photography is to be true to its essential nature, nothing should get in the way of the exact documentation of reality. Since the public expected that the camera always told the truth, any manipulation of the photographic image seemed downright immoral to many of the twentieth century's leading photographers.

From Mathew Brady's images of the battlefields of the Civil War to the news photos of the latest disaster around the globe, photographs have been devoured by the public as an unfailing and fascinating source of information. Until photography, no other medium was able to put the viewer so convincingly and so immediately in the shoes of the observer. Photographs have preserved great events in history as well as the ordinary affairs of daily life. Sam Shere's photograph *Explosion of the Hindenburg, Lakehurst, New Jersey* (Figure 10-9) made the dis-

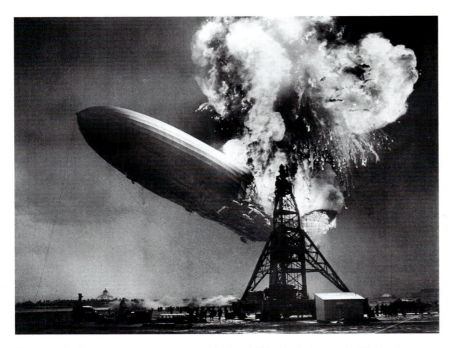

Figure 10-9 Sam Shere [American, 1905–1985], *Explosion of the Hindenburg, Lakehurst, New Jersey*, May 6, 1937. © Bettmann/Corbis.

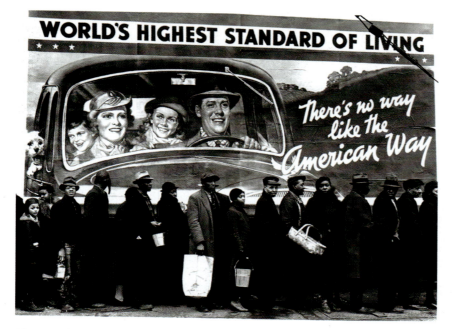

Figure 10-10 **Margaret Bourke-White** [American, 1906–1971], *At the Time of the Louisville Flood*, 1937. © Photo by Margaret Bourke-White/Time Life Pictures/Getty Images.

Margaret Bourke-White epitomized the tireless and aggressive photojournalist who, often at great risk, covers the dramatic events of the day. She was one of the first four photographers on the staff of *Life* magazine when it was founded in 1936. For *Fortune* and *Life* she was a pioneer in the development of the photographic essay. She photographed the Dust Bowl of the 1930s and the effects of the Depression on the rural South. She photographed World War II from the front lines in Italy and was with the American army when it entered the prison camp at Buchenwald. After the war, she covered Ghandi in India and the war in Korea. Without a doubt, she was the most famous photojournalist of her day.

aster of the German zeppelin one of the most remembered catastrophes of the twentieth century. Margaret Bourke-White's photos in the 1930s, 1940s, and 1950s captured the heroism and the tragedy of those times. Her photo *At the Time of the Louisville Flood* (Figure 10-10) isolated a part of a relief line as it stood in front of a billboard. The reality of the people contrasts not only with the artificial image of the stereotypical American family but also with the advertisement's claim, made during one of the worst years of the Depression.

Like Bourke-White, photojournalists from magazines and newspapers have also captured the way people lived. Publishing their work in a mass medium

such as *Life,* photojournalists had the potential to affect the conscience of the nation. In the mid-1930s the federal Farm Security Administration hired Dorothea Lange and other photographers to document the ravages of the Great Depression on American farm and family life. In her photograph *Migrant Mother* (Figure 10-11), Lange captured a woman and her children stopping at a roadside camp. Two of the children turn away, seeking comfort and protection from their parent. The mother, perplexed, worried, and holding a newborn in her lap, looks out to the left as she touches the side of her mouth. The language of gestures and facial expressions communicates the mother's feelings as surely as those of any Old Master painting. Lange made sure that nothing

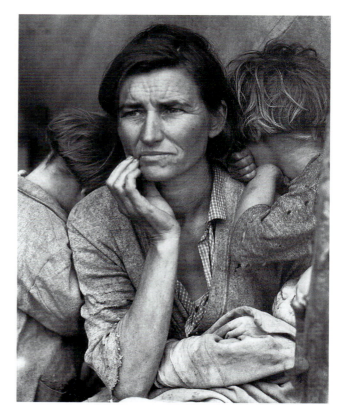

Figure 10-11 **Dorothea Lange** [American, 1895–1965], *Migrant Mother, Nipomo, California*, 1936. Gelatin-silver print. © The Dorothea Lange Collection. The Oakland Museum of Art.

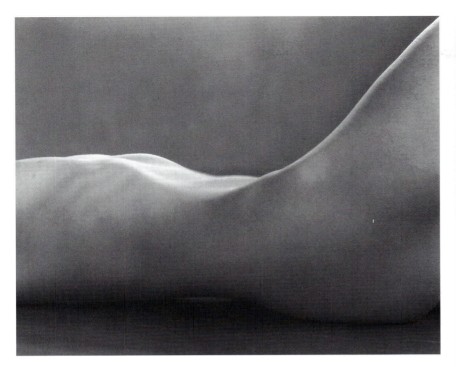

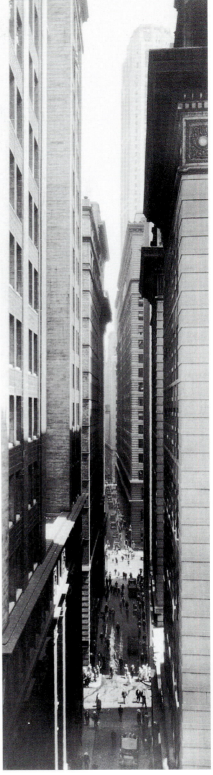

Figure 10-12 **Edward Weston** [American, 1886–1958], *Nude*, 1925. Platinum print. Collection, Center for Creative Photography, University of Arizona, Tucson. © 1981 Center for Creative Photography, Arizona Board of Regents.

distracts the eye; on the contrary, the tight composition focuses our interest. The iconography and style of Lange's photograph communicate personal feelings and personal experience as does every other work of art. And the image had an immediate impact: as soon as the photo was published, aid was sent to the unemployed migrant workers in the camp.

The most important choice every photographer has to make is a subject—some potentially meaningful person, place, or thing. Many well-known photographers have devoted their lives to the pursuit of a distinct iconography: Edward Weston, another proponent of straight photography, for many years studied vegetables (see *Pepper,* Figure 3-3), clouds, and the nude as abstract forms (see *Nude,* Figure 10-12). Berenice Abbott made portraits of New York City (see *Exchange Place, New York City,* Figure 10-13) with a large camera that recorded the rich detail of city life. These and many other photographers often create a visual essay about a certain topic, and consequently they publish their series of photographs in book form. Abbott published her work in *Changing New York* in 1939.

Ansel Adams, who made the American West his subject, was a long-time believer in Stieglitz's straight photography. Although Adams was opposed

Figure 10-13 **Berenice Abbott** [American, 1898–1991], *Exchange Place, New York City,* 1934. From the collections of the Library of Congress.

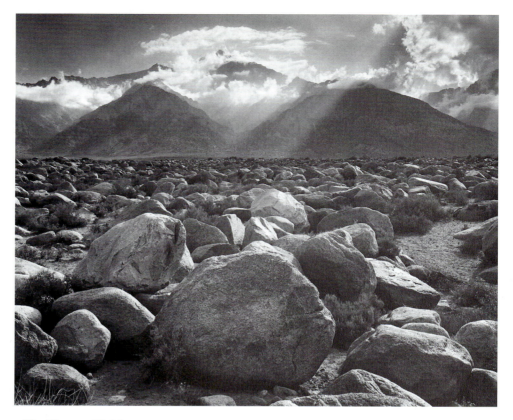

Realizing that distant rock-faced mountains blended with the sky, Ansel Adams waited until a storm in the mountains brought everything to life. Luminous clouds and their cast shadows created contrasts that made the shapes of the mountains appear. Sunlight streamed down parallel to the diagonal of the mountains, and in the foreground, the light came from somewhat behind the boulders so that their dark bulk would loom before the viewer. Adams set his camera on the roof of his car to get a view over the boulders and aimed it so that the mountains in the distance were arranged symmetrically. With a hand-held light meter, he made calculations about speed, aperture, and filtering.

to any artificial manipulation of the image, his photograph *Mount Williamson—Clearing Storm* (Figure 10-14) does not lack calculation. In fact, Adams carefully controlled the exposure and the developing of his negative to achieve the subjective effect that he wanted. In his work he strove for a great range of gray as well as dramatic light and dark contrasts. He usually adjusted his camera for a sharply focused image from the foremost rock to the distant clouds. He carefully chose the composition and the right camera angle and waited for the right sunlight to produce straight photography with great sophistication. He took several photos of Mount Williamson in which the clouds and light were not satisfactory, so he discarded the negatives.

FABRICATION AND MANIPULATION IN EARLY PHOTOGRAPHY

In contrast to straight photography, photographs from the beginning have sometimes deviated from the raw facts, whether by the fabrication of objects in front of the camera or the skilled manipulation of photographic techniques. Timothy O'Sullivan may have rearranged the bodies on the Gettysburg battlefield to get a better composition for *A Harvest of Death*. Some photographers in the nineteenth century, attempting to raise photography to a higher artistic level, imitated the appearance of paintings by arranging artificial compositions of figures that

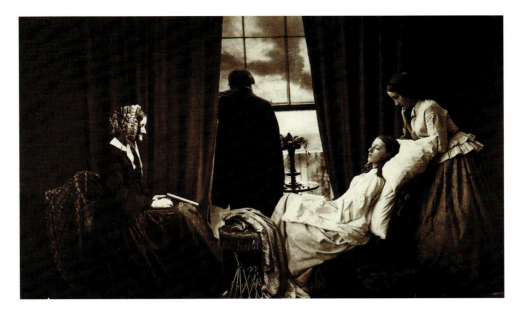

Figure 10-15 Henry Peach Robinson [British, 1830–1901], *Fading Away*, 1858. George Eastman House, Rochester, New York.

resembled the popular genre paintings of the day. In 1858 Henry Peach Robinson enlisted four people to pose for his carefully designed photograph *Fading Away* (Figure 10-15). In order to get the exact expression for each character, Robinson made the print from five separate negatives. In the print a young woman lies dying while two other women—perhaps her older sister and mother—keep vigil. Her father turns away and stares through the win-

dow at what lies beyond. The image shocked some people because its realism was too painful; others ridiculed it as contrived.

In the 1860s, Julia Margaret Cameron made some striking portraits of famous writers and artists by manipulating the means she used to take them. Her portrait of the historian and philosopher Thomas Carlyle (Figure 10-16) captures the spirit of the great Victorian writer perfectly. She deliberately

(text continued on page 218)

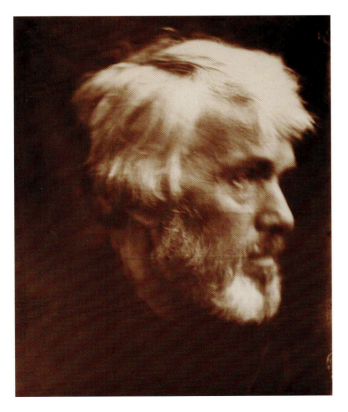

Figure 10-16 Julia Margaret Cameron [British, 1815–1879], *Thomas Carlyle*, 1867. Albumen print. George Eastman House, Rochester, New York.

Julia Margaret Cameron entertained many famous poets and writers of her era at her home, where she often cajoled them into sitting for her. Cameron concentrated on the inner spirit of the person and forced her guests to pose until she was satisfied with the result. With regard to "taking the great Carlyle," Cameron wrote, "When I have had such men before my camera my whole soul has endeavored to do its duty towards them in recording faithfully the greatness of the inner as well as the features of the outer man."[1] She experimented with different means to get the effect of simplicity and concentration. She deliberately used poorly made lenses or had lenses specially built so that the image would lack definition and appear softly focused. Her manipulated representation of Carlyle fits the leonine, ponderous writer—the image of the man we get from reading his work.

To document African American life in the United States, Carrie Mae Weems majored not only in art and photography in college and graduate school, but also in folklore, the study of a people's customs, sayings, and myths that are passed on from generation to generation. Even though her photographs seem documentary in style, Weems often arranges the objects of her compositions, poses her subjects, and adds written and voice-recorded commentary to the photos. She clearly belongs to a new generation of photographers who have rejected the aesthetic of straight photography. Her photographs, mounted in exhibitions or printed in book form, sometimes appear as a sequence in a narrative. The printed texts and the tape-recorded comments do not exactly explain the photographic images but add another, usually ironic dimension or interpretation to them.

The large square photograph *Untitled (Man Smoking)* belongs to a series of photographic narratives, the *Kitchen Table Series,* in which the same wooden table and the same overhead light appear. They constitute the stage on which the photographer enacts her dramas. Although Weems herself plays the leading role in each of the photographs, the images are not self-portraits, autobiographies, or even personal fantasies. They concern the ambiguity of the decisions that women make in everyday relationships.

Smoking cigarettes and drinking Scotch, the couple in *Man Smoking* are playing cards. It is not known who has to make the next move. Questioning how to play their hand, they eye each other, and the game easily becomes a metaphor for the physical attraction between them. The portrait of Malcolm X on the wall adds a reference to a world outside their game to which the two seem completely oblivious. Weems likes to leave her work open to a variety of opinions and interpretations. The text at the right, which Weems wrote after taking the photograph, was hung alongside it in the original exhibition, although it may or may not apply to that picture.

In her work, Weems usually stays somewhat aloof, like an observant researcher who records the facts. From early photographs of her family to photo-essays of the African American folk culture of the Sea Islands of South Carolina and Georgia, Weems captures the unique way that African Americans live in North America. She speaks to blacks themselves about the drama and the rich humanity of their own culture. She speaks to all races about the nature of the human condition.

She'd been pickin em up and layin em down, moving to the next town for a while, needing a rest, some moss under her feet, plus a solid man who enjoyed a good fight with a brave woman. She needed a man who didn't mind her bodacious manner, varied talents, hard laughter, multiple opinions, and her hopes were getting slender.

He had great big eyes like diamonds and his teeth shined just like gold, same reason a lot of women didn't want him, but he satisfied their souls. He needed a woman who didn't mind stepping down from the shade of the veranda, a woman capable of taking up the shaft of a plough and throwing down with him side by side.

———————

They met in the glistening twinkling crystal light of August/September sky. They were both educated, corn-fed-healthy-Mississippi-stock folk. Both loved fried fish, greens, blues, jazz and Carmen Jones. He was an unhardened man of the world. She'd been around the block more than once herself, wasn't a tough cookie, but a full grown woman for sure.

Looking her up, down, sideways he said, "So tell me baby, what do you know about this great big world of ours?" Smiling she said, "Not a damn thang sugar. I don't mind telling you my life's not been sheltered from the cold and I've not always seen the forest or smelled the coffee, played momma to more men than I care to remember. Consequently I've made several wrong turns, but with conviction I can tell you I'm nobody's fool. So a better question might be: what can you teach me?"

He wasn't sure, confessing he didn't have a handle on this thing called life either. But he was definitely in a mood for love. Together they were falling for that ole black magic. In that moment it seemed a match made in heaven. They walked, not hand in hand, but rather side by side in the twinkle of August/September sky, looking sidelong at one another, thanking their lucky stars with fingers crossed.

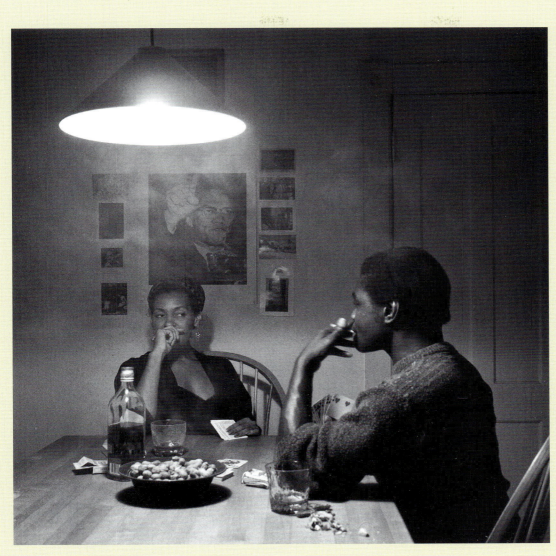

 Carrie Mae Weems [American, 1953–], *Untitled (Man Smoking)*, 1988. 27 1/4 × 27 1/4 in. (69.2 × 69.2 cm). Courtesy of the artist and P.P.O.W. Gallery, New York.

Figure 10-17 **Edward Steichen** [American, 1879–1973], *Woods Interior*, 1898. Platinum print, 7 7/16 × 6 5/16 in. (18.9 × 16.1 cm). Metropolitan Museum of Art, New York. Alfred Stieglitz Collection, 1933 (33.43.8). Photograph © 1999 The Metropolitan Museum of Art.

used a simple camera that required long exposures and also put the edges out of focus to make outstanding portraits.

To express the spiritual in his photograph *Woods Interior* (Figure 10-17), Edward Steichen deliberately put the film out of focus in order to imitate the vagueness of art, like Whistler's dreamy vision of Venice (Figure 8-13). Many critics in the nineteenth century could not accept photography as an art because it did not convey a spiritual dimension, which they assumed to be a necessary component of all great art. Photography seemed to be so obviously a matter-of-fact and realistic medium. Steichen's dark, softly focused, misty image of woods, low in value contrasts, suggests something mysterious. The vague forms of nature imply that there is a presence lying beyond ordinary reality and that the spiritual suffuses this dreamy woodland.

MODERN CHALLENGES TO REALISM

In recent years many photographers, such as Sandy Skoglund and Carrie Mae Weems, have fabricated

their subjects not just for compositional reasons but also to express themselves, explore psychic reality, or deliver a particular message through photography. More and more photographers have challenged the aesthetic of straight photography and made their reputations with photographs of thoroughly staged subjects. Sandy Skoglund obviously painted the room, arranged the green cats and furniture, and posed the actors in her photograph *Radioactive Cats* (Figure 10-2). For a series of photographs that explore contemporary male-female and mother-daughter relationships, Carrie Mae Weems fabricated her subjects. In *Untitled (Man Smoking)* (see "Artist at Work"), she portrayed herself playing cards.

Cindy Sherman, America's best-known photographer of fabricated images, has spent nearly three decades taking photographs of herself. They are not traditional self-portraits that reveal a personality but images of the way women are seen in the media and in art. She first achieved her reputation with a series of several dozen black-and-white photos she called "Untitled Film Stills"—stereotypes of women as depicted in Hollywood B movies. Using sets, costumes, and props, she portrayed the jilted lover, the blonde, the office worker, the housewife, and so forth. In a

Figure 10-18 **Cindy Sherman** [American, 1954–], *Untitled #223 (Madonna)*, 1990. Color photograph. Courtesy Cindy Sherman and Metro Pictures.

later series, "History Portraits," Sherman took on the role of characters in Old Master paintings. In *Untitled #223* (Figure 10-18), she posed as a Madonna nursing her child in a painting by a Renaissance master. The photograph is in fact as large as an oil painting. Sherman has the same serene and loving look on her face as a Renaissance Madonna. But the misplaced exposed breast is obviously artificial, and the child seems malformed; his tiny feet look more like hands. Sherman undercuts her faithful imitation with elements that are clearly unreal, calling attention to her artifice. Even the most venerated image of motherhood is shown to be a fiction.

In addition to fabrication, retouching and embellishing photographs has become quite common, especially with the advent of digital photography. Today, more photographs are recorded on digital memory devices than taken on chemically processed film, and digital images are often viewed on computer screens rather than in prints. In the computer, software programs can change colors and values, add or eliminate details, or rearrange textures and shapes. More than ever, the realism of photography is only a realism of appearance. From photographs of a doorway, water, and a woman swimming, Pat Gooden put together a Surrealistic fantasy she calls

Figure 10-19 **Pat Gooden** [American, 1954–], *Journey—Room for Thought*, 18 × 12 in. (45.7 × 30.5 cm). Inkjet print Courtesy of the Artist.

Figure 10-20 **Mitch Eckert** [American, 1968–], *Still Life with Mandible*, 2003. Archival pigment print. Collection of the artist.

Journey (Figure 10-19) that has the sharp-focused reality of a dream.

Computer manipulation opens up exciting new possibilities to make images. In fact, photographer Mitch Eckert used a scanner instead of a traditional camera to make *Still Life with Mandible* (Figure 10-20). In his recent work he lays objects on the scanner to record them, then imports the images into a computer, where he manipulates the color and scale of the objects with image-editing software such as Photoshop. For example, the pomegranate, gourd, and lavender bud at the bottom were made the same scale with a few mouse clicks. He may also scan other photographs or slides to incorporate them into the design he is creating on the computer screen.

CREATIVE POSSIBILITIES

Photographers have always had to choose amid countless creative possibilities and artistic decisions. The idea that photographers lose their subjectivity

The objects that Mitch Eckert records in his work are either gifts from friends or found objects that have a place in his life. Like many traditional still lifes, his compositions concern the cycle of life and the vanity of things. For example, in this work he juxtaposed fruit and buds—symbols of life—with the jawbone of a dead animal. The shadowed figures seem to be spinning the circle of rocks, which has no beginning and no end.

behind a camera is an illusion. From the beginning, photographers had to choose different kinds of film—high or low light sensitivity, high or low contrast, black-and-white or color film, available commercially since the 1930s. For a long time, art photographers were prejudiced against color because of its commercial exploitation in garish advertising. They concentrated instead on the subtlety and richness of values in black-and-white photography. Now most modern photographers are eager to display their sensitivity to color in their work, as Joel

Figure 10-21 **Joel Meyerowitz** [American, 1938–], *Longnook Beach*, 1983. Color photograph. Courtesy of Ariel Meyerowitz Gallery, New York.

Meyerowitz did in *Longnook Beach* (Figure 10-21), with its complementary contrast between baby blue and the very pale orange of the sand. The photographer needs an awareness of color theory and a feeling for color relationships, as does any other artist.

Other technical variables include the many different kinds of cameras on the market, some of which take very different kinds of pictures. The amount of light entering a camera can be controlled by the size of the aperture (f-stop) or by the length of time that the aperture is open (shutter speed). The size of the aperture affects how much of the subject will be in focus at a given distance from the camera (depth of field). On many cameras the standard lens can be removed and replaced with wide-angle or telephoto lenses. Filters can be placed on the lenses to change the nature of the light entering the camera and change the contrasts between light and dark. Flash attachments and artificial lights create special light sources that allow us to see things in new ways or to see things that are not ordinarily visible. All of these technical variables influence the appearance of the image that the camera is copying.

Today, most cameras operate automatically whenever the photographer presses the button because they are programmed to make all the choices about light, focus, shutter speed, f-stop, and so forth.

Photographers in effect agree to all these programmed choices whenever they decide to use the automated features of a camera. An automatic camera does not deny creativity, but it does limit the possibilities.

Traditionally, the character of the image can also be changed in the darkroom with variations in the techniques of developing and printing. The composition can be changed into a new design by cutting off part of the original photograph, or separate photographs can be combined or superimposed to make a new image. Computer software now allows the almost unlimited transforming of digitized images. The variables of developing and printing explain why original prints made by the photographer-artist are collector's items worth thousands of dollars whereas mass-produced prints of the same image are not.

When something of interest comes along, the photographer has to decide on the distance from the subject: whether he or she wants a long shot or a close-up. The photographer has to decide on the angle from which the subject will be taken, how the light will affect the image, and whether artificial or natural light should be used. Looking through the viewfinder, the photographer has to examine the entire frame and make sure that the lines, shapes, val-

Figure 10-22 **Andreas Gursky** [German, 1955–], *99 Cents*, 1999. Chromogenic color print. 6 ft. 9 1/2 in. × 11 ft. (207 × 337 cm). Courtesy Matthew Marks Gallery, New York, and Monika Spruth Galerie.

ues, and colors are arranged in a way that reinforces the meaning of the image—or work on those problems later. The photographer has to compose the image with the same principles of consistency, variety, and balance that every artist must employ. Whether reproducing reality or manipulating reality, an artistic photograph imposes on reality a significant formal design. The photographer, in creating the image, injects awareness absent from raw reality. The signs and symbols that convey this subjective message—lines, shapes, values, and colors—are similar to those of the other two-dimensional media.

In general, having made dozens of technical and personal choices, the photographer makes the ordinary look extraordinary. Andreas Gursky's mural-size photograph *99 Cents* (Figure 10-22) makes the aisles of a discount store seem strange indeed. Although the photograph is realistic, its high point of view, near symmetry, endless detail, gaudy color, and minimal human presence make the place alien and remarkable. All sensitive photographers cause us to stop for a moment and see reality in a new way. They help us to realize the significance latent in the image, as we never would have without their intervention.

Photography

Straight photography	Straight photography holds that the photographic print should reproduce what the photographer saw through the camera lens when the picture was taken; it claims to document reality.
Straight photography in the nineteenth century	Despite the difficulty of taking photographs in the nineteenth century, viewers were amazed by the amount of detail in photographs and their immediacy.
Straight photography in the twentieth century	Throughout most of the twentieth century, straight photographers maintained that photographs documented reality. It was the great age of photojournalism.
Fabrication and manipulation in early photography	It has always been possible to create or rearrange the subject of photographs. It has also been possible to alter the photographic image in the camera or darkroom.
Modern fabrication and manipulation	In recent decades many photographers have staged subjects and altered photographic images, especially with the advent of digital photography and computer software.
Creative possibilities and choices	Photographers have to choose a subject; camera equipment and settings; types of film, including chemical-based or digital; developing and printing techniques; and a design that coordinates the visual elements.

INTERACTIVE LEARNING

Foundations Modules: Style, Form, and Content

 Flashcards

Artist at Work: Carrie Mae Weems

Companion Site: http://art.wadsworth.com/buser02

Chapter 10 Quiz

InfoTrac® College Edition Readings

Talking Flashcards

Online Study Guide

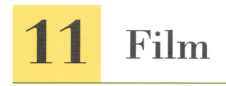

11 Film

THE MODERN MEDIUM

No modern art form commands such attention as film. None has been so popular. No other art stirs the emotions quite like film, causing the audience to laugh, cry, or scream out loud (see Figure 11-1). No other art has had such an impact on the modern imagination. Distributed in movie theaters or over media such as television, videotape, and DVD, film is everywhere.

Motion pictures serve many functions, such as documentation, scientific study, training and general education, reporting of news events, advertising, travelogues, and entertainment of all sorts, including sports and musical performances. A filmmaker may transform any kind of film into an art medium. But the art of filmmaking reveals itself most fully in feature films—narratives that last for at least an hour and a half. They are none other than the movies that have been produced for decades as mass entertainment.

Some people are reluctant to include film among the visual arts because the complexity of the medium does not quite fit the traditional categories of art. Moreover, film seems to be too popular and too entertaining. Because it is a multi-billion-dollar industry and is most often driven by market pressures, film seems tainted. And because most of us have been watching film since earliest childhood and have grown quite used to it, we sometimes take its grammar and vocabulary for granted. Nevertheless, as

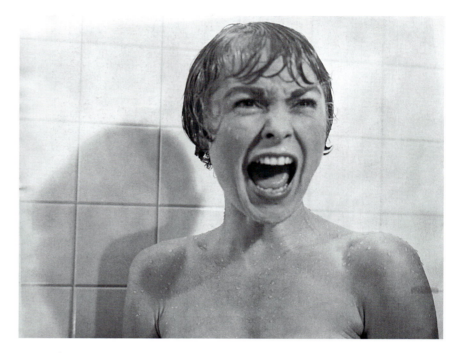

Figure 11-1 Alfred Hitchcock [American, 1899–1980], Janet Leigh in *Psycho*, 1960. © Bettmann/Corbis.

with any language, by expanding our vocabulary, we might actually see more. And by making ourselves conscious of the rules of film grammar, we might comprehend more of what we see.

THE NATURE OF FILM

Motion pictures became possible at the end of the nineteenth century, when the exposure time for photographs became fast enough to stop action and when George Eastman developed a flexible film that could roll through the machinery of a camera and a projector. The inventors of motion pictures already knew that when still images, depicting the successive stages of an action, were rapidly flicked before the eye, the illusion of motion would be produced.

Figure 11-2 **Thomas Edison** [American, 1847–1931], *Fred Ott's Sneeze*, 1891. © Corbis.

The brain retains each image for a fraction of a second so that the eye blurs the succession of still images into continuous movement.

Eadweard Muybridge had mounted his photos of a moving horse (Figure 10-8) in a revolving wheel of a stroboscope to give the appearance of movement. In 1891 Thomas Edison patented a machine he called a kinetoscope, in which an individual looking through a peephole could view an action photographed by a single camera on a continuous strip of film. Within months of examining Edison's kinetoscope, Auguste and Louis Lumière in France invented a motion picture projector and then opened the first movie theater in Paris in December 1895.

Of course, the very first motion pictures that demonstrated the new process showed things that moved—a couple kissing, a train coming into a station, or a man sneezing, as in *Fred Ott's Sneeze* (Figure 11-2), the earliest whole film in the possession of the Library of Congress. In short, it has been obvious from the beginning that film specializes in **movement** rather than in the static depiction of things such as still life, landscape, or portraiture. Unlike photography, which has been so successful at reproducing actual, seemingly unrehearsed events, motion pictures demand "actors" who know how to move.

And so because of their obvious affinity to actors and acting, films were soon reproducing theatrical productions. The camera gave the viewer the best seat in the house—front row, center. In many of the earliest films, the camera was stationary and never stopped running until the theatrical scene was over. But it was not long before moviemakers realized that not only must the actors move but also the camera can and should move. Unlike a member of the theater audience, it can shift to any position, even onto the stage or behind the scene. Moreover, moviemakers soon realized that a complete film is not con-

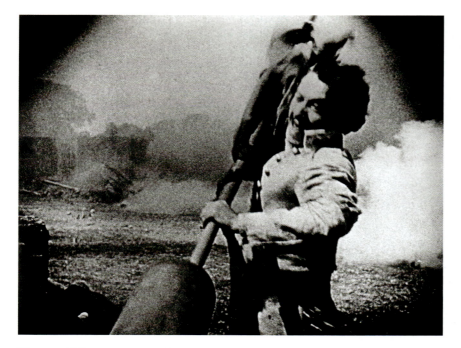

Figure 11-3 D. W. Griffith [American, 1875–1948], *Birth of a Nation*, 1915. © Epoch/The Kobal Collection.

Birth of a Nation paints a broad picture of the South before, during, and after the Civil War through the eyes of two families, one southern and one northern, who finally unite in marriage at the picture's end. The most expensive film of its time, at $125,000, *Birth of a Nation* had a cast of thousands, big interior sets, exciting action sequences, and an intimate focus on a handful of people. In the battle sequences, Griffith cut from the heroic efforts on one side to the heroic efforts on the other, from long shots of the raging battle to close-ups of individual men, from the living to the dead.

When the film opened, it was condemned by the National Association for the Advancement of Colored People and by liberal politicians for its glorification of the Ku Klux Klan and for its bigotry and racism. Griffith, who wanted blacks to keep their place, felt that social change was the cause of evil in the world. Although the film was banned in several cities, its huge success indicates that its pernicious point of view was shared by a large segment of the American public. A historic, inventive, and dramatic piece of filmmaking, *Birth of a Nation* remains an embarrassing reflection of American society as it was in 1915.

structed from scenes as in a stage play but is based on the segments of film shot by the camera.

One of the first persons to exploit the potential of a mobile camera and consequently the potential of a shifting point of view in film was the American director D. W. Griffith, who began making films in New York in 1908. He was the first moviemaker to develop various camera positions and to compose a film by the combination of the individual pieces of film shot from the changing positions. His 1915 movie *Birth of a Nation* (Figure 11-3) was one of the first feature-length films as well as the first blockbuster, earning

millions of dollars. In many ways Griffith invented the movies, both the art and the industry.

A COMPOSITE ART

Film is a **composite art** in the sense that it borrows and combines elements from a number of older art forms. Film resembles theater because it usually has actors, sets, and dialogue like any dramatic production. However, unlike a theater production, where the audience goes to see a living performance with all its risks and spontaneity, a film is a recording. Unlike the observer's point of view in a theater, the camera's point of view in a film is not limited to a fixed seat in the audience. The camera can focus now on one part of the dramatic action, now on another, whereas all the actors involved in a theatrical scene remain on a stage and are constantly visible to the audience. Furthermore, a film can easily move back and forth between different activities staged at different times and places. A stage play changes scenes, in most cases, as infrequently as it can.

Film is a composite art also because it incorporates the art of photography—in the sense that every image on the motion picture screen is governed by the same principles of design as any good photograph. The big difference between film and photography is, of course, that film images move. The actual movement of lines and shapes in a moving picture adds another element of visual stimulation to be balanced in the composition.

In actual practice, however, the photographic element in film has looked quite different from art photography because film so often depicts fantasy. Until recently, straight photographers have emphasized the realistic basis of their art in their work, but movies have always delighted in stretching the imag-

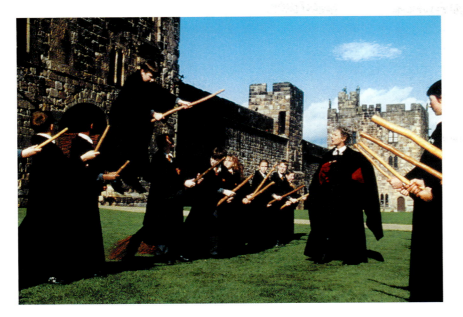

Figure 11-4 Movie still. *Harry Potter and the Sorcerer's Stone*, 2001. Photo courtesy of Warner Bros./Getty Images.

ination—whether the reenactment of history, science fiction, impossible adventures, or outlandishly romantic love stories. Some of the most financially successful movies in recent years have been film fantasies such as *Star Wars, Spider-Man, The Lord of the Rings,* and *Harry Potter* (see Figure 11-4).

As a composite art, film often incorporates music, although the music on a typical sound track is not a complete musical work such as that performed at a concert. Music in film is generally sub-ordinate to the action. Dramatic productions staged in a theater often have musical interludes, but seldom does the music accompany the action as it does in the movies. Audiences rarely go to the movies to listen to the sound track. Even Walt Disney's *Fantasia,* which includes passages from renowned compositions such as Igor Stravinsky's *The Rite of Spring,* emphasizes the visual element. However, the music in the opening sections of Disney's *Beauty and the Beast* (see Figure 11-5) synthesizes several

Figure 11-5 Walt Disney Company [American]. *Beauty and the Beast,* 1991. © The Walt Disney Company.

Figure 11-6 Shrek (voice of Mike Myers) and the Donkey (voice of Eddie Murphy) in a still from the computer-animated film *Shrek*, 2001. Photo by Dream Works Pictures/Courtesy of Getty Images.

levels of the action on the screen in a stunning fashion. While Belle sings about her need for romantic adventure and the boredom of provincial life—undercut by the visual mayhem on the screen—Gaston sings of his intention to marry Belle, and the chorus of villagers sings about how strange she is. The blending of different voices, establishing plot, character, and setting in one song, is almost operatic in its scope.

Animated films are a composite art that also incorporates the arts of drawing and painting. Made in the traditional way, an animated feature such as *Fantasia* required close to a million drawings by dozens of artists and took years to complete. Today, most professional animation—*Shrek* (Figure 11-6), for example—is painted through a computer program, which greatly eases production. Computer animation requires the combined talents of drawing and sculpture because the object depicted will not just move across a two-dimensional surface but also turn itself around or be seen from different points of view. The animator often begins by drawing a grid, or wireframe, of the contours of an object such as a human face (Figure 11-7). The computer can display the entire grid of contours, front and back, or hide the lines in the back for the

sake of clarity. The animator, through a process called modeling, has in effect created a three-dimensional piece of sculpture. The wireframe can then be shaded or textured to render the object more solid and lifelike. Using programs such as 3DS Max or Maya, the animator next decides on the lighting and the "camera," the stationary or moving point of view.

Even in live-action films, computer animation has enabled dinosaurs to stampede in *Jurassic Park* and the silver cyborg to transmogrify itself in *Terminator 2*. Computer-generated imagery appears to be on the verge of revolutionizing all filmmaking. *Sky Captain and the World of Tomorrow* (Figure 11-8), starring Jude Law, Gwyneth Paltrow, and Angelina Jolie, was filmed without the construction of a single set. The actors were shot in front of a "blue screen." The sets, lighting, and color were all designed on a computer and then combined with the live action later.

Actors and scenery can now be manipulated on the computer screen with the same freedom enjoyed by a modern artist applying paint to a canvas. Hair-raising stunts can be produced with little danger to the actors and actresses and at a much lower cost. With digitized technology, all these images can have

Figure 11-7 Jeremy Birn, *Wireframe Head Model.*
http://www.3drender.com/jbirn/ea/HeadModel.html. Courtesy
of the artist.

a flawless simulation of reality or, as in *Sky Captain,* have the appearance of film shot in 1939.

Film also resembles the novel and incorporates some of its features. Like a novel, a film can easily develop a story through various times and places. Like a novel, a film can focus now on one character, then on another. Yet film has trouble reproducing the equivalent of a first-person author or all-knowing narrator, a device that is typical of fictional literature. The narrator in a novel can get inside the head of the characters and describe what they are thinking or feeling.

In a film, a camera angle will sometimes establish the point of view of a character, as when the villains are photographed suddenly from above, from Indiana Jones's position on the cliff. The audience may not exactly know what Indiana Jones is thinking, but at least it sees what he sees. In general in the movies, the camera is the main storyteller and has to reveal thoughts and feelings implicitly by the images it captures for the screen.

Film is a composite art form also in the sense that many people collaborate in the making of a typical movie. Painters, sculptors, and printmakers frequently employ assistants, but the assistants usually subordinate their activities to the artist's wishes. Architects depend on numerous contractors and workers to build a building, but they necessarily work together to realize the architect's established plans. But in the movie industry, many individuals have a strong voice in determining the appearance of a typical film.

Figure 11-8 *Sky Captain and the World of Tomorrow,* 2004. © Keith Hamshere/Paramount
Pictures/Bureau L.A. Collections/Corbis.

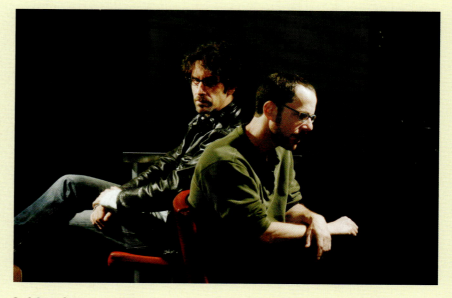

Joel Coen [American, 1954–] and Ethan Coen [American, 1957–]. © Photo by Jean-Christian Bourcart/Getty Images.

The credits for their first movie, *Blood Simple* (1982), listed Joel and Ethan Coen as the writers, Ethan Coen as the producer, and Joel Coen as the director. Most of their movies since then have repeated the same arbitrary listing. But, in fact, both brothers write, produce, direct, and—under the pseudonym Roderick Jaynes—edit each film jointly. Writing a screenplay, they take turns typing and pacing the floor, wildly tossing out possible lines of dialogue and twists in the plot. Directing a scene, they finish each other's sentences. They are a single entity known as the Coen brothers, the leading independent filmmakers in America.

Their work has often been inspired by earlier film genres such as *film noir* (French for "black" or "dark film")—American crime and detective films from the 1940s and 1950s that had a dark look about them. Not only were *film noir* stories shot with strong contrasts of light and dark, but they also had a feeling of menace, double-cross, disillusionment, and gloom. In fact, the Coen brothers set their 2001 film *The Man Who Wasn't There* in the 1940s and shot it in deeply contrasted black and white. The main character, played by Billy Bob Thornton, attempts blackmail, kills someone, and then sees his wife falsely accused of the murder.

Misunderstanding seems to be the theme that runs through all their films. In *The Big Lebowski,* The Dude, played by Jeff Bridges, is mistaken for someone else named Lebowski. Like many characters in Coen films, he gets into schemes and situations that are way over his head. The movie parodies a Raymond Chandler detective novel, *The Big Sleep,* in which a disillusioned hero encounters a string of bizarre West Coast characters while searching for the truth. Egged on by his bowling buddy Walter, played by John Goodman, The Dude gets involved with gangsters, a performance artist, a group of German nihilists, and an assortment of weird characters.

The brothers put a heavy emphasis on dialogue full of wit and irony. Their films often satirize specific regions of the country—the Southwest in *Raising Arizona,* South Dakota and Minnesota in *Fargo,* the Deep South in *Oh Brother, Where Art Thou?,* and Los Angeles in *The Big Lebowski.*

Before filming, they usually develop an extensive storyboard. Storyboarding saves money—an important consideration for filmmakers not dependent on big-studio budgets. It helps them communicate their ideas to the crew, and it also means that they do little improvisation on the set. They like to work with the same artists and actors, who seem to be in sympathy with their art.

Their screenplays are filled with visual information about set design and photographic design, camera angles and camera movement. They like a moving camera and often use

Joel Coen [American, 1954–] and **Ethan Coen** [American, 1957–], *The Big Lebowski*, 1998. © Sygma/Corbis.

tracking shots. Even in supposedly still shots, the camera will seem to drift slightly to one side. For many shots, they often choose a wide-angle lens, which increases the depth of focus. The lens tends to broaden the scene by including a lot more of the surrounding set with the actor. It pulls close things forward and pushes distant things farther away. Camera movements with a wide-angle lens become more dynamic.

By writing, producing, directing, and editing their films, the brothers are free to pursue their own vision. Books have been written on the meaning of their films, but as one author put it, a Coen brothers film "reflects nothing quite so much as their desire to amuse each other."[1]

Figure 11-9 Sofia Coppola with Bill Murray on the set of *Lost in Translation*, 2003. © Focus Features/The Kobal Collection.

bear the mark of a forceful imagination capable of exercising artistic control.

But significant portions of any film are not under the director's immediate control. A producer, for example, arranges for the millions of dollars of financing that a movie usually requires. Holding the purse strings, a producer often has a great deal to say about what goes into a film and what the end product should look like. In the 1930s, 1940s, and 1950s, the big film studios in Hollywood tightly controlled every facet of movie production and made most of the big decisions about any film.

Other people responsible for creating a film include the cinematographer, who oversees the photographic quality of each image on the screen and so gives important directions about lighting and color. In *Seabiscuit* (Figure 11-10), the design of the photograph of the wealthy businessman, who has just lost his son, conveys the sad mood at that point in the film better than any dialogue. Editors put the pieces of film together, participating in one of the most vital and artistic parts of filmmaking. Someone else chooses a cast of actors, who may or may not cooperate with the director. A scriptwriter prepares a story and dialogue. Professionals design and build sets; other professionals design and make costumes. A gaffer, the chief electrician, achieves the lighting. Experts compose and record music and integrate it with the film. To say the least, even the most talented director depends on the skills of dozens of other people to make a successful film.

Directors, such as Sofia Coppola (Figure 11-9) or the Coen brothers, plot and supervise the shooting of a film as they guide the actors in the interpretation of their roles. The director is usually credited with the overall responsibility for the outcome of the film as though she or he is the individual author of a novel. The idea that the director functions as the creative artist of a film is known as the **auteur theory** (*auteur* in French means "author"). Most successful films

Figure 11-10 *Seabiscuit.* © Dreamworks.

THE LANGUAGE OF FILM

Ever since D. W. Griffith realized that the motion picture camera must change its location, the filming done from each position has become the fundamental building block with which every film is constructed. This basic unit is called a **shot,** which consists of one uninterrupted moving or nonmoving image. A shot is usually one continuous rolling of the camera. It may be only a few frames long or several thousand frames long. It may last for a fraction of a second or for many minutes.

A longer portion of a film is called a **sequence,** which usually consists of a number of shots related to one another by some visual or conceptual coherence. A sequence often resembles a scene in a theatrical production. When we talk about the love scene or the chase scene in a movie, we are probably referring to a sequence. Strange as it may seem, in filmmaking, the sequence is subordinate in importance to the shot.

Very little of what appears in any shot is accidental or gratuitous. Everything appearing on the screen at any given moment has probably been put there because of someone's decision. The French, who have been leaders in film criticism, call what is in each frame the **mise en scène** (pronounced meez-ahn-sen), which means "put into the scene." The mise en scène includes elements that are similar to those in a theatrical production—the actors, the setting, the lighting, and the costumes. The filmmaker decides who will be in the shot and what part of the set will be included in the frame. Even when the film is made out of doors on location, the director has to decide whether he or she wants those trees on the left or on the right of the screen. Decisions about lighting have to be made. Unusual lighting can establish a dramatic mood, or it can put a sparkle in the leading lady's eyes.

Mise en scène also pertains to movement on the screen. This includes the actors' gestures and expressions while standing in place or walking across the screen. Filmmakers have to decide whether the spaceship should fly across the screen from left to right, right to left, or, as in the *Star Wars* movies (Figure 11-11), appear at the top of the screen and move into the distance. Since the essential element of film is movement, many directors like to see activity in every frame and seldom allow a mise en scène that is as static as a still photograph.

The mise en scène also includes elements that are closely related to the art of photography. Issues such as lenses, focal length, and depth of field can dramatically change the appearance of a shot. Camera angle and camera distance have to be decided for each image. For example, in Orson Welles's

Figure 11-11 George Lucas [American, 1944–], *Star Wars* spaceship.
© LucasFilm/20th Century Collection/The Kobal Collection.

Figure 11-12 **Orson Welles** [American, 1915–1985], *Citizen Kane*, 1941. © 1941 RKO Radio Pictures. © Ann Ronan Picture Library, Oxfordshire, UK.

Orson Welles came to Hollywood after gaining fame for his radio dramas, especially his dramatization of *The War of the Worlds,* which chronicled an invasion of New Jersey by Martians. His first motion picture, *Citizen Kane,* tells the story of the rise and fall of a wealthy newspaper mogul, Charles Foster Kane, who fails to win love and find meaning in his life. The movie opens with the hero's death, then without explanation changes to a strident newsreel biography of Kane. The rest of the film is a series of flashbacks prompted by a newsman's search for the real Kane and the meaning of his last word, "Rosebud."

Citizen Kane, now considered by many to be one of the greatest American films ever made, was withdrawn from circulation after only a few showings in New York and Los Angeles. Orson Welles was booed at the Oscar ceremony. His film's stylish innovations in camera work, its complex narrative techniques, and its tragic mood made unusual demands on the audience in 1941.

Citizen Kane (Figure 11-12), the hero is photographed continually from a low point of view so that he towers above the set and appears heroic on the screen. The motion picture photographer also has to balance the composition of every frame with the same principles of design that painters and pho-

tographers use, except that the image usually contains movement that is real rather than implied.

The mise en scène of each moment of film also includes elements that are peculiar to the motion picture camera. The director might speed up the motion—usually for comic effect—or use slow motion to stretch out and savor something that would otherwise happen too quickly for the eye to catch. Slow motion adds grace to the movement of the lovers' embrace or exaggerates the agony of the dying victim of a shooting. The camera itself might move. It might **pan** by turning on its axis and sweeping horizontally across a scene. Panning across the horizon gave a feeling of wide-open space in old cowboy movies. Cameras can **tilt** up and down. Tilting the camera up the side of a tall building emphasizes its height. Another common device is **tracking,** where the camera is pulled on a dolly, running on small tracks. The tracking camera often moves along with the actors, who are also in motion. The cinematographer can rapidly change the focal length of the camera's lens so that it seems to **zoom** toward something on the screen. Professional motion picture cameras are now small enough so that they can be **handheld** by an operator who is moving. The slightly jerky shots made by a handheld camera often give a more personal, intimate, or documentary-like appearance to the image. At the other extreme, cameras can be borne aloft by a **crane,** as when it filmed the makeshift hospital at the railway station in *Gone with the Wind* (Figure 11-13), or the camera can perform a complicated series of movements programmed by a computer.

EDITING

One of the most distinctive and creative parts of filmmaking is the construction of a film out of the shots. This essential procedure, lying at the heart of filmmaking, is called **editing.** Editing means the relating and coordinating of one shot with another. Some people consider editing the essence of film as an art since it is the one important visual technique that film alone possesses and that no other art form can match. The French call the editing process ***montage*** (mounting or assembling), which is perhaps a better word because it stresses the positive aspects of connecting the shots. The English word *editing* suggests to us merely the omission of bloopers and

Figure 11-13 **Victor Fleming** [American, 1883–1949], *Gone with the Wind*, 1939. Metro-Goldwyn-Mayer. © Hulton Archive/Getty Images.

The director Victor Fleming used a memorable crane shot to photograph the makeshift hospital at the railway station in *Gone with the Wind*. The shot occurs after Scarlett O'Hara has gone to the military hospital in besieged Atlanta to find a doctor to help deliver Melanie's baby. The shot begins by focusing on her stepping between the wounded and the dying lying outside the train station. The camera, mounted on a crane, gradually moves up and back to reveal more and more of the railroad yard covered with bodies as far as the eye can see. Without saying a word, the camera contrasts the awesome devastation of the war with the self-centeredness of Scarlett. Meanwhile, the "southern" music on the soundtrack ("Old Folks at Home") makes an ironic comment on the once-proud Confederacy. The lengthy shot ends as a tattered Confederate flag, seen very close to the camera, comes into view to the left of the panorama of devastation on the screen.

unnecessary shots—a negative procedure. However, blunders in filming have usually been discarded before the real editing process begins.

Film editing is primarily a constructive procedure. The director and editors actively choose which parts of the hours of filming finally best fit together. They might even change their mind about what was the best take in the context of the film. Although editing usually takes place after the shooting is over and the actors have gone home, the shooting script or a **storyboard**—sketches of all the individual shots—usually gives a rough idea of the construction of a film from the beginning.

The visual connection or juncture between one shot and another can be made in a number of ways. We are concerned with the visual connection on the screen—not with the physical means of "gluing" one piece of film to another. The image of one shot may grow dim, or **fade** out, the screen turn dark, or sometimes light, and then the image of another shot fade in. The speed at which the fade occurs affects the emotional flow of the film because it can create a quite obvious break between shots. Indeed, it normally creates such a considerable break in the action that it is used infrequently in a typical film. The image of one shot may also merge, or **dissolve,**

Figure 11-14 George Lucas [American, 1944–] *Star Wars* wipe. © LucasFilm.

gradually into the image of another. A dissolve makes the transition to the next shot faster than a fade, but still takes some time to complete.

Editors in some older films liked to employ a **wipe** to make the juncture between shots. A wipe looks as though a windshield wiper blade, moving across the screen, is removing one image while introducing another. The *Star Wars* movies have a greater-than-usual number of wipes to give the films the look of an old-fashioned serial (Figure 11-14). Television sports has played with all sorts of computerized variations on the wipe. A diamond pattern containing the new image might gradually grow larger as it eliminates the old shot. Or the old image may seem to flip off the screen as though someone were rapidly turning the pages of a book.

By far the most common technique of editing is the simple **cut,** in which one shot suddenly ends and the next one immediately begins. The cut instantly joins the old and new images together in the mind. In fact, it mimics the instantaneous sequencing of different images that can take place in the human brain. The close resemblance to human thinking and imagining is probably why cutting from shot to shot in a film rarely seems to us abrupt or unnatural. Cutting is as natural as consciousness itself.

Whatever the means of junction used, editing gives the filmmaker a powerful tool to build a film. More than merely holding the pieces together, it shapes and gives meaning to the whole. To develop the narrative or visual idea, editing functions in a number of ways. Editing may establish purely **visual relationships** between shots. Through editing, the lines, color, light, movement, or any part of the mise en scène of one shot is shown to be similar to—or, by contrast, thoroughly different from—that of the next shot. By stressing the visual relationship between them, editing can relate completely different subjects. For example, a television commercial might show a swimmer diving into a pool and then cut to a spoon plunging, at the very same angle, into a bowl of breakfast cereal. The cut suggests a connection between healthy activity and eating the cereal.

Editing may establish a **pace**—a rhythm or tempo—in a film. To set a pace, editors calculate the shots in a sequence to last on the screen about the same length of time. A series of brief shots tends to correspond to speedier action. A series of longer shots may establish a slower pace. Cuts usually start appearing more frequently in a movie—the shots start getting shorter—whenever the action gets more exciting, as in a chase scene. In *Shrek,* the editing of the action scene shown in the storyboard in Figure 11-15 sets up a very fast pace. Although the editing may establish a pace only for the sake of consistency in a particular part of the film, the pace will have a psychological effect on the viewer. In television commercials the pace of the editing often reinforces the rhythm of the jingle. Music videos always seem to have the same beat going both in the music and in the often frantic pace of the editing.

Editing may also establish **spatial relationships.** The moviegoer will believe that two things are in the same place because the editing has connected them. The film may present a shot of the White House, then cut to a man sitting behind a

Figure 11-15 Storyboard for *Shrek*. © Eric Risberg/AP/Wide World Photos.

And editing may establish **temporal relationships.** It can expand or contract time. The Russian film director Sergei Eisenstein, in the famous "Odessa Steps sequence" from his 1925 film *The Battleship Potemkin* (Figure 11-16), shows a crowd of people rushing down the steps ahead of the Tsarist soldiers firing at them. Eisenstein dramatizes the massacre in shot after shot, quick cut after quick cut, over a period of time that is far longer than the event must have taken in reality. He thus expands the time of the event.

It is more common to telescope time in editing. For example, an actress in one shot might say, "Let's get away from it all!" Then the film cuts to a second shot, of a jet plane taking off. The film cuts again to a third shot, panning the Eiffel Tower, and a fourth shot of the actress eating in a restaurant.

desk. The editing of the film has told the viewer that the man behind the desk is the president of the United States in the White House. In all likelihood, the first shot was filmed in Washington, D.C., and the second shot was filmed 3,000 miles away in Hollywood, California.

Figure 11-16 Sergei Eisenstein [Russian, 1898–1948], stills from the "Odessa Steps sequence," in *The Battleship Potemkin*, 1925. © The Kobal Collection.

Asked to celebrate in film the uprisings of 1905 in Russia that foreshadowed the Revolution of 1917, Eisenstein decided to concentrate on the mutiny aboard the *Potemkin*. The first time he saw the steps in Odessa, he realized that they would be the source of the movement of the massacre sequence, even though the event took place in various parts of the city. To film the panic and slaughter on the steps, he used tracking shots, a camera strapped to the waist of a running man, and several cameras filming simultaneously. In this sequence the camera moves, the actors move, the shots jump from one point to another, and the editing creates a rhythm that is intensely felt by the audience. By editing the shots for the maximum psychological impact of their relationships, Eisenstein transformed Soviet propaganda about the solidarity of the masses against capitalism into profound universal drama.

Through editing, the time it takes to pack, fly across the Atlantic, register in a hotel, and unpack has been condensed to approximately twenty seconds or less. Editing the four shots constructs the journey. It would be absurd to imagine that the filmmaker photographed the entire trip and then, in the editing process, cut out the unwanted parts.

Editing may also establish that different events are happening simultaneously. In one shot, a villain might be threatening the heroine with a fate worse than death. The film suddenly cuts to the hero galloping on a white horse. We understand not only that he is racing to save her but that the two actions are happening at the same time.

Editing, in short, can direct our attention, arouse our emotions, make connections, develop an idea, and further the narrative of a film. Most films do not have a narrator on the sound track telling us the story, but through editing, the camera becomes an omniscient narrator who can go anywhere, see everything, and guide our perception of events. Editing allows the camera to make comments and discoveries for which no dialogue is necessary. If the film cuts from a shot of an actress walking out of a room to a close-up of keys lying on a table, we might imagine that the character has forgotten the keys and is heading for trouble. Many special effects in the movies depend on editing to make them convincing. After a close-up shot of the hero running from his enemy, the film cuts to the hero (this time played by a stuntman) crashing through a glass window, then cuts to another shot of the hero picking himself up from the sidewalk. Editing is often responsible for making the dangerous and daring possible in a film and for making fantasy convincing.

The motion pictures were over thirty years old before sound was added in the late 1920s. Yet sound has a distinctly cinematic potential and enhances a film in a number of ways. Sound in a movie includes speech, music, sound effects, and even the sound of the location. The manipulation of sound and its relation to the visual images is a vital part of the editing process.

The quality of the sound—whether it is loud or soft, high pitched or low—affects the emotions of the audience. Sound quality can suggest an ambience beyond what is actually on the screen. The sound quality of the human voice could suggest that the actress is speaking outdoors in one instance or in another instance in a crowded room, even though both shots were filmed in the same Hollywood studio.

The sound is usually connected with the image on the screen, but sometimes it is not. Sometimes the sound of the next scene appears before the cut to the next shot is made. Or the music from a dance sequence might continue after a cut has been made to the actress driving away in her car. The source of the sound might be visualized on the screen and in the story's space or the source might come from outside the shot. Many films have actors turn on a radio to provide, realistically, music for the sound track. Aside from film musicals, music on a sound track usually occurs only in certain places, such as love scenes or chase scenes, to heighten an emotion. The kind of music—a symphony orchestra or a rock band—has to fit the character of the entire film.

FILM STYLE

Since film is a composite art, no one element can distinguish a good from a bad film. Theatrical, literary, photographic, and even musical elements contribute to the overall achievement or lack of it. The photography in a film may be beautiful, but the acting bad. The acting may be outstanding, but the story trivial. Nevertheless, the visual elements of the mise en scène, the shot, and the editing engulf every element in the final analysis. They are decisive in determining whether the film is a coherent and consistent whole that achieves its desired effect. A mobile and moving camera, visible on screen as edited shots, unfolds the story and develops ideas, attitudes, and feelings while captivating and moving imagery delights the eyes. Throughout the film there is consistency, with variety, about the camera work, the lighting, the color scheme, and most importantly the pacing. No shot is wasted; no shot distracts. Every shot is just the right length and helps build the narrative. To achieve such coherence, the director has to impose a design or style from beginning to end. In the hands of directors such as Orson Welles, Alfred Hitchcock, or, more recently, Tim Burton (Figure 11-17), the style of the camera work and the style of the editing have a distinctive signature that betrays a unique personality.

 Figure 11-17 Tim Burton [American, 1958–]. *Big Fish*, 2003. © Columbia/Tri-Star/The Kobal Collection.

12 Sculpture

THE NATURE OF SCULPTURE

Reclining Figure: Angles (Figure 12-1), the work of British sculptor Henry Moore, clearly demonstrates the importance in sculpture of solids and voids. Moore deliberately exaggerated the knees, hips, and shoulders of his figure so that we recognize without fail their projection into space. In addition to the big, bulky masses that jut out at differing angles, he created cavities between and under the legs and arms and the great void between the torso and the knees. The visual relationships between the masses and voids of *Reclining Figure: Angles* shift and change as the viewer moves around the figure.

The reclining female figure was Moore's favorite theme throughout his long career because he liked the naturally swelling masses of the female form. His sculptural forms approach the naturalness of time-worn rocks and caverns; they can be compared to a landscape with mountains and valleys. Moore was also impressed by the grandiloquent sculpture from the Athenian Parthenon in the British Museum in London (see *Three Goddesses,* Figure 2-8).

As Moore's *Reclining Figure* makes evident, the art of sculpture creates solid objects that take up real space. Sculpture has real **mass**—that is to say, solid forms and three-dimensional shapes that have weight and project themselves into space. Sculpture also shapes space itself. The empty spaces between the masses create **voids** that are an essential part of the experience of sculpture. Sculptural masses can

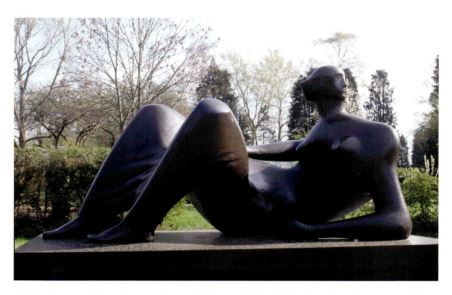

Figure 12-1 **Henry Moore** [British, 1898–1986], *Reclining Figure: Angles,* 1979. Bronze, over-life-sized. Henry Moore Foundation.

also reach out and take possession of the space around them.

Sculptural mass constitutes not just something we see with our eyes but something we can feel with our bodies as well. Sculpture is actually present in real space; it creates a duplicate of reality that shares the space we physically inhabit. The experience of sculpture restores for us the feelings we had as an uninhibited infant, crawling on the floor, exploring the shape, texture, and weight of every new thing we could handle, plus the gaps in between. Sculpture repeatedly reminds us of what we essentially are, a body in space.

THE VISUAL ELEMENTS IN SCULPTURE

The human eye tends to follow lines created by the thrust of three-dimensional masses. In Moore's *Reclining Figure: Angles,* the projection of the massive

Figure 12-2 Style of Phidias [Greek, ca. 490–430 BCE], detail of *Three Goddesses*, 448–431 BCE. Marble, over-life-sized. From the east pediment of the Parthenon. British Museum, London. © Scala/Art Resource, NY.

Light reflected from sculpture has a variety of characteristics. Polished white marble captures the most subtle shadows whereas polished bronze appears glossy and accentuates the light. Marble is also slightly translucent—in other words, light can penetrate a short way through the surface before it is reflected. Chisel marks left by a sculptor in a stone carving mute and soften the surface light; lumpy clay surfaces fragment the light. Modern sculptors exploit the gleam of polished aluminum and the hidden shadows of rusty steel.

It was long assumed that sculpture lacked color. For many

limbs generates movement in a certain direction into space. Figural sculpture places special importance on the lines of contrapposto—the counter-thrusts resulting from the weight shift of the *Spearbearer* (Figure 2-7) or from the torsions of Michelangelo's figures (see *Awakening Slave,* Chapter 6, page 137).

Lines are also formed by the edges and grooves of the sculpture, especially in the folds of the drapery. In *Three Goddesses* (see Figure 2-8 and detail, Figure 12-2), drapery stretched tightly over the prominent knees reveals the underlying masses and accentuates their roundness. Between the massive knees appear lines of tension as these masses pull against the cloth. Drapery folds also accentuate the mass of the thighs by flowing around them in curved lines, in effect modeling the masses.

Although some sculptors try to imitate a particular material that falls and wrinkles in a certain way, others habitually create drapery in a personal manner no matter what the natural material might be. The Greek sculptor Phidias invented drapery folds that seem to ripple like water as they flow around solid forms. In most of his sculpture, including *Virgin and Child* (Figure 12-3), the German sculptor Tilman Riemenschneider employed drapery that breaks at right angles and folds in sharp creases—more like heavy aluminum foil than any ordinary cloth. These distinctive folds become the sculptor's signature.

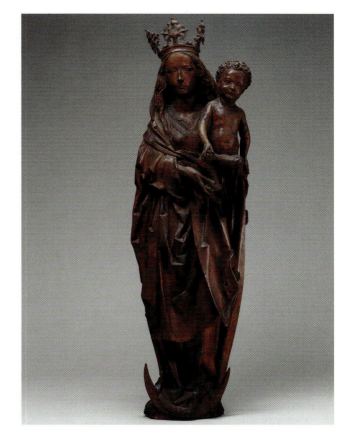

Figure 12-3 Tilman Riemenschneider [German, ca. 1460–1531], *Virgin and Child,* ca. 1490–1495. Limewood, 47 1/2 in. (120.7 cm) high. Museum of Fine Arts, Boston. Gift in memory of Felix M. Warburg by his wife Frieda Schiff Warburg, 41.653.

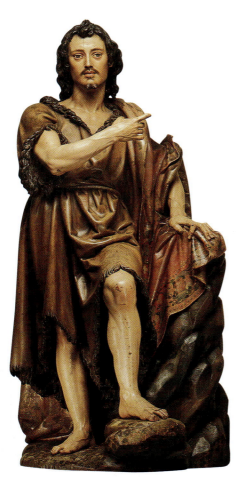

Figure 12-4 **Juan Martínez Montañés** [Spanish, 1568–1649], *Saint John the Baptist*, ca. 1630. Painted wood, 61 in. (154.9 cm) high. Metropolitan Museum of Art, New York.

tween art and life, color attracts the eye and forces further examination of the sculptor's transformation of reality. Some modern sculpture is once again painted in full color—for example, Viola Frey's *Questioning Woman* (Figure 12-19) and Duane Hanson's *Jogger* (Figure 12-23a). Color is now free to add its space-creating potential and its sensuous appeal to sculpture.

In sculpture, the design principle of balance takes on a special significance since we intuitively have a sense of a work's physical stability—or lack of it. Richard Serra often employs large pieces of steel, as in *Tilted Arc* (Figure 12-5), which seems to be in danger of falling. In traditional figural sculpture we instinctively understand how the symmetrical human body achieves balance when any of its masses are displaced. Late in his career, the French Impressionist painter Edgar Degas modeled figures of dancers in wax, conceiving fully three-dimensional forms twisting and thrusting out into space in several directions. In *Dancer Looking at the Sole of Her Right Foot* (Figure 12-6), a bronze casting of his wax figure, Degas chose not some classic ballet posture but an unguarded, potentially awkward moment that sprang from a spontaneous, mundane action. (The poor model had to hold this pose for Degas!) The nude figure throws her left leg, hip, torso, and head into a continuous curve to balance her projecting limbs. The foot on the floor lies under the center of gravity.

A PUBLIC ART

Because sculpture is often made of metal or stone, it can be placed out of doors—on the facade of a building or in any open space. Like architecture, sculpture's exposed presence makes a public statement. As a consequence, institutions and communities have called on sculpture to fulfill the same task time and again: to make tangible the gods and heroes of the society.

Examples of sculpture in this public role are not hard to find. The **pediments,** the triangular gables at either end of the Parthenon in Athens, had splendid sculptural groups of Athena and other gods and goddesses (see *Three Goddesses,* Figure 2-8) that told the essential myths of the foundation of the city. In the Christian Middle Ages, teams of sculptors carved dozens of statues of saints and the sacred

centuries, sculptors confined themselves to the pure white of marble or the several colors of **bronze,** which is an alloy of copper and tin. When the Renaissance rediscovered the sculpture of Greece and Rome, they saw no paint on it and concluded that true sculpture was without color. They thought color would detract from the beauty of pure sculptural forms.

But they were mistaken: sculpture in ancient times did not lack color. The Greeks normally painted their sculpture, and statues in the Middle Ages were also frequently painted. Sculpture from around the world—masks from North America, Africa, and Japan, for example—was customarily painted. Color stimulates our awareness of the physical actuality of sculpture, a phenomenon demonstrated clearly in Juan Martínez Montañés's *St. John the Baptist* (Figure 12-4). Narrowing the gap be-

Figure 12-5 **Richard Serra** [American, 1939–],
Tilted Arc, 1981. Hot-rolled steel, 12 × 120 ft. (3.7 ×
36.6 m). Installed Federal Plaza, New York City by the General
Services Administration, Washington, D.C. © Mario Carbrera/
AP/Wide World Photos. © 2006 Richard Serra/Artists Rights
Society (ARS), New York.

The General Services Administration of the federal government,
under its Art-in-Architecture Program, commissioned *Tilted Arc*
from Serra specifically for the plaza in front of the Javits Federal
Building in lower Manhattan. Serra erected there a thick, single,
curved slab of steel, twice human scale. *Tilted Arc* leaned omi-
nously to one side and created a wall that bisected the plaza
and deliberately contradicted the plaza's curved design. The
threatening intrusion of *Tilted Arc* called attention to the force-
ful experience of its leaning and curved form in space. A work
of art, integrated into a particular location, can be called **site
specific.**

The office workers in the federal building did not like the piece,
and they petitioned to have it removed. The storm of contro-
versy that raged around its removal raised numerous artistic and
legal issues, especially since the removal of a work designed for
a specific site destroys the work's meaning. Many in the arts
community claimed that an artist has a right to the preservation
of his or her work even though someone else owns it. Serra
filed suit, claiming that mutilation of an artist's work violates
freedom of speech. The incident raised the larger question of
whether the members of the taxpaying public, who commission
art, have a right to "censor" a work they do not like. Even
though Serra lost his lawsuit and *Tilted Arc* was put in storage,
the questions surrounding it have not been given final answers.

Figure 12-6 **Edgar Degas** [French, 1834–1917], *Dancer
Looking at the Sole of Her Right Foot*, 1896–1911. Bronze,
18 in. (46 cm) high. © Réunion des Musées Nationaux/Art
Resource, NY.

Figure 12-7 **Maya Ying Lin** [American, 1960–], *Vietnam Veterans Memorial*, 1981–1983. Granite, each wing 246 ft. (75 m) long. Washington, D.C. © Frank Fournier/Contact Press Images.

When the twenty-one-year-old Maya Ying Lin submitted her proposal for a memorial sponsored by Vietnam veterans, she wrote that "the memorial appears as a rift in the earth—a long, polished black stone wall, emerging from and receding into the earth."[1] The grass eventually grew over the cut, but the wound remains—the loss of 58,226 men and women whose names are inscribed on the wall. They are listed in the order of their death or disappearance from 1959 to 1975, beginning at the right of the intersection of the two wings and ending at nearly the same spot, to the left of the intersection.

The two wings are aligned with the Washington Monument on the right and the Lincoln Memorial on the left. The alignment connects the veterans with two of America's greatest heroes. Visitors descend into the earth with those commemorated there, and as they scan the thousands of names, they are reflected in the polished black granite. The present is joined with the past. The Vietnam Veterans Memorial has become a national shrine where visitors have left thousands of mementos in an attempt to heal the trauma of the war in their own lives and that of the nation.

ancestors of the community for the porches of Gothic cathedrals. In the Middle Ages and the Renaissance, countless tombs with figural sculpture, often placed inside the church, celebrated the memory of noteworthy individuals. The tradition of erecting public monuments and memorials in sculpture is a long one.

Indeed, public sculpture is thriving in the contemporary art world. Throughout the United States and many other countries it is not hard to find large-scale pieces situated in or on public buildings or in the open spaces of cities. Washington, D.C., the nation's capital, is dotted with sculpture memo-

rializing the nation's heroes and heroines. For some years Maya Ying Lin's *Vietnam Veterans Memorial* (Figure 12-7) has been the most popular attraction in Washington. The stark V-shaped black granite slab, half sunken into the earth and inscribed with the names of the dead, exercises a strange power over visitors. Federal, state, and local governments often allocate a percentage of the cost of a new building toward art, including a prominent piece of sculpture. This was the case with Richard Serra's ill-fated *Tilted Arc* (Figure 12-5), commissioned for a federal office building in New York City.

Figure 12-8 [Japanese], *Amida Butsa, the Great Buddha*, 1252. Bronze, 37 1/3 ft. (11.4 m) high. Created under the patronage of samurai Yoritomo. Kotoku-in, Japan. © Werner Forman/Art Resource, NY.

IMAGERY

Considering the commemorative role that sculpture often has to play, it should come as no surprise that the favorite iconography of sculptors has been the human figure. Greek and Roman sculptors carved their gods and goddesses in human form. For a long period of time, Indian, Chinese, and Japanese sculptors have made statues of Buddha, including the enormous bronze *Amida Butsa, the Great Buddha* (Figure 12-8) at Kamakura, Japan. This Buddha sits in a restful position, meditating in order to free himself from earthly desires and to achieve perfect peace and happiness, or nirvana. For centuries, Christians carved statues of Christ and the saints for veneration and inspiration. Even in prehistoric times, sculptors represented the human figure in keeping with their beliefs. Although the *Venus of Willendorf* (Figure 12-9) does not, as its name im-

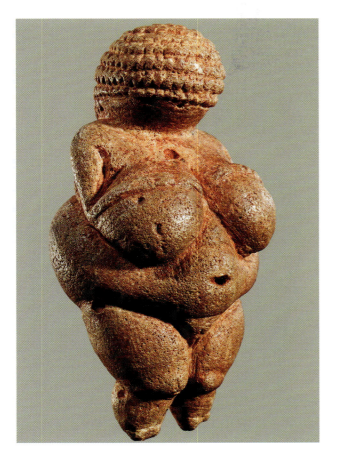

Figure 12-9 *Venus of Willendorf*, twenty-fifth millennium BCE. Limestone, 4 1/2 in. (11.4 cm) high. Naturhistorisches Museum, Vienna. © Archivo Iconografico, S.A./Corbis.

This very small piece of sculpture from the Stone Age is thousands of years older than the splendid cave paintings discovered in Spain and France. Those cave paintings represent animals almost exclusively, whereas the earliest European sculpture represents the female human figure more than any other subject. The paintings are remarkably true to nature, but the sculpture distorts physical features for symbolic purposes. The sculptor inflated the breasts, hips, and abdomen—the areas of fertility, sexuality, and maternity. The faceless head wears a stylized cap of hair. The arms, folded over the breasts, are barely incised on the torso; the legs taper toward the missing, inconsequential feet. Only the swelling of rounded masses seems to have meant anything to the sculptor, who may have felt that the bulbous stone had the power to ensure the changes due to pregnancy in female members of the tribe.

horse (Figure 12-10). Falconet imagined that the emperor has just charged up a rocky prominence and, as his horse rears up dramatically, raises his hand over his people to assure them of his protection. The wild pose of the horse and the relaxed attitude of the rider give the statue energy and authority.

Portrait **busts,** which show only the head and shoulders or chest, have always been popular, even though it must be rather difficult to capture the likeness of someone in a hard, white material such as marble. The Baroque sculptor Gianlorenzo Bernini did not hesitate to manipulate the flesh of his portraits in marble to produce a fluid surface so that it would catch some light and create some shadow and thus *appear* to come alive. Bernini observed that a person who sits still for a long time loses the traits that make the person an individual. To capture a likeness of Cardinal Scipione Borghese in stone (see Figure 12-11a), Bernini had the cardinal move

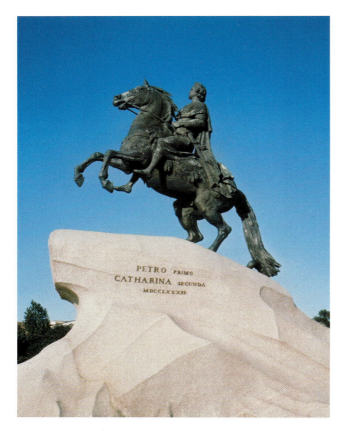

Figure 12-10 **Étienne-Maurice Falconet** [French, 1716–1791], *Monument to Peter the Great*, 1782. Bronze. Head modeled by Falconet's associate Marie-Anne Collot. St. Petersburg, Russia. © Giraudon/Art Resource, NY.

plies, depict the Greek goddess Venus or probably any deity, it must have embodied the beliefs of the community.

Sculptors sometimes depict animals other than the human animal. Many cultures around the world have expressed the natural powers of bulls, birds, and lions in sculpture. Horses have been very common subjects, especially in the days when the horse was the major means of transportation. Many older cities feature an **equestrian monument,** which is a statue of a horse ridden by some famous hero or heroine who led the nation to victory.

In an equestrian monument, the sculptor has to decide the pose and expression of the horse, as well as those of the rider. If the horse exhibits a certain gait, the sculptor has to balance the weight of the horse and the rider on three or perhaps only two legs. The eighteenth-century French sculptor Étienne-Maurice Falconet designed the most famous statue in all of Russia, Peter the Great on his rearing

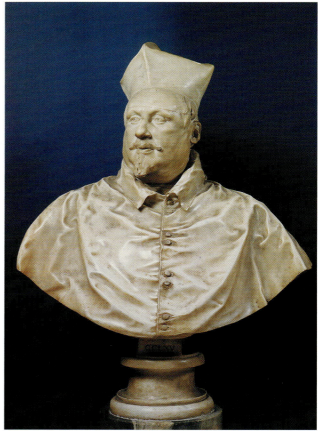

Figure 12-11a **Gianlorenzo Bernini** [Italian, 1598–1680], *Cardinal Scipione Borghese*, 1632. Marble. Galleria Borghese, Rome. © Scala/Art Resource, NY.

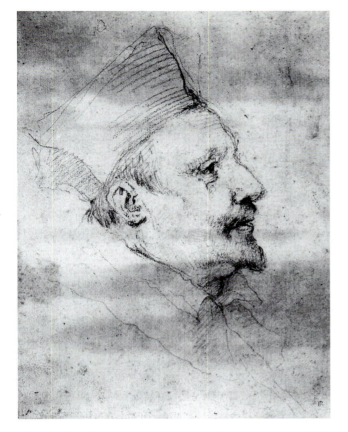

Figure 12-11b **Gianlorenzo Bernini** [Italian, 1598–1680], *Cardinal Scipione Borghese*, 1632. Red chalk over graphite, 9 15/16 × 7 1/4 in. (25.3 × 18.4 cm). © Pierpont Morgan Library/Art Resource, NY.

Figure 12-12 **George Walkus**, [Kwakiutl], *Dance Mask*, 1938. Wood, carved and painted, cedar bark, 47 in. (119.4 cm) long. Denver Art Museum. Collection: Native Arts acquisition funds, 1948.229. © Photo by the Denver Art Museum. All rights reserved.

around and talk while Bernini made sketches of him (see Figure 12-11b). When he carved the marble, Bernini was thoroughly familiar with the cardinal's animated features.

If portraits reproduce the features of an actual person, **masks** that cover the face or head allow someone to impersonate a totally different persona—perhaps even that of a spirit. Masks are affiliated with the worlds of theater and religious ritual, where they are worn in a performance. Chinese and Japanese and Greek and Roman theater employed masks. Black Africans and Native North Americans have extensive traditions of mask making closely tied with life's rituals. *Dance Mask* (Figure 12-12) represents the fearful bird spirits that guard the Man-Eater at the North End of the World. Masks hide the identity of the wearer and imbue the performer with the powers of another. In general, then, mask makers are concerned not with the imitation of reality but with the expression of the forces within the adopted persona.

Dance Mask was worn in the Hamatsa society's winter ceremonial dances of the Kwakiutl people living on the northwest coast of North America, in British Columbia. Initiates into the Hamatsa society had to confront guardian bird spirits. The dance reenacted the killing of the Man-Eater and the revival of dead tribespeople. The Man-Eater symbolized the mouth of a river that annually devoured the salmon.

This single mask contains four bird spirits pointing in three different directions. The beaks project far from the face, and the lower part is movable to make the bird spirits more frightening. The dancer could manipulate one or all the beaks by strings. Red lines accentuate the mouth and the flair of the nostrils. Black and white lines accent the curves of the beak. Within the confines of a tradition, the artist has displayed a sensitivity to mass and void, line and color.

TYPES OF SCULPTURE

Reclining Figure: Angles (Figure 12-1) by Henry Moore is sculpted fully **in-the-round.** In other words, it is freestanding and finished both back and front so that a person can walk all around it to

Figure 12-13 **Desiderio da Settignano** [Italian, 1428–1464], *Saint Jerome in the Desert*, ca. 1460. Marble relief, 16 15/16 × 21 5/8 in. (43 × 54.9 cm). National Gallery of Art, Washington, D.C. Acc.#1942.9.113.

that they lie deeper in space. Trees diminish in size into the distance, and clouds in the sky are suggested merely by random scratches on the surface.

Relief sculpture such as *Saint Jerome* resembles painting in its openness to different kinds of iconography like landscape and in its use of pictorial effects like perspective. In addition, relief sculpture may give the sensation of recession in space by variations in the depth of relief, as *Saint Jerome* does. The device works because a decrease in depth produces less contrast of light and dark and thus simulates the decreased chiaroscuro of atmospheric perspective in painting and drawing.

Other variations on the relief method are possible. Ancient Egyptians, for example, liked a distinct form of relief, illustrated in *Portrait of Akhenaten* (Figure 12-14), in which the carving

observe it. As one examines a piece in-the-round from different points of view, the masses and voids can easily shift into new and revealing relationships. Unlike Moore's work, not every piece made in-the-round looks good from every point of view. Usually, when figures are carved for niches in a wall, they might be executed in-the-round but are not designed to be seen from the back.

Desiderio da Settignano's *Saint Jerome in the Desert* (Figure 12-13) illustrates another kind of sculpture, called **relief,** in which the work projects from a background. The surface of almost any relief does not extend physically very far into space, although the relief itself can be described as high or low. Low relief, often referred to by the French term *bas relief* (pronounced bah relief), and high relief are thoroughly relative terms. A protrusion of two inches above the surface in a small piece might be considered high relief; a protrusion of two inches in a large-scale work might be low relief.

Desiderio treated the marble slab of his relief *Saint Jerome* like a canvas on which he depicted a landscape and a little story. In the center of the composition, St. Jerome is kneeling in rapt adoration of the crucifix. Behind him, the lion who became his mascot chases away a very frightened intruder. Although the saint protrudes somewhat from the surface, the lion and fleeing man are barely raised, as an indication

Figure 12-14 [Egyptian]. *Portrait of Akhenaten*, ca. 1360 BCE. Limestone relief, 13 11/16 × 9 3/16 × 1 3/4 in. (34.8 × 23.3 × 4.5 cm). The Metropolitan Museum of Art, Fletcher Fund, 1966, and The Guide Foundation Inc., Gift. 1966 (66.99.40). Photograph, all rights reserved, The Metropolitan Museum of Art.

Figure 12-15 [Mayan], relief from Pyramid of the Feathered Serpent, after 800 CE. Xochicalco, Mexico. Photo: David R. Hixson.

sinks the figure into the slab instead of removing the background. The Egyptian method emphasized the outline of the figure by, in effect, doubling it. Caught in a raking light, the depression in *Portrait of Akhenaten* causes dark and light outlines around his face and head cloth. Recessing the portrait into the stone, the sculptor still builds forms by swelling masses and sinking voids.

Unlike the gradually swelling reliefs of Renaissance and Egyptian sculptors, the majority of reliefs carved by Mayan artists are flat along their outer surface. One example, a relief from the Pyramid of the Feathered Serpent (Figure 12-15) at Xochicalco (pronounced show-chee-*cal*-co), near Cuernavaca in Mexico, portrays an enormous serpent god with squatting noblemen framed in the serpent's undulations. The relief stands out from the surface like raised letters on typewriter keys. It thus has two flat surfaces—the recessed background and the basically flat upper surfaces of the serpent and human. Although the Mayan relief stands out starkly, aided by strong light and dark contrasts, it still respects the surface of the wall. Instead of dissolving the wall in a pictorial illusion, this kind of bold relief strengthens the appearance of the wall's thickness.

Inspired by reliefs on Mayan and Aztec architecture, Louise Nevelson constructed numerous reliefs that appear to be both raised from the back and recessed into the front surface. Stacking many boxes of similar dimensions in her work *Reflections of a Waterfall I* (Figure 12-16), Nevelson

Figure 12-16 Louise Nevelson [American, 1900–1988], *Reflections of a Waterfall I*, 1982. Centre Pompidou-CNAC/MNAM/Dist. Réunion des Musées Nationaux/Art Resource, NY © 2006. Estate of Louise Nevelson/Artists Rights Society (ARS), New York.

Nevelson collected old pieces of wood—rejected fragments of urban life such as shafts of columns, chair and table legs, and bits of decorative molding—which she most often painted a flat black so that the various found parts are brought together into a unity and the formal properties of the piece are heightened. She intuitively arranged the found pieces in boxes stacked one on top of the other. The solid shapes in each box both stand out from the far surface and sink into the shadowy depth of the box. The paradoxes of utilitarian objects and an intuitive design, of regularity and irregularity in the design itself, of flatness and a rich array of masses and dark voids, make Nevelson's work appear mysterious—like the indecipherable hieroglyphs on the walls of an ancient ruin.

also created a flat wall. In other words, the front plane of her relief is very pronounced along with the murky space behind it. Her relief both projects from the back plane and sinks away from the front plane.

Another way of categorizing sculpture is to ask whether the artist adds to the material or subtracts from the material when making the sculpture. Leon Battista Alberti first made this distinction in his book *De statua (On Sculpture),* written about 1435. Taking lumps of clay and forming them into a head is an example of **additive sculpture.** Taking a block of stone and eliminating part of it with a chisel is an example of a **subtractive** process. Some sculptors have preferred one method over the other. Michelangelo insisted that the subtractive process of carving defined the essential activity of a sculptor. In his mind, the additive process duplicated the activity of a painter.

Some people have maintained that a different mental outlook governs each process and that the results of the additive process ought to look different from the results of the subtractive. But the consequences of the distinction are hard to demonstrate in practice. In fact, many subtractive statues are based on additive models that the sculptor executed beforehand, perhaps in clay. A sculptor's small "sketch" in clay or wax is called a **maquette.** Henry Moore usually made small clay models of his large-scale stonework so that he could readily turn the maquettes in his hands and carefully examine their forms from every angle. In other words, the important first moments of his artistic inspiration involved the process opposite to that used for the finished product.

TRADITIONAL MATERIALS AND TECHNIQUES

Although sculptors constantly translate their work from one material to another, different materials require different techniques, and some visual effects are possible or, at least, easier in one material or another. Louise Nevelson could never have invented her painted wooden boxes in *Reflections of a Waterfall I* (Figure 12-16) if she

Figure 12-17 [Peruvian, Moche], *Portrait Vessel,* ca. 100 BCE–500 CE. Ceramic, 10 1/4 (26 cm) high. Art Institute of Chicago. The Kate S. Buckingham Endowment (1955.2338).

had been confined to stone carving. The lumpiness of Rodin's figures, such as his *Monument to Balzac* (Figure 12-21; see page 252), initially modeled in clay and in plaster, distinguishes them from the chiseled marbles of Michelangelo despite the affinity that Rodin had for Michelangelo's style.

Modeling, or shaping forms with clay or wax, is an old technique found in most ancient civilizations. Peruvian potters of the Classical period, about 250 BCE to 750 CE, often made vessels of clay in animal or in human form, as in *Portrait Vessel* (Figure 12-17). They cleverly amalgamated the swelling of the vessel with the masses of a human head. Soft and pliable clay, wax, or modern plastic equivalents are easy to manipulate compared with stone. Clay and wax can be pinched, squeezed, kneaded with the hand, or shaped with tools. Extra lumps or rolls of

Figure 12-18 **Luca della Robbia** [Italian, 1399/1400–1482], *Madonna and Child.* Enameled terra cotta, 19 1/2 in. (49.5 cm) high. Detroit Institute of Arts.

Figure 12-19 **Viola Frey** [American, 1933–], *Questioning Woman*, 1999. Glazed ceramic, 89 × 27 × 31 in. (226 × 68.6 × 78.7 cm). Nancy Hoffman Gallery, New York.

the material are added as the work progresses. An **armature,** a skeletal bracing within the clay or wax, is frequently needed to support the soft material before it hardens. Since mistakes can be corrected, modeling materials provide the sculptor with the closest thing to a three-dimensional sketching medium.

Clay can be made hard and permanent by firing it in a kiln. The result is known by the Italian words **terra cotta** (baked earth). Kiln-fired works of any kind, whether sculpture or pottery, may be called **ceramics.** In the Renaissance, three generations of the della Robbia family from Florence became well-known for their charming religious work in terra cotta. In *Madonna and Child* (Figure 12-18), Luca della Robbia applied to the clay colored **glazes,** which are glass-like coatings baked right onto the clay.

Ceramic sculpture again became popular in the 1980s. A number of West Coast sculptors have mod-eled in their preferred medium of clay, even though they work on the scale of life. Their imagery and techniques often derive from popular culture or affect the deliberately simple look of a modern amateur artist. Viola Frey's seven-foot-tall *Questioning Woman* (Figure 12-19) captures a child's sensation of a towering adult. Animation comes from the garish color liberally laid on the figure with dabs and crude lines that usually accentuate the swelling masses.

Carving wood or stone with hammer and chisel is also an old technique. Sculptors' tools include punches, flat and claw-toothed chisels, saws, drills, abrasives, and today all kinds of power tools, including lasers. Stone sculptors have long preferred marble, a metamorphic rock that is hard yet pliable enough for subtle carving. The ancient Egyptians, who were greatly concerned with permanence, often carved in harder igneous stones such as granite or basalt that lend themselves to a style of large simple forms and smooth polished

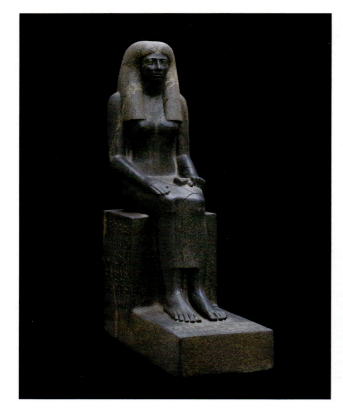

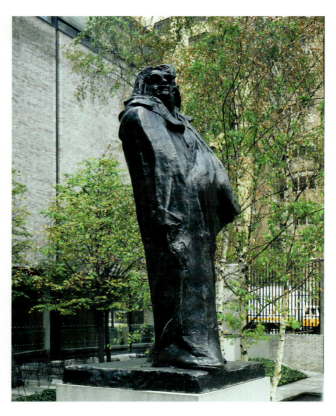

Figure 12-20 [Egyptian, Middle Kingdom, Dynasty 12, reign of Senwosret I], *Statue of Lady Sennuwy*, 1971–1926 BCE. Granodiorite, 67 11/16 × 45 7/8 in. (172 × 116.5 cm). Museum of Fine Arts, Boston. Harvard University–Boston Museum of Fine Arts Expedition, 14.720.

Figure 12-21 Auguste Rodin [French, 1840–1917], *Monument to Balzac*, 1898. Bronze (cast 1954), 9 ft. 3 in. (282 cm) high. Museum of Modern Art, New York. Digital image © The Museum of Modern Art. Licensed by Scala/Art Resource, NY.

surfaces. In the statue of *Lady Sennuwy* (Figure 12-20), carved in a kind of granite, the subject sits bolt upright, her hands on her thighs. The uncarved part of the block of stone becomes her throne. Every mass of the throne and figure lies at right angles to every other. Her limbs, torso, and wig have been generalized into cylindrical forms. Since so many Egyptian statues carved in different materials seem to have the same rigid style, it is impossible to determine which came first, a material suited to a certain kind of carving or a style that preferred the material.

Casting in a permanent material such as bronze goes back several millennia. The process of casting requires molds into which the molten metal can be poured. The molds themselves are usually formed around a clay or plaster model, as was Auguste Rodin's *Monument to Balzac* (Figure 12-21). In short, most cast statues began with modeling. Bronze may be polished to a mirror-like surface or

When Auguste Rodin's statue *Balzac* was rejected by the French literary society that commissioned it, he kept the work for himself. At his death in 1917, Rodin left the original plaster version to the French state. Under the care of the Musée Rodin in Paris, twelve bronze castings of Balzac were made—the first in 1930—by the foundry of Alexis Rudier, who had worked with Rodin since 1902.

No other work of his satisfied Rodin as much or summed up so profoundly what he believed in as an artist. Rodin imagined the writer Honoré de Balzac wrapped in a voluminous dressing gown and striding across his room in the throes of inspiration. Imperious yet almost shapeless, the powerful figure thrusts up and back from his tall pedestal. By exaggerating the masses and voids, Rodin captured the genius of the writer rather than his appearance.

allowed to tarnish. When it is exposed to certain chemicals or to the weather, it oxidizes and forms a brown or greenish **patina.** This thin film is usually desired because it protects the bronze from further oxidation.

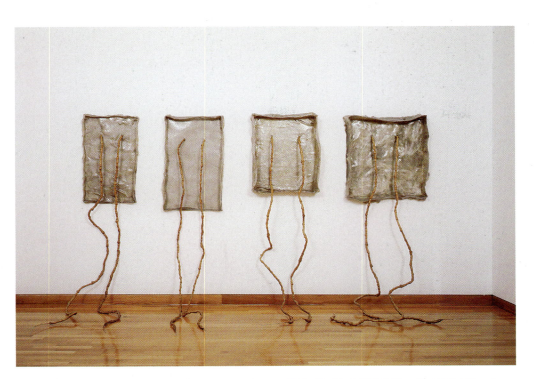

Figure 12-22 **Eva Hesse** [American, 1936–1970], *Untitled ("Wall Piece")*, 1970. Fiberglass over wire mesh, latex over cloth and wire. Four units, each approximately 40 × 30 in. (102 × 76 cm). Purchased with funds from the Coffin Fine Arts Trust; Nathan Emory Coffin collection of the Des Moines Art Center, 1988. © Estate of Eva Hesse.

Since a large amount of solid bronze can get heavy and expensive, a large-size bronze statue will have a hollow center. Rodin's statue of the great French writer Honoré de Balzac is hollow because it was cast in bronze by the **lost wax process** (*cire perdue* in French). The secret of this process is to create two molds, an inner core and an outer shell, kept apart by a suitable thickness of wax. When the molds are heated, the wax melts, runs out the bottom, and leaves a gap between the outer shell and the inner core. Molten bronze poured in through a hole at the top replaces the wax between the two molds and fills the gap. The idea of the lost wax process is simple; however, the execution is quite difficult and requires the collaboration of a team of skilled workers, as does most bronze casting. Therefore, large-scale metalworks are often cast in pieces, **Plaster** **VIDEO** which are then welded together. **casting**

MODERN TRENDS
New Materials

In the twentieth century, sculptors began working with new metals, plastics, or any other material that suited their imagination. The new materials opened up new possibilities of style. Mostly, the new materials opened up new possibilities of self-expression. Some sculptors feel that these new materials, because they belong to contemporary society, better reflect the modern age of technology and rapid change than do traditional marble or bronze. In modern times, sculptors work with even the most commonplace materials.

In the late 1960s, Eva Hesse turned to fiberglass, a polymer of polyester resins, which allowed her to shape the shallow boxes in her work *Untitled ("Wall Piece")* (Figure 12-22) in a free yet permanent fashion. Hesse had a short-but-influential five-year career as a sculptor. In *"Wall Piece"* the luminous windows, trays, or pictures of fiberglass clearly reflect their rough shaping by her hands. In contrast, two rubbery latex cords from each box reach out across the floor in a haphazard fashion determined by whoever installs the piece. Through them, her shallow frames invade the viewer's space.

Duane Hanson produced sculpture by the traditional casting process, but the material he used for

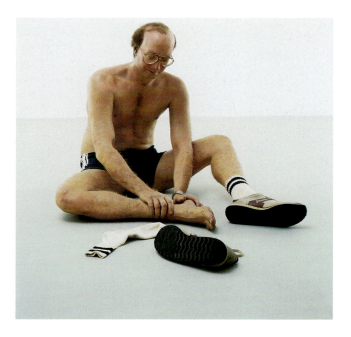

Figure 12-23a **Duane Hanson** [American, 1925–1996], *Jogger*, 1984. Polyvinyl, polychromed in oil, life-sized. Saatchi Gallery, London. Art © Estate of Duane Hanson. Licensed by VAGA, New York.

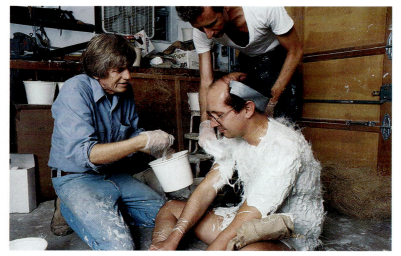

Figure 12-23b Duane Hanson making casts of *Jogger*.

Jogger (Figure 12-23a) was polyvinyl plastic, not bronze. Hanson formed the molds for his jogger from plaster casts of a living human being (see Figure 12-23b); then he poured into the plaster molds the modern material in liquid form. In addition to the painted plastic material of the figure's body, the work includes natural hair, clothing, shoes, and props taken from the real world. Beyond the startling realism of the piece, Hanson was just as concerned with the meaningful arrangement of masses and voids in space as are sculptors using traditional materials. Because of its realistic presence, Hanson's work also gets off its pedestal, so to speak, and inserts itself in the viewer's space.

Artists sometimes simply find objects that are already made and combine them, rather than shaping raw material into sculptural form. This sort of work has been called **found object sculpture.** The sculptor's appropriation of the found material asserts that he or she can transform everyday objects into art. Marcel Duchamp started the trend of found sculpture with work such as *Fountain* (Figure 1-21). The sculptor Louise Nevelson included pieces of ordinary building materials and other common items in her high relief of stacked boxes, *Reflections of a Waterfall I* (Figure 12-16). The pieces she "found" were cut and assembled when they were incorporated into her abstract compositions. The usual word for her kind of construction is **assemblage** (pronounced like *collage*).

Nevelson's work makes it clear that clay is not the only material that can be added to and built up to form a piece of sculpture. Metal constructions have

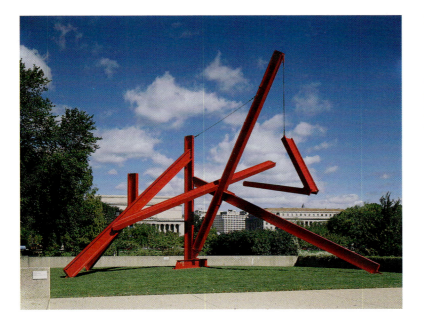

been quite popular in the modern era. Mark di Suvero assembled *Are Years What? (for Marianne Moore)* (Figure 12-24) with gigantic steel I-beams, normally used for industrial structures. Instead of forming the horizontals and verticals of a building, these beams intersect along mostly diagonal lines in di Suvero's work. The beams touch the ground like the long legs of a spider so that the space between them is left open for exploration. One beam, folded at an acute angle and suspended from a cable attached to a mock crane, twists in the wind. *Are Years What?* makes heavy steel beams dynamic and light. Modern sculptors such as di Suvero or Nevelson are as likely to have a welding torch, glue, or hammer and nails in their hands as a hammer and chisel.

Mixed Media

Artists around the globe are experimenting with new forms of sculpture, combining materials in works of mixed media. Modern artists love to break down the boundaries between one art form and another and combine them, blurring even the distinction between architecture and sculpture. Some sculptors transform the whole of an interior space to create an **environment** into which the viewer enters and moves and which then surrounds the viewer on all sides. In Judy Pfaff's environment *Neither Here Nor There* (Figure 12-25), installed in the Ameringer & Yohe Fine Art gallery in New York, metal tubes and wooden slats create a latticework from floor to ceiling inside the

(text continued on page 259)

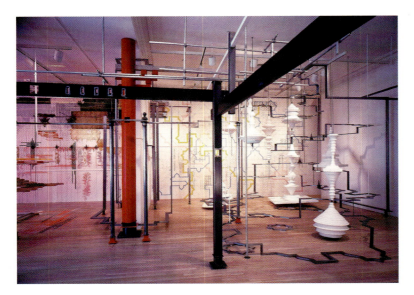

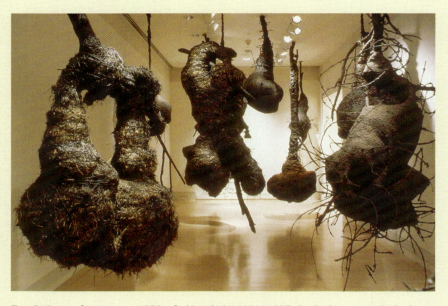

Petah Coyne [American, 1953–], *Untitled #465A*, 1987. Barbed wire, steel, chicken wire, mud, wood, hay, cloth, clay, polymer, tar, paint. Installation at Whitney Museum of American Art at Equitable Center, New York. Photograph by Steven Rubin.

Petah Coyne developed a personal style of sculpture in which she suspended large-scale masses of organic materials such as tree branches, hay, and mud from the ceiling of a gallery or museum. Working intuitively on each piece, without preliminary drawings or clay models, she tied, wrapped, and bound the material together with clay and mud. Branches and twigs often project from the mass like tentacles. Her work challenges our expectations of sculpture because they are made from impermanent material, which in fact will disintegrate and rot, and also because the bulbous masses defy gravity. Instead of resting securely on the floor like ordinary sculpture, they are suspended. The air around them seems to be sustaining their growth; at the same time, it eats away at their substance.

The materials Coyne used suggest a natural form of growth. They also make a statement about our environment, which because of human pollution is causing the death and destruction of nature. Coyne herself referred to each of her pieces as a female personage. When she first began making hanging masses covered with mud and cloth, she was working with cancer victims and AIDS patients. The bulbous masses of her protuberances suggested to her the growth and rot of tumors.

At the Whitney Museum of Art at Equitable Center in New York in 1987, she installed an unlucky thirteen of her biomorphic personages in the gallery. Each personage had a strange presence and a different character. Aggressive and threatening, yet also fragile, they aroused visceral feelings. To increase their menace, Coyne wrapped these excrescences in barbed wire. Twisting and writhing, the massive tumors grow up or grow down from their stems. They are symbols of death and of life, for they also resemble cocoons.

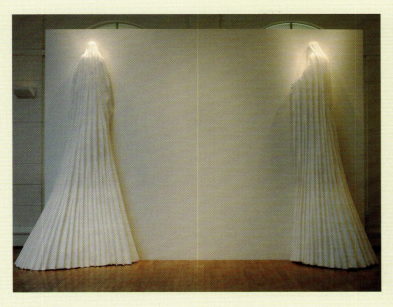

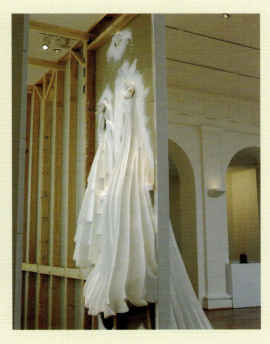

Petah Coyne [American, 1953–], *Untitled #978 Gertrude and Juliana (The Whitney Women)*, 1999–2000. Mixed media, 144 × 206 × 53 in. (365.8 × 523.2 × 134.6 cm) Albright-Knox Art Gallery, Buffalo. Anonymous gift in honor of Marian Griffiths, 2001.

In 1993 Coyne turned away from her dark and brooding "personages" to white, wax-encrusted pieces she calls "girls." Many of the new pieces resemble chandeliers, and also dresses, wedding cakes, and hats. These works also hang from the ceiling, on chains covered in white satin, and are still grown organically. As many as ninety layers of translucent white wax cover an armature of wire mesh. Some of the melted wax comes from the lighting of dozens of candles inserted into the armature—like the popular Catholic ritual of lighting candles in church. Coyne believes that the white wax symbolizes tears. These enchanted creatures from some fairy tale are weighty yet seem fragile and vulnerable.

In more recent work, Coyne has started to drape rather than suspend material. In *Untitled #978 Gertrude and Juliana (The Whitney Women),* she has embedded two statues of the Virgin Mary into a plaster wall. Their long pleated white cloaks cascade to the floor, and parts of them are also visible on the other side of the wall. Because the work was first shown at the Whitney Museum's Biennial Exhibition in 2000, the title refers to Gertrude Vanderbilt Whitney, the founder of the museum, and to Juliana Force, its first director. The religious element derives from Coyne's Catholic upbringing, as she revealed in remarks about the piece: "I love 'the front' of this sculpture, its presentation of quiet and beauty. But if I had to 'hang out,' the back is where you would find me. Its unfinished roughness is closer to the world in which we actually live. It has the intimacy of a conversation. . . . In this private back area, all can be said and forgiven (not unlike the old confessionals in the Catholic Church). It is a small space, full of light and hope, the same one I still hold out for the world-at-large."[1]

Figure 12-26 Alexander Calder [American, 1898–1976], *Lobster Trap and Fish Tail*, 1939. Hanging mobile — painted steel wire and sheet aluminum — about 102 in. (259.1 cm) high × 114 in. (289.6 cm) in diameter. Museum of Modern Art, New York. Digital image © The Museum of Modern Art. Licensed by Scala/Art Resource, NY.

Figure 12-27 Michael Heizer [American, 1944–], *Double Negative*, 1969–1970. 240,000-ton displacement of rhyolite and sandstone, 30 × 1,500 × 50 ft. (9.1 × 457.2 × 15.2 m). Mormon Mesa, near Overton, Nevada. Museum of Contemporary Art, Los Angeles.

Disparaging the overcrowded museums and galleries of America's cities, Heizer chose the peaceful and untouched open space of the western desert for his work. Heizer began making earthworks in the desert in the late 1960s, as did his friends Walter De Maria, Robert Smithson, and Nancy Holt. For *Double Negative,* Heizer gouged out two enormous trenches facing each other across a depression in the rock. The material for his sculpture is the earth itself, the very space in which the work is located. *Double Negative* is pure void—the excavated material forms no shape or mass—and the voids echo and attract one another across the gap.

Double Negative seems like a mysterious ruin, an enigmatic trace of a lost civilization—perhaps for good reason: Heizer's father was an archaeologist. However, the work has been criticized for destroying the pristine environment with a man-made scar. And paradoxically, despite his disparagement of the commercialization of art, Heizer's project received financial backing from the Dawn Gallery in New York City. The contradictions only make *Double Negative* seem even more relevant to modern life.

Figure 12-28 Ana Mendieta [American, 1948–1985], *Arbol de la Vida (Tree of Life)* No. 294, from the *Arbol de la Vida/Silueta (Tree of Life/Silhouette)* series, 1977. Color photograph, 20 × 13 1/4 in. Documentation of earth-body sculpture with artist, tree trunk, and mud, at Old Man's Creek, Iowa City, Iowa. © The Estate of Ana Mendieta and Galerie LeLong. Collection Ignacio C. Mendieta. Courtesy The Estate of Ana Mendieta and Galerie LeLong, New York.

the act of seeing. They all push forward the contemporary trend to break down the barriers between two-dimensional and three-dimensional media.

New Techniques

New techniques of sculpture have been devised for materials old and new. Sculptors have constructed **kinetic sculpture**—work that actually moves because of wind or water or is powered by an electric motor. Alexander Calder made kinetic sculpture popular in the form of intriguing and fanciful **mobiles.** His *Lobster Trap and Fish Tail* (Figure 12-26) is balanced on a wire suspended from the ceiling. The vanes, shaped like fish fins, catch any breeze and change relationships as they dance about one another in space. The open wire cage balances all the triangular vanes, and each vane balances the remaining vanes. The pivoting movement of thin planes attached to rods suggests the delicate balance of tightrope walkers in the circus.

Some sculptors make earth sculpture, land art, or **earthworks** by using outdoor nature as their material and by shaping earth and rocks, often in remote places. When Michael Heizer constructed *Double Negative* (Figure 12-27), in Nevada, his tools were bulldozers and power shovels. Earthworks are created at the site, not in the studio, and often take into account the environmental conditions of the site. They sometimes make points about the environmental crisis and about the relationship between the earth and humankind.

The Cuban American artist Ana Mendieta practiced a different kind of earth art, using her own body as a component in her work. In *Arbol de la Vida (Tree of Life)* (Figure 12-28), she covered herself in mud and—arms raised—stood against the rough bark of an enormous tree. In other works, Mendieta burned an imprint of her body onto a log, formed mounds in its shape, or made her silhouette in the sand and covered it with flowers. All these events are reminiscent of a primitive religious ritual, perhaps homage to a primordial earth goddess. Cut off from her roots and family in Cuba, Mendieta felt that her earth/body sculpture reestablished bonds with the maternal source of the universe: "Through my earth/body sculptures I become one with the earth. I become an extension of nature and nature becomes an extension of my body. This obsessive act of re-

space. Viewers move through the environment as though they have shrunk and entered the world of an abstract painting or drawing. Pfaff's *Neither Here Nor There,* Petah Coyne's *Untitled #465A* (see "Artist at Work"), and many other recent works of sculpture are so large and complex that they arrive in pieces that must be assembled and situated within the exhibition space. Sculptors have coined the generic term **installation** to describe them.

In recent years, the number of installations has exploded. Countless painters, photographers, and video artists, as well as sculptors, now exhibit their work in installations, complex three-dimensional presentations of their work, which exist only for the time of the show. They all try to involve the viewer more in

Figure 12-29 Gilbert [British, 1943–] and **George** [British, 1942–], *The Singing Sculpture: We Dream Our Dreams Away*, 1991 re-creation of performance originally staged in 1971. Sonnabend Gallery, New York.

asserting my ties with the earth is really the reactivation of primeval beliefs."[2] Needless to say, time has erased these fragile totems. They exist only in the photographs and films that were taken of her work.

Artists such as Mendieta who put themselves and their creative activity on display practice what is known as **performance art.** In another example, two London art students, Gilbert and George, declared that they were "living sculpture" as they performed their work *The Singing Sculpture: We Dream Our Dreams Away* (Figure 12-29). Properly dressed in suit and tie, they painted their faces gold and stood on a small table for about six minutes while a tape recorder played the song "Under the Arches." They moved slowly and stiffly, like robots. If artists have the freedom to transform any material into art, Gilbert and George took the final step of transforming themselves into art. By doing so, they completely severed the barrier between the artist and his work

so that they could communicate directly with their audience. They maintained that their lives were art.

Gilbert and George's performance challenged conventional notions about art as a commodity to be bought and sold. It stimulated new perceptions about experiencing art and about the relationship between artists and their work. Performance art emphasizes the process of making art and the imaginative attitudes that make art possible. Shocking or not, performance art often provides a feast for the eyes and delights several senses at once as it tries to turn life into art. Performance art, to be sure, can make the borderline between the visual arts and theater very fuzzy.

At the beginning of the twentieth century, the Futurists, Dadaists, and Surrealists, in cabarets, galleries, and in the streets, all staged numerous performances combining nonsense declamations, bizarre costumes, and absurd activity. They strove to shock the insensate public into the heightened awareness of art. Their artistic revolts sometimes protested political events. They sometimes protested the artistic establishment since, by its nature, performance art is ephemeral and does not create an object that can be hung in a museum.

Performance art grew quite popular in the post–World War II years as younger artists again attempted to shock the public and also, paradoxically, eliminate the distance between artist and public. In the 1940s and 1950s, the musician John Cage, the dancer Merce Cunningham, and the young painter Robert Rauschenberg staged performances at Black Mountain College, North Carolina, an institution famous for its experimental approach to art teaching. In 1959 Allen Kaprow, who had studied with Cage, invited an audience to participate in *Eighteen Happenings in Six Parts,* held in the Reuben Gallery in New York (Figure 12-30). The performers, reciting fragmentary speeches, moved amid the audience sitting in three separate "rooms" created by plastic sheets. Meanwhile, painters painted, musicians played, and slides were shown—all simultaneously. Kaprow's eighteen carefully orchestrated events provided a total immersion in art. Similar **happenings,** or loosely staged public events of all descriptions, were organized by other artists in the 1960s, and the term "happening" entered the popular vocabulary. In the 1970s and 1980s, performance art went commercial. Robert Wilson's *Einstein on the Beach* (1976), a work of operatic scope, became an

Figure 12-30 Allan Kaprow
[American, 1927–], *Part Four, Room 1: The Orchestra*, in *Eighteen Happenings in Six Parts*, 1959. Performed by Shirley Prendergast, Rosalyn Montague, Allan Kaprow, and Lucas Samaras at the Reuben Gallery, New York. Courtesy of the artist. Photo by Scott Hyde.

international success. Laurie Anderson's *United States,* a four-part piece performed in the early 1980s, included her electronic violin playing, the projection of drawings and images from movies and from television, and songs, stories, and constant comments on the process of perception by the artist. The five-hour performance rivaled the spectacle of a rock concert. Since then, this master of high tech has become undoubtedly the best-known performance artist. For her *Songs and Stories from Moby Dick* (1999) (Figure 12-31), Anderson invented a six-foot-long "Talking Stick" (symbolic of Captain Ahab's harpoon), which she played by rubbing her hands along its length.

Because these experiments have a three-dimensional quality or at least have their existence in the real space of the viewer, they can be classified, albeit quite loosely, under the traditional heading of sculpture. Thus, in recent decades, sculpture has become a most daring and exciting art.

Figure 12-31 Laurie Anderson
[American, 1947–], *Songs and Stories from Moby Dick*, 1999. Performance at Brooklyn Academy of Music, October 5, 1999. Canal Street Communications.

Sculpture

The nature of sculpture	Sculpture consists of masses and voids in real space.
The visual elements	The thrust of masses and the lines of drapery accentuate masses in space; light reflections and color enhance sculpture; masses are balanced—or not.
A public art	Sculpture is often connected with architecture. Sculpture often illustrates a community's values.
Common iconography	The human figure, animals, portrait busts, and masks are all found in sculpture.
Types of sculpture	The types of sculpture include in-the-round and relief, additive and subtractive.
Traditional techniques	Traditional techniques include modeling, carving, and casting.
New techniques	New techniques include assemblage, installation, environment, kinetic, earthworks, performance, and happenings.

INTERACTIVE LEARNING

 In the Studio: Plastercasting

Flashcards

Artist at Work: Petah Coyne

Companion Site: **http://art.wadsworth.com/buser02**

Chapter 12 Quiz

InfoTrac® College Edition Readings

Talking Flashcards

Online Study Guide

13 Applications of Design

GLASSMAKING

Medieval Stained Glass

As soon as the workers building Chartres Cathedral had vaulted a part of the church, another team of workmen began installing the stained-glass windows. Within about 35 years, all 164 windows in the church had been filled with deeply colored glass. In modern times Chartres is unique because, of all the great medieval cathedrals in France, it is the only one whose original windows remain intact. No discordant style of window from another age or, worse, clear glass spoils the effect of the ensemble of glowing colored walls. The glass at Chartres, famous for its deep red and its celestial blue, transports the architecture into the sublime and makes it a vision of the heavenly city. A window near the entrance to the choir, *La Belle Verrière* (Figure 13-1), contains panels from the preceding cathedral building that were reused in the new. The cobalt blue of the Virgin's robe has never been matched.

The king of France and the local aristocracy paid for some of the windows, as did many of the guilds (associations of workers) who identified themselves by incorporating scenes of their occupations in the window. To complete so many windows in such a short time, crews came from different parts of France and no doubt coordinated their efforts in a common work yard. Six master designers seem to have been at Chartres at one time, each with about four or five assistants to cut and assemble the glass.

The design for each window was drawn on a large wooden table over which the pieces of glass were cut and fitted together like a mosaic into the H-shaped borders of lead. The thick dark borders kept the colors separate so that, without interference, they retained their brilliance. Manufactured by hand

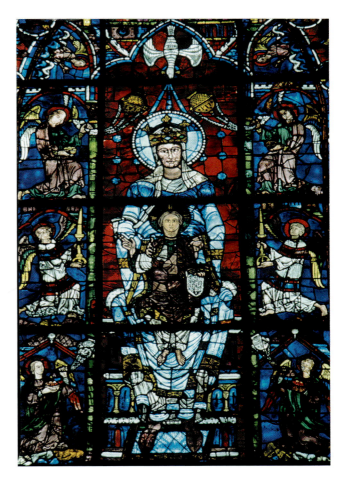

Figure 13-1 [Medieval French], *La Belle Verrière*, ca. 1170. Stained glass. Chartres Cathedral, France. © Anthony Scibilia/Art Resource, NY.

on the site, the glass had numerous imperfections and impurities and an uneven surface—all of which increased the refraction of the light and the richness of the color. This glass is called "pot metal" because metal oxides such as cobalt, copper, or gold, permeating the molten glass, fused with it to give it color. Details such as facial features and drapery folds were painted with similar oxides onto the glass,

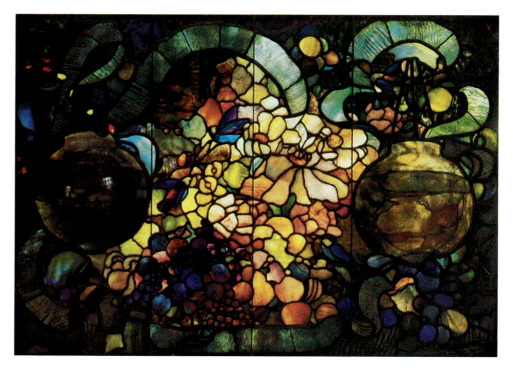

Figure 13-2 **Louis Comfort Tiffany** [American, 1848–1933], *Flower, Fish, and Fruit*, 1885. Stained Glass. Baltimore Museum of Art.

which was then refired so that the paint fused with the glass.

For nearly two centuries, Western civilization has looked back with nostalgia on the Middle Ages as a golden age for **crafts,** special skills needed for making certain kinds of practical objects. Medieval craftspeople such as those at Chartres supposedly had a close familiarity with all the materials and techniques of glassmaking and directed the whole of the creative process from the initial conception to the final touches. Westerners assume that medieval craftspeople lived meaningful lives as they practiced their well-respected crafts in total harmony with their culture.

Tiffany Glass

In the late nineteenth century, during a surging revival of the use of stained glass in Europe and America, Louis Comfort Tiffany in New York experimented with glass to achieve the translucency and richness of medieval stained glass. An early commission, *Flower, Fish, and Fruit* (Figure 13-2), decorated the transom of the dining room of a private home in Baltimore. Tiffany—and the painter John La Farge—invented an opalescent glass that was only partially

translucent and could therefore imitate the imperfection of medieval glass with its supple texture and variegated surface. Tiffany insisted that details in a window come only from the color of the glass, not from painting on the glass, and that the leading should surround only the shape of each object.

As with the medieval crafts at Chartres, Tiffany trained apprentices and controlled the manufacture and design of each window from the production of the pot metal to the installation of the window in the client's home or church. However, Tiffany did not manufacture all his raw materials; he employed some modern machinery; and he ran his studio and shops like a modern business, with workers who specialized in only certain aspects of the operation. Moreover, independent designers outside the firm sometimes supplied the imagery for windows, which the Tiffany Company then produced.

Another big difference between Tiffany glass and medieval glass resides not in style and technology but in purpose. Tiffany glass was a luxury item crafted for the well-to-do. It was created in an age when industrial techniques of mass manufacture could produce endless quantities of cheap and perfectly flawless clear glass—something people in the

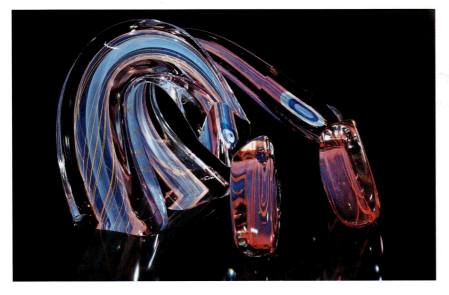

Figure 13-3 **Harvey K. Littleton** [American, 1922–], *Ruby, Lemon, Blue Sliced Descending Forms*, #2-1990-5. Approximately 12 1/2 × 18 × 12 1/2 in. (31.8 × 45.7 × 31.8 cm). Glass. Courtesy of Littleton Company, Inc.

In 1962 Littleton demonstrated in a workshop at the Toledo Museum that individual artists could have their own furnace in a studio so that they could work hot glass themselves. In this way they could be directly involved in the creative process and realize individual works of art. (Previously, artists had submitted designs to the glass industry for manufacture.) Littleton, the father of the studio glass movement, caused a revolution in glassmaking that still continues to grow.

Littleton, could never serve a practical function as either a vessel or a window. His skillful shaping of glass makes sense only as art. In many ways Littleton acted like a sculptor whose medium is glass.

Glass as a sculptural material can be opaque, as well as absolutely transparent, so that one can see clearly deep inside a mass many inches thick. A transparent mass might possess a series of colored layers. Another accomplishment of glass is that it transports light and contains light as though it were itself a source of light. Since glass is initially worked in a molten state, it frequently retains the appearance of a frozen liquid as in Littleton's *Sliced Descending Forms*. Glass can have a perfectly rounded, polished surface, or it can have a perfectly straight, razor-sharp edge. Glassmakers

Middle Ages could not dream of doing. For those who could afford a more personal look and who cultivated a fashionable nostalgia for medieval handiwork, Tiffany's craft was a revolt against the uniformity, impersonality, and tastelessness of modern mass-manufactured goods. Positively speaking, Tiffany glass was also a promotion for integrity, self-expression, and individuality. Medieval craft objects never carried such a heavy burden of connotations when they were first made.

Art Glass

Another kind of glassmaking developed in the late twentieth century, featuring works made, exhibited, sold, and collected predominantly as works of art. Although people now consider the Chartres and Tiffany windows to be works of art, they were also manufactured to serve practical functions, such as keeping out the weather or letting light into a room. The glasswork titled *Ruby, Lemon, Blue Sliced Descending Forms* (Figure 13-3), by Harvey K.

Glassblowing by Stephen Rolfe Powell. Photo credit: Kate Philips. Studio K design credit: Richard Groot. Centre College, Danville, Kentucky.

Figure 13-4 **Dale Chihuly** [American, 1941–], *Macchia Forest*, 2002. Glass installation. Oklahoma City Art Museum. Photo by Teresa N. Rishel. Courtesy of Chihuly Studio.

can blow hot, liquid glass into a bubble and spin it into shape or press hot glass into a mold. They can etch cold glass with acid, cut it with grinding tools, or blast it with a thin stream of sand to produce a rough texture. Above all, the glassmaker's primary "tools" are heat and gravity, which, for example, caused Littleton's *Double Descending Arc* to slump into its curved shapes.

America's preeminent glass artist Dale Chihuly first studied glass with Littleton. He also studied at the Venini glass factory on the island of Murano, Venice, where he realized that glassmaking is a collaborative effort. Chihuly often makes paintings and drawings of potential pieces, then works with his team to translate them into glass. Four or more people collaborate on executing a single piece or on an enormous installation with multiple components. The fluid forms of much of his work, including an in-

stallation of pieces called *Macchia Forest* (Figure 13-4), often look like colorful sea plants floating in the water of a tropical reef.

Modern craft artists such as Littleton and Chihuly are not just concerned with mastering traditional materials and techniques; they are more concerned with expressing themselves and creating art just as their colleagues do in painting or sculpture. Many craft artists, who practice so-called **studio craft,** consider glass, clay, wood, fiber, or metal to be simply the means to an end—namely, art. Most craft artists today have received the same kind of training in the same art schools and university art departments as painters or sculptors. They also create original works of art that are sold in galleries and collected by individuals **Glassblowing** **VIDEO** or museums.

THE NATURE OF CRAFT

From the beginning of civilization, people everywhere made weapons and tools for hunting, sewed skins and wove fibers for clothing, made baskets for transporting goods, and shaped clay pots for cooking and storage. People made by hand every implement needed to support life. Ordinarily, certain people in the community developed these special skills, or crafts. The word *craft* derives from the German word for power, *Kraft,* because the maker exercised a kind of magic power over nature.

The examples of craft that we have discussed thus far—the ethereal stained glass of Chartres, the luxury glass of Tiffany, and the art craft or studio craft of Littleton and Chihuly—demonstrate that the term *craft* cannot simply be defined as the making of objects that are useful as opposed to the creation of nonfunctional art objects made for their own sake. The distinction between crafts and the fine arts (see Chapter 1) arose in the Renaissance among artists who wanted to improve their social status by insisting that they were not mere laborers who worked with their hands but intellectuals who employed their mind. The distinction between art and craft helped Michelangelo and other Renaissance artists claim that they were inspired geniuses, independent and not restricted by the traditions of handwork.

In modern times, the major differences between fine arts and crafts are frequently economic. In the current art world, crafts are normally given less exhi-

bition space, less critical attention, and much lower prices. Despite these disadvantages, craft work attracts many people because it has become an alternative way of life for individuals seeking self-expression and self-fulfillment. The modern craftsperson imagines, designs, and creates things with his or her own hands. The craftsperson works according to the rhythms of his or her own talent, imagination, and enthusiasm. Craft work becomes a satisfying way of life protesting the alienation of mass culture. It asserts the worth of the individual through personalized production of often familiar, comforting items.

In short, people practice at least four types of craft work, each of which gives a somewhat different meaning to the word *craft*. The four types are (1) the employment of an original handicraft skill to create a useful item out of raw material; (2) the revival of handicraft skills in modern times as a rejection of mass manufacture and an assertion of personal integrity; (3) the use of traditional craft materials specifically as an art medium; and (4) the production of luxury goods, whenever skilled workmanship and the preciousness of the materials make the object rare and desirable for collecting. These four types constantly overlap in actual practice and appear in all the traditional craft materials—namely, glass, fibers, metals, and clay.

FIBER ARTS

A variety of crafts have been designated **fiber arts** because they involve sewing, weaving, or joining in numerous ways all sorts of fibrous materials. Since prehistoric times, human beings have woven fibers to manufacture clothing, blankets, carpets, and containers. In addition, fibers can be entwined to make ropes.

Basket Weaving

People wove baskets for storage or transportation of goods even before they made pottery, which presupposes a sedentary existence. In **basket weaving,** organic materials from the weaver's own environment were used—she or he had to work with nature and the seasons. In the process of twining, plaiting, or coiling the vegetable materials from the center out, the weaver gave shape to the three-dimensional form already present in his or her imagination.

Figure 13-5 Louisa Keyser (Datsolalee) [Native American, 1831–1926]. *Washo Bowl,* ca. 1918. Degikup: coiled mountain willow, bracken fern root, and redbud bark, 12 1/4 in. (31.1 cm) high × 16 1/4 in. (41.3 cm) in diameter. Philbrook Art Center, Tulsa, Oklahoma. Gift of Clark Field. 1942.14.1909.

Women typically wove baskets, and they continued to be the primary practitioners of many crafts as long as the crafts remained centered in the family.

Early in the twentieth century, several Native American women in the western United States still practiced the ancient art of basket weaving. Centuries-old tradition had passed on to them the technical skills, the appreciation of proportion, and the ability to integrate form and decoration. The bowl-shaped basket of Figure 13-5 is an example of the work of Datsolalee of the Washo tribe in Nevada. Datsolalee built the basket with a very tight and uniform weave. From a narrow base the basket swells in a fully rounded curve toward a narrow opening that reflects the diameter of the base. Four groups of three vertical stripes decorate the basket and enhance the monumental appearance of the small basket. The stripes, with their feather-like design, bend away from one another in harmony with the swelling shape of the basket.

Datsolalee's baskets were immediately sold to collectors who appreciated their artistic merits—the baskets never served a useful function. But she did not consider her baskets a form of art because her culture had no distinction between art and handi-

Figure 13-6 [Medieval French], *Bayeux Tapestry*, detail, 1070–1080. Linen and wool embroidery, about 1 2/3 × 230 ft. (0.5 × 70 m). Centre Guilluamem le Conquerant, Bayeux. Pubbli Aer Foto.

craft or any other form of visual expression. Perhaps as a consequence of her approach to craft, she easily possessed the integration of life and art that many craftspeople in modern times have sought in the revival of older crafts.

Figure 13-7 **Judy Chicago** [American, 1939–], *The Crowning NP 4* (detail), from *The Birth Project*, 1984. Painting on 18 mesh canvas by Judy Chicago with Lynda Healy; needlepoint by Frannie Yablonsky, 40 1/2 × 61 1/2 in. (102.9 × 152.4 cm). Photo: Through the Flower Archives. © 2006 Judy Chicago/Artists Rights Society (ARS), New York.

Over a five-year period (1980–1985), Chicago created a whole series of designs or patterns for *The Birth Project,* which she then gave to volunteer needleworkers all over the United States and Canada. The craftswomen interpreted the designs in embroidery, quilting, needlepoint, crocheting, and knitting according to the directions and with the materials supplied by Chicago. *The Crowning* was executed by Frannie Yablonsky of Somerville, New Jersey, in a rich texture with a variety of stitches that try to match the feeling of the design.

Needlework

Traditionally, women also practiced the craft of **embroidery,** the decoration of cloth with needlework designs. Throughout history, queens and princesses were known for their skill in the crafts employing needle and thread. According to legend, Queen Matilda, the wife of William the Conqueror, embroidered the famous *Bayeux Tapestry* (Figure 13-6) with the events preceding the Battle of Hastings and the Norman conquest of Britain in 1066—events that happened only a few years earlier. The *Bayeux Tapestry* is not a woven tapestry, with the design created by interlacing differently colored threads, but a strip of linen 230 feet long embroidered with colored wool cutouts that have been stitched onto it. The scenes are full of accurate detail and lively movement despite the absence of modeling and perspective. The unity of style throughout the entire length of the *Bayeux Tapestry* indicates that it is the work of a single designer, whoever that might have been.

In the 1970s the American painter Judy Chicago resolved to make contemporary art using techniques long associated with women and depicting explicitly feminine imagery. One result of her determination was *The Birth Project,* a series of needlework images

Figure 13-8 Mary Jane Smith [American, 1833–1869] and **Mary Morrell Smith** [American, 1798–1869], Whitestone, Queens, New York. *Log Cabin Quilt, Barn Raising Variation*, 1861–1865. Cotton, wool, and silk, 81 × 74 in. (205.7 × 188 cm). Collection American Folk Art Museum, New York. Gift of Mary D. Bromham, grandniece of Mary Jane Smith (1987.9.1). Photo by Schecter Lee, New York.

of childbirth. From the start, she intended childbirth to symbolize creation itself, but she was soon amazed that childbirth—one of the basic facts of life, one of the most awe-inspiring experiences in life—had almost never been illustrated in art. *The Crowning NP 4* (Figure 13-7) illustrates the moment when the child's head first appears in the birth canal. The woman who holds her legs demonstrates powerful muscular movements to bear the child. The symmetrical design includes the fallopian tubes and the nurturing breasts. Lines of force radiating from the woman generate energy and life throughout the universe.

Feminist art in every sense, *The Birth Project* also created an unusual participatory form of art. The artist consulted with hundreds of women about their experience of childbirth as she developed imagery for the series. The work, done by dozens of needleworkers in collaboration with the artist, became the property of the nonprofit corporation Through the Flower, which maintains and exhibits it around the United States.

American women needleworkers had practiced a community-wide craft generations earlier, in the eighteenth and nineteenth centuries: **quilting.** When women came together for a quilting bee, the completing of a quilt was a social event and a cause for celebration. The top of a patchwork quilt was made either by appliqué, which involves sewing cut-out patches to a white backing, or by the piecework method, which involves sewing geometric shapes of cloth to one another to form a pattern. At first, quilt makers cut material salvaged from discarded goods, but by 1800 they generally purchased a special selection of colored and printed materials just for the quilt.

The pieced method, usually reserved for everyday blankets, often produced astonishing abstract designs in lively colors. Patterns, some of them handed down and spread around, were given popular names such as Courthouse Steps, Log Cabin, or Crazy. The popular Log Cabin design dates from the period of Abraham Lincoln's presidency, the years when Mary Jane Smith and her mother, Mary Morrell Smith, pieced together the *Log Cabin Quilt* in Figure 13-8. In addition to placing individual "logs" around each

Figure 13-9 [Medieval (French?)], *The Unicorn Leaps the Stream*, from the *Hunt of the Unicorn*, ca. 1500. Wool, silk, silver thread, about 145 × 168 in. (368.3 × 426.7 cm). Metropolitan Museum of Art, Gift of John D. Rockefeller, Jr., 1937 (37.80.3). Photograph © 1988 The Metropolitan Museum of Art.

The tapestry is the third in a series of seven tapestries that tell the story of the hunt of the unicorn. The unicorn, a fabulous horse-like creature, has on his head a single white horn that is capable of repelling poison. In medieval thought, the story is an allegory of Christ and the Virgin Mary. In this tapestry, the unicorn narrowly escapes the dogs and spears of the hunters by leaping across a stream. The ten hunters and as many dogs pursue the unicorn in a landscape dominated by a steadfast oak tree and strewn with hawthorn, pomegranate, daisy, primrose, and iris—all of which have symbolic meaning. Unable to capture the unicorn by force, the hunters trick the unicorn, who is tamed into submission by a maiden. Although he is killed and brought back to the castle, the last tapestry shows him happily alive in a flowery meadow.

square, they arranged light and dark pieces in concentric diamond shapes, a variation known as Barn Raising. Mother and daughter made the quilt for Mary Jane's trousseau, but her fiancé died the day before the wedding, and it was never used.

Tapestry

In contrast to quilted blankets for everyday use, **tapestries** are fabric wall coverings for the well-to-do. Tapestries woven into pictorial designs have been treasured as works of art for centuries. A prized example of tapestry weaving, *The Unicorn Leaps the Stream* (Figure 13-9), is one of a series of seven tapestries that tell the story of the hunt of the unicorn. To make the tapestry, the craftspeople, working from the back, wove finer horizontal threads of brilliantly colored wool (the weft) between strong, tightly twisted vertical threads of undyed wool (the warp). They also employed silk and metallic thread to complete the highlights of the image.

Modern Fiber Art

Since the 1950s, a number of artists sympathetic to the traditions of fiber work have explored ways to

make fiber a vehicle for self-expression by moving the craft in the direction of sculpture. Modern fiber art has evolved into a major means of artistic expression. The wall hangings of fiber artists do not simply imitate two-dimensional paintings as do many older tapestries but emphasize the texture of the material and the three-dimensional relief of the fibers. Many modern works of fiber art, which were never woven on a loom, are suspended or draped from a wall or a ceiling, stuffed and fitted over an internal support, or flopped on the floor. These fiber works have sculptural mass and move through space while maintaining some of the traditional techniques of fiber handicraft and only a symbolic reference to their original function.

In *Double Wall Triptych* (Figure 13-10), a work by Claire Zeisler, a pioneer of fiber art in America, two cascades of plaited material spill down the wall. Between them, independent of the wall, rises a steep pyramid of loosely woven fibers. The bright red rope seems to emerge from the wall, submerge itself in the chaos of fiber on the ground, then surge back up the pyramid. The linear movement of the piece descends from order into disorder or, in the other direction, rises up out of chaos into order.

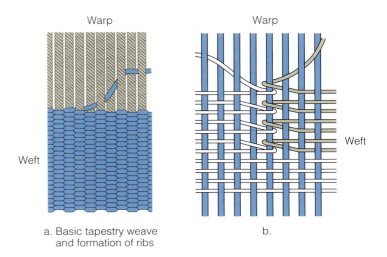

a. Basic tapestry weave and formation of ribs

b.

METALWORK

Through the centuries, craftspeople skilled in working with metals have produced objects of great artistic merit such as horse bridles, ceremonial swords, weather vanes, grille work, vessels, and countless other items. **Metalwork** has also long been associated with the making of luxury goods such as jewelry. The rarity of gold, silver, and precious stones as well as their color and radiance has made jewelry a

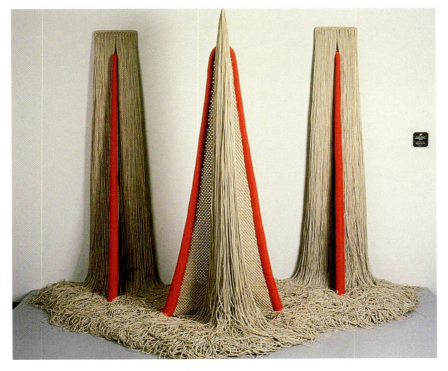

Figure 13-10 **Claire Zeisler** [American, 1903–1991], *Double Wall Triptych*, 1985. Fiber, 81 in. (206 cm) high × 53 in. (135 cm) deep × 108 in. (274 cm) wide. Illinois Collection, James P. Thompson Center, Chicago.

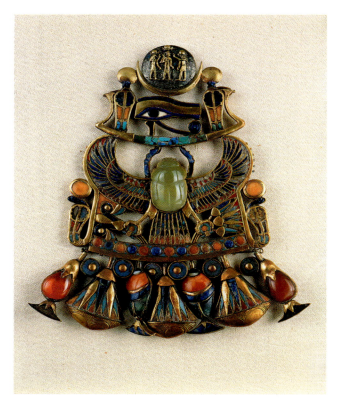

Figure 13-11 [Egyptian], Pectoral with solar and lunar emblems, ca. 1340 BCE. Gold, silver inlaid with carnelian, lapis lazuli, calcite, obsidian (?), turquoise, and red, blue, green, black, and white glass, 5 7/8 in. (14.9 cm) high, 5 11/16 in. (14.4 cm) wide. Egyptian Museum, Cairo. © Scala/ Art Resource, NY.

pleasure-filled extravagance for most people. Although jewelry decorates the human body, its sumptuousness and costliness place this craft far beyond the common meaning of the word *functional*.

Nevertheless, jewelry has had many functions throughout history other than the expression of personal vanity. Jewelry marked important stages in a person's life: birth, marriage (wedding rings), and death. Jewelry expressed upper-class status; it indicated wealth and therefore power. In times when currencies were nonexistent or unstable, jewelry was a secure form of capital investment.

The ancient Egyptians spent lavishly for jewelry. A pectoral (chest ornament) (Figure 13-11), found wrapped in the cloths covering the mummy of King Tutankhamen of Egypt (ca. 1334–1326 BCE), is a splendid example of their skill. The discovery in 1923 of King Tut's tomb—the only tomb of an Egyptian pharaoh uncovered in modern times that

had not already been robbed of its treasure—produced sensational headlines around the world. The pectoral, less than six inches across, lavishly displays the wealth of the pharaoh, and its religious symbolism transforms it into a talisman appropriate to be buried with the king.

The pectoral represents the moon and the sun. The Egyptians revered the sun as the creator and ruler of the world and as the renewer of life and of eternal existence. The sun appears in the form of both a falcon and a scarab (a beetle). The royal jeweler cleverly made a composite animal from the body of the insect and the wings of the bird. The wings and tail of the falcon as well as other parts of the pectoral were made in the **cloisonné** technique by setting colored glass and semiprecious stones within borders of gold. At the top, the left eye of the god Horus, the crescent, and the silver circular disc stand for the moon. The fringe dangling at the bottom represents lotus and papyrus flowers and poppy buds. The pectoral protected Tutankhamen and equipped him for the afterlife in royal splendor.

Royal courts in Europe in the Middle Ages and the Renaissance sometimes maintained their own workshops where luxury goods were created for the palace. For centuries, the court of the Medici in Florence, Italy, maintained workshops where designers produced some of the most elegant luxury goods in Europe. The Rospigliosi Cup (Figure 13-12) looks like the kind of precious metalwork that was once made for them. It used to be attributed to the goldsmith Jacopo Bilivert (d. 1593) but now is thought to have been made in the early nineteenth century in imitation of the fantastic designs of sixteenth-century work. Metalwork like this normally sat in a display to exhibit the wealth and exquisite taste of the owner.

CERAMICS

Pottery is one of the oldest crafts, synonymous with civilization itself, since it grew out of the essential human need to store and carry food and drink. At the same time, pottery has been for centuries a collector's item, a precious and treasured object, a symbol of status and wealth, and a thing of admired beauty. It epitomizes the paradoxical power of craft to transform the mud of the earth into something rare and beautiful.

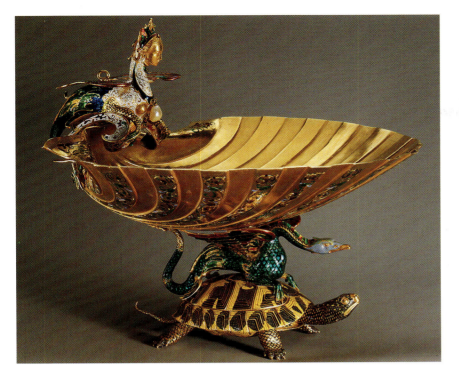

Figure 13-12 Jacopo Bilivert (attributed) [Dutch, 1550–1593] Believed to be a copy of the late-Mannerist Rospigliosi Cup, first quarter nineteenth century. Gold, enamel, pearls, 7 3/4 × 8 1/2 × 9 in. (19.7 × 21.6 × 22.9 cm). Metropolitan Museum of Art, Bequest of Benjamin Altman, 1913 (14.40.667). Photograph © 1999 The Metropolitan Museum of Art.

The gold scalloped shell rests on the back of a green-scaled dragon perched on the back of a realistic turtle. The creatures look at each other with curiosity. On the rim of the shell sits a winged sphinx with a double fish tail, pearl earrings, and a large pearl dangling from her front. The unusual design displays a virtuosity of execution manifest in the painstaking detail and the delicate colored enamel work. At the same time, the cup possesses a clearly defined outline and a solid sculptural quality.

Pottery is made of clay (chiefly pulverized granite and gneiss), sand, and other materials that, when wet, can both retain their shape and be molded by the human imagination into a thousand forms. When the dried clay is fired in open flames or in a kiln, it is baked to permanent hardness because the particles within it begin to melt and run into one another above 1200 degrees Fahrenheit (650 degrees Celsius). Fired at a low heat, ordinary clay remains grainy and is called **earthenware**. Increased heat and more refined clay produce smoother and harder **stoneware** because more of the particles melt into one another. At the highest temperatures, the particles melt and fuse completely, producing creamy white **porcelain**—provided that the highly refined clay contains the white clay kaolin.

Traditionally, almost all pottery was molded by hand, and the essential form of a pot remains the shape of the cupped hands. Potters can simply stick their thumbs into a lump of clay and, between their thumb and fingers, squeeze the clay up into containing walls. Or they can coil a rope of clay around and around to build up the walls of the pot, then beat the walls smooth against a smooth stone held against the inside. The most common procedure is to "throw" the clay on a rotating wheel and, as the wheel turns, run the clay between wet hands that raise and shape the pot.

Wheelworking VIDEO

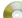 Pottery wheel. © Royalty-Free/Corbis.

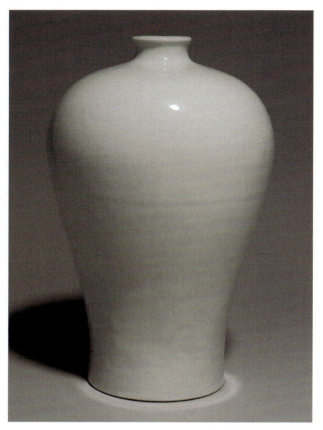

Figure 13-13 [Chinese, Jiangxi Province], *Meiping (Prunus) (Vase with Cloud Collar and Peony Sprays)*. Ming dynasty, reign of Yung Lo, 1402–1424. Porcelain with incised decoration and white glaze, 12 5/8 in. (32.1 cm) high. Cleveland Museum of Art, Severance and Greta Milikin Collection, 64.167.

Most pottery is circular in its horizontal circumference—unless it is assembled from rectangular slabs of clay. The endless creative variations of pottery usually lie in the vertical elevation—the generally convex swelling of the form. Almost all pottery is made to stand erect on the ground like a human being, and for centuries potters have spoken in anthropomorphic terms about the body of a pot, its lip, neck, shoulder, belly, and foot.

To make a pot impervious to liquids and to enhance its appearance, potters frequently apply a **glaze**—a hard, glass-like coating. The countless recipes for glaze include coloring pigments and some form of silica, which will liquefy in the kiln and coat all parts of the pot to which the glaze was applied with a thin layer of glass. The chemical relationship of the glaze to the clay, the humidity of the air, and the time for the firing and cooling process can all make some differences in the color and texture of the glaze.

During the Ming dynasty in China (1368–1644), an Imperial kiln was established at Ching-Te-Chen, where thousands of the best Chinese porcelains were produced for six centuries. Some of the finest white porcelains were made during the reign of Yung Lo in the early 1400s. A delicate curvilinear floral motif was incised on the vase in Figure 13-13 before it was glazed. The thick transparent glaze tints the vase slightly and mysteriously hides the decoration underneath it. The broad, slightly concave foot of the vase gathers together the forces of the earth around it; then it gradually rises and swells in a broad, bulbous upper body. The shoulder rapidly folds over the interior toward a narrow high lip. Vases such as this were appreciated by the Chinese for the skill of the workmanship and for the subtle variations that resulted from hand throwing on the potter's wheel. They contemplated in the vase, as do we, the very meaning of swelling and closure.

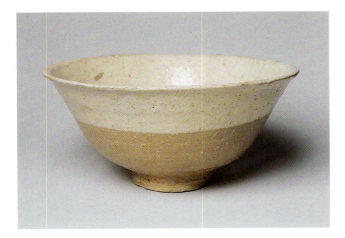

Figure 13-14 [Korean], Punch'ong ware bowl, Yi dynasty, fifteenth to sixteenth centuries. Glazed stoneware partially covered with white slip, 3 3/4 × 7 1/8 in. (9.5 × 18.1 cm). Brooklyn Museum of Art. Gift of John Lyden, 82.184.1.

On the rugged peninsula of Korea, the ceramic workshops of the court and monasteries often imitated the styles of Chinese pottery. But the Korean peasant rice bowl in Figure 13-14 displays something lacking in the Chinese Ming vase—a feeling for clay as clay. Even though the shape of the rice bowl is irregular, the surface is coarse, and the glazing is pitted, the anonymous potter stayed in close touch with the medium. From a small base the sturdy sides of the bowl flair to a slightly curved lip.

Korean potters had a taste for plain, undecorated ware so that nothing would get in the way of appreciating the shape of the pieces. The upper half of the bowl was dipped in a slip of liquid white clay that also coated the inside of the bowl. Over years of use, liquids penetrated the cracks and pinholes in the glaze and stained it. The signs of use in the bowl give added delight to its frugal and humble appearance.

The Japanese cultivated a similar style of "peasant" pottery in conjunction with their ritualized tea ceremony. The aristocracy and upper middle class deliberately chose to use at this ceremony a peasant style of pottery such as that of the Raku tea bowl in Figure 13-15. The Japanese also appreciated the bowl for its simplicity and its rough irregularity, for the evidence of hand workmanship visible in the dimples and bulges, and for the lack of symmetry, the uneven glaze, and the pitted surface. The clay was usually mixed with ground-up flint so that when it was rapidly fired the clay body would "open up" to display evidence of the firing. Cupping the bowl in the palms of the hand, the user could feel the weight of the ceramic and feel the hand of the artist in the surface of the bowl. The Japanese taste for irregularity in Raku teaware became an art of profound dignity under the influence of Zen Buddhism, which stressed simplicity and challenged formality.

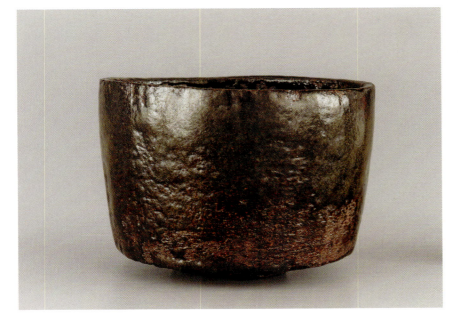

Figure 13-15 Honami Koetsu [Japanese, 1558–1637], tea bowl. Raku stoneware. Freer Gallery of Art, Smithsonian Institution, Washington, D.C. Gift of Charles Lang Freer, F1899.34.

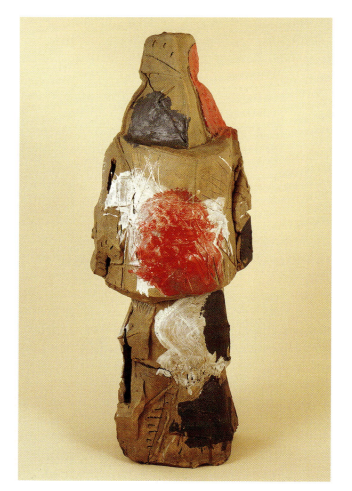

Figure 13-16 **Peter Voulkos** [American, 1924–2002], *Red River*, ca. 1960. Stoneware with slip, glaze, and epoxy paint, gas fired, 37 × 12 1/2 × 14 1/2 in. (94 × 31.8 × 36.8 cm). Whitney Museum of American Art, New York. Gift of Howard and Jean Lipman Foundation, Inc., 66.42.

The ceramist Peter Voulkos was encouraged to change clay into a vehicle for self-expression by the freedom of Japanese teaware, by its evidence of the maker's hand, and by its incorporation of random accidents. In 1954 Voulkos had just witnessed Abstract Expressionist painters Franz Kline and Willem de Kooning at work in New York City before he went to head the department of ceramics at the Otis Art Institute in Los Angeles. Since then, he has moved to the University of California at Berkeley, where he still lives and works.

Although the Japanese revere pottery as an art form, many American potters, inspired by the British potter Bernard Leach, consider themselves primarily professional craftspeople. They developed the handcrafting of vessels of clay into a wholesome way of life. The meaning of their craft and of their lifestyle was upset in the mid-1950s, when several ceramists ignored traditional techniques and forms. They used clay instead to make expressive ceramic sculpture. Peter Voulkos's *Red River* (Figure 13-16) looks like it may have originally been thrown on the potter's wheel but then reassembled, ripped open, pierced, and painted in an emotional struggle between the clay and the potter. Voulkos negated the pot's pretensions toward a function. He manipulated clay with the bold freedom of a contemporary Abstract Expressionist painter. The Expressionist potter and the Expressionist painter both left evident traces of their creative activity in their medium.

THE ARTS AND CRAFTS MOVEMENT

The modern revival of crafts as a wholesome way of life began in the late nineteenth century to protest the dismal quality of mass-manufactured products. In England the writer John Ruskin and the painter William Morris, who both called for the return to handcrafted work, started the **Arts and Crafts movement.** Most machine-made products at that time tried to imitate a material other than what they were or tried to camouflage what they were in florid, extraneous designs. Ruskin and Morris could not imagine that machine-made products might have artistic value in any form.

To remedy the poor state of mass-production design, Ruskin and Morris insisted that the designer should also be the one who makes the product so that the object reflects an individual's humanity. Handmade work, they believed, would not have the exact finish of a machine-made item and thus would reveal the personality and skill of the maker. And since the designer would understand the entire process of making, the craftsperson would exploit the genuine nature of the material. There would be no more false imitations.

In 1861 Morris established in England the design firm Fine Art Workmen, soon called Morris and Company, in order to bring the qualities of handcrafted work to commercial products for the household. His *Trellis* pattern (Figure 13-17) was the first of the famous wallpapers designed by his company. Hand printed from twelve different blocks, his pattern of straight-lined trellis and curving rose is offset by the sprightly activity of birds. Straightforward and based on nature, the *Trellis* paper may have

Figure 13-17 **William Morris** [English, 1834–1896], *Trellis wallpaper*, 1862. William Morris Gallery, Walthamstow, London.

Figure 13-18 **Gustav Stickley** [American, 1857–1942] and **Harvey Ellis** [American, 1852–1904], armchair, 1903–1904. White oak (fumed) inlaid with copper, pewter, and wood, rush, seat. 46 7/8 × 22 7/8 × 20 in. (119.06 × 58.10 × 50.80 cm). Carnegie Museum of Art, Pittsburgh; AODA Purchase: gift of Mr. and Mrs. Aleon Deitch by exchange, 82.50.

given a small room an airy appearance as though it were the interior of a garden bower. Morris's wallpapers set a high standard of quality and were affordable for the general public.

The British Arts and Crafts movement soon spread to America, where craftsmen and craftswomen were not so reluctant as Ruskin and Morris to industrialize and mass-market handcrafted goods. In the opening years of the twentieth century, Gustav Stickley ran his Craftsman Workshops as a business where Harvey Ellis designed the armchair in Figure 13-18. Stickley sought to restore simple, clean lines to furniture so that the material would express itself naturally.

Except for Ellis's abstract floral design on the central back slat, Stickley avoided extraneous ornament and let the lines and proportions of the chair speak for themselves. The Craftsman Workshops built simple, massive furniture meant to last by assembling each piece with old-fashioned mortise and tenon joints instead of screws and nails. While promoting his furniture as art that was handwrought by a craftsperson, Stickley "mass-produced" artistic goods that the general public could afford. He characterized his work as the "mission style" because in the home it would fulfill a moral mission to educate the American family in good proportions and honest construction and thus influence their lives toward goodness and truth.

Individuals now often approach furniture design as a form of art. Wendell Castle, perhaps America's most famous woodworker, deliberately turned his back on traditional furniture design in order to clear his mind of preconceived notions and to make some-

Figure 13-19 **Wendell Castle** [American, 1932–], *Desk*, 1967. Mahogany and cherry laminated to plywood; gesso, silver leaf, 40 1/2 × 89 × 62 1/2 in. (102.9 × 226.1 × 158.8 cm). Collection of the Racine Art Museum. Gift of S. C. Johnson & Son, Inc. Courtesy of Racine Art Museum, Racine, Wisconsin. Photograph by Jon Bolton, Racine, Wisconsin.

In order to build his desk, Castle first glued together into a mass a number of boards that were cut in general conformity to the overall configuration of the final piece. The first person to apply the procedure to furniture, he calls his method "stacked lamination." To begin shaping the rough wood, he first worked over the piece with a chain saw! Castle then smoothed the surface with an assortment of power tools, as well as old-fashioned chisels and sandpaper. Noted for his exquisite craftsmanship, Castle does not care what tools he uses as long as he can push wood beyond the ordinary.

thing original. His *Desk* (Figure 13-19) seems more like an organic growth, in which the root-like legs have sprouted a top, than the standard rectangular desk with four screwed-on legs. In fact, Castle's desk rests on only three points, two of which are far to the side of the top. More than building a piece of furniture, Castle sought to create a piece of sculpture in which he expresses himself with curved lines, swelling masses, and color contrasts.

INDUSTRIAL DESIGN

The Arts and Crafts movement did not push back the tide of mass manufacture initiated by the industrial revolution. The newly enfranchised middle class demanded their share of the relatively inexpensive consumer goods now available. It was the rapidly increasing demand for consumer goods for the home, starting in the 1920s, that gave rise to the art of **industrial design.** An industrial designer cre-

ates for the manufacturer's product a style that will increase its usefulness and efficiency and, most importantly, increase its appeal to the consumer. Unlike most craft workers, industrial designers do not usually get their hands dirty making something. Although designers may help set up the means of production, they ordinarily leave the actual manufacture of the object to someone else.

A designer or, more likely, a team of designers has shaped and styled all the machine-made vehicles, appliances, communications equipment (Figure 13-20), furniture, tools, toys, and utensils that we constantly use. For generations, the American public has had a passion to possess stylish consumer goods and the status they afford. With countless mass-manufactured goods filling our homes and businesses, industrial design has become a pervasive and powerful influence on our daily visual experience.

Although machines can repeatedly manufacture goods with far greater precision than the human hand,

Figure 13-20 Early telephone. © Edward Bock/Corbis. Modern cell phone. © Royalty-Free/Corbis.

the skill and imagination of designers still give shape to each product. Their inventiveness often challenges the impersonality of the machine or exploits the machine's accuracy. For example, the common paper-thin aluminum Coke can (Figure 13-21) has an attractive simplicity. Earlier metal craftsmen would have admired not only its balanced shape but also its accuracy and perfection, which can be repeated over and over again.

Figure 13-21 Coke can (side) © Barry Bland/ Alamy. Coke can (from top) oote boe/Alamy.

Figure 13-22 Ford Model T, 1908. © Bettmann/Corbis.

Purely visual concerns are not enough to determine whether the shapes of an industrial product are well designed. Industrial designers have to consider other important factors not usually found in traditional works of art. The visual elements must satisfy the functional needs of the product and enable it to work well. The shapes must also be suited to efficient and low-cost manufacture by machines. Finally, the design must be eye-catching and yet not too innovative so that it gives the product an identity that appeals to the mass market.

The evolution of the visual appearance of one product, the American automobile, illustrates the complex nature of industrial design. Henry Ford created a revolution when he mass-produced the Model T at the beginning of the twentieth century (Figure 13-22). Before that, cars were handcrafted. Ford's introduction of standardized parts, assembled by people working at a moving assembly line, meant a high volume of production. The same factors meant

low cost to the consumer since the constancy of the standardized parts reduced costs. For years, Ford refused to change the Model T's design until he was forced to do so by the increased sales of other manufacturers that had introduced new styles of body design to entice buyers.

The introduction of new styling soon became a yearly event calculated to make an old style obsolete—a policy called "planned obsolescence"—and to force new sales. Design became an important factor in marketing the product. Streamlining was introduced to automobiles in the 1930s (Figure 13-23). Lights were absorbed into the fenders, and fenders took on teardrop shapes and began to merge into the body. The shape of the hood became united with the passenger compartment.

In the 1950s, styling became a futuristic Buck Rogers fantasy (Figure 13-24). Cars of enormous size and weight had bullet noses, tail fins, and simulated jet exhausts. These emblems of speed and advanced science increased the appeal of the cars to consumers, but they did little to further the effective functioning of the machine. The 1950s Cadillac symbolizes the post–World War II boom years of American consumerism.

In recent decades, auto design has been influenced by the desire for fuel efficiency and safety, by the cost and conservation of raw materials, by adaptations to robot manufacture, as well as by aerodynamics. Masses and lines have become fewer, smaller, simpler, more rounded, and cleaner. Despite rising SUV sales, many consumers now look to see that energy efficiency and concern for the environment are incorporated in any product's design.

Many designers have claimed that the form of the product ought to follow from its function. The functional look is often associated with the Bauhaus,

Figure 13-23 Lincoln Zephyr, 1936. © Ford Motor Company.

Figure 13-24 Cadillac Eldorado Brougham, 1957. © Bettmann/Corbis.

even though the famous German art school produced only a few viable examples of industrial design. In the mid-1920s, Walter Gropius, the director of the school, declared that the workshops of the Bauhaus would henceforth be laboratories to develop prototypes for mass production by industry. The Bauhaus would train students in the technology of materials as well as in the elements of artistic design.

One member of the Bauhaus faculty, Marcel Breuer, designed extremely innovative chairs that eventually went into limited production and were

Figure 13-25 Marcel Breuer [American, 1902–1981], Casca side chair, 1928. Chrome-plated tubular steel, wood, and cane. 13 1/2 × 17 1/2 × 18 3/4 in. (80 × 44.5 × 47.6 cm). Possibly an adaptation of a design by Mart Stam. Museum of Modern Art, New York. © The Museum of Modern Art. Licensed by Scala/Art Resource, NY.

widely imitated. Employing chrome-plated tubular steel—like that used for bicycle handles—Breuer designed a revolutionary chair (Figure 13-25) with an S-curved frame in which the seat and back were thrust away from the two front legs, their only support. Breuer thought that all his tubular steel furniture had a modern, style-less style since the design resulted only from the quality of the material and the simplified structure. The bent tubing makes the chair lightweight and springy while the aggressively simple modern design is transparent and mass-less. Chrome furniture never found much place in the home furnishing market, but it became fashionable for the office, where the note of avant-garde taste and modernity made it a status symbol.

Modern electrical equipment often takes exception to the rule that form follows function. Complex internal systems are seldom expressed in the external design of computers, DVD players, and telephone equipment. Expressing the inner workings of such machinery would probably only confuse and dismay most consumers. For years, most designers have simply housed such high-tech equipment in a plain box. They strive at best to make the external controls arrayed by the electronic engineers easy to find and easy to use.

Still, it is possible to achieve good design in consumer electronic equipment. When Apple Computer resolved to market a new digital music player, it first decided on the shape of the box. In the words of CEO Steve Jobs, Apple's iPod (Figure 13-26) "lets you put your entire music collection in your pocket." The device had to be a smooth white rectangle that fits securely in one's hand and slips easily into one's pocket. In effect, Apple designed the device from the outside in. The designers envisioned what it should look like and let that vision dictate the internal components. To keep the exterior flat, the controls are touch pads. Scrolling is done by a user-friendly flat circle, rather than a movable wheel. Propelled by a sophisticated advertising campaign (see Figure 4-4) and tied to a new music delivery system (iTunes), the iPod has been a commercial success.

GRAPHIC DESIGN

To sustain the mass production of goods, manufacturers must continually advertise their products to

Figure 13-26 Apple iPod. © Kim Kulish/Corbis.

the public to stimulate sales. Large corporations such as Nike pay advertising agencies millions of dollars for designers such as Jelly Helm (see "Artist at Work") to devise print and video commercials about the goods they manufacture. Advertising enables consumers to identify a product at the point of sale by informing them about the product and persuading them to want a particular brand. Advertising can attribute something unique, such as a special status, to the possession of this particular brand. Some would say that advertising can create the very need to have any product. Advertising can also identify and promote services. Medical, legal, financial, and charitable institutions as well as government and political parties buy advertising to inform the public about issues and promote the personal services they offer.

Advertising is probably the most common form of **graphic design.** Graphic design encompasses all printed and visual images that communicate messages—messages that identify, inform, and persuade. Graphic designers work in a variety of media, from traditional printed publications to computer graphics and television. Graphic designers are also responsible for the arrangement of museum exhibits and the exhibition of commercial products. They design packaging and displays of all sorts as well as informational systems.

To perform its task, graphic design should catch the attention of the audience, and at the same time it should make sure that the audience gets the message. All art is a form of communication between a sender and a receiver through a medium, but in graphic design not only does the medium very often involve words; the message is normally directed to a mass audience. Designers also target special groups of people and respond to age, ethnic group, and socioeconomics in their work. Like architects, graphic designers generally take a considerable amount of direction from the client.

TYPOGRAPHY

The root meaning of the word *graphic* refers to writing, and one of graphic design's major tasks is to create the visual appearance of words and numbers, or **typography.** In printing, designers normally work with four general styles of letters or type: script, italic, roman, and sans serif.

Script looks like handwriting because the fluid letters slant and are connected. Italic type, *which conveys an emphatic impression,* also slants, but the letters are not connected, nor do they appear as fluid. Roman type resembles the elegant letters carved in ancient Roman inscriptions. The main strokes of each roman letter end in a distinctive finishing stroke called a serif. The bolder, modern-looking sans serif letters do not have these finishing strokes (*sans* in French means "without"). Another possibility, the solemn Old English, or black letter, type, resembles the lettering used in the European Middle Ages. Because of its serious and traditional character, black letter is still used to print the nameplate of many newspapers (Figure 13-27). Each style

The Times-Picayune
The Miami Herald
The Atlanta Journal
The New York Times

Figure 13-27 *The Times-Picayune; The Miami Herald; The Atlanta Journal; The New York Times.*

Figure 13-28 Herb Lubalin [American, 1918–1981]. Courtesy of the Herb Lubalin Study Center of Design and Typography at The Cooper Union School of Art. Typography. Courtesy Rhoda Sparber Lubalin.

of lettering comes in hundreds of individual variations in the formation, size, and weight of the letters. A certain style and size of lettering is called a **typeface.** In addition to legibility and emphasis, a creative designer such as Herb Lubalin is capable of expressing visual meaning in the spacing, expansion, contraction, elongation, or thickness of the type, as illustrated by the example of his work in Figure 13-28.

Graphic designers also fashion all kinds of signs, some of which may convey their messages in images alone. Such signs, called **pictographs,** use visual images to represent a word or an idea. A highway sign with a curving black arrow on a diamond-shaped yellow background clearly alerts a driver to an upcoming curve in the road. A diagonal red bar through a cigarette conveys perhaps a stronger message than the words "No Smoking." Using a number of these well-known symbols, the U.S. Department of Transportation developed a system of pictographs for use in terminals throughout the United States (Figure 13-29).

(text continued on page 286)

Figure 13-29 Roger Cook and **Don Shanosky,** Cook and Shanosky Associates, Inc. The U.S. Department of Transportation Symbol Sign System, 1974. Courtesy of AIGA.

Jelly Helm (1966–)

Graphic Designer Jelly Helm. © Jim Clark/The portland Tribune.

Jelly Helm published his first advertisement in his college newspaper and has been hooked on advertising ever since. He rose rapidly to the top of the profession. After two years at the Martin Agency in Richmond, Virginia, he became art director for the Nike and Microsoft accounts at Wieden + Kennedy in Portland, Oregon. Two years later the agency made him creative director for its Amsterdam office. Along the way his ads earned numerous awards.

His ad for Nike Air shows what made his work so appealing. Cut-out photos of the shoes are pasted on a ludicrous drawing of an athlete's legs. Crammed into the space at the left, the "artist" criticizes his own drawing in a very engaging manner. The text is crudely printed, as the hairy legs are crudely drawn. The wacky combination of drawing and a very personal text catches the attention of readers and makes them dwell, favorably, on the product if only for a moment.

Then, at the height of his career, less than ten years out of college, Helm started to criticize the advertising profession. He recently summed up his opinions as follows:

> My criticism of advertising has always gone like this: if you take the underlying messages of all the ads we're exposed to, they are remarkably consistent in the values they promote. And if you built a society on those values, it would be a pretty self-centered, materialist, live-for-the-moment, hedonistic, hyper-competitive sicko freak show society. Which is pretty much what we've got.[1]

In articles and lectures he has preached about the impact that advertising has on creating a consumer economy. He deplores that an ad agency does not examine whether the business is ethical or that the product injures the environment. He advocates that advertising help promote sustainability by taking responsibility for the sale of a product—asking how it helps or hurts the community and how the company treats its employees. He believes that as designers and art directors who strive for beauty in their work, advertising professionals cannot promote clients who pollute the environment or exploit people. The contradiction prevents advertisers from ever achieving real beauty in their work, he argues. Helm would "promote only those goods and services that benefit human development . . . refrain from promoting reckless, irresponsible, competitive consumption . . . ban all broadcast advertising to children under 12."[2]

Because of his views and the impact they were having, Jelly Helm was appointed to the Advisory Board for the United Nations Environmental Program's Initiative of Sustainable Consumption. He returned to Richmond, where he taught at Virginia Commonwealth University, and to Portland, Oregon, where he works in an ad agency, trying to put into practice what he preaches.

Jelly Helm [American, 1966–], Nike ad, 1992. Wieden + Kennedy Ad Agency. Courtesy of the artist.

Figure 13-30 Duracell Battery package. © The Advertising Archive Ltd/The Picture Desk.

The clarity and consistency of signs throughout an airport, office building, or a hospital are welcome to a visitor and project an image of concern and competence.

PRODUCT PACKAGING

Product packaging, usually a three-dimensional design problem, is calculated not only to inform the viewer but to create a favorable image and a distinctive identity for the product that the consumer can readily pick out on the shelf. Most people around the world recognize a package of Duracell batteries by the distinctive black and copper color

of its box and the thick sans serif capital letters of its name (Figure 13-30). Most people around the world recognize a Coca-Cola soft drink by the florid script of its name set against a bright red background (Figure 13-21). A sophisticated packaging design can also symbolize quality, prestige, or status for the manufacturer. Many corporations strive to design for themselves a distinctive trademark, whether through typography, through a symbolic logo, or through both (Figure 13-31). In contrast to the lowercase letters and circle of the American Broadcasting Company's logo, Music Television developed call letters that could be animated. The block-like M, in colors and textures that often mutate, operates as a background for the small letters (tv) projected across it. The letters have the character of spray-painted graffitti. The MTV logo thus evokes hip street culture, and its animated transformations reflect the dynamism of its product.

PRINT MEDIA AND VIDEO

Graphic designers also design book jackets, recording covers (Figure 13-32), and magazine covers and create the page layouts for books, magazines, and brochures. For these tasks they must choose the size and style of type; arrange the columns of print; and integrate headings, text, borders, and images on each page or series of pages. The designer usually tries to create a consistent style so that the publication has a personality that will captivate and guide the audience.

For several years the Target Corporation has waged advertising campaigns based on the company's red and white bull's-eye logo. In one ad (Figure 13-33), the design team simulated a very young, very blond American family in their backyard using products sold in Target stores. They wear

ABC logo IBM logo MTV

Figure 13-31 ABC, IBM, MTV logos. IBM logo © IBM. MTV logo. Courtesy of Viacom.

Figure 13-32 Björk, *Homogenic*, CD cover of Björk's 3rd album. © Sygma/Curbis.

clothes featuring Target patterns; the grass and garden hose are red. A young boy kicks a red ball through the hose, recreating the Target logo in the center of the composition. The ads are fun, youthful, and modern. They convey a sense of style that reflects on the store as a fun and fashionable place to shop.

Since advertisements for products, services, and political ideas appear in a variety of formats, an advertiser such as Target, Apple, or Nike will

Figure 13-33 Target magazine ad. Printed with permission by Target, Minneapolis, Minnesota.

Figure 13-34 A TV still showing FOX News' computer graphics. Photographer: © Katja Heinmann/AURORA.

Figure 13-35 Myst 2 computer game image. © Cyan Worlds, Inc. All rights reserved Myst ®, Riven ®, D'ni ®, Uru ®, respective logos ® Cyan Worlds, Inc. No part may be copied or reproduced without express, written permission of Cyan Worlds, Inc.

only on television ads but also in the animated lead-ins that graphic designers have created for almost every television show or channel identification (Figure 13-34). These multimedia productions combine text, graphics, sound, animation, and full-motion video. Multi-media work has flourished not only in commercial presentations and educational programs but also in web page design and in video games, such as Myst 2 (Figure 13-35).

POSTERS

Posters and billboards challenge graphic designers to communicate effectively in a large-scale, public format. Because they must catch the attention of the passer-by, posters and billboards have for a long time emphasized a visual simplicity and directness. The artistry of posters has made them collectors' items since they first appeared in the late 1800s. At the end of the nineteenth century, following new developments in color lithography, the French painter Henri Toulouse-Lautrec brought the poster to a new level of art and effective advertising. In his poster advertising the Moulin Rouge (Figure 13-36), the text in a rounded sans serif remains simple and integrated with the total composi-

often develop the same message or concept in both electronic and printed media at the same time. Television advertisers frequently spare no expense on a dazzling array of film techniques to persuade the consumer to think favorably of the product and to want it. The computer's ability to manipulate and to make words and images move appears not tion. Toulouse-Lautrec also simplified the imagery and boldly manipulated space in the manner of Japanese printmakers. Four simple flat colors and the strong outline of each form make a striking and original design.

Although the dominance of commercial posters in American advertising has been overtaken by

Figure 13-36 Henri Toulouse-Lautrec [French, 1864–1901], *Moulin Rouge (La Goulue)* poster, 1891. Color lithograph, 75 3/16 × 46 1/16 in. (191 × 117 cm). © Historical Picture Archive/Corbis.

In 1891 the manager of the Moulin Rouge nightclub in Paris commissioned a new poster from the painter Henri Toulouse-Lautrec. When 3,000 copies of his very large lithographed poster appeared on the street, Toulouse-Lautrec became the talk of Paris. The artist featured the dancer La Goulue (Louise Weber) in the very center of the poster, where she performs her notorious high kicks. Her shadowy, grimacing dance partner (Valentin-le-Désossé) looms close to the surface in the foreground. The audience has become a black silhouette in the background. Three yellow globes of a gas lamp appear on the left. Proud of his poster, the artist submitted it to two art exhibitions.

Figure 13-37 Julius Friedman [American, 1943–], *Louisville Ballet*, 1980. Poster. Courtesy Julius Friedman, Louisville, Kentucky.

magazine and television ads, the poster more than ever appeals to collectors of the art of graphic design. Consequently, in addition to announcing an ad campaign, a well-designed poster may simply lend prestige to an advertiser who sponsors a poster as an art form. The imaginative works of Julius Friedman, for example, are preserved and displayed long after the event they announce. Friedman, who has designed more than 250 posters, realizes that a good poster needs an arresting image that will make an impression. His poster for the Louisville Ballet (Figure 13-37) captures attention by the stark simplicity of its axial design, its striking pink and black contrast, and the surreal impression of a dancer standing on an egg. The airborne lightness and delicacy implied in the image are reinforced by the florid script of the minimal text, Louisville Ballet.

April Greiman, who pioneered the use of computers in graphic design, created a poster for *Design*

Figure 13-38 **April Greiman** [American, 1948–], *Does It Make Sense?* 1986. *Design Quarterly* #133, MIT Press/Walker Art Center, 1986. Courtesy April Greiman/Made in Space.

Quarterly titled *Does It Make Sense?* (Figure 13-38) entirely on her Macintosh computer, soon after the first Macintosh appeared. The six-foot-long poster was folded and mailed as an issue of the magazine. To create it, images from a video camera were edited by the MacPaint program; lines were produced with the computer's MacDraw tool. The text, images, and lines float in the sea of space that surrounds her nude figure. Greiman had to print her computer-generated poster on about two dozen pieces of ordinary 8 1/2-by-11-inch bond paper, which were then fitted together like a mosaic. Her dazzling combination of text and imagery opened the eyes of graphic designers to the potential of the computer.

Today, almost all graphic design is computer generated. The computer allows the communicator to arrange and harmonize text and visuals in a total design on the page. It is the designer's perfect sketch pad because alterations of any or all of the design elements are easy and rapid, and they instantly have a finished appearance. But even though the computer allows a graphic designer great versatility, flexibility, and speed in designing layouts, only a trained eye and a creative imagination can create designs that succeed.

Whether creating a poster, a magazine ad, or a page layout for this textbook, graphic designers use the same visual elements and principles of design as every artist. In applying these principles, they organize words and images to attract and inform the audience and to persuade it, not usually about their own personality, but about the company, the product, or the service. Like the products of industrial design, the messages of graphic design are everywhere, calling for our attention and shaping our attitudes and way of life. Through their ubiquitous and pervasive work, creative designers bring artistic values out of the museums and into daily life.

Crafts

Four types of craft work exist:

1. The practice of original handicraft skills to make useful items. Examples: Basket weaving, pottery, quiltmaking.

2. The revival of original handicraft skills to oppose mass manufacture and to reassert personal integrity. Examples: Morris, Stickley.

3. The use of traditional craft media as art media. Examples: Castle, Littleton, Voulkos, Zeisler.

4. The production of luxury goods because of their fine materials, workmanship, or design. Examples: Tiffany glass, Rospigliosi Cup, Tutankhamen's pectoral.

Industrial Design

Industrial design is the creation of mass-produced objects, manufactured largely by machines, by someone who is normally not involved in the actual manufacture of the object.

Industrial design has four main characteristics:

1. It uses the same visual elements and principles of design as every artist.

2. It fulfills and enhances the functional needs of the product.

3. It is suited to manufacture by machines.

4. It creates an appeal for the mass market.

Graphic Design

Graphic design is the creation of printed and visual messages.

Its purpose is to inform and persuade a mass audience.

The major kinds of graphic design are typography, signs, publishing layouts, computer graphics, advertising, film and TV production, packaging, and exhibitions.

INTERACTIVE LEARNING

 In the Studio: Glassblowing, Wheelworking

Flashcards

Artist at Work: Jelly Helm

Companion Site: **http://art.wadsworth.com/buser02**

Chapter 13 Quiz

InfoTrac® College Edition Readings

Talking Flashcards

Online Study Guide

14 Architecture

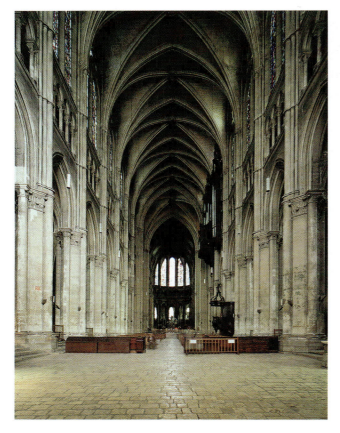

🔘 **Figure 14-1** [French] Chartres Cathedral, interior looking east, begun 1194. Chartres, France. Photo Paul M. R. Maeyaert.

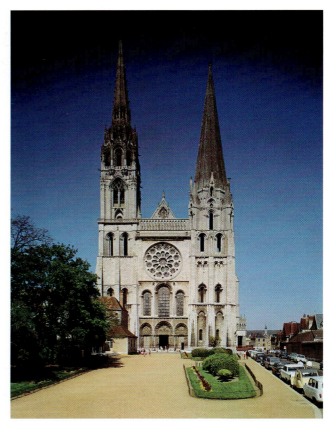

Chartres Cathedral, exterior looking east.

Imagine what it is like to visit the great cathedral at Chartres (Figure 14-1). From a distance, we see the impressive bulk of the stone building with its spires and pinnacles rising above the rooftops of the city. Up close, the asymmetry of the two spires flanking the front entrance presents a puzzling but picturesque outline against the sky. The spire on the right appears simple, massive, and clear-cut, even stodgy by comparison to its counterpart. The left spire, rebuilt later in more up-to-date style, has taller and more slender members and is more open and delicate.

The slanting sides of the three front porches funnel us inside the church. Once through the door, we are thrilled by the depth, breadth, and height of the cathedral. At the same time, we are immersed in its cool darkness. A colored fog seems to fill the space; the gray stones of the walls seem faint. The most striking sights are the large windows filled with glass glowing red and blue.

After we have adjusted to the dim light and the soaring space, the repetition of the arches down the center of the building impels us to move forward. As

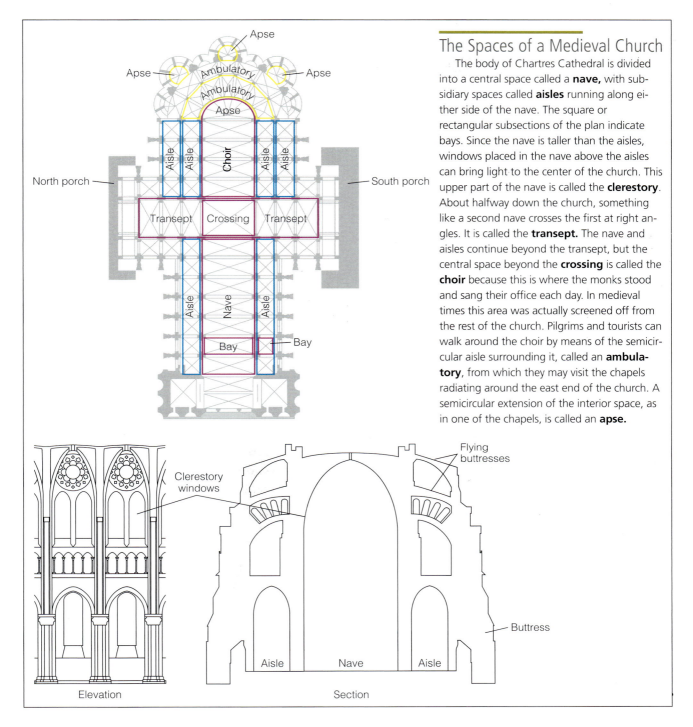

Apse

Apse

Ambulatory

Apse

Ambulatory

Apse

North porch

South porch

Aisle | Aisle | Choir | Aisle | Aisle

Transept | Crossing | Transept

Aisle | Nave | Aisle

Bay | Bay

Elevation

Section

Clerestory
windows

Flying
buttresses

Buttress

Aisle | Nave | Aisle

The Spaces of a Medieval Church

The body of Chartres Cathedral is divided into a central space called a **nave,** with subsidiary spaces called **aisles** running along either side of the nave. The square or rectangular subsections of the plan indicate bays. Since the nave is taller than the aisles, windows placed in the nave above the aisles can bring light to the center of the church. This upper part of the nave is called the **clerestory.** About halfway down the church, something like a second nave crosses the first at right angles. It is called the **transept.** The nave and aisles continue beyond the transept, but the central space beyond the **crossing** is called the **choir** because this is where the monks stood and sang their office each day. In medieval times this area was actually screened off from the rest of the church. Pilgrims and tourists can walk around the choir by means of the semicircular aisle surrounding it, called an **ambulatory,** from which they may visit the chapels radiating around the east end of the church. A semicircular extension of the interior space, as in one of the chapels, is called an **apse.**

we advance along this avenue marked by thick clusters of columns, our eye turns to follow their thin lines up the wall. They thrust up between the windows and then spread like a fan across the ceiling. As we walk, we sense the worn stones beneath our feet and the texture of eight-hundred-year-old stone walls. Footsteps and voices reverberate within the stone vaults. All our senses are heightened.

Halfway through the church, spaces similar in their proportions to the main body of the church open to the left and right and interrupt our progress forward. This crossing of east–west and north–south directions is marked with thicker supports at the corners and a square vault overhead. We pause to look around and appreciate the extent of the symmetry in all four directions. We notice particularly the great circular rose windows—shaped like the blossom of a rose—in three of the arms.

Eventually we are forced to choose an aisle to the side of the main altar. The aisle proceeds

Figure 14-2 [Tallensi], a compound at Tongo, 1969. Ghana, Africa. Diagram from *Architecture in Northern Ghana* by Labelle Prussin. © 1969 The Regents of the University of California. Photo by Dennis Stock, Magnum.

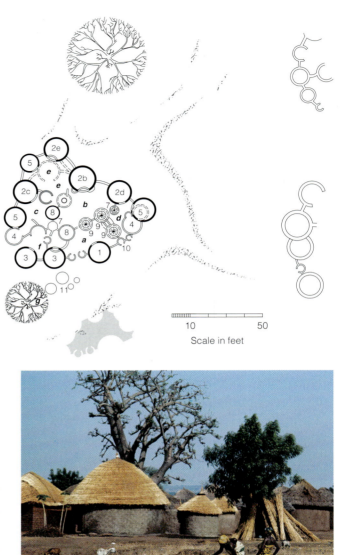

Among the Tallensi in northern Ghana, building technology is extremely well suited to the available materials, the semi-arid climate, and the way of life of the people. Male relatives and friends build the walls of the circular sleeping rooms and granaries by applying layer upon layer of wet mud balls; the women finish the surfaces and decorate the tapering walls with incised patterns. Extended families live in compounds that are vaguely circular like the circular huts themselves. Since most of daily life takes place in the courtyards and other open spaces of the compound, the entire compound shapes spaces for living. The layout of the compound effectively diagrams family relationships. When family relationships change, parts of the architecture are demolished, altered, and added to.

The parts of the compound in this illustration are labeled as follows: a, subcompound for the animals; b, senior wife's courtyard; c, second wife's courtyard; d, brother's wife's courtyard; e, son's wife's courtyard; f, courtyard of the unmarried sons; g, shade tree and sitting area; 1, compound founder's (present owner's father's) room, containing his possessions; 2b–e, wives' rooms; 3, unmarried sons' rooms; 4, dry-season kitchens; 5, wet-season kitchens; 6, bathing enclosure; 7, millet granaries; 8, millet-grinding rooms; 9, sheep and goats; 10, chicken roosts; 11, ancestral shrines.

forward, then moves us around the altar. In this far end, the east end of the church, the external walls radiate out into small chapels. Before starting our return journey, we stop to delight at the way that the building itself has guided our pilgrimage through it.

Inside the church are many more places to explore and many more observations to make. But perhaps at one point we are persuaded to leave the building through a side door. Outside we are surprised to see, extending beyond the building, porches more elaborate than those between the front towers. Stepping down from the church, we notice the heavy piles of stone that protrude from the building and almost engulf the windows between them. They impress us with their sturdy mass. These **buttresses** rise above the outer walls of the building and support arches that reach out like arms to apply pressure against the walls of the tall central part of the church. Powerful and dynamic forces are at work in the masses and lines of the exterior.

Even without knowing the history of the building and the culture associated with it, we could spend hours exploring the architecture of Chartres. The simplest pilgrims in the Middle Ages had the same experience. Although the pilgrims were probably unable to articulate it, their experience of the magnificent cathedral building may have been made more intense by the contrast with their ordinary surroundings.

THE EXPERIENCE OF ARCHITECTURE

Our imaginary pilgrimage through Chartres discloses that architecture shapes our experience like no other art form. Architecture physically causes us to live in a certain way and makes it difficult, if not impossible, to live in other ways. In a building such as Chartres, hun-

dreds of people can assemble in an open space that seems like a world of its own. The masses and open areas of any building can support certain activities, or they can obstruct and confuse movement. Stairs are either convenient or inconvenient. The lighting and ventilation make it a pleasure to pursue the intended activities within the building, or they make those activities almost impossible. On the exterior, the masses and height of the architecture can invoke a forbidding presence, or the architecture, growing up with its surroundings, can welcome the visitor.

Architecture separates a space apart from the endless space of nature and creates an environment for our activity. Architectural forms then wrap around us and shelter us. Since we experience architecture by living in it for a while, architecture takes an amount of time to observe. Architecture has to unfold itself over time, the way music needs to be played for its forms to develop. Experiencing architecture might also be compared to watching a movie. The movie might start with a panoramic establishing shot of the whole building in its context, then move in for a closer look. Suddenly the film cuts to some detail, dwells on some aspect, or moves in a rhythm from room to room to explain how the sequence of spaces unfolds. But even the probing, shifting eye of the camera cannot give an awareness of masses looming in our presence or a truly three-dimensional experience of space or the feeling of being surrounded and covered all over.

A SOCIAL ART

Architecture remains a very familiar branch of the visual arts because everyone spends a good part of every day living in some form of architecture. Architecture is also perhaps the only essential art form, since we must have buildings to live comfortably, safely, and efficiently. We may ignore any painting on a wall or any statue on a pedestal, but we cannot get along without architecture.

Some theorists have distinguished between Architecture with a capital A and ordinary buildings that merely provide human shelter. They define archi-

tecture as a special form of building that affords a privileged aesthetic experience similar to the aesthetic experience of other "fine" arts. However, the distinction between high-minded Architecture and ordinary buildings is hard to maintain because structures of all kinds may embody the architectural experience—some more, some less—provided our imagination is open to it.

For instance, the Tallensi people in northern Ghana, like many other people in sub-Saharan Africa, have tended to build simple rounded mud structures with thatched conical roofs (Figure 14-2). Although their technology is simple and basic, they sculpt their dwelling spaces around their daily activities like a sensitive artist working with clay. More than most people, they express in the spaces that they create the way that they live.

In short, all kinds of buildings can symbolize the same kind of personal, feeling-filled awareness that the other forms of art express. Architecture communicates its own personalized experience of living in space through a language of forms, materials, and techniques. Sometimes, a building may stand out as the personal expression of an individual great architect. Just as often, a building communicates the ideas and aspirations of the society for which it was built. Even though we do not know the names of the architects, the ruins of the metropolis of Teotihuacán (pronounced tay-oh-tea-wha-*cahn*) (Figure 14-3) in

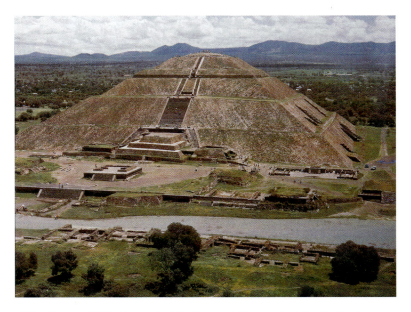

Figure 14-3 Pyramid of the Sun, with Pyramids of the Ciudadela in foreground, ca. 100 BCE–500 CE. Teotihuacán, Mexico. Photo courtesy Ester Pasztory.

Figure 14-4 New York City skyline. © Bill Ross/Corbis.

central Mexico speak volumes about the culture of the ancient people who lived there from about 100 BCE to 500 CE. And the skyscrapers of New York (Figure 14-4) symbolize a modern society built on technology, even though we know the name of each architect of each modern building.

The center of an empire in central Mexico, Teotihuacán had a population of about two hundred thousand. The city was set out in a grid-like pattern and covered eight square miles. The three-mile-long Avenue of the Dead ran north–south through the heart of the city and terminated in the Pyramid of the Moon. More than seventy-five temples, situated on the flat tops of pyramid mounds, lined the avenue—including the largest building in the city, the Pyramid of the Sun, 230 feet high. Since the inhabitants of the empire believed that Teotihuacán was the birthplace of the sun and the moon, the city became an important religious center. The scale and regularity of the architectural remains indicate the religious fervor of the people and point to a strong authority and an organized work force that lasted for centuries in central Mexico.

The skyline of America's largest city, its towers rising above the water, presents a dramatic image of the financial and technological vitality of the country. The towers serve the needs of banking, management, communications, commerce, and government—the complex nervous system of modern life. To function, the buildings themselves demand complex public services—transportation, utilities, and electronic communications. Coupled with the tech-

nology that makes tall buildings possible, the skyline symbolizes at a glance the dynamism of modern life.

VITRUVIUS

The distinctive character of architecture was long ago recognized by the Roman architect Vitruvius, who, in the late first century BCE, wrote a book called *About Architecture.* His was the only architectural treatise from ancient times that survived the fall of the Roman Empire. The Renaissance revived his ideas, and for centuries they have formed the basis for the discussion of architecture in the West, even when they have been rejected.

Vitruvius wrote that architecture has three characteristics: *firmitas, utilitas,* and *venustas.* The words mean, respectively, "firmness," "utility," and "the pleasures of Venus." In plainer English, Vitruvius probably meant something like solid construction, suitability, and beauty. His words refer to building materials and techniques, appropriateness or practicality, and the artistic expression of architecture.

Everyone agrees with his first principle, that a building should be well built. Vitruvius wrote at length in his book on such fundamental things as bricks, concrete, and stone and the proper methods of building walls: "Durability will be assured when foundations are carried down to the solid ground and materials are wisely and liberally selected."[1] In modern buildings, we too want the walls to stand on solid foundations, and we want the plumbing to work. Every architect has to be concerned with ma-

Figure 14-5 Joseph Paxton [British, 1801–1865], Crystal Palace, 1851. London. © Time Life Pictures/Getty Images.

Some of the most remarkable achievements in architecture in the nineteenth century were made by engineers who designed thoroughly utilitarian structures such as factory buildings, railway bridges, railway terminals, market halls, and shopping arcades with glass-covered vaults constructed of prefabricated iron parts. The Crystal Palace set the standards for a series of spectacular iron and glass exhibition structures in the late nineteenth century. For such new building types, the weight of architectural tradition did not impede the inventiveness of the structural engineer. Joseph Paxton had experience with building hothouses when he was called upon at the last moment to design the Crystal Palace. Not only was the entire building sheathed in glass, but its modular parts were mass produced and shipped to the site. Once under way, the Crystal Palace took only four months to construct. Framing an enclosed world, the thin structural members dissolved in the light. The heat radiated by the sun—a greenhouse effect—plagued the Crystal Palace, as it does every glass building.

terials, construction techniques, and the principles of engineering.

Some modern architects and engineers are concerned only with technology, and they even claim that technology determines the very appearance of a building. Vitruvius's *firmitas* becomes their most important principle. After all, building techniques and available materials leave open only certain possibilities for shaping a building. For example, the discovery of new techniques of lightweight stone vaulting made possible the great cathedrals of the Middle Ages such as Chartres. In modern times, the introduction of iron and steel as a building material changed the appearance of architecture. Metal beams can be assembled into a relatively thin skeleton to support a large building. In the distant past,

stone walls had to be thick and massive in order to sustain a large roof or numerous stories. A skeletal structure can also leave open large amounts of interior space—an achievement demonstrated at an early date, 1851, in Joseph Paxton's Crystal Palace (Figure 14-5).

Modern technology and new materials continue to stimulate creativity in architecture. In fact, most architects today are trained primarily not as artists but as engineers who must master a complex technology. Nevertheless, the whole story of architecture cannot be reduced to engineering since the needs of the society and the imagination of the architect also significantly influence the medium.

Architects have argued much more over Vitruvius's two characteristics, suitability and

Figure 14-6 [Greek], Temple of Athena Nike, 427–424 BCE. Acropolis, Athens. Pentelic marble: length 17 ft., 9 in. (5.4 × 8.2 m); width 26 ft., 10 in. © Susanna Pashko/Envision.

Figure 14-7 Dankmar Adler [American, 1844–1900] and Louis Sullivan [1856–1924], Wainwright Building, 1890–1891, St. Louis. © Art on File/Corbis.

beauty. Vitruvius understood suitability to mean, on the one hand, that certain styles and building types were proper for certain uses. According to Vitruvius, male gods such as Mars should have a virile style of temple; delicate divinities such as Venus should properly have a feminine style of temple. The Temple of Athena Nike (Figure 14-6) in Athens is one of the earliest temples built in a feminine style on the Greek mainland. However, the Greeks considered the nearby Parthenon (Figure 15-15), dedicated to the same goddess, to be masculine in style. Perhaps they felt that the celebration of Nike, which in Greek means "victory," was more delicate and fragile. The small scale, slender columns, and precise carving of the Nike temple convey that feeling.

On the other hand, Vitruvius also understood that suitability will be ensured when the arrangement of the rooms is "faultless and presents no hindrance to use."[2] Houses in town should have one form of building, he wrote, and houses on farms another because they each have different functions to perform. He proposed, in short, that different types of building suit different purposes.

Many leading architects of the modern age seem to have agreed with Vitruvius when he said that the

Sullivan once wrote that the

> shape, form, outward expression, design . . . of the tall office building should in the very nature of things follow the functions of the building. . . .
>
> Does this not readily, clearly, and conclusively show that the lower one or two stories will take on a special character suited to the special needs, that the tiers of typical offices, having the same unchanging function, shall continue in the same unchanging form, and that as to the attic, specific and conclusive as it is in its very nature, its function shall equally be so in force, in significance, in continuity, in conclusiveness of outward expression? From this results, naturally, spontaneously, unwittingly, a three-part division.[3]

Sullivan understood the tall office building as the equivalent of a classical column—its base containing commercial space open to the public, its shaft corresponding to the tiers of similar offices, and the capital an attic housing water tanks and mechanical equipment. But the chief characteristic of the tall office building must be its loftiness: "It must be tall, every inch of it tall, . . . a proud and soaring thing, rising in sheer exaltation that from bottom to top it is a unit without a single dissenting line."[4]

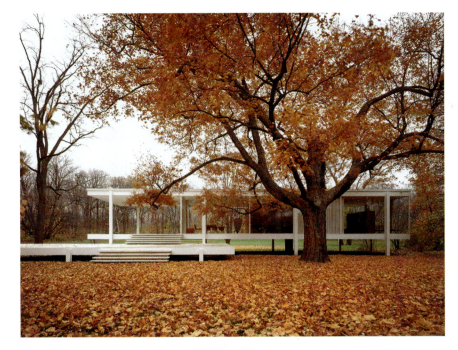

Figure 14-8 Ludwig Mies van der Rohe [American, 1886–1969],
Farnsworth House, 1950. Plano, Illinois. © Jon Miller/Hedrich Blessing.

shapes of a building (its form) depend upon the practical demands made of the building (its function). The first person to use the catchphrase "Form follows function" was the nineteenth-century American sculptor Horatio Greenough, who found exceptional beauty in the sleek, functional lines of the clipper ship. At the end of the century, the Chicago architect Louis Sullivan developed the maxim into a theory of architecture. In his work, Sullivan sought to combat the meaningless revival of past styles in architecture and to develop a new organic style that would grow out of the structure and functions of the building. He put his principles into practice in one of the first "skyscrapers" to take advantage of steel-frame construction, the Wainwright Building (Figure 14-7) in St. Louis.

Functionalism in another sense was adopted by many modernist architects of the mid-twentieth century who wanted to strip architecture of all ornament and build only with spare, sharp-edged, machine-made forms. They wanted the structure and the materials to reveal how the building was put together and how it operated. Interior spaces remained open to allow maximum flexibility. With its efficient, industrial-style forms, this pure and rationalized architecture, they thought, would lead humankind to a bright tomorrow. The architect Ludwig Mies van der Rohe embodied these ideals in his Farnsworth House (Figure 14-8), the summer home of Dr. Edith Farnsworth. Eight steel posts in two parallel rows support two horizontal slabs, the floor and ceiling. The external walls between the slabs are nothing but glass. They enclose an interior space that is entirely open except for the wood-paneled service core.

Last, Vitruvius declared that architecture should have *venustas,* or beauty. Many architects pay lip service to beauty by adding ornaments, such as elegant columns or potted plants, at the last minute. Vitruvius meant that architecture should have more than some decorative elements to attract the eye. He felt that the whole building, including the details, should give pleasure because of the harmony built into the entire work. Beauty is ensured, he wrote, "when its members are in due proportion according to correct principles of symmetry [harmony]."[5]

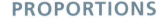

PROPORTIONS

Vitruvius and other classical and Renaissance architects believed that the beauty of architecture lay primarily in the proportions of a building. By proportions, they meant the correspondence and relationship of one dimension to another. All parts of

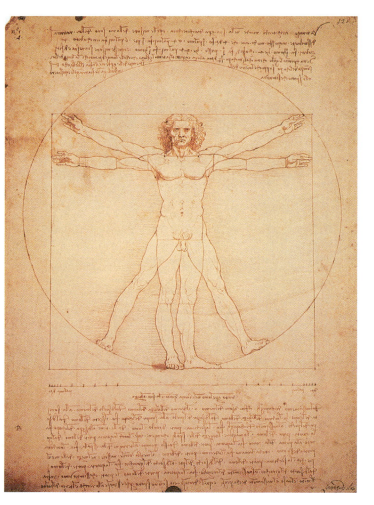

Figure 14-9 Leonardo da Vinci [Italian, 1452–1519], *Proportions of the Human Figure (after Vitruvius)*, ca. 1485–1490. Red chalk, 13 1/2 × 8 3/4 in. (34.3 × 22.2 cm). Galleria dell'Accademia, Venice. Dr. Mauro Pucciarelli, Rome.

These proportions reproduced the harmony and symmetry found in music and in the human body; therefore, according to Vitruvius, they ought also to govern the relationships among the parts of a building. To prove his point, he demonstrated how the "perfect" geometrical figures, the square and the circle, can be derived from the body, using the navel as the natural center:

> For if a man be placed flat on his back, with his hands and feet extended, and a pair of compasses centered at his navel, the fingers and toes of his two hands and feet will touch the circumference of a circle described therefrom. And, just as the human body yields a circular outline, so too a square figure may be found from it. For if we measure the distance from the soles of the feet to the top of the head, and then apply that measure to the outstretched arms, the breadth will be found to be the same as the height, as in the case of plane surfaces which are perfectly square.[7]

Leonardo da Vinci illustrated this analogy in a red-chalk drawing *Proportions of the Human Figure (after Vitruvius)* (Figure 14-9).

The urge to achieve harmonic beauty through proportions has a long history in architecture. The Greek architects Iktinos and Kallicrates, long before Vitruvius, designed the Parthenon (Figure 15-15) in ancient Athens using the ratio 4:9 for several essential dimensions. And the Roman Pantheon (Figures 15-18 and 15-19), several generations after Vitruvius, conforms to a perfect circle and sphere. In the Renaissance, the architects Brunelleschi, Alberti, Bramante, and Palladio revived Vitruvius's understanding of architectural beauty when they designed proportional buildings. In the 1930s, the modern French architect Le Corbusier again devised a system of proportions, this time based on the numbers of the golden section. He called it the **modulor,** or the module of gold, and thought it conformed to human proportions (Figure 14-10).

Although the ear naturally intuits the harmonies of music, the eye cannot immediately perceive numerical relationships in physical dimensions. How then can proportions affect our judgment of a build-

the building relate to one another and to the whole. A certain system governs the relationships of height to width to depth of rooms, walls, and all solids and voids throughout the entire building.

Vitruvius declared that "there is nothing to which an architect should devote more thought than to the exact proportions of his building with reference to a certain part selected as the standard."[6] The proportions that Vitruvius and many other architects envisaged were ratios of simple, small whole numbers such as 1:1, 1:2, or 3:4. Selecting the width of one room in a proposed building as the standard, an architect might design that room as a square (1:1) and the room next to it a rectangle twice as long (1:2).

ing? This question would not concern Vitruvius because to him a building with systematic proportions is inherently beautiful. Proportionality is an intellectual ideal, not a matter of perceptions. Nevertheless, architecture designed with a system of proportions usually produces spaces and masses that are elegant, integrated one with another, and pleasant to the eye.

Despite Vitruvius, many excellent buildings are asymmetrical in design. H. H. Richardson gave the facade of Stoughton House (Figure 14-11) in Cambridge, Massachusetts, a very agreeable irregularity in keeping with the structure's L-shaped room arrangement. The various rooms on the interior are loosely organized around a spacious hall. The parlor, protruding on the left, ends in a gable on the exterior; a round stair tower bulges from the angle of the L; and the entrance porch penetrates into the house. Richardson clad the house in dark olive-green shingles, thereby eliminating almost all ornament and articulation so that the masses and voids stand out all the more. This sturdy-looking Shingle Style grew quite popular in the eastern United States in the 1880s.

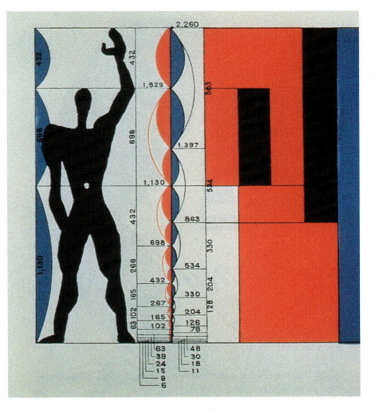

Figure 14-10 Le Corbusier (Charles-Édouard Jeanerret) [French, 1887–1965], modulor figure. © 2006 Artists Rights Society (ARS), New York/ADAGP, Paris/FLC.

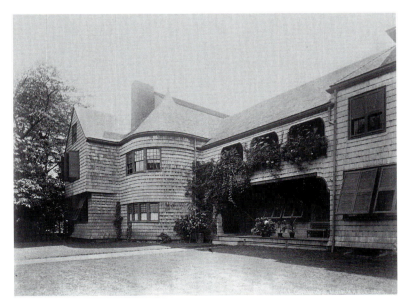

Figure 14-11 H. H. Richardson [American, 1838–1886]. Stoughton House, 1882–1883. 90 Brattle Street, Cambridge, Massachusetts. From the Collections of the Library of Congress.

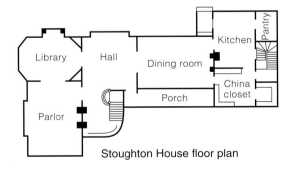

Stoughton House floor plan

TRADITIONAL MATERIALS AND CONSTRUCTION TECHNIQUES

Many of the building materials that Vitruvius discussed in the first century BCE—such as wood, brick, stone, and cement—are still in common use today. Roman architects also employed a number of construction methods that are still viable.

Solid Wall Construction

Thick walls of brick, stone, or mud, as in the Tallensi compound in Ghana (Figure 14-2), will suffice to build a simple human shelter. In the resulting **solid wall construction** technique, the mass of the wall holds itself up and supports the roof. This technique can also be referred to as a shell system of architecture. It might be used today to build a small shop with cinder-block walls on which rest thin steel or wooden **trusses.** Taking advantage of the stability and strength of the triangle, which cannot easily be pushed or pulled out of shape, a lightweight truss can span considerable space.

Problems with solid wall construction arise when the builder wants to put holes in the walls for windows and doors or when the walls are asked to support more than a few stories. Doors and windows rob a solid wall of its basic strength, and the added weight of tall elevations requires walls at ground level that would be prohibitively thick.

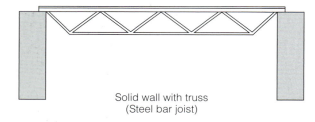

Solid wall with truss
(Steel bar joist)

Post-and-Lintel System

To avoid overly thick walls, another simple construction method entails placing a beam across two uprights. In this technique a solid wall is replaced, as it were, by the open structure of posts and beams. This is called the **post-and-lintel system** or the **post-and-beam system.**

Uprights of any kind will support beams over the interior of a building to create larger rooms. The span covered by the beam depends on the material. A sturdy wooden beam can cross some distance because wood is naturally elastic and can absorb a considerable amount of bending and stretching under its load before it becomes permanently deformed and snaps. Although a stone lintel might not rot or catch fire like wood, it is also more likely to crack when it is stretched across two posts. Consequently, a stone lintel has to be shorter.

When a beam of any material rests on two upright posts and bends under its load, the top part of the beam is pushed together and compressed, and the bottom part is in tension because it is being stretched and pulled apart. Since stone has great compressive strength but weak tensile strength, stone lintels have obvious limitations as a building material.

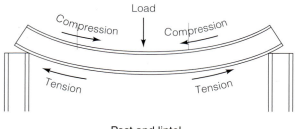

Post and lintel

The Classical Orders

Despite stone's weak tensile strength, the ancient Greeks made their famous temples with close-fitting blocks of stone in the post-and-lintel system. The Greeks and Romans also had three basic systems for the design of the posts and lintels—three systems that have become perennial motifs in Western architecture. These basic systems are called the Doric, Ionic, and Corinthian orders. In the terminology of classical architecture, the order encompasses the columns and the **entablature,** the horizontal part of the building above the vertical columns.

The **Doric order** was designed as the most solid and hefty of the three classical orders. The Greeks thought of it as masculine. The tapered shaft of the Doric **column,** fluted with concave grooves, rests right on the platform without a base. The column terminates in a simple cushion-like **capital,** which makes a nice transition between the vertical lines of the shaft and the horizontal lines of the entablature. A Doric entablature is carved with

triglyphs (three vertical cuts) and **metopes** (nearly square relief panels).

The **Ionic order** is more decorated than the Doric. It is taller and has more elegant proportions, including a thinner entablature without triglyphs and metopes. Sometimes the Greeks placed a **frieze,** a continuous band of relief sculpture, in the entablature. The Greeks thought of the Ionic as feminine (see the Temple of Athena Nike, Figure 14-6). The Ionic column has a base to form a transition between horizontal and vertical, and the Ionic capital has four distinctive volutes, or scrolls.

The **Corinthian order** is a larger, more elaborate version of the Ionic and has somewhat different proportions, too. Its capital has a big, basket-like arrangement of acanthus leaves. The Romans made more use of the majestic Corinthian order than did the Greeks.

Architect Henry Bacon designed the Lincoln Memorial (Figure 14-12) in the Doric order in imitation of a Greek temple. However, the Lincoln Memorial does not have a short end with a triangular gable like the front of a Greek temple; in fact, the entrance to the giant statue of President Lincoln (by Daniel Chester French) is in the middle of the long side instead of the short side. Above the Doric columns, Bacon set a narrow Ionic frieze of floral swags instead of the triglyphs and metopes expected of the Doric order. And in the place of a pitched, gabled roof, the architect substituted an attic, also decorated with swags. The block-like form of the attic is perhaps the only concession to the twentieth century in this severe and impressive building.

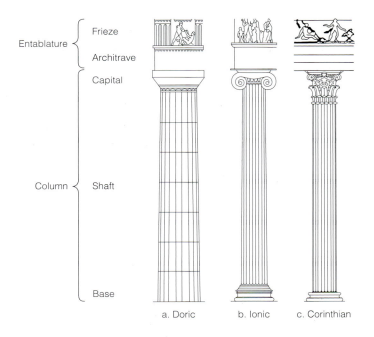

The Ionic Jefferson Memorial (Figure 14-13), designed by John Russell Pope, imitated the combination of temple porch and domed rotunda made famous in the Roman Pantheon (Figure 15-18) and in Jefferson's own architecture for the University of Virginia (Figure 16-40). Pope employed the Ionic order not only in the porch but also in the "ambulatory" around the periphery of the rotunda. Instead of resting on thick walls, the dome swells above an open Ionic colonnade. What the building thus loses in apparent strength in the absence of external

Figure 14-12 Henry Bacon [American, 1866–1924]. Lincoln Memorial, completed 1917. Washington, D.C. © Royalty-Free/Corbis.

Figure 14-13 John Russell Pope [American, 1874–1937]. Jefferson Memorial, 1938–1943. Washington, D.C. © James P. Blair/Corbis.

Figure 14-14 **Cass Gilbert** [American, 1859–1934], *Supreme Court Building*, 1932–1935. Washington, D.C. © Carl & Ann Purcell/Corbis.

walls, it gains in grace and openness, a perfect fit for its picturesque setting above the Tidal Basin in the midst of cherry blossoms.

The architect Cass Gilbert designed the Supreme Court Building (Figure 14-14) to have a noble and stately porch of eight Corinthian columns set on top of a broad and tall flight of steps. Its use of the classical Corinthian order fulfills splendidly the popular ideal of Roman grandeur.

Arches and Vaults

Since stone beams have to be short, columns cannot be very far apart; they would take up a considerable amount of the floor space. However, stone **arches** can span wider spaces than stone lintels. Arches are made from wedge-shaped stones placed, usually, in a semicircle so that they press against one another. Since stone has great compressive strength, the compression of one stone on the other can hold up an arch spanning a considerable distance and supporting a considerable weight.

Arches are built over wooden scaffolding, or **centering,** which is dismantled once the structure is completed. The top stone, or **keystone,** is probably the last stone put in place before the centering is removed. However, all the stones, not just the keystone, maintain the arch because their weight wedges them against one another. They will not collapse as long as they are buttressed at the sides to counterattack the pressure that an arch exerts to the sides. The buttressing might be additional heavy masonry, the sides of a valley, or, more often, another arch.

The Romans made good use of arches to build large bridges and extensive aqueducts that brought

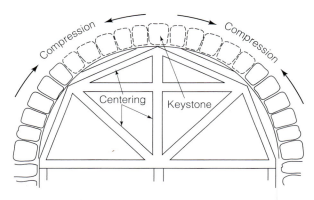

Figure 14-15 [Roman], aqueduct, ca. 100. Segovia, Spain. © Vanni Archive/Corbis.

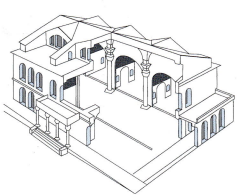

Figure 14-16 [Roman], Basilica of Constantine, begun by Maxentius in 307–312, completed by Constantine after 312. Rome. © Canali Photobank.

All that remains of this magnificent building of ancient Rome are these three enormous barrel vaults that once formed the north side or aisle of the basilica, a covered hall. Their walls served as the supports for the cross vaults that covered the nave 115 feet above the floor. Most basilican plans separate the nave from the aisles by an arcade or colonnade. The large side barrel vaults, set perpendicular to the central hall, do not. The space flows continuously east–west and north–south throughout the building.

water over considerable distances to urban populations. In many ways, the arch made the cities of the Roman Empire possible. The Roman aqueduct at Segovia, Spain (Figure 14-15), stretches nearly 900 yards across a valley to bring fresh water to the hilltop town. The water channel, carried 100 feet above the lowest point of the valley, rests on top of a series of 128 arches. The Romans built the aqueduct with big, rough-cut, almost square blocks of stone as an expression of the sturdiness of their construction.

Semicircular arches can be expanded in one direction to form a semicylindrical roof called a **barrel vault** or a **tunnel vault.** The three enormous tunnel vaults of the Basilica of Constantine (Figure 14-16) on the Roman Forum still command respect. Tunnel vaults, like arches, also need buttressing at the sides to support their lateral pressure. If two tunnel vaults intersect, a **groin vault** or **cross vault** results. Cross vaulting opens up the floor space underneath it because now the weight of the vault rests only on the four corners. Lofty cross vaults once covered the central hall of the Basilica of Constantine, where its vast interior space flowed uninterruptedly into the barrel-vaulted aisles.

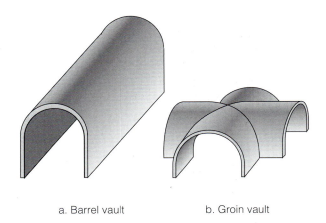

a. Barrel vault b. Groin vault

Architects in the Middle Ages preferred to use a pointed arch because pointed arches may rise much higher than semicircular arches, and they also exert somewhat less lateral pressure. The height of a semicircular arch is determined by the span between the posts from which the arch springs; its height has to be the radius of the semicircle. In contrast, the height of a pointed arch bears no relationship to the span underneath and can rise considerably higher than the radius. A pointed arch works basically the same way as a cir-

cular arch. Although the first few stones at the bottom of a tall pointed arch practically rest on one another, eventually the upper stones wedge themselves together like the stones of any other arch. Medieval architects never failed to secure pointed arches at the sides with buttressing to counteract lateral pressure.

Domes

If a round arch is rotated 360 degrees, a hemispherical **dome** results. Therefore, a dome operates according to structural principles similar to those of an arch, since the stones in a dome compress one another for support. A dome is even more stable than an arch because the stones in a dome are being compressed from all four sides and so cannot buckle. At the top of a dome, the compression of stones against one another prevents warping and wobbling. At the lower horizontal levels, the stones are in tension as they resist the pressure to expand and move out. Many domes have something like a steel chain tied around their lower circumference to help prevent this expansion. Because of the advantageous dynamics of a dome, its material can be much thinner than that of an arch with a comparable span.

A contemporary architectural writer calls the dome "the king of all roofs, . . . the greatest architectural and structural achievement of mankind in over 2,000 years of spiritual and technological development."[8] Ancient writers thought that the dome imitated the shape of the heavens, and even today domes can shelter worshippers or sports fans like a friendly sky. The most famous and most ambitious dome that the Romans built, the dome of the Pantheon (Figures 15-18 and 15-19), set a standard that has seldom been surpassed. In Renaissance Italy, domes became the dominant feature of churches, whereas in the United States domes are commonly the distinctive feature of state capitol buildings as well as of the Federal Capitol Building in Washington, D.C.

In 532 the architect Anthemius of Tralles, assisted by Isidorus of Miletus, designed for the Byzantine Emperor Justinian a splendid dome for the church of Hagia Sophia (Figure 14-17) in Constantinople (now Istanbul, Turkey). Instead of resting a hemispherical dome on a thick cylindrical wall, as in the Roman Pantheon, the Byzantine architect set his shallow dome at the apex of four giant arches that rose from four large pillars within the church. The curving triangular areas underneath the dome and between the arches are called **pendentives.** The curved surfaces of pendentives make a smooth transition between the rectangular arrangement of the four pillars below and the circle of the dome's base above.

Originally, Anthemius designed a shallow dome, ninety feet in diameter but only about twenty-five feet high. Furthermore, he pierced the lower circumference of the dome with forty windows so that when light shone through them, it effectively cut the dome off from the structure below. The dome even today seems to float miraculously over the church as though suspended from above. Unfortunately, earthquakes caused parts of Anthemius's daring architecture to collapse, and the dome was later rebuilt in a hemispherical fashion.

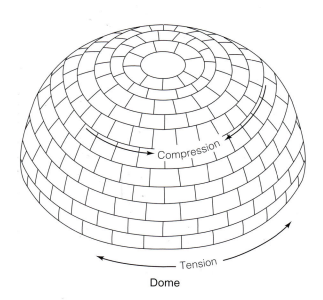

Dome

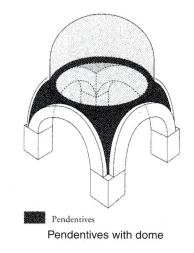

Pendentives

Pendentives with dome

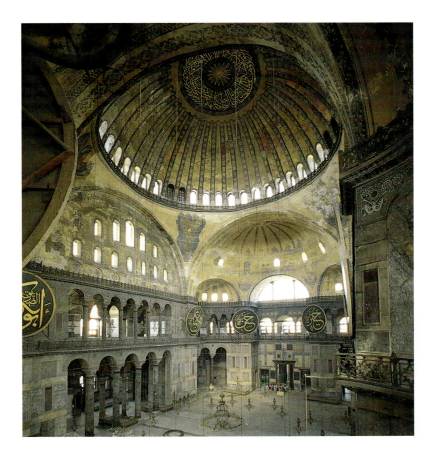

Figure 14-17 **Anthemius of Tralles** [Byzantine, sixth century] and **Isidorus of Miletus** [Byzantine, sixth century]. Hagia Sophia, 532–537. Istanbul, Turkey. Photo Henri Stierlin.

MODERN ARCHITECTURAL TECHNIQUES

During the nineteenth and twentieth centuries, new construction techniques as well as new building materials energized architects to create many exciting and very different buildings. The new materials and construction methods changed the shape of architecture because they were better suited to the needs of modern society. A new material such as steel and a new technology such as reinforced concrete allow structures that are relatively lighter in weight and very much stronger than traditional building materials. They have both high compressive and tensile strength and allow large areas such as factory floors to be spanned.

Steel Cage and Curtain Wall Construction

For over a century, architects have built tower-like structures—the Empire State Building, for example (Figure 14-18)—using **steel cage construction,** with a skeleton of steel girders instead of thick walls to support the buildings. Tall buildings are the hallmarks of

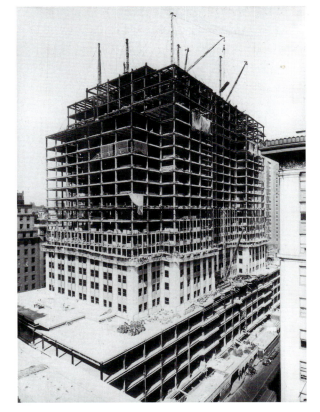

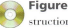 **Figure 14-18** Empire State Building under construction. © Lewis W. Hine/Getty Images.

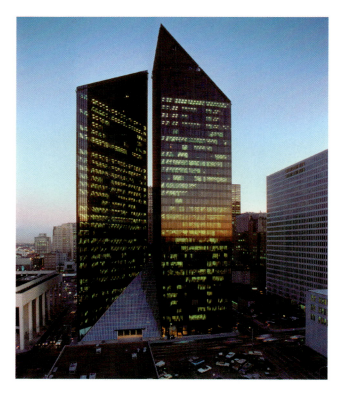

Figure 14-19 Philip Johnson [American, 1906–] and **John Burgee** [American, 1933–], Pennzoil Plaza, 1970–1976. Houston. Photo © Ron Scott/Alamy.

a prosperous urban life dominated by big corporations and large government bureaucracies. Soaring dramatically, they literally scrape the sky when their tops are hidden in the clouds on a stormy day. The invention of the elevator also made the tall building pos-

sible. Since the outside walls of a steel cage building do not support the building, they can be made of any material—brick, stone, glass, bronze, or plastic—to keep out the heat or the cold, the wind or the rain. These walls are hung on the frame like a curtain, hence the name **curtain walls.** Many of these high-rising towers have the same straight lines, box-like shapes, and rectangular panels of plate glass. With tall and relatively thin supports, this giant-size architecture paradoxically affords little experience of architectural mass since the thin curtain walls merely confine volumes. At Pennzoil Plaza in Houston (Figure 14-19), the black-glass, prism-shaped towers cleverly confront one another.

Reinforced Concrete

Reinforced concrete has become a versatile new building material in modern times. Concrete, such as the ancient Romans used, has great compressive strength, but it easily cracks because it lacks tensile strength. Embedding steel rods in the concrete and tying the ends of the rods to the vertical supports give the concrete beam the tensile strength it otherwise lacks. Fireproof reinforced concrete can replace steel beams to erect rather lofty office towers. Concrete can also be molded into any shape or form, making it a very flexible building material. This flexibility allows architects to express themselves in it with nearly the same freedom as sculptors modeling clay. The soar-

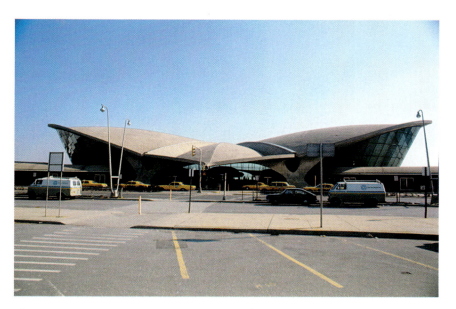

Figure 14-20 Eero Saarinen [American, 1910–1961], Trans World Airlines Terminal Building, 1962. Kennedy Airport, New York. © Bettmann/Corbis.

ing concrete shapes of Eero Saarinen's Trans World Airlines Terminal Building (Figure 14-20) in New York dramatically express the feeling of flight.

Reinforcing bar

Cantilevering

The strength of reinforced concrete (and of steel beams) makes it possible that the upper floors extend out beyond the first floor. The technique is called **cantilevering.** In one form of cantilevering, the vertical pillars are placed at a short distance in from the end of a beam so that a part of the beam hangs out beyond the pillar. In this way, relatively little of the beam is actually cantilevered.

Frank Lloyd Wright, a great architect of the early twentieth century, realized that cantilevering allowed

the construction of a tree-like tall building. Since Wright felt that the tall office tower ought to resemble the forms of nature, for the Johnson Wax research laboratory (Figure 14-21) he designed a building with a stable central core like a tree trunk and cantilevered branches balancing one another around the core.

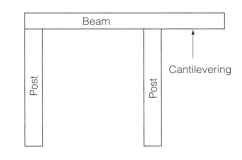

Beam

Post

Post

Cantilevering

Suspension

For centuries, the pre-Columbian peoples of America crossed precipitous ravines with bridges that were suspended from fiber ropes attached to the cliffs at

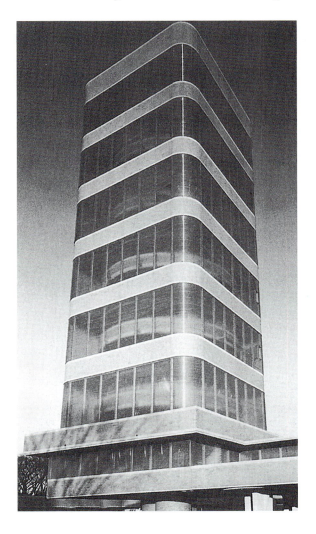

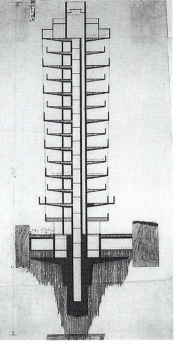

Figure 14-21 Frank Lloyd Wright [American, 1867–1959], Johnson Wax tower, designed 1936–1939, completed 1950. Racine, Wisconsin. © 2006 Frank Lloyd Wright Foundation, Scottsdale, Arizona/Artists Rights Society (ARS), New York.

Frank Lloyd Wright built the fifteen-story Johnson Wax laboratory building in imitation of the structure of a tree, with a core of reinforced concrete, which holds all utilities, and floors that cantilever out from the core. The floors alternate in size. The upper floor in each pair has private offices and acts like a balcony overlooking the floor below.

Instead of accentuating the vertical lines of the tower on the exterior, Wright accentuated the horizontal with brick bands that correspond only to the larger alternate floors. Instead of using sharp corners, Wright curved the glass around the corners. And instead of installing plate glass, Wright inserted a curtain of glass tubing. His ingenuity created a structure that is as simple as it is unique.

(text continued on page 312)

Zaha Hadid (1950–)

Iraqi-born Zaha Hadid is widely considered the greatest living female architect. After early education in Lebanon and Switzerland, she studied under Dutch-born architect Rem Koolhas at England's Architectural Association. At the age of thirty she won the first of many design competitions but found it difficult to get her visionary projects actually built. She was in her forties before her first work, a German fire station, was completed. Since then, she has worked on projects as diverse as a cancer center in Scotland, an arts center in Rome, and a ski jump in Austria.

Hadid considers herself a modernist and traces one influence on her architecture to Russian painters of the early twentieth century (see Figure 17-17) who explored shifting viewpoints and saw space as a system of rays and fields rather than as a series of objects. She uses her own drawings and acrylic paintings to study multiple perspectives and to find new ways to manipulate space and light in an architectural design. Drawings that employ computer animation as well as models of Plexiglas, acetate, and resin contribute to the creation process.

According to Hadid, the main functions of any building are to provide shelter and to feed the soul. She is careful to make her designs suit their setting and then combines shapes and materials in unexpected ways to challenge and please the viewer. She loves motion, odd angles, and curves.

She won the competition for the Contemporary Arts Center in Cincinnati because her design made a strong statement on a narrow urban street corner and, on the inside, enhanced the display of art. Many architects design bland, boxy spaces for showing contemporary art. Hadid instead designed a variety of spaces to allow different kinds of art to be displayed to the best advantage. The massive rectangular tubes that seem to be stacked together to form the building become in fact the galleries and administrative offices on the inside. They interlock like a giant jigsaw puzzle, their lines meet at a distant vanishing point, and they float above the glass of the first floor. The external architecture of the museum tells the visitor to expect something different.

Zaha Hadid [British, 1950–], Photograph by Steve Double. Courtesy of Zaha Hadid.

At ground level, Hadid created what she calls an urban carpet—the lines of the sidewalk pierce the transparent glass wall, run across the lobby, and curve up the far side of the building. The urban carpet draws the pedestrian into the building and helps make the museum a public space. In the lobby, a stair ramp invites the visitor to ascend into the galleries on a zigzag magic-carpet ride. The stair ramp offers continually changing views of the galleries and the art on display. At the back of the building, a narrow atrium connects all six levels and casts natural light on the first-floor lobby and on the stair ramp as it reaches upward.

This one building has secured Hadid's position as a major force in contemporary architecture.

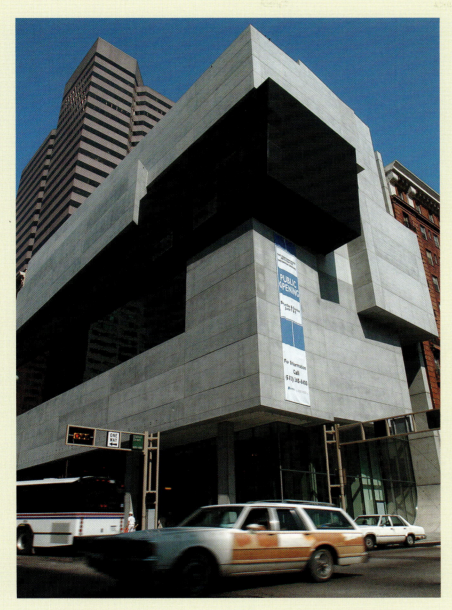

Zaha Hadid [British, 1950–], Contemporary Arts Center, 2003. Cincinnati.
© Getty Images.

Figure 14-22 Santiago Calatrava [Spanish, 1951–], Olympic Stadium in Athens, 2004. © Yiorgos Karahalis/Reuters/Corbis.

either end. In modern times, the **suspension** of roadways from very strong steel cables has enabled the erection of enormous rail and auto bridges—from the Brooklyn Bridge to the Golden Gate Bridge. A number of architects have also designed buildings in which roofs or floors are likewise suspended on steel cables. The Spanish architect Santiago Calatrava suspended the roof of the 2004 Olympic Stadium in Athens (Figure 14-22) from enormous arches that soared above the seating area.

Computer-Aided Planning

Since the 1980s, practicing architects have been designing supports and spaces with sophisticated computerized graphic design programs. Many architects have thrown away their pencils and drafting tables and instead sketch out a two-dimensional or three-dimensional design on the computer. Zaha Hadid, the architect of the acclaimed Contemporary Arts Center in Cincinnati (see "Artist at Work"), uses the computer to make visionary studies of space and light to stimulate her imagination and explore solutions. While the architect designs the building, computer-aided design and drafting (CADD) programs can calculate the laws of physics and the na-

ture of the materials and can take into account the local building codes and the foreseeable stresses on any structure. Computers turned the complex walls and spaces of Frank Gehry's architecture (Figures 18-28 and 18-29) into structurally sound reality. Modifications in the design can be made easily and rapidly. Computer programs can test the design for the adequacy of the lighting, ventilation, and heating. The computer can then send the detailed information to a printer or plotter, which automatically produces the drawings needed by the suppliers and construction teams. The computer can select materials and fixtures from enormous databases and at the same time prepare cost estimates. The computer program can also depict the building from any angle or even allow the client to take an animated walk through or flight over the proposed building. More and more, clients themselves expect architects to submit their proposals in a computerized format.

URBAN ENVIRONMENT

Contemporary architects have become increasingly aware that the practice of architecture involves more than erecting individual, isolated buildings. No mat-

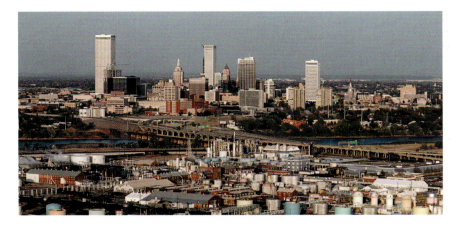

Figure 14-23 An urban environment, Tulsa. © Annie Griffiths Belt/Corbis.

ter how beautiful or grand they are, buildings cannot ignore their surroundings and the context in which they operate. The architects and builders of our cities now realize that they have created an **urban environment** (Figure 14-23)—a human-made landscape of buildings, roads, open spaces, and facilities that have been built over the natural landscape. The words *urban environment* signify all our visible physical surroundings in a city, not just the air quality. The architecture of the people-built urban environment affects our way of life much more than any individual building does.

Every building is connected to its environment and forms a part of it. A building in modern times needs electricity, fuel, water, and sewers from the local community. Buildings attract people, and the flow of people means that for every new building, the community is concerned about transportation, parking, safety, food distribution, and the rights of other people to light, air, and freedom of movement. Urban areas pass building codes and zoning regulations to make sure that architects take these factors into consideration for the greater good. Most communities take a broad view of these concerns about livability and put them on a rational basis by engaging in **urban planning** to direct growth. After decades of unregulated growth, America is realizing that there is a need for suburban planning also.

Although few people ever have the opportunity to choose an architect for a new office tower, every citizen is affected by the physical development of the urban community, even those who do not live inside a city's limits. The distinctions between urban and suburban, even between urban and rural, have largely broken down, and the vitality of urban life influences the nation. Cities are transportation hubs, they specialize in certain industries and kinds of commerce, and all cities have become management, media, and cultural centers.

THE AUTOMOBILE AND AMERICAN CITIES

To demonstrate how the built environment in any urban area is an interconnected web of relationships, consider how the introduction of just one new factor—the automobile—shaped the urban environment of American cities during the twentieth century. When automobile use became widespread, old roads had to be paved and widened to accommodate the increased traffic. Mass transportation facilities in many cities were generally neglected in favor of the auto. Highways between cities became the major means of transportation and now connect rural areas with urban centers. The expressway system has often cut right through and divided urban neighborhoods. Urban streets have become congested with parked cars, and a parking lot or garage often must accompany a new building in any city. Old, narrow streets in many downtown areas make it difficult to travel them by automobile, leading to the neglect of those areas.

The automobile has allowed people to move farther from work and away from means of mass transportation. In every city from New York to Los Angeles, suburbs have spread out from the city center, with the result that today more than half the

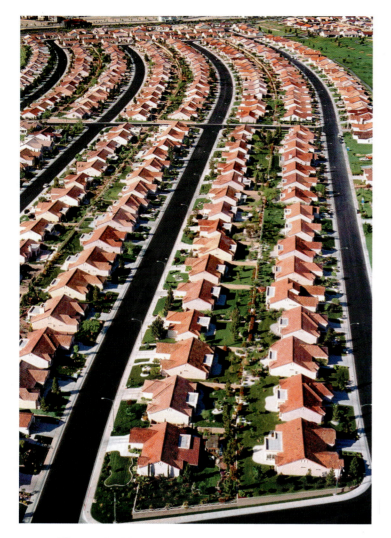

Figure 14-24 A suburban subdivision in Las Vegas, Nevada. © Lester Lefkowitz/Corbis.

Figure 14-25 Interior view of Seattle, Washington's Westlake shopping center. © Nick Bunderson, Corbis.

population lives in suburban developments (Figure 14-24). In fact, many people no longer go downtown for work, for shopping, or for entertainment because these activities have themselves moved out into the suburbs. Downtown areas tend to contain mostly bank buildings, government buildings, and convention hotels. These areas are often dangerously deserted at night. Instead, Americans congregate at the environmentally controlled shopping malls that have sprung up in the suburbs (Figure 14-25) and have become the new hub of social interaction. In the suburbs, thoroughfares that were once country lanes have developed into garish commercial strips that cater to the automobile trade. Vast areas of the earth have been covered with the dead space of parking lots. The whole of suburban sprawl has used up resources, and not always in the most efficient manner.

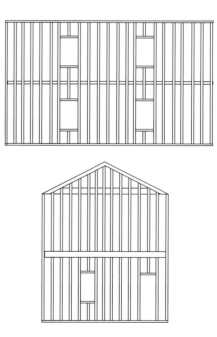

Balloon frame construction. Adapted from William D. Bell's *Carpentry Made Easy,* 1858.

SUBURBAN AMERICAN HOUSING

Most of the private houses in the suburbs were not designed by architects but by builders who have limited resources and design experience. Prefabricated and factory-made mobile homes are also a big part of the housing industry. The shapes and fixtures of most houses are limited by the materials available at local supply houses. Partly for economic reasons, at any one time only a few common housing types seem to be possible. What the great majority of Americans want in a house is something traditional and comfortable. House designs tend to resemble something out of the past—colonial, for example—or perhaps some regional style that gives the home owner a sense of belonging.

Home builders typically use the **balloon frame** technique, which was invented in the United States in the early 1800s. The walls of a balloon-framed house are constructed with two-by-fours and then covered with veneers both inside and out. Balloon frame construction has made possible the rapid and easy expansion of suburban housing.

For decades, suburban developers in America have taken a tract of land, traced on it a system of curving streets (usually serviced by one main artery), and then subdivided the remaining land into small homogeneous plots. Set back from the street, repetitious houses on each plot are typically designed by formulas worked out by the developers, builders, and financial institutions. This kind of suburban subdivision generally lacks any sense of identity or community.

At Seaside, Florida (Figure 14-26), a new attempt to establish suburban housing has had great success. The developer, Robert Davis, tried to imitate an old-fashioned small town of the kind already existing in the region (the Florida Panhandle and

Figure 14-26 Andres Duany [American, 1949–] and **Elizabeth Plater-Zyberk** [American, 1950–], architects. Seaside, Florida, begun ca. 1980. Courtesy DPZ Architects.

The building code of Seaside specifies that the houses must be constructed of wood. They must have specific roof pitches and windows that are square or rectangular in a vertical direction. There are no picture windows or plate-glass patio doors in Seaside. Houses on many streets must have front porches, just as they have traditionally had in the South. The porch helps extend the house into the public sphere. Streets and alleys must have picket fences. Building materials must be those generally available before 1940—no synthetics or imitations allowed. The architects who designed Seaside, Andres Duany and Elizabeth Plater-Zyberk, have not built a single house in the town because they want different architects and builders to develop a variety of house designs.

southern Alabama). Seaside was deliberately placed straddling the main highway along the Gulf Coast so that an active commercial center would develop there as it has in many towns. Seaside's streets radiate from this town center in a regular, straight-line

pattern. Most streets are kept narrow and houses set close to the street so that roadways become shared places for people on foot to interact, rather than thoroughfares to drive through. A building code makes sure that the houses resemble the vernacular architecture of the American Southeast before 1940, since this style of architecture has the best chance of being compatible with its environment. Rather than instantly dropping on the land an isolated, anonymous, and exclusive subdivision, the developers have encouraged Seaside to grow organically like a small town—a place that people can identify with, a place that people can say they come from.

HISTORIC PRESERVATION

When the urban environment includes the visible presence of the location's past, people see in its architecture evidence of their roots and derive a sense of belonging from what they see. The retention of the historic buildings from a region's past helps give it some character and identity. Therefore, vital urban planning attempts to preserve what is good and meaningful from the architectural history of the area. Making sure that a region can find its roots through its building history is called **historic preservation.**

Historic preservation in the United States at first entailed the saving of historic landmarks, such as Jefferson's Monticello and Washington's Mount Vernon, or sites of famous battles, such as Fort Sumter, because of their association with historic people or events. A new kind of historic preservation happened at Williamsburg, Virginia, starting in the 1920s: at Colonial Williamsburg the entire town was preserved, reconstructed, and maintained like an open-air museum to give an idealized picture of what life was like in colonial days.

In addition to creating "museums" such as these, historic preservation can help revitalize whole neighborhoods and restore community life to a viable residential area. Charleston, South Carolina (Figure 14-27), and Madison, Indiana, are two examples of many preservation success stories of this kind. Maintaining and preserving the integrity of a neighborhood usually makes better sense than tearing it down through urban renewal and then waiting for new development to happen.

On a smaller scale, historic preservation often engages in **adaptive reuse** by finding new functions for an old building compatible with the building and its surroundings. Abandoned railroad stations around the United States have been turned into restaurants and shopping malls. Boston has converted Quincy Market into a restaurant and shopping arcade, and New York City has converted the Fulton Fish Market and nearby wharf (Figure 14-28)

Figure 14-27 Anson Street after renovation. Charleston, South Carolina. Courtesy Historic Charleston Foundation.

Figure 14-28 South Street Seaport, New York. © Gail Mooney/Corbis.

into a lively commercial and tourist attraction, South Street Seaport. In this way, preservation has brought people back into the urban area and in some cases has been the focus of economic development.

Historic preservation preserves the character and feel of the city. The restoration of an important old building can act as an anchor to stabilize a changing community. Historic preservation often upgrades property values in an area and increases economic prosperity through tourism. It has begun preserving America's ethnic and multicultural heritage as well. The National Park Service is attempting to preserve Auburn Avenue in Atlanta (Figure 14-29)—the site of the birthplace of Martin Luther King, Jr., and the longtime center of the African American business and social community in the city. Historic preservation has challenged the ingenuity of architects to seek new solutions for buildings while respecting tradition, respecting people, and respecting the urban environment.

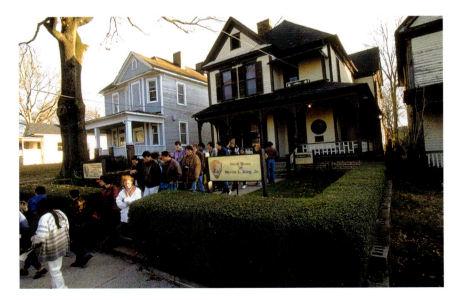

Figure 14-29 Auburn Avenue, Atlanta. The yellow house was the birthplace of Martin Luther King, Jr. © John Van Hasselt/Corbis Sygma.

Architecture

The nature of architecture

Architecture shapes living experience.

The experience of architecture unfolds in time.

Architecture is the functional art.

Architecture expresses the way a society lives.

Vitruvius

Vitruvius's Principles	**Modern Equivalent**
Solid construction (*firmitas*) requires the correct materials and the correct method of building.	Architecture is engineering.
Suitability (*utilitas*) depends on the correct use of architectural orders and the proper building type.	Form follows function.
Beauty (*venustas*) comes from symmetry and proportions.	Beauty involves the symmetrical or asymmetrical planning of the experience of space.

The Practice of Architecture

Construction techniques

Architectural construction techniques include solid wall, post and lintel, arch, barrel and cross vaults, dome, steel cage, suspension, reinforced concrete, and cantilevering.

Urban environment

The urban environment is a built environment.

The automobile has profoundly changed the nature of American cities and suburbs.

Suburban housing has followed conventional designs.

Historic preservation

Historic preservation preserves the roots and character of a locality through its historic buildings.

Types of historic preservation include saving historic homes and sites, creating living museums, finding new uses for old buildings, and revitalizing neighborhoods.

INTERACTIVE LEARNING

 In the Studio: Architecture

Flashcards

Artist at Work: Zaha Hadid

Critical Analysis: The Visual Arts

Companion Site: **http://art.wadsworth.com/buser02**

Chapter 14 Quiz	Talking Flashcards
InfoTrac® College Edition Readings	Online Study Guide

When Mary Cassatt began an oil painting such as *Summertime: Woman and Child in a Rowboat,* she sketched the contours of the main forms with a color diluted in turpentine. Painted contour lines around the two people are still highly visible in *Summertime,* although most of them were added later to strengthen the original sketch. We can get a better idea of the procedure that she used in painting by examining an unfinished work, *Young Woman Picking Fruit.* In both pieces, after sketching the essential contours, Cassatt then probably laid in the basic colors of the figures, including their flesh areas. Rather than filling in the contours with a smooth layer of paint, at this stage she often rubbed thin opaque paint with her brush across the texture of the oatmeal-colored canvas to create a fuzzy blur of colors. Other strokes of opaque paint were scumbled across the canvas. Cassatt then usually let these roughed-in colors dry.

In general, she seems to have preferred to paint with thick-bristled hogs-hair brushes that leave their traces in the paint. At first glance, *Summertime* looks like a mosaic of different colored brushstrokes set side by side. On close inspection, it becomes clear that Cassatt built up her painting with successive layers of paint. Sometimes a brush wet with paint was scumbled over the dry paint underneath. Sometimes a brush wet with one color was dragged through an area of another wet color. This

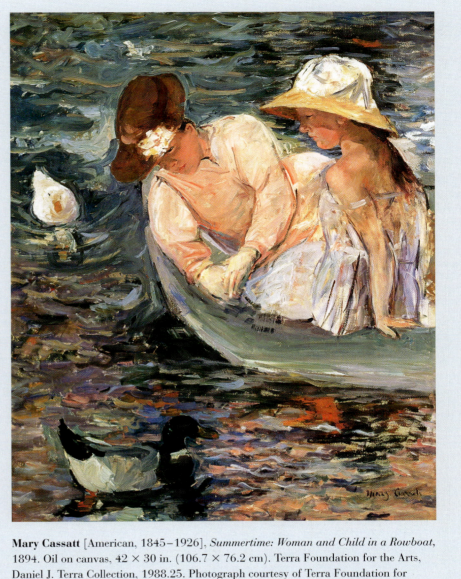

Mary Cassatt [American, 1845–1926], *Summertime: Woman and Child in a Rowboat,* 1894. Oil on canvas, 42 × 30 in. (106.7 × 76.2 cm). Terra Foundation for the Arts, Daniel J. Terra Collection, 1988.25. Photograph courtesy of Terra Foundation for the Arts.

wet-into-wet technique fused the two colors without actually blending them. Sometimes Cassatt took a completely dry bristle brush and dragged it over wet colors to soften and blur them. Her varied yet decisive brushwork captures atmosphere, light, and movement.

The unfinished painting *Young Woman Picking Fruit* was a sketch for *Modern Women,* the only

Mary Cassatt [American, 1845–1926], *Young Woman Picking Fruit*, sketch for a mural, 1892. Oil on canvas, 23 5/8 × 28 3/4 in. (60 × 73 cm). Sotheby's Transparency Library.

mural Cassatt ever painted. Since the face is finished more than any other part, Cassatt probably painted the sketch to study the foreshortening of the head. Painted in Paris, the fifty-eight-foot mural was commissioned in 1893 for the Woman's Building of the World's Columbian Exposition in Chicago. Unfortunately, the painting was not preserved when it was taken down after the fair.

Like many artists, Cassatt had skills in more than one artist's medium. In addition to painting, she was accomplished at drawing and printmaking. She preferred painting as the highest form of art; consequently, pastel chalks, which resemble paint, became her favorite drawing medium. From her earliest association with the Impressionists she exhibited paintings, pastels, and prints that reproduce nearly the same compositions.

The pastel and charcoal drawing *At the Window* resembles in many ways the slightly later drypoint print *Baby's Back* (Figure 8-12), although in reverse and without the window theme. Cassatt adopted the pastel techniques of Edgar Degas (see Figure 7-18), and, like Degas, she found ways to fix the preliminary layers of pastel and charcoal so that she could draw on them vigorous strokes of very different color. Intermeshed warm and cool colors, mixed optically by the eye, enliven the somber gray tone of the whole drawing.

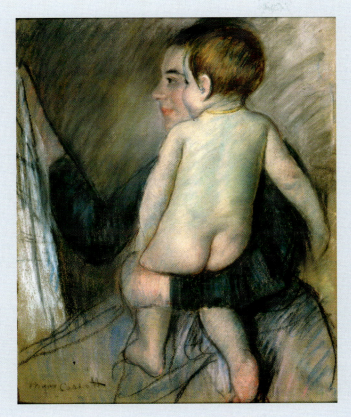

Mary Cassatt [American, 1845–1926], *At the Window*,
1889. Pastel and charcoal on gray paper, 19 3/4 × 24 1/2 in.
(75.6 × 62.2 cm). Musée d'Orsay, Paris. © Réunion des Musées
Nationaux/Art Resource, NY.

Cassatt once declared that it was the discipline
of printmaking that taught her how to draw. Her in-
taglio print *Baby's Back* demonstrates her point. The
unforgiving scratches of the drypoint needle in the
copper plate demanded of her a precise eye and an
exacting line.

As a printmaker, Cassatt is most famous for her
two dozen full-color works. Here too she took a
painterly approach. Her print *Feeding the Ducks*
bears an obvious resemblance to her oil painting
Summertime and several oil sketches for it. Only

months before creating these paintings and prints,
Cassatt had moved her intaglio press from Paris to a
pavilion overlooking a little lake on the property of
her summer home at Mesnil-Beaufresne, France.
She could look out on the scene as she was making
her print.

Cassatt began *Feeding the Ducks* by first delin-
eating in drypoint the contours of the boat, the fig-
ures, and the ducks. At this point Cassatt printed a
trial impression (an *artist's proof*) of her work to get
a better idea of what her design looked like. She
continued to do additional drypoint work on the
plate, giving more detail to the dresses and the
ducks. At the third stage, or *state,* in the develop-
ment of her plate, she added aquatint to the area of
the boat.

To supply color to the print, Cassatt etched two
more copper plates with aquatint; she probably used
the soft-ground method to transfer the design by
tracing it onto the second and third plates. On these
plates she created different values of green in the
water by stopping out the distant water and the
nearby ripples with varnish brushed freely on the
plate before it was returned to the acid bath. She
made the polka dots on the woman's blue skirt with
drops of stopping-out varnish applied to the plate.
Like the Japanese ukiyo-e printmakers she admired,
Cassatt brushed the individual colored inks onto
each plate, then hand-wiped the plates to force the
inks into the grooves. As the third plate lay on the
bed of the printing press, Cassatt painted several
monotype touches on the plate—the reflections
under the boat and the purple duck—just before the
impression was made. Since she varied the mono-
type work and the inking of the plate with each
printing, the coloring of each impression of *Feeding
the Ducks* varies. Only ten impressions of the print
are known.

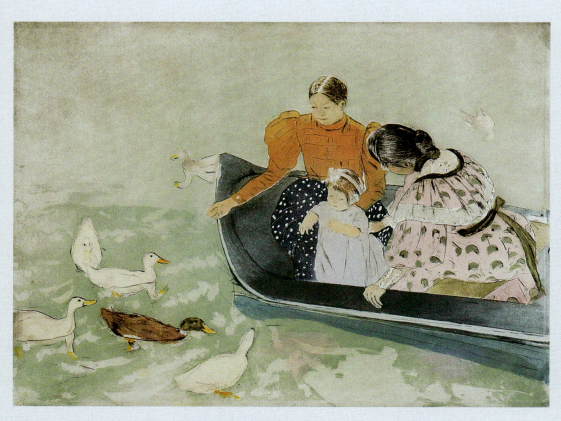

Mary Cassatt [American, 1845–1926], *Feeding the Ducks*, ca. 1895. Drypoint, soft-ground etching, and aquatint, 11 5/8 × 15 1/2 in. (29.5 × 39.3 cm). Allen Memorial Art Museum, Oberlin College, Ohio; R. T. Miller, Jr. Fund, 1957. Acc. #57.19.

15 The Ancient and Medieval World

STONE AGE ART

In 1991 a French diver named Henri Cosquer (pronounced kos-kay) explored an underwater cave along the Mediterranean coast near Marseilles, France. The entrance to the cave had been concealed when the glaciers melted and the sea level rose at the end of the last ice age, about 10,000 BCE. After swimming through the 450-foot-long submerged tunnel, Cosquer entered a large air-filled cavern, part of which now lies above sea level. He discovered there dozens of drawings of animals painted on and incised into the cave wall in addition to dozens of hands "printed" on the wall by tracing their outlines in paint (Figure 15-1). A few months later, a research team from the French Ministry of Culture swam into the Cosquer Cave and confirmed that its art came from the Paleolithic period—the Old Stone Age. Indeed, the scientists determined through the technique of radiocarbon dating that many of the hand-stenciled paintings might date from about 25,000 BCE, making them among the oldest works of art in the world. The approximately one hundred paintings and incised drawings of horses, ibex, and other animals date from a later period, about 17,000 to 16,000 BCE.

Cosquer had discovered new prehistoric art that was created earlier than the famous paintings at Lascaux (see Figure 2-13) in southwest France. Although scientific tools can date a cave painting to

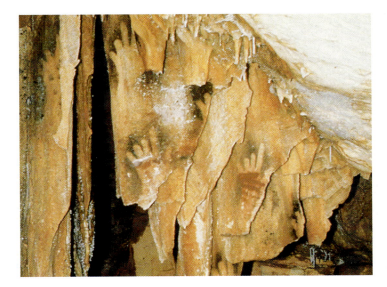

Figure 15-1 Handprints, Cosquer Cave, Paleolithic period, 25,000 BCE. Cape Morgiou, France. Photo © A. Chêné, CNRS Centre Camille-Julian.

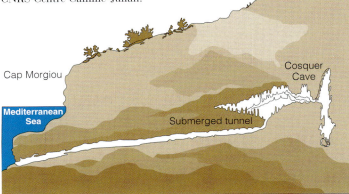

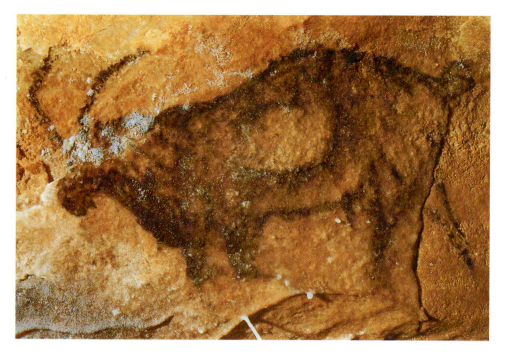

Figure 15-2 Ibex engraved over two horses, Cosquer Cave, Paleolithic period, 25,000 BCE. Cape Morgiou, France. Photo © J. Clottes.

within a decade of its creation, no one knows for sure why the art was made. Certainly, the deceptively simple representations required a considerable amount of careful observation and previous practice on the part of the primitive artist. Some of the Cosquer Cave drawings have been cut on top of animals that already existed on the wall (Figure 15-2), as though the early art had already served its function. Consequently, the hands and animals have been interpreted as part of a magical or religious ritual to ensure fertility or success in hunting. Through the magic of artistic representation, the people could exercise some control over the forces of nature. Still unanswered are some questions: Why is there an eight-thousand-year gap between the first period of cave painting and the second? What happened to these people and their talent when the Ice Age ended and the herds moved away?

Archaeologists have also discovered dozens of small-scale female figures, such as the limestone Venus of Willendorf (Figure 12-9). It has long since been conceded that the figures do not represent a goddess like the ancient Roman Venus or an ideal of feminine beauty. These Stone Age figures more likely had a magical function in primitive society, where they helped ensure fertility. A group of similar clay "Venus" figurines have been discovered at Dolní Vestonice, about twenty miles south of Brno in the Czech Republic. Most of the Czech figures, which date from about 25,000 BCE, are broken like the one in Figure 15-3, which has a fracture in its right hip and

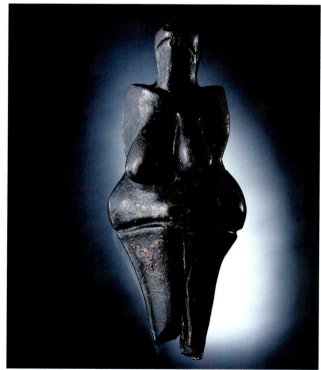

Figure 15-3 Venus from Dolní Vestonice, Paleolithic period, ca. 25,000 BCE. Baked clay, 4 5/16 in. (11 cm) high. Czech Republic, Moravian National Museum. Photo by Ira Block.

thigh. From the nature of the fractures, researchers have speculated that the figurines were created to be tossed into a fire. The artist, it seems, only partially or imperfectly dried the clay figure so that it would explode with a bang in the flames. The fragmentation of

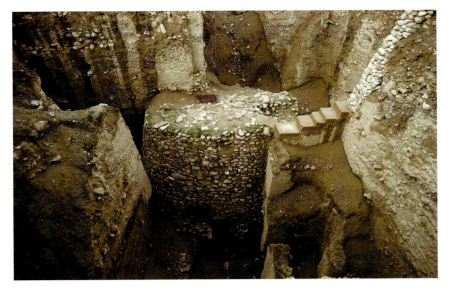

the ceramic figures very likely served some ritual or divination purpose. It is remarkable that these people were making fire-hardened ceramic figures thousands of years before the first examples of utilitarian pottery appeared.

About 8000 BCE the human race discovered the benefits of agriculture. This great change from hunting and gathering food meant that groups of people settled permanently in fertile river valleys where they built homes and defenses such as the Round Tower of Jericho (Figure 15-4) to

Figure 15-4 Round Tower, Tel-el-Sultan, ca. 7000 BCE. Jericho, Israel. © Erich Lessing/Art Resource, NY.

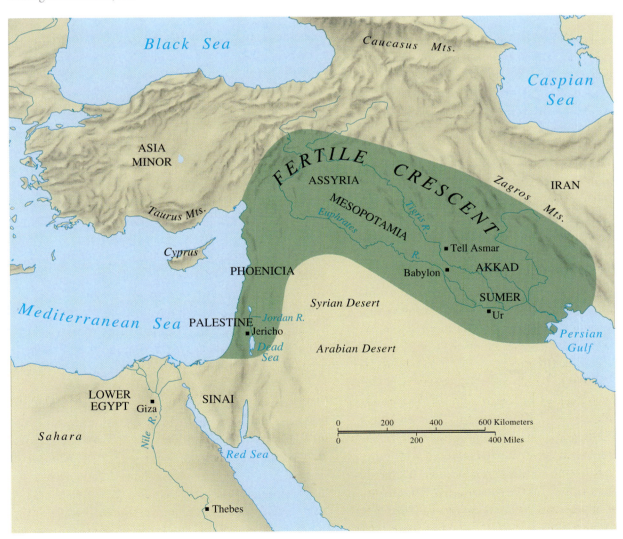

The Ancient World. From *World History*, 4th ed., by Duiker/Spielvogel. © 2004. Reprinted with permission of Wadsworth, a division of Thomson Learning, Inc.

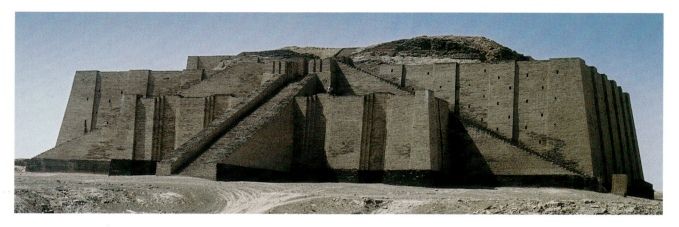

Figure 15-5 [Sumerian]. Ziggurat, northeastern facade with restored stairs, ca. 2100 BCE. Ur, Iraq. Photo: Erwin Bohm.

protect their farms. The city of Jericho, very likely the oldest town in the world, is located at an oasis in the Jordan River valley only nine miles from the Dead Sea. Over the centuries, new generations at Jericho built their dwellings on the ruins of the peoples that went before them, creating a tell, or mound, that rose more than fifty feet above the valley floor. In the 1950s, archaeologists led by Kathleen Kenyon probed through the site to the bedrock, uncovering the successive layers of civilization. At some of the lowest, earliest levels, the people built round, single-room houses of oblong bricks. From a small porch, narrow steps led down to the slightly sunken floor of the house. The houses were spread over an area of ten acres and were surrounded by massive walls at least twenty feet high. Flanking the wall was an even taller stone tower, with an interior stairs that gave access to the top of the wall. In defense of their water, the people of Jericho organized into a community and built the first monumental architecture.

SUMERIAN ART

Human beings also moved into the fertile plains of southern Iraq, where they harnessed the waters of the Tigris and Euphrates rivers for farming. We know these people as the Sumerians, who invented an early form of writing called **cuneiform** as a means of controlling their extensive commerce. They were the first of several great civilizations to inhabit the region.

The Sumerians, in the fourth and third millennium BCE, built a thriving civilization of great walled cities in Mesopotamia, the land between the two rivers. They were independent city-states. The plains they lived on lacked stone and timber, so they built their walls out of mud brick. In the center of each city rose a mountainous **ziggurat,** an enormous mass of mud brick faced with kiln-hardened burnt brick set in bitumen. The land belonged to the god, and the people turned to the god that they worshipped atop the ziggurat to protect them from calamity. The great ziggurat of Ur (Figure 15-5) was built in the Third Dynasty of Ur (the Neo-Sumerians) by Ur-Nammu, whose stamp appears on every brick. The walls and buttresses of the restored ziggurat at Ur slope inward to sustain the enormous mass that rises in three stages to the temple at the top. Three flights of stairs lead straight to the temple.

The Sumerians depicted their gods and goddesses in human form although usually on a slightly larger scale. Among a group of small limestone figures found at the Abu Temple, Tell Asmar (Figure 15-6), the tallest figure may be the god Abu, or it may be a priest. The other smaller figure represents a worshipper. Both of them clasp their hands across their chest. Broad-shouldered and stiff-legged, they wear rounded skirts, many of which terminate in

feather-like fringes. Most of the men wear full, curly beards. The most distinctive feature of these Sumerian statues is their large, bug-proportioned eyes, exaggerated by the colored shells set in them. Their fixed stare probably symbolized religious awe and constant vigilance in the presence of the all-powerful deity.

EGYPTIAN ART

About the same time that civilization arose in the valley of the Tigris and Euphrates rivers, the Egyptian civilization established itself in the valley of the Nile River in northeastern Africa. As the Nile River flows north, it transforms the African desert into the fertile land of Egypt. By 3000 BCE, the narrow strip of land along the river had been unified under a powerful pharaoh, King Menes. Isolated and relatively safe from invaders, Egypt enjoyed a continuous culture for approximately the next three thousand years, although subdivided into three periods: Old Kingdom, Middle Kingdom, and New Kingdom.

Constancy characterized life along the Nile not only because of the long periods of political stability but also because of the regularity of the river itself. Without fail, each spring the river would inundate the land and deposit rich silt to fertilize the fields. Change from one generation to the next was negligible. Life seemed to stretch endlessly into the future as it did into the past. Perhaps as a consequence of their steady existence, the Egyptians tended to think of life after death as a repetition of life along the Nile. Wealthy Egyptians arranged to have their bodies embalmed and mummified so that their spiritual alternate, the *ka,* could inhabit their bodies after death. And on the chance that the mummy did not survive, statues that substituted for the embalmed body were placed in the tomb and in the temples of the tomb complex.

Most of the art of ancient Egypt that we now possess comes from tombs. One form of Egyptian tomb architecture, the **pyramid,** is the obvious expression of the permanence and stability that Egyptian culture sought in the afterlife. Of the eighty-some pyramids built during the Old Kingdom,

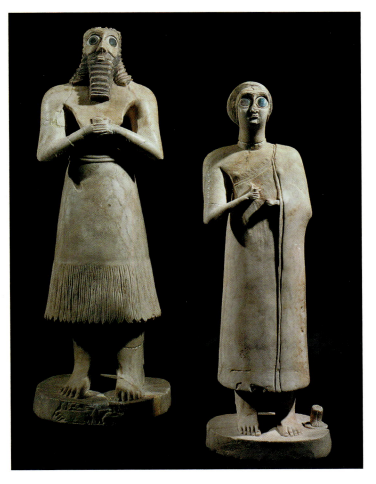

Figure 15-6 [Sumerian], Statuettes from the Abu Temple, Tell Asmar, ca. 2700–2600 BCE. Marble with shell and black limestone inlay. Male figure 28 in. (72 cm) high, female figure 23 in. (59 cm) high. Oriental Institute, University of Chicago and the Iraq Museum, Baghdad. Erich Lessing/Art Resource, NY.

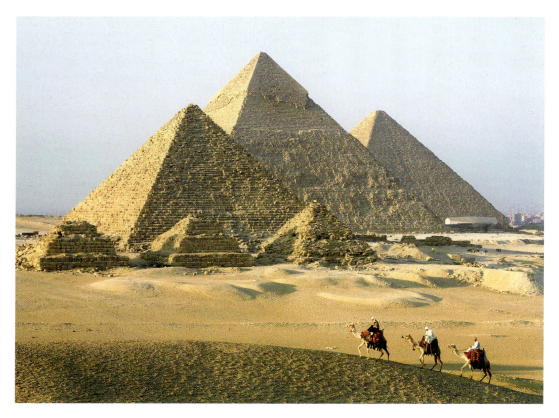

Figure 15-7 [Egyptian], Great Pyramids of Giza. Mycerinus Pyramid, ca. 2460 BCE; Chephren Pyramid, ca. 2500 BCE; Cheops Pyramid, ca. 2530 BCE. © Simon Harrus/Robert Harding Picture Library.

the most famous are the three at Giza (Figure 15-7), across the Nile River from Cairo. These giant pyramids bear witness to the strong religious beliefs of the ancient Egyptians and to the power and wealth of the pharaohs that enabled their construction. The simple, stable pyramid shape epitomizes permanence, and the pyramids themselves needed an army of laborers to quarry and transport the stones up ramps to their place. The largest of the three pyramids, the Great Pyramid of Cheops, contains over two million blocks of stone. An average stone weighs five thousand pounds. This human-made stone mountain covers 13 acres and was 481 feet high when all its stones were in place. The second largest pyramid, the pyramid of Chephren, was 471 feet high, only 10 feet lower. The sophistication of the builders is remarkable. Erected on a completely level site, each side of the Great Pyramid is about 755 feet long, within a tolerance of a few inches. Each side is oriented exactly north–south and east–west. Never again has humankind so striven to secure such a permanent site for the dead.

The same feeling for rigid geometric simplicity and massiveness characterizes the style of ancient Egyptian sculpture (see *Lady Sennuwy*, Figure 12-20). In a remarkable group also in the Boston Museum of Fine Arts (Figure 15-8), Mycerinus, the builder of the third pyramid at Giza, stands alongside Queen Kha-merer II. The strength and solidity of the sculpture are ensured by the presence of some of the original block of stone behind and between the figures and at their feet. They both stand stiffly erect and frontal, and both place the left leg forward, as does almost every standing Egyptian figure. Mycerinus holds his clenched hands at his side, and Queen Kha-merer bends her left arm at a right angle to touch him while her right arm embraces him around the waist. It has been suggested that the embrace signifies that she is conferring legitimacy and power on her husband because the Egyptians traced descent through the female line. The limbs and tightly wrapped clothing of the figures reveal almost no details, and essential elements of the anatomy such as the legs and chest seem swollen to exagger-

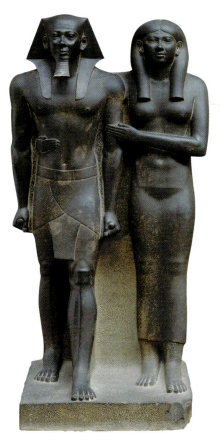

Figure 15-8 [Egyptian] *Mycerinus and Kha-merer II,* from the Valley Temple of Mycerinus, Giza, Fourth Dynasty, 2490–2472 BCE. Greywacke, 56 × 22 1/2 × 21 3/4 in. (142.2 × 57.1 × 55.2 cm). Museum of Fine Arts, Boston. Harvard University–Boston Museum of Fine Arts Expedition 11.1738.

ber of the tomb of King Tutankhamen (Figure 15-9). The tomb's discovery caused a sensation in 1923 because its treasure was still intact (see Figure 13-11). On the north wall the young king is depicted three times. On the left he embraces Osiris, king of the dead, as he enters the underworld. Behind him stands his *ka,* or spiritual double. In the middle, Tutankhamen is welcomed among the gods by the goddess Nut. On the right the king appears as Osiris. He can be so identified because his name appears above him in **hieroglyphics**—pictures and symbols that constitute the Egyptian system of writing.

As discussed in Chapter 3, Egyptian artists employed conventions of representation of the human figure in their art. Rather than imitating their perceptions of reality, they made diagrams of reality in order to illustrate information about the subject. They combined the most characteristic and thus the most constant aspects of the figure. They did not use foreshortening or single-point perspective either— the figures stand on a horizontal baseline. The picture surface remains intact because the figures are as flat as the adjacent hieroglyphics. In addition to black and white, Egyptian artists generally used the three primaries: red, yellow, and blue, plus green. The unmixed color was applied flatly, without modeling, within a precise outline.

ate mass. Yet within those masses the Egyptian sculptor exhibited a subtle sensitivity to the differences between male and female anatomy and even displayed some character on the face. The Egyptian style gives the figures serenity and strength.

The ancient Egyptians also painted the walls of their tombs, especially the tombs cut into the rock along the west bank of the Nile near ancient Thebes in the so-called Valley of the Kings during the New Kingdom. Paintings cover the four walls of the burial cham-

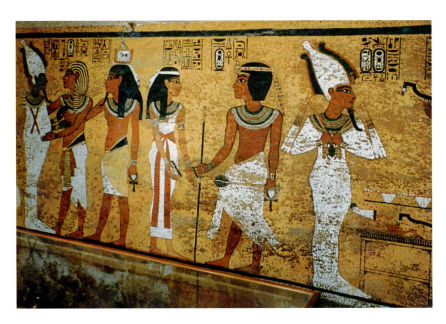

Figure 15-9 [Egyptian], north wall of King Tutankhamen's tomb, ca. 1339 BCE. Valley of the Kings, Egypt. © Scala/Art Resource, NY.

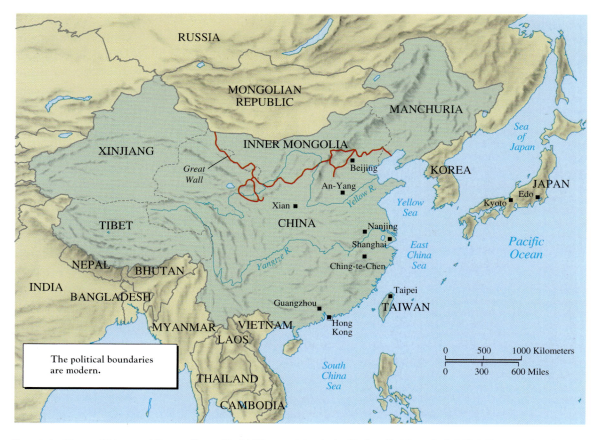

East Asia: Korea, China, and Japan. From *World History*, 4th ed., by Duiker/Spielvogel. © 2004. Reprinted with permission of Wadsworth, a division of Thomson Learning, Inc.

EARLY CHINESE ART

A few centuries after the building of the pyramids in Egypt and the ziggurats in Sumer, historic civilization began in China in the valley of the Huang He (Yellow River). Unlike unified Egypt, China for a long time was divided into many small states until the creation of the Shang dynasty about 1750 BCE. After that date, the history of China and its art was closely associated with the series of dynasties that ruled China until the twentieth century. One of the great civilizations of ancient and modern times, China has to its credit the invention of gunpowder, paper, and silk, and it developed one of the earliest systems of writing. It is the invention of writing that the Chinese treasure the most and equate with civilization itself. Chinese writing is **ideographic writing,** with thousands of symbols and characters standing for objects or concepts. From the start it was an art form—we call it **calligraphy** (see Chao Meng-fu's *Spring Poem,* Figure 3-12)—closely related to the art of painting.

Not much remains of the architecture or painting of early China, but hundreds of splendid bronze vessels from the Shang dynasty (ca. 1750–1045 BCE) and the early Chou dynasty (1045–256 BCE) still exist. During that time, for more than a thousand years, Chinese craftspeople excelled at casting these richly decorated vessels that the aristocracy employed in ritual offerings of food and wine to the spirits of their ancestors. Because of these bronzes' quasi-sacred character and their artistic achievement, Chinese collectors have treasured them for centuries. In the twentieth century, in excavations at Anyang in the Yellow River basin in northern China, many more bronze vessels were discovered in tombs. Here, they acquired their green or blue patina. It was the custom in China, as it was in ancient Egypt, to bury with the dead their finest earthly possessions—their clothing, jewelry, and carriages. In Shang dynasty China, even human sacrifices, as well as the ritual bronze vessels, were buried.

The Shang and Chou bronzes come in all sizes, from a few inches to a few feet high, and in all

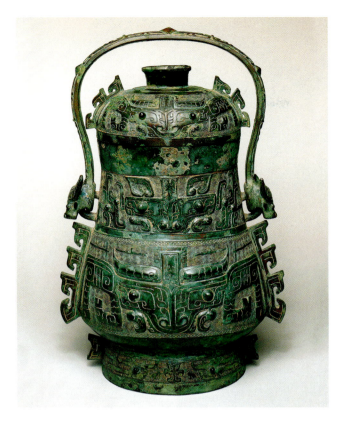

Figure 15-10 [Chinese], *ritual wine vessel: yu (or you).* North China, Western Zhou period (1050–770 BCE), about late eleventh century BCE. Bronze, 14 7/8 in. (37.8 cm) high, including handles, 8 3/4 (22.2 cm) wide across flanges. Asia Society, New York. Mr. and Mrs. John D. Rockefeller 3rd Collection. Photo by Lynton Gardiner.

shapes, from cooking tripods to bowls and pitchers such as the *yu* (a covered wine jar) in the collection of the Asia Society, New York (Figure 15-10). The vessels were cast in separate pieces with a precision that is still remarkable. The design covers most of the surface of the vessel, and hooked flanges sprout from its sides. The designs that curve and spiral in bands around the vessels are based on animal motifs—for example, the tiger, water buffalo, or elephant—that have been abstracted, combined, and stylized almost beyond recognition. A favorite device is to split the eye, mouth, and tail of an animal in two and spread the two sides out

mirror-fashion, as though someone could see the two side views from the front. The mask on the belly of the *yu* has a bovine snout, eyes, and horns. Claw-like fangs appear beneath each eye.

MINOAN ART

The Egyptians were not the only ancient culture in the Mediterranean region. In the second millennium BCE, a separate culture flourished on the island of Crete. It has been called Minoan after the legendary ruler of that island, King Minos. The Minoans were seafarers whose island was strategically placed for trade through which they spread their influence to the islands of the Aegean Sea and to the European mainland. Like the cities of Egypt, protected by the desert, the cities of Crete did not have defensive walls because the sea protected them.

Around 1600 BCE, a new palace was built at Knossos on the island of Crete. The ample and comfortable residence, constructed around a large courtyard, contained rows of storerooms, suites of living quarters, reception rooms, and in the northwest corner a small arena with theater-like steps on two sides to serve as seats. The palace was built two and three stories high in places. Stairs went around light wells that brought illumination and ventilation to the lower floors. The reconstruction in Figure 15-11 shows that the Minoans employed a column that

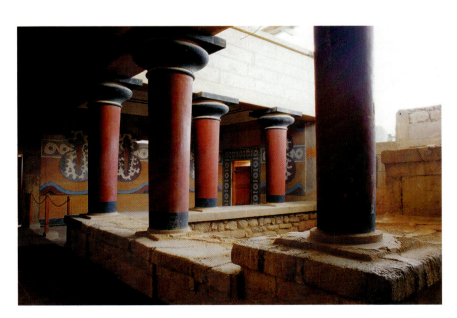

Figure 15-11 [Minoan], view of the interior of the palace at Knossos, 1600–1400 BCE. Crete. © Third Eye Images/Corbis.

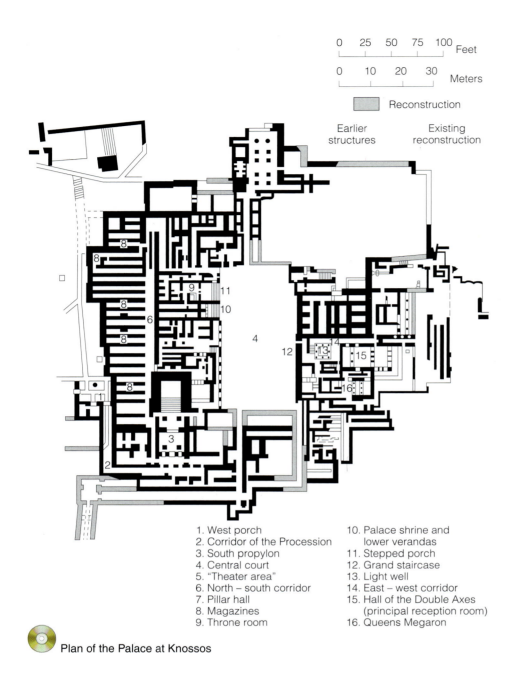

Scale:
0 25 50 75 100 Feet
0 10 20 30 Meters

■ Reconstruction

Earlier structures Existing reconstruction

1. West porch
2. Corridor of the Procession
3. South propylon
4. Central court
5. "Theater area"
6. North – south corridor
7. Pillar hall
8. Magazines
9. Throne room
10. Palace shrine and lower verandas
11. Stepped porch
12. Grand staircase
13. Light well
14. East – west corridor
15. Hall of the Double Axes (principal reception room)
16. Queens Megaron

Plan of the Palace at Knossos

tapered downward. The palace at Knossos even had plumbing—terra cotta pipes in the floor that drained the complex. The complicated plan of the palace may have given rise to the Greek legend that Minos had the monstrous Minotaur kept in an enormous labyrinth.

Many of the walls of the palace at Knossos were painted with colorful frescoes such as *Bull Leaping* (Figure 15-12), reconstructed from fragments found in the palace. Instead of being trampled by the charging bull, a dark-skinned young man in the fresco seems to be tumbling over its back while a fair-skinned young girl on the right waits to catch the acrobat. Another girl on the left grabs the horns of the bull to begin her dangerous performance over the bull's back. The artist made bull leaping appear to be a death-defying stunt rather than the lethal ritual it might have been. All the curved lines of the painting convey buoyancy and liveliness. Even the curved lines of the border pulsate around the fresco with vital energy.

When the Minoan culture on the island of Crete was devastated by an earthquake about 1400 BCE, the people living on the Greek mainland asserted

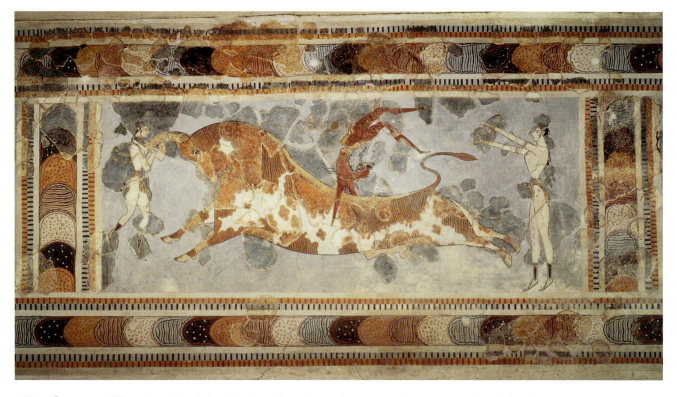

Figure 15-12 [Minoan], *Bull Leaping*, from the palace at Knossos, ca. 1500 BCE. 32 in. (81.3 cm) high. Archaeological Museum, Herakleion. © Studio Kontos.

their power. They are called Mycenaeans after one of their heavily fortified cities, Mycenae. From these cities sailed the warriors who attacked the stronghold of Troy on the Bosporus Strait and who were later immortalized by the poet Homer in his epic poems *The Iliad* and *The Odyssey*. The Mycenaeans built their thick walls of roughly cut blocks of stone so large that later Greeks imagined that the mythical one-eyed giants called Cyclopes had built the walls. The Lion Gate (Figure 15-13) formed an impressive entrance into the citadel of Mycenae. The gate itself is capped with an enormous lintel, above which the Mycenaeans carved a triangular relief of two lions who place their front paws on an altar at the base of a Minoan column. Their heads, made from separate stones, have fallen. The lion relief acts like a gigantic heraldic device of fearsome power at the approach to

the city, just as the brutally simple and massive architecture conveys strength and dignity.

The fortifications of Mycenae did not protect the city for very long: within a few generations, Mycenae was sacked and burned. Mycenaean civilization on

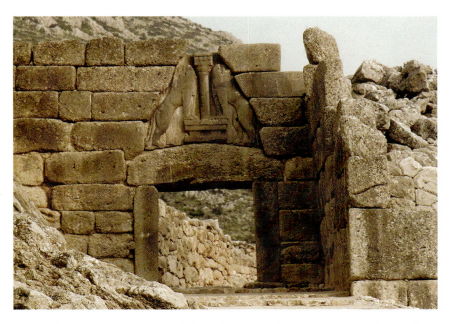

Figure 15-13 [Mycenaean], Lion Gate, ca. 1300 BCE. Limestone, relief panel approximately 114 in. (289.6 cm) high. Mycenae, Greece. © Vanni Archive/Corbis.

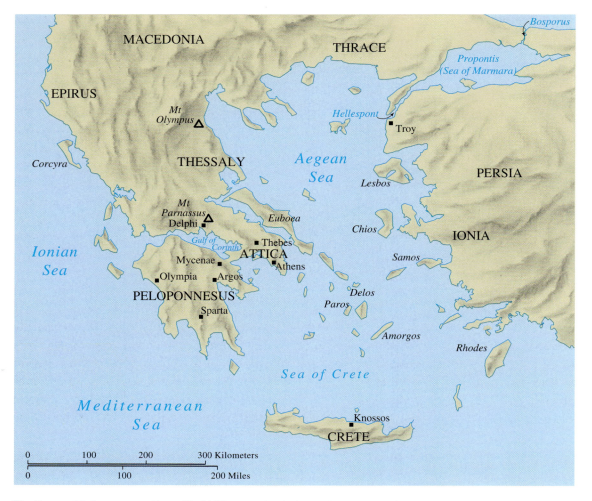

The Eastern Mediterranean. From *World History*, 4th ed., by Duiker/Spielvogel. © 2004. Reprinted with permission of Wadsworth, a division of Thomson Learning, Inc.

the Greek mainland collapsed by 1100 BCE, perhaps under the weight of invasions from the north. A "dark age" ensued, but by the fifth century BCE the people of Greece again came to dominate the Mediterranean world.

GREEK ART

In the fifth century BCE, the rocky peninsula of Greece itself and the Greek islands of the Aegean Sea were peopled by independent city-states, although the city of Athens soon overshadowed them in almost every respect. Athens was home to some of the most famous philosophers, scientists, historians, playwrights, poets, and artists of ancient times. The Athenians invented a democratic form of government and amassed an intellectual heritage of which we are still the proud heirs. Applying reason and logic to discover the laws of nature, they also investigated

the nature of mankind and fundamental human principles such as goodness, truth, and justice. In this golden age, Athens spared no expense to make its civic and religious center the showplace of the Greek world and the expression of its high culture.

The center of the city of Athens was a citadel called the Acropolis (Figure 15-14), and the major building on the Acropolis was the Parthenon (Figure 15-15), the temple dedicated to the patroness of Athens, the virgin goddess Athena. Despite its ruined condition, the Parthenon has long been considered one of the most beautiful buildings in the world. Behind the porch that ran around all four sides of the building, the Parthenon contained one small storeroom and one large room whose single purpose was to house a giant statue of Athena. The famous Greek sculptor Phidias carved the overpowering idol of Athena out of ivory and gold and also supervised the carving of much of the sculpture

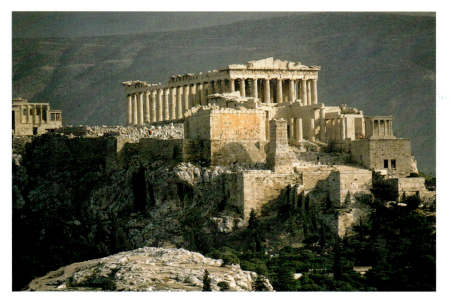

Figure 15-14 The Acropolis. Photo: Scala/Art Resource, NY.

The basic design of the Parthenon is similar to that of other Greek temples built in the Doric order, although the Parthenon has eight columns across the front instead of the usual six, making it broader than others. Other temples also had a large room for the statue of the god, porches, and a pitched roof forming gables at the ends. What does make the Parthenon different are the so-called refinements that brought this building to a kind of perfection.

Iktinos and Kallicrates, the architects of the Parthenon, believed that they could perfect the design of their temple if harsh straight lines were avoided. In fact, every line in the building curves slightly. The platform on which the temple sits curves upward gradually toward the middle of each side. It deviates from the true horizontal 4 5/16 inches in the

placed on the building itself. Except for the statue of Athena, the interior structure of the Parthenon was ordinary and of little significance. The shaping and elaboration of the exterior were much more important to the Greeks.

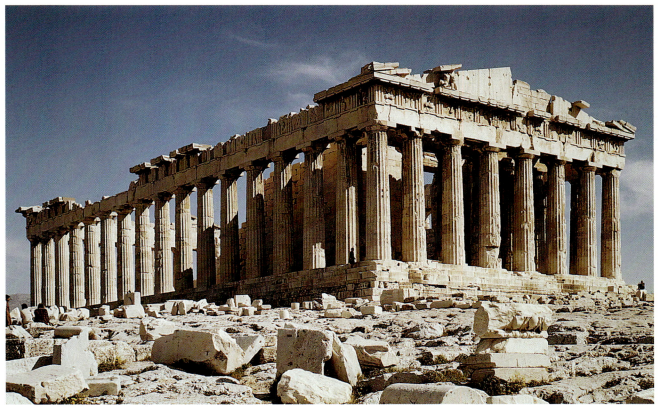

Figure 15-15 **Iktinos** [Greek, fifth century BCE] and **Kallikrates** [Greek, fifth century BCE], Parthenon, 448–432 BCE. Acropolis, Athens. Pentelic marble. Height of columns 34 ft., dimensions of structure 228 ft. × 104 ft. © Photodisc Green/Getty Images.

Parthenon refinements

harmonious and beautiful, worthy of the great goddess, such simple ratios must determine the dimensions of the building. Only numerical relationships could achieve perfection because numbers had a universal validity. In fact, simple number relationships seemed to be one of the basic laws governing the universe.

The Greek sculptor Polyclitus, from the city of Argos, demonstrated that numerical relationships also produced the perfect or ideal human being when he made his famous statue *Spearbearer* (Figure 2-7), around 450 BCE. He was so convinced of his achievement that he wrote a book of rules, the *Canon,* about the correct proportions to be used. Unfortunately, his book no longer exists, but we

middle of the long side and 2 3/8 inches on the short side. The platform is in fact a rectangular section of a very large sphere. The same sort of curvature appears in the entablature, the horizontal part placed on top of the columns. The columns themselves are curved—that is to say, they do not taper in a straight line. They have a refined **entasis:** the slight bulge in the tapering about a third of the way up the shaft. (Some earlier temples employed an exaggerated entasis.) Furthermore, the columns do not stand exactly perpendicular. They all lean in slightly toward the center of the building. Finally, the four corner columns are thicker than the others, and they are placed closer to their neighboring columns to make them appear stronger and more stable—isolated as they are against the light of the sky. All these curves and deviations from a rigid scheme make the Parthenon appear elastic and alive, like a human body flexing in the performance of a task.

The architects also believed that to harmonize the work, to make it "beautiful," the building should embody in its dimensions a system of proportions with the relationships of small whole numbers. In fact, the ratio 4:9 can be found in several important places in the building. The width-to-length ratio of the entire building is 4:9. The ratio between the height of the order (the column and the entablature) and the width of the building is 4:9, and the distance between the central axes of two columns is related to the diameter of the column in the ratio 4:9.

The ancient Greeks knew that these mathematically determined ratios did not necessarily add to the structural stability of the building. Nevertheless, many Greeks believed that for the building to be

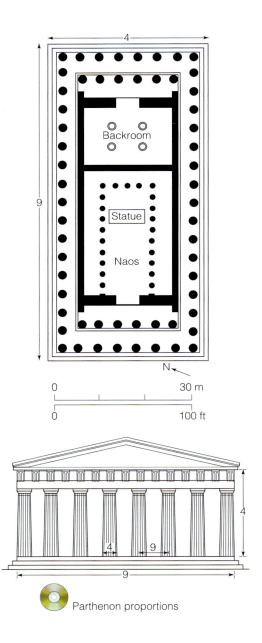

Parthenon proportions

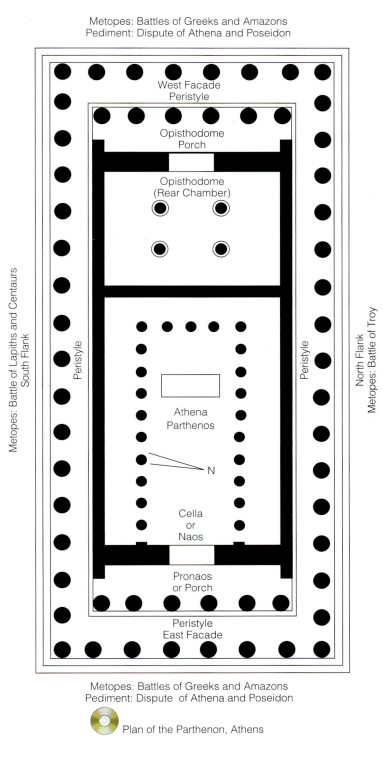

Metopes: Battles of Greeks and Amazons
Pediment: Dispute of Athena and Poseidon

West Facade
Peristyle

Opisthodome
Porch

Opisthodome
(Rear Chamber)

Metopes: Battle of Lapiths and Centaurs
South Flank

Peristyle

North Flank
Metopes: Battle of Troy

Peristyle

Athena
Parthenos

N

Cella
or
Naos

Pronaos
or Porch

Peristyle
East Facade

Metopes: Battles of Greeks and Amazons
Pediment: Dispute of Athena and Poseidon

Plan of the Parthenon, Athens

know that it discussed human proportions in terms of ratios. The height of every normative male statue was to be eight times the length of the head, the fingers were to be in proportion to the palm of the hand, the palm of the hand in proportion to the forearm, and so forth.

The original bronze *Spearbearer* no longer exists; we have an idea what it looked like only from copies. Fortunately, several bronze statues from the period still exist—for example, the *Riace Warrior* (Figure 3-15) and the *Zeus* from Cape Artemision

(text continued on page 340)

After Athens defeated the Persians in 479 BCE, many of the cities of Greece paid Athens a regular assessment to maintain a strong navy against a renewed Persian threat. By mid-century, Athens had grown powerful and wealthy. Pericles, the leader of the Athenian democracy, then decided to spend a portion of his city's wealth on the rebuilding of Athens's temples that the Persians had destroyed. The new temples would symbolize Athens's power and prestige. Pericles appointed the sculptor Phidias as the director and overseer of all the projects. The sculptor was to answer immediately to him.

The major monument of Pericles's program for Athens was the new temple to the patron goddess Athena, the Parthenon. In addition to the perfection of its architecture, the lavish amount of sculpture that adorned the building made the Parthenon stand out from all other Greek temples. In the brief fifteen years of the temple's construction, Phidias could not possibly have carved all the sculpture; in fact, sculptors from different parts of Greece must have been pressed into service. While Phidias supervised and directed all these sculptors, he concerned himself mainly with the creation of the gigantic statue of Athena located inside the temple.

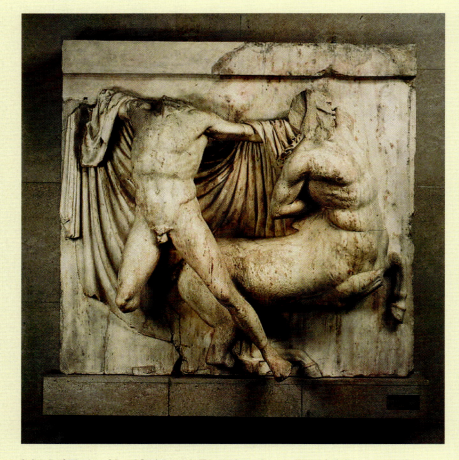

School of Phidias [Greek], *A Lapith Triumphing Over a Wounded Centaur*, south metope XXVII, 447–438 BCE. Marble, 56 in. (142 cm) high. British Museum, London. © Art Resource, NY.

The costly statue of Athena has long since vanished, but some sculptures from other parts of the temple remain. Phidias developed the iconographic program that unifies all the sculpture, and he developed the extraordinary style that he imposed on the many carvers of the pediment sculpture. They were able to combine large-scale masses with the sensuous, supple flesh and gossamer, wind-blown clothing of the gods as in *Three Goddesses* (Figure 2-8). The sculpture in the pediments (the triangular gables at each end of the building), where the group was located, celebrates the special relationship between Athens and its patroness.

The squarish metopes above the columns on all four sides of the temple illustrate legendary or mythological conflicts in the history of Greece. On the south side, the metopes represent the battle between the Lapiths (a Greek people) and the centaurs. Since centaurs were half animal and half human, they symbolized for the Greeks the animal side of human nature, easily succumbing to unbridled emotions. The battle itself symbolizes the conflict between rational control and lower instincts.

The frieze, a continuous relief located under the porch along the chamber wall, is quite an unusual feature in any Greek temple. It illustrates an actual event, the Panathenaic Procession, the religious procession in honor of Athena that took place every four years in Athens. Instead of recounting the deeds of gods or legendary heroes, the frieze extols the

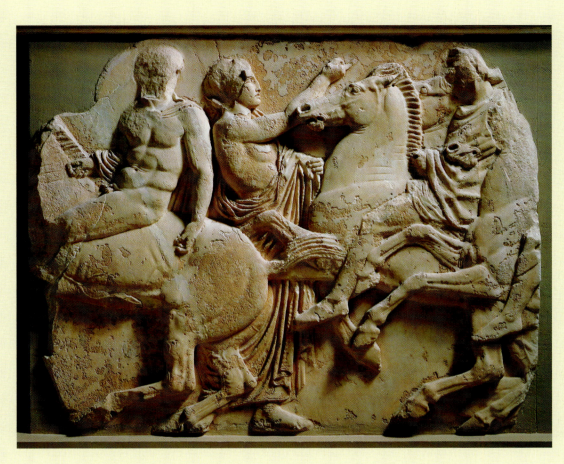

School of Phidias [Greek], *Horsemen*, from Parthenon frieze, 442–438 BCE. Marble, approximately 43 in. (109 cm) high. Acropolis Museum, Athens. © Scala/Art Resource, NY.

religious piety of mere mortals, the Athenians themselves, who accept their fate and fulfill their duty. The immortal gods in Greek art were seldom depicted as so noble or so serious.

The centerpiece of Phidias's program was the statue of Athena, which towered forty feet above the floor. Athena's flesh was carved in ivory; her robes were formed from sheets of gold. The statue was in effect part of the city treasury. Afterward, Phidias also made a colossal ivory and gold statue of Zeus for the god's temple at Olympia. Phidias's conception of the gods made them so vivid in the Greek imagination that one ancient writer said that the sculptor "added something to traditional religion."[1] The majestic sculpture of Phidias became one of the standards for the representation of divinity in the Western world.

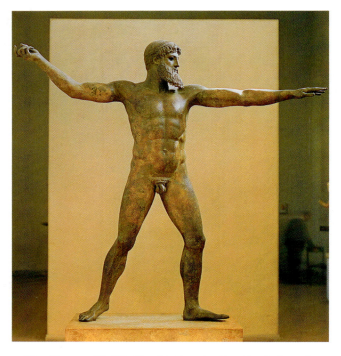

Figure 15-16 [Greek], *Zeus* (or *Poseidon?*), from Cape Artemision, ca. 460–450 BCE. Bronze, approximately 82 in. (208 cm) high. National Archaeological Museum, Athens. © Scala/Art Resource, NY.

(Figure 15-16). However, marble copies lack the subtle modulation of the masses that appear in Greek bronze originals.

Other statues of Zeus depict him in this pose hurling a thunderbolt. But if the weapon the god was about to throw was a trident, he should be identified as Poseidon, the god of the sea who saved the Greeks by destroying the Persian fleet in 479 BCE. If the missing weapon was a javelin, he might be a warrior or an athlete. The Greeks made little distinction between god and man in both their literature and their art. This similarity lent to humankind a certain god-like dignity.

The powerfully built *Zeus,* like the *Riace Warrior,* is bearded and thus older than *Spearbearer.* He stands in a completely frontal pose. Even his extended arms do not break from a single plane. However, his head is nearly profile—his gaze fixed on his adversary. He does not exhibit the sinuous movement of *Spearbearer,* who shifts his weight as though taking a step. Yet there is nothing stiff about him. He stretches his left arm straight out to balance his body. His right leg resting on his toes and his left on his heel demonstrate his flexibility.

In his *Spearbearer,* Polyclitus depicted a nude young man in the prime of life. Perhaps he is taking a step, but otherwise he is not doing anything special, and he has a blank look on his face. The shifting of weight sets up within the figure a series of balanced contrasts between relaxed and tensed muscles and contrasts in the directions of limbs. He once carried a spear in his right hand—a reminder that Greek society specially rewarded athletic achievement and heroism on the battlefield. The young man in *Spearbearer* appears well built and athletic, yet the marble copy exhibits a certain chunkiness or blockiness about his anatomy. The lines separating chest from abdomen and abdomen from thigh are quite precise, perhaps overly precise. Furthermore, the major blocks like the chest and thigh are rather smooth and almost abstracted into solid geometric forms. Few tendons or individual muscles are shown. There are no individuating features—just the essentials. These factors indicate that Polyclitus created his figure not so much from duplicating a model but from his system of measurements. *Spearbearer* is not the representation of an individual, but of an ideal. He represents not any man as he is (a fact), but man as he ought to be (a necessity).

The art of fifth-century Greece has been called classical. The word *classic* means not only something outstanding and of lasting significance, but a classic also establishes norms or rules for others to follow, as Polyclitus did. Not all Greek art shared the same classical style as that of the fifth century. Nevertheless, later generations throughout the history of Western art have believed that Greek art achieved a high point of perfection and harmony that set standards for their age as well.

Several Greek painters, such as Polygnotos and Appeles, seem to have had even higher reputations than the sculptors. Unfortunately, not one piece of the work of these painters survives. To catch a glimpse of what Greek painting looked like, we have to examine the imitations of it made at a later date by the Romans or examine the small pictures baked onto the pottery that contemporary Greek craftspeople manufactured.

The Battle Between the Greeks and Amazons (Figure 15-17), painted on the body of a red-figured volute krater (mixing bowl) by an anonymous artist known as the Painter of the Woolly Satyrs, might actually reflect a lost mural of Polygnotos. As in a

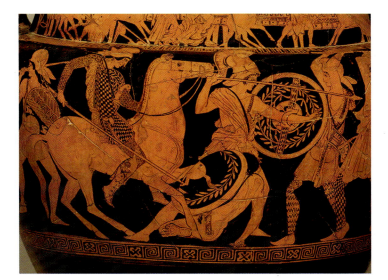

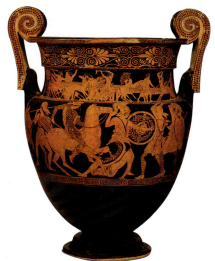

Figure 15-17 [Greek], attributed to the Painter of the Woolly Satyrs, *The Battle Between the Greeks and Amazons*, ca. 450 BCE. Red-figured volute krater, 25 1/8 in. high. Metropolitan Museum of Art, New York, Rogers Fund, 1907 (07.286.84). Photograph © 1991 The Metropolitan Museum of Art.

large-scale painting, the elaborately detailed and very active figures crowd the surface of the vase. Most of the warriors stand on the scene's lower border, which acts as the ground line, but some of them step up on indications of an internal landscape. One warrior, who has fallen to the ground beneath the hooves of a horse, exposes the sole of his foot to the viewer. A man with spear and shield stands in the space behind him. These attempts at a greater illusion of reality indicate that the pottery painter had in mind a work in another medium. The battle scene differs from the scene of revelers on the earlier vase by Euthymides (Figure 5-10), in which the figures do not overlap and thus adhere better to the vessel's curving surface.

ROMAN ART

The Romans were an active people whose military power transformed Rome from a small city to a mighty republic. Then, during the first five centuries of the Christian era, Rome extended its control over a vast empire in which Roman law and practical sense built great cities as well as the roads, bridges, aqueducts, markets, and large government buildings to serve them (see Figures 14-15 and 14-16). The very ruins of their empire teach us how great it was. Although they borrowed heavily from Greek art, the

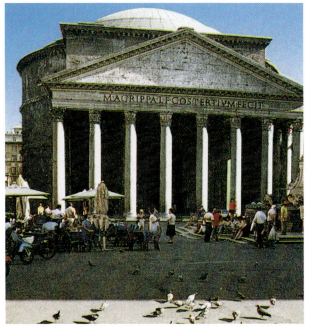

Figure 15-18 [Roman], Pantheon, exterior, ca. 118–125. Rome. Height of portico 59 ft. (18 cm). © Jan Halaska/Photo Researchers, New York.

Romans developed new forms of art and architecture to serve their needs.

The arch and the dome, concrete and bricks served the Romans' need to cover large spaces better than the precisely cut blocks of rare marble used in the columns of the Parthenon. The Pantheon (Figures 15-18 and 15-19), still standing as it was

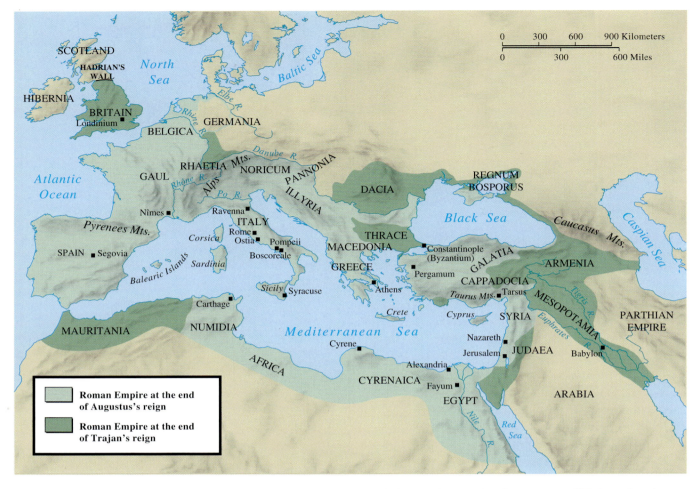

The Roman Empire. From *World History*, 4th ed., by Duiker/Spielvogel. © 2004. Reprinted with permission of Wadsworth, a division of Thomson Learning, Inc.

originally built, demonstrates the amazing structures the Romans could erect using these ordinary materials. The Emperor Hadrian built the Pantheon in 125 as a temple to all the planetary gods and as his audience hall. In the Greek Parthenon the architectural achievement is best seen from the outside of the building; in the Roman Pantheon it is best understood from inside the building.

The visitor enters the Pantheon through what looks like the porch of a Greek temple, incongruously connected to a large **rotunda** (a circular building or room). In ancient times, adjacent construction close to the building made it impossible to walk around the Pantheon to examine the exterior of the rotunda. The only door into the building opens onto an enormous cylinder of space that is capped with a hemispherical dome 142 feet in diameter—the largest dome in antiquity. If the full circle of the shape of the dome were inscribed within the building, its lowest point would be tangent to the floor. In other words, the height of the dome above the floor and the diameter of the rotunda are the same.

Although the rotunda itself is quite thick, to withstand the weight and pressure of the dome, it is actually built out of concrete and bricks in a system

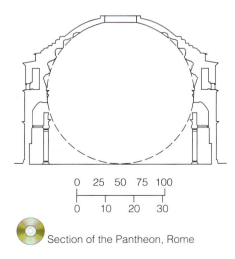

0 25 50 75 100

0 10 20 30

Section of the Pantheon, Rome

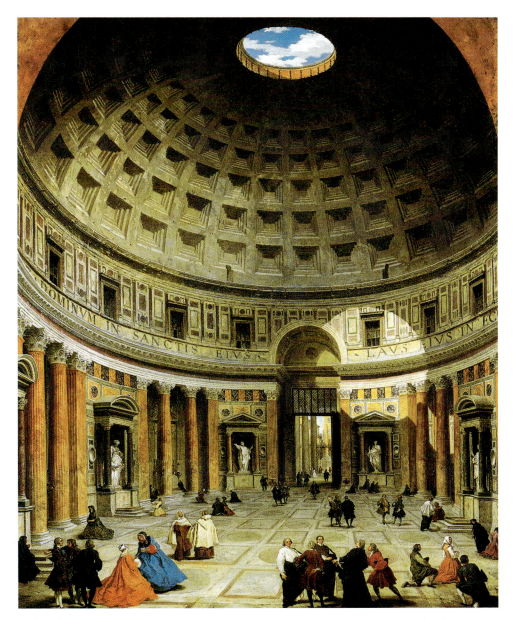

Figure 15-19 [Roman], Pantheon, interior, ca. 118–125. Rome. Painting by Giovanni Paolo Pannini [Italian, ca. 1692–1765], *The Interior of the Pantheon, Rome*. National Gallery of Art, Washington, D.C.

of arches that allows the cylindrical rotunda to be penetrated with rooms that lie behind a screen of columns. These openings along the circumference of the rotunda remove from the interior any feeling of confinement. The dome is made not of cut stones but of solid concrete shaped on the interior into a pattern of **coffers** (sunken squares) that gives the appearance of ribs.

On the exterior, the lower part of the dome descends in steps that thicken the base of the dome against the pressures to pull itself apart. Right at the

apex of the dome, where the keystone of an arch would be located, is an opening or **oculus** (Latin for "eye"). Since the opening is circular, the compression of its solid ring of material makes a keystone unnecessary. Drains in the floor remove the rainwater that enters through this opening. The only window in the Pantheon is the oculus, which nevertheless suffuses the interior with more than enough light and also projects a disk of sunlight that jiggles perceptibly as it moves across the walls. Open to the sky and built in the shape that the ancients

relaxed at his side, the Emperor's right arm is extended in a gesture that the Romans knew meant speaking. He is no doubt addressing his troops, and he looks straight ahead at them. He also wears Roman armor decorated in relief with scenes of a Roman victory—the return of the standards from the Parthians. The facial features of Augustus are symmetrical and somewhat idealized, yet they also bear a resemblance to more exacting portraits of the emperor.

The Romans displayed outstanding sculptural originality in portraiture. Roman sculptors created some of the most lifelike and expressive heads ever carved. For example, the head of the Roman Emperor Caracalla (Figure 15-21) conveys the vivid impression of a determined and fierce individual. Caracalla glares out from under knotted eyebrows; his mouth turns down in a sneer; he looks around suspiciously. History books confirm that our impression is correct: Caracalla killed his brother to get the throne. After that, he spent most of his short reign fighting the barbarians on the

Figure 15-20 [Roman], Portrait of Augustus as general, from Primaporta, Italy, copy of a bronze original of ca. 20 BCE. Marble, 80 in. (203 cm) high. Vatican Museum, Rome. © M. Sarri/Photo Vatican Museums.

imagined the dome of the universe, the Pantheon functions like a planetarium demonstrating the rotation of the earth. The experience of vast space contained within the building is like no other in the world.

When it came to creating sculpture, the Romans depended heavily on Greek models for inspiration. The Romans collected Greek art avidly, made copies of it frequently, and imitated Greek classicism extensively in their own work. For example, the proportions and the stance of the statue of the Emperor Augustus (Figure 15-20) are based on those of Polyclitus's *Spearbearer*. However, instead of falling

Figure 15-21 [Roman], portrait of Emperor Caracalla, ca. 211–217. Marble, 14 1/4 in. (36.2 cm) high. Metropolitan Museum of Art, New York, Samuel D. Lee Fund, 1940 (40.11.1a). Photograph by Schecter Lee. Photograph © 1986 The Metropolitan Museum of Art.

be sure how accurate the portrait is, when compared with the smooth and expressionless head of a Greek ideal statue, it invites us to interpret an individual's character.

As in ancient Greece, most Roman painting has been destroyed by time. Fortunately, the deserts of Roman Egypt have preserved a number of examples of Roman painting—small portraits painted in encaustic on wooden panels that were once buried with the mummy cases of ordinary people. One painting from the second century of the Roman Empire, *Portrait of a Young Man* (Figure 15-22), portrays a sensitive-looking fellow with a distinctive style of hair and beard, whose brown eyes gaze thoughtfully at us and whose bow-shaped mouth seems ready to speak. Separate brushstrokes of light and dark round out the features of his face and make him come alive. The Roman artist is capable of creating a portrait of a distinct individual—a person we could imagine meeting.

A considerable amount of Roman painting has been unearthed under the ash laid down by the eruption of Mount Vesuvius over Pompeii and the surrounding area in 79 CE. Most of these paintings once decorated the walls of the homes of the well-to-do. *Woman with a Veil* (Figure 15-23) illustrates one

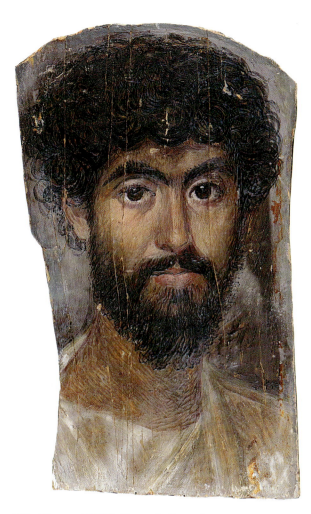

Figure 15-22 [Roman]. *Portrait of a Young Man*, from Fayyum, early second century. Encaustic, 15 1/2 × 7 5/8 in. (39.4 × 19.4 cm). Metropolitan Museum of Art, New York.

far borders of the empire until he himself was assassinated.

We might have expected that the sculptor would have flattered the emperor and made him more appealing. We cannot imagine that the sculptor did not know how to portray the emperor favorably. But the mean and aggressive look apparently pleased the emperor. After all, Caracalla must have approved this official image. If the emperor wanted everyone to see him as alert and ruthless, the image was good propaganda. Although we cannot

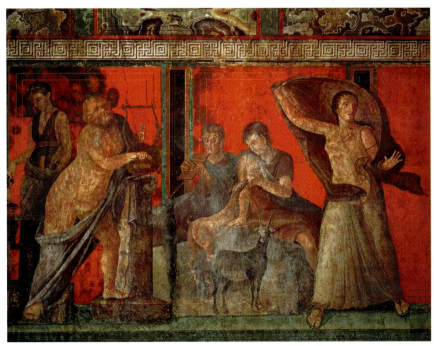

Figure 15-23 [Roman]. *Woman with a Veil*, ca. 60–50 BCE. Frieze approximately 64 in. (163 cm) high. Villa of the Mysteries, Pompeii, Italy. © Scala/Art Resource, NY.

ART OF THE CHINESE EMPIRE

When the legions of Rome had begun forming an empire in the West, in the East, Qin Shi Huangdi (the Chinese words mean "the first emperor of China") united China in 221 BCE. The first emperor of China built the Great Wall (Figure 15-24) to protect his empire from the nomads of the Asian steppes. To defend the wall, he conscripted an enormous army. He also spent more than three decades building an elaborate tomb complex with forced labor. The emperor was buried near the city of Xi'an under a fifteen-story earth mound, which remains largely unexcavated.

In 1974 some farmers digging a well discovered a subterranean area, less than a mile to the east of the tomb mound, that contains a huge army of approximately 7,000 life-sized soldiers, 100 chariots, and 400 horses (Figure 15-25). The horses and soldiers were made of clay pieces molded or modeled by hand and then joined together. Excavations revealed row upon row of soldiers, still on guard after more than 2,000 years. Once brightly painted, the clay soldiers were in a sense stand-ins for the living sacrifices that were made in earlier Chinese royal burials.

Figure 15-24 [Chinese], Great Wall. Brick faced, average height 25 ft., 1.500 miles long. Construction began in the Qin dynasty, 221–206 BCE, with major work occurring in the Ming dynasty, 1368–1644. © Michael Howell/Index Stock Imagery/Picturequestca.

section of a mural that runs around the four walls of a room in the villa, or country estate, known as the Villa of the Mysteries. Along the walls the artist painted a narrow green stage where human and mythological figures enact, against vivid red panels, the initiation ceremonies of a mystery cult, perhaps the cult of Dionysus. The woman seems to be running in fear as the breeze catches her veil and reveals her features. The detail demonstrates that the artist can handle large, statuesque figures that move with solemnity and grace. Well proportioned and firmly modeled, they effectively mirror the arcane rituals that must have taken place in this room.

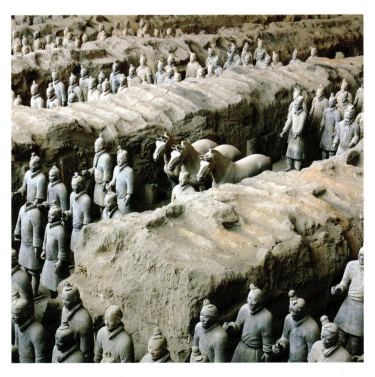

Figure 15-25 [Chinese], Bodyguards of the first emperor of China. Qin dynasty, 221–206 BCE. Painted ceramic, average figure 71 in. (180 cm) high. Xi'an, Shensi Province, China. © Imaginechina.

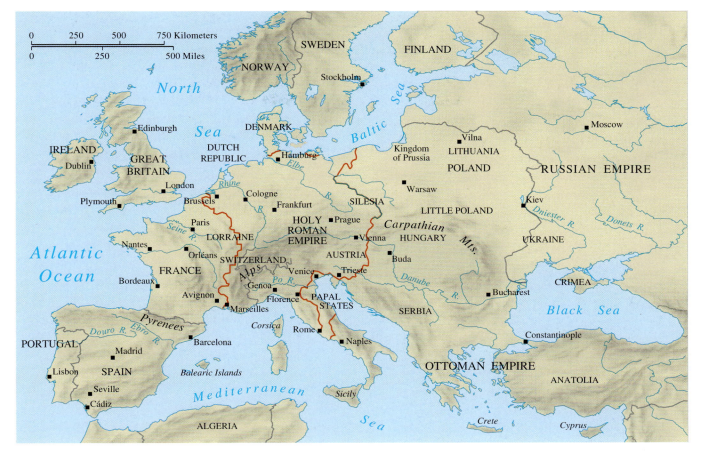

Medieval Europe. From *World History*, 4th ed., by Duiker/Spielvogel. © 2004. Reprinted with permission of Wadsworth, a division of Thomson Learning, Inc.

No two soldiers look exactly alike. The artists used a fine clay for the faces, individualizing them with various types of features, styles of facial hair, and kinds of expression. Perhaps their faces imitated those of actual soldiers in the imperial guard. Obsessed with security and eager to perpetuate his life, the emperor ordered this ceramic army to guard forever his tomb and the approach to the capital of his new empire.

THE MEDIEVAL WORLD

In the West, the period after the fall of the Roman Empire has been called the Middle Ages because it was seen as a mere gap between Rome and the revival of classical culture in the Renaissance in the fifteenth century. But even before the Roman Empire fell apart, forces were at work building the foundations of vigorous new cultures. New peoples migrated into the Mediterranean world—the Greeks and Romans called them barbarians. Several major religions of the modern world began their territorial ex-

pansion at this time. First Christianity and then Islam spread through Asia, Europe, and Africa. Buddhism worked its way east through Asia during the period. Each religion brought with it a new view of life that transformed the art and architecture of the world.

EARLY CHRISTIAN AND BYZANTINE ART

In 330 the Roman emperor Constantine established a new capital in the East at Byzantium, on the Bosporus Strait separating Europe and Asia. He changed its name to Constantinople; the city is now known as Istanbul. Constantine had recognized Christianity as an official religion of the empire, and he and his family sponsored magnificent church buildings for Christian worship—buildings such as old St. Peter's in Rome and the Church of the Resurrection in Jerusalem. After years of persecution, Christianity now came out in the open and soon became the dominant force in the declining,

battered empire. People throughout the Roman Empire found meaning in Christianity as life around them grew more uncertain. As the Roman Empire decayed, as barbarians sacked Rome itself in 410—in short, as the realities of this world crumbled away—Christianity gave people hope in a future life. This new attitude to nature and spirit gave rise to new forms of art.

At Constantinople, a Christian Roman empire survived the fall of western Rome for another thousand years. In the sixth century, the Byzantine emperor Justinian I built the splendid church of Hagia Sophia in his capital city (see Figure 14-17). Justinian even won back the Italian peninsula from the barbarian people who ruled the remains of the Western Roman Empire. The Byzantine Empire controlled Italy through the city of Ravenna, a few miles below Venice on the Adriatic coast. The city still contains some of the best-preserved examples of art and architecture from those early years of Christian Byzantine rule.

The earliest Christians during the years of persecution had generally worshipped in private houses. When congregations became larger after Constantine, Christians adopted for their church buildings an all-purpose Roman building type called the **basilica.** The basilica filled their needs because it is fundamentally a large covered hall. Its big interior space provided room for the entire Christian congregation that came together every Sunday to

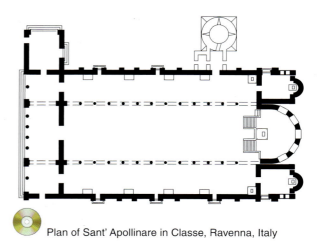

Plan of Sant' Apollinare in Classe, Ravenna, Italy

hear scripture, listen to sermons, and participate as a group in the liturgy.

Sant' Apollinare in Classe and Sant' Apollinare Nuovo (Figure 15-26) in Ravenna, Italy, illustrate typical early Christian basilicas. The long space within the building is covered by wooden roofs and subdivided by two **arcades.** In the arcades the arches rest on top of the columns—a combination that was rare in Roman architecture. The repetition of columns and arches creates something like a covered street leading to the altar. Sant' Apollinare already possesses some of the essential features of church planning that are later present at Chartres Cathedral (Figure 14-1). It has a **nave,** the tall central space, and **aisles,** the subsidiary spaces that run along either side of the nave. The nave terminates in a semicircular extension of space called an **apse.** The upper part of the nave, the **clerestory,** has windows that throw plenty of light into the center of the church. The simple plan of Sant' Apollinare became the standard design for a Christian church in the West.

San Vitale (Figure 15-27), a smaller, more intriguing building also in Ravenna, resembles the more complicated kind of church which was built at Constantinople under the rule of Byzantine Emperor

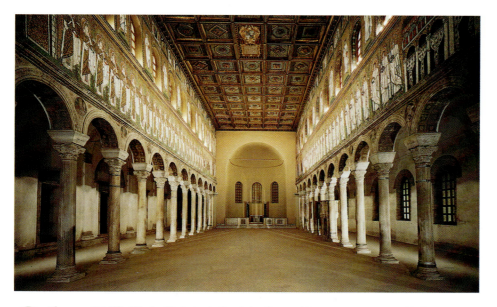

Figure 15-26 [Early Christian]. Sant' Apollinare Nuovo, interior, ca. 490. Ravenna, Italy. © Scala/Art Resource, NY.

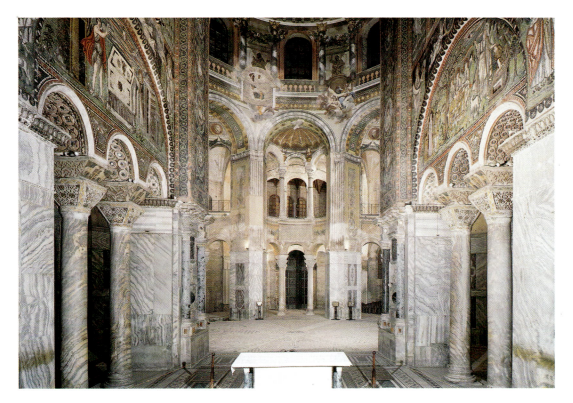

Figure 15-27 [Early Christian and Byzantine]. San Vitale, interior, 526–547. Ravenna, Italy. © Canali Photobank.

Justinian. Unlike the rectangular basilican shape of Sant' Apollinare, San Vitale's is octagonal. The tall, central space has clerestory windows and is covered by a dome. Dome-covered churches became more popular in eastern Christianity, whereas the basilican type dominated in the West. An **ambulatory,** a circular aisle that allows the circulation of people around most of the church, surrounds the central

space. The upper part of the outer octagon is known as a **gallery**—an area reserved for less distinguished participants in the liturgy. A tall and deep **chancel,** or altar area, breaks the ring of the ambulatory and gallery around the central core. Apses between most of the wedge-shaped piers, or upright supports, billow out from the central octagon into the ambulatory and gallery, nicely meshing and interlocking the inner and outer spaces of the interior of the church.

The interwoven spaces of the interior of San Vitale take a bit of time for the visitor to figure out. The shape of the interior is also made unclear because the surfaces are covered with **mosaics** (pictures made from small colored pieces of stone) and veneers (thin slices) of colored marble. The color and the reflections from these surfaces take away any impression of solid structure in the building. Even the capitals of the columns are carved with a lace-like pattern of circles and floral motifs, undercutting the solid appearance of the stone. The carving of the capitals, the mosaics, and the colored veneers dematerialize the interior and help make it a mysterious, sacred space.

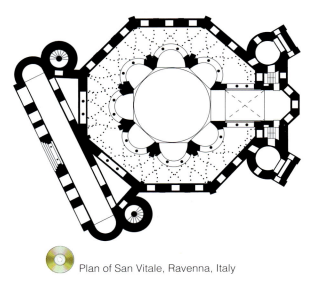

Plan of San Vitale, Ravenna, Italy

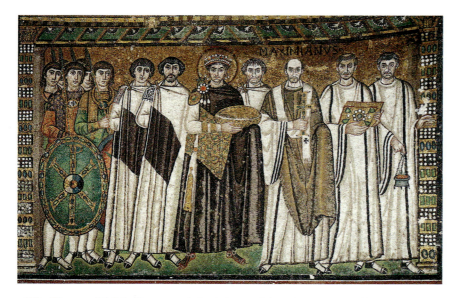

Figure 15-28 [Byzantine], *Justinian and Attendants*, mosaic from the north wall of the chancel of San Vitale, ca. 547. Ravenna, Italy. © Canali Photobank.

look beyond the viewer into the next world. Throughout the mosaic, representation of the realities of this world has given way to representation of a spiritualized existence. The style of the mosaic reflects the change in values brought on by Christianity.

BUDDHIST ART

Although Buddha (ca. 563–ca. 483 BCE) lived five hundred years before the birth of Christ, the first images of Buddha in art appeared in the Christian era. Born in Nepal, on the northern border of India, Buddha guided his followers on an ethical path that led them to peace of mind, to wisdom, and to enlightenment. Buddha taught that the only way to escape the troubles of the world was through detachment, meditation, and good works. By these means, one could break the cycle of death and rebirth to achieve perfect peace and happiness, or *nirvana*. Buddhism spread rapidly through India and from there to China and Japan and to all of Southeast Asia, subsuming, as it went, many local religious traditions.

The chancel walls of San Vitale hold some of the most famous mosaics in the world: *Justinian and Attendants* (Figure 15-28) and *Theodora and Attendants* (Figure 15-29). The two mosaics show Emperor Justinian and his wife, Theodora, who probably never came to Ravenna, surrounded by their court as though they are making the offerings of bread and wine for the liturgy. They both wear halos as an indication of the spiritual importance of the Byzantine emperor, who considered himself the direct representative of the divine on earth. In fact, almost everybody and everything in the mosaic is spiritualized by the style of representation. There is very little indication of space around or behind the emperor. The gold background, rich and reflective, naturally symbolizes the measureless heavens. Everybody's feet are spread flat out, giving the impression that the figures are levitating. Dark lines represent the folds in their garments, but the garments do not seem to wrap around solid bodies. The symmetrical facial features of classical art have turned into a stereotyped stare that seems to

The most typical Buddhist monument in India is the **stupa,** a large, hemispherical, solid mass that

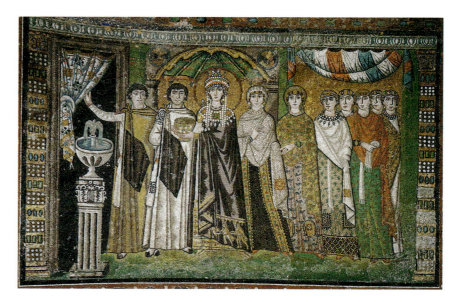

Figure 15-29 [Byzantine], *Theodora and Attendants*, mosaic from the south wall of the chancel of San Vitale, ca. 547. Ravenna, Italy. © Canali Photobank.

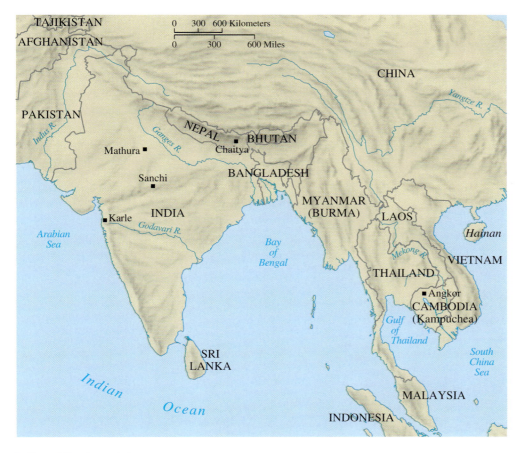

India and Southeast Asia

may have originally
contained relics of the
Buddha. A stupa also
symbolizes the World
Mountain. The Great
Stupa (Figure 15-30), at
Sanchi, India, has four
gateways—facing north,
east, south, and west—
that penetrate a high
railing. The pilgrim en-
tering the gate would fol-
low counterclockwise the
Path of Life by walking
the route marked by the
railing around the stupa.
The bricks that cover the
mound of rubble and
earth underneath the
stupa were once covered
with white stucco and

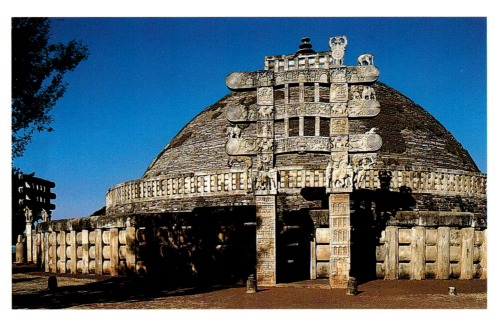

Figure 15-30 [Buddhist]. The Great Stupa, completed first century. Sanchi, India.
© Robert Harding Picture Library.

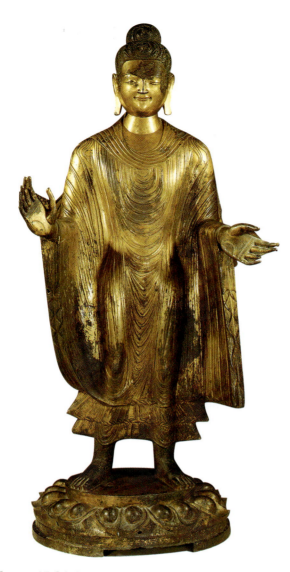

Figure 15-31 [Chinese, Northern Wei dynasty], *Standing Buddha*, 477. Gilt bronze, 55 1/4 in. (140.2 cm) high × 19 1/2 in. (48.9 cm) wide. Metropolitan Museum of Art, New York, John Stewart Kennedy Fund, 1926 (26.123). Photograph © 1991 The Metropolitan Museum of Art.

Buddha from China (Figure 15-31) illustrates Maitreya, the Buddha of the Future, or the Buddha yet to come. He stands front and square on a lotus-covered platform, spreads out his arms, and raises one hand as if to speak or perhaps to bless. His gesture unfurls his robe like the wings of a beatific angel. His eyes lowered, Buddha smiles serenely, mysteriously, charmingly. His monk's robe clings to him like wet cloth and reveals the smooth modeling of the body underneath. The double-pleated folds of his robe fall in loops down his torso and descend in V-shaped folds between his legs and end in swirls at the hem. Because of these curving and concentric lines, his golden body appears to radiate his glory.

ROMANESQUE ART

In Western Europe, Christianity survived the fall of the Roman Empire and the decline of civilization that followed. In fact, for centuries after the fall of Rome the Christian church in the West took charge of many essential aspects of social life such as education, social welfare for the poor and sick, and the establishment of law and order. As Christian missionaries and monks spread the faith among the barbarians, they brought new territories in Europe under cultivation. In the Middle Ages, the church created a new society of the invading peoples and the remains of Rome—a society in which the Christian religion pervaded every aspect of European life. Medieval life centered around the church and the estates of the feudal lords. When people traveled across Europe, they often traveled for religious reasons in pilgrimages or in crusades to the Holy Land. Gradually, commerce returned and cities slowly came back to life while the reinvigorated arts flourished in towns, at court, and in monasteries.

During the Middle Ages, the pilgrimage was a popular form of devotion. Chaucer's *Canterbury Tales* are told by pilgrims on their way to the shrine of St. Thomas à Becket in Canterbury, England. Even more pilgrims traveled to the Holy Land, when they could, to the shrines of Peter and Paul and other early martyrs in Rome, and to Santiago de Compostela in northwestern Spain, where the apostle Saint James was buried. Monasteries in France and Spain along the routes to Santiago de Compostela built hostels for the pilgrims about every

gilded. The three umbrellas at the top of the stupa symbolize Buddha, the Buddha's Law, and Order—the three aspects of Buddhism. The stupa is a structure to be experienced from the outside, rather than an architectural construction that encloses interior space.

For centuries, Buddha was not shown in human form, but was symbolized by things such as his footprints or the tree under which he achieved enlightenment. The nearly life-size gilt bronze *Standing*

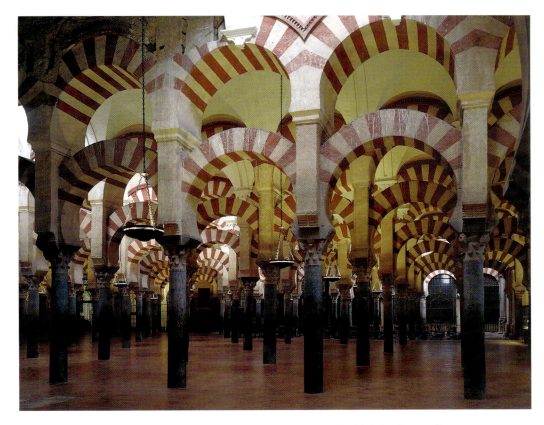

Figure 15-34 [Islamic], Great Mosque, interior, 784–988. Córdoba, Spain. © www. bednorzphoto.de.

church, it is a place for worship, prayer, scripture reading, and preaching. A fine example of an early mosque survives in the Spanish city of Córdoba, once the center of Islamic civilization in Spain (Figure 15-34). The high walls of the Great Mosque

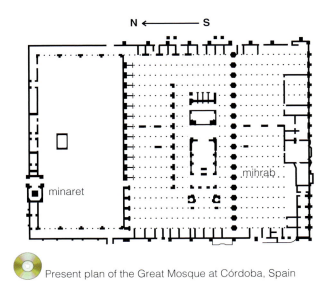

Present plan of the Great Mosque at Córdoba, Spain

of Córdoba enclose on the north a rectangular courtyard. Built into the wall at the entrance is a **minaret,** a tower from which the muezzin (Muslim crier) chants a call to prayer five times a day.

Enlarged several times over the course of two hundred years, the covered sanctuary of the Great Mosque at Córdoba contains along the south wall the **mihrab,** a niche that points to Mecca. Worshippers must face Mecca during prayer. The original wooden roof of the sanctuary was sustained by eighteen **arcades** formed with an unusual series of arches. To raise the height of the roof of the sanctuary, pillars were constructed on top of the small columns to support the semicircular arches under the roof. To stabilize these lofty arches, horseshoe-shaped arches were inserted below to brace the pillars. All the arches, decorated in stripes of alternating brick and stone, seem to billow up from the slender columns and keep the extensive interior light and airy in appearance.

In front of the mihrab of the Great Mosque lies a square bay covered with a remarkable dome (Figure

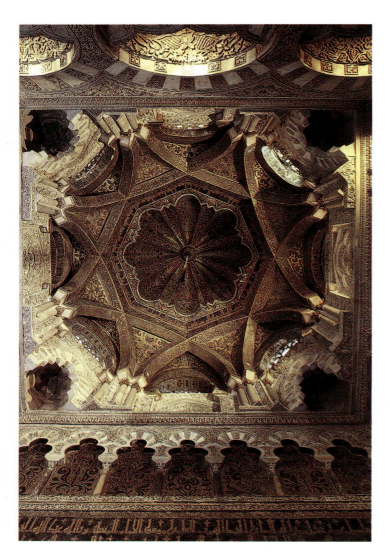

and stories of its scripture, as did Christianity in the West and Buddhism in the East. Instead, Islamic craftspeople often made the beautiful calligraphy of the Arabic text of the Koran itself part of the decoration of sacred architecture, as they did in the mihrab from Iran that is now in the Metropolitan Museum of Art in New York (Figure 15-36). Composed of red, white, and, for the most part, blue glazed ceramic tiles, this pointed niche has a border of ornate calligraphy. The unequaled decoration in the borders and other areas filled with interwoven plant and floral motifs almost conceals the mihrab's architectural structure.

GOTHIC ART

At the end of the twelfth century in Western Europe, a new medieval style arose called Gothic. The name was later given by architects of the classical Renaissance who despised Gothic architecture and

Figure 15-35 [Islamic], Great Mosque, dome before the mihrab, 784–988. Córdoba, Spain. © Adam Wollfitt/Robert Harding Picture Library.

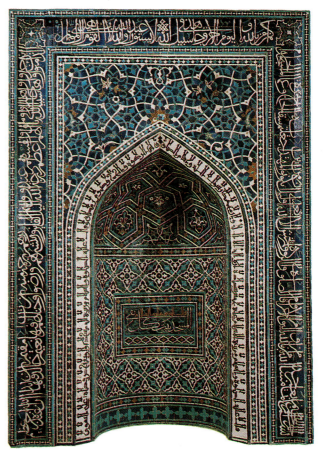

Figure 15-36 [Islamic], Mihrab, from Madrasa Imami, Isfahan (Iran), after 1354. Mosaic of glazed terra cotta, 11 ft. 3 in. (342.0 cm) high. Metropolitan Museum of Art, New York.

15-35). The scalloped dome in the center of the ceiling seems to rest on an octagon created by intersecting ribs springing from the side walls of the clerestory. Each rib, rising from a slender column, skips the nearby vertical support and crosses over to the next set of columns. The result is an interwoven star shape that forms the octagon. Rather than leading to a new way of building, the sophisticated structure of the dome at Córdoba remains a dazzling architectural fantasy.

The dome is covered with gold mosaic, lavishly decorated with plant motifs. Since the Koran forbids the representation of human beings and animals, Islamic religious art never developed a tradition of painting and sculpture that illustrated the characters

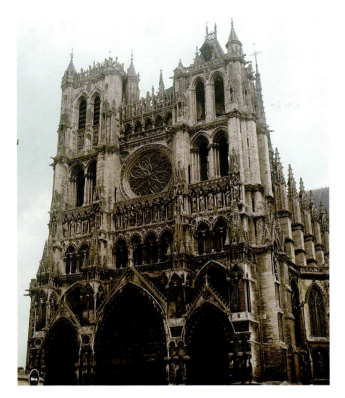

Figure 15-37 **Robert de Luzarches, Thomas de Cormont,** and **Renaud de Cormont** [French], Amiens Cathedral, exterior, begun 1220. Amiens, France. © Paul Almasy/Corbis.

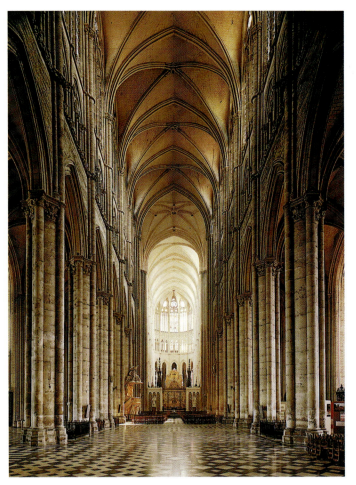

Figure 15-38 **Robert de Luzarches, Thomas de Cormont,** and **Renaud de Cormont** [French], Amiens Cathedral, interior, begun 1220. Amiens, France. © Hirmer Fotoarchiv, Munich.

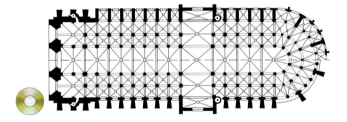

thought it had been invented by the Goths, one of the barbarian tribes that had ravaged the Roman Empire. People living in the thirteenth century simply called the new style modern. The Gothic style manifests itself best in the great cathedrals that rose heavenward in the cities of France and the rest of Europe between 1150 and 1500. The revitalized cities of Europe now possessed increased wealth to afford the cathedrals' construction and had sufficient numbers of skilled craftsmen, organized into guilds, to carry out such tasks. These buildings clearly express the religious aspirations of an age when almost all of Western Europe was Christian.

The cathedral of Chartres (Figure 14-1) was the first to bring together all the innovations of the new Gothic style in one building. The slightly later cathedral of Amiens (Figures 15-37 and 15-38) imitated the plan and structural system of Chartres and continued to refine its achievements. Both plans appear similar: they both have a generous nave flanked by aisles, although Amiens added six square chapels along each aisle. A transept crosses the nave about halfway down the church, allowing more space for

the monks' choir beyond the crossing than at Saint-Sernin. In the past, a stone screen segregated the choir at Chartres and Amiens from the rest of the church. Aisles on either side of the choir lead to the ambulatory, from which radiate curved chapels.

The facade of Amiens Cathedral has two towers, constructed unevenly at different periods, as were those at Chartres. Despite its bulky proportions, every surface of the facade has been embellished

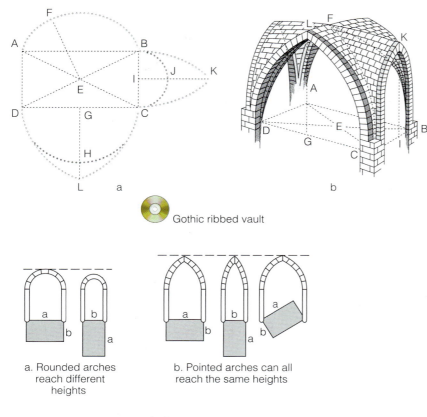

Gothic ribbed vault

a. Rounded arches reach different heights

b. Pointed arches can all reach the same heights

Arches

with sculpture or pierced by windows and niches that seem to dissolve solid masses. Three large porches across the facade funnel the visitor into the nave and aisles of this basilican church.

The interior of Amiens Cathedral also resembles that of Chartres, but the stone vaults over the nave soar to a height of 144 feet, about 25 feet higher than the nave at Chartres. Slender colonettes along the nave arcade continue through the clerestory, then fan out in ribs across the ceiling, supporting a canopy of thin, tent-like cross vaults. Instead of building vaults of thick masonry, the Gothic architect first built the arches across the vaults to form ribs on which the thin webbing of stone between the ribs would actually rest. Architects quickly took advantage of the new lightweight Gothic vaulting technique and abandoned the heavy Romanesque style and its emphasis on mass.

All the ribs of a typical rectangular bay in the nave—whether long, short, or diagonal—now reach approximately the same height because their arches are pointed. Semicircular arches over those three different spans would attain three different heights.

The pointed arches and the thin, light rib vaulting of the Gothic style allowed the architects of Chartres and Amiens to open up the walls of the building as much as possible to stained-glass windows because the walls no longer supported the vaults. Taking advantage of the increased height of the pointed arch, they drove stained-glass windows up the clerestory to nearly the same level as the apex of the vaults over the nave. At the east end of Amiens, even the triforium, the area between the clerestory and the arcade, has stained glass behind the window-like openings in the wall.

The lighter rib-vault system allowed solid wall to be replaced by glass because the wall no longer had any weight-bearing function. Walls now seem light and thin compared to the heavy walls of the Romanesque style. The system also allowed Gothic builders to cut costs because much less stone was needed and also, more importantly, much less costly timber was needed for scaffolding. The same centering could be moved from bay to bay.

The support system for most Gothic churches lies on the outside of the building, where massive

buttresses throw their weight against the building and counter the thrusts of the vaults. Furthermore, the buttresses rise above the roof of the aisles, and from their tops, **flying buttresses,** arches that sail over the aisles, brace the nave vaults from the outside. On the exterior, the Gothic architect displayed all the muscles and bones of the structure. On the inside, the Gothic architect created a vision of the biblical Heavenly Jerusalem out of the spider's web of thin supports and tent-like stones and the brilliant jewel-like color of the glass that once filled the windows.

Medieval sculptors surrounded the doors of Chartres and Amiens with statues that begin to work free of the architecture. In the elaborate porches at the ends of the transept at Chartres, sculptors set the figures entirely free from the architectural supports around the doors. Compared with the ecstatic figure of Christ over the door at Vézelay (Figure 15-33), the so-called *Beau Dieu (Handsome God)* at Chartres (Figure 15-39) has swollen to more normal proportions. In fact, he possesses somewhat classical features. This figure of Christ attached to the central doorpost (or *trumeau* in French) of the south porch at Chartres holds his gospel message in one hand and blesses those entering the church with the other. His calm and serene expression is accentuated by the severe and austerely beautiful vertical lines of the drapery folds that fall down the figure. His serenity resembles to some extent that of the Chinese *Standing Buddha* (Figure 15-31).

While craftsmen designed the large, colorful stained-glass windows for the Gothic cathedrals of Europe (see Figure 13-1), other artists painted on a small scale illustrations and decorations in sacred books. Throughout the Middle Ages this practice, called **illumination,** had been carried out by monks in monasteries, but by the thirteenth century laypeople started to paint the miniature pictures in prayer books, which were increasingly paid for by the wealthy for their own use. A major center of this book trade was Paris, where Saint Louis, king of France, commissioned a luxurious psalter for his library. The king was an avid collector of books. In the *Psalter of St. Louis,* most of the seventy-eight miniature paintings, such as *Balaam and His Ass*

(text continued on page 362)

Figure 15-39 [French Gothic]. *Beau Dieu,* from the porch of the south transept, trumeau of central portal, ca. 1220–1240. Chartres Cathedral. Chartres, France. © www.bednorzphoto.de.

The Architect in the Middle Ages

Although the name of the architect who first designed Chartres Cathedral has been lost, we know the names of thousands of architects who designed many of the castles and cathedrals of the Middle Ages. The name of Robert de Luzarches, the first architect of Amiens Cathedral, was inscribed in a labyrinth set into the floor of the nave in 1288. Like any modern architect, architects in the Middle Ages were responsible for planning the spaces, ensuring adequate foundations, determining the height and width of columns and walls, designing vaulting and windows, and overseeing the construction. Unlike a modern architect, architects in the Middle Ages had actual building experience cutting stones and laying them in walls or arches.

A medieval architect often had a father or at least a cousin who was an architect, since professions tended to be passed down in families through generations. At the age of thirteen he was apprenticed to a master craftsman for up to seven years in order to learn the trade. Apprenticeship was a contractual obligation, and the apprentice sometimes paid the master for the privilege of working for him. Through hard labor, the apprentice learned the basic manual skills of the building trade—how to cut and dress stone, how to mix cement, how to join stones together. Eventually, the apprentice would also learn the secrets of the building profession—how to build straight or perpendicular walls or how to plan a series of spaces according to

"The Architect in the Middle Ages," as pictured in a manuscript illumination. © The British Library, London/Art Resource, NY.

Villard de Honnecourt [French, ca. 1225–ca. 1250], page from notebook, ca. 1240. Bibliothèque Nationale, Paris.

might spend a year in traveling across the country or even to foreign lands to see and learn all he could about architecture—in Germany this year was called the *Wanderjahr* ("travel year"). Most medieval builders remained journeymen, moving from job to job, but an ambitious journeyman might set up his own shop as a master. In some countries, the architect had to successfully produce a specified "masterpiece" to become a recognized master.

After consulting with his clients, the architect then set about drawing plans. Only a few architectural drawings from the late Middle Ages have survived, the most significant exception being those in the notebook of Villard de Honnecourt of about 1240. The architect also made templates for the stone carvers to use when cutting the profiles of blocks of stone that were to be stacked and formed into clusters of columns. The design of each profile, as well as the larger dimensions of every space, was probably determined by geometry. In addition to the square, the favorite geometrical configuration of the Middle Ages was undoubtedly the triangle. The medieval architect might arrange proportions based on the ratio between the height and the side of an equilateral triangle, between the side and the diagonal of a square, or between the sides of the Golden Rectangle (see page 131).

A medieval preacher once complained about architects who, carrying a measuring stick and wearing gloves, gave orders and did no physical labor themselves. The preacher also protested that these masters were paid two, three, or four times the wage of a journeyman. But in reality, medieval architects had worked hard to acquire a firsthand acquaintance with the building trade. They also had specialized knowledge of the building techniques and principles of design that enabled them for several centuries to experiment boldly with ever more lofty, glass-filled Gothic cathedrals.

correct proportions. Medieval builders guarded these trade secrets as modern industrial firms guard the technology of production.

At the end of his apprenticeship, the future architect became a journeyman because he could now receive a day's wage for his work (*jour* in French means "day"). He also

Figure 15-40 [French Gothic], *Balaam and His Ass*, from the Psalter of St. Louis, ca. 1260. Ink, tempera, and gold leaf on vellum, 8 1/4 × 5 5/8 in. (21 × 14.5 cm). Bibliothèque Nationale, Paris. © Snark/Art Resource, NY.

arms in amazement, and the donkey looks annoyed as he turns his head to speak to Balaam. The drapery folds flow with the twists of the bodies. The same style of dainty figures with small heads appears in other art sponsored by the royal court, including contemporary stained glass, which emphasizes like the psalter the colors red and blue.

HINDU ART IN SOUTHEAST ASIA

Half a world away in Cambodia, the Khmer people ruled a kingdom second only to that of China in East Asia. Their capital at Angkor (which means "city" or "capital") (Figure 15-41), stretching fifteen miles east to west and five miles north to south, supported a population of a million people through an extensive system of reservoirs and canals. Since the ninth century, each of the successful kings of Cambodia enlarged and improved the irrigation system that allowed three crops of rice a year on the fertile soil. Each king also had the duty to build at Angkor a temple to the Hindu gods, which would also be a monument to his own glory as god-king. Although the houses and palaces of Angkor were made of wood that has long since gone back to the soil, the seventy-two stone monuments that rise up from the flat floodplain with its network of canals still attest to the magnificence of Angkor.

Hinduism, which began in prehistoric times in India, spread to Southeast Asia. It developed gradually, assimilating numerous cultures and beliefs along the way. Hinduism does not depend on the teaching of an individual, as does Christianity, Buddhism, and Islam. It has many gods, and its doctrines can be found in many sacred books such as the four Vedas, which are older than any other sacred texts; the *Puranas,* which narrate important Hindu myths; and *The Bhagavad-Gita,* which discusses the meaning of existence.

Only a few years before the citizens of Chartres built their cathedral, the Khmer king Suryavarman II, who ruled until 1150, built the enormous temple of Angkor Wat. Of all the temples of Angkor, Angkor Wat is the largest, the most beautiful, and the best preserved. Dedicated to the Hindu god Vishnu, the

(Figure 15-40), illustrate Genesis and other early books of the Old Testament rather than the Psalms. Each scene has a decorated border—in this example an undulating floral motif with intertwined animal necks in the corners. And each scene is placed underneath two gables with rose windows in the latest style of Gothic architecture. The architecture divides most of the Bible stories into two parts. *Balaam and His Ass* is one of the rare scenes that spreads across the page.

In the Bible story (Numbers 22:1–35), the king of Moab sends Balaam to curse the Israelites. When an angel bars the way and the donkey turns aside, Balaam strikes the animal, who starts arguing with him. Then God reveals the angel with the sword to Balaam. The elongated figures act out the scene with lively gestures—the swaying angel brandishes his sword, Balaam twists and raises his

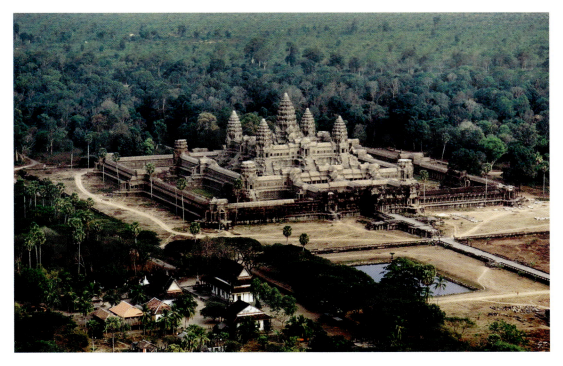

Figure 15-41 [Khmer], view of the temple complex near Siemréab, including Vishnu temple of Angkor Wat, 1113–1150. Cambodia (Kampuchea). © Michael Freeman/IPN.

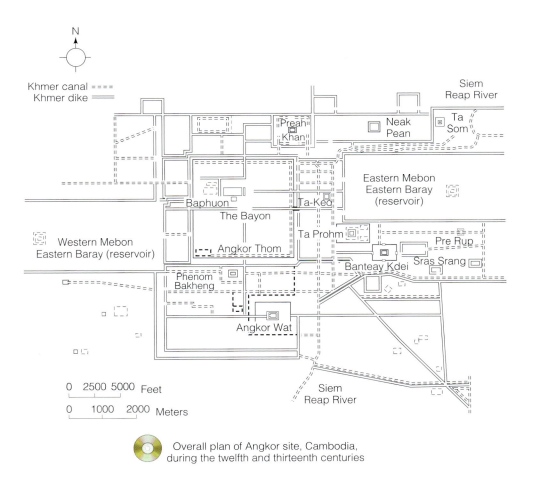

N

Khmer canal ====
Khmer dike ====

Siem Reap River

Preah Khan

Neak Pean

Ta Som

Eastern Mebon
Eastern Baray
(reservoir)

Baphuon

Ta-Keo

The Bayon

Western Mebon
Eastern Baray (reservoir)

Ta Prohm

Pre Rup

Angkor Thom

Banteay Kdei

Sras Srang

Phenom Bakheng

Angkor Wat

Siem Reap River

0 2500 5000 Feet

0 1000 2000 Meters

Overall plan of Angkor site, Cambodia, during the twelfth and thirteenth centuries

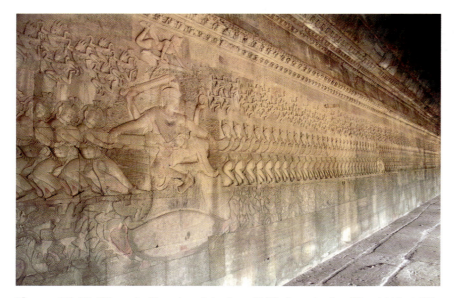

Figure 15-42 [Khmer], *Churning of the Sea of Milk*, from Angkor Wat, 1113–1150. Cambodia (Kampuchea). Robert Harding Picture Library.

enormous splendor of Angkor Wat represents the Hindu view of the universe.

The five main towers are the peaks of Mount Meru, home of the gods and center of the universe, and the outer wall represents the mountains at the edge of the world. These walls, a half-mile in circumference, contain vaulted galleries where the myths of Vishnu, Krishna, and Rama are carved in low relief. Up stair ramps aligned with the cardinal directions, terraces rise to the five main towers, which are connected by a rectangular grid of galleries. The central tower reaches a height of 215 feet. Soon after the Kingdom of Siam sacked a declining Angkor in 1431, the city disappeared in the Cambodian jungle until its rediscovery in the late nineteenth century.

Just as the porches of French cathedrals are filled with sculpture, so is almost every square foot of the magnificent stone temple mountain covered with reliefs depicting such scenes as the Hindu myth of creation, *Churning of the Sea of Milk* (Figure 15-42). This 160-foot-long, very low relief in one of the galleries shows an incarnation of Vishnu when

he gained the cooperation of the gods and demons to stir the Sea of Milk with a serpent. By churning the Sea of Milk, Vishnu obtained the Dew of Immortality for the gods and other benefits for humankind. Vishnu appears in the center portion of the relief holding, with a pair of additional arms, his attributes—a club and a discus—while he directs the numerous figures holding the serpent churning the sea. Vishnu also manifested himself on earth in the form of a tortoise, depicted below his figure. The small figures flying through the air were born of the foam, and they symbolize the god-king's beneficence.

The Cambodian sculptors delighted in lively and active poses that make the figures look as though they are in the middle of a ritual dance. Their identical and repeated movements are not static but appear to interlock in a curvilinear rhythmic design. Walking along the gallery, visitors had to let the low relief unfold as they moved. Unfortunately, centuries of neglect and devastating war have taken a toll on Angkor Wat. Recently, efforts have begun to preserve and restore parts of it.

INTERACTIVE LEARNING

Flashcards

Artist at Work: Phidias

Artist at Work: The Architect in the Middle Ages

Companion Site: **http://art.wadsworth.com/buser02**

Chapter 15 Quiz
InfoTrac® College Edition Readings
Talking Flashcards
Online Study Guide

THE ANCIENT AND MEDIEVAL WORLD

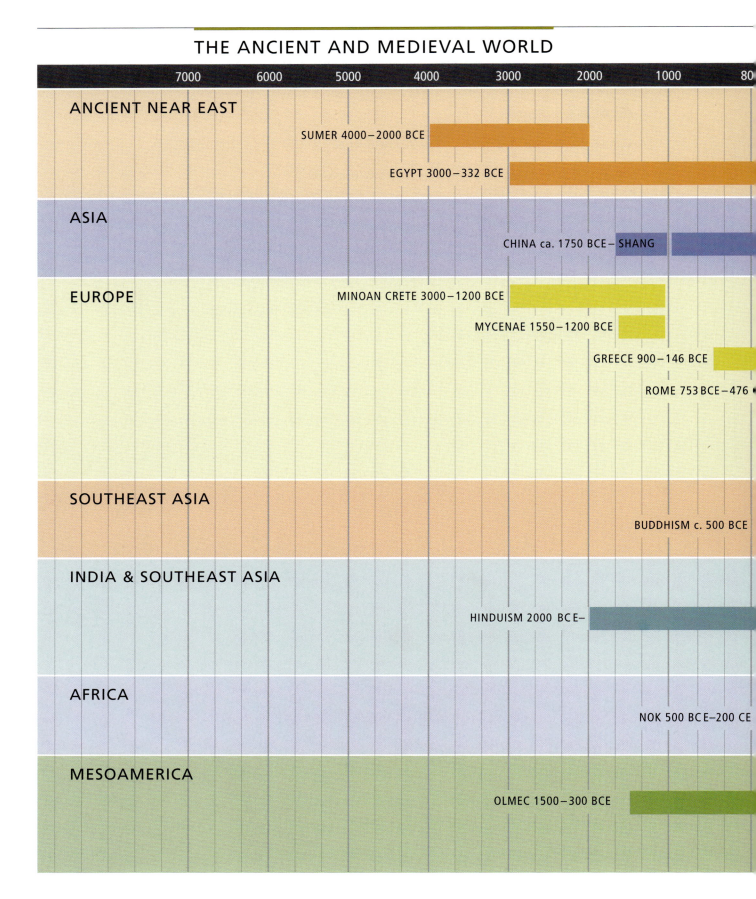

	7000	6000	5000	4000	3000	2000	1000	80

ANCIENT NEAR EAST

SUMER 4000–2000 BCE

EGYPT 3000–332 BCE

ASIA

CHINA ca. 1750 BCE– SHANG

EUROPE

MINOAN CRETE 3000–1200 BCE

MYCENAE 1550–1200 BCE

GREECE 900–146 BCE

ROME 753 BCE–476

SOUTHEAST ASIA

BUDDHISM c. 500 BCE

INDIA & SOUTHEAST ASIA

HINDUISM 2000 BCE–

AFRICA

NOK 500 BCE–200 CE

MESOAMERICA

OLMEC 1500–300 BCE

600	400	200	BCE	CE	200	400	600	800	1000	1200

HOU CHIN HAN TANG SUNG

REPUBLIC EMPIRE

EARLY CHRISTIAN and BYZANTINE 314–1453 CE

ROMANESQUE and GOTHIC ca. 950 CE– GOTHIC

ISLAM 622 CE–

CLASSIC MAYA 200–900 CE

16 Expanding Horizons of World Art

EARLY RENAISSANCE ART

As the thirteenth and fourteenth centuries advanced, European cities, with their independent merchants and craftspeople, continued to prosper and grow. The cities eventually bypassed feudal manors and monasteries in importance. Town life flourished especially in Italy, where, by the fifteenth century, a number of thoughtful people came to believe that a new age had arrived. When the intellectuals of this new age rediscovered and studied ancient Latin and Greek manuscripts, they grew confident that their generation could emulate the achievements of the ancients. They were especially proud of their own accomplishments in literature and in the fine arts. Their artists were at the forefront of those who were rediscovering the world around them. They began to call this renewal of ancient thought and this return to a more correct ancient style the Renaissance, or rebirth (the Latin word *renasceri* means "to be born again").

In painting, the Italian Renaissance in many ways began as early as 1300 with the Florentine artist Giotto. Although Giotto still lived in the medieval world, his artistic accomplishments look forward to key aspects of the Renaissance style. Not in Florence, but in the city of Padua, inside a small building known as the Arena Chapel (Figure 16-1), Giotto painted his best-known work.

The Arena Chapel has few windows and very plain walls, an architecture that seems to have been designed for murals. It contrasts with the French medieval practice of transforming as much of the wall space of their churches as possible into light-filled stained glass. An Italian banker named Enrico Scrovegni paid for the Arena Chapel and its murals in order to atone for his father's sinfully attained money and to win his own eternal salvation. Giotto portrayed him in the middle of the *Last Judgment* donating the chapel to the Virgin (visible above the door in Figure 16-1).

Giotto covered the rest of the interior of the Arena Chapel with other frescos that narrate on its three levels the life of the Virgin and the life and death of Jesus Christ. One of the scenes he painted is *Lamentation* (Figure 3-16), depicting a moment of mourning that focuses on the dramatic embrace of mother and son after his death. An earlier scene in the narrative, *The Betrayal of Judas* (Figure 16-2 and between two windows in Figure 16-1), likewise

Figure 16-1 Arena Chapel, interior toward door, 1305–1306. Padua, Italy. © Scala/Art Resource, NY.

Figure 16-2 Giotto [Italian, ca. 1266–1337], *The Betrayal of Judas*, ca. 1305. Fresco. Arena Chapel, Padua, Italy. © Scala/Art Resource, NY.

concentrates on an embrace—this time between Christ and his betrayer. In both compositions, lines in the painting bring the human drama to a climax. As Judas puts his left arm around Christ, the drapery folds of his yellow cloak swing up to Christ's head. The spears behind them form nine diagonal lines that force the viewer to focus on the moment of deceit. The priest in the right foreground stretches out his arm in accusation, creating a diagonal line headed straight for Christ. Faces in the crowd on either side of the pair glare at them and rivet them in place with their eyelines. Even the servant, whose ear St. Peter cuts, stares at Christ and Judas. Giotto heightens the drama by keeping their faces a suspenseful inch apart. As Judas distorts his face for a kiss, Christ tries to look into Judas's eyes; the implied line between them locks the two heads together.

Modeling them in light and dark, Giotto painted weighty, bulky figures that take up real space and sink like rocks to the bottom of the composition. Giotto was a pioneer in the use of chiaroscuro as well as in the depiction of human emotion. He was no expert in anatomy, but it is obvious that he wanted his figures to have the gravity and grandeur consistent with their deep feelings. Giotto must have had in his imagination the statue-like figures of ancient Roman painting or actual Roman sculpture. In the Arena Chapel, it is clear that he created nothing short of a revolution in art, when we compare his work to the weightless and ethereal figures in the mosaics at Ravenna (Figure 15-28 and Figure 15-29) or the relief at Vézelay (Figure 15-33).

The importance of Giotto's discovering for painting the statue-like human figure can be seen in the

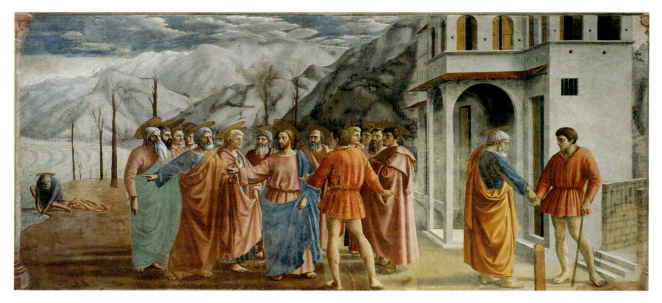

Figure 16-3 **Masaccio** [Italian, 1401–1428], *The Tribute Money*, ca. 1427. Fresco, 8 ft. 1 in. × 19 ft. 7 in. (2.5 × 6 m). Brancacci Chapel, Santa Maria del Carmine, Florence. © Canali Photobank. Milan.

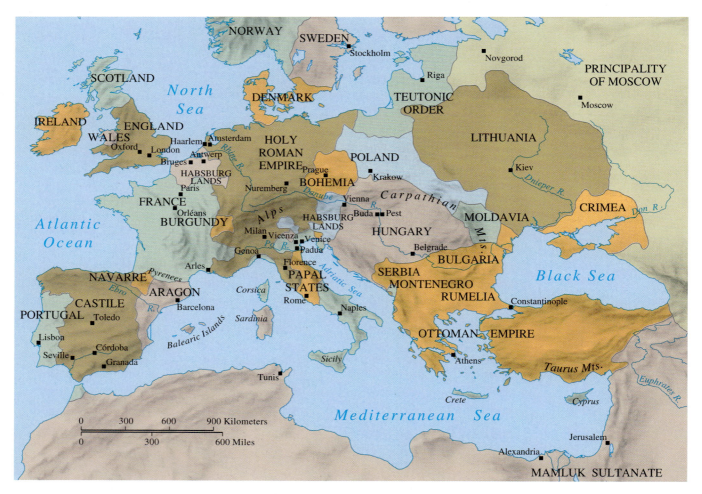

Renaissance Europe. From *World History*, 4th ed., by Duiker/Spielvogel. © 2004. Reprinted with permission of Wadsworth, a division of Thomson Learning, Inc.

work of Masaccio, an artist who lived one hundred years later. On the walls of a Florentine chapel belonging to the Brancacci family, Masaccio depicted in fresco *The Tribute Money* (Figure 16-3). In the painting, the artist tells the gospel story of Peter and the tax collector in an old-fashioned way—often called **continuous narrative**—by spreading three events from the narrative across a single landscape. The story begins with the main group in the center, where Christ instructs the apostle Peter to pay a tax after a tax collector had approached them for it. On the left, St. Peter miraculously finds the money in the mouth of a fish, and on the right he reluctantly pays the tax.

The three incidents take place in a unified landscape. To render the buildings on the right in space, Masaccio used the new system of perspective projection that his friend the architect Brunelleschi had just invented. On the left, the trees diminish in size as they go back in space, like telephone poles along a roadway. The treeless hills seem far away not only because they are small in size but also because they are enveloped in atmosphere; compare them with Giotto's conventionalized hill in *Lamentation* (Figure 3-16).

But Masaccio captured a three-dimensional feeling best by painting grand, simple, solid figures whose bulk creates space. In *The Tribute Money*, Masaccio's characters also develop space by encircling the figure of Christ. One of them, the tax man, even has his back toward us and faces in, as do several of Giotto's figures. Masaccio had a better understanding of anatomy than did Giotto and also a better understanding of how natural light falls consistently across rounded objects from a single source. In fact, the light source in Masaccio's fresco lies on the right, where a window in the chapel is located. Therefore, the figures cast shadows on the ground toward the left. In sum, Masaccio expanded upon Giotto's lesson that human figures attain substance and grandeur when treated as painted sculpture.

EASTERN LANDSCAPE ART

Despite Masaccio's considerable achievement in rendering space and atmosphere in *The Tribute Money*, his landscape remains a background subordinate to the main interest in the biblical narrative. It would be several more generations before European artists began to concentrate on nature itself as their primary focus—as some Roman painters seemed to

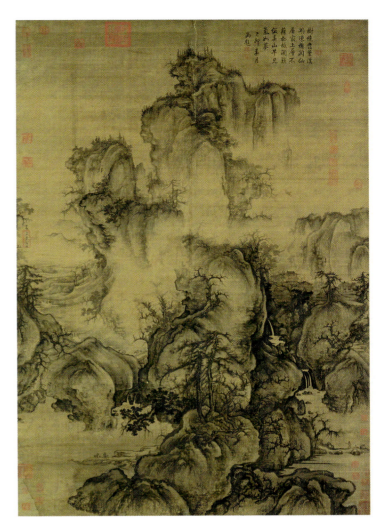

Figure 16-4 **Kuo Hsi** [Chinese, eleventh century], *Early Spring*, 1072. Hanging scroll, ink and color on silk, 62 3/8 in. (158.3 cm) high. National Palace Museum, Taipei.

have already done in ancient times. But by this time, the fifteenth century, artists in China had behind them a centuries-old heritage of landscape painting. And Asian artists would concentrate on landscape painting for centuries to come.

Li Ch'êng, one of the great names of the Chinese landscape tradition, painted the classic Chinese landscape *A Solitary Temple Amid Clearing Peaks* (Figure 2-29) during the early Sung dynasty in the tenth century. The Chinese always looked back on that period as an exemplary high point of their landscape painting history. Late in the next century, Kuo Hsi painted another masterpiece, *Early Spring* (Figure 16-4), but in a very different manner. He was a prolific court artist, the most famous painter of his day, and a follower of Li Ch'êng. Nevertheless, Kuo Hsi took the same elements—tall, vertical rock strata woven with mist and

gnarled trees—and changed them into a complex organism of constantly twisting forms.

In the foreground of the painting, a barrier of rock lies at the bottom edge of the painting, pushing back the scene behind it. On the left, a traveler arrives by boat; on the right, another wanderer walks into the scene on foot. Farther back on the left, horsemen travel a road. It is not obvious how the paths are connected, but perhaps they lead to the buildings cradled in the hills on the right. Behind them—and behind all the waterfalls, trees shaped like crab claws, and knobs of rock in the foreground—tower several broken peaks. In contrast to the S-curves of the rocks, a serene valley penetrates the distance on the left. Kuo Hsi masks the gap between foreground and background with impalpable mist. In his *Advice on Landscape Painting,* he insists that artists study nature and that they observe the seasons, the difference between morning and evening, the movement of water and the complexion of mist; in his work, however, he painted from his imagination. Although Chinese landscape artists such as Kuo Hsi studied nature carefully, they also tried to distill in what they depicted the essential nature of trees, rocks, hills, or clouds. *Early Spring* is a meditation about nature, emerging from winter and pulsating back to life in spring.

In Chinese landscapes, the viewer is offered a journey to wander through the land and contemplate fresh views of nature at every turn. Chinese Taoism and Ch'an Buddhism consider human beings to be a part of nature. Through the contemplation of landscape, viewers try to put themselves in tune with nature and seek consolation for the return to life. Because the restrictions of a single point of view would hinder such a journey, the Chinese artist deliberately avoided perspective and shadows that fell from a single source of light—two of the high points of Masaccio's historic achievement in painting. Sensitive to subtle changes of light in atmosphere, the Chinese developed, as did Masaccio, aerial perspective.

We understand Masaccio's conquest of perspective and light in nature as part of a Renaissance scientific victory over nature, even though the subject of *The Tribute Money* is biblical. However, the Chinese saw nature as spirit, not something to be conquered. They felt that artists who could use painting to reveal the truth that lay beneath the surface appearances of nature must be very much in tune with the divine spirit of the universe. In their art, painters would pass

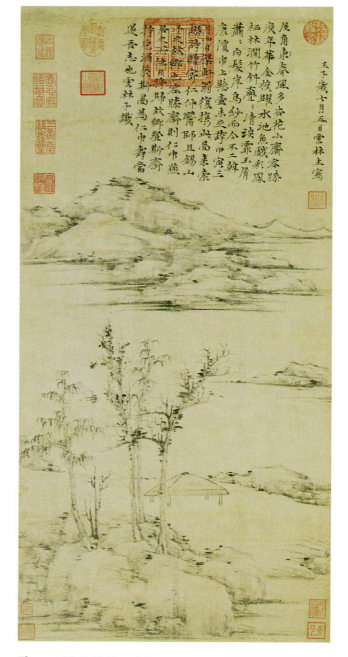

Figure 16-5 Ni Tsan [Chinese, 1301–1374], *The Jung-hsi Studio.* Hanging scroll. Ink on paper, 28 7/8 in. (73.3 cm) high. National Palace Museum, Taipei.

on that spiritual experience to the viewer. The Chinese also believed that landscape artists could find moral law and order in nature just as it exists in the heavens and in humankind. For example, Kuo Hsi's *Early Spring* has been interpreted as a Confucian allegory about the order and harmony of good government.

The Chinese, in addition, developed a tradition of scholars and poets who painted landscapes. These people avoided associating with professional

artists, and they avoided the style of those who worked for the court. Their aim was no longer to evoke in the viewer the same feeling that the viewer would have by wandering in an actual landscape, but to express their own mood and personality at the time of painting. Their brushwork especially reveals their personal character.

Of the four great masters of the Yüan dynasty, who founded a new school of "literary" painting in the early fourteenth century, Ni Tsan was the most famous. A poet in paint, he always considered himself an amateur painter rather than a professional. His landscape *The Jung-hsi Studio* (Figure 16-5), with its collectors' stamps and commentary written right on the picture's surface, is a good example of his style.

Ni Tsan depicted only a few bare trees growing out of the rocks in the foreground, and several hills on the other side of the water. He built a tension between them by their ambiguous spatial relationship to each other. His austere landscapes are always devoid of the human figure. For the most part, he outlined rocks and mountains with long, thin, very dry brushstrokes that appear gray on the paper. In con-

trast, Ni Tsan also set down dashes of paint for the sparse leaves in the trees. He kept a good part of the paper empty as though he were saving precious ink, as a Chinese commentator once observed. The distinct style of Ni Tsan's landscapes suggests very delicate and very personal emotions.

NORTHERN RENAISSANCE ART

At approximately the same time that Masaccio in Italy was painting *The Tribute Money,* a very talented artist named Jan van Eyck, living in Flanders, in the north of Europe, was developing a different approach to the depiction of reality. Van Eyck based his approach on precise observation of nature rather than on general rules such as perspective and the imitation of Roman sculpture. His personal style of exacting realism is evident in *The Arnolfini Wedding* (Figure 2-27) and in *Madonna of Canon George van der Paele with Sts. Donation and George* (Figure 16-6). The Madonna sits on a throne in the apse of a Romanesque church. St. Donation, dressed in a magnificent blue and gold bishop's robe, stands on the left; opposite him, St.

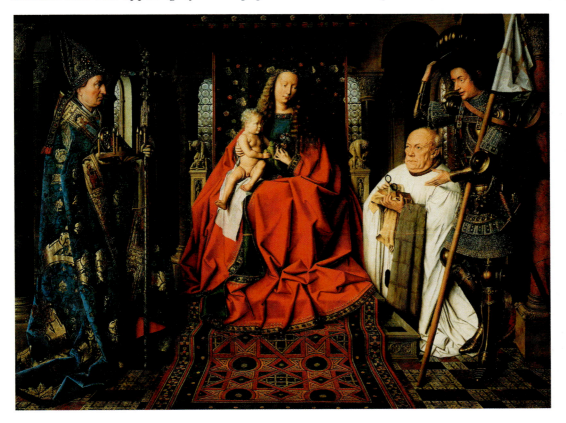

Figure 16-6 Jan van Eyck [Flemish, ca. 1390–1441], *Madonna of Canon George van der Paele with Sts. Donation and George,* 1436. Oil and tempera on wood, 32 1/4 × 23 1/2 in. (81.9 × 59.7 cm). London, National Gallery. © Erich Lessing/Art Resource, NY.

George, the namesake of the patron, introduces Canon van der Paele to the Madonna and child. The canon stares aimlessly, as though he is having a vision—perhaps the vision that van Eyck has depicted of the Madonna and saints. In religious art in the past, artists often included donors, portrayed in perpetual prayer.

Van Eyck painted bulky, space-creating figures, but he had not yet learned the rules of linear perspective, and he did not understand anatomy as well as his Italian contemporaries. Yet he surpassed them easily when it comes to rendering the surface appearances of things in great detail—for example, the minute features of the canon's face. Van Eyck's achievement is made possible in good part by the newly discovered oil painting medium. His works are totally different from the broadly painted frescoes of Giotto and Masaccio due to the different techniques required for painting panels. More importantly, van Eyck painted in thin colored glazes so that light, reflected from the white ground of the panel, shines through the translucent layers to create rich, enamel-like color. Another part of van Eyck's success in rendering materials comes not just from using tiny paintbrushes but also from observing how light reflects from different textures such as fur, wood, or brass. He found in the new medium of oil paint the means to record these reflections on every different surface. Moreover, throughout the *Madonna of Canon George van der Paele,* light suffuses into the room and casts soft shadows just as it would in an actual interior space.

ITALIAN RENAISSANCE ARCHITECTURE AND SCULPTURE

In architecture, the Renaissance in Italy began in the early fifteenth century with Filippo Brunelleschi, the architect who taught Masaccio the new science of perspective. The people of Florence boasted that their adopted son Brunelleschi was the first architect to turn away from the barbarism of the Gothic style and to introduce the good principles of the ancients. He amazed them with his technology and engineering skills when he erected over the cathedral of Florence a dome (Figure 16-7) nearly as wide as that of the Pantheon's in Rome. Although he gave the dome a Gothic, pointed profile, Brunelleschi placed it high on top of the walls of the cathedral

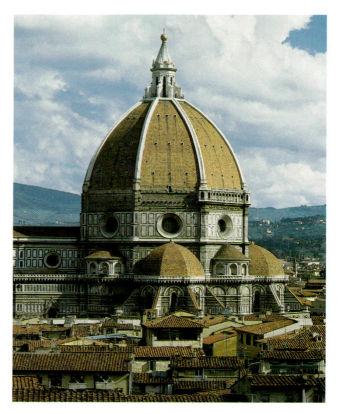

Figure 16-7 **Filippo Brunelleschi** [Italian, 1377–1446], Florence Cathedral, view of the dome, 1420–1436. © Scala/Art Resource, NY.

and solved the problems of its construction by building the dome out of a lightweight inner shell and an outer shell. After his success, double-shelled domes became standard for most large-sized buildings.

When Brunelleschi examined the architecture of ancient Rome to find models for his new architecture, he included structures, such as Sant' Apollinare (Figure 15-26), built by the early Christians during the last years of the Roman Empire. To him, these buildings had the advantage of being both Roman and Christian. Also, classical architecture meant more to Brunelleschi than a return to rounded arches and correctly used columns. He realized that ancient builders achieved perfection by arranging the architectural spaces according to a system of proportions. He must have felt that a Christian church, more than any other type of building, ought to repeat through numerical ratios the same principles that harmonize the universe and reflect the perfection of the Divine Architect.

When Brunelleschi designed the church of Santo Spirito in Florence in 1436 (Figure 16-8), he made the crossing bay a square with, of course, a "perfect" ratio of 1:1. This crossing bay became the **module**

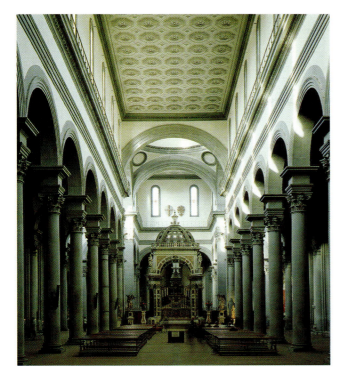

Figure 16-8 Filippo Brunelleschi [Italian, 1377–1446], Santo Spirito, interior, begun 1436. Florence. © Alinari/Art Resource, NY.

tire church—around the transept and choir and even across the front. If the church had been built as he conceived it—he died before much of it was built— Santo Spirito would have had a kind of symmetry. A spectator standing in the center of the crossing and looking in all four directions would have gotten the same perspective view in each direction.

One outstanding sculptor of the early years of the Renaissance in Florence went by the name of Donatello. The exact circumstances surrounding Donatello's casting of the bronze statue *David* (Figure 16-9) remains a mystery, although it was

out of which the rest of the church was shaped. For example, the choir and each arm of the transept repeat the module of the crossing. Brunelleschi made the nave exactly two times as high as it is wide and four times the module in length. Each bay of the aisle is half the length or one-quarter the area of the module, and apses that project from each bay of the aisles are one-half the length of an aisle bay. Brunelleschi intended to run the aisle around the en-

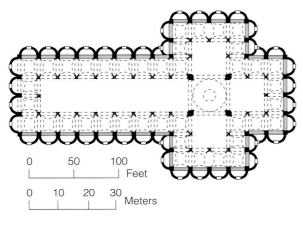

Plan of Santo Spirito

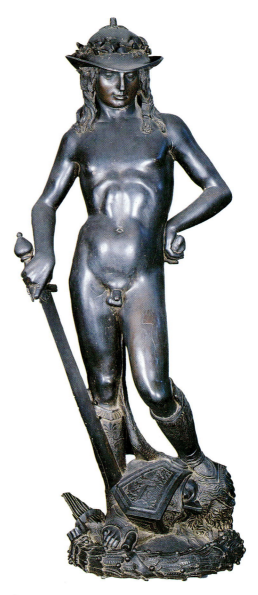

Figure 16-9 Donatello [Italian, 1386?–1466], *David*, ca. 1428–1432. Bronze, 62 1/4 in. (158.1 cm) high. Museo Nazionale del Bargello, Florence. © Ralph Lieberman.

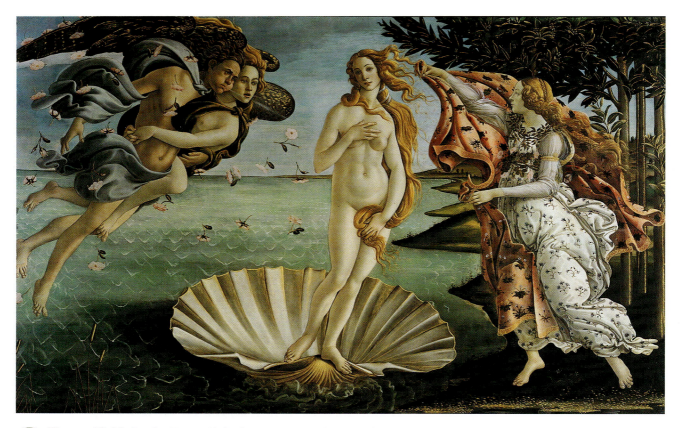

Figure 16-10 **Sandro Botticelli** [Italian, 1445–1510], *Birth of Venus*, ca. 1482. Tempera on canvas, approximately 68 × 109 in. (172.7 × 276.9 cm). Galleria degli Uffizi, Florence. © Summerfield Press Ltd.

probably commissioned by the leading family of Florence, the Medicis. Also, the small city of Florence sometimes considered itself a David against enemies that were the size of Goliath. Donatello made David nude in imitation of classical sculpture, yet his David wears boots and a broad-brimmed hat. Donatello also invented his own version of idealism. Unlike the more mature and chunky Greek athlete in *Spearbearer* (Figure 2-7), Donatello's David is a boy with soft flesh and an undefined physique. The pose is different too, most noticeably in the rather medieval thrust of the hips, the outward thrust of the elbow, and the turn of the head. Whereas Polyclitus seems to have been studying the mechanics of the body in the pose of *Spearbearer* as well as the body's balance in motion, Donatello used the pose of David to express a psychological message. David looks down toward the head of Goliath at his feet and yet seems to be actually contemplating his own flesh and his newly discovered powers.

LATE-FIFTEENTH-CENTURY PAINTING: BOTTICELLI

In the second half of the fifteenth century, Sandro Botticelli, one of the leading painters of Florence, embarked on a personal stylistic journey that in many ways ran counter to the mainstream. His *Birth of Venus* (Figure 16-10), also for the Medici family, who became the wealthy and powerful rulers of Florence, illustrates the pagan myth of the birth of the goddess Venus from the sea. In Botticelli's work, her already full-grown figure is perched on the edge of a seashell and blown by zephyrs (winds from the west) to her island of Cyprus, where a spirit or a nymph flies through the air to clothe her with a flowered red robe. The representation of pagan mythology and the nude figure shows not so much the secularization of art in the Renaissance as the sophistication of the aristocratic society for whom it was painted. By the end of the fifteenth century, the Medici family and their courtiers were giving elabo-

rate and often arcane interpretations to pagan mythology—interpretations based on Christian allegory and a revival of Platonic philosophy called Neo-Platonism. In general, according to their interpretation, Venus in Botticelli's painting represents not the ancient goddess of love and passion but the inspiration of Divine Beauty into the mind of the artist and the viewer.

Botticelli derived the pose of his Venus from an ancient statue that was part of the Medici collection and represented the *Venus pudica,* or "modest Venus," who covers herself with her hands. Beyond that reference, he went out of his way to deny the ponderousness of classical sculpture by ignoring many of the achievements of Giotto and Masaccio in Florentine painting. Only softly modeled by a light source from the right, his Venus stands off-balance, moving light as a feather in a breeze toward the right. Instead of her solid mass, Botticelli emphasizes her willowy outline and the undulating curves of her hair—echoed in the contours of the cloak. Throughout the painting, curved lines play across the surface. Botticelli of course knew about perspective, but he made the sea virtually a flat background with a pattern of stylized V-shaped waves. The total effect of his sharp-focused style creates an unreal world and a beautiful dream.

OLMEC, MAYAN, AND AZTEC ART

The Spanish explorers have epitomized for many historians the adventurous spirit of the Renaissance. A decade after Botticelli painted *Birth of Venus,* Christopher Columbus reached America for the first time. The Spanish, who came in search of gold and the fabled countries of the East, found a rich culture that Europeans never knew existed. They discovered the flourishing cities of the Aztecs, who had recently come to power in Mesoamerica, as well as the cities of the Inca in South America. Tragically, the Europeans, who could not comprehend what they discovered, did not appreciate the art of the people they so quickly conquered by means of their superior weapons and contagious diseases.

The Spanish conquerors were not aware that other great civilizations had flourished in North and South America in the past. They did not see the abandoned massive sculpture of the Olmec (see the Las Limas sculpture, Figure 3-21) or the deserted cities and pyramids of the Maya, which largely remained covered with jungle growth until the twentieth century. Starting in the third century, alongside the empire of Teotihuacán near Mexico City (Figure 14-3), the Maya in Guatemala built extensive cities dominated by steep temple pyramids

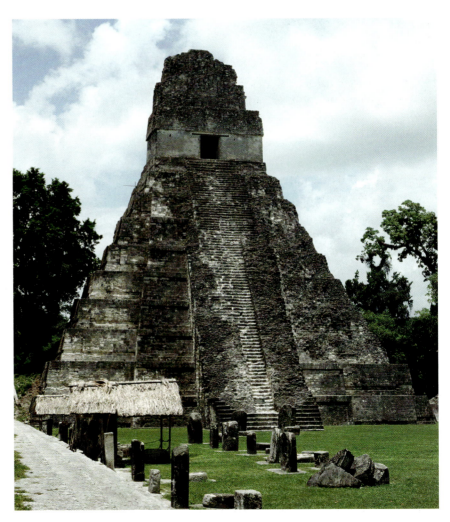

 Figure 16-11 [Mayan], Temple I (Temple of the Giant Jaguar), ca. 700. Tikal, El Péten, Guatemala. © Enzo and Paolo Ragazzini/Corbis.

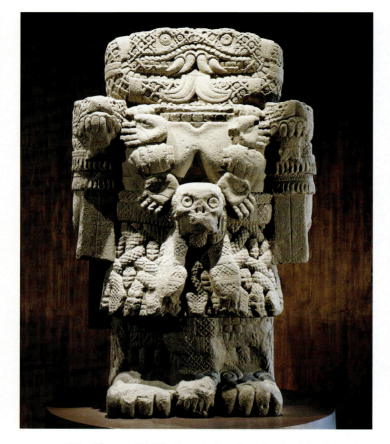

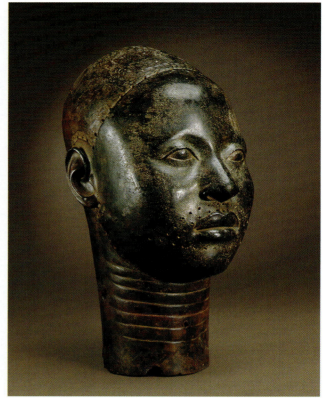

Figure 16-12 [Aztec], *Coatlicue (Lady of the Skirt of Serpents)*, fifteenth century. Andesite, 99 in. (257 cm.) high. Museo Nacional de Antropología, Mexico City. © Gianni Dagli Orti/Corbis.

Figure 16-13 [Ife, Nigerian], *Head of an Oni*, twelfth to fourteenth century. Zinc brass, 12 1/4 in. (31 cm). National Museum, Lagos, Nigeria. Photograph © 1980 Dirk Bakker.

and broad, open plazas. Erected many centuries later than the pyramids of Egypt and the ziggurats of Sumer, the Mayan pyramids manifest the same urge to build a mountain stairway to the sky and the gods. The Maya also developed writing in the form of hieroglyphics and a sophisticated arithmetic by means of which they kept a complex but very accurate calendar.

The Mayan city of Tikal once spread over an area of about seventy-five square miles. Causeways connected the ritual centers, where massive stone temples, tombs, and pyramids rise above the city. The most impressive complex at Tikal is the Great Plaza, where the two largest pyramids face each other across an open court. At the top of one pyramid sits the Temple of the Giant Jaguar (Figure 16-11), a structure that imitates in stone the shape of the Mayan thatched house. Inside, three vaults run the length of the temple. For unknown reasons, the Maya abandoned Tikal about 900.

In 1519, twenty-seven years after Columbus landed at San Salvador in the Bahamas, the Spanish conquistador Hernando Cortés entered the flourishing Aztec capital of Tenochtitlán (tehn-oak-teet-lan) (now Mexico City) in astonishment. Cortés and his men greatly admired the city, with its canals, markets, and magnificent pyramids and temples, but the blood that covered the walls and floors of the Aztec sanctuaries horrified them. Fierce and ruthless warriors, the Aztecs practiced human sacrifice to placate their gods and to keep their conquered victims in submission. In their ritual sacrifice, the victims probably had to face the awesome statue of Coatlicue (kwah-tlee-kwey) (see *Lady of the Skirt of Serpents,* Figure 16-12). A massive freestanding statue more than eight feet tall, every inch of it is designed to strike terror. In place of her head, two serpent heads, their fangs bared, face each other. She wears a necklace of severed hands and excised hearts. Her skirt is woven with snakes. Leaning forward, she stands on enormous clawed feet with which she tears human flesh. The details of the sculpture are carved in relief on the statue's enor-

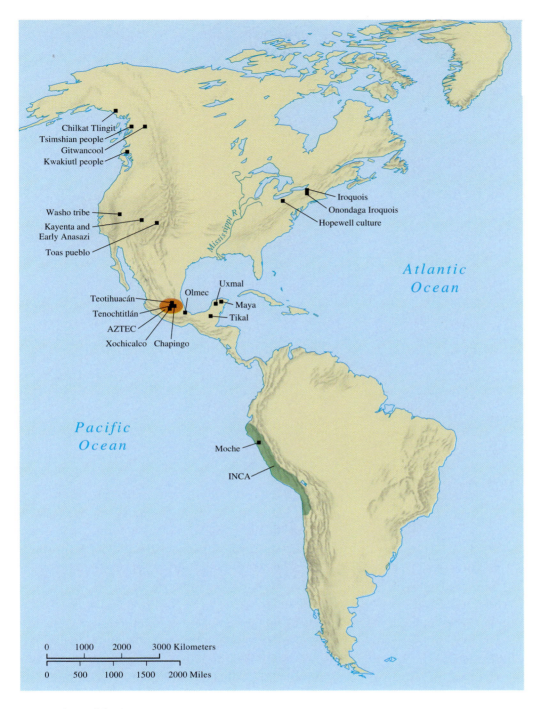

Historic Sites of the Americas

mous masses, which on their own have an overpowering effect.

WEST AFRICAN ART

Five years before Columbus reached America, Portuguese explorers discovered the Kingdom of Benin flourishing on the coast of West Africa. When other Europeans later visited the capital city of Benin (now located in Nigeria), they saw a wealth of exceptionally well-crafted bronze sculpture produced for the court of the Oba, the god king of Benin. The Beninese admitted that they had been taught the skills of bronze casting from Ife, another sacred city about one hundred miles to the northwest. It was only in the twentieth century that excavators unearthed in Ife itself about thirty bronze heads, such as the one in Figure 16-13.

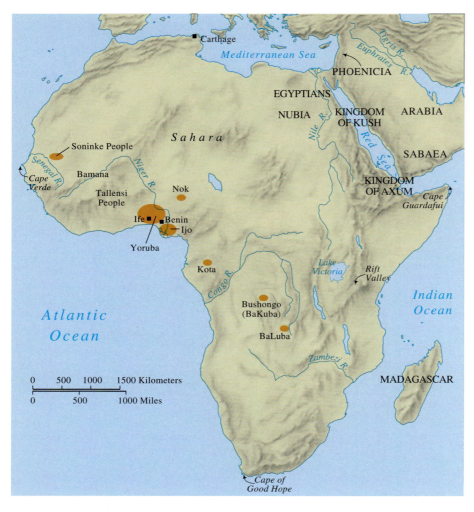

Africa's Historical Cultures. From *World History*, 4th ed., by Duiker/Spielvogel. © 2004. Reprinted with permission of Wadsworth, a division of Thomson Learning, Inc.

More recent African sculptors have generally avoided lifelikeness in art, but at Ife hundreds of years ago it was the rule. The full facial features of the bronze heads are consistently smooth and rounded to perfection. The small holes across the head indicate that facial hair and probably a wig were once attached to the head—a practice common in African art.

These striking and sensitive idealized masterpieces parallel the classical art of Europe both in antiquity and in the Renaissance. They were cast flawlessly by means of the lost wax process. Their perfected naturalism and cool demeanor remind us of the emotional reserve of classical Greek art, although the line of the mouth is a little lower on the face. However, the African artists could not have come in direct contact with European art or learned the sophisticated technology of bronze casting from European artists. Their discoveries seem to be indigenous.

ITALIAN HIGH RENAISSANCE ART

In the opening years of the sixteenth century, a number of artists, trained in the Florentine style, began to work for the Catholic church in Rome. They came to Rome during the reign of Pope Julius II (1503–1513), who had great ambitions to make the papacy the dominant power in all Italy. This warrior pope nearly succeeded in doing it. His ambitions as a patron of the arts matched his political ambitions. For example, Julius commissioned Michelangelo to build for him a three-story tomb covered with some forty pieces of sculpture, changed his mind, and then had the sculptor paint the Sistine ceiling. In a suite of rooms in the Vatican apartments, Julius had the artist Raphael paint large murals illustrating learned themes that appealed to Renaissance humanists such as the pope.

Figure 16-14 Donato Bramante [Italian, 1444–1514], Medal by Caradosso showing Bramante's design for St. Peter's, 1506. British Museum, London.

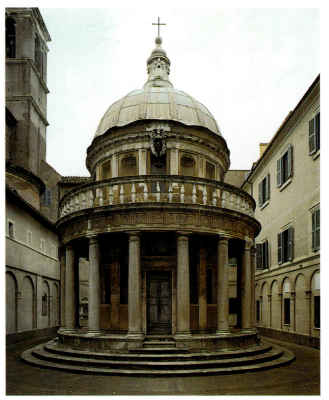

Figure 16-15 Donato Bramante [Italian, 1444–1514], Tempietto, 1502. Marble, height 46 ft. (14 m), diameter of colonnade 29 ft. (8.8 m). San Pietro in Montorio, Rome. © Canali Photobank, Milan.

For his most ambitious scheme, the pope tore down the venerable basilica of St. Peter, built by Emperor Constantine in the fourth century, and asked the architect Donato Bramante to erect a new church of magnificent dimensions in its place (see Figure 16-14). It was said that Bramante proposed to place a solid dome like that of the Pantheon's (Figures 15-18 and 15-19) on top of four intersecting barrel vaults on the scale of those of the Basilica of Constantine (Figure 14-16). The new St. Peter's, with its complex interior configuration of circle, square, and cross shapes, was to have a perfectly symmetri-cal **central plan**. Probably impossible to build, Bramante's visionary scheme for St. Peter's was considerably changed even before he died in 1514.

Bramante did live to complete a much smaller centrally planned church, the Tempietto, or little temple (Figure 16-15), which also embodied his ideal proportions. Perfectly circular, the Tempietto's small chapel is surrounded by a porch supported by severe **Tuscan Doric** columns, which have a base and are not fluted. The core of the building is a tall cylinder, penetrated everywhere by niches and capped with a solid hemispherical dome. As tall as it is wide at the base, the Tempietto seems massive and larger than it actually is. Several illustrators during the Renaissance paid it the ultimate compliment by including the new building among the ruins of ancient Rome.

As we have indicated, during the first two decades of the sixteenth century artists of the caliber of Michelangelo, Raphael, and Bramante designed works of ambitious scale and outstanding merit. The term *High Renaissance* has been given to this period

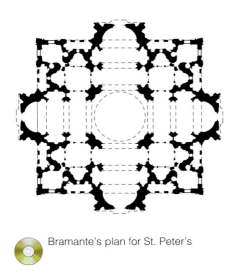

Bramante's plan for St. Peter's

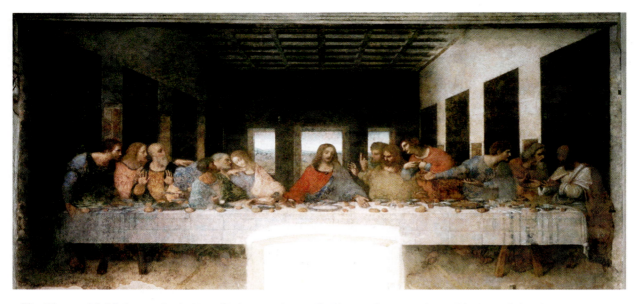

Figure 16-16 **Leonardo da Vinci** [Italian, 1452–1519], *The Last Supper*, 1495–1498. Fresco (oil and tempera on plaster), 13 ft. 9 in. × 29 ft. 10 in. (4.2 × 9.1 m). Santa Maria delle Grazie, Milan. © Edimedia.

to suggest that Renaissance art achieved in it a harmonious style similar to the high classical style of fifth-century Greece. Used in this sense, the term implies that Renaissance art, like a human being, had a birth, growth, maturity, and then decline. This analogy makes a certain kind of sense. But even if styles follow a regular life cycle, who can say that the period of maturity is always better—"higher"—than that of youth?

The Last Supper of Leonardo da Vinci (Figure 16-16) is often considered the first work of the High Renaissance because in this late fifteenth-century painting Leonardo achieved such perfect harmony. The diagonal lines of the roof beams, as rendered in perspective, all point to the figure of Christ in the center. His head is silhouetted against the light of the window in the middle of the back wall. Christ stretches his arms out on the table and forms an equilateral triangle, a very stable configuration. The apostles surrounding him—six on one side and six on the other—are in turmoil because he has announced that one of them is about to betray him. Their expressions and gestures embody various kinds of emotions, such as surprise, anger, puzzlement, and pain. Most of the apostles move away from Christ: the angle formed by the contours of Christ and Judas puts a wedge of empty space between them. The apostles at either end of the table, by the lines of their gestures and glances, move our eye back to the center of the controversy. Thus, all

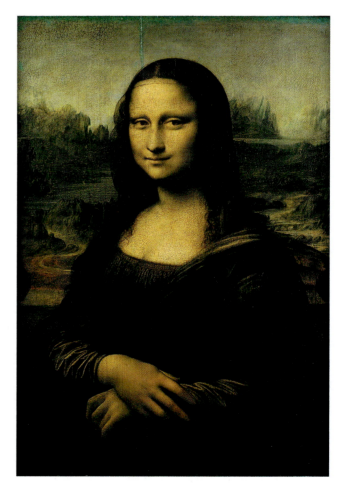

Figure 16-17 **Leonardo da Vinci** [Italian 1452–1519], *Mona Lisa*, ca. 1503–1505. Oil on wood, approximately 30 × 21 in. (76.2 × 53.3 cm). Louvre, Paris. © RMN/Art Resource, NY.

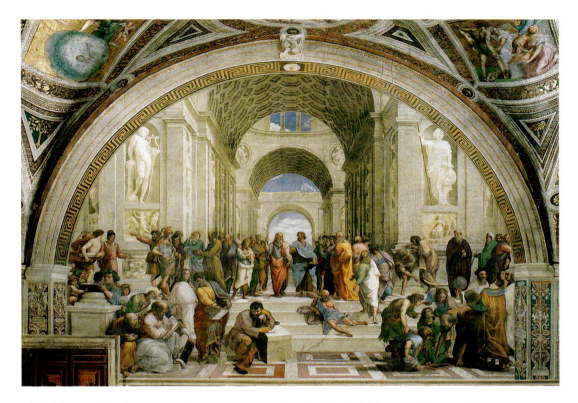

Figure 16-18 Raphael [Italian, 1483–1520], *The School of Athens*, 1509–1511. Fresco, approximately 19 × 27 ft. (5.8 × 8.23 m) Stanza della Segnatura, Vatican Palace, Rome. © 1983 M. Sarri/Photo Vatican Museums.

the lines of the setting and of the figures contribute to a single dramatic moment.

Leonardo not only balanced the elements of his composition in rigid symmetry; he also packaged the emotional drama within the strict organization of the design. Locked into place, the emotional excitement, like compressed gunpowder, explodes with all the more force to the left and right of Christ's serenely stable figure. In its balanced control of tension, the painting defines the High Renaissance style: emotions are confined by strict symmetry, and figures move with ease and naturalness and with the nobility and grace of classical sculpture.

Ease and grace characterize another famous work by Leonardo, *Mona Lisa* (Figure 16-17). *Mona Lisa* is a portrait of an actual woman, but Leonardo so perfected her portrayal, and her image has become so popular, that she seems more like a religious icon, a goddess, or a saint. She sits in an armchair, facing left, on a terrace that overlooks a deep, mist-filled landscape, extremely rugged in contrast to the polite lady before it. Her left forearm, the one closest to us, rests on the arm of the chair. Her right hand relaxes on her left wrist. The gesture gently draws her shoulder around, and her head and its

gaze follow the movement toward the front. Leonardo has enlivened a profile portrait with contrapposto. Soft shadows round out her face and play around her mouth so that we can never be sure whether she is smiling or not. Leonardo painted her portrait in oil with transparent glazes that made the modeling so smooth and the contours so soft that his figure seems to emerge gradually from a twilight atmosphere. Italian writers called the smoky haze in his paintings **sfumato**.

The High Renaissance spirit of grace, ease, and harmony is also embodied in the work of the painter Raphael. His fresco *The School of Athens* (Figure 16-18) is one of four large murals illustrating four branches of learning—law, poetry, philosophy, and theology—in a room (or *stanza* in Italian) in the Renaissance papal apartments in the Vatican. *The School of Athens* illustrates philosophy through an imagined gathering of all the eminent thinkers of ancient Greece. Plato and Aristotle, framed by the arches in the center and set against the light of the sky, hold forth at the top of the steps as the most prominent of the school.

Raphael has placed nearly sixty figures within a vaulted space that resembles the architecture that

(text continued on page 386)

Leonardo da Vinci (1452–1519)

Considered by many people to be a universal genius, Leonardo da Vinci was in many ways a typical Renaissance artist. The general public in the early Renaissance considered an artist to be no different from any other craftsman who worked with his hands. Like every artist of the Renaissance, Leonardo served an apprenticeship, starting in his early teens, probably to the sculptor and painter Verrocchio. Most painters and sculptors had to belong to a local guild to practice their craft just as certain craftspeople today might have to belong to a labor union in order to find work. In Renaissance Florence, painters belonged to the guild of the *medici e speciali,* "doctors and pharmacists," because they bought most of their materials for pigments from the local pharmacist.

The workshops of many Renaissance artists were capable of producing not only paintings and sculptures, but also painted shields, banners, and chests or, in Verrocchio's case, altars, tombs, tabernacles, pulpits, medals, and fountains. All the members of the shop, in one capacity or another, collaborated on executing the master's designs. An apprentice might develop a dozen different skills, as Leonardo certainly did.

For some unknown reason, Leonardo opted out of the workshop system in 1482 to become an artist at court. Perhaps he wanted more independence to pursue his own interests. The wide range of Leonardo's interests stands out in the letter that he wrote to the Duke Ludovico Sforza asking for a job at his court in Milan. In his "résumé," Leonardo emphasized his skill at inventing instruments of war such as prefabricated bridges, siege machines, explosives, mortars, armored boats, mining techniques, primitive tanks, catapults, guns, and other firearms. "In time of peace," he concluded, "I can give perfect satisfaction and to the equal of any other in architecture and the composition of buildings, public and private; and in guiding water from one place to another." Then Leonardo added at the end, almost as an afterthought, "I can carry out sculpture in marble, bronze or clay, and also I can do in painting whatever may be done, as well as any other, be he whom he may."[1] Leonardo got the job.

As a court artist, Leonardo did most of the things he wrote about and more. During his seventeen years in Milan he designed military fortifications, gave advice about architecture, organized court pageants, set up an over-life-sized model in clay of a horse and rider, painted portraits of members of the court, and painted as well *The Last Supper.* He also began extensive research into anatomy, botany, geology,

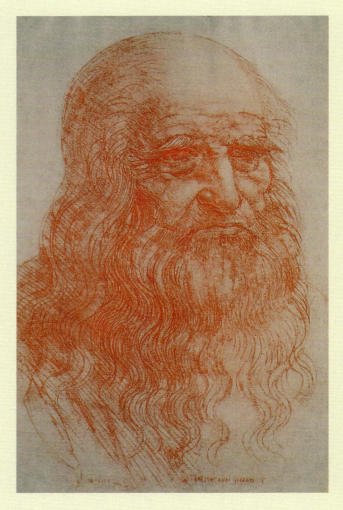

Leonardo da Vinci [Italian, 1452–1519], *Self-Portrait,* ca. 1512. Chalk on paper, 13 × 8 1/4 in. (33 × 21 cm). Reale Library, Turin, Italy. © Alinari Archives/Corbis.

airborne flight, and hydraulics, much of which he recorded in hundreds of notebook pages. Leonardo did not wish to conceal his inventions and discoveries, but as he was left-handed, he wrote backward from right to left so that his handwriting has to be read in a mirror.

Like other Renaissance painters, his desire to capture the real world led him to study anatomy and physical nature. But Leonardo went far beyond the ordinary painter's practical needs for representation and pursued the mechanics of muscles, the flow of water, and the growth of plants for their own sake. He would have loved a modern computer graphics program capable of displaying change in a video anima-

Leonardo da Vinci [Italian 1452–1519], page from anatomy notebook, 1510. Royal Collection, Windsor Castle, London. The Royal Collection © 2004, Her Majesty Queen Elizabeth II.

tion! His scientific interests distracted him from ever completing many of his later paintings, and in the last years of his life, he barely painted anything at all.

Some Renaissance artists, such as Giotto and Donatello, were more famous than others, but they still maintained the same social status as other craftspeople of their time. Only at the beginning of the sixteenth century, with Michelangelo and Raphael and Leonardo, did people get the idea that an artist was a very special sort of person. Aloof and self-absorbed, Leonardo was no doubt the most mysterious of them all.

Figure 16-19 **Titian (Tiziano Vecelli)** [Italian, ca. 1488–1576], *Bacchus and Ariadne*, 1523. Oil on canvas, 69 × 75 in. (175.2 × 190.5 cm). National Gallery, London. © Erich Lessing/Art Resource, NY.

contemporaries. Titian, who knew the work of Raphael through drawings, painted *Bacchus and Ariadne* (Figure 16-19) for the Alabaster Study of the Duke of Ferrara, Alfonso d'Este. In the story, derived from the Latin poets Ovid and Catullus, Bacchus, accompanied by his revelers, instantly falls in love with Ariadne, who had been abandoned by Theseus on the island of Naxos. Leaping from his cheetah-drawn chariot, Bacchus is caught suspended in midair before the startled Ariadne.

Bramante was contemplating at that time for St. Peter's. The figures are convincingly arranged throughout the space in two groups in the foreground and in two rows stretching into the distance above the steps. The figures contemplate, discuss, observe, and write in a variety of imaginative poses that often reveal the spirit of the individual's philosophy. The Greek philosopher Pythagoras, writing in a book, draws the attention of the group on the left. The philosopher Heraclitus, resting his elbow on a block in the center foreground, is lost in thought. He is said to be a portrait of Michelangelo. Euclid, on the right, who may have the features of Bramante, demonstrates a theorem to an avid group of students, who pay him rapt attention. The balanced composition and the natural elegance with which the figures conduct themselves give *The School of Athens* the dignity and serious concentration of deep philosophical discourse.

In the High Renaissance, painting in the city of Venice developed a style that emphasized the application of color to build forms, as opposed to the precisely outlined figures of the Renaissance in Florence and Rome. Despite that difference, the painter Titian, the leading master in Venice for nearly seventy years, was as inspired by the iconography and style of classical antiquity as were his central Italian

Figure 16-20 **Michelangelo** [Italian, 1475–1564], *David*, 1501–1504. Marble, approximately 13 ft. 5 in. (4.1 m) high. Galleria dell'Accademia, Florence. © Michael S. Yamashita/Corbis.

In addition to reflecting the influence of Raphael on his figures, Titian enjoyed contrasts of warm and cool colors for their own sake to enrich his painting. The vivid red scarf of Ariadne provides a strong warm accent against the predominantly cool blue and green of the left side. Titian observed the gleaming highlights of glossy materials and delighted in reproducing the value changes of colors as they disappear into the half-light of shadows. In *Bacchus and Ariadne* he employed some deeply saturated colors for their own sake. He is also known for veiling his colors in numerous colored glazes that attempt to unify different areas of color. Titian is perhaps the first painter in history to exploit the sensuous appearance of richly applied paint and to exploit brushwork itself as a means of personal expression.

MICHELANGELO

In sixteenth-century Italy, Michelangelo was undoubtedly the greatest sculptor, and he is now probably the most famous sculptor who ever lived. In his hands, the High Renaissance style went beyond a harmonious idealism and became a vehicle for psychological struggle. From the start, Michelangelo was recognized as a prodigy, a genius, someone who worked by different rules.

In his early twenties, Michelangelo carved the famous *Pietà* (see Chapter 6, page 136), the epitome of High Renaissance harmony and grace in sculpture. When he was twenty-eight years old, he carved the statue of *David* (Figure 16-20) out of a giant block of marble that no one else could handle. Michelangelo had probably seen Donatello's much smaller bronze *David* (Figure 16-9) created seventy years earlier. Michelangelo reconceived the composition so that it might rival classical sculpture such as Polyclitus's *Spearbearer*. Unlike Donatello's *David*, Michelangelo's is thoroughly nude.

Michelangelo's David has yet to kill Goliath, and the gangling youth, almost a young man, is older than Donatello's. Michelangelo's *David* holds the sling over his left shoulder, and the fatal stone is in his right hand. As he looks sharply to the side, sizing up the enemy, his precisely defined muscles tense beneath the skin. As a result, his skin seems like an elastic covering stretched over his taut muscles and tendons. Every inch of *David* conveys a feeling of pent-up energy ready to burst forth. Michelangelo gave classical nudity a psychological potency quite unlike the smooth and passionless idealization of Polyclitus's *Spearbearer*.

Michelangelo translated into paint the same sense of restrained force struggling within the human figure when he frescoed the ceiling of the pope's Sistine Chapel in the Vatican. Michelangelo covered the entire ceiling with illustrations of the biblical story of creation and of Noah's flood along with dozens of biblical and symbolic figures. In *Creation of Adam* (Figure 16-21), toward the middle

of the ceiling, it is not the nude figure of Adam that is alive with energy, but the flying figure of God the Father who rushes in to inspire a soul into the human lump of clay that is Adam. The giant Adam's muscles are so flaccid he can barely raise his arm toward the outstretched hand of God. The contrast between the two figures, between passivity and action, can be read in the contrasting gestures of the hands, separated by a small gap between which sparks seem to fly from positive to negative energy. The dynamic shape of God and his companions sheltered under his billowing cloak visually overwhelms the reclining form of Adam. In this composition, Michelangelo upset the symmetrical balance that had become a key feature of the High Renaissance style. Confident of his own genius, he felt free to transform the Renaissance into the expression of his own personality.

Toward the end of his long life, Michelangelo became more and more involved with architecture. It was Michelangelo who found a way to complete the Vatican church of St. Peter's begun by the architect Bramante many years before (see Figure 16-14). After years of delay and changed plans, Michelangelo, as soon as he took charge, returned to the design of Bramante, strengthening and simplifying it. To make the scheme work, Michelangelo greatly thickened the piers and the walls in most places. In contrast to Bramante's plan, which was based on complex geometry, Michelangelo's church retains only the essential features of Bramante's symmetry: four barrel-vaulted arms of equal length radiate out in cross shape from

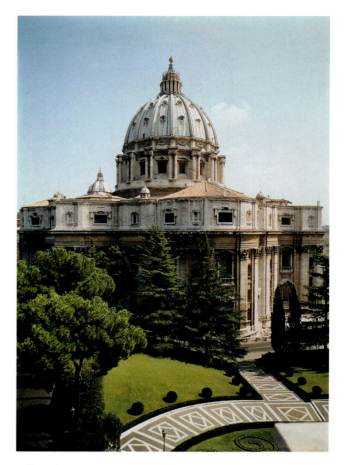

Figure 16-22 Michelangelo [Italian, 1475–1564], exterior of St. Peter's, west end, 1546–1564. Vatican, Rome. © Scala/Art Resource, NY.

the central domed area, and a square ambulatory surrounds the four enormous piers supporting the dome.

Michelangelo did not live to see his own dome in place, and it was constructed with a pointed profile instead of in the hemispherical shape that he probably wanted (Figure 16-22). Furthermore, in the next century, another architect added a nave to St. Peter's, which distorted the symmetry of Michelangelo's church and made his architecture virtually invisible from the front. But the rear of the church is still Michelangelo's.

Michelangelo the sculptor thought of architecture as the equivalent of a living human body. Therefore, in his hands St. Peter's expressed the same muscular tension as one of his nude figures. On the exterior of the building, Michelangelo placed pairs of giant **pilasters** (flat supports) against the walls, which he then pierced with an assortment of niches and windows. Along the exterior periphery of

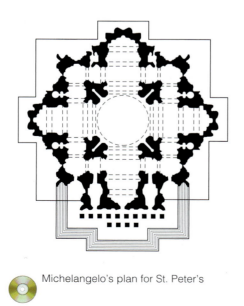

Michelangelo's plan for St. Peter's

the cathedral, the wall curves and juts out at different angles as though it were kneaded out of clay. The vertical lines of the pilasters continue through the building and surge up through the ribs of the dome, although Michelangelo's original plan for a hemispherical dome would have provided more contrast between horizontal and vertical lines than the building now possesses. With its unrestrained energy, St. Peter's created new rules for Renaissance architecture.

NORTHERN HIGH RENAISSANCE ART

During the period of the High Renaissance in Italy, a German artist named Albrecht Dürer set out to learn the lessons of classical art discovered by the Italian Renaissance. Convinced that he had a mission to bring an Italian style and Italian principles of art to northern Europe, he visited Italy twice and wrote his own treatises on measurements, proportions, and artistic theory. But it was the example of his own art, especially his prints, that carried Renaissance art to the North.

Dürer's fame as a printmaker rests on his remarkable skill both in woodcutting (see *The Four Horsemen,* Figure 8-4) and in engraving (see *Adam and Eve,* Figure 8-11). Dürer displayed in the figures of Adam and Eve his knowledge of anatomy, of classical sculpture, and of proportions as the correct means of designing the human figure. His print also shows that he synthesized in his style these principles of Italian idealism with a wealth of significant detail that northern artists since Jan van Eyck have relished.

His extraordinary *Self-Portrait* (Figure 16-23) reveals that he also cultivated Italian thinking about an artist as a divinely inspired genius. In his portrait, his long hair and beard and the rigidly frontal and perfectly symmetrical pose make the artist look like Jesus Christ. By adopting the solemnity and formality of a portrait of Christ the Savior, Dürer was not being blasphemous but was indicating that, as a creator, the artist has a divine vocation and takes on almost divine powers. About the only thing to break the symmetry of his portrait is Dürer's rather tense-looking hand, the instrument through which his inspired vision imparts new life in art.

Figure 16-23 Albrecht Dürer [German, 1471–1528], *Self-Portrait,* 1500. Oil on panel, 25 5/8 × 18 7/8 in. (65.1 × 47.9 cm). Alte Pinakothek, Munich. © Scala/Art Resource, NY.

SPANISH LATE RENAISSANCE ART: EL GRECO

When Titian was a very mature artist, a young painter named Doménikos Theotokópoulos, from the Venetian island of Crete, worked for a short time in his studio in Venice. The young artist, who had some training in a very late Byzantine style at home, soon became known by his nickname El Greco ("The Greek") because of his ethnic origins. El Greco also studied the work of Michelangelo and his followers in Rome for several years. Sensing an opportunity for success at the court of the Spanish king Philip II, who favored Italianate artists, El Greco left for Spain in 1577. There he remained for thirty-seven years, not at court but in the city of Toledo, which for generations had been the spiritual center of Catholic Spain.

In Toledo, El Greco painted mostly religious art for the monasteries and churches in and around the city. With the color and brushwork of Venetian painters such as Titian, with the expressionism of

heavens. In the background, El Greco depicted what John saw when the Fifth Seal was broken—martyrs for the faith being clothed with white robes and also perhaps with the yellow and green robes behind them.

Since the painting was intended for the church of a hospital, El Greco may have interpreted the biblical text in the context of its setting. The nude figures, representing the elect in general and the suffering patients of the hospital in particular, seem to be rising from the grave toward the Last Judgment, where they will be gloriously transformed. Their bodies taper and writhe like the flickering flame of a candle. Although based on Michelangelo's nude figures, they are spiritual beings who float weightlessly. Three-dimensional space in the painting is equally unearthly. The gap between John and the saints is never explained. El Greco often painted a dark aura around each figure that allows the thick strokes of green and yellow between them to rise to the surface. In sum, he expressed the spiritual significance of John's mystic hallucination by means of elongated and dematerialized forms, brilliant colors, flickering lights and darks, and undefined space.

Figure 16-24 El Greco (Doménikos Theotokópoulos) [Spanish, 1541–1614], *The Opening of the Fifth Seal of the Apocalypse*, from *The Vision of Saint John*, 1608–1614. Oil on canvas (top truncated), 87 1/2 × 76 in. (222.3 × 193 cm), with added strips 88 1/2 × 78 1/2 in. (224.8 × 199.4 cm). Metropolitan Museum of Art, New York, Rogers Fund, 1956 (56.48). Photograph © 2003 The Metropolitan Museum of Art.

Michelangelo, and with his own colorful character and background, El Greco developed a unique personal style, very evident in his painting *St. John the Baptist* (Figure 2-15). Elongated far beyond normal proportions, the gaunt saint towers above the landscape. His contours and those of the clouds behind him twist and turn in serpentine curves, and light and dark flicker across the entire surface.

At the end of his life, El Greco began to paint *The Opening of the Fifth Seal of the Apocalypse* (Figure 16-24) for the Tavera Hospital just outside the walls of Toledo. He never finished it, and at one point about four or five feet of the top of the canvas was cut off. Like Dürer's *The Four Horsemen* (Figure 8-4), the painting illustrates a vision described in the Apocalypse by Saint John, who looms in the foreground of El Greco's work. The elongated, ecstatic figure kneels and raises his head and arms to the

THE CLASSIC HOUSE, WEST AND EAST

The architect Andrea Palladio expounded a more classical style of Italian Renaissance architecture than did Michelangelo at St. Peter's. Palladio employed the classical orders more correctly than Michelangelo, and he rejected Michelangelo's obvious self-expressionism in architecture. Just as important, Palladio returned to

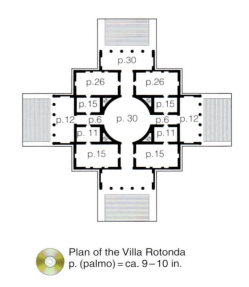

Plan of the Villa Rotonda
p. (palmo) = ca. 9–10 in.

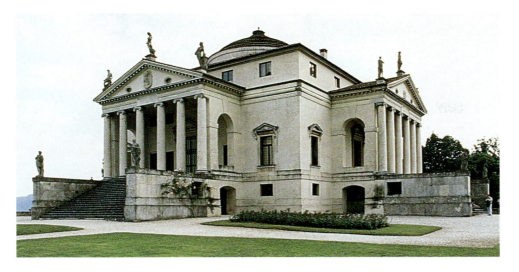

the rationalized system of mathematical proportions in laying out the dimensions of a building. Confident of the correctness of his principles, Palladio wrote a book about architecture, *I quattro libri dell'architettura (The Four Books of Architecture),* illustrated extensively with his own work. Translated into different languages, the book gave his architecture international influence for generations.

His best-known building, the Villa Rotonda (Figure 16-25), in the suburbs of Vicenza, Italy, is perfectly symmetrical on all four sides. The central block is a cube, in a ratio of 1:1, within which sits a perfect circle and cylinder. Palladio arranged the rooms symmetrically according to another set of proportions. The Villa Rotonda may not be the most comfortable or convenient house to live in, but it is about as classically ideal as a piece of architecture can get. Its simple mass and serene harmony give it an authority that few other buildings possess.

The Villa Rotonda was a country house used by a wealthy gentleman for vacationing and entertaining. The four identical porches around the building provide pleasant views across the countryside and offer shelter from the sun at different times of day. Each porch looks like the front of an ancient Roman temple, and the combination of temple front and domed rotunda may remind us of Emperor Hadrian's temple, the Pantheon in Rome (Figure 15-18). Palladio also borrowed the dome motif from the tradition of Christian church architecture. He transferred elements of ancient and modern religious architecture to a private home because he believed (erroneously) that the Romans themselves first used these features in domestic architecture. Because of his mistaken idea, but captivating example, builders have been placing Roman temple porches on houses ever since.

The Japanese had a different idea of what a house should be. The Katsura Palace (Figures 16-26 and

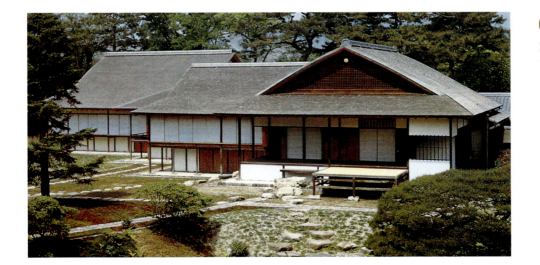

Figure 16-27 [Japanese], Katsura Palace, interior, ca. 1615–1663. Kyoto, Japan. © Sakamoto Photo Research Laboratory/Corbis.

16-27), outside Kyoto, Japan, has for centuries embodied their ideal of domestic architecture. The Katsura Palace was built for members of the imperial family as a country retreat, just as Palladio's smaller Villa Rotonda served as a place of relaxation in the country.

In both the East and the West in the sixteenth and seventeenth centuries, the main living area was normally on the second floor, not the ground level. Rooms in a house at that time were sparely furnished by our standards and could serve different functions. Neither the Japanese building nor the Italian building had plumbing or central heating—things we now take for granted in the most modest homes.

The Katsura Palace is built of lacquered wooden posts using the post and lintel system, with merely paper screens set between the posts. In contrast, the Villa Rotonda has solid masonry walls that support vaults, and the whole of the villa has an imposing block-like appearance. In place of the symmetry of the Villa Rotonda, the three large halls and several dozen rooms of the Japanese palace are arranged in a more relaxed zigzag pattern. The rooms are divided from one another by sliding screens, which when pushed aside or removed create a variety of new spaces and room arrangements. The palace has no central focus: no dramatic staircase or main entrance.

From the top of its four porches, the Villa Rotonda commands the countryside around it. In contrast, the Katsura Palace is integrated with nature. Winding paths leading to the house through extensive informal gardens provide glimpses of the building. Many of the external walls of the palace slide open to reveal various views of the gardens. If the fluid spatial arrangement and the sliding doors of the Katsura Palace seem more familiar to us than the formal grandeur of the Villa Rotonda, it is because these Japanese features were imitated by Frank Lloyd Wright and other Western architects in modern homes.

N

Plan of Katsura palace

BAROQUE PAINTING

At the beginning of the seventeenth century, Italian artists invented a dynamic new style that years later became known

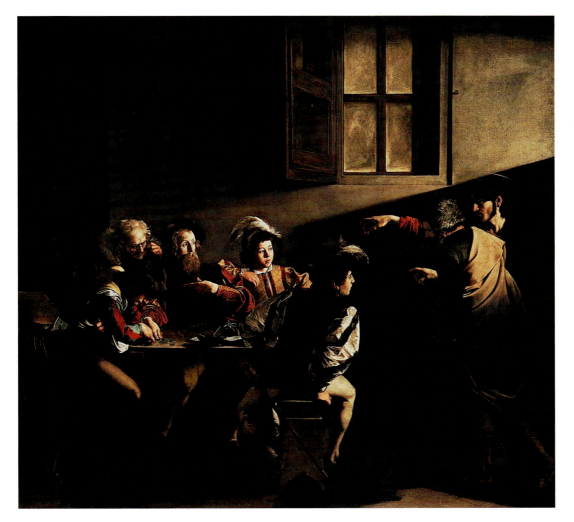

Figure 16-28 **Caravaggio** (**Michelangelo Merisi**) [Italian, 1573–1610], *The Calling of St. Matthew*, 1599–1600. Oil on canvas, 133 × 137 in. (322 × 340 cm). Contarelli Chapel, San Luigi dei Francesi, Rome. © Scala/Art Resource, NY.

as Baroque. *Baroque,* like the word *Gothic,* was originally intended to disparage this new seventeenth-century style, which late-eighteenth-century critics considered bizarre and irregular. But at its inception the new style suited the vigorous new age that was dawning. After generations of religious conflict in the sixteenth century, the boundaries between Catholics and Protestants in Europe became stable. Each group, assured of its religious beliefs, felt a sense of security in its political alliances. In this period, great nation-states emerged, usually ruled by a monarch who claimed a God-given right to absolute authority. First Spain, then France, then England dominated European politics. It was an age of power and expansion, as the European nations sent their ships around the world to develop colonial empires. Discoveries in science and technology ex-

panded humankind's horizon as well. When Galileo built a telescope and revealed the true movement of the planets, the seventeenth century learned the meaning of immense space for the first time. The Baroque style savored these vigorous new attitudes and this new awareness of nature, and, in contrast to the Renaissance style before it, relished dynamic movement through space.

The Baroque painter Caravaggio, right at the turn of the century, started a revolution in painting by working directly from nature—even in his religious pictures. Caravaggio's *The Calling of St. Matthew* (Figure 16-28) depicts Matthew as a disreputable tax collector surrounded by his accountants and sword-carrying henchmen at the moment when Jesus Christ calls him to be his disciple. Matthew and his associates wear the striped cloth-

(text continued on page 396)

When Michelangelo Merisi came from the small town of Caravaggio to Rome in 1593, the twenty-year-old artist (soon nicknamed Caravaggio) had to support himself painting cheap religious images or adding fruits and flowers to other artists' work. Then Caravaggio started painting half-length images of provocative adolescents holding strikingly realistic fruits or musical instruments. A wealthy collector (a cardinal of the church) bought two of these paintings and furthermore let Caravaggio live and work in his town house. The patron introduced the artist to other collectors and pulled strings to get Caravaggio a commission for religious paintings in the nearby church of San Luigi. Centuries ago, a successful religious painting—always on exhibition in a church—was about the only way that an artist could get his work before the public's eye.

Caravaggio's religious paintings about St. Matthew (see Figure 16-28) were phenomenally successful. Everyone in the art world of Rome came to see them, and over the next several decades they were imitated by hundreds of artists. Caravaggio shocked his contemporaries by using common people in the street as models for some of the men and women in his religious paintings. His religious characters were too real for some clergymen, who complained that his figures were so coarse they did not look like saints. They had several of his paintings removed from their churches.

Caravaggio's paintings also caused a stir because he started to paint with such strong contrasts between light and dark that outside the strongly lit parts, there was mostly darkness. A seventeenth-century critic compared his paintings to events taking place in a dark basement room illuminated by a single lamp up above. The stark contrast of light and dark combined with the realism of the painting makes the figure of his St. John the Baptist, now in Kansas City, almost spring out from the canvas. Caravaggio depicted St. John, wrapped in a vibrant red cloak, as a brooding adolescent. A strong light strikes his left side, casting deep shadows under his brows and illuminating only the kneecap of his left leg.

Some critics complained that Caravaggio's skill was limited, that he could not paint more than a few figures at a time. Furthermore, Caravaggio either could not or would not paint in fresco because he developed a method of direct painting. As far as we know, he never made preliminary drawings, but he began composing his images from the start right on the canvas. Sometimes he would merely incise the outlines of the head and arms with a stick into the reddish-brown underpainting as he did in painting St. John the Baptist. He often changed his compositions while painting. This kind of direct painting has become standard procedure in modern times but was unheard of in Caravaggio's day.

Caravaggio painted the way he did probably because of his impetuous temperament. While he was becoming more and more successful as a painter, he was appearing more and more frequently before the police and in court because of his fighting, slandering, and general contentiousness. Eventually, he killed a man in a street brawl over a gambling debt on a tennis match. Caravaggio spent the last four years of his life as a fugitive in Malta and southern Italy, earning his way by rapidly painting even more startling—though less realistic—canvases. Some of them are large, thinly painted, almost colorless images over which his brush, thick with paint, streaks only the highlights across the surface. Caravaggio's short life was truly a tragedy because the very impetuousness that drove him to succeed as a painter led to his eventual undoing.

Caravaggio (Michelangelo Merisi) [Italian, 1573–1610], *St. John the Baptist in the Wilderness*, ca. 1605. Oil on canvas, 68 × 52 in. (172.5 × 134.5 cm). Nelson-Atkins Museum of Art, Kansas City. Purchase: Nelson Trust, 52-25. Photo credit: Robert Newcombe and Edward C. Robsion III.

ing of contemporary liverymen and servants. Caravaggio reinforced his realism with an intense chiaroscuro that has been given the name *tenebrism*. A strong light enters the scene from the upper right, causes a diagonal shadow across the wall, and illuminates only the body parts that face the light. This natural light, which might also be interpreted as the traditional symbol of divine grace, acts like a spotlight on a darkened stage. Using realism and dramatic light, Caravaggio reinvented the biblical event with a profound meditation on what it must have actually been like, had we been there. The truth to nature, or naturalism, that Caravaggio emphasized and his manipulation of light and dark for dramatic effects became key characteristics of the Baroque style. (See Artemisia Gentileschi's *Judith and Maidservant*, Figure 4-6.)

Caravaggio's tenebrist style became known at an early date in Spain, where a young artist from Seville, Diego Velázquez, experimented with a realist approach and strong contrasts of light and dark. In his later years in Spain, Velázquez also had ample opportunity to absorb the lessons of the Venetian Renaissance painter Titian, who was avidly collected by Spanish royalty. At twenty-four years of age, Velázquez fulfilled his youthful ambitions as a painter when King Philip IV of Spain called him to Madrid to be the royal portrait painter.

Of all the portraits of the king and his court that Velázquez painted until the end of his life, none is more unusual than that of the royal family now known by the title *Las Meninas*—Portuguese words for *The Ladies-in-Waiting* (Figure 16-29). In *Las Meninas,* members of the court are portrayed in Velázquez's studio, where the artist himself stands poised, paintbrush at the ready, behind a very large canvas. Velázquez, who was an educated gentleman, was surely aware that in antiquity Alexander the Great honored the famous painter Apelles by watching him at work in his studio.

The center of attention in *Las Meninas* is the five-year-old princess Margarita, to whom one lady-in-waiting is offering a drink. It is impossible to tell whether Velázquez is supposed to be painting the princess's portrait on that large canvas or, more likely, the portrait of the king and queen, who are reflected in the mirror on the back wall. Just like Jan van Eyck in *The Arnolfini Wedding* (Figure 2-27), the king and queen must be standing outside the painting in the viewer's space as they pose for Velázquez. Later, when the king looked at *Las Meninas* hanging in his study in the royal palace, he saw life at court recreated in his presence.

In *Las Meninas,* Velázquez demonstrated that he had mastered the perspective of the dim interior space, where light and dark contrast help define his composition. He also dis-

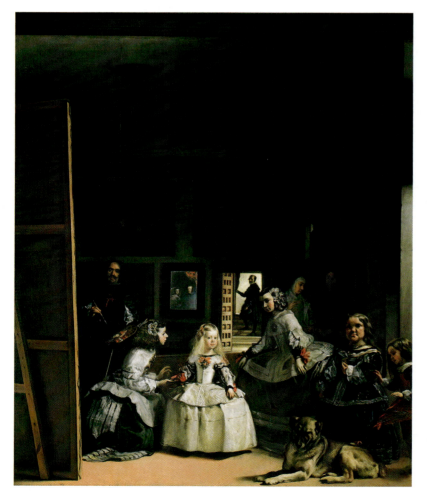

Figure 16-29 **Diego Velázquez** [Spanish, 1599–1660], *Las Meninas,* 1656. Oil on canvas, approximately 10 ft. 5 in. × 9 ft. (3.2 × 2.7 m). Prado Museum, Madrid. © Erich Lessing/Art Resource, NY.

Figure 16-30 **Peter Paul Rubens** [Flemish, 1577–1640], *The Coronation of Saint Catherine*, 1631 (1633?). Oil on canvas, 105 5/8 × 84 3/8 in. (265.75 × 214.3 cm). Toledo Museum of Art, Ohio. Purchased with funds from the Libbey Endowment, Gift of Edward Drummond Libbey, 1950.272.

Peter Paul Rubens, a Baroque artist trained in Antwerp in the north of Europe, observed Caravaggio's paintings at first hand during an extensive sojourn in Italy when he was a young artist. In fact, the incredibly fertile imagination of Rubens absorbed everything he could see in Italy, from classical sculpture (see *Laocoön,* Figure 7-8) to the masters of the High Renaissance. On a trip to Spain, he even copied El Greco.

In *The Coronation of St. Catherine* (Figure 16-30), Rubens, like Velázquez, returned to the loose brushwork and vivid color of Titian—in fact, it was Rubens on a visit to Spain who encouraged Velázquez to study the paintings of Titian. Rubens transformed Titian's colorful Renaissance style into something Baroque. He painted large, heroic figures on the scale of Michelangelo's nudes. But they do not look like statues. The Madonna, child, and three female saints are ruddy and full of life. Some of them are indeed reddened by the reflection of the fiery arrows that one angel holds. They emerge out of deep shadow into bright light, their clothing radiant with touches of color and flickering highlights. The figures bend and sway and seem to circle around the Madonna. The painting is alive with Baroque movement.

BAROQUE SCULPTURE

When late-eighteenth-century critics first applied the word *baroque* to seventeenth-century art to condemn it as bizarre and abnormal, they especially had in mind the sculptor Gianlorenzo Bernini. To them, Bernini seemed to have made strange new works that broke the rules of art laid down by the Greeks and the Romans and by Renaissance artists such as Raphael.

played his thorough understanding of the style of Titian, now his favorite painter. The surface of *Las Meninas* has become fundamentally a texture of visible brushstrokes of light and color. Rather than starting with a firm outline drawing that he then modeled with local color, Velázquez represented appearances by means of colored touches of light. Some touches are transparent; some are opaque. The seemingly haphazard touches build solid forms with a kind of magic, as one steps back from the painting. At the same time, the soft and fuzzy edges of shapes give the impression of a palpable atmosphere surrounding the figures. In the late nineteenth century, Manet and the Impressionists especially admired Velázquez's manner of painting.

Figure 16-31 Gianlorenzo Bernini [1598–1680].
The Ecstasy of St. Teresa, 1645–1650. Cornaro Chapel.
Santa Maria della Vittoria, Rome. © Scala/Art Resource, NY.

saint's body, her robe itself seems to pulsate with her ecstasy.

In short, the sculptor mixed together architecture, sculpture, painting, and glass, instead of observing the traditional boundaries of each art form. The marble group of angel and saint floats on a cloud instead of standing on a pedestal as might a Renaissance work. In fact, later critics condemned Bernini for using his sculptor's tools to imitate in stone soft flesh, the heavy cloth of the nun, the flimsy gown of the angel, and vaporous clouds beneath them. They said he denied the stoniness of the material; they obviously disliked the sensuous naturalism of the new Baroque style.

REMBRANDT AND THE GOLDEN AGE OF DUTCH PAINTING

If Bernini established a Roman Catholic Baroque vision of divine intervention into the natural world, the great Dutch Baroque artist Rembrandt van Rijn set forth a distinctly Protestant image of a personal inner Christianity. Rembrandt made his fame and fortune as a portrait painter, until the public found his dark, penetrating insights into character unfashionable. But to the end of his life, in his paintings and his prints (see Figure 6-7), Rembrandt tenaciously explored biblical subject matter, even though Protestant denominations in Holland, where he lived, would not allow religious art inside a church building. Like a good Protestant, Rembrandt believed that the message of the Bible came to each person individually when that person heard the word of God and experienced the presence of God within.

Rembrandt illustrated his beliefs in a large painting, *The Return of the Prodigal Son* (Figure 16-32), one of the last canvases he ever painted. In it, the son, who had abandoned his father and squandered his inheritance, returns home in rags. Kneeling on the ground, he sinks into his father's embrace. Three bystanders, like us, contemplate the meaning of the event. The father's stiff hands on his son's shoulders signal uncompromising forgiveness. Rembrandt illustrated the biblical parable of divine mercy through the image of a loving father. He emphasized the forms of father and son with thick impasto, and he painted in thin glazes the three witnesses of the event, who barely emerge from the darkness.

In *The Ecstasy of St. Teresa* (Figure 16-31), part of the Cornaro family chapel in Rome, Bernini activated the entire space of the chapel by means of a drama in which the group of St. Teresa and the angel plays only a part. Levitating above the ground, the saint swoons as an angel plunges into her an arrow symbolizing the fire of divine love. Teresa had in fact experienced such a mystical vision. In a fresco on the ceiling of the chapel, the dove of the Holy Spirit bursts through the architecture to inspire her. Bernini placed a hidden window above St. Teresa so that the afternoon sun, like rays of divine light emanating from the Spirit above, streams down the gilded bronze rods behind her. The directed illumination creates typically Baroque patches of light and dark all over the deeply folded drapery. Although the heavy cloth conceals the

Figure 16-32 Rembrandt van Rijn [Dutch, 1606–1669], *The Return of the Prodigal Son*, ca. 1665. Oil on canvas, approximately 8 ft. 8 in. × 6 ft. 9 in. (2.6 × 2.1 m). Hermitage Museum, Saint Petersburg. © Scala/Art Resource, NY.

In Rembrandt's religious painting, God's love comes about through personal contact. No miraculous vision of celestial beings bursts into people's lives to overwhelm them, as in Bernini's concept of divine grace. And yet Rembrandt's use of light and dark leaves no doubt that something mysterious is going on. Rembrandt avoids the sharp contrasts of Caravaggio, although his work contains areas of bright light and deep dark. Softened shadows and hazy light build a feeling of mystery and of warm personal union. The manipulation of chiaroscuro once again plays a key role in a Baroque style.

Although some artists in Protestant Holland, like Rembrandt, continued to illustrate religious iconography, the great majority turned to portraiture, landscape, still life, and genre subjects—works that fit more appropriately in the ordinary homes of the burgeoning middle class of Holland. Dutch Baroque painters favored an iconography that viewers could actually see around them, and Dutch artists fostered a style that faithfully reproduced selected aspects of

reality. Except for portraits, most Dutch paintings were not commissioned but were painted by the artist for the open market. Most Dutch painters specialized in a particular category to increase their productivity and sales. The seventeenth-century Dutch art world was quite different from the rest of Europe at the time and foreshadowed some more recent developments in the production of art.

Dutch genre painters often depicted scenes of merrymaking, with people drinking, smoking, or making music—whether in a tavern or at home. These enjoyable paintings often illustrated moral foolishness. Jan Vermeer, who worked all his life in the city of Delft, focused his art on the daily life of women. Whether a kitchen maid pours milk in one of his rare paintings or the lady of the house reads a letter or drinks a glass of wine, the women behave with decorum and reserve in surroundings that are always tidy.

In *Woman with a Water Jug* (Figure 16-33), no one knows for sure what the woman is doing:

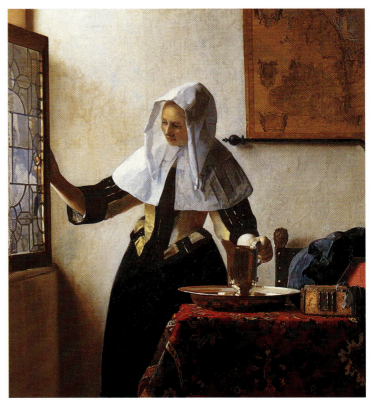

Figure 16-33 Jan Vermeer [Dutch, 1632–1675], *Woman with a Water Jug*, ca. 1662–1665. Oil on canvas, 18 × 16 in. (45.7 × 40.6 cm). Metropolitan Museum of Art, New York. Henry G. Marquand, 1889. Marquand Collection (89.15.21). © The Metropolitan Museum of Art, New York.

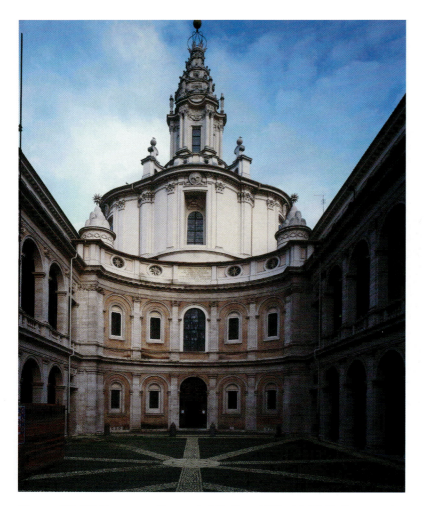

Figure 16-34 Francesco Borromini [Italian, 1599–1667], St. Ivo, exterior, begun 1642. Rome. © Scala/Art Resource, NY.

of the chair and the red oriental rug that covers the table. Using the primary colors, Vermeer took ordinary reality and made it an essay on glorious light.

BAROQUE ARCHITECTURE

The Italian Baroque architect Francesco Borromini towers above the other architects of his generation because he invented an exciting new style. His architecture broke all the classical rules of proportion beloved by the Renaissance; consequently, his architecture was one of the first to be labeled Baroque. In 1642 he fit a small chapel, dedicated to St. Ivo (Figure 16-34), into one end of a courtyard of a college called the Sapienza (Wisdom). The dome of his chapel rises above the curved courtyard wall and resembles nothing ever built before or since. The walls of the dome and the steps above them seem to ooze out from the pressure applied by the buttresses. The lantern above the dome is supported by protruding pairs of columns capped with an entablature that swings back between each pair. The lantern terminates in a spiral crowned with flames. Although the spiral can be explained as a symbol of wisdom, Borromini made it an integral part of an architecture that pushes and pulls and swirls with Baroque energy.

On the interior of St. Ivo (Figure 16-35), instead of designing a building with perfectly proportioned squares and circles as in the Renaissance, Borromini used overlapping triangles to form a six-pointed star shape that becomes the basis of the floor plan of the chapel. He then rounded the six points of the star, first with a concave arc of a circle, then with a convex. As our eye runs along the walls of the interior, we see that one section of wall is straight and juts forward whereas the next section curves out. The next is again straight but at a different angle, the next curves away, the next is straight, and so on around the chapel. The dynamic energy

opening the window or closing it, picking up the brass pitcher or putting it down. The artist has frozen her momentary gesture by placing it exactly in between the window, the corner of the map on the wall, and the edge of the chair behind the table. She cannot move an inch without destroying the perfectly balanced composition and hence the timelessness of her situation. Vermeer makes an everyday activity into a source of contemplation.

Unlike the dark manner that Rembrandt clung to, bright daylight floods through the window and bathes the room in yellow light. Vermeer observed subtleties of interior light much as his compatriot Jan van Eyck did over two hundred years earlier. Shadows against the wall are soft. The woman's wimple is translucent in the light and modeled in the faintest tints of blue. The polished brass pitcher and basin reflect the blue cloth on the back

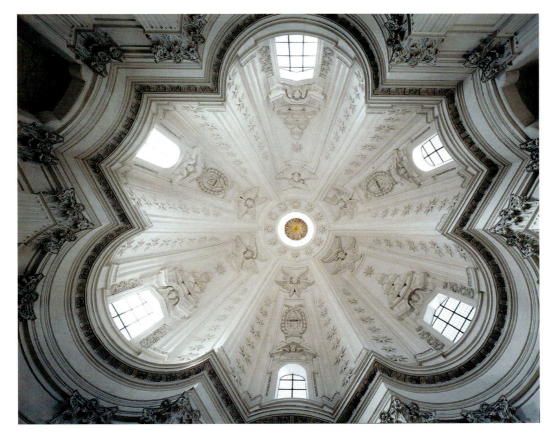

Figure 16-35 Francesco Borromini [Italian, 1599–1667], St. Ivo, interior, begun 1642. Rome.
© Scala/Art Resource, NY.

of the walls can best be seen in the entablature, which rests on giant pilasters around the chapel. The charging vertical lines of these pilasters are continued, after only a slight horizontal interruption, right into the dome, which is not hemispherical in shape, but irregular like the walls of the chapel beneath it. Magically, Borromini finally resolved the undulating shape of the chapel into a cir-

cle at the base of the lantern. The soaring vertical lines of the interior can legitimately remind us of Gothic architecture, which Borromini in fact admired. He also admired the architecture of Michelangelo. Indeed, the interior of St. Ivo resembles the energetic walls and vertical lines of the exterior of Michelangelo's St. Peter's, turned outside-in as it were.

Borromini's flamboyant Baroque architecture was widely imitated in Austria and Germany in the eighteenth century. But nothing like it ever took root in France. When France adopted the Baroque style in the seventeenth century, the country's innate sense of classical restraint modified the style. The French consider the late seventeenth century their golden age, a classical period when, under King Louis XIV, French political power and cultural life dominated Europe. Early in his reign, Louis XIV moved his royal residence and the government of France from Paris to his estate at Versailles, about eleven miles away. There he built an enormous

Plan of St. Ivo

Figure 16-36 **Louis Le Vau** [French, 1612–1670] and **Jules Hardouin-Mansart** [French, 1646–1708], garden and west facade of the Palace of Versailles, 1669–1685. Versailles, France. © Réunion des Musées Nationaux/Art Resource, NY.

 Plan of Versailles gardens. Engraving from Francois Blondel. © Foto Marburg/Art Resource, NY.

palace (Figure 16-36) to house himself and his court in a splendor that would declare to the entire world the political power and elevated artistic taste of France.

The architecture of Versailles focuses on the king's bedroom right in the center of the palace facing the rising sun in the east. Artistic imagery at court fashioned Louis as Apollo, the sun king. One of the greatest privileges at court was to attend Louis's rising in the morning as though it were a sacred ritual. On the opposite side of the palace, facing west, formal gardens spread out as far as the eye could see. Near the Palace of Versailles are flower beds arranged like embroidery patterns, along with reflecting pools and sculpture-filled fountains. Away from the palace, avenues and canals extend in straight lines toward distant focal points. In his design for the gardens, the landscape architect André Le Nôtre forced nature into a rational plan that radiates from the center of the palace, the king's bedroom. Not even the grandeur of Versailles's architecture symbolizes the absolute authority of the king as well as its famous gardens.

ROCOCO ART

The Baroque style lasted well into the eighteenth century, during which time there appeared a lavish style of interior decoration that has a name all its own—Rococo. In the eighteenth century, the wealthy aristocracy in France avoided the formality of court life at Versailles and lived in town houses *(hôtels)* in Paris that grew ever more comfortable, convenient, and elegant. For a generation or two, roughly between 1720 and 1750, it was the rage among the well-to-do to decorate the rooms of their town houses with large mirrors in fancy frames, with sleek fireplace mantels, and with oak wall panels delicately carved with patterns formed by ribbons, scrolls, vines, and shells.

In the 1730s the Count de Soubise had the architect Germain Boffrand add suites of Rococo

Figure 16-37 **Germain Boffrand** [French, 1667–1754]. Salon de la Princesse. 1737–1740. Hôtel de Soubise, Paris. © Saskia.

rooms, one for himself and one for his wife, to his town house in Paris. The all-glass French doors of her oval-shaped salon (Figure 16-37) give access to balconies that overlook the garden. Along the inside wall, those same arched bays are filled with mirrors that reflect the window light. Gilded filigree ornament surrounds the mirrors and covers the panels between them. Paintings illustrating the story of Cupid and Psyche mask the transition between wall and ceiling. Above the paintings, the architect covered the ceiling with a trellis-like decoration that treats the room as though it were a light and airy outdoor garden gazebo.

Counterpoised C-shaped curves in the decoration immediately identify the Rococo style. The gilded scrolls, ribbons, and moldings have the delicacy of embroidery and contribute to the light and gay appearance of the room. The room, used for receptions and entertaining, was furnished for the occasion as needed. At the time, the Rococo style spread from the walls and engulfed

the design of chairs, tables, candlesticks, and other furniture that might have been placed in the room. This style betrays a clever and charming way of life dedicated to the pursuit of happiness.

A typical French Rococo interior leaves very little room for paintings on the walls. In fact, the paintings of Cupid and Psyche along the walls of the salon are housed in irregular frames that are actually part of the paneling. Painting in mid-eighteenth-century France had become in many cases a subordinate part of the architectural decoration. The taste for small-scale works with an intimate iconography and a colorful style suited to the pleasures and comforts of eighteenth-century living was established early in the century by the artist Antoine Watteau. However, Watteau died very young, just as the Rococo style of decoration was getting under way, and we now appreciate Watteau as a more serious artist than his frivolous imitators.

Figure 16-38 **Antoine Watteau** [French, 1684–1721], *Pilgrimage on Cythera*, 1717–1719. Oil on canvas, approximately 51 × 76 in. (129.5 × 193 cm). Louvre, Paris. © Scala/Art Resource, NY.

Watteau's unusually large painting *Pilgrimage on Cythera* (Figure 16-38), his most famous work, was submitted by him to the French Academy so that he might be accepted as a member. The academy let him choose his own subject: a voyage by boat to the island of Cythera (Cyprus), where Venus was born. Young couples, who came as pilgrims seeking favors from the goddess of love, have paid homage to her shrine at the right. Some of the couples, their prayers answered, now return happily; some are reluctant to go. Watteau has clothed his small-scale characters in fancy-dress costumes adapted from the theater. To suggest also that the pilgrimage is a dreamy make-believe symbolizing the attraction between the sexes, he enveloped the scene and especially the distant shores in misty light reminiscent of the background of Leonardo's *Mona Lisa* (Figure 16-17), which Watteau saw in Paris. Delightful and colorful, yet drawn from life (see Figure 7-9), Watteau's fantasy about young love also strikes in the imagination deep chords about the human condition.

NEOCLASSICAL ART

In the second half of the eighteenth century, Europe was captivated by the spirit of the Enlightenment. In this period, often called the Age of Reason, a number of bright and bold individuals dared to think for themselves, free from the restrictions of religion and traditional authority. In France and other countries, cultural leaders such as Voltaire used their clever wit to ridicule vice and superstition and at the same time to praise tolerance, democracy, industriousness, and sincere human feelings. Enlightened men and women felt confident that the human intellect by itself could solve all problems, even social and moral problems. Needless to say, a reaction set in against the irresponsible way of life of the aristocracy—a reaction that eventually led to political revolution in America, in France, and in other countries, under the banner of liberty and equality.

A similar moral revolution took place in the art world. Art was now supposed to move a person's deepest feelings and teach virtue—not cater to wasteful living. Artists and critics believed that it should once again serve the nation and be good for the people, just as it had for the ancient Greeks and Romans. Classical art had depicted serious subjects in a serious way, so late-eighteenth-century artists and architects deliberately began imitating Roman and Greek art. Their work became known as Neoclassicism, a new imitation of classicism which

Figure 16-39 **Jacques Louis David** [French, 1748–1825], *The Oath of the Horatii*, 1784. Oil on canvas, approximately 11 × 14 ft. (3.4 × 4.3 m). Louvre, Paris. © R.M.N./Art Resource, NY.

was nevertheless conscious for the first time that Roman art was one style among many different styles in history.

The leading Neoclassical painter in France was Jacques Louis David (da-veed). He made his reputation with a very large painting, *The Oath of the Horatii* (Figure 16-39). It tells a story from early Roman history that, in line with Enlightenment thinking, illustrates patriotism and moral courage. The Romans and their enemy the Albans decided that three warriors from each side would fight instead of their two armies. In the painting, the three sons of Horatius swear on the swords held aloft by their father that they will fight to the death for their country. However, one of the daughters of Horatius was engaged to marry one of the Alban warriors. Whoever wins, she will lose a brother or a husband.

David staged the scene in a stark setting rendered, like an early Renaissance painting, in single-point perspective. The three arches divide the work into three parts, similar to a triptych. All the figures line up across the front of the stage as though in a

Roman relief carving, and the male figures stand as stiff as statues. Nevertheless, strong Baroque contrasts of light and dark dramatize the event. David had studied the lighting and the realism of Caravaggio's style as a student in Rome. The slumping figures of the women on the right break the symmetry of the painting and emphasize by contrast the heroic male virtue of the father and sons.

When the painting was exhibited in France in 1785—four years before the outbreak of the French Revolution—no one missed the point that *The Oath of the Horatii* was foremost a moral lesson in courage and sacrifice for one's country. David's painting encouraged those who saw it to stand by their convictions no matter what the consequences. By illustrating this subject, David obviously sided with many of the philosophers of the Enlightenment who also held that human nature, independent of the superstitions of the Church, could show the path to a virtuous life. Courageous pagans such as the Horatii could set an example of martyrdom for their beliefs to rival that of any Christian saint.

Figure 16-40 **Thomas Jefferson** [American, 1743–1826], Rotunda and courtyard of the University of Virginia, 1817–1826. Charlottesville. © Kit Kittle/Corbis.

Just as the Neoclassical painters criticized in their work the presumed frivolousness of Rococo art, architects of the Neoclassical period also condemned the excesses and abnormality of the Baroque and Rococo styles. They turned to the examples and principles of a classical style for their modern buildings. Everywhere in Europe and America, architects wanted public buildings to be in a monumental classical style so that they would make manifest the courage and strength of the Roman republic, as though these virtues would rub off on the citizens of the new republics that used the buildings.

The American patriot and president Thomas Jefferson shared these feelings about architecture and expressed them in the design of a number of his buildings. He designed his own house at Monticello (reproduced on the United States nickel) after Palladio's Villa Rotonda and, ultimately, after the Pantheon in Rome. Jefferson copied the Pantheon more closely—but in a one-half scale to the original—when he designed the rotunda as the centerpiece of the campus of the University of Virginia in Charlottesville (Figure 16-40). The ground level of the rotunda was designed for scientific experiments, the main floor for lectures, the upper floor as a library. It looks out over a lawn flanked on either side by two colonnades that connect a series of ten pavilions, symmetrically arranged. Each pavilion housed a different discipline and contained a lecture room and an apartment for the professor. Each pavilion reflects a different kind of classical architecture. The buildings themselves would provide lessons to the students about the history of architecture.

Jefferson thought of the campus as an "academic village" where students and faculty would live together in a democratic community. It reflected his

Jefferson's plan for the University of Virginia (The Papers of Thomas Jefferson, The Albert & Shirley Small Special Collections Library, University of Virginia Library).

Figure 16-41 **Caspar David Friedrich** [German, 1774–1840], *The Monk by the Sea*, 1809–1810. Oil on canvas, 42 1/2 × 67 in. (108 × 170 cm). Schloss Charlottenburg, Berlin. © Bildarchiv Preussischer Kulturbesitz/Art Resource, NY.

dream for the new nation. Both the university and the country borrowed from the past but rearranged the elements in a new order. The focus of the community is on the rotunda, the secular temple to scientific investigation and learning. At the University of Virginia he attempted not only to elevate the taste of his countrymen, but also to form the values of the new nation.

ROMANTICISM

Whereas the Neoclassicists believed that human reason could discover the universal rules of morality and the arts, by the beginning of the nineteenth century a younger generation protested that their personal feelings were being slighted. Soon labeled Romantics, they were convinced that the heart was even more important than the head, and they began to express their deepest emotions in their work. Not only did Romantic works of art place subjective feeling ahead of reason; Romanticism, like a serious religious belief, fostered a new way of life. Art was supposed to make a person whole. By joining material reality with universal truth in a work of art, an inspired artist could help people integrate body and soul. As a spiritual activity, art freed people from slavery to material conditions. Art allowed the artist and viewer to find nothing less than the infinite in the finite, to find God in nature. These Romantic

feelings rejuvenated landscape painting in the early nineteenth century.

The Romantics developed a strong feeling for the beauty of nature and an awareness of Divine Providence in nature. The sensitive artist had the ability to intuit this presence and portray it for others to see. In Caspar David Friedrich's *The Monk by the Sea* (Figure 16-41), the unbroken horizon line creates the impression of an infinite cosmos existing beyond the frame. A lone monk, the only vertical in the composition, stands on a slightly parabolic promontory of sand. He contemplates the immensity of the sky and the vastness of the sea. A bank of clouds, perhaps a heavy mist, rises up from the horizon like a wall to block the light of dawn, so the picture, implying great depth, becomes rather flat. Although the monk provides a sense of scale, it is impossible to measure any of the other dimensions and distances. The composition implies that the monk realizes his puniness and powerlessness when faced with the superior powers of the infinite. Such feelings of awe, Friedrich thought, formed the basis for religious faith.

Typically, a Romantic artist chose an unusual and dramatic subject, in which basic human feelings would be exposed and art would escape the humdrum of daily life. The Spanish painter Francisco Goya captured such a theme in his gripping painting

 Figure 16-42 **Francisco Goya** [Spanish, 1746–1826], *The Third of May, 1808*, 1814. Oil on canvas, 104 × 135 in. (264.2 × 342.9 cm). Prado Museum, Madrid. © Museo del Prado.

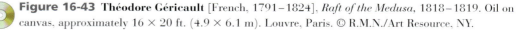 **Figure 16-43** **Théodore Géricault** [French, 1791–1824], *Raft of the Medusa*, 1818–1819. Oil on canvas, approximately 16 × 20 ft. (4.9 × 6.1 m). Louvre, Paris. © R.M.N./Art Resource, NY.

The Third of May, 1808 (Figure 16-42). Goya, who had been court painter for many years, had turned to the rationalism of the French Enlightenment to cure the social and moral problems of backward Spain. But soon after Goya satirized the superstitions, stupidity, and immorality of Spain in his series of etchings and aquatints *Los Caprichos* (Figure 8-15), Spain was invaded by Napoleon's armies. The horrible devastation and inhumanity of that war aroused in Goya a Romantic attitude, as he witnessed human beings stripped of all the restraints of civilization and relying only on their instincts.

The Third of May illustrates an incident at the beginning of the war when French troops, in retaliation for riots in the city, rounded up numerous suspects outside the gates of Madrid, where they were summarily shot by faceless soldiers. In the painting, bloody corpses already lie on the ground as more citizens file toward the place of execution. Of the group facing the firing squad, one man raises a fist in defiance, a monk tries to pray, and the others cannot look. Only one man, prominent in his white shirt brightened by the square lantern on the ground, can stare down the barrels of the guns. He raises his arms like Jesus Christ on the Cross, ready to sacrifice himself for the Spanish people. At the moment before death, the moment of truth, these men can depend only on themselves and live by their supercharged feelings. It is the supreme Romantic moment.

The French Romantic painter Théodore Géricault also explored in his enormous painting *Raft of the Medusa* (Figure 16-43) humanity's emotional confrontation with the brute forces of nature and with unreasoning death. The incident he depicted, a recent scandal in the French government, took place far away off the west coast of Africa. French officers of the foundering ship *Medusa* had set 149 men and 1 woman adrift on a raft as they themselves sailed off in a lifeboat to safety. After days of facing raw nature on the sea and raw humanity among themselves, the 15 survivors on the raft pulled together to flag down a distant ship. Reduced to basic instincts, they found among themselves a common brotherhood.

Géricault's Romanticism used a dynamic Baroque composition of strong diagonals as the sea lifts the raft and as the figures surge up together toward their salvation. Ignoring probability, Géricault

Figure 16-44 Richard Upjohn [American, 1802–1878], Trinity Church, 1839–1846. New York. Photo by Leo Sorel.

made the starving survivors as heroic in stature as Michelangelo's race of giants, and he boldly contrasted light and dark throughout the scene. Géricault borrowed these elements of style to dramatize the Romantic confrontation of people and nature when life is lived according to subjective feelings.

Neoclassicists had tried to associate the revival of a classical style of architecture with the heroism of ancient Rome and the ideals of ancient Greece. The Romantics revived the Gothic style in church architecture, believing that the style would restore to the nineteenth century the confident Christianity of the Middle Ages. When Richard Upjohn and the members of Trinity Church in New York began to design a new building for their congregation in 1839, they expressed a desire to restore Christian worship by returning to a medieval style.

Although overall the building has a rather simple, boxy layout and the ribs in the nave vaulting are false, Trinity Church (Figure 16-44) has pointed

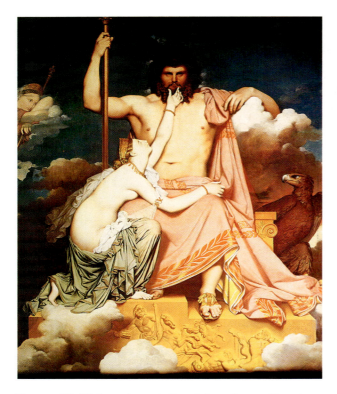

Figure 16-45 **Jean Auguste Dominique Ingres** [French, 1781–1867], *Jupiter and Thetis*, 1811. Oil on canvas, 130 5/8 × 101 1/4 in. (331.8 × 257.2 cm). Musée Granet, Aix-en-Provence. © Erich Lessing/Art Resource, NY.

arches, clerestory windows, and an impressive tower and spire in a late English form of Gothic known as the Perpendicular style. Upjohn's church was the first large-scale revival of the Gothic style in America, and it succeeded in identifying the Gothic style with church building for generations to come. Nineteenth-century church people believed that a Gothic style would restore the age of faith because Romantic feeling let them escape the harsh truths about secular modern urban life.

In the 1820s, 1830s, and 1840s in France, the Neoclassical and Romantic styles existed side by side. They were championed by two prominent artists, the Neoclassical painter Jean Auguste Dominique Ingres and the Romantic painter Eugène Delacroix. Ingres asserted that line was the major element in all art; Delacroix maintained that the chief element was color. Other artists as well as the public took sides in this clash between the two forceful painters and their rival styles.

Ingres, a student of David, continued to champion Neoclassicism into the middle of the nineteenth century. His belief in the superiority of line resulted

in works that have an abstract and primitive feel to them because he modeled his art on the vase painting of early fifth-century Greece. His painting *Jupiter and Thetis* (Figure 16-45) portrays an immense Jupiter, lord of the gods, posed frontally in imitation of Phidias's lost statue of Zeus at Olympia. The much smaller figure of Thetis, who begs Jupiter to assist her son Achilles, kneels at his side in pure profile. The contours of her lightly modeled body form elegant curves and emphatic diagonal lines that describe an impossible anatomy. Ingres's affection for a pre-classical phase of Greek art leads to a number of contradictions in his work. The ponderous Jupiter and his block-like throne float incongruously on clouds—one of which serves Jupiter as an armrest. The folds of the drapery are precisely, almost photographically rendered, yet seem flattened across the surface of the emphatic triangular composition. His obsession with line drove him to refine forms until they became almost abstract configurations. Contemporary French critics noticed at once that Ingres's Neoclassical style was a far cry from David's style of well-proportioned, statue-like Romans.

In the very large Romantic canvas *The Death of Sardanapalus* (Figure 16-46), Delacroix illustrated a poem by the English poet Byron about the ancient Assyrian despot Sardanapalus. At the defeat of his city by his enemies, Sardanapalus surrounds himself on his funeral pyre with all his possessions—his harem, horses, and jewels—rather than allow them to fall into the hands of the enemy. Reclining on the billowing mattress of his elephant bed, Sardanapalus calmly surveys the sex and violence going on beneath him. He willingly, and in full control, meets his fate while indulging his passion for sensual delight. Sardanapalus's conscious and deliberate confrontation with his emotions epitomized for Delacroix the Romantic artist.

Delacroix followed the example of Titian and Rubens by making color and chiaroscuro the basic elements of his composition. He applied the paint with passion and excitement, blurring contours by "drawing" with colored strokes of paint. A rich, saturated red, accentuated with cool color contrasts, runs throughout the composition. Delacroix observed the play of light on textures and the reflections of one color on another surface. He often experimented with touches of complementary colors, especially in the shadows, and with separate

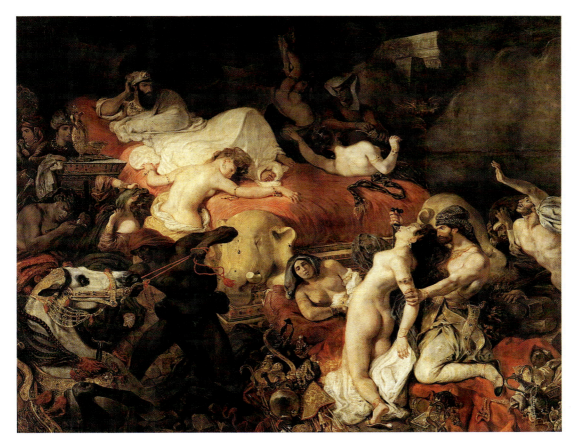

Figure 16-46 Eugène Delacroix [French, 1798–1863], *The Death of Sardanapalus*, 1826. Oil on canvas, 12 ft. 1 in. × 16 ft. 3 in. (3.7 × 5 m). Louvre, Paris. © R.M.N./Art Resource, NY.

dabs of color to be mixed optically with the eye. He applied paint with a variety of strokes, from thin and transparent to thick and opaque. The lush application of paint and contrasts of light and color intensify the emotional impact of the drama.

REALISM

Around the middle of the nineteenth century, a new and different kind of society emerged among most men and women in Europe and America. The most visible manifestation of the new age was the Industrial Revolution, which meant not only the proliferation of factories and mass-produced goods but also a network of railroads, cities exploding with large populations, and a wealthy middle class. Underlying these changes in the landscape, and stimulated by the changes themselves, were the fundamental ideas that practical business sense, technology, and science were the rules of life. Business and science seemed to be laying foundations for a new society. Since progress in these fields depended

on hard facts, artists likewise developed a factual and realistic style to depict modern life.

This next generation of artists shunned the Romantic movement because it seemed too much like an escape from reality. Some young artists, who declared themselves dedicated to "facts," felt that they should paint and immortalize only what they saw. Critics and collectors encouraged them to depict the world around them and to choose more relevant, modern subjects. The discovery of photography by Daguerre and others in 1839 and its rapid adoption resulted in good part from the growing desire to copy everyday reality. Photography in turn stimulated the growing desire for realism in other art forms.

The mid-century French artist Gustave Courbet claimed rather loudly that since the people were better served when art was true to reality, he would paint only from nature. "Show me an angel and I'll paint one," he wrote, declaring that he would only copy reality.[1] His famous remark also asserted the material nature of art itself. In defiance of the great

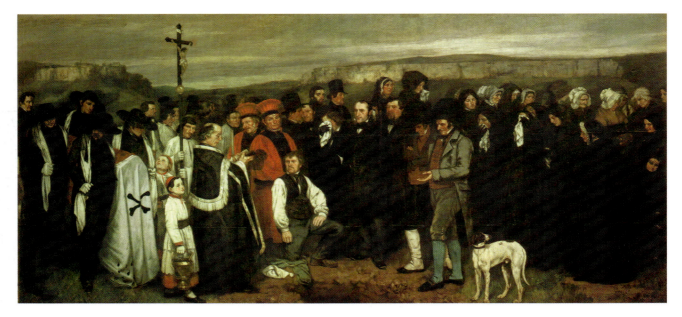

Figure 16-47 **Gustave Courbet** [French 1819–1877], *A Burial at Ornans*, 1849. Oil on canvas, approximately 10 × 22 ft. (3 × 6.7 m). Louvre, Paris. © Erich Lessing/Art Resource, NY.

tradition of religious art, his painting *A Burial at Ornans* (Figure 16-47) depicted a Catholic funeral ceremony simply as an event, depriving it of spiritual meaning. The funeral takes place in a newly opened municipal cemetery—not in the churchyard—in the provincial town where Courbet was born. He had dozens of its citizens, including his parents and sisters, pose for its mourners. People stand about, waiting for the ritual to begin. Most of the women in the back turn toward something on the right. Grim pallbearers hold the coffin on the left. A priest is about to recite prayers over the grave while altar boys and other attendants look about in distraction. We viewers stand on the other side of the grave, the gaping hole in the earth that sinks beneath the frame into our space. A crucifix, which no one notices, rises above the horizon against the flat gray sky and looms over the grave. In Courbet's painting, grave and cross seem to challenge each other.

Viewers in 1850 complained not only about the lack of transcendence in Courbet's painting but also about the crudity of its execution. (See *The Stone Breakers,* Figure 1-12.) It seems that the harsh dabs of paint on the surface of Courbet's painting insistently pressed home to them the materialism of Courbet's Realist point of view. The public wanted art with a polished surface that idealized reality, and it was not yet ready to abandon that desire.

The American artist Thomas Eakins (rhymes with *bacons*) also committed himself to painting from reality. The first painting he exhibited in America, after three years of study in Paris, was *Max Schmidt in a Single Scull* (Figure 16-48), an exacting portrait of a friend who had just won the three-mile race for the single sculls championship on the Schuylkill River in Philadelphia. The picture does not record the race but shows the racecourse up and down the river under the bridges in the distance. It also shows the time of victory, late afternoon on a crisp, clear day in early October.

To paint as a Realist, Eakins ordinarily made extensive preliminary studies, although only two small drawings related to *Max Schmidt* still remain. He usually made careful perspective drawings in pencil, charcoal sketches of motifs made at the location, and broadly painted oil sketches of the light. He had studied anatomy, even attended anatomy classes in medical school, so that he could draw the human figure with assurance. To Eakins, Realism meant that the artist must study objects with a scientific diligence.

In the painting, Schmidt feathers the oars (holds the blades horizontal) as he glides across the still water to the center of the composition, where he turns to look at the viewer. At the first exhibition, Eakins titled the painting *The Champion Single Sculls.* Eakins's friend Schmidt,

Figure 16-48 **Thomas Eakins** [American, 1844–1916], *Max Schmidt in a Single Scull (The Champion Single Sculls)*, 1871. Oil on canvas, 32 1/4 × 46 1/4 in. (81.9 × 117.5 cm). Metropolitan Museum of Art, New York, Purchase of The Alfred N. Punnett Endowment Fund and George D. Pratt Gift, 1934 (34.92). Photograph © 1994 The Metropolitan Museum of Art.

a lawyer and amateur athlete, had just proven himself in a sport the nineteenth century considered manly. Races drew large crowds and enthusiastic coverage in newspapers and journals. Eakins, just starting out in his career, depicted himself in the scull behind Schmidt. A rowing enthusiast himself, Eakins pulls at the oars to make headway and metaphorically his own reputation in art. Five years later, the realism of *The Gross Clinic* (Figure 2-6) still failed to win him the acclaim he deserved. The public was not ready for truthfulness in art.

INTERACTIVE LEARNING

 Flashcards

Artist at Work: Leonardo da Vinci

Artist at Work: Caravaggio (Michelangelo Merisi)

Companion Site: **http://art.wadsworth.com/buser02**

Chapter 16 Quiz

InfoTrac® College Edition Readings

Talking Flashcards

Online Study Guide

EXPANDING HORIZONS OF WORLD ART

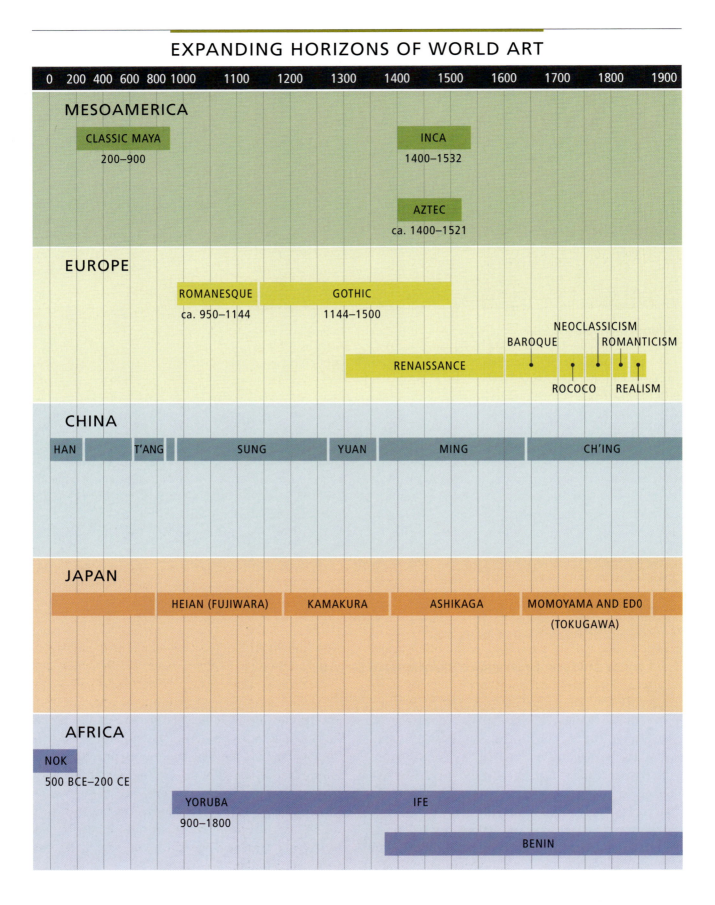

| | 0 | 200 | 400 | 600 | 800 | 1000 | 1100 | 1200 | 1300 | 1400 | 1500 | 1600 | 1700 | 1800 | 1900 |

MESOAMERICA

CLASSIC MAYA
200–900

INCA
1400–1532

AZTEC
ca. 1400–1521

EUROPE

ROMANESQUE
ca. 950–1144

GOTHIC
1144–1500

RENAISSANCE

BAROQUE

ROCOCO

NEOCLASSICISM

ROMANTICISM

REALISM

CHINA

HAN T'ANG SUNG YUAN MING CH'ING

JAPAN

HEIAN (FUJIWARA) KAMAKURA ASHIKAGA MOMOYAMA AND EDO
(TOKUGAWA)

AFRICA

NOK
500 BCE–200 CE

YORUBA IFE
900–1800

BENIN

17 The Early Modern World: 1860 to 1940

LATE-NINETEENTH-CENTURY PAINTING

For many years the French government, through its Academy of Fine Arts, held an annual, sometimes biennial, exhibition of art in a large salon, or room, in the Louvre Palace in Paris. The British government established the same system of yearly exhibitions in London at the Royal Academy. By the beginning of the nineteenth century, the French Academy exhibition, or **Salon,** as it became known, dominated artistic life. Instead of working directly for a wealthy and usually knowledgeable patron, artists now produced their work to satisfy members of the general public, who came by the thousands to the exhibitions. Artists also planned their work for the eyes of the often-prejudiced critics and for the members of the Academy, who passed judgment on their work.

During the late nineteenth century a revolutionary new movement began in the history of European styles when new artists successfully challenged the art establishment. After two of his paintings were rejected by the Salon jury, Gustave Courbet in 1855 held his own exhibition of Realism apart from the official Salon. In 1863 the French government, under pressure, held an exhibition of the many works that were rejected by the judges that year from the official Salon. Forewarned of official disapproval, the public came to scoff at this **Salon des refusés** (Salon of the Rejected), as it be-

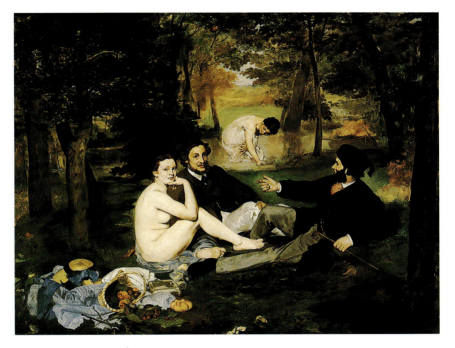

Figure 17-1 **Édouard Manet** [French, 1832–1883], *Le Déjeuner sur l'herbe (Luncheon on the Grass)*, 1863. Oil on canvas, approximately 84 × 106 in. (213.4 × 269.2 cm). Musée d'Orsay, Paris. © Edimedia.

came known. The critics singled out as the most notorious offender of good taste *Le Déjeuner sur l'herbe (Luncheon on the Grass)* (Figure 17-1) by Édouard Manet. In the painting a nude woman catches the viewer's eye while she sits at a picnic in the woods with two men in contemporary dress. It did not matter to the critics that museums displayed paintings illustrating nude women associating with dressed men or that Manet borrowed the composition from a design by Raphael. The public and critics felt that *Luncheon on the Grass* was intended as pornography, not art, especially because the figures were real, not ideal.

It is hard to imagine that Manet was so naive that he did not realize what he was doing or fore-

see the objections his painting would raise. More likely, he was fully aware and fully convinced of the correctness of Courbet's Realistic approach and the need for modern subjects painted in the modern manner. Conscious of the tradition of European art, he worked with seeming indifference to it, asserting the right to paint as he saw. Inspired by the open brushwork of several famous Baroque artists—of Velázquez, for example (see *Las Meninas,* Figure 16-29)—Manet painted with broad strokes of color. By illuminating the figures with a source of light from the front, he reduced modeling and all transition between values to a few distinct tones. Up close, his painting seems

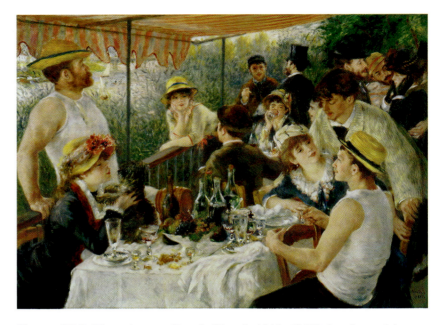

Figure 17-2 **Pierre Auguste Renoir** [French, 1841–1919], *Luncheon of the Boating Party,* 1880–1881. Oil on canvas, 51 3/16 × 68 1/8 in. (130 × 173 cm). Phillips Collection, Washington, D.C.

like a sketch of what the eye immediately sees: patches of colored light. Manet's handling of paint calls attention to it and declares that the arrangement of colors on the surface is more important in art than a moral message. Manet's assertion of the primacy of the surface was the beginning of the revolution.

We have no name for the general style period ushered in by this revolution other than **modern art.** This term generally refers to the art of recent times ever since the end of the nineteenth century. The phrase **contemporary art** means the art of the current generation, the last ten or fifteen years.

IMPRESSIONISM

Photography in the nineteenth century both challenged painters to be true to nature and also encouraged them to exploit aspects of the painting medium, such as color, that photography lacked. This divergence away from photographic realism appears in the work of a group of artists who from 1874 to 1886 exhibited together, independently of the Salon. The leaders of the movement were Claude Monet, Auguste Renoir, Edgar Degas, Camille Pissarro, Berthe Morisot, and Mary Cassatt. They became known as Impressionists because a newspaper critic thought that they were painting mere sketches or

impressions. However, the Impressionists considered their works finished.

Many Impressionists painted pleasant scenes of middle-class urban life, extolling the leisure time that the Industrial Revolution had won for the middle class. In Renoir's luminous painting *Luncheon of the Boating Party* (Figure 17-2), for example, young men and women eat, drink, talk, and flirt with a joy for life that is reflected in sparkling colors. The sun filtered through the orange-striped awning colors everyone in the party with its warm light. Their glances cut across a balanced and integrated composition that reproduces a very delightful scene of modern life.

Since they were realists, followers of Courbet and Manet, the Impressionists set out to be "true to nature," a phrase that became their rallying cry. When Renoir and Monet went out into the countryside to paint, they carried their oil colors and canvas with them so that they could stand before the motif and record what they saw at that time. Most earlier landscape painters worked in their studio from sketches.

Realism meant to Monet that the painter recorded his sensations of color and light. By capturing a very specific light, this style conveyed the notion of a distinct and fleeting moment of time. In *The Regatta at Argenteuil* (Figure 4-27), Monet caught the light of a tranquil summer day when the boats have just opened their sails and begun to pull away

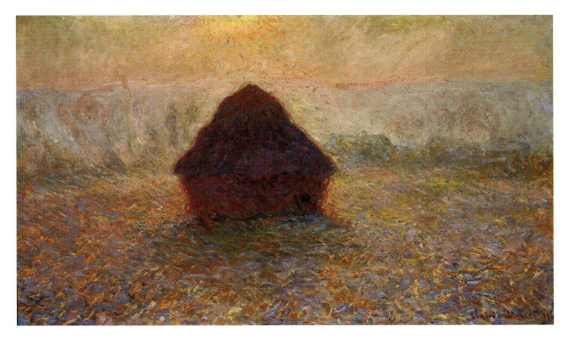

Figure 17-3 Claude Monet [French, 1840–1926], *Grainstack, Sun in the Mist*, 1891. Oil on canvas, 23 5/8 × 39 1/2 in. (60 × 100.3 cm). Minneapolis Institute of Arts, Gift of Ruth and Bruce Dayton, the Putnam Dana McMillan Fund, the John R. Van Derlip Fund, the William Hood Dunwoody Fund, the Ethel Morrison Van Derlip Fund, Alfred and Ingrid Lenz Harrison, and Mary Joann and James R. Jundt (93.20).

from shore. He recorded what he saw in separate patches of bright color, attempting to approximate the scintillation of natural sunlight. The public back then was upset that Impressionist paintings looked like sketches and did not have the polish and finish that more fashionable paintings had. But applying the paint in independent strokes allowed Monet, Renoir, and Cassatt to display their color sensations openly, to keep the colors unmixed and intense, and to let the viewer's eye mix the colors.

The more an Impressionist like Monet looked, the more he saw. Sometimes Monet painted the same subject at different times of day or in different weather conditions. In 1891 he exhibited fifteen views of haystacks, their squat mass dissolved in light and color. He never repeated himself in these series because the light and color always changed with the passage of time, and the variations made each painting a new creation. In *Grainstack, Sun in the Mist* (Figure 17-3), the fifteen- to twenty-foot-high stack— the product of a good harvest—stands like the lone survivor in the field of stubble. Touches of yellow at the top of the canvas indicate the source of light behind the silhouetted stack. Monet covered the canvas with dabs of mostly warm colors, a thick mat of reds, oranges, yellows, and red-violets. Only the dark stack,

its shadow, and the shadows in the field exhibit any cool touches—the complements of yellow sunlight. As mist still clings to the morning landscape, the sky, distant houses or hills, and the field become a flat reddish background against which the grain stack hovers. Monet's observations of light and color have become so subjective that the scene looks like a hallucination, symbolizing some mysterious life force.

The Impressionists remained realists in the sense that they remained true to their sensations of the object, although they ignored many of the old conventions for representing the object "out there." Truthfulness lay in their personal perceptions, and reality became what the individual saw. With Impressionism, the meaning of realism was transformed into subjective realism, and the subjectivity of modern art was born.

JAPANESE ART OF THE EIGHTEENTH AND NINETEENTH CENTURIES

Many Impressionist artists collected woodblock prints published in Japan in the eighteenth and nineteenth centuries. The Japanese call these works

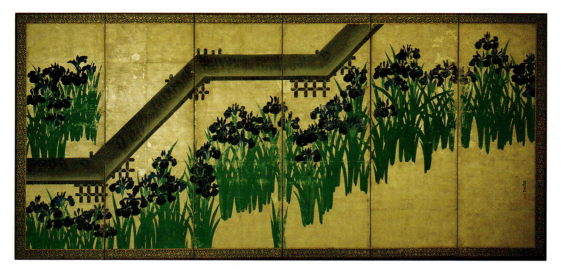

Figure 17-4 Ogata Korin [Japanese, 1658–1716], *Eight-Planked Bridge*, early eighteenth century. From a pair of six-panel folding screens; ink, color, and gold leaf on paper, 70 1/2 × 146 1/4 in. (179.1 × 371.5 cm). Metropolitan Museum of Art, New York. Louisa Eldridge McBurney Gift. 1953 (53.7.1–.2) Photograph © 1993 The Metropolitan Museum of Art.

ukiyo-e, "images of the floating world" — that is, images of the entertainment district of Edo (modern Tokyo). These popular prints illustrate famous actresses or courtesans, wrestlers, landscapes (Hokusai's *Great Wave,* Figure 8-8), or scenes of contemporary life (Kiyonaga's *Interior of a Bathhouse,* Figure 5-17). The Impressionists and their followers were attracted to them; Degas owned an impression of Kiyonaga's print. European painters admired their flat areas of color, their lack of chiaroscuro (they had no cast shadows, no modeling), their flattened perspective and different points of view, their bold designs, and their popular iconography.

Traditional Japanese artists and their upper-class patrons in the nineteenth century looked down on ukiyo-e prints as vulgar. Japanese art over the centuries had borrowed heavily from Chinese art with its high-minded spiritualism. Nevertheless, these popular woodblock prints in many ways represent the culmination of traditional Japanese art, which can be seen in the early-eighteenth-century painting *Eight-Planked Bridge* (Figure 17-4). The piece is one of a pair of folding screens, now in New York, painted on gold leaf by Ogata Korin. The Japanese raised to a high level the painting of folding screens, which were used as space dividers in their homes.

Korin's painting alludes to a brief passage in a work of literature, the *Tales of Ise,* in which a character stops at Yatsuhashi, or Eight-Plank Bridge. The

irises that he sees from the bridge make him nostalgic for home. Korin reduces the iconography to just the bridge and the irises; in another set of screens in Tokyo, the irises alone capture the literary allusion.

The composition and color of Korin's screen are as bold as the design of any of the ukiyo-e prints that late-nineteenth-century Western artists saw. The small bridge, seen from two different points of view, becomes a zigzag line roughly parallel to the long row of irises. The bridge and irises become a flat design on the surface of the gold screen. Having reduced the composition to its quintessence, Korin painted the spiky leaves of the irises with vivid unmodeled green and the flowers in two shades of blue. Full of life and vitality, the irises virtually dance across the screen. Only van Gogh succeeded in giving irises the same energy (see *Irises,* Figure 19-1).

POST-IMPRESSIONISM

Toward the end of the nineteenth century, many people in the West grew dissatisfied with the materialism of modern industrial society. Important spiritual aspects of human nature were being neglected. Many modern artists began to challenge their contemporaries and prod them into new consciousness. Some artists declared themselves prophets of a new age being born. They purposely created art that was different, difficult in its symbolism, and ahead of its time. When they were scorned or neglected, many

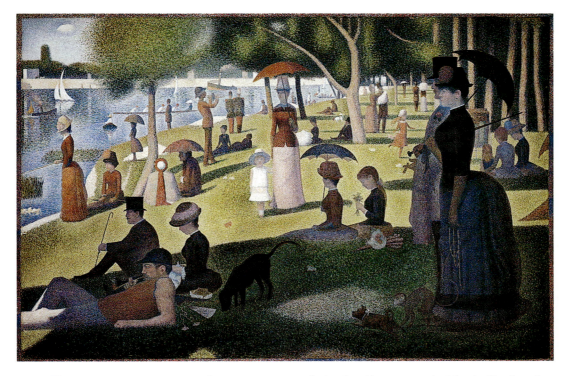

Figure 17-5 Georges Seurat [French, 1859–1891], *Sunday Afternoon on the Island of La Grand Jatte*, 1884–1886. Oil on canvas, approximately 81 × 120 in. (205.7 × 304.8 cm). Art Institute of Chicago (Helen Birch Bartlett Memorial Collection, 1926). Photo courtesy of The Art Institute of Chicago.

artists started to feel alienated from the mass of ordinary people who lagged behind.

At the eighth and final exhibition of Impressionism in 1886, it was clear that many artists had grown dissatisfied with the formlessness of its bright-colored strokes. Artists wanted to regularize the style, give it more content, or let it express more feeling. Many of the Impressionists themselves changed their style after 1885. These new aims and new directions for Impressionism are now grouped together under the label Post-Impressionism. The name does not denote a distinct style; it only implies that a new movement came after Impressionism and that Impressionism was its starting point.

One Post-Impressionist artist, Georges Seurat, tried to make Impressionism scientific and systematic. He transformed the intuitive brushstrokes of Impressionism into a regular system of separate colored dots. Seurat calculated his dots of paint, applied in accord with the laws of physics and psychology, so that they would produce the correct light and color sensation when mixed by the viewer's eye. His **Divisionism,** as he called it, or **Pointillism,** as it is also termed, works like the colored ink dots in modern magazine illustrations. The

painstaking technique forced Seurat to paint indoors, not outdoors like Monet.

Seurat died young and painted only a few major works in his exacting process. The Art Institute in Chicago exhibits his most popular work, *Sunday Afternoon on the Island of La Grand Jatte* (Figure 17-5). When a viewer looks closely at the painting, it is possible to see thousands of points of light and color. Any one area—a face, a dress, the grass—displays a rainbow of different colors and a variety of light and dark dots. In them, Seurat tried to capture the most subtle color sensations of reflected and tinted light.

Something else happened to Seurat's painting while he was changing Impressionism into his own system. Since he was no longer capturing a fleeting moment with spontaneous brushwork, his orderly procedures made his figures appear frozen in time. In fact, he placed them carefully in the composition along parallel lines in frontal or profile poses. A friend said they looked Egyptian.

Seurat may not have intended to imitate the Egyptian style, but another Post-Impressionist painter, Paul Gauguin, deliberately rejected many European traditions of painting in order to incorporate other traditions in his work. In fact, he left

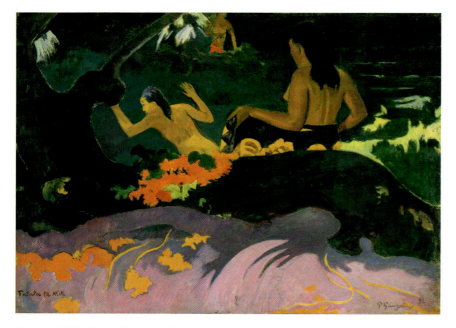

Figure 17-6 **Paul Gauguin** [French, 1848–1903]. *Fatata Te Miti (By the Sea)*, 1892. Oil on canvas, 26 3/4 × 36 in. (67.9 × 91.4 cm). National Gallery of Art, Washington, D.C., Chester Dale Collection 1963.10.149 (1813). PA image © 2004 Board of Trustees, National Gallery of Art, Washington, D.C.

France and lived for many years among the Polynesians of the South Pacific in his search for an unspoiled paradise where he hoped to find more genuine sources of inspiration. Gauguin believed that Western civilization had corrupted the spiritual revelation common to all mankind and that less developed societies were closer to the original truth. Ever since the eighteenth-century French philosopher Jean-Jacques Rousseau praised the "noble savage," the myth had developed in the West that the early, primitive manifestations of a society were better than later, civilized developments because the primitive was more original, more inspired, and closer to the Truth. Fascination with so-called primitive cultures was to have a profound impact on European and American art for many generations.

Gauguin first learned how to record sensations of color and light like an Impressionist, but he soon felt free to intensify colors and manipulate colors, lines, and shapes according to the "music" of a painting, as he called it. Colors might even be used for symbolic reasons. When he depicted life in the South Pacific, he often injected symbolic motifs from other primitive cultures. His *Fatata Te Miti (By the Sea)* (Figure 17-6), in which two Polynesian women undress and walk into the sea, is far from an accurate depiction of life on a South Pacific island. Gauguin intended the

pose of the more distant figure with raised arms to symbolize Buddhist Nirvana. The sea would thus symbolize the abyss. To back up his esoteric symbolism, Gauguin also made sure his painting had a corresponding musical part in the visual elements. The wavy forms in the foreground and the exotic color scheme of secondary colors, green, orange, and violet come from his imagination and do not necessarily imitate real appearances. They correspond to his own rhythms and harmonies for the painting.

In Paris in the 1880s, the Dutch artist Vincent van Gogh met Gauguin and some of the Impressionists, whose lessons he absorbed. (See page 10.) Van Gogh then developed a style all his own that changed Impressionism into something quite different. In *Night Café* (Figure 4-22), this very intense young man used color to express his feelings. In his *Starry Night* (Figure 17-7), the thick dabs and swirls of paint also express his feelings. Everything in *Starry Night*—hills, trees, sky, clouds—undulates with the same energetic line. The pulsating stars and writhing sky express his dynamic vision of time and eternity. Van Gogh daydreamed of traveling to distant stars (his symbol of eternity) in the next life—the cypress tree that cuts through the sky symbolizes death. Just as pilgrims take a train to distant spots on a map, death would take him to the eternal stars.

Another Post-Impressionist, Paul Cézanne, sought to make out of the Impressionist style something stable and ordered like the Old Master paintings hanging in a museum. Like Monet, Cézanne went into the countryside with his paints to record his sensations before nature. Tied to the realist tradition, he had to look at what he painted. But Cézanne worked for days on a still life or landscape, making subtle adjustments on his canvas to unify and balance his composition.

Cézanne's *The Basket of Apples* (Figure 17-8) at first seems like a casual arrangement of fruit, cookies, and a bottle of wine on a tabletop. Closer examination shows that Cézanne manipulated line and color to balance his composition and achieve a more

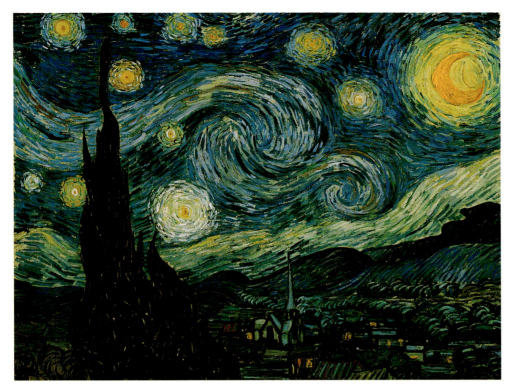

Figure 17-7 **Vincent van Gogh** [Dutch, 1853–1890], *Starry Night*, 1889. Oil on canvas, 29 × 36 1/4 in. (73.7 × 92.1 cm). Museum of Modern Art, New York (acquired through the Lillie P. Bliss Bequest). © 2004 The Museum of Modern Art, New York/Art Resource, NY.

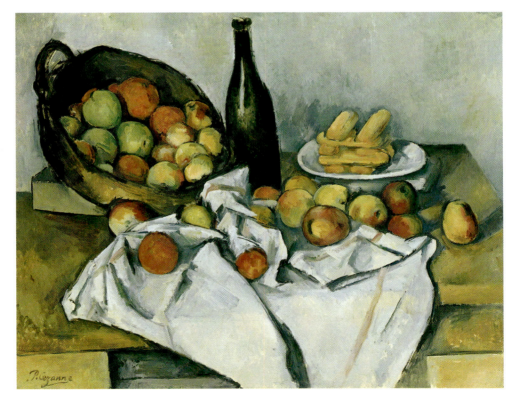

Figure 17-8 **Paul Cézanne** [French, 1839–1906], *The Basket of Apples*, ca. 1895. Oil on canvas, 24 3/8 × 31 in. (65 × 80 cm). Art Institute of Chicago (Helen Birch Bartlett Memorial Collection, 1926). Photo courtesy of The Art Institute of Chicago.

coherent design. For example, the edges of the table on the left and the right do not match, as though the weight of the basket pushed the lines of the table down on the left, and the vacant space of the back wall pulled the sides of the table up on the right. He seems to have interpreted many parts of his still life from different points of view. Cézanne continued the diagonal of the tilted basket in the crease of the tablecloth, which does not break over the edge of the table and seems to lie flat on the surface. Cézanne painted most of the canvas in patches of color, and solid objects such as the apples can also be read as circular patches. Cézanne's method of constructing a composition out of patches of color meant a lot to the next generation of artists, who ignored the remnants of Impressionist realism in his art.

POST-IMPRESSIONIST SCULPTURE: RODIN

Auguste Rodin, more than any other artist at the end of the nineteenth century, transformed sculpture into a modern idiom. Until Rodin, most sculpture continued to reproduce the idealized images of heroes or heroines. Rodin changed sculpture into a powerful means of personal expression and into a vehicle for profound symbolism. His statue *The Thinker* (Figure 17-9) strikingly illustrates his achievement. Michelangelo's art obviously inspired the giant-like proportions and the nudity of *The Thinker.* The nudity also signifies a timeless universality. Rodin originally designed *The Thinker* for a position on the lintel of a large museum doorway that became known as the Gates of Hell. He intended his seated figure as Everyman contemplating scenes from Dante's *Inferno,* illustrated in relief on the doors below.

Rodin may actually have adopted *The Thinker's* pose from printed images of Christ in distress during his passion, but the massive torso leans far forward through space in a thoroughly three-dimensional way. The figure's right elbow rests uncomfortably on his left leg. He does not quietly meditate. He hunches over, bites his knuckles, and claws at the rock with his toes as he agonizes over the human condition. The kneaded irregular surface catches the light, and the vigor of the modeling reinforces the contortions and distress of the figure. Through pose, mass, light, and texture, Rodin made his sculpture express powerful human emotions.

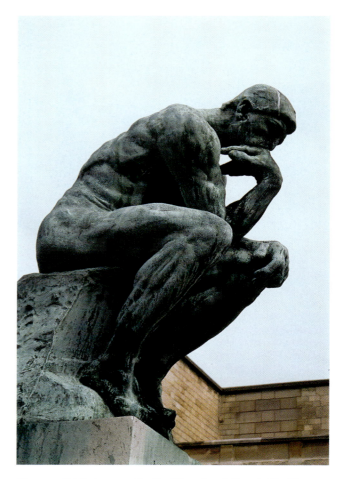

Figure 17-9 Auguste Rodin [French, 1840–1917], *The Thinker,* 1880. Bronze, 79 in. (201 cm) high. Musee Rodin, Paris. © Vanni/Art Resource, NY.

LATE-NINETEENTH-CENTURY ARCHITECTURE

Rapid changes in society in the nineteenth century challenged architects as never before. Since the early 1800s, as urban life mushroomed, architects have had to provide new types of structures such as railroad stations, factories, and office buildings. At first, architects tried to dress the new structures in the old styles of building: Greek, Roman, Gothic, Renaissance, or whatever else was fashionable. But the old styles said nothing about modern life and, in general, ill suited the new types of building. All the while, new materials and technologies gave architects the resources for a new architectural style.

The steel and glass office tower, born from the need for large modern bureaucracies and the economic demands of crowded urban space, takes its stylistic cue from modern materials and from the ef-

Figure 17-10 **Daniel Hudson Burnham** [American, 1846–1912], Reliance Building (32 North State Street), 1894–1895. Chicago. © Angelo Hornak/Corbis.

Figure 17-11 **Louis Sullivan** [American, 1856–1924], Carson, Pirie, Scott Building, 1899–1904. Chicago. Photo courtesy of Stephen A. Edwards.

ficiency of the machine. Stripped to the essentials and dependent on technology—elevators, electricity, central heating, and air conditioning—the modern skyscraper has become the symbol of belonging to the advanced culture of industrialized society.

After the Great Fire of 1871 leveled most of downtown Chicago, the booming city rebuilt itself with increased energy and freshness. Chicago architects became world leaders in new building technology and design. In 1884–1885, William Le Baron Jenny built the first metal frame skyscraper, the ten-story Home Insurance Building in Chicago, torn down in 1931. Another early skyscraper, the fourteen-story Reliance Building (Figure 17-10), by Daniel Hudson Burnham, still stands. From the sidewalk to the tiny cornice at the top, slender vertical steel supports are left unmasked between the large plate-glass windows. (Movable sash windows were still needed to catch summer breezes.) Instead of placing on the exterior

massive vertical supports that would look as though they were bearing the weight, Burnham created horizontal strips of glass subdivided by thin frames. Bands of decorative terra cotta panels separate the floors. The walls are truly a curtain hung from the skeleton and do not support the building. New materials and techniques permit a logical and honest new style of architecture.

Louis Sullivan was another of the pioneers of modern architecture in Chicago at the end of the nineteenth century. In the Wainwright Building in St. Louis (Figure 14-7), he sought an organic style of architecture in which the verticality of the office building and the forces at work in the structure would be expressed on the exterior. In the Carson, Pirie, Scott Building (Figure 17-11) in Chicago, Sullivan made the steel cage construction explicit, then covered its horizontal and vertical lines with panels of white ceramic. Seen from an angle, the lines seem to wrap

around the department store's curved corner, which houses the main entrance.

Sullivan framed the entrance and the display windows of the first two stories in a wrought-iron filigree design of his own invention (Figure 17-12). Delighting the eye of shoppers, this decoration stands in great contrast to the plain white ceramic above. Sullivan's fantasy of curvilinear vine and floral motifs is a good example of the so-called **Art Nouveau** (New Art) style, which was quite fashionable at the end of the century. The Art Nouveau style derived its love of swirling lines from the British Arts and Crafts movement (for example, William Morris's *Trellis* wallpaper, Figure 13-17) and from Japanese art (for example, Hokusai's *Great Wave*, Figure 8-8).

EARLY-TWENTIETH-CENTURY ARCHITECTURE

Gaudí

The Art Nouveau style received monumental expression in the architecture of Antoni Gaudí. The massive stone facade of his Casa Milà (Figure 17-13), an apartment house in Barcelona, curves like a sinuous vine or a surging wave. Up close, the rugged surface of the stone and its rounded forms seem like the weather-beaten rock of a steep cliff penetrated by numerous caverns where a primitive people have started to live. Gaudí, like Louis Sullivan, designed for the building decorative ironwork based on plant and vegetable growth. The iron railings of the exterior balconies of the Casa Milà look like clumps of seaweed that have been flung across the stone. Above the sinuous line of the tiled roof, bell-shaped chimneys spiral into the air as though they have been squeezed out of pastry dough. Each one is different.

The plan of the first floor reveals that Gaudí designed the rooms and corridors of the apartments with the same freedom as the exterior. The irregular and often poly-sided rooms curve around two oval-shaped courtyards. The complex steel skeleton that Gaudí designed for Casa Milà finds no expression

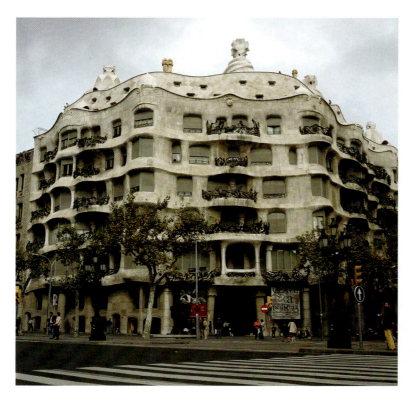

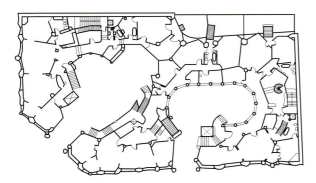

Plan of Casa Milà, ground floor

1. Porch
2. Living room
3. Dining room
4. Balcony
5. Guest room
6. Kitchen
7. Servants
8. Billiard room
9. Children's playroom
10. Entrance hall
11. Boiler room
12. Laundry
13. Garage
14. Court
15. Garden
16. Lavatory or bath
17. Fireplace
18. Bedrooms

Roof

Outdoor walls (garden, terrace, balcony, etc.)

Structures above or below plan level

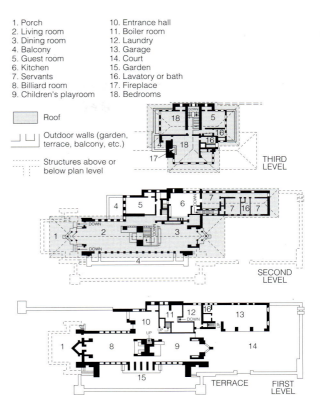

Plan of the Robie House

on the exterior. For Gaudí, a building was a living thing in which the architecture grows out of natural forms. Inspired by the revival of Gothic and Moorish architecture of his native Catalonia, Gaudí created a new expressionistic form of architecture.

Wright

At the same time that Gaudí worked on Casa Milà in Barcelona, the architect Frank Lloyd Wright built the Robie House (Figure 17-14) in Chicago. The Robie

(text continued on page 428)

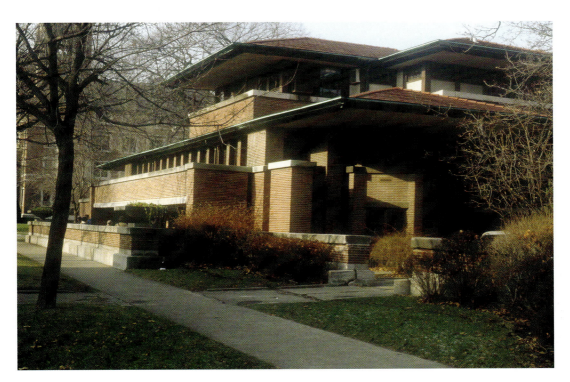

Figure 17-14 Frank Lloyd Wright [American, 1867–1959], Robie House, 1907–1909. Chicago. © Ray F. Hillstrom, Jr./The 11th Hour Pictures. © 2006 Frank Lloyd Wright Foundation, Scottsdale, Arizona/Artists Rights Society (ARS), New York.

Frank Lloyd Wright, a pioneer of twentieth-century architecture, retained all his life nineteenth-century ideas about American culture, its roots in the agrarian heartland, and the freedom of the individual—ideas that he tried to embody in his architecture. Raised in rural Wisconsin, Wright hated the congestion and mob behavior of cities. America remained for him the open spaces and broad plains of the Midwest. He championed the freedom of the individual to move and determine his or her own destiny.

Wright was a precocious child who was destined by his mother to become a famous architect. He studied engineering for two years at the University of Wisconsin, then went to work in Chicago at the architectural firm of Adler and Sullivan, where Louis Sullivan became his inspiration. He left Adler and Sullivan in 1893 to develop his own ideas as an architect while building a series of large suburban homes outside Chicago. There, Wright developed his Prairie style of architecture, characterized by long horizontal lines, low roofs, and interior spaces that flow freely one into another. Wright scorned buildings, old or new, in the shape of a box.

Early in his career, Wright discovered the potential of reinforced concrete and of cantilevering. For example, in the Unity Temple (1906–1908) in Oak Park, Illinois, he left the concrete exposed. Cantilevering in the Johnson Wax Company tower (Figure 14-21) in Racine, Wisconsin, simulates the natural architecture of trees whereas Falling Water cantilevers out dramatically from the hillside. Wright invented his own set of forms that he eventually called organic or natural. His theory of natural architecture required that buildings

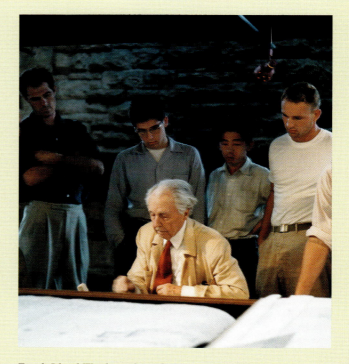

Frank Lloyd Wright with students near Spring Green, Wisconsin. © Marvin Koner/Corbis.

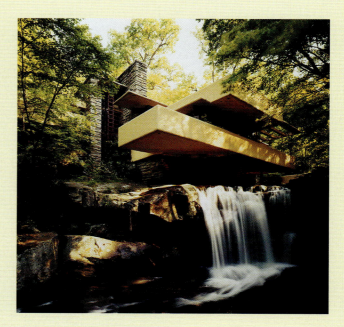

Frank Lloyd Wright [American, 1867–1959], Falling Water, exterior, 1936–1939. Bear Run, Pennsylvania. Western Pennsylvania Conservancy/Art Resource, NY. © 2006 Frank Lloyd Wright Foundation, Scottsdale, Arizona/Artists Rights Society (ARS), New York.

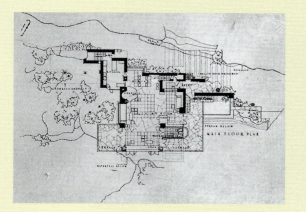

Plan of Falling Water. © 2006 Frank Lloyd Wright Foundation, Scottsdale, Arizona/Artists Rights Society (ARS), New York.

Frank Lloyd Wright [American, 1867–1959], Falling Water, interior, 1936–1939. Bear Run, Pennsylvania. © Art Resource, NY. © 2006 Frank Lloyd Wright Foundation, Scottsdale, Arizona/Artists Rights Society (ARS), New York.

be placed in their natural setting and be built with natural materials and with techniques drawn from nature.

Falling Water, the summer home he built for Edgar J. Kaufmann, the owner of a department store in Pittsburgh, illustrates Wright's principles in a memorable fashion. Using reinforced concrete and the local stone, he built the house on the rock outcropping above a waterfall and amid the trees, thereby literally integrating the house with nature. The reinforced concrete terraces cantilever out from the cliff as though they were a natural growth. Their lines parallel the rock strata. The rooms on the interior flow into one another. Large windows give the feeling that the house embraces the surrounding woods. Indeed, part of the rock cliff comes up through the living room floor to form the base of the fireplace, which Wright still considered the central focus of a home.

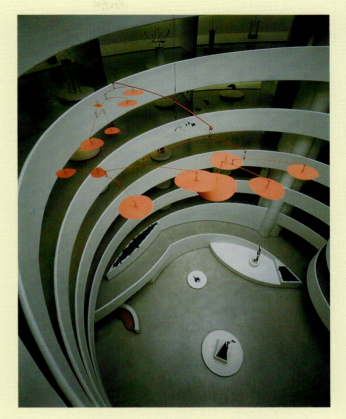

Frank Lloyd Wright [American, 1867–1959], Guggenheim Museum interior, 1943–1959. New York. Photo by David Heald © The Guggenheim Foundation, New York. © 2006 Frank Lloyd Wright Foundation, Scottsdale, Arizona/Artists Rights Society (ARS), New York.

After World War II, Wright designed several buildings that to this day have the appearance of a science fiction fantasy. The Solomon R. Guggenheim Museum in New York, with its gallery spiraling down beneath its dome, looks like a fantastic movie set. Visitors to the museum are expected to take the elevator to the top of the ramp and to view the art along the walls on the way down. Some museumgoers have complained that the building, with its tilted ramp and tilted walls, overwhelms the art on display. The Guggenheim Museum was one of the few buildings Wright ever designed for a city street. Like many of his buildings, these personal expressions of a strong individual have had very few imitators.

Wright had a long and successful career, noted for numerous technical and stylistic innovations. He proudly considered himself the greatest architect of the twentieth century. Articulate and outspoken, he wrote an autobiography and several books about architecture, while leading a colorful, sometimes flamboyant life.

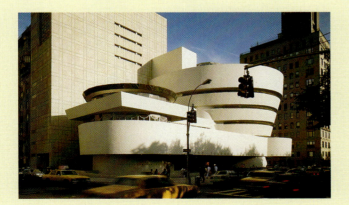

Frank Lloyd Wright [American, 1867–1959], Guggenheim Museum, exterior, 1943–1959. New York. Photo by David Heald © The Guggenheim Foundation, New York. © 2006 Frank Lloyd Wright Foundation, Scottsdale, Arizona/Artists Rights Society (ARS), New York.

House has a long, low roof and windows arranged in strips that accentuate the horizontal direction. He named this kind of architecture the *Prairie style* since these low horizontals mimic and hug the flat midwestern prairie—even though the house is sited on a residential street corner. Terraces extend the house into the outdoors and integrate it with nature so that the house seems to grow naturally out of the ground. Rather than break the horizontal lines of the building, Wright placed the street entrance to the house on the short side and toward the back.

On the interior, the Robie House has an asymmetrical plan, in which the rooms of the main floor radiate out from the central focus, the fireplace. Even though his houses have separate kitchens and central heating, Wright made the hearth, the traditional source of heat, food, and light, the symbolic core of family living. Wright adapted the low horizontal roof, the fluid interior spaces, and the integration of the house with nature from Japanese architecture (see the Katsura Palace, Figures 16-26 and 16-27), which he knew and admired. In the Robie House he declared to the rest of the twentieth century that the essential factor in architecture is the experience of space.

EARLY-TWENTIETH-CENTURY PAINTING

The twentieth century was a period of enormous material progress and technological change. Great advances in education, social welfare, medicine, and mass communications altered the lives of billions of people throughout the world. The twentieth century also produced two world wars of unprecedented devastation, dictatorial governments that practiced oppression on a massive scale, and for the first time in history the real threat of nuclear and environmental extinction for the human race. The century had a mixed record of achievement, to say the least. Modern artists, sensitive to the changing values around them, reflected these upheavals in their work.

Twentieth-century artists did not invent a single, unified style—nor could there be a single modern style, since rapid change and personal freedom of expression are an overwhelming part of modern culture. In fact, the variety of stylistic possibilities within the modern movement was one of the century's strengths. Within the variety of modern styles, artists time and again concerned themselves with the search for the essential, the primitive, and the inner self.

In the early years of the twentieth century, artists felt an exciting freedom to experiment and create one new style after the other. These pioneers of the modern movement came to realize that Gauguin, van Gogh, and Cézanne had won for them the freedom to use color as an expressive means and to let purely artistic considerations control lines and shapes. Early-twentieth-century Western artists borrowed freely from other cultures to find new ways of seeing with simplified forms, nonperspective space, and bold, overt designs.

Leading artists often felt a growing frustration with traditional Western values, but at the same time they often hoped that their new art would lead the human race to a better future. Paradoxically, the modern styles they created often became difficult for the public to understand because artists attempted to return to such basic, simple forms of seeing and to such purity of means. These tensions and contradictions have not made modern art easy for the general public. Nevertheless, modern art reflected the pace, the changing values, and the tensions of modern life, as well as its dreams of progress, equality, and individual freedom.

EXPRESSIONISM

The early modern French painter Henri Matisse wanted his art to be an expression of his feelings. The styles of van Gogh and Gauguin showed him the way. In 1905 Matisse so shocked the public with an exhibition of vividly colored and freely painted work that he and his friends were labeled wild beasts (*fauves* in French). One of the paintings in the exhibition, *Open Window, Collioure* (Figure 17-15), illustrates a marina seen through a vine-covered window. Flowerpots rest on the sill. Matisse painted this pleasant view with thick strokes of color almost totally unrelated to natural appearances. Shapes and lines become bold patches of color that lie flat and emphatically decorate the surface despite the distant view. His painting has the intuitive simplicity of a child yet achieves a vibrant harmony of the secondary colors. The bright colors and simple forms express his feelings and downplay the imitation of reality.

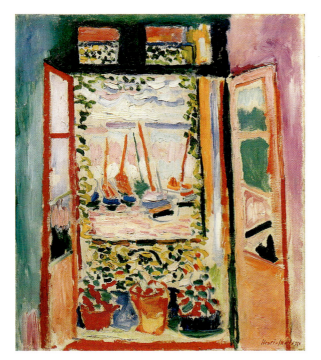

Figure 17-15 Henri Matisse [French, 1869–1954], *Open Window, Collioure*, 1905. Oil on canvas, 21 3/4 × 18 1/8 in. (55.25 × 46.04 cm). National Gallery of Art, Washington, D.C., Collection of Mr. & Mrs. John Hay Whitney, NY. © 2005 Succession H. Matisse, Paris/Artists Rights Society (ARS), New York.

Matisse had positive feelings about life to express. His common practice was to paint his emotions intuitively and then refine his instincts by continually adjusting his lines and colors and planes to reflect his mental state. Matisse's emotional sensitivity and his artistic refinement make his art a pleasure to look at—at least, after the initial shock. He wanted his paintings to be as comfortable as an old easy chair.

Other Expressionists, close to Matisse in time, used similar stylistic means to express, instead of Matisse's joy about living, their anxiety about life in the modern world. An outstanding group of young German Expressionists—including Ernst Ludwig Kirchner (see *Self-Portrait with Model*, Figure 4-17) and Erich Heckel (see *Two by the Sea*, Figure 6-5)—had strong feelings about the emptiness of modern urban society. Meanwhile, they searched frantically for personal integrity by a return to direct self-expression. They identified their association as *Die Brücke* (The Bridge) because they hoped to span the gap between the corrupt past and a bright new future.

In 1908 Kirchner depicted, in the large painting *Street, Dresden* (Figure 17-16), a city thoroughfare filled with well-dressed women wearing broad-brimmed flowered hats. But Kirchner used a primitive style derived from Edvard Munch (see *The Scream*, Figure 3-4) and the art of the Post-Impressionists, the Fauves, and the Middle Ages to elicit the smugness and apprehension looming in their complacent world. The German Expressionists embodied their anxiety-filled view of life in flattened perspective, harsh flat colors (the pink pavement in

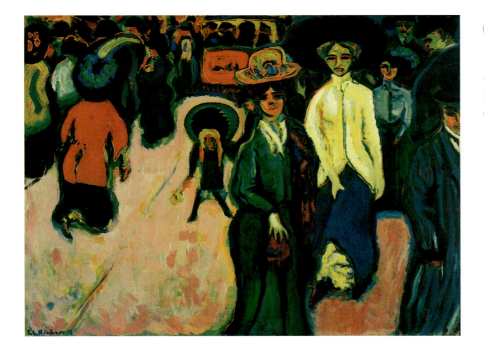

Figure 17-16 Ernst Ludwig Kirchner [German, 1880–1938], *Street, Dresden*, 1908 (dated 1907). Oil on canvas, 59 1/4 × 78 7/8 in. (150.5 × 200.3 cm). Museum of Modern Art, New York. © MOMA/Art Resource, NY.

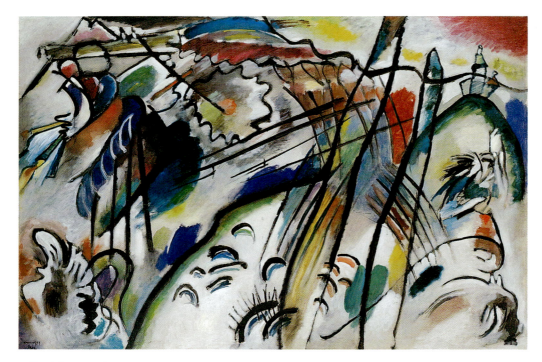

Figure 17-17 **Wassily Kandinsky** [Russian, 1866–1944], *Improvisation Number 28*, 1912. Oil on canvas, 44 × 63 3/4 in. (111.8 × 161.9 cm). Solomon R. Guggenheim Museum, New York. Photo David Heald © The Solomon R. Guggenheim Foundation, New York. © 2006 Artists Rights Society (ARS), New York/ADAGP, Paris.

Street, Dresden), jagged lines, distorted shapes, and mask-like features.

Even though artists for years had come to depend chiefly on visual elements such as lines and colors to express themselves, it was only about 1912 that a few of them dared to eliminate all natural appearances from their work and use only the visual elements. The Russian painter Wassily Kandinsky, in works such as *Improvisation Number 28* (Figure 17-17), was one of the first to make truly nonobjective art.

The theory of the correspondences among different sense perceptions helped Kandinsky take the final step toward creating a thoroughly abstract expressionism. Furthermore, Kandinsky believed that colors, lines, and shapes had symbolic or spiritual significance, so by themselves they could convey the personal meaning that he wanted. In 1913 he described his feelings and his beliefs in a book called *On the Spiritual in Art*. In it, he wrote that he found blue restful and heavenly, the equivalent of horizontal direction. Yellow was vertical and aggressive. Each shape to Kandinsky had a particular spiritual perfume. Visual forms also had aural equivalents—the mu-

sical title *Improvisation Number 28* betrays his thinking. His abstract forms were far from meaningless scribbling; instead, they were intended to reproduce a spiritual aura. They created a new sort of space; his free-form lines and shapes seem to float in an ambiguous world appropriate for his personal spiritual message.

CUBISM

In the years before World War I, Pablo Picasso, a Spanish artist living in Paris, invented a new style called Cubism, very likely with an eye to rivaling the bold steps taken by Matisse in his Fauvism. Picasso asserted the new style in *Les demoiselles d'Avignon (The Women of Avignon)* of 1907 (Figure 17-18), the sudden and violent manifestation of a bold new direction. The painting began as the representation of five prostitutes in a Barcelona brothel on Avignon Street displaying themselves before a curtain for two male viewers. Eventually, the specific narrative elements of the painting were eliminated from everything but the title. In keeping with the harshness of the subject, the figures twist so violently that their forms become geometric shapes like the

Figure 17-18 Pablo Picasso [Spanish, 1881–1973], *Les demoiselles d'Avignon* (begun May, reworked July 1907). Oil on canvas, 96 × 92 in. (243.8 × 233.7 cm). Museum of Modern Art, New York (acquired through the Lillie P. Bliss Bequest). © MOMA/ Art Resource, NY © 2006 Estate of Pablo Picasso/Artists Rights Society (ARS), New York.

square, triangle, and circle lying flat on the surface. Picasso also fragmented the brown and blue drapes behind them into flat shapes. Only differences in color isolate the pink flesh-colored figures from the ground.

By 1907, Picasso had discovered the colored planes in Cézanne's paintings (see *The Basket of Apples,* Figure 17-8), and he had heard that Cézanne wanted artists to see above all the geometry inherent in nature. He had also noticed that African artists made even more radical reductions into geometry: the two faces on the right of *Les demoiselles d'Avignon* especially resemble African masks (see the Bushongo mask in Figure 17-22, page 433). Furthermore, Picasso rejected Renaissance perspective and, along with it, the single point of view from which an image was depicted. In the figures on the left, Picasso showed the eye of a face from one point of view, the nose from another—just as the ancient Egyptians did. The posi-

tion of things and the shape of the patches on his canvas are governed by his desire to build a composition of forms on the surface arranged in a new kind of picture space.

In this landmark painting, Picasso here and there extended the lines of the shapes of the figures right to the edge of the canvas. For example, the contours of the forearms of the figure in the upper right seem to be projected into the surrounding space. The projection ties the figure and surrounding space together, thus making it increasingly difficult to tell where the figure ends and the ground begins. The flatness of the surface is preserved, and equality among the shapes across the surface is maintained.

In the Cubist style that Picasso and his friend Georges Braque developed over the next several years, they filled the entire surface with almost colorless Cubist fragments. Their method is evident in Picasso's painting *Ma Jolie (My Pretty Girl)*

Figure 17-19 **Pablo Picasso** [Spanish, 1881–1973], *Ma Jolie*, 1911–1912. Oil on canvas, 39 3/8 × 25 3/4 in. (100 × 65.5 cm). Museum of Modern Art, New York. Digital image © The Museum of Modern Art. Licensed by Scala/Art Resource, NY. © 2006 Estate of Pablo Picasso/Artists Rights Society (ARS), New York.

Figure 17-20 **Pablo Picasso** [Spanish, 1881–1973], *Mandolin and Clarinet*, 1913. Painted wood and pencil, 22 7/8 × 14 1/8 × 9 in. (58 × 36 × 23 cm). Musée Picasso, Paris. © Giraudon/Art Resource, NY. © 2006 Estate of Pablo Picasso/Artists Rights Society (ARS), New York.

(Figure 17-19), in which the human subject cannot be separated from the background. (The painting began as a portrait of Marcelle Humbert playing a guitar. She was Picasso's mistress, whom he called *ma jolie* after the title of a popular song.) By breaking the entire surface into Cubist pieces, Picasso did away with the usual relationship between a dominant figure and a subordinate ground. To a Cubist's mind, the entire space is important. The shapes we perceive in space are all relative to one another and to our point of view—no one of them should dominate. Light and dark contrasts contribute to making the spatial relationships in Cubism ambiguous (see *Nude,* Figure 4-8). The relativity of human perceptions is a very modern attitude.

Picasso himself offered an insight into the kind of spatial composition that Cubism created when he constructed some relief sculpture in a Cubist style. To make *Mandolin and Clarinet* (Figure 17-20), he found ordinary scrap materials, cut some of them into simple shapes, then assembled the shapes into a shallow relief several inches deep. With a few painted lines, a plank of wood became a mandolin's fret board; a few dots and circles changed a cylinder of wood into a clarinet. However, the pieces, which resemble the facets of painted Cubism, lie this way and that. They overlap and intersect and fragment the objects. Picasso never exhibited his Cubist reliefs, but a number of sculptors who visited his studio were deeply impressed by them. Every modern sculptor who welds or nails or glues shaped pieces together or assembles things in any way owes Picasso a debt.

AFRICAN ART

In addition to Picasso, a number of early-twentieth-century artists admired and collected pieces of African sculpture. They valued the bold expression of its designs and the essential nature of its forms as the

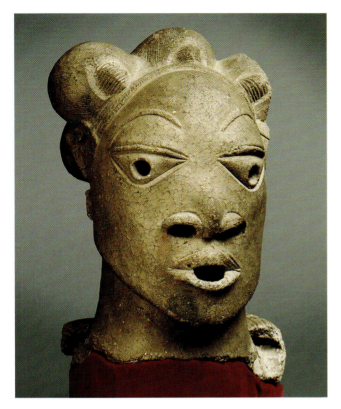

Figure 17-21 [Nok, African], head, ca. 500 BCE–200 CE. Terra cotta, 14 1/4 in. (36.2 cm) high. National Museum, Lagos, Nigeria. Photograph © 1980 Dirk Bakker.

Figure 17-22 [Bushongo tribe, Bakuba, African], dance mask. Painted wood, 17 × 12 1/4 × 11 1/8 in. (43.2 × 31.1 × 28.3 cm). Cleveland Museum of Art. James Albert and Mary Gardiner Ford Memorial Fund.

means to wipe the slate clean and make a new beginning in art. Like Gauguin, they probably felt that non-Western artists got closer to the essential truth in their art. However, Picasso and his contemporaries may have had little idea about the range of African sculpture and its actual significance within African society.

Since so much African sculpture was carved in wood, which perishes quickly in the climate of Africa, most examples seen in European and American collections date from the nineteenth and early twentieth centuries. Nevertheless, pieces in more durable terra cotta and bronze date back to centuries ago. A number of fully developed terra cotta heads have been found in the village of Nok and other areas in northern Nigeria. The life-sized example in Figure 17-21 illustrates several characteristics of the Nok style. Within the overall naturalism of the rendition exist a few elements of abstraction: the upper eyelid is horizontal, whereas the lower lid is curved, and the lips top and bottom are symmetrical. It is quite possible that the sculpture carried out in the Nok area influenced the idealized bronze pieces of Ife (see the head in Figure 16-13) and then Benin.

Outside of Egypt and Nubia, African sculpture is found in Nigeria and the forests along the West African coast as well as in the Congo Basin (see the map on page 380). Of all the many different peoples who inhabit those regions, the Yoruba of southern Nigeria seem to relish most the making of sculpture. These prolific sculptors have worked in a variety of materials, techniques, and types, including masks, freestanding figures (see *Twin Memorial Figures,* Figure 1-8), and architectural reliefs.

African art, like other arts around the world, usually served a function in society; divorced from its function, it loses a part of its meaning. African sculptors carved many masks meant to be worn in rituals in which the wearer could be empowered with the spirit of the god or person the mask expressed. The painted wooden mask in Figure 17-22, of the Bushongo tribe among the Bakuba people of the Congo, was worn in a dance to promote an increase of an aspect of the life force. The exaggeration of the features of the face were intended to squeeze as much power as possible from the impersonation.

DADA AND SURREALISM

While World War I raged in Europe, a number of artists rebelled against a materialistic society engaged in mass slaughter on the battlefield by emphasizing the absurd in life. A small group of them assumed the childish name Dada for their movement. In a famous incident, the prominent Dada artist Marcel Duchamp drew a mustache on a reproduction of the *Mona Lisa* and displayed it as a protest and as a rejection of traditional values. He also exhibited everyday objects as works of art, which he called ready-mades. For example, in 1917 he tried to enter a urinal he named *Fountain* (Figure 1-21) in an exhibition of art in New York. In another, earlier example, just before the war broke out, Duchamp took a bicycle wheel, secured it to an ordinary stool, and exhibited the piece, called *Bicycle Wheel* (Figure 17-23).

Underneath the social protest and the mockery of high art, Dada asserted, positively, that art resides in the creative intention of the artist. Duchamp's new intention for the wheel and stool forces us to look at those objects in a different way. Asked to view *Bicycle Wheel* as art, we become aware of the shapes and their relationship to one another. We notice the legs supporting the piece, the circular head, and the frustrated motion of the wheel.

After the war, in the 1920s, the absurd element in Dada was put in a more positive light by the Surrealists, who also sought to transform reality into something extraordinary. Led by the poet André Breton, who wrote the movement's manifesto in 1924, Surrealism contended that true reality lies in the subconscious. The discoveries of Sigmund Freud's *The Interpretation of Dreams* (1900), which were just then becoming popular, influenced Surrealism a great deal with the revelation that dreams were a fundamental avenue to explore the subconscious. Surrealist artists wanted to paint nothing less than the images of the unconscious mind; therefore, they depicted the often irrational combinations of things that seem very real at the time we are dreaming.

In *Two Children Are Threatened by a Nightingale* (Figure 17-24), the Surrealist artist Max Ernst made the sweet and gentle songbird a source of terror in the same way that ordinary things become sources of fright in a nightmare. He combined traditional painting with miniature real objects so as to destroy the distinction between illusion and reality. Objects lie within and in front of the deep, dark frame, obscuring the distinction between picture space and the real space, between the dream world and real life. In the painted portion, one child lies dead and another threatens the bird with a knife— or perhaps she is running from her victim on the ground. On the rooftop a faceless man carrying a child runs toward an actual door buzzer to set off an alarm. Ernst's work makes no rational sense, but for that very reason it captures the feel of a dream as it stimulates hidden recesses of our unconscious imagination.

René Magritte also practiced Surrealist painting (*The Birthday*, Figure 6-12); Meret Oppenheim made Surrealist sculpture (*Object*, Figure 2-34). Joan Miró (*Figure*, Figure 3-22) and Yves Tanguy (*Indefinite Divisibility*, Figure 4-5) explored the possibility of an abstract Surrealism in their work. The American photographer Man Ray produced a Surrealist photography that exploited chance and the dislocation of things from everyday reality. To make his *Rayograph* (Figure 17-25), a pun on his name, he

Figure 17-23 **Marcel Duchamp** [French, 1887–1968], *Bicycle Wheel*, 1913 (lost). Third version, 1951. 50 1/2 in. (128.3 cm) high. Museum of Modern Art, New York. Digital image © The Museum of Modern Art. Licensed by Scala/Art Resource, NY. © 2006 Artists Rights Society (ARS), New York/ADAGP, Paris/Succession Marcel Duchamp.

randomly placed objects on a piece of light-sensitive paper in a darkroom and then exposed the paper momentarily to light. By means of his cameraless photography, the soft white silhouettes of real objects seem to float through space in a dreamy new existence.

In the early years of the twentieth century, Expressionism, Cubism, Dada, and Surrealism became the basis for many new styles and new ways of seeing. Cubism taught modern artists to see picture space in a new way. No longer a mirror of nature, pictorial space is now constructed afresh by each image maker. Van Gogh and Matisse taught artists to express their feelings in color and form. Kandinsky pioneered pure subjectivity, painting nonobjective compositions of lines and colors. The Surrealists made artists aware of the subconscious and opened the door wide to the free use of fantasy and imagination. Modern artists have adapted the achievements of these pioneers to their own needs, in many ways working out the possibilities in the modern style established by Picasso, Matisse, Duchamp, Ernst, and others at the beginning of the century.

FUTURISM

In 1910, several Italian artists declared that they would reflect the dynamism of modern life in their art. They had read the *Manifesto of Futurism* by the poet F. T. Marinetti, who wrote that a "roaring automobile, which appears to run like a machine gun, is more beautiful than the *Victory of Samothrace,*" the most famous Greek statue in the Louvre Museum.[1] Italian Futurist artists rejected all the representational art of the past and declared that museums ought to be swept clean of it. They set out instead to depict the movement of forms in space and the integration of all material bodies in space as revealed by modern science. Their art glorified speed, power, and aggression.

Umberto Boccioni illustrated these ideas in his sculpture *Unique Forms of Continuity in Space* (Figure 17-26). The masses of the powerful running figure flow out into the space around it, and space penetrates the figure's masses. The flowing curves indicate the different positions of the figure through successive moments of time. The sculpture is filled with lines of force that express dynamic motion, a key feature of Futurism. Many Futurist artists, like Boccioni in his painting *Dynamism of a Soccer*

Figure 17-26 **Umberto Boccioni** [Italian, 1882–1916], *Unique Forms of Continuity in Space*, 1913, cast 1931. Bronze, 43 1/3 in. (110.1 cm) high. Museum of Modern Art, New York (acquired through the Lillie P. Bliss Bequest). Digital image © The Museum of Modern Art. Licensed by Scala/Art Resource, NY.

Player (Figure 3-6), changed the flat facets of Cubism into signs of energy by repeating them rhythmically and by projecting the facets across the picture space as lines of force.

CONSTRUCTIVISM

One of the most creative periods in the modern movement occurred in Russia between 1910 and about 1925. In the early years of the twentieth century, Russia was in turmoil as new ideas from the West fanned the fires of revolution against the oppressive czarist regime. The avant-garde artists of Russia welcomed and celebrated the victory of the Russian Revolution of 1917, and many Russian artists dedicated their work to the service of the utopian communist state. Their modern art would help revolutionize society and help build the new socialist culture. In a short number of years before the Revolution, several Russian artists had absorbed the lessons of the Post-

Figure 17-27 Lyubov Popova [Russian, 1889–1924], *Constructivist Construction*, 1921. Oil on panel, 36 5/8 × 24 1/4 in. (93 × 61.5 cm). Collection Mr. and Mrs. Roald Dahl.

Figure 17-28 Piet Mondrian [Dutch, 1872–1944], *Composition with Red, Yellow and Blue*, 1922. Oil on canvas, 16 1/2 × 19 1/4 in. (41.9 × 48.9 cm). Minneapolis Institute of Arts.

Impressionists and of Matisse and Picasso. In general, they combined the modern style from France with the colorful primitivism of their own folk art.

When the Russian Revolution began in 1917, the painter Lyubov Popova was practicing a dynamic form of Cubism that Russians also called Futurism. By the early 1920s, she had moved from the investigation of Cubist space to the construction of nonobjective lines and planes, or Constructivism. In her *Constructivist Composition* (Figure 17-27), diagonal lines crisscross the panel. They can be read as thin strips or the leading edges of intersecting planes. Since it has no Cubist build-up toward the center, her painting seems like a fragment of a new kind of visual world.

Popova was concerned only with the material organization of the visual elements in the belief that the solution of these design problems would contribute to the new socialist society. In fact, she and her Constructivist colleagues soon gave up easel painting altogether and devoted themselves to theater production, furniture and textile design, book illustration, and other forms of graphic design. A few years after her early death, the Soviet Union, under Stalin, turned its back on the Russian artists who had struggled to find a new visual art for the Revolution. Some were persecuted; others fled the country.

DE STIJL: MONDRIAN

The lessons of Cubism had a different effect on the Dutch painter Piet Mondrian, who was the theoretician for a group of Dutch artists and architects called De Stijl (Style). In a typical work of Mondrian's maturity, *Composition with Red, Yellow and Blue* (Figure 17-28), the intuitively formed and ambiguously placed shapes of Cubism give way to a carefully thought-out choice of elements. Purging his style of personal expression, Mondrian reduced the facets of Cubism to the most basic of visual means. He distilled all lines to the intersection of only horizontal and vertical lines; he subsumed all shapes into the rectangle; he expressed every possibility of light by black and white, every color by the three primaries: red, yellow, and blue. To Mondrian, these

were the fundamental principles of nature, corresponding to essential mental antitheses such as active and passive, male and female. His paintings were not an imitation of nature—not even a reduction or abstraction of forms found in nature—but the re-creation of the essential in nature and the underlying forces of nature.

To express the dynamic harmony of reality, Mondrian arranged his essential elements in an asymmetrical balance. A large rectangle might play against several small rectangles. A rectangle of attractive color counterbalances the activity of a number of lines. The size, shape, and location of each element in a Mondrian composition are adjusted to the balance of the whole. No one element stands out and demands attention.

Mondrian was a mystic who searched for ultimate reality and who envisioned that the universal harmony of the visual elements in his paintings would spread over all society and make the world a better place. His dream of a universal community through art may not have come true, but a lot of modern architecture and modern design throughout the world speaks the language of his rectangular style.

SCULPTURE: BRANCUSI

The desire to simplify external reality in order to attain the essence of things also became manifest in modern sculpture. Likewise, the example of arts from around the world demonstrated to Western sculptors which forms to use in order to attain essential reality. When Constantin Brancusi, a pioneer of twentieth-century sculpture, carved the portrait of the artist dancer *Mademoiselle Pogany* (Figure 17-29), he was striving to reduce the forms of nature to a basic egg-shaped mass, symbolizing the origin of all life. The wide eyes and arched brows of his bust portrait came from African masks. Brancusi's primitivism took him far from the emotional expression and rippling surface of Rodin's *The Thinker* (Figure 17-9). Mademoiselle Pogany's tubular arms taper to her hands at the side of her head, and the curving, streamlined flow of the forms reproduce the lanky, long-necked grace of a dancer. Brancusi's witty and often elegant sculpture demonstrated to generations of artists how to shape elemental masses and portray primitive essences.

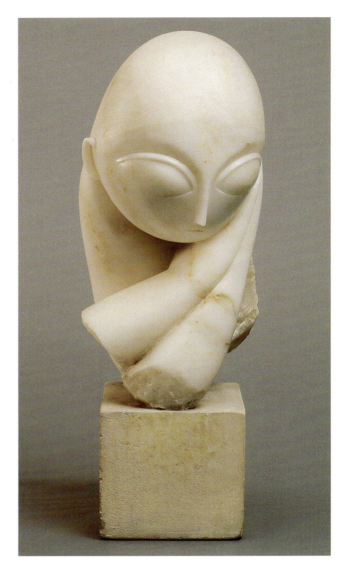

Figure 17-29 Constantin Brancusi [Rumanian, 1876–1957]. *Mademoiselle Pogany*, 1913. White marble and stone base, 17 1/2 in. (44.5 cm) high, 6 in. (15.2 cm) wide. Philadelphia Museum of Art. Given by Mrs. Rodolph Meyer de Schauensee. © 2006 Artists Rights Society (ARS), New York/ADAGP, Paris.

THE BAUHAUS

The **Bauhaus,** the most famous school of art in modern times, was founded in Weimar, Germany, in 1919 by the architect Walter Gropius. Over the years, the Bauhaus had on its staff an illustrious group of teachers: Paul Klee arrived in 1921; Wassily Kandinsky joined the Bauhaus in 1922. Josef Albers and others transformed the curriculum after 1923 into a systematic study of the visual elements and their application not only in painting and sculpture but also in the applied arts. In fact,

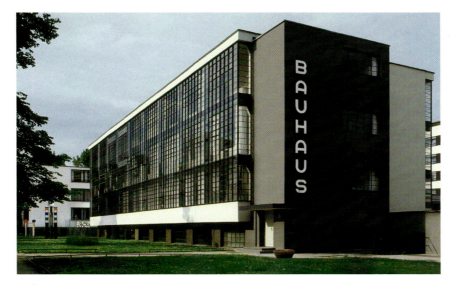

Figure 17-30 **Walter Gropius** [German-American, 1883–1969], The Bauhaus, 1926. Dessau, Germany. © Vanni/Art Resource, NY. © 2006 Artists Rights Society (ARS), New York/VG Bild-Kunst, Bonn.

In 1926 the Bauhaus moved to Dessau, Germany, where Gropius designed new buildings (Figure 17-30) that became the foundation for the **International Style** of modern architecture. Constructed of reinforced concrete, the flat-roofed buildings contained classrooms, workshops, a cafeteria, a theater, and twenty-eight studio-dormitory rooms. The glass curtain wall that encased the workshop building stood free from the piers a few feet behind. A two-story-high bridge across a road connected the workshops with the administration building.

After Hannes Meyer, a militant Marxist, ran the school for a few years, the architect Mies van der Rohe was appointed director from 1930 to 1933, when the school closed under pressure from fascists, who condemned the Bauhaus as a nest of communists and Jews. Nevertheless, its art, architecture, design, and art theory influenced the course of modern art long after its closing.

those at the Bauhaus did not distinguish between the fine arts and crafts, and a community or team spirit united all the arts. During its turbulent fourteen-year history, ideas of every kind were put to the test, resulting in simple, unornamented household furnishings (see Marcel Breuer's side chair in Figure 13-25) and graphic design.

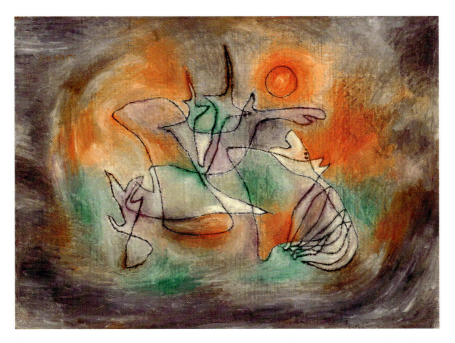

Figure 17-31 **Paul Klee** [Swiss-German, 1879–1940], *Howling Dog*, 1928. Oil on canvas, 17 1/2 × 22 3/8 in. (44.5 × 56.8 cm). Minneapolis Institute of Arts. Gift of F. C. Schang (56.42). © 2006 Artists Rights Society (ARS), New York/VG Bild-Kunst, Bonn.

The Swiss-German artist Paul Klee helped direct several craft workshops at the Bauhaus and for years taught the course in basic design. In his own work—for example, *Howling Dog* (Figure 17-31)—he often invented whimsical designs in which the clever title is very much part of the visual message. Over floating, translucent areas of orange, green, and blue-violet gray, Klee drew black lines that correspond to the wailing noise of a dog baying at the moon—the orange circle at the top. It would be hard to recognize the image as a dog without the title because the lines convey the feel more for the reverberating noise, rather than for the animal's contours. The curving lines form transparent shapes that overlap

one another, yet they can also be seen as one continuous line that ambles around and around like a doodle. The movement of the line creates a playful rhythm that is echoed in the colors that dance around it. More than likely, Klee "took a line for a walk" (his own definition of drawing), giving his imagination free rein, then labeled the result *Howling Dog* to add a whimsical note to his creation.

MEXICAN MURALS

In the 1920s and 1930s, the painters Diego Rivera, José Clemente Orozco, and David Alfaro Siqueiros led a resurgence of mural painting in Mexico. The new socialist government of Mexico offered the artists the walls of schools and government buildings for fresco paintings that would condemn the historical forces of oppression, glorify the people of Mexico, and illustrate the bright future promised through revolutionary social change. The artists were actively committed to the government's task of educating the people and winning their favor through art. They succeeded in creating a new image for the Mexican nation that helped forge a new national identity.

Diego Rivera and a team of artists decorated the wall of the newly constructed Ministry of Education building in Mexico City with more than 116 compositions. The work is a compendium of the life of the Mexican people, celebrating their festivals and work, their struggles for social improvement, and their achievements. The murals line the walls on three levels around the perimeter of two courtyards. One series of murals on the third level of the larger courtyard imitates two *corridos*—popular Mexican ballads full of sentiment and satire. The composition *Orgy—Night of the Rich* (Figure 17-32) forms part of the Corrido of the Agrarian Revolution. In this section, Rivera alternates scenes of the corruption of the rich with scenes of rural peasants who lead simple but much healthier lives. *Orgy* mocks two rich men, dressed in tuxedos, who spend the night drinking cocktails with scantily clad young women. On the right, a cigar-smoking landowner is fawned over by two men, one of whom carries a bag. Above and behind this allegory of corruption, a red-shirted soldier prepares others for the revolution.

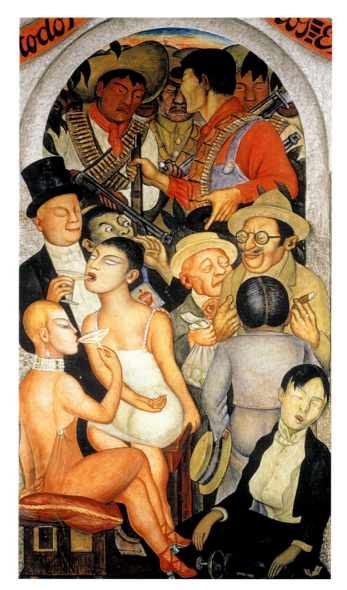

Figure 17-32 Diego Rivera [Mexican, 1886–1957], *Orgy—Night of the Rich*, 1923–1928. Fresco, Secretaría de Educación Pública, Mexico City. © Schalkwijk/Art Resource, NY.

Rivera studied modern art in Paris and then spent a year studying mural painting in Italy before returning to Mexico. He combined those influences with the example of Mayan art and the popular art of Mexico, like that of the printmaker José Posada (Figure 8-16). In his murals, Rivera invented a rich, new iconography expressed in a bold and simple style that spread a Marxist-socialist interpretation of national life.

1930S ART

The 1930s witnessed the rise of fascism in Italy, Spain, and Germany, where Hitler ridiculed modern

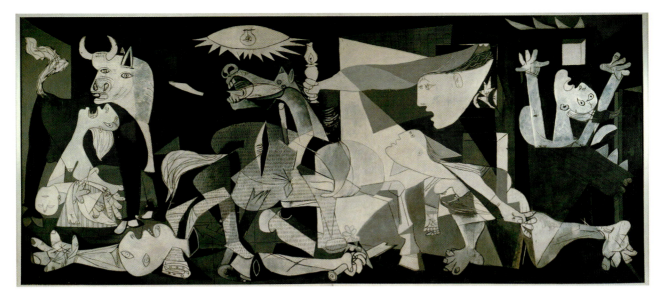

Figure 17-33 **Pablo Picasso** [Spanish, 1881–1973], *Guernica*, 1937. Oil on canvas, 11 ft. 6 in. × 25 ft. 8 in. (3.5 × 7.8 m). Museo Nacional Centro de Arte Reina Sofia, Madrid. © 2006 Estate of Pablo Picasso/Artists Rights Society (ARS), New York.

art as degenerate. The decade also witnessed the dictatorship of Stalin, which crushed every trace of revolutionary art in Russia. It saw the Great Depression and a world heading relentlessly to a second great war. While social realism characterized art in Mexico and the United States, in France Surrealism became the dominant artistic force. It even attracted Picasso, who used Surrealist principles of distortion and psychic investigation as a new means to express the crises in the world.

In 1937, Picasso painted the mural *Guernica* (Figure 17-33). During the Spanish Civil War, the small town of Guernica, the capital of the Basque region of Spain, was the first city in history to receive saturation bombardment from the air. Picasso rapidly painted the mural illustrating this uniquely twentieth-century experience for the pavilion of the ill-fated Spanish Republic at the Paris World's Fair that year. It did not take much imagination in 1937 to see that the bombing of civilian populations by the fascists was a nightmarish prediction of things to come.

Rather than illustrating the actual bombing, Picasso developed the iconography of *Guernica* from the ritual killing of the bullfight and other traditional sources. The scene is ineffectually illuminated by the harsh light of a bare bulb overhead. On the left, a bull, the symbol of brute force and darkness, menaces a screaming woman holding her dead son—a reference to the *pietà*, the image of Mary mourning over the body of Christ in Christian art (see Michelangelo's *Pietà*, page 136). The horse of the picador (Picasso said it represented the people) writhes in pain because it has been wounded by its rider's spear. At its feet lie the broken limbs of a warrior—perhaps the statue of a hero from a different time, when warriors had faces. On the right, a woman in flames leaps from a burning building. An elongated head and arm protrudes from a window and tries to illuminate the scene with her lamp.

Guernica, painted in black, white, and gray, has a fairly balanced and traditional composition—a triangle—that keeps the Cubist planes and ambiguous space organized across the compressed surface. But the gross distortion of the figures, especially of the human figures, aptly fits the madness of the event. In this painting, Picasso successfully amalgamated the facets and shallow space of Cubism, the dream-like and irrational connections of Surrealism, and the distortions of Expressionism into a powerful evocation of a very shameful practice of modern war.

INTERACTIVE LEARNING

Flashcards

Artist at Work: Frank Lloyd Wright

Companion Site: **http://art.wadsworth.com/buser02**

Chapter 17 Quiz
InfoTrac® College Edition Readings
Talking Flashcards
Online Study Guide

ART OF THE MODERN WORLD

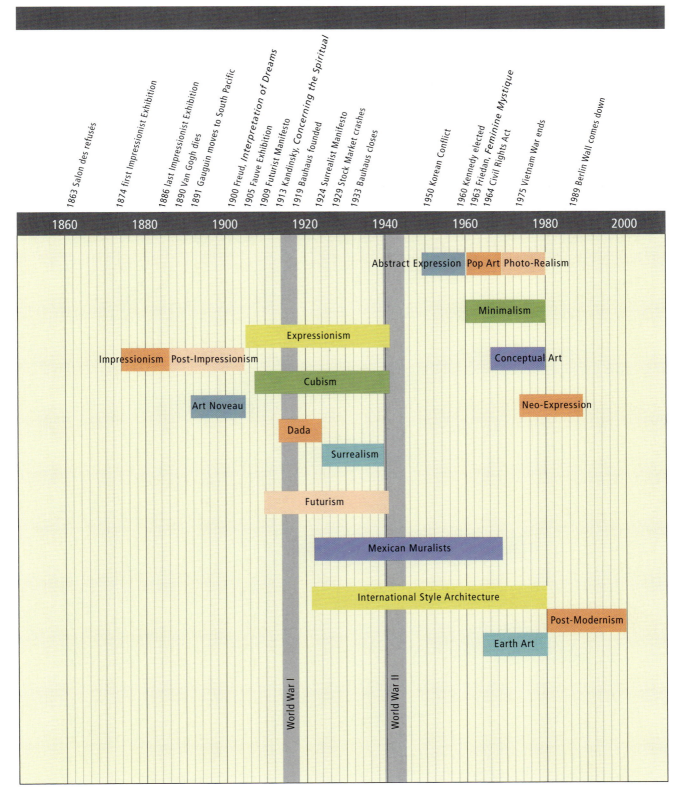

1863 Salon des refuses
1874 first Impressionist Exhibition
1886 last Impressionist Exhibition
1890 Van Gogh dies
1891 Gauguin moves to South Pacific
1900 Freud, Interpretation of Dreams
1905 Fauve Exhibition
1909 Futurist Manifesto
1913 Kandinsky, Concerning the Spiritual
1919 Bauhaus founded
1924 Surrealist Manifesto
1929 Stock Market crashes
1933 Bauhaus closes
1950 Korean Conflict
1960 Kennedy elected
1963 Friedan, Feminine Mystique
1964 Civil Rights Act
1975 Vietnam War ends
1989 Berlin Wall comes down

| 1860 | 1880 | 1900 | 1920 | 1940 | 1960 | 1980 | 2000 |

Abstract Expression Pop Art Photo-Realism

Minimalism

Expressionism

Impressionism Post-Impressionism

Conceptual Art

Cubism

Art Noveau

Neo-Expression

Dada

Surrealism

Futurism

Mexican Muralists

International Style Architecture

Post-Modernism

Earth Art

World War I

World War II

18 The Modern World: Since 1940

ABSTRACT EXPRESSIONISM

When World War II ended, the people of the earth inherited the atom bomb, a divided Europe, and an arms race among powerful cold warriors. America, the relatively unscathed victor, found itself the world's political leader and the dominant economic power. Migrations of large numbers of people in and out of cities across the nation as well as the spread of television and suburbia changed the nation's lifestyle. American culture quickly rose from a provincial status to an international force. During the war, Mondrian and many Surrealists—Breton, Dalí, Ernst, Tanguy—lived in exile in the United States. Stimulated by their work and impelled by their example, American artists asserted their independence of Europe, and the New York School soon established its leadership in the art world.

Artists in New York—Jackson Pollock, Franz Kline, and Willem de Kooning (*Woman IV,* Figure 2-35), to name a few—boldly asserted a new Abstract Expressionist style by making very visible, energetic gestures on relatively large canvases. Since their tangible paint strokes reproduced the action of the artist in the process of creating, their style also became known as **Action Painting.** While becoming a hero of American art of almost mythic proportions, Pollock led the way with his dripped and splattered paintings such as *Cathedral* (Figure 18-1).

The Abstract Expressionists, who felt new freedom and self-assurance in postwar America, also built on styles invented before them. They expressed themselves in paint like any Expressionist. Like Wassily Kandinsky, they created forms floating in space with their painted gestures. Like the Surrealists, they found meaning in automatic painting, where chance and accidents help reveal the

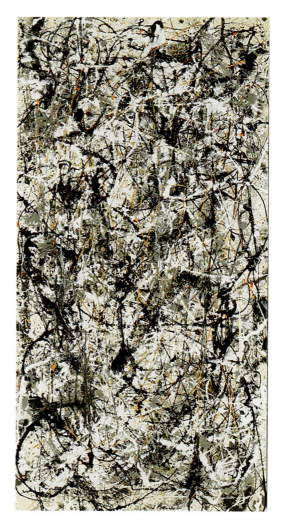

Figure 18-1 **Jackson Pollock** [American, 1912–1956], *Cathedral,* 1947. Enamel and aluminum paint on canvas, 71 1/2 × 35 in. (181.6 × 88.9 cm). Dallas Museum of Art. © 2006 The Pollock-Krasner Foundation/Artists Rights Society (ARS), New York.

inner person and create dream-like images and shapes. They felt that their gestures and color fields were the modern equivalent of the totems once worshipped by some distant culture.

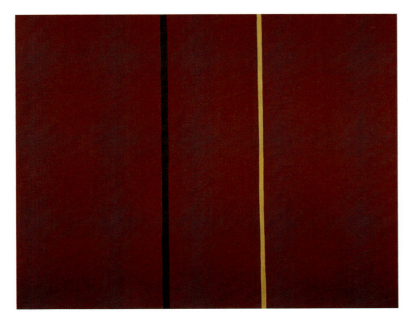

Figure 18-2 **Barnett Newman** [American, 1905–1970], *Covenant*, 1949. Oil on canvas, 47 3/4 × 59 5/8 in. (121.9 × 152.4 cm). Hirshhorn Museum and Sculpture Garden, Smithsonian Institution, Washington, D.C. Gift of Joseph H. Hirshhorn, 1972. Photo by Lee Stalsworth.

physical significance that he sought to secure within his art.

In the 1950s, while Henry Moore (see *Reclining Figure: Angles,* Figure 12-1) and Tony Smith (see *Cigarette,* Figure 3-19) were emerging as leading sculptors on the international art scene, the career of Isamu Noguchi likewise continued to accelerate in accomplishment and fame. Born of an American mother in Los Angeles, Noguchi grew up in Japan, then studied sculpture in New York and in Paris with Brancusi. The roots of his imagination were truly international. For half a century, Noguchi was extremely successful at creating monumental public sculpture around the world—in Paris, Osaka, New York, and the courtyard for the Beinecke Rare Book and Manuscript Library at Yale University (Figure 18-3).

Other Abstract Expressionists—Mark Rothko and Barnett Newman, for example—painted large areas of color in the exploration of their inner selves. Their style of Abstract Expressionism is called **Color Field Painting.** Newman's search to express his spiritual being led him to cultivate a style of large canvases painted uniformly in a single strong color and cut by thin stripes of another color. In *Covenant* (Figure 18-2), a black stripe and a light yellowish stripe subdivide the deep maroon canvas into three unequal parts. Newman called the stripes *zips,* perhaps because they opened up the uniform color field to new possibilities of perception. The large field of color has a mesmerizing effect, and the intuitive placement of the dissecting stripes sends ambiguous signals to our perceptions about space, color, and rhythmic pulsations.

The two stripes in *Covenant* seem symmetrically placed because the stronger value and color contrasts on the right balance the visual stimulation of the larger color field on the left. The two very different stripes thus bring the painting into agreement—the meaning of the word *covenant.* The stark assertion of the vertical stripes in a mysterious field of color evokes feelings of awe and power that have reminded critics of the eighteenth-century notion of the sublime in art. Many of Newman's paintings, such as *Covenant,* have religious titles that point to the meta-

Figure 18-3 **Isamu Noguchi** [American, 1904–1988], Sunken Garden at Beinecke Rare Book and Manuscript Library, Yale University, New Haven, 1960–1964. Photograph © Richard Cheek for the Beinecke Rare Book and Manuscript Library.

In 1947, just as Jackson Pollock was starting to drip and splatter paint on canvas, he wrote a brief statement about his technique. The laconic artist never described his working methods more fully than in these short paragraphs:

> I prefer to tack the unstretched canvas to the hard wall or the floor. I need the resistance of a hard surface. On the floor I am more at ease. I feel nearer, more a part of the painting, since this way I can walk around it, work from the four sides and literally be in the painting. This is akin to the method of the Indian sand painters of the West.
>
> I continue to get further away from the usual painter's tools such as easel, palette, brushes, etc. I prefer sticks, trowels, knives and dripping fluid paint or a heavy impasto with sand, broken glass and other foreign matter added.
>
> When I am in my painting, I am not aware of what I am doing. It is only after a sort of "get acquainted" period that I see what I have been about. I have no fears about making changes, destroying the image, etc., because the painting has a life of its own. I try to let it come through. It is only when I lose contact with the painting that the result is a mess. Otherwise there is pure harmony, an easy give and take, and the painting comes out well.[1]

Pollock found it possible to drip and splatter paint and pour paint straight from the can thanks to his acquaintance with the ideas of a number of European Surrealist artists who were exiled in New York during World War II. They taught him that the source of art lies in the unconscious and that even accidental drips on a canvas could be signs of that unconscious life. European Expressionists, such as Kirchner (see *Street, Dresden,* Figure 17-16), for years had also used visible brush marks as symbols of their feelings. Like the Expressionists, Pollock wanted to express himself in paint, but instead of describing or arranging his feelings, Pollock communicated his feelings directly. The splattered and tangled lines of paint become not the representation of his feelings but their equivalent.

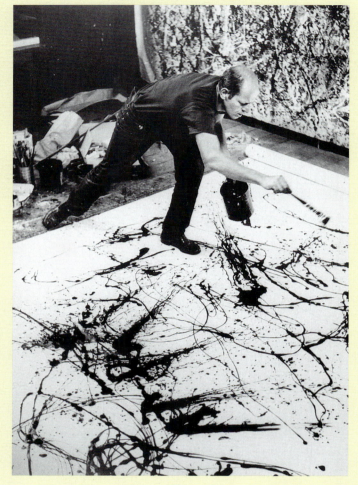

 Jackson Pollock at work in his studio. © Center for Creative Photography.

Pollock did not work from drawings, but his drips and splashes have some of the characteristics of a drawing in paint. Like most drawings, each painting is a fresh creation. When Pollock began a painting, he doodled, as it were. He may have had a general idea of what he was about, but at this initial stage of his work he came closest to the Surrealist techniques of "automatic writing" that attempt to explore the unconscious. This stage he called his "get acquainted" period. Then the painting itself gradually took over in the sense that the forms already on the canvas suggested new

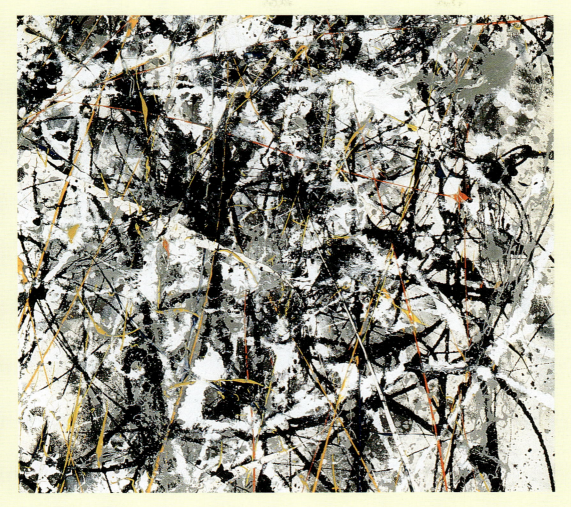

Jackson Pollock [American, 1912–1956], detail of *Cathedral*, (Figure 18-1), 1947. Enamel and aluminum paint on canvas. Dallas Museum of Art. © 2006 The Pollock-Krasner Foundation/Artists Rights Society (ARS), New York.

forms: new lines, new drips and splashes to work with. The danger in painting as Pollock did is that the artist can lose control of the design and the canvas can become a mess. His technique did not allow him to correct mistakes or make improvements. Instead, he abandoned and destroyed what he had done.

In 1949, *Life* magazine published a double-page feature devoted to Pollock, asking whether he was "the greatest liv-

ing American artist."[2] The words were those of the critic Clement Greenberg. Pollock knew success in his lifetime. Yet crushed under the intense public pressure to produce something new and different, he painted nothing the last two years of his life before he died in a car accident. Pollock was a pioneering art hero, not only in his innovative techniques but also because he broke the ice and won worldwide acceptance for American art.

Noguchi conceived the sunken courtyard at Yale as a traditional enclosed garden, although everything in it is white marble. Moreover, the growths in the garden are solid geometry—a cube balanced on one corner, a cylinder punctured with a void, and a broad pyramid. The ground out of which they grow is incised with lines, more like the pavement of a piazza than the raked sand of a traditional Japanese garden. But the Beinecke courtyard is fundamentally a fantasy landscape where modern abstract masses easily take on symbolic meaning. Noguchi intended the pyramid to represent earth or matter; the cube reminded him of a die, a symbol of chance and the arbitrariness of fate. He thought of the circle as the sun's energy. However, the simplicity of the cube, cylinder, and pyramid opens up the courtyard to other interpretations about the meaning of life or the continuity of existence. As a garden within a library, it is a place for spiritual retreat and silent reflection.

THE INTERNATIONAL STYLE AND LE CORBUSIER

After World War II, the International Style of architecture, evident in the Bauhaus and pioneered in the United States by Mies van der Rohe, became the common language of modernity. Lever House (Figure 18-4), designed by Skidmore, Owings, and Merrill, one of the largest architectural firms in the United States, makes an elegant variation on the idiom of the International Style. An early example of the steel and glass office tower in New York City, it consists of a tall vertical slab rising on short stilts above the low horizontal slab that covers the building plot. The horizontal second floor is also raised on stilts, above a street-level plaza that is open to the sky in its middle. Since the vertical window mullions form only a delicate netting over the vertical slab, the horizontal bands of green material dominate the design. The poise and proportions of the two slabs in this structure have seldom been matched in countless subsequent International Style buildings.

Although the French architect Le Corbusier had been one of the inventors of the International Style during the 1920s and 1930s, after World War II he proposed a very different alternative to it. Le Corbusier's pilgrimage church Notre Dame du Haut

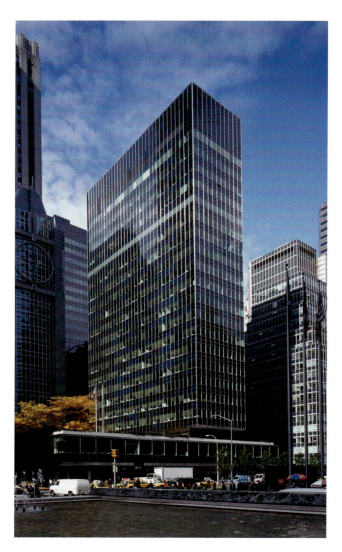

Figure 18-4 Skidmore, Owings, and Merrill, Lever House, 1951–1952. New York. © Angelo Hornak/Corbis.

at Ronchamp, in a remote part of eastern France, challenged the rigid glass and steel box in every way. Abandoning the smooth machine-made appearance of the International Style's flat planes, Le Corbusier built a chapel of curved concrete forms that reflect the undulating hills of the site. As the pilgrim approaches the church from one angle, the structure appears to be shaped like the prow of a ship cutting through space (Figure 18-5). (The wedge is actually one corner of an essentially rectangular plan.) On top of the curved and sloping thick walls rests an enormous roof that curves upward like a hollow shell. Le Corbusier molded the forms of the building as freely as sculptors model in clay or as freely as painters express their personality on canvas.

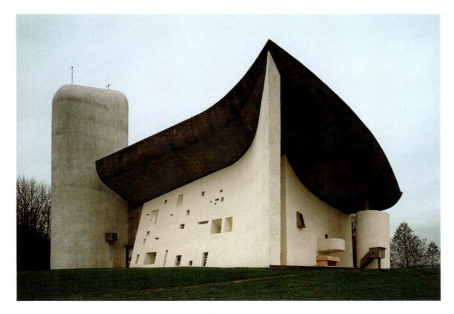

Figure 18-5 Le Corbusier (Charles-Édouard Jeanneret) [French, 1887–1965], Notre Dame du Haut, exterior, 1950–1954. Ronchamp, France. © Erich Lessing/Art Resource, NY. © 2006 Artists Rights Society (ARS), New York/ADAGP, Paris/FLC.

In many ways the building seems to have been constructed simply, using the centuries-old thick-wall building techniques of rural southern Europe. Although a framework of reinforced concrete lies hidden within them, the walls were made massive with rough masonry, which was then coated with sprayed gunite (a mixture of cement, sand, and water). Randomly placed windows penetrate their depth. On the interior (Figure 18-6), a subdued light enters the chapel through the deeply recessed

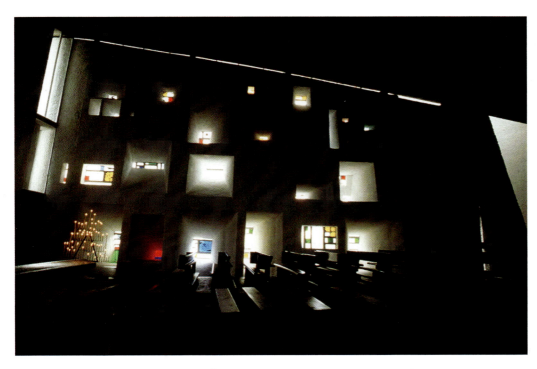

Figure 18-6 Le Corbusier (Charles-Édouard Jeanneret) [French, 1887–1965], Notre Dame du Haut, interior, 1950–1954. Ronchamp, France. © Artur/Archipress/Marc Loiseau, www.bildarchiv-monheim.de. © 2006 Artists Rights Society (ARS), New York/ADAGP, Paris/FLC.

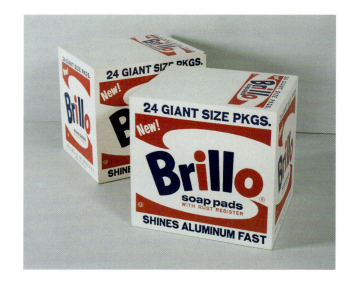

Figure 18-7 **Andy Warhol** [American, 1925–1987], *Brillo Boxes*, 1970 (enlarged refabrication of 1964 project). Commercial silkscreen inks on industrially fabricated plywood box supports, each 20 × 20 × 17 in. (50.8 × 50.8 × 43.2 cm). Allen Memorial Art Museum, Oberlin College, Ohio. © 2006 Andy Warhol Foundation for the Visual Arts/Artists Rights Society (ARS), New York.

windows and through a slit along the top of the walls. Separated from the walls by the strip of light, the bulging roof floats weightlessly overhead. Despite the massiveness of Le Corbusier's forms, they do not oppress. They embody instead a feeling of intimacy and an aura of mystery.

THE 1960S: POP ART, MINIMALISM, AND CONCEPTUAL ART

From the assassinations of John F. Kennedy and Martin Luther King Jr., to the divisive upheaval of the Vietnam War, the 1960s were a time of turmoil and change, in contrast to the apparent calm of the preceding decade and a half. American society was galvanized by the civil rights movement and convulsed by protests against the war. "Hippies" became the byword for dropouts from society and rebels against the establishment. When the Vietnam War gripped the nation, however, many artists recoiled from the moral dilemmas of American society into increased formalism. At the same time, the nation was reaping the fruits of life centered on television and mass marketing to suburbia. As the space race joined the arms race, the late 1960s saw an economic boom and the increased commercialization of art as a commodity.

Even before the decade began, in the late 1950s Robert Rauschenberg (see *First Landing Jump*, Figure 9-20) and Jasper Johns (see *Painting with Two Balls*, Figure 9-4) had broken away from the heroic gestures of Abstract Expressionism by introducing representation and even real objects into their art. Then Pop Art made a considerable splash in the early 1960s with imagery drawn from advertising and the popular media. A leading Pop artist, Andy Warhol, appropriated the images of cult heroes such as Marilyn Monroe and Elvis, or he painted deadpan images of a Campbell soup can and boxes of Brillo pads (see Figure 18-7) in the flat colors of industrial design.

Opposed to the aggressive self-expression of the Abstract Expressionists, Warhol remained passive in his art, like the millions of Americans who sit in front of their television sets every night watching the very same commercial imagery. Nevertheless, Pop Art restored representational iconography to art after a generation dominated by abstraction. It asserted that advertising, comic strips, movies, and television had become the true visual reality of the second half of the twentieth century. The presentation of these commonplace images in Pop Art sometimes recalled the absurdity of Dada, yet in a positive vein Pop Art commented on the impersonality of consumer products, the banality of the mass media, and the materialism that formed the basis of American society.

Claes Oldenburg developed a sculptural form of Pop Art by enlarging common household objects

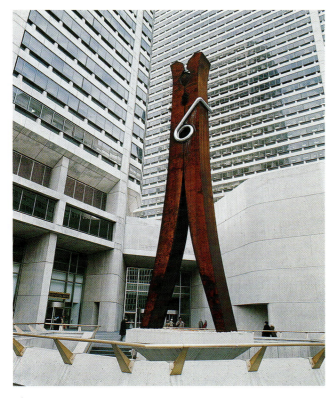

Figure 18-8 Claes Oldenburg [American, 1926–], *Clothespin*, 1976. Cor-Ten steel with stainless steel base, 45 ft. (13.7 m) high. Philadelphia. Courtesy Pace Wildenstein.

Figure 18-9 Agnes Martin [American, 1912–2004], *The Tree*, 1965. Acrylic and graphite on canvas, 72 × 72 in. (182.9 × 182.9 cm) Albright-Knox Art Gallery, Buffalo. Gift of Seymour H. Knox, 1976.

such as a hamburger, a clothespin (Figure 18-8), or an electrical plug to an enormous scale. At such a gigantic size, these items appear both comical and frightening. The expansion celebrates the forms of the commonplace object and changes it into something surprisingly different. Oldenburg's cleverness recognized the mysterious nature of everyday reality that no one had thought to be art.

Oldenburg himself discerned that the two mirrored parts of the clothespin resemble the embrace of two people kissing, the theme of a carving by Brancusi in the Philadelphia Museum. The metal spring holding it together looks like the number 76, the year the piece was erected and the bicentennial of the country. At this scale, the simple item holds its own against the tall buildings that surround it—Oldenburg first tested *Clothespin* by holding a clothespin he used as a clip in his studio against some skyscrapers. He also thought of the work as another skyscraper.

In the late 1960s, another group of artists emerged, the Minimalists, who pared the visual elements down to a bare minimum. The Minimalists also rejected Expressionism for something like the cool detachment apparent in the attitude of the Pop artists. However, the Minimalists remained in the mainstream of modern abstract art, since their work reflected earlier Constructivist tendencies. In fact, they took the reduction to elemental and primary forms to its ultimate conclusion and produced elegant paintings and sculpture of the simplest geometric shapes.

Working in New York City, the Minimalist Agnes Martin went beyond Mondrian in reducing her forms to just the essentials. On a six-foot square canvas that she called *The Tree* (Figure 18-9), Martin drew hundreds of straight pencil lines creating thousands of thin rectangles. She employed no optical illusion to dazzle the eye. Her drawing has simply broken the big square canvas into something mysteriously fragmented. The once powerful square now seems light in weight and tremulous. Her painting hints at fleeting experience.

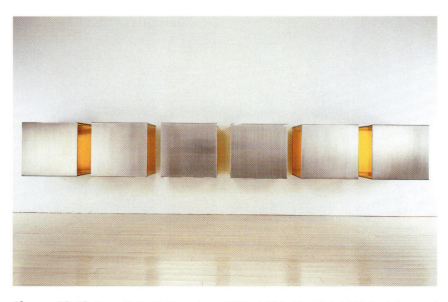

Figure 18-10 **Donald Judd** [American, 1928–1994], *Untitled*, 1966. Stainless steel and yellow Plexiglas, each cube 34 × 34 × 34 in. (86.4 × 86.4 × 86.4 cm). © Christie's Images Art. © Judd Foundation. Licensed by VAGA, New York.

The Minimalist sculptor Donald Judd created *Untitled* (Figure 18-10), in which rectangular metal boxes defy gravity as they hover along a wall. Fabricated in an industrial foundry and painted with automotive colors, the smooth boxes are uniform in manufacture and devoid of any trace of the artist's hand. They have been called *primary structures* because they simply assert masses and voids in the most elemental and physical way. Judd's work contains no visual metaphors of personal or philosophic significance; it presents no illusion of space, only the real space and void of the work.

In Minimalism, an important part of the modern movement reached an impasse in the sense that visual forms could not get much more pure or primitive without disappearing altogether. In fact, in the late 1960s several Conceptual artists no longer made any objects. Often they merely documented their intentions with photographs and printed statements. Some Conceptual artists have been known to put their ideas for a new piece down on paper and leave it at that—without executing the work at all. Works in any media that call into question the very existence of the art object and our perception of art—often with clever wit—characterize the phenomenon of Conceptual Art.

In *One and Three Chairs* (Figure 18-11), the Conceptual artist Joseph Kosuth examined the nature of perception itself with the chair—the classic example used to discuss the nature of reality and the ideal. As installed in the museum, the real chair acts as the fulcrum balancing and equating the visual image of a chair and the dictionary definition of the word *chair*. Or perhaps Kosuth merely lines up the three chairs in a row and asks whether they are equal.

Conceptual Art began as a protest against the development of art as a high-priced, mass-produced commodity. In a positive vein, it also reaffirmed the principle that art lies in the intention of the artist to transform perception rather than in the making of an object.

Likewise, artists in the 1960s staged happenings and performance art—works that are not collectible or salable objects (see the discussion at the end of Chapter 12). Happenings cannot even be repeated because they depend on spontaneity. Tired of producing more objects to be consumed by an eager art-buying public, Michael Heizer (see *Double Negative,* Figure 12-27) and other sculptors directed bulldozers to build one-of-a-kind earthworks in remote locations. Christo began wrapping buildings and reshaping nature with temporary curtains across the land (see *The Gates,* Figure 7-11). Sculpture came out of the studio and off the pedestal to interact in an organic way with a specific site or situation.

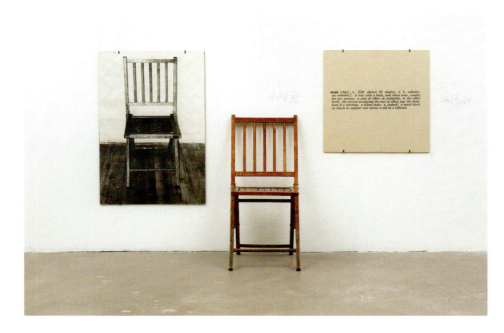

THE 1970S: PHOTO-REALISM, FEMINISM, AND OTHER TRENDS

The Vietnam War continued into the 1970s, only to be eclipsed by the Watergate scandal. Both events shook America's confidence in big government and raised concerns about the misuse of power. The oil embargo and the energy crisis called into question limitless industrial progress and exposed the international nature of energy and the environment. The nation lost some of its naive idealism, and the me generation sought self-gratification instead of the solutions to social problems. Nevertheless, the feminist movement began to change the consciousness of the entire population about the second-class status of half the population.

Even as Minimalism continued into the 1970s, realism returned to prominence in sculpture with the work of Duane Hanson (see *Jogger*, Figure 12-23) and several other artists. In painting, the new realism aspired to imitating the reality of the pho-tographic image. Chuck Close (see *Paul*, Figure 6-11), Richard Estes, and other Photo-Realists of the 1970s based their art on a photograph or the appearance of a photograph.

In general, a photograph freezes light reflections for the painter and turns a fleeting moment into something permanent. In *Diner* (Figure 18-12),

Figure 18-12 Richard Estes [American. 1932–]. *Diner*, 1971. Oil on canvas, 40 1/8 × 50 in. (101.7 × 126.8 cm). Hirshhorn Museum and Sculpture Garden, Washington, D.C. Museum Purchase, 1977. Photo by Lee Stalsworth.

Figure 18-13 Mary Miss [American, 1944–], *Perimeters/Pavilions/Decoys*, 1978. Nassau County Museum of Fine Arts, Roslyn, New York.

Richard Estes not only painted precise details across the entire surface, as is typical of photography, but he also imitated the range of highlights and value contrasts that give photography a distinctive appearance. Strangely, the street scene is devoid of people, and the lines of the telephone booths and the diner are as perpendicular to one another as the lines in a Mondrian. The reflections in the glass and metal tend to flatten out the illusion of reality, call into question the solidity of the objects, and suggest the elusiveness of our perceptions.

In the 1970s, site-specific works that function organically with the space around them grew in importance. Nancy Holt aligned *Sun Tunnels* (Figure 4-10) in the Great Basin Desert, Utah, shortly after Michael Heizer carved *Double Negative* (Figure 12-27) into the Nevada desert. In New York, Mary Miss designed *Perimeters/Pavilions/Decoys* (Figure 18-13), a work that is part sculpture, part architecture, and part landscaping integrally woven into a multi-sensory experience. Her site was a sloping meadow almost entirely surrounded by trees. The field was divided in two by a five-foot-high embankment. In the lower part were three wooden towers, standing like observation posts. In the upper part, a ladder projected from a seven-foot-deep square hole in the ground. Under the ground was a larger space that contained corridors and openings beyond the wooden walls of the pit. To experience *Perimeters/Pavilions/Decoys,* the viewer had to move through the space and climb down the ladder and let the work unfold. Miss's work was a temporary installation, built of relatively ephemeral materials. Even while it lasted, there was something fragile and vulnerable about the piece.

The 1970s were an eclectic period in which many artists explored new avenues. Mixed media and shaped canvases grew in importance. Outdoor murals and graffiti art often expressed concerns about the pressing issues in society. The feminist movement raised concerns about women in the arts as it stimulated a number of women artists to create overtly feminist art—either work about women or work that could be identified as made by women.

When Miriam Shapiro joined the feminist movement, she felt free to express herself in what she considered a female style. In *Personal Appearance #3* (Figure 18-14), she combined straight-edged geometric areas of paint with irregularly shaped pieces of highly patterned cloth pasted to the canvas. She

Figure 18-14 **Miriam Shapiro** [American, 1923–], *Personal Appearance #3*, 1973. Acrylic and fabric on canvas. 60 × 50 in. (152.4 × 127 cm). Marilyn Stokstad Collection. Courtesy of Steinbaum Krauss Gallery, New York. Photo by Robert Hickerson. Courtesy of the artist.

organized these shapes into a composition that resembles both a quilt and a modern abstract painting. Like a quilt, *Personal Appearance #3* has an underlying symmetry, but the cloth patches seem to explode from the central axis. Quilt making has always been considered a female art medium, and Shapiro obviously wanted to identify her painting with it. The history of art, written by men, had consigned the quilt to a minor form of art, but Shapiro intended to bring it into the mainstream. The feminist art movement, by criticizing the assumption of what constituted high art, redefined *art* itself in the process.

If Miriam Shapiro created a feminist style, Ana Mendieta (Figure 12-28) and Judy Chicago developed a feminist iconography. In the decade before she organized *The Birth Project* (Figure 13-7), Chicago and a team of hundreds worked on assembling *The Dinner Party* (Figure 18-15) to celebrate the achievements of women throughout

history. Like Shapiro, with whom she ran a feminist art program in California, she employed craft techniques traditionally practiced by women. In *The Dinner Party*, places are set around the triangular table for thirty-nine women, thirteen to a side, as in *The Last Supper*. The women invited to dinner include the painter Georgia O'Keeffe, the writer Virginia Woolf, and the activist Susan B. Anthony. Each woman has a painted porcelain plate and a tablecloth with images about her life and work stitched into it. The names of 999 other women of achievement are inscribed into the white floor under the table. The triangular shape of the table symbolizes not only women but also the Mother Goddess. Indeed, along with the lessons it has to teach, there is a religious feeling about *The Dinner Party*.

Another manifestation of the return to a content-based art was the emergence of African American artists, such as Faith Ringgold, who also had a message to communicate. In the 1960s, Ringgold ex-

plored race relations in America in paintings that conveyed a pointed political message. Nothing could have been further from the cool detachment of Pop and Minimal Art. In the 1970s, in collaboration with her mother, Willi Posey, she stitched soft sculpture of masks and life-scale figures that explored the experience of the African American woman. Bucking the commercial gallery system, she took her work to university and college art galleries across the country, where she often added a performance to the exhibition. In the 1980s, Ringgold concentrated on painting story quilts such as the charming *Tar Beach* (Figure 18-16). Although her work then received mainstream attention, she continued to be a political activist for women of color.

Ringgold paints on quilts because of their female tradition and because on them she can tell stories. *Tar Beach* is both an autobiographical recollection of pleasant summer evenings she spent with her family on the rooftop in Harlem and a symbolic paradigm of the power of a woman's imagination. It de-

Figure 18-16 **Faith Ringgold** [American, 1930–], *Tar Beach (Woman on a Beach Series #1)*, 1988. Acrylic on canvas, tie-dyed and pieced fabric, 74 5/8 × 68 1/2 in. (189.5 × 174 cm). Solomon R. Guggenheim Museum, New York. © 1988 Faith Ringgold.

picts Ringgold's actual experience of falling asleep under the stars, surrounded by the city's lights, as the great George Washington Bridge looms in the distance. The bridge also becomes the symbol of women's unstoppable courage, creativity, and freedom. *Tar Beach,* like her other story quilts, has a printed narrative that not only describes the painted scene but also extends its meaning. The simple text of an eight-year-old corresponds to the naive style of the painting, where the young girl dreams of flying among the stars above the bridge. Ringgold and other contemporary artists combine verbal and visual messages in their art.

In the 1970s, video art came of age (see Vito Acconci's *Theme Song,* Figure 9-21), and electronics became part of the creative process of art. Much of the technology had existed earlier, but developments in the hardware and software of electronic art made it available to almost any artist. The Korean-born Nam June Paik has been the outstanding pioneer of

video art. Trained in music and Eastern philosophy, Paik participated in avant-garde musical performances under the banner of the international Fluxus movement. (*Fluxus* means "flow" or "change.") Rather than a style, the movement is an attitude of mind that had as its goal the upheaval of the ordinary. Fluxus mixed-media events were anarchic and often filled with erotic energy. In performances, Paik often collaborated with radical activist Charlotte Moorman, who once wore miniature televisions sets as a bra while playing the cello.

Paik bought the first inexpensive video camera sold in New York in 1965 and has been experimenting with video ever since. Soon he and a colleague developed a "video synthesizer" so that he could twist, shrink, or break up the video image, change its color, or superimpose and manipulate it in a great variety of ways. By "painting" electronically this way on a videotape recording, Paik created a "time-collage," as he called it—a visual montage that unfolds on the

Figure 18-17 Nam June Paik [Korean-American, 1932–], still from *Global Groove*, 1973. Videotape. Courtesy of the artist.

screen. His best-known synthesized video is *Global Groove* (Figure 18-17) (available at www.eai.org) of 1973, in which Paik offers the viewer "a glimpse of the video landscape of tomorrow, when you will be able to switch to any TV station on earth." In reality, the video is a frantic collage of sights and sounds, from high art to Pop. A Japanese Pepsi commercial, avant-garde music, Charlotte Moorman playing a TV cello, rock and roll, Richard Nixon, and much more are interlaced, colorized, distorted, layered, and disrupted. *Global Groove* had a profound influence on the future.

The British architect Richard Rogers and the Italian architect Renzo Piano collaborated on the unusual Georges Pompidou National Center of Art and Culture (Figure 18-18) in the heart of Paris. The Pompidou Center completely reinterpreted the twentieth-century adage that a building is a functional machine for living by exposing the building's mechanisms rather than covering them with a slick veneer. Rogers and Piano turned the body of the building inside out. Not only the skeleton but also the guts are visible on the exterior. Conduits for heating, plumbing, and electricity—painted

in bright, coded colors—are exposed. Escalators and corridors run through transparent tubes on the outside. The colorful and exotic building has a carnival atmosphere that attracts people to the neighborhood and to the exhibits.

THE 1980S: POST-MODERNISM

In political life, government took a conservative turn in the 1980s as baby boomers known as "yuppies" concentrated on the acquisition of money, power, and material possessions. The Chernobyl nuclear disaster, AIDS, and increasing famine in Africa taught sobering lessons to the modern world. While Communism grew liberalized and then collapsed in eastern Europe and the Soviet Union, artists around the world claimed independence from American trends. The connection between art and big money peaked in the late 1980s. Photography won recognition among museums and collectors as a significant modern art form. In the midst of these developments, many people began asserting that the modern style, begun a century ago, was now dead.

In the 1980s the modern movement seemed to have lost its way, and art and architecture were in a state of crisis. Although it was not at all clear what the new period style looked like, many were con-

Figure 18-18 Richard Rogers [British, 1933–] and **Renzo Piano** [Italian, 1937–], Georges Pompidou National Center of Art and Culture, 1977. Paris. Photo Richard Bryant © Exto/Arcaid.

Figure 18-19 Georg Baselitz [German, 1938–], *Die Verspottung (The Mocking)*, 1984. Oil on canvas, 120 × 100 in. (304.8 × 254 cm). Carnegie Museum of Art, Pittsburgh. Women's Committee, Washburn Memorial Fund and Carnegie International Acquisition Fund.

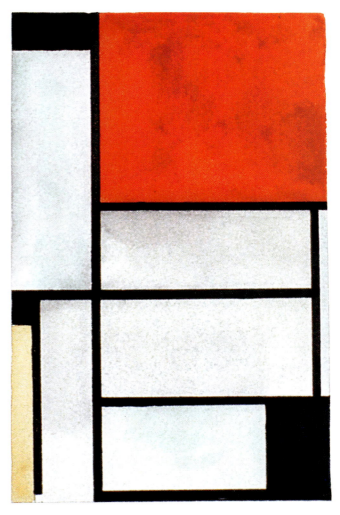

Figure 18-20 Sherrie Levine [American, 1947–], *After Piet Mondrian*, 1983. Watercolor, 14 × 11 in. (35.6 × 27.9 cm). Collection of Eugene and Barbara Schwartz, New York. Courtesy of the Paula Cooper Gallery, New York.

vinced that they were already living in a Post-Modern world. Some reacted against the impersonal machine-made look of modern architecture and the mannered repetitiveness of modern painting.

A key characteristic of the Post-Modern period is the resurrection of styles that were once thought to have been surpassed. In Germany and Italy as well as the United States, artists developed a Neo-Expressionist style to paint once again images from life with strongly felt emotions. For example, the German Neo-Expressionist painter Georg Baselitz painted the human figure with crude, bold brushstrokes, although unlike some earlier German Expressionists he did not illustrate his social environment. Baselitz often upset viewers by hanging the figures he painted upside down—a comment in itself on the topsy-turvy modern world. The title of his painting *Die Verspottung (The Mocking)* (Figure 18-19) suggests that the figures refer to the traditional iconography of the mocking of Christ as well as to modern interrogation and torture and to all forms of intimidation. Baselitz resurrected the devices of early twentieth-

century Expressionism—aggressive brushwork, crude and distorted drawing, and strong, clashing color.

Like the Pop artists and Photo-Realists before them, some artists in the 1980s merely appropriated their images from other visual sources. Sherrie Levine appropriated her imagery from the art of the recent past. Her small painting *After Piet Mondrian* (Figure 18-20) contests the preoccupation in modern art for originality above all else. Like a Pop artist, Levine hid her personality behind her matter-of-fact appropriation. Reproduced on a small piece of paper, her picture has the quality of a museum shop postcard or a textbook illustration, rather than the real thing. Her work questions how we experience art.

Figure 18-21 **Martin Puryear** [American, 1941–], *Old Mole*, 1985. Red cedar, 61 × 61 × 32 in. (154.9 × 154.9 × 81.3 cm). Philadelphia Museum of Art.

Figure 18-22 **Michael Graves** [American, 1934–], exterior of Humana Building, 1982. Louisville, Kentucky. Photo: Paschall/Taylor.

Martin Puryear's *Old Mole* (Figure 18-21) illustrates at the very first glance that Puryear has a sensitivity for working with wood—but not as a carver of wood and not even as a more modern assembler of wood such as Louise Nevelson. Instead, Puryear has developed a love for woodworking as practiced by traditional cabinet and furniture makers, wheelwrights, and coopers. Puryear makes sculpture by using their methods of bending and joining wood. In the pursuit of his art, he studied with woodworkers in Sierra Leone, Africa, and in Scandinavia. In *Old Mole,* wooden laths are bent and ingeniously secured into a simple but irregular biomorphic mass. It seems to grow from the ground and come to a head in a point at one side. The interwoven laths create a deep network beneath the surface. Puryear's work has a refreshing simplicity and directness, and the skillful execution of the piece betrays the hand of an accomplished artist.

In reaction to the coldness of the International Style, Post-Modern architects believed that architecture should include the traditional language of building, with which people still feel a great deal of

familiarity. They also believed that unlike a typical International Style glass tower, architecture should not ignore the context in which a building stands. The Post-Modern style has meant a return to mass instead of flat glass planes, to columns and arches, to a variety of rich materials, and to quotations of earlier architectural motifs.

Michael Graves's headquarters for the Humana Corporation in Louisville (Figure 18-22) successfully displays these principles. The bulkiness of the Humana Building contrasts with the flat planes of the glass curtain walls of typical office towers nearby. The rich granite facing and the marble veneers of the formal lobby (Figure 18-23) resemble elegant buildings of the 1920s and 1930s. The grand entrance, of almost Egyptian proportions, also declares the power and wealth of the modern corporation. The setback above the first few stories of the Humana Building respects the scale of the historic nineteenth-century buildings adjacent to it. The truss work underneath the terrace at the top symbolizes the bridges across the Ohio River, a block away. The Post-Modern architecture of Graves tries to ingratiate itself to the people it serves and to integrate itself with its surroundings.

THE 1990S AND BEYOND

In the last decade of the twentieth century, the cold war abruptly stopped when communism rapidly declined and the Soviet Union fell apart. As Russia struggled with a declining economy, the United States enjoyed the boom times of the dot-com bubble. Free from foreign domination, ethnic groups around the world reasserted themselves, stirring old hatreds of which the Serbian and Croatian fight for Bosnia was a vicious example. The 9/11 terrorist attack on the United States challenged modern society to find a new world order. Earlier, America tried to redefine itself as a multicultural society. Although white middle-class males of European origin have long dominated American life, Americans recognized the importance of Native American, African American, Asian American, and Latino cultures thriving within the country. Artists struggled to find their identity in this new world and to actively address some of the problems facing society.

The search for identity in art seems to be manifesting itself in at least two ways: first, the increased

Figure 18-23 Michael Graves [American, 1934–], interior of Humana Building, 1982. Louisville, Kentucky. Photo: Paschall/Taylor.

assertion and visibility of artists who, because of their race, ethnic origin, or gender, have been heretofore excluded from the mainstream, and second, the resurgence of performance and video art, perhaps because these media so readily lend themselves to self-examination by the artist.

Survey exhibitions, such as the Whitney Biennial, the international Venice Biennial, and the exhibition called Documenta held every four years in Germany regularly attempt to confirm the trends that contemporary artists are setting. The 1993 Whitney exhibition—acknowledged as the most political in recent memory—deliberately focused on works concerned with gender, sexuality, racism, and ethnic and multicultural identity. Despite the shallowness of some of the art and its one-dimensional solutions, which critics deplored, the Biennial proclaimed that the new generation of artists were searching, through their work, for their cultural and sexual identity in a multicultural society.

Figure 18-24 **Guillermo Gómez-Peña** [Mexican, 1955–] and **Coco Fusco** [American, 1960–], *Two Undiscovered Amerindians Visit the West*, 1992. Performance in Madrid in 1992. Photo courtesy of the artists.

The *kinds* of artwork exhibited at the Venice and Whitney Biennials and Documenta in the 1990s were perhaps of greater significance than the success of any single artist or work. The scores of artists in the shows exhibited very few paintings and very little sculpture of a standard kind. Many of the works were photographs and found objects, which often had social or political significance. Many of the pieces were mixed media and installations. Artists' video was in abundance and given a prominent place in the exhibitions. Furthermore, an increasing number of the artists were women, African Americans, Latinos, Asian Americans, or gays—groups that have often felt excluded from the mainstream of American art.

At the 1993 Whitney Biennial, museumgoers were treated to a performance piece titled *Two Undiscovered Amerindians Visit the West* (Figure 18-24), by Guillermo Gómez-Peña and Coco Fusco. The two performance artists locked themselves in a gilded cage furnished with glitzy artifacts from Mexican and American culture. They impersonated two glamorous showbiz types, residents of the island of Gautinau, whom Columbus and subsequent generations had never discovered. Visitors could pose with the two natives and have their picture taken as a souvenir. The performance satirized the fantasies that Western culture perpetuates about colonization.

In his art, Gómez-Peña examines not just the clash between Mexican and American cultures but also the invasion of one culture into another. A dozen years earlier in San Diego, he led a collective of Mexican and American artists who denounced ethnic stereotyping and the artificiality of borders. They took their art out of the galleries and into the streets, and staged performances on the border itself. Rejecting the marginal status given to minority groups within the dominant white culture, Gómez-Peña wanted to actively build a new society. His performances allow him to cross back and forth over the boundaries between the two cultures and begin the process of building.

Alison Saar builds her provocative art out of the traditions of diverse cultures. Like many sculptors working today, she makes installations such as her

Figure 18-25 **Alison Saar** [American, 1956–], *Slow Boat*, 1992. Mixed media installation. Whitney Museum, New York.

Figure 18-26 Bill Viola [American, 1951–], *The Locked Garden*, 2000. [head of man and woman]. Color video diptych on two freestanding hinged LCD flat panels. Video Installation. Photo: Ikra Perow.

Slow Boat (Figure 18-25). For *Slow Boat,* she draped the walls of a gallery with canvas painted like a camouflage and played a recording of moving water. Into the top of a large wooden boat at the front of the installation Saar carved the negative impression of a life-sized human form. High above the boat she suspended a wooden door. Beyond the boat stood a large copper relief of a woman that seems to have been formed by being beaten into the hollow body mold carved in the boat. A visitor to the gallery could stand behind the figure, look out through the holes in its eyes, and see as she sees. To the side the artist had suspended a pair of metal wings fitted with a harness so that they might be attached for flight. Drawing on archetypal imagery about death from religions around the world (wings, boat, door), Saar fashioned a ritual space for the transmigration of souls from this life to the next. Visitors were also invited to write the names of their dead on yellow ribbons and thus actively participate in *Slow Boat.* Like many contemporary artists, she finds "junk," reuses it in her work, and thereby brings out the spiritual power hidden in common objects.

Video art plays a big role in the contemporary international art scene. Bill Viola, perhaps America's best-known video artist, has produced a substantial body of work since the 1970s. The narratives that he records on video are a far cry from the heavily ed-ited narratives of commercial movies. They are more like slow-motion meditations on the soul—part of his quest to recover the spiritual meaning of life. Most of his videos have been presented as large-scale installations exploring elemental topics such as birth, death, and memory or earth, fire, air, and water. Since the mid-1990s, he has been exploring the passions, the expression of emotions evident in Renaissance paintings. Sometimes, as in *The Locked Garden* (Figure 18-26), these videos are presented on flat LCD screens, hinged together like a fourteenth-century diptych and placed on a small pedestal or table. The images of *The Locked Garden* at first seem like two close-up portraits of the actors, but slowly they go through four kinds of emotion—joy, sorrow, anger, and fear. The two were recorded separately, and the viewer's interest focuses not only on the changing expressions and the ambiguous states in between them, but also on the relationship between the man and woman who feel the same emotions.

Many artists today work with computers, and their art has come into the mainstream. The Web site of the Whitney Museum maintains an archive of artists' computer art (www.whitney.org/artport/gatepages). Kenneth Perlin, who doubles as a professor of mathematical science at NYU and has worked in Hollywood, added the interactive

Figure 18-27 Kenneth Perlin [American, 1957? –], Web page (www.whitney.org/artport/gatepages). January 2004. Whitney Museum, New York. Ken Perlin, Director, Media Research Laboratory Department of Computer Science, New York University.

computer graphics programs on his Web page (Figure 18-27) to the Whitney archive in January 2004. They are playful sketches that explore the application of computer graphics to art and science. Perlin contends that the notebooks of Leonardo da Vinci, which mix science and art, inspired his work.

One of the most talked about architects of recent years has been Frank Gehry. A few years before he began work on his internationally acclaimed Bilbao Museum in Spain, Gehry designed a new concert hall for Los Angeles (Figure 18-28). Gehry won the competition for the Walt Disney Concert Hall in 1988, but because of construction delays, it was completed sixteen years later.

Gehry designed the hall from the inside out; the shape of the auditorium and the numerous ancillary spaces surrounding it determined the shape of the outside walls. In fact, the auditorium sits diagonally

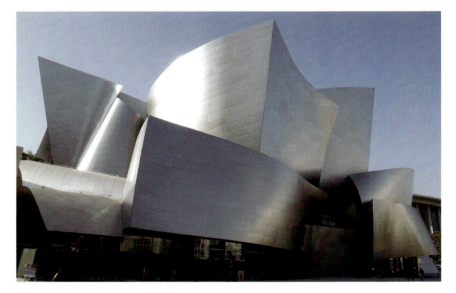

Figure 18-28 Frank Gehry [American, 1929–], exterior of Walt Disney Concert Hall, 2004. Los Angeles. © Lucy Nicholson/Reuters Newmedia Inc./Corbis.

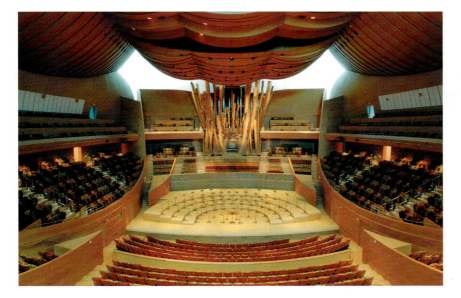

Figure 18-29 Frank Gehry [American, 1929–], interior of Walt Disney Concert Hall, 2004. Los Angeles. © Ted Soqui/Corbis.

on its rectangular plot, and the billowing walls that wrap around the building mask the change in direction. At one corner the stainless-steel-clad walls move aside to invite people in, revealing at the same time the interior. Other breaks in the wall let natural light into the lobbies and even the auditorium. Modern architecture such as Gehry's, which is asymmetrical and irregular, arranges volumes and planes in a seemingly haphazard order, and disguises the structure of the building, has been called Deconstructivist architecture because it questions traditional categories of architecture.

The concert hall (Figure 18-29) is an open, unencumbered space in which the audience surrounds the orchestra. Gehry thought of the banks of seats as ceremonial barges, and in keeping with that idea, the interior walls and ceiling billow like sails in harmony with the outside walls. In addition to inspired study drawings (see Figure 7-10), Gehry built numerous three-dimensional models to test his design and the acoustics. He then used a computer program to scan the model with a laser stylus to feed into the computer information that was used to make construction drawings.

Contemporary artists and architects, like artists of earlier times, search for styles that will express themselves and the times in which they live. The challenges of original creativity and the dangers of failure add excitement to the viewing of contemporary art. But most of all, like it or not, contemporary art is exciting because it belongs to us, speaks to us, talks about us, is us.

Flashcards

Artist at Work: Jackson Pollock

Critical Analysis: History of World Art

Companion Site: **http://art.wadsworth.com/buser02**

Chapter 18 Quiz
InfoTrac® College Edition Readings
Talking Flashcards
Online Study Guide

French Impressionism and Mary Cassatt (1845–1926)

Mary Cassatt and her painting *Summertime* were very much a part of the historical context in which she lived and worked. She had an upper-middle-class background—her father was a stockbroker. Like many American artists after the Civil War, she came to Europe (from Pennsylvania) to study the Old Masters in the museums and to study under leading painters of the day. Cassatt began exhibiting at the Salon, and deciding to make her career in France, she stayed there for the rest of her life. In fact, her sister and her parents eventually came to live with her in Paris, and she cared for them in their sickness and old age. Her actions disclose the most striking aspects of her personality: her independence and her determination to become a successful artist. Mixing marriage and a professional career was out of the question for an American woman in the nineteenth century.

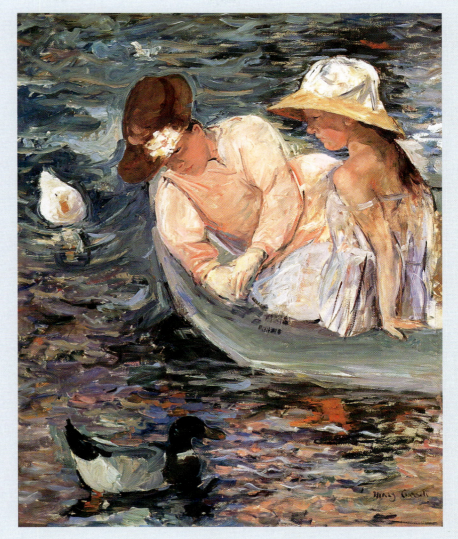

Mary Cassatt [American, 1845–1926], *Summertime: Woman and Child in a Rowboat*, 1894. Oil on canvas, 42 × 30 in. (106.7 × 76.2 cm). Terra Foundation for the Arts, Daniel J. Terra Collection, 1988.25. Photograph courtesy of Terra Foundation for the Arts.

Mary Cassatt had achieved some success at the government-sponsored Salon when she boldly threw in her lot with the "Independents," as she called the Impressionists. She joined them for their fourth exhibition in 1879, where she showed eleven works. Her decision made her feel free and alive. Among the Impressionists, Cassatt particularly admired Degas since they both shared an interest in good draftsmanship and Japanese art. Like the other Impressionists, Mary

Cassatt wanted to be "true to nature" in her art. Cassatt painted *Summertime* out of doors, where the motifs are filled with light and where even shadows are filled with color. In her art she experimented with uncommon light sources and light-filled shadows, with asymmetrical compositions.

Like the other Impressionists, she tended to reflect middle-class interests in her work. She and they favored the depiction of leisure-time activities—

boating, picnicking, the theater, walking through the park—activities that the urban middle class could now enjoy on that newfound phenomenon, the weekend. It was only in the 1890s that she developed her specialty of mother and child. Although they were realists, Cassatt and the Impressionists almost never depicted physical labor, the poor, or slums. They never overtly espoused social causes in their work. Their iconography manifested the same joy in living as their bright colors and spontaneous brushwork.

Cassatt made a significant contribution to the history of Impressionism. Primarily a figure painter, she was able to breathe new life into the old categories of portrait and genre painting. By the turn of the century, she had realized her girlhood dream to be a great artist and to be recognized for her accomplishments. Despite all the conventional restrictions that society set about her life, Mary Cassatt was one of a growing number of modern women who asserted their independence, built their own career, and added their personal vision to the history of the human imagination.

19 The Art World

Every so often, the news contains a feature about a painting that has sold for millions of dollars. In May 1987, for example, *Sunflowers,* by Vincent van Gogh, sold for $39.9 million; in November of the same year *Irises* (Figure 19-1), by van Gogh, sold for $53.9 million; and in May 1990 van Gogh's *Portrait of Dr. Gachet* sold for $82.5 million. The news item almost always recounts how the original owner once bought the painting for a few thousand dollars or how the artist who painted it lived in poverty and scarcely sold any work while alive.

Reading features like this, we cannot help question whether any piece of art is worth such a high price and cannot help wonder who determines that a work of art is deserving of such high esteem. To answer those questions requires some investigation of what has become known as the **art world**—a very informally structured society of artists, critics, dealers, galleries, museums, collectors, and educators who work in the business of art. The

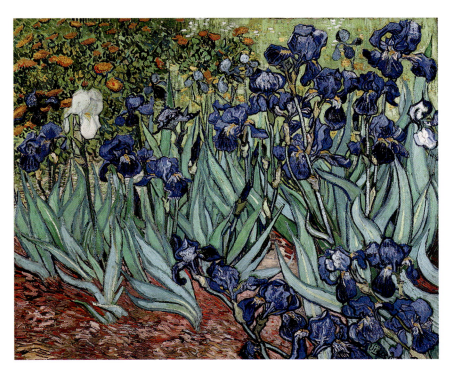

Figure 19-1 **Vincent van Gogh** [Dutch, 1853–1890], *Irises,* 1889. Oil on canvas, 28 3/4 × 36 5/8 in. (73 × 93 cm). Collection of the J. Paul Getty Museum, Los Angeles.

The Australian businessman Alan Bond bought *Irises* at Sotheby's auction house in New York for $53.9 million. The sale created a sensation when it was revealed that Sotheby's itself had financed the purchase. Because it supplied the financing, the auction house was accused of pumping up the price. In any case, Bond was unable to pay for the painting, and *Irises* was resold for an undisclosed price to the very rich Getty Museum. Although the sale to Bond fell through, the event raised troubling questions. Should the bidding for other similar paintings by van Gogh now start at $54 million? At what price should other collectors expect to sell their van Gogh? Rather than rejoicing in the price, dealers and museum directors were troubled by the sale.

Figure 19-2 Rembrandt van Rijn [Dutch, 1606–1669], *Aristotle with a Bust of Homer*, 1653. Oil on canvas, 56 1/2 × 53 3/4 in. (143.5 × 136.5 cm). The Metropolitan Museum of Art, purchase, special contributions and funds given or bequeathed by friends of the Museum, 1961 (61.198). Photograph © 1995 The Metropolitan Museum of Art.

art world appears to have increasing clout in the evaluation of art. It may even have direct influence over what and how some artists create.

Not every artist, collector, or museum curator is pleased that the visual arts have become big business. Nevertheless, the visual arts have developed some very tangible human organizations that handle large sums of money and that guide the experience of art in contemporary society. The business of art provides many people, in addition to artists, with a livelihood and supports numerous large institutions. Although aspects of the art world have existed for some time, since 1950 phenomenal growth has occurred in every aspect of art in the United States and around the world.

THE ART MARKET

One feature that distinguishes the visual arts from literature and the performing arts is that, traditionally, the visual arts create objects that can be bought and sold on the **art market,** especially through galleries and auction houses. A best-selling author may sell a work to a publisher for an inflated price, but once the book is published, the original manuscript is generally neglected or, if preserved, seldom attains a monetary value anywhere near that of a renowned painting.

Because objects of visual art continue to be bought and sold after the artist's work is finished, the ordinary economic laws of supply and demand come into play. Great demand for a small supply of goods inflates prices. Since a painting by Rembrandt, for example, will now rarely appear on the market for sale, dealers and museums who are eager for a Rembrandt will try to outbid one another when one is offered, raising the price as high as they can afford to go. In fact, the sale of Rembrandt's *Aristotle with a Bust of Homer* (Figure 19-2) to New York's Metropolitan Museum in 1961 for over $2 million set the pace for runaway prices in recent times. Another Dutch artist, Jan Vermeer, painted very little in his lifetime, and when a work of his came on the market in 2004 for the first time in 83 years, it sold for over $30 million—even though the painting was only 9 7/8 inches high. Coincidentally, it was in seventeenth-century Holland that there first arose anything like the current art market, where artists painted in quantity for the open market and collectors speculated on works of art.

Needless to say, Rembrandt and Vermeer will not profit from the current market for their work. Even living artists may never see the big amounts of money involved in the resale of their work, although proposals and court rulings have required that a percentage of the resale price be given to the living artist. Indeed, only a small percentage of the thousands of artists living today are able to support themselves from the sale of their work. Many earn a living by teaching or by working in other art-related fields. Although they want to communicate their vision and would enjoy recognition, many artists prefer to pursue their art without the pressure of trying to achieve economic success through it. They refuse to concern themselves with the quantity or specific qualities that would increase marketability. They make art for the sheer joy of it and for the self-discovery found in their creative activity.

Sale prices for works of art, since they fluctuate for economic reasons, do not necessarily reflect the

artistic value of any piece. A price may instead reflect the scarcity of the artist's work, the quantity of collectors eager to buy, or the affluence of the current market, which, because of the economy, can or cannot afford to spend large sums for art. For economic reasons, the art market prefers rare treasures and the original as opposed to derivatives.

The art market also falls prey to collectors' fashions for certain artists, periods, or styles. Impressionist and Post-Impressionist paintings are now extremely popular with affluent collectors around the world who seem willing to pay any price for them. Other styles that have an admired place in the history of art may nevertheless be neglected by the same market and command low prices. In the 1950s, Victorian painting was so disregarded that it was virtually given away, but by the late twentieth century a new fashion for it has rocketed prices into the stratosphere. Until the mid-1970s, original photographs were scarcely collected and could be purchased for a few dollars. Now prints by Ansel Adams sell in the six figures.

Some speculative investors in the art world are eager to catch the first wave of a new fashion in the hopes that their original investment will earn huge profits. Speculation in art is far from a sure thing. Prices for art do not always go up—despite a myth to the contrary that few people in the business of art want to puncture. The art market, which during the economic boom of the late 1980s was driven to a fever pitch by speculation, experienced a significant decline in activity and in prices during the recession in the early 1990s.

THE INSTITUTION OF ART

Economics and fashion do not completely explain why collectors would pay thousands or millions of dollars to possess a work of art. People and events also stimulate fashions and develop the taste of collectors for certain works. (**Taste** is the kind or degree of appreciation for art that someone has acquired through culture or education. By this definition, bad taste signifies a lack of exposure or education.) Indeed, certain consultants, critics, gallery and museum directors, journalists, and educators are in the business of building and guiding taste. For example, educators write art appreciation textbooks in the attempt to influence taste. All these people

have extensive—though far from invincible—powers to decide what works of art and which artists are worthy of attention.

The art world exercises its influence on the art of both the past and the present. Artists living in modern times have virtually complete freedom to use any material, adopt any technique, and declare that anything is art, yet someone in the art world must "ratify" their work before it becomes known as art. Although education in art is no guarantee of talent or creativity, unless an artist receives "credentials" through training in a recognized art school, unless the work is discussed by critics or given a "stamp of approval" through exhibition by art organizations and galleries, museums, and influential collectors—unless at least one of these events takes place—the work will probably not become known as art. At this very moment, countless artists are waiting to be discovered by a gallery or praised by a critic or purchased by a pacesetting collector. If none of these events happen, most of those artists may eventually abandon the profession.

The need for ratification by the art world held as true for Marcel Duchamp's *Fountain* (Figure 1-21) as it holds true for works of art produced today. As discussed in Chapter 1, if an ordinary plumber had displayed a urinal in a plumbing shop in 1917 and called it art, the results would not have been similar to those of *Fountain.* Duchamp, unlike the plumber, had been accredited by the art world. Furthermore, his *Fountain* was meant to be exhibited in a gallery, was reproduced in art publications, and has been discussed by critics, historians, philosophers, and educators—most of whom have accepted his challenging work as art.

THE CRITICS

The taste of the art world is influenced by **criticism**—by what is written about art and what "the experts" say is good or bad. Published criticism of contemporary work began to influence art in the eighteenth century, when, for the first time, new art was shown to the general public in large-scale exhibitions. In many countries, art academies at that time began holding regular exhibitions open to the public. Before then, most artists worked for the satisfaction of a patron, who commissioned each work from the artist. With the appearance of public exhi-

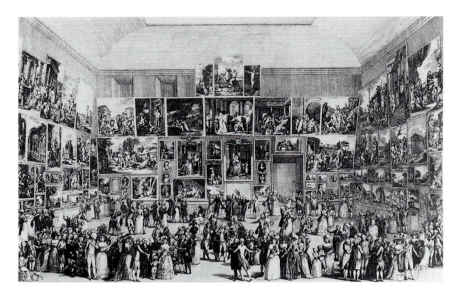

Figure 19-3 Pietro Martini [Italian, 1738–1797] *Salon at the Louvre, 1787.* Engraving, Bibliothèque Nationale, Paris. © Foto Marburg/Art Resource, NY.

cussed in newspapers and magazines in the 1940s and 1950s. The prominent critic Clement Greenberg gave them strong support and no doubt contributed to their acceptance as leaders of an avant-garde movement. Despite the attention paid them, sale of their work was modest until the Metropolitan Museum of Art gave its stamp of approval by paying the remarkable price of $30,000 for a Jackson Pollock. Since then, the Abstract Expressionists have found such a hallowed place in every discussion of modern American art that their best work now sells for millions. In the 1960s, Greenberg scorned Pop Art, Minimalism, and Conceptual Art, but he could do nothing to halt their success.

ART GALLERIES

It is the dream of many if not most young artists in America today to be recognized and handled by an **art gallery** (Figure 19-4). Many cities around the United States—Chicago, Los Angeles, Washington, Houston—have several dozen business establish-

bitions, artists now tended to produce work that might please the general public. Writers soon appeared in newspapers and magazines to educate and guide public opinion. The most famous public exhibition was the annual or biennial Salon of the French Academy in Paris (see *Salon at the Louvre, 1787,* Figure 19-3). Success at a Salon, in the eyes of a critic, could make a career.

At the present, it is rather unlikely that any critical review of an artist's work appearing in a newspaper or magazine could make or break that artist's career. The critics writing about art today usually review only the work of artists who have already been recognized by galleries and museums. The attention that an artist receives from a feature in *The New York Times* or the magazines *Artforum, Art News,* or *Art in America* might help define a new trend, and even a bad review might stimulate interest. Criticism appearing in exhibition catalogs and books about the history of art more likely affect the sale of work by established artists about whom a critical consensus is developing.

The Abstract Expressionists in New York were much dis-

Figure 19-4 Artist Marina Abramovic sits in her exhibition, *The House with the Ocean View,* at the Sean Kelly Gallery in Soho, November, 2002. © TIMOTHY A. CLARY/AFP/Getty Images.

Figure 19-5 **Julian Schnabel** [American, 1951–], *Claudio al Mandrione (zona rosa)*, 1985–1986. Oil and plates with Bondo on wood, 114 × 228 in. (289.5 × 579 cm). Milwaukee Art Museum. Gift of Contemporary Art Society, MI1986.76. Courtesy of the Artist and the Gagosian Gallery.

In 1979 the Mary Boone Gallery in New York held two exhibitions (February and December) of Julian Schnabel's work, presenting his first expressionistic "plate paintings." Because of deft word-of-mouth preparation by the dealer, the exhibition sold out at once. That same year Schnabel received critical attention in *The Village Voice* (twice), *Artforum* (three times), *Art in America,* and *Arts Magazine*—all prominent voices in the art world. His career was instantly in orbit. By 1982, major museums (the Stedilijk in Amsterdam and the Tate in London) were holding exhibitions of his work, and his paintings were soon reproduced in anthologies of contemporary art. As much a phenomenon as a painter, Schnabel was one of the superstars of the 1980s.

ments that, through their showrooms, promote and sell art. But New York outdoes them all because it has *hundreds* of galleries. At least until recently, New York has been the indisputable capital of art in the Western Hemisphere, if not the world. The New York art scene is not simply larger; it also has the museums, money, communications media, and international connections to exert more influence on the art world than does any other place.

An artist living and working in another part of the country might have more talent than a New York artist and might do quite well in the region, but unless the artist is exhibited and sold in New York, he or she will probably never become a superstar in fame or fortune. For example, careful handling by a New York gallery, plus numerous reviews in art magazines, aroused sudden interest in the work of Julian Schnabel (Figure 19-5) and stimulated high prices for it. Because having a New York show is

such a mark of distinction, a growing number of vanity galleries in that city will rent an artist a wall or the entire facility for a brief exhibition.

Whether the gallery system of recognizing, promoting, and rewarding creative talent is desirable is a difficult question to answer. Even disregarding the nonsense of contemporary superstardom, some measure of financial success afforded by a legitimate art gallery in any city can give an artist the resources to continue. But because those who run galleries are under some pressure to carry what is marketable, they may be limiting the public's access to really innovative or difficult work. Artists who have success with an art gallery may find themselves under pressure to produce much more of the same sort of work that the gallery sells so well. There has been criticism that galleries, which have been run mostly by white males and sell mostly to white males, have discriminated against women and peo-

Figure 19-6 The Guerrilla Girls are a group of artists and art professionals who since 1985 have been protesting the art world's racism and unfairness to women. They wear gorilla masks to protect their anonymity and as a clever media ploy when they appear on panels and at public demonstrations. Courtesy of www.guerrillagirls.com.

the dealer has painstakingly nurtured. Dealers may select and cultivate prestige clients to enhance the marketability of the gallery's artists. Dealers have been known to inflate prices or bid up prices at auction to increase or maintain an artist's reputation in the market. When artists go out of favor with collectors, dealers usually discourage them from selling their work at lower prices for fear that deflation would undermine the whole marketing system.

ALTERNATIVES TO THE GALLERY SYSTEM

To counteract the gallery system, many artists have for decades formed independent **artists' organizations** for showing their work. They have found

ple of color. Organizations such as the Guerrilla Girls (Figure 19-6) have taken to protesting in public the unfairness of the system.

A gallery devoted to contemporary art typically handles the work of about fifteen to twenty artists. Gallery owners usually find it stimulating to recognize new talent and take the chance to promote the artist. Many galleries specialize in a certain kind of work or in a certain kind of artist. Other galleries handle only Old Masters or operate like interior design agencies, fitting art into a client's decor.

Artists are continually soliciting **art dealers** (Figure 19-7) who run a gallery to handle their work, but dealers seem to accept new talent more on the recommendations of friends and other artists than on direct solicitation. Dealers typically receive a 40-percent to 50-percent commission from each sale. For that money, they are expected to promote the artist through advertising and regular exhibition of the artist's work. Most sales in a gallery are made not to browsing visitors but to regular clients whom

Figure 19-7 Leo Castelli with Jasper Johns, 1988. New York. Photograph by Hans Namuth © 1991 Hans Namuth Estate Collection Center for Creative Photography, University of Arizona.

An art dealer since the mid-1950s, Leo Castelli (1907–1999) handled the work of some of the most famous modern artists, such as Jasper Johns and Robert Rauschenberg. Few dealers had as much influence on American art as Castelli did for four decades.

Figure 19-8 P. S. 1 Contemporary Art Center, Long Island City, Queens, New York. Photo, Elan Cole.

alternative spaces (Figure 19-8)—often places such as storefronts, vacant warehouses, or empty churches—to exhibit new and experimental work not always commercially viable in most galleries. Artists have also taken to exhibiting in coffeehouses, restaurants, and even streets and subway platforms (see Figure 19-9) to try to get some exposure for their work. Exhibiting gives new artists a chance to develop, break new ground, make mistakes, and receive criticism. An increasing number of artists have their own Web sites and exhibit their work on the Internet.

New forms of art—conceptual art, performance art, video and computer art—because they are not usually collectible objects by their very nature, attempt to break free of the gallery system and the marketplace. Video art is sometimes distributed via satellite to cable television's public access channels by groups such as Deep Dish Television in New York or Artists' Television Access in San Francisco. Artists' videos are more commonly distributed by mail-order houses (New York's Electronic Arts Intermix, for example) to museums and universities, which seem to be the only ones that are collecting them.

Artists without a gallery and independent art groups have often leaned on government support for their activity. Many groups have recently found that the government funding they depended on can shrink with economic recession and with adverse

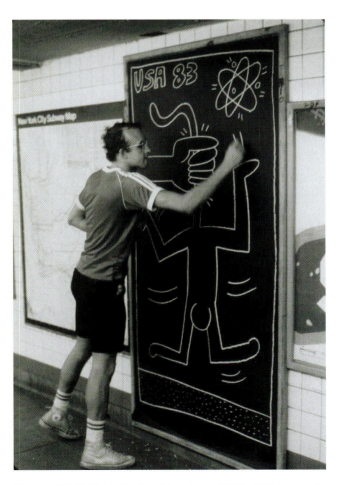

Figure 19-9 Keith Haring [American, 1958–1990], at work in the subway. Keith Haring artwork © The Estate of Keith Haring. Photo by Chantal Regnault.

Jeff Koons's *Rabbit* has been called the icon of the 1980s. Koons took a large inflatable rabbit toy and had it cast in highly polished stainless steel. It gleams like the latest shiny kitchen appliance and reflects the people who look at it. Through clever marketing and self-promotion, Koons became a media star, who then asked collectors to pay high prices for his work. Critics have either loved or hated his art. They cannot decide whether his art is a joke or a serious comment on the consumerism of the art market.

Koons attended art school in Baltimore and Chicago, but the most important influence on his career was probably the five years he spent as a commodities broker on Wall Street. There he learned marketing skills—especially the ability to sell himself—that have served his career as an artist well. He has packaged himself, organized advertising campaigns, and pulled off publicity stunts in order to sell his new products.

In addition to *Rabbit,* his works include two basketballs suspended in a large fish tank, new vacuum cleaners encased in clear plastic, oil-paint reproductions of Nike advertisements, a life-size ceramic of Michael Jackson and the chimpanzee Bubbles, and billboard-size photographs of himself and his porn-star wife, Cicciolina, having sex. His art fits no traditional category such as painting or sculpture or photography. In fact, his objects are manufactured for him by commercial workshops according to his designs.

Other artists in the past appropriated commercial products for their art. Marcel Duchamp set a urinal on a pedestal as a Dada act of protest and as a statement about the nature of art. Andy Warhol replicated boxes of Brillo pads and Campbell soup cans to break free from the emotional self-expression of the Abstract Expressionists. But it infuriates many critics that for his art Koons has so often chosen to appropriate kitsch—mass-produced objects or art that caters to a supposed low-class or middle-class taste. Sophisticated collectors have paid large amounts of money to bring into their home objects that are popular with the masses.

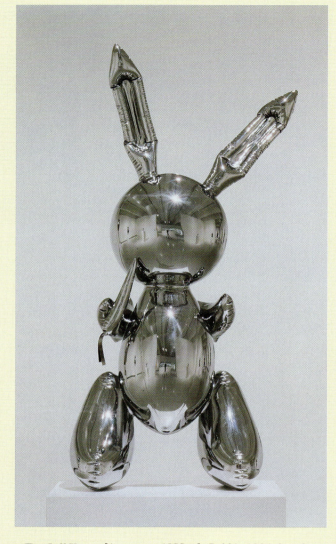

Jeff Koons [American, 1955–], *Rabbit*, 1986. Stainless steel, 41 1/2 × 19 × 11 7/8 in. (105.4 × 48.3 × 30 cm). Fractional and Promised Gift of Mr. and Mrs. S. I. Newhouse, Jr. © 1986 Jeff Koons. Photo credit: Ellen Von Unwerth.

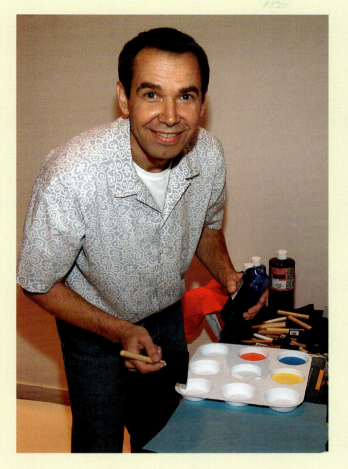

Jeff Koons at work in his studio. © 2004 Getty Images.

What is more, instead of the deadpan attitude of Duchamp or Warhol, Koons effuses over his art, making excessive claims for it. For example, he defends translating the balloon rabbit into stainless steel by comparing his work to traditional religious art that strives for a spiritual meaning: "Polished objects have often been displayed by the church and by wealthy people to set a stage of both material security and enlightenment of spiritual nature; the stainless steel is a fake reflection of that stage."[1]

Is he being ironic? Yes and no. The more serious he gets, the more he underscores the hype that drives the art market.

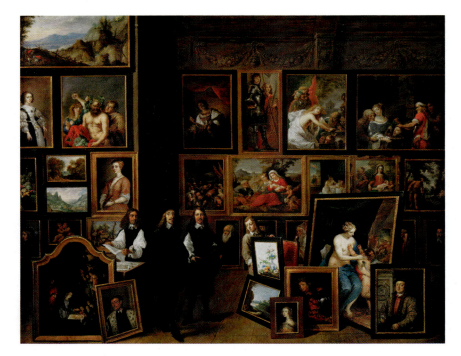

Figure 19-10 **David Teniers** [Flemish, 1610–1690], *The Picture Gallery of Archduke Leopold Wilhelm*. Oil on canvas, 27 1/2 × 33 7/8 in. (70 × 86 cm). Kunsthistorisches Museum, Vienna. © Erich Lessing/Art Resource, NY.

political pressure. The culture wars in America have forced the National Endowment for the Arts to cut or drastically reduce funding for many alternative organizations, which have been forced to cut back or close their doors.

COLLECTORS

Dealers themselves insist that their influence in the art world is quite limited and that **collectors** have a greater effect on which works are more highly valued. In a world in which success is most often measured in terms of money, collectors create the real demand for an artist's work. In addition to the thrill of speculation and the prestige of ownership, they have the delight of enjoying on a daily basis the art they own. Corporations such as IBM, Philip Morris, and Chase Manhattan Bank have also become very significant collectors of modern art. Companies invest in art to decorate their places of business, to perform a public service, and to enjoy the prestige that collecting brings.

Although collectors frequently ignore what is critically fashionable at the time and reach out on their own, the interest of well-heeled collectors seldom accounts for the sudden discovery of a living artist. Instead, collectors may have more effect on the fame of already established artists, whether living or dead. The purchase of a work by a collector who is well-known in the art world for his or her good taste can raise an artist's reputation considerably.

Because of the collector's eagerness to possess original works of art, many people in poor countries around the world and even in the United States dig up and steal pieces of art from archaeological sites. By smuggling them out of the country and surreptitiously selling them to unscrupulous dealers, they are depriving their nation of its artistic treasures. Often such thievery damages the archaeological site and destroys the context that would have helped explain the art. Legal and social pressure is mounting to return art to its place of origin, even if a collector purchased it in good faith.

Collecting goes back to ancient times. For example, the Romans avidly collected Greek art both to display the extent of their conquests and the extent of their culture. Throughout history, many aristocrats defined their importance, wealth, and fame in terms of the precious, rare, and finely wrought items

Figure 19-11 Annie Leibovitz, [American, 1949–], *Steve Martin, Beverly Hills*, 1981. Steve Martin imitates his painting called *Rue*, 1959, by Franz Kline [American 1910–1962]. He sold it at Christie's in 2003 for $2,247,500. © Photograph by Annie Leibovitz/Contact Press Images.

modern art on a shoestring. Beloved by the New York art world, they donated the bulk of their collection to the National Gallery of Art for the general public to enjoy. Since making that gift, they have again filled their apartment with art.

PATRONS

For most of recorded history in the West, the arts have been produced for wealthy **patrons**—individuals or groups that have enough means to buy art and assist artists. (Patrons usually have direct contact with the artist; collectors usually do not.) Patrons in a sense make art possible; they also have considerable influence on the appearance of art. Pericles, the political leader of Athens and the patron of the Parthenon, no doubt collaborated with Phidias on the program of the sculpture of the Parthenon. Medieval churchmen, who closely directed the work of architects and sculptors, took credit for the art and architecture of the church. Throughout the Medieval, Renaissance, and Baroque periods, almost all works of art were produced on commissions from a patron who sometimes had his or her portrait painted amid the religious figures of the work, as in Titian's *Madonna of the Pesaro*

they possessed. Beautiful art and luxurious surroundings distinguished them from ordinary people. David Teniers's painting *The Picture Gallery of Archduke Leopold Wilhelm* (Figure 19-10) was intended as a display of the archducal collection to reflect his wealth and good taste.

Starting in fifteenth-century Flanders and Italy, collections of art were also developed by nonaristocratic individuals as an expression of the intelligence and refinement of the owner. Since it has always taken a certain amount of money to buy art, it is no surprise that the wealthy upper classes or successful modern media personalities—such as Steve Martin (Figure 19-11), Jack Nicholson, Oprah Winfrey, and Bill Cosby—have assembled large collections of art. Nevertheless, Herbert Vogel, a postal clerk, and his wife, Dorothy, a librarian in Brooklyn (Figure 19-12), haunted the New York galleries for decades and diligently put together an outstanding collection of

Figure 19-12 Herbert and Dorothy Vogel with works from their collection in the 1994 exhibition *From Minimal to Conceptual Art: Works from the Dorothy and Herbert Vogel Collection* at the National Gallery of Art, Washington, D.C. Photo by Lorene Emerson © 1994, National Gallery of Art, Washington, D.C.

Figure 19-13 **Titian** [Italian, ca. 1490–1576], *Madonna of the Pesaro Family*, 1519–1526. Oil on canvas, approximately 16 × 9 ft. (4.9 × 2.7 m). Santa Maria dei Frari, Venice, Italy. © Scala/Art Resource, NY.

Benin, brass casting was the exclusive right of the king. Heads of Benin kings, such as the *Head of an Oba* (Figure 19-14), were placed on altars dedicated to the more than thirty ancestors of the oba. The royal art of Benin reinforced the legitimacy of the monarchy and functioned as a source of political and spiritual power.

By the nineteenth century in the West, nonaristocratic patrons required small easel paintings and small-scale sculptures from artists and new kinds of iconography such as still life and genre. Artists abounded who were glad to oblige them. Artists in recent centuries may have felt drawn to large-scale religious and heroic themes, but the patronage of the time compelled them to paint landscapes and portraits. In architecture, patrons—or clients—generally assume a considerable direction over the design of the building.

Michelangelo occasionally defied the patronage system with his independent genius, but it was the Romantic movement in the nineteenth century that finally won freedom for the inspired artist to work as she or he liked—or, as some writers have put it, the freedom to starve. The French government throughout the nineteenth century helped artists by purchasing countless works of religious art for churches and secular art for public buildings. During the Great Depression, government patronage in the United States supported hundreds of unemployed artists in all media through the Works Progress Administration and other agencies. For many years, the National Endowment for the Arts supported artists through individual grants, but the culture wars choked off this kind of patronage in 1996.

Family (Figure 19-13). Artists in those times typically signed a contract that specified not only the iconography but also the number of figures, the colors and other materials to be used, and even the quality of the work as reflected in the price.

The Medici in Florence, King Louis XIV of France, and other rulers took an active role in directing the arts to glorify the state. Costly materials, high-quality work, and a distinct style reflected the power of the ruler. The emperor in China and the oba, the king of Benin in Africa, also patronized this kind of art to enhance their rule. In the kingdom of

Figure 19-14 [Nigerian, Edo, Court of Benin], *Head of an Oba*, eighteenth century. Brass, iron, 13 in. (33 cm) high. The Metropolitan Museum of Art, Gift of Mr. and Mrs. Klaus G. Perls, 1991 (1991.17.2) Photograph © 1991 The Metropolitan Museum of Art.

AUCTION HOUSES

The buying and selling of art at auction is one of the most dramatic events in the art world. The two dominant auction houses in London and New York, Sotheby's (Figure 19-15) and Christie's, were by the 1980s each selling over a billion dollars worth of art per year. During that decade the Japanese became major players in bidding wars that drove up prices. Until the recession of the early 1990s, auction houses were continually setting record prices not only for Old Masters but also for the work of contemporary artists. As well, Sotheby's and Christie's have experts who handle other areas, such as African art, Asian art, furniture, and decorative arts. There was a time when collectors went to an art auction to find a bargain. Today the auctioning of art has become instead a verifiable way of setting price levels in the market.

The auctions at Sotheby's and Christie's are often played by such mysterious rules that only the highest rollers dare enter a game filled with secret codes and secret agents. For example, the auctioneer and the seller generally agree beforehand on a minimum price (known as a reserve) for an object, below which the work will not be sold. The buyers do not know this reserve price, nor do they always know that the auction house itself has bought back an object when the bidding did not meet the reserve price. Auctioneers try to keep this information hidden because unsold work is considered psychologically damaged or "burned" and will not elicit significant bidding when it again comes up for sale.

In the late 1990s, Sotheby's was accused of illegally transporting art out of countries such as Italy that forbid such transfer, in order to earn higher prices for the art in their auction houses in London or New York. Because Sotheby's and Christie's handle 90 percent of the auction market, they formed a secret cartel to end the intense competition between the two. A U.S. federal investigation revealed that they agreed to fix the commissions they charged clients and to control advances and other payments made to sellers. Sotheby's former chairman received a year in jail, and multi-million-dollar fines were levied against the firm in both New York and

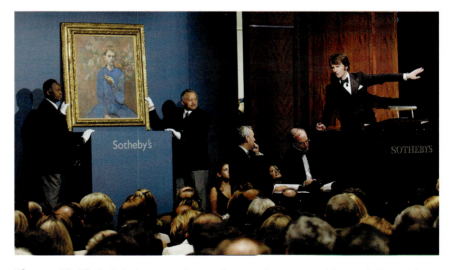

Figure 19-15 Sotheby's auction house, showing the auction of Picasso's *Boy with a Pipe (The Young Apprentice)*, which sold for $104.1 million, May 5, 2004. © Chip East/Reuters/Corbis.

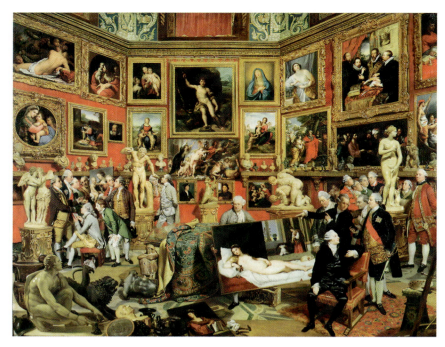

Figure 19-16 **John Zoffany** [British, 1734/35–1810], *The Tribuna of the Uffizi*, 1772–1776. Oil on canvas, 48 5/8 × 61 in. (123.5 × 154.9 cm). Windsor Castle, The Royal Collection © 2004, Her Majesty Queen Elizabeth II.

Zoffany was commissioned by Queen Charlotte to reproduce in a painting the Florentine duke's collection, which had recently been open to the public. When the queen saw that the artist had included in the painting a large number of English gentlemen visiting the Uffizi on their Grand Tour, she refused to hang the Zoffany painting in the palace.

London. The scandal seems to have had little lasting effect on the auctioning of art—in May 2004, Sotheby's sold Picasso's 1905 painting *Boy with a Pipe (The Young Apprentice)* (Figure 19-15) for a new record price of $104.1 million.

MUSEUMS

Among the most active collectors, deeply involved in the art market, are the many **museums** of art in the United States and throughout the world. Most of the famous museums of Europe, such as the Louvre in Paris or the Uffizi in Florence, were started from royal or aristocratic collections, which remain the core of their holdings. Acquisitions by these museums in modern times are limited, in general, to examples of their own national heritage.

Art museums began in the late eighteenth century, when the collections of the pope in Rome, the French king in Paris, the duke of Florence (see John Zoffany's *The Tribuna of the Uffizi*, Figure 19-16), and other aristocrats were made accessible to the public. One goal in opening these collections was to allow artists to study the work of the great masters. In the nineteenth century, the public art museum became a temple dedicated to beauty, committed to the task of uplifting the spirit of the people and instilling virtue in the masses. Invariably, early museums were designed like the Philadelphia Museum of Art (Figure 19-17)—as temples to the gods of beauty, in which large spaces, grand staircases, and imposing classical columns would awe the viewer.

In America in fairly recent times, the museums themselves or their millionaire patrons have had to purchase on the market everything that they now own. Although most items in most museums are gifts from wealthy donors, art museums in America are still keen on new acquisitions and will sometimes outbid wealthy collectors for a new prize. Museums, including new, well-endowed institutions

Figure 19-17 Charles Lewis Borie [American, 1870–1943], **Horace Trumbauer** [American, 1868–1938], **Clarence Clark Zantinger** [American, 1872–1954], Philadelphia Museum of Art. © Lee Sneider/Corbis.

they own. They also frequently gather pieces from all over the world for special exhibitions in order to expand the viewer's awareness of an artist or a theme. Museums investigate works of art and publish catalogs that communicate their research, which often becomes the definitive word about the subject. They run research libraries that are open to scholars and to the public. They hold lectures and show films that teach about art, and they train docents—volunteer tour guides—to instruct visitors of all ages, or they record electronic tour guides. They run shops that sell books about art, souvenirs, and other art-related materials. Enmeshed in the cultural life of the locality, they help make the community a desirable place to live and visit and thus contribute to the economic development of the region.

There are all kinds of art museums. Some attempt to cover every aspect of the history of art, such as the

such as the J. Paul Getty Museum in Malibu, California (Figure 19-18), thus have a considerable effect on the art market. Dependent on private, corporate, and government funding, these facilities run the risk of becoming the spokesperson of wealthy donors, big business, and government—or they may simply avoid taking risks that might offend their patrons.

Museums exert more influence on art than do most collectors because the works that they purchase go on public display and receive, as it were, the institution's seal of approval. A museum's acquisitions and the display of its holdings imply a favorable critical attitude toward the art. Museums also greatly enhance the esteem given a work of art by the special exhibitions that they hold. A work from a private collection exhibited in any museum and thoroughly documented and discussed in the catalog published by the museum's experts will surely rise in value from all the attention. With such power comes an ethical responsibility for scrupulous fairness in exhibition and acquisition procedures.

Functions of a Museum

Museums in the United States and Canada play an important educational role. They collect, maintain, exhibit, and explain their art, although major museums regularly display only a small fraction of what

Figure 19-18 John Stephens, The J. Paul Getty Museum, Los Angeles, California. © 2000 The J. Paul Getty Trust.

Figure 19-19 **Arata Isozaki** [Japanese, 1931–], Museum of Contemporary Art, 1984–1987. Los Angeles. © Kevin Burke/Corbis.

In Los Angeles, artists themselves decided that they should have a museum of contemporary art. They first converted a warehouse (the conversion was designed by the architect Frank Gehry) and dubbed it the Temporary Contemporary. Arata Isozaki's building opened in 1987, and the Temporary Contemporary is still being kept in use.

Metropolitan Museum of Art in New York City, and some are dedicated to only certain kinds of art, such as the Museum of Contemporary Art in Los Angeles (Figure 19-19). Most museums in the larger cities of the United States and Canada are general museums that can illustrate a broad range of styles and techniques. However, the Contemporary Arts Center in Cincinnati (see Chapter 14, page 311), which holds only special exhibitions, has no permanent collection. Many universities run general museums, although few of them can rival the extraordinary collections of the Fogg Art Museum at Harvard or the Yale University Art Gallery. Most campus museums are much smaller and are dedicated to the education of students.

Many museums take part in the ongoing artistic life of the community. Artists can learn lessons from the art in the museum, where they may determine to emulate or rebel against what was accomplished by others. Furthermore, many museums stimulate the production of art by holding exhibitions of the latest work from artists of the region or around the country. The Whitney Museum of American Art in New York, through its biennial exhibition, has a long tra-

dition of assessing for the nation the best of recent art. Some museums, like the Art Institute of Chicago, run art schools to train artists.

The Structure of an Art Museum

Most art museums in the United States are private institutions that may or may not receive a portion of their operating expenses from the municipality in which they are located. Usually the museum is governed by a board of directors made up of wealthy patrons who frequently have paid for many of the museum's acquisitions. A **museum director** (Figure 19-20), the chief administrator, sets the overall policies for the museum's financial, personnel, educational, and research operations as well as supervises the general nature of its displays and exhibitions. A director oversees public relations, courts past and future donors, answers to the board of directors, and keeps an ear to the ground of popular taste for ways to boost attendance.

A **curator** (Figure 19-21) is usually an expert in one field, such as European painting or Chinese

Figure 19-20 Thomas Krens, President of the Solomon R. Guggenheim Museum foundation, at the Guggenheim Bilbao Museum in 2003. © AFP/Getty Images.

As director, Thomas Krens presided over the renovation of the Guggenheim Museum in which a controversial slab tower was added behind Frank Lloyd Wright's spiral. Despite the increased gallery space that the renovation provided uptown, Krens opened a new Guggenheim annex downtown in SoHo, the area in Manhattan south of Houston Street where many galleries were located. (The Guggenheim SoHo recently closed.) He also struck a deal with the government of Bilbao, Spain, which will pay the Guggenheim Museum about $20 million to exhibit art from the New York museum's collection in Frank Gehry's new museum. He formed a unique alliance between the Guggenheim Foundation in New York, the State Hermitage Museum in St. Petersburg, and the Kunsthistorisches Museum in Vienna to present exhibitions at the Venetian Hotel in Las Vegas. Krens defends his plans because they will bring more of the Guggenheim's collection, usually kept in storage, to more people more of the time.

Figure 19-21 Thelma Golden, Deputy Director for Exhibitions and Programs at the Studio Museum in Harlem. © Wide World/AP/Jennifer Graylock.

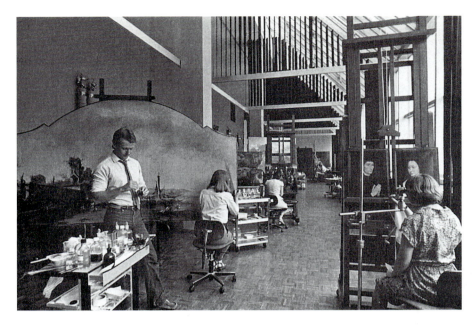

Figure 19-22 Painting Conservation Department. Photograph 1980. The Metropolitan Museum of Art, New York.

The cleaning and restoration of works of art demand great familiarity with the style and techniques of the past so that the conservator does not falsify the work by imposing on it an alien style. Cleaning art often runs the risk of damaging the work permanently by removing delicate glazes and other essential features along with the grime. Despite the professional and technical expertise of the conservators, the cleaning and restoration of Michelangelo's Sistine Chapel ceiling aroused heated debate about the true nature of Michelangelo's style. (See page 190.)

ceramics, who investigates the objects in the museum's collection, attends to the care and preservation of the objects, arranges exhibitions of work owned by the museum or borrowed from elsewhere, and publishes research and educates the public about art. For years, the Fogg Art Museum at Harvard has had a famous training program for museum administrators and curators.

A museum may also employ librarians, laboratory technicians, preparators who design and carry out displays, educators, maintenance staff, and security guards. Museum personnel, almost without exception, enjoy the opportunity to handle actual art objects.

Conservation

Some of the larger museums have departments devoted to the **conservation** of works of art because they recognize their responsibility to preserve the works in their care and pass them on to future generations in the best possible condition. Conservation departments may attempt to clean works obscured with grime and to restore works that have been damaged by vandalism or neglect. The Metropolitan Museum in New York has extensive conservation laboratories (Figure 19-22). Together with the nearby Conservation Center of New York University, it teaches the science and techniques of examining, preserving, and restoring paint, wood, cloth, metal, stone, and other art materials.

The success of art museums and the enormous increase of tourism around the world threaten works of art with another danger: too many people. A large volume of viewers increases the likelihood of accidental damage at some point; great numbers of people can simply wear down the floors or stairs of a historic building; crowds can affect the environment where art is housed. In the 1960s the curators of the Lascaux cave (Figure 2-13), where paintings had been preserved for 15,000 years, noticed green bacteria growing rapidly on the walls and threatening the art. A ventilation system introduced to eliminate carbon dioxide and condensation caused by the breathing of increasing numbers of tourists brought the bacteria into the cave. Since 1963, the Lascaux cave has been closed to tourists, and a reconstruction of the cave has been built nearby.

Forgeries and Fakes

Museum laboratories also help determine the authenticity of works of art with scientific techniques of examination. A **forgery,** such as those painted by Han van Meegeren (Figure 19-23), is the deliberate falsification of another artist's work for purposes of deceit. Forgeries have been made since ancient times whenever art has entered into commerce and thus offered the possibility of gain. Millennia ago, fake jewels, silver, gold, and other

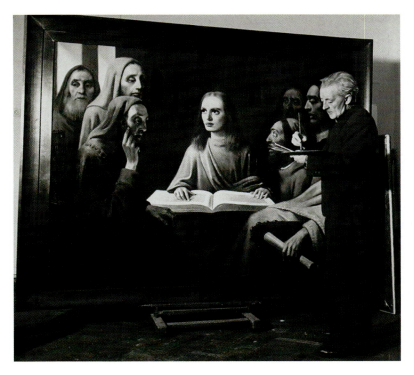

Figure 19-23 **Han van Meegeren** [Dutch, 1889–1947], painting a Vermeer-style canvas. © Photo by George Rodger/Time Life Pictures/Getty Images.

From 1937 to 1945, Han van Meegeren fooled experts and collectors with his forgeries of Vermeer and another seventeenth-century Dutch painter. A traditional and conservative painter, disgruntled by the critics' rejection of his original work, van Meegeren wanted to prove that he was as great an artist as an Old Master. Cleverly, he chose not to mimic Vermeer's mature style (Figure 16-33) but his problematic early style, which is still debated by art historians. Van Meegeren painted his forgeries on actual seventeenth-century canvas, and he ground his own pigments, using only materials available to Vermeer. Most importantly, he found ways to harden his paint, as though it had been drying for centuries, and to reproduce the crackle or pattern of fine crack lines evident in most three-hundred-year-old paintings. Only after he confessed was his work submitted to laboratory examination.

precious materials were fabricated to deceive the consumer. Sculptors who copied Greek statues for the Romans signed their copies with the names of the Greek sculptors Phidias or Polyclitus. Even Michelangelo is supposed to have carved a cupid and then buried it in a vineyard to make it look antique.

Modern forgers still concentrate on the re-creation of antiquities as well as pre-Columbian art, where gaps in our knowledge of the range of that art allow the possibility of new "discoveries." Italy, Mexico, and East Asia have been home to veritable industries devoted to the production of fakes.

Their diligence in the selection of materials, simulation of old techniques, and replication of the aging process has often fooled the experts.

A work that is merely false or unauthentic is different from a forgery. Since the beginning of the history of art, artists have made copies and reproductions of an original work of art without any intention to deceive. Young artists often work for a time in the style of an older master. With the passage of time—even a short period of time—a copy or imitation may be confused with the real thing.

The buyer or the museum expert must decide, frequently without the aid of documentation, whether the work is genuine. Scientific analysis has only a partial usefulness to disclose forgeries or false works. Tests can determine if the materials are old enough and whether the chemical components of certain colors were indeed those used at the period of time in question. Laboratory examination can judge if the techniques were those of the time or if the weathering of the stone or the cracking of the paint shows sufficient age. An expert opinion is still needed to tell the scientists what to look for and to judge whether it is the style of the original and the hand of the master. Forgers and copyists tend to betray the taste of their own time in their replications and also betray their time-bound understanding of the original.

Since the early 1970s, five expert Dutch art historians have formed a committee to examine with an exhaustive thoroughness every painting claimed to be by Rembrandt. Known as the Rembrandt Research Project, they have published three volumes of their studies so far. Rembrandt scholars once believed that about six hundred paintings by Rembrandt existed; the Rembrandt Research Project is expected to pare that number down to about three hundred. Using all the latest tools of scientific investigation and basing their findings on supposedly objective criteria, they have rejected paintings that have long been considered to be among

Figure 19-24 **Rembrandt van Rijn** [Dutch, 1606–1669], *Polish Rider*, ca. 1655. Oil on canvas, 46 × 53 in. (116.8 × 134.6 cm). © The Frick Art Collection, New York.

Problems of attribution to Rembrandt arise not only because Rembrandt had numerous pupils who imitated their master's style but also because Rembrandt is believed to have signed his own name to work painted by his students and assistants. The amount of participation by Rembrandt in any work painted entirely or in part by others in his workshop probably varied. Such collaboration was common practice in Rembrandt's day and happens even today. The Rembrandt Research Project is trying to identify authentic Rembrandts by assigning to his students work that does not manifest Rembrandt's hand exclusively. It has set itself standards with which Rembrandt would likely have disagreed.

accepted notions about the nature of art itself. It is difficult philosophically to understand why a nearly perfect fake van Gogh is so much less esteemed than a genuine van Gogh. The art world rejects the fake van Gogh partly because the modern cult of personality exalts originality, which the false can never have, and partly because the art market is interested in promoting the limited number of authentic works by van Gogh or any artist. More important, instead of revealing the personality of the artist or the artistic attitudes of an ancient culture, a forgery reveals the ingenuity of the forger. It does not give us the true picture or the genuine imaginative experience of its artist or people.

Experiencing Art in a Museum

Local museums and museums around the world offer us a wealth of art to see and enjoy firsthand (Figure 19-25). Museums can be exciting places because nothing equals the direct experience of art, when we can finally see the true color, the correct scale, and the actual texture of a painting. In a museum we can walk around sculpture and sense its mass and movement through space. In a museum we can see the actual work of some master that the experts have praised or examine a new and different example of the artist's style. Unfamiliar works challenge us to open our eyes to the new, make our own judgments, puzzle out the iconography for ourselves, and—like an explorer seeing new territory for the first time—follow the lines, walk around the shapes, and discover the colors. Unless we engage in direct communication with the work of art for ourselves, the opinions of the art world matter very little.

Rembrandt's most admired work. A member of the committee has questioned the painting *Polish Rider* (Figure 19-24) in the Frick Museum in New York and assigned it to a student and imitator, Willem Drost. Many owners of Rembrandt paintings and many other art historians disagree with the committee's decisions—despite the research project's claim of objectivity.

Forgeries and fakes puzzle many people not simply because they have fooled the experts who have at one time lauded the pieces as significant art but because they call into question some commonly

Figure 19-25 Visitors experience art as they view the Vincent van Gogh exhibit at the National Art Gallery in Washington,D.C., July, 1998. © Getty Images.

 Flashcards

Artist at Work: Jeff Koons

 Companion Site: **http://art.wadsworth.com/buser02**

Chapter 19 Quiz

InfoTrac® College Edition Readings

Talking Flashcards

Online Study Guide

Notes

Chapter 1

1. *The Complete Letters of Vincent van Gogh,* vol. 3 (Greenwich, CT: New York Graphic Society, 1959), nos. 526 and 534.

2. *The Encyclopedia of World Art,* vol. 5 (New York: McGraw-Hill, 1961), 31a.

3. Erwin Panofsky, *Idea: A Concept in Art Theory* (New York: Harper & Row, 1969), 60.

4. Arturo Schwarz, *The Complete Works of Marcel Duchamp* (London: Thames & Hudson, 1965), 466.

Artist at Work

1. *The Complete Letters of Vincent van Gogh,* vol. 3 (Greenwich, CT: New York Graphic Society, 1959), 64, no. 544a.

2. *The Complete Letters of Vincent van Gogh,* vol. 3 (Greenwich, CT: New York Graphic Society, 1959), 29, no. 533.

3. *The Complete Letters of Vincent van Gogh,* vol. 3 (Greenwich, CT: New York Graphic Society, 1959), 203, no. 604.

Chapter 2

1. Roy Sieber, *African Art in the Cycle of Life* (Washington, DC: National Museum of African Art, 1987), 65.

Critical Analysis

1. Nancy Mowll Mathews, ed., *Cassatt and Her Circle: Selected Letters* (New York: Abbeville, 1984), 259.

2. Nancy Mowll Mathews, ed., *Cassatt and Her Circle: Selected Letters* (New York: Abbeville, 1984), 274.

Chapter 3

1. Paul Klee, *The Thinking Eye: The Notebooks of Paul Klee,* ed. Jürg Spiller (New York: George Wittenborn, 1961), 105.

2. Edvard Munch, *La Revue blanche* (Paris), 2 (1895), 528, as quoted in George Heard Hamilton, *Painting and Sculpture in Europe, 1880–1940* (Baltimore: Penguin, 1967), 75.

3. Letter from Georges Seurat to Maurice Beauborg, in William Innes Homer, *Seurat and the Science of Painting* (Cambridge: MIT Press, 1964), 199.

4. Georgia O'Keeffe, "About Myself," in the *An American Place* exhibition catalog (New York, 1939).

Chapter 4

1. *The Complete Letters of Vincent van Gogh,* vol. 3 (Greenwich, CT: New York Graphic Society, 1959), 28–29, no. 553; 31, no. 534.

Chapter 5

1. Maurice Denis, "Definition of Neo-Traditionalism," in *Theories: 1890–1910* (Paris: L'Occident, 1912), as translated in Elizabeth G. Holt, *From the Classicists to the Impressionists* (Garden City, NY: Doubleday, 1966), 509.

Chapter 6

1. Quoted in Peter Murray, *The Architecture of the Italian Renaissance* (New York: Schocken, 1986), 6.

Artist at Work

1. Giorgio Vasari, *Lives of the Painters, Sculptors and Architects* (New York: Knopf, 1996), 2, 736.

Chapter 7

1. Kenneth Clark, *Leonardo da Vinci* (London: Viking, 1988), 94.

Chapter 9

1. Quoted in Michael Crichton, *Jasper Johns* (New York: Abrams, 1977), 28.

Chapter 10

1. From "Annals of My Glass House" (1874), in *Photographic Journal,* vol. I (July 1927).

Chapter 11

Artist at Work

1. Carolyn R. Russell, *The Films of Joel and Ethan Coen* (Jefferson, NC: McFarland, 2001), 1.

Chapter 12

1. www.nps.gov/vive/memorial/description.htm

2. Petra Barreras del Rio and John Perrault, *Ana Mendieta: A Retrospective* (New York: New Museum of Contemporary Art, 1987), 10.

Artist at Work

1. www.albrightknox.org/acquisitions/acq_2002/Coyne.html

Chapter 13

Artist at Work

1. Jelly Helm, "Good and Evil and Throwing Your Clothes Down the Sewer." *Communication Arts: Interactive Annual,* vol. 45, no. 5 (September/October 2003), 36.

2. Jelly Helm, "Advertising's Overdue Revolution." *Communication Arts: Advertising Annual,* vol. 41, no. 7 (December 1999), 238, 240.

Chapter 14

1. Vitruvius, *The Ten Books on Architecture* (New York: Dover, 1960), 17.

2. Vitruvius, *The Ten Books on Architecture* (New York: Dover, 1960), 17.

3. Louis Sullivan, *Kindergarten Chats* (New York: Wittenborn, Schultz, 1947), 208.

4. Louis Sullivan, *Kindergarten Chats* (New York: Wittenborn, Schultz, 1947), 206.

5. Vitruvius, *The Ten Books on Architecture* (New York: Dover, 1960), 17.

6. Vitruvius, *The Ten Books on Architecture* (New York: Dover, 1960), 174.

7. Vitruvius, *The Ten Books on Architecture* (New York: Dover, 1960), 73.

8. Mario Salvadori, *Why Buildings Stand Up* (New York: Norton, 1990), 226.

Chapter 15

Artist at Work: Phidias

1. Quintilian, *Institutionum Oratoriarum,* XII, 10, 9.

Chapter 16

1. Robert Goldwater and Marco Treves, *Artists on Art* (New York: Pantheon, 1945), 296–297.

Artist at Work: Leonardo da Vinci

1. Elizabeth Holt, *A Documentary History of Art,* vol. I (Garden City, NY: Doubleday, 1957), 274–275.

Chapter 17

1. F. T. Marinetti, "The Foundation and Manifesto of Futurism." *Le Figero* (Paris), 20 (February 1909), as reprinted in Herschel B. Chipp, *Theories of Modern Art* (Berkeley and Los Angeles: University of California Press, 1968), 286.

Chapter 18

Artist at Work

1. Jackson Pollock, "My Painting." *Possibilities: An Occasional Review* (Winter, 1947–1948), edited by Robert Motherwell and Harold Rosenberg (Schultz, NY: Wittenborn, 1947), p. 79. Reprinted with permission from Wittenborn Art Books, art-books.com.

2. Dorothy Sieberling, "Jackson Pollock: Is He the Greatest Living Painter in the United States?" *Life,* 27 (August 8, 1949), 42–43.

Chapter 19

Artist at Work

1. Quoted in Museum of Contemporary Art, Chicago, "Jeff Koons," Online Teacher Resource Book.

Glossary

abstract art Art that fragments, simplifies, or distorts reality so that the formal properties of lines, shapes, and colors are emphasized.

accent A touch of a complementary color to enliven the other colors.

acrylic A painting medium in which the vehicle is plastic (synthetic resin).

Action Painting A form of Abstract Expressionism in which the artist uses forceful brushwork or drips and splashes the paint on the surface to express emotion. The dynamic brushwork and splashes make evident the gestures employed in the act of painting.

adaptive reuse New functions for an old building compatible with the building and its surroundings.

additive sculpture The use of clay, wood, or metal to build up sculptural forms.

aesthetics A branch of philosophy that attempts to define the artistic experience.

aisle A corridor-like space commonly running alongside the nave in a basilica.

alla prima A method of painting directly onto the canvas or panel, without much preparatory drawing or underpainting.

allegory A representation of two or more personifications performing some action that has a conceptual or moral message.

alternative space An area, apart from the spaces of museums or galleries, in which artists can exhibit new and experimental work not always accepted by those institutions.

ambulatory The semicircular aisle that surrounds the apse or sanctuary of a Christian basilica.

analogous colors Several colors that are next to one another on the color wheel; also called adjacent colors.

applied arts Arts concerned with the design of objects that perform some useful function, as opposed to fine arts, whose objects have a purely aesthetic function.

apse A semicircular extension of space in a building.

aquatint A form of printmaking in which acid etches a metal plate around acid-resistant particles attached to the plate, to produce areas of value.

arcade A series of arches.

arch An arrangement of wedge-shaped stones forming a span because they compress one another.

armature A skeletal bracing within clay or wax sculpture, needed to support the soft and malleable material before it hardens.

art dealer A person who buys and sells art, usually through an art gallery.

art for art's sake The aesthetic theory that the essence of art lies in perfecting and enjoying its purely formal properties rather than in creating something to serve a purpose.

art gallery A business establishment that, through its showrooms, promotes artists and sells art.

art market The buying and selling of works of art, especially through galleries and auction houses.

Art Nouveau A style of art, popular at the end of the nineteenth and the beginning of the twentieth centuries, that employed curvilinear, swelling, plant-like forms.

art world The artists, critics, dealers, galleries, museums, collectors, and educators who work in the business of art.

artists' organization An association for the exhibition and sale of art, run by artists themselves and functioning in ways similar to a commercial gallery.

Arts and Crafts movement A late-nineteenth- and early-twentieth-century activity and tendency to replace machine-made goods with hand-crafted objects.

asphaltum The tar-like acid-resistant ground in the etching process that coats the plate and into which the design is made.

assemblage Sculpture constructed out of material that has been cut and pieced together and transformed into something new.

asymmetrical balance A balanced design in which the visual elements on one side are rather different from those on the other side.

atmospheric perspective The projection of three-dimensional space by observing that the intervening air causes distant objects to change in color and to diminish in sharpness of focus and to decrease in chiaroscuro.

auction house A business that sells art through bidding. The two largest are Sotheby's and Christie's.

auteur theory In filmmaking, the belief that the director, like the author of a novel, is the person responsible for the artistic achievement of a film.

avant garde Artists who break away from accepted norms of style or iconography and invent new art.

balance A principle of design in which the stimulation of the visual elements on one side of a work visually seems to "weigh" as much as the stimulation of those on the other side.

balloon frame A construction technique in which the walls of a building are assembled from two-by-fours called studs and then covered with veneers both inside and out.

baren A smooth, rounded pad about five inches in diameter that printmakers use to press the paper into the inked surface of a relief block.

barrel vault A semicylindrical covering over an architectural space; also called a tunnel vault.

basilica A Roman building type adopted for Christian churches.

basket weaving The creation of handcrafted fibrous containers.

Bauhaus An influential school of architecture and design located in Germany, first in Weimar (1919–1925), then in Dessau (1925–1932), and finally in Berlin (1932–1933).

bay The often square or rectangular subsection of a building divided into similar multiple units by columns, arches, or vaults.

biomorphic Having an irregular shape and resembling a biological organism such as a cell or tiny animal.

bistre A brown ink made from wood soot, popular before the twentieth century.

body art A kind of performance art in which the artist's body is the focus of his or her work.

body color See **gouache.**

bronze An alloy of the metals copper and tin.

brush and ink A drawing tool that employs pigmented liquids used in writing to make lines or areas of wash.

burin A small tool with a diamond-shaped steel tip, used to cut the lines of an engraving into a metal plate.

bust A representation of the head and shoulders of a person.

buttress A mass of masonry set against a wall to give it added strength or to counteract the forces of an arch or vault.

calligraphic Consisting of animated and decorative curved lines, which resemble the elegant flourishes of a fancy handwriting.

calligraphy A fancy or beautiful handwriting or printing often with elegant flourishes; long considered an art form in China and Japan.

calotype The early photographic process invented by Fox Talbot in England. Calotype produced a negative from which copies could be printed.

camera obscura A box with a small hole in one wall. The light coming through the hole projects an upside-down image of the outside world on the opposite wall of the box.

cantilevering A construction technique in which the horizontal beam resting on vertical supports projects some distance beyond one of those supports.

capital The part of a column that rests above the vertical shaft and forms a transition between the shaft and the horizontal beam.

caricature A drawing or other form of representation that exaggerates prominent or characteristic features of a well-known individual or a common type for either satirical effect or social commentary.

cartoon (1) The full-size preparatory drawing used by a fresco painter to transfer to the wall the essential lines of the composition. (2) Often humorous drawing in a simple style that appears on the comic pages of most daily newspapers.

carving Cutting material away from blocks of wood, stone, ivory, or other material to create sculptural form.

cast shadow The dark shape projected onto another surface by objects as they intercept the light.

casting Creating sculptural forms by pouring liquid material into a mold, where it hardens.

centering The wooden scaffolding placed underneath an arch during its construction until the last stone is in place.

central plan An architectural design that is symmetrical in all directions, as though it radiates from a focal point.

ceramic Fired clay shaped into pottery or sculpture.

chalk Black, red, or white drawing material found naturally in the earth.

chancel The area of a church where the main altar is located.

charcoal Charred wood made into a soft, dry, granular drawing medium that easily smudges.

chiaroscuro Any contrast between light and dark.

chiaroscuro woodcut A form of relief printmaking popular in the sixteenth century, in which several colors printed from separate blocks indicate different values rather than local colors.

choir The area where the monks sang, beyond the crossing of the transept and nave in a Christian basilica.

clerestory The upper part of the nave where windows placed above the aisles bring light into the center of a basilica.

cloisonné The technique of setting colored glass and semiprecious stones within thin borders of gold.

coffer A square or other polygon sunk into the ceiling of a dome or vault as part of its decoration.

collage The modern painting technique, developed by Pablo Picasso and Georges Braque, in which pieces of newspaper, colored paper, or other materials are pasted upon the work's surface.

collector A person who amasses a collection of art.

collodian process A method of photography invented in 1851 by the English sculptor Frederick Scott Archer, in which he coated a glass plate with a film of chemicals and placed it in the camera while the plate was still wet.

Color Field Painting A kind of Abstract Expressionism in which large areas of canvas are covered with a single color, rather than with forms that exhibited the artist's gestures while painting.

color wheel The spectrum arranged in a circle so that red appears next to violet and complementary contrasts of colors stand opposite one another across the diameters of the circle.

complementary colors Hues that are diametrically opposite one another on the color wheel. Complementary colors provide the greatest color contrast.

composite art A characteristic of filmmaking because it combines elements from a number of other art forms and also because many people collaborate in the making of a typical film.

computer art The use of the digitized electronic impulses of a computer as a painting tool to create visual images.

conceptual artists Artists who depict what they have stored in their imagination—what they conceive or know an object looks like.

conservation The cleaning, repairing, and preserving of works of art.

consistency with variety A principle of design that helps integrate a work of art by making most of the lines or shapes resemble one another in some way, by treating the value contrasts in a uniform way, or by establishing homogeneous relationships among the color contrasts and other visual elements. However, occasional differences, changes, and variations in the treatment of the visual elements break from absolute consistency so that the elements do not look static, dull, or monotonous.

Conté crayon A stick of hard chalk compounded with an oily material so that it adheres to the surface better.

contemporary art Art produced within the last ten to fifteen years.

continuous narrative An image in which two or more events in a story are indicated on the same pictorial field.

contour line A line that surrounds the edge of a form; it limits and distinguishes one area from another.

contrapposto Movement in the human body displayed by placing parts of the human body in contrasting positions; one part may turn in one direction at the same time that a related part turns in another.

convention A device of representation or design that nearly all the artists in a culture accept and employ.

cool colors Hues that are near blue on the color wheel.

Corinthian order The most elaborate of the Greek and Roman systems of building design; its column has a base and a large capital carved with acanthus leaves.

craft A special skill for making common practical objects; the revival of that skill to protest mass manufacture and to promote integrity of workmanship; the use of traditional craft materials to create art.

crane shot A shot filmed by a camera born aloft by a crane; it usually provides a dramatic revelation of the action.

criticism Written analysis of art, especially of contemporary art, that attempts to form judgments about its quality.

cross vault A vault formed by the intersection of two tunnel vaults; also called a groin vault.

cross-hatching A printmaking or drawing technique for producing dark values by crisscrossing two or more series of parallel lines on top of one another.

crossing The space where the transept crosses the nave in a basilica.

cuneiform Sumerian writing formed by arranging wedge-shaped marks.

curator An art expert who investigates the objects in the museum's collection, arranges exhibitions of work owned by the museum or borrowed from elsewhere, publishes research, and educates the public about art.

curtain wall The outside walls that are hung on the framework of a modern steel skeletal building.

cut The most common type of film editing procedure, in which one shot suddenly ends and the next shot immediately begins.

daguerreotype The photographic process announced to the public in 1839 by Louis Daguerre; it produced a finely detailed positive image on a metallic surface.

design The selection, arrangement, or organization of visual elements in a work of art.

diminishing size A method of spatial projection in which the small size of objects relative to others within a pictorial representation indicates that they are located farther back in space.

director The person who plots and supervises the shooting of a film and tries to guide the actors in the interpretation of their roles. The director is usually credited with the overall responsibility for the outcome of the film.

dissolve A type of film editing in which one shot gradually disappears from the screen while another shot gradually emerges.

Divisionism The late-nineteenth-century painting style in which separate colors are applied in a methodical series of touches of the brush according to the laws of color theory.

dome A normally hemispherical vaulting covering an architectural space.

dominance The emphasis placed on the main center of interest by giving it the brightest illumination, the main linear movements, the strongest color, the most detail, the most striking contrast, or a prominent location in space.

Doric order The most austere and weighty of the Greek and Roman systems of building design; its column is baseless and has a simple cushion capital.

drapery The loose garments arranged on human figures in sculpture and painting.

drypoint A form of intaglio printmaking in which lines are made on a metal plate by scratching the surface directly with a sharp diamond-tipped or carbide steel needle.

earth colors Hues resulting from the mixing of secondaries. These mixtures—brick red, yellow ocher, olive green—mimic the colors of minerals found naturally in the earth.

earthenware Pottery fired at a low heat so that the clay remains grainy and porous.

earthwork Large-scale shaping of earth and rocks, often in remote places, into sculpture.

easel painting A painted work intended to be hung on a wall, whether it was painted on an easel or not.

editing Relating, coordinating, and connecting of one shot of film with another.

edition The total number of prints that a printmaker pulls from a plate or a block.

egg tempera A painting medium in which the vehicle is egg.

embroidery The decoration of cloth with needlework designs.

encaustic The process of painting in hot beeswax.

engraving A form of intaglio printmaking in which lines are cut into a metal plate with a burin.

entablature In classical architectural, the horizontal part of the building above the vertical columns.

entasis The slight swell of a column as it deviates from the straight line of its tapering.

environment A work of sculpture that transforms the whole of an interior space and then surrounds the viewer on all sides.

equestrian monument A work of sculpture that includes both horse and rider.

etching An intaglio printmaking process in which a drawing tool removes some of the acid-resistant ground covering a metal plate, and then acid cuts the exposed places of the plate.

eye-line An imaginary line between an eye and the object of its glance.

fabrication In photography, the process in which the photographer deliberately constructs or assembles the subject of a photograph instead of merely documenting existing reality.

fade A type of film editing in which the image of one shot disappears as the screen turns dark and then the image of another shot appears out of the darkness.

fantasy art An illusion or a vision of something that exists only in the artist's imagination.

fiber arts Arts in which all sorts of fibrous materials are sewn, woven, or joined in any number of ways.

figure–ground relationship The perception that figures or objects in a foreground tend to dominate the shapes in the background.

fine arts Arts that have only an aesthetic function, as opposed to applied arts, which serve practical functions.

firmitas The Latin word for solid construction; one of Vitruvius's principles of architecture.

flying buttress In Gothic architecture, an arch that counters the lateral thrust of clerestory vaults by spanning the gap over the roofs of the aisles between the upper wall and the external buttresses.

folk art Traditional arts and crafts that have been passed down within the confines of a culture.

foreshortening The projection into space of irregularly shaped, nonlinear objects such as arms and legs.

forgery The deliberate falsification of another artist's work for purposes of deceit.

found object sculpture Sculpture in which artists simply find objects that are already made and combine them, rather than shape raw material into sculptural form.

fresco Painting on plaster that is wet so that the pigment soaks into the fresh plaster.

frieze A horizontal area of the entablature of a classical order located below the cornice and above the beam that rests on the column capitals. It is often decorated with relief sculpture.

frottage The technique, exploited by the Surrealist Max Ernst, in which an image is created with a pencil or other drawing tool by rubbing a paper placed over a textured surface.

gallery A story in a basilica, located over an aisle and open to the nave.

genre The depiction of scenes of everyday life of anonymous, ordinary people doing ordinary things.

gesso Plaster of paris or white chalk mixed with glue; the traditional ground for painting a wooden support.

Gestalt psychology The school of psychology that studies the natural tendency to perceive a unified whole or a pattern rather than its individual fragments or parts.

glaze (1) Paint that is applied in a thin, transparent layer. (2) In ceramics, a glass-like coating that is baked right onto the clay, normally coloring it and making it impervious to liquids.

golden section The relationship between two unequal lines such that the smaller is to the larger as the larger is to the whole (the addition of the two).

gouache An opaque form of watercolor.

graphic design The art of designing all printed and visual images that communicate messages appearing in print, film, and television, exhibitions and displays, and packaging and informational systems.

groin vault A vault formed by the intersection of two tunnel vaults; also called a cross vault.

ground A layer of paint or gesso applied to a support so that the support will receive the paint.

handheld shot A shot filmed by a camera operator who is moving.

handling The manner or method of production evident in a work of art.

happening A type of performance art, popular in the 1960s, in which loosely staged public events of all descriptions were organized by artists.

hard-edged abstraction Shapes bounded by precise contours and resembling regular geometric forms such as squares, circles, or triangles.

hatching A series of close, parallel lines that conventionally indicate darker values.

hieratic representation The depiction of the important people in a larger scale than subordinate individuals in order to symbolize their significance.

hieroglyphics Pictures and symbols that constitute the Egyptian system of writing.

highlight On any modeled surface, the area of the brightest light where the light might actually be reflecting its source.

historic preservation The protection and maintenance of what is good and meaningful from the architectural history of an area to ensure that the region can find its cultural roots through that history.

history painting A picture that relates a religious, mythological, or historical narrative and usually contains an inspiring or moral message.

hue A color such as red or green; the perception of a wavelength of light.

iconography The subjects and the symbols of works of art.

ideal A state of perfection that is known or imagined in the mind.

ideographic writing A writing system, such as Chinese, that uses symbols and characters to stand for objects or concepts, without conveying pronunciation.

illumination A miniature illustration or decoration painted in manuscripts and books, especially in the Middle Ages.

impasto The thick buildup of paint on the surface of a canvas.

implied line An imagined line created by the eye that tends to treat a series of many irregular forms and disjointed shapes as a line that moves in one comprehensible direction.

impression Each single sheet that the printmaker pulls from the plate, block, or stencil.

India ink A drawing pigment made from lampblack (soot from burning oil or resin). Centuries ago, it was imported in cakes or sticks from the Far East.

industrial design The art of creating for a mass-manufactured product a style that will enhance its appearance, increase its usefulness and efficiency, and raise its appeal to the consumer.

inspiration The Platonic belief that art is divinely inspired, as though an outside force takes possession of, and acts through, the artist. The inspired artist can imitate the ideal immediately.

installation A large and complex work of sculpture that must be assembled and situated within a museum or gallery space.

institutional theory of art The theory that the art world of museums, collectors, critics, and artists defines what is art.

intaglio Any printmaking process in which the image to be printed is created by cutting grooves in a plate and forcing ink into those grooves.

intensity The purity of the hue; the true spectrum color; also called brilliance, saturation, or purity.

International Style A style of architecture, popular in the mid-twentieth century, characterized by cubic shapes, glass curtain walls, and a lack of ornament.

in-the-round A kind of freestanding statue that is finished both back and front.

Ionic order The Greek and Roman system of building design in which a fluted column shaft rests on a base and has a capital elaborated with scrolls or volutes in the four corners.

isometric projection A representation of the three-dimensional character of a building or some object, in which parallel lines are depicted as always parallel to one another.

keystone The top stone in an arch, probably the last stone put into place.

kinetic sculpture Sculpture that actually moves because of wind, water, or a motor.

landscape art Art whose major focus is the depiction of elements of nature, such as sky, mountains, valleys, rivers, fields, and trees.

light source The kind and the direction of the light that illuminates a work of art.

line A point in motion; a mark made to form a design on a surface.

linear perspective A scheme for creating the illusion of three-dimensional space on a two-dimensional surface, in which parallel lines that move away from the viewer are not drawn as parallels but as diagonal lines that converge and meet at some point.

linocut A reduction method of relief printmaking employing linoleum, which is gradually cut away after each new colored ink is printed.

lithography A planographic form of printmaking in which the flat surface of a block of stone is chemically treated to receive or reject printer's ink.

local color The color that an object is known to be, without any regard for temporary or accidental effects.

lost wax process A method of casting hollow metal sculpture by creating two molds, an inner core and an outer shell, kept apart by a suitable thickness of wax. When the molds are heated, the wax melts, runs out the bottom, and leaves a gap into which molten bronze is poured through a hole at the top. The bronze replaces the missing wax.

manipulation In photography, the control of photographic techniques and materials, often to the extent that the image is obviously changed from a straightforward reproduction of reality.

maquette A sculptor's small sketch in clay, wax, or other material.

mask A face covering that enables a person wearing it to cover his or her features and assume the persona of another.

mass A solid, three-dimensional form that has weight and takes up real space.

metalpoint A drawing stylus made of gold, copper, tin, lead, or silver.

metalwork Art produced by the craft-related techniques of designing and fabricating all kinds of metals.

metope The nearly square panel alternating with triglyphs in the frieze of the Doric order; often decorated with relief carving.

mihrab A niche in the wall of a mosque that points to Mecca, the focus of prayer.

mimesis The imitation of nature by copying or reproducing what artists see before them.

minaret A slender tower, attached to a mosque, from which the muezzin chants a call to prayer five times a day.

mise en scène Everything that is put into each frame of a film; everything that appears on the screen at any given moment; it includes all theatrical and photographic elements.

mixed media Different techniques combined in one work, as in tempera combined with oil paint; different art media in combination, as in oil painting combined with photography.

mobile A form of kinetic sculpture invented by Alexander Calder, in which the pieces are balanced from a wire suspended from the ceiling.

modeling (1) Gradual variations from light to dark across rounded surfaces such as a face, an arm, or a leg. (2) Adding and manipulating clay or wax to create sculptural forms.

modern art The dominant art of the twentieth and twenty-first centuries that grew out of the radical ideas and bold experiments of the Post-Impressionists.

module A part of a building whose measurements govern the proportions of the rest of the building.

modulor "The module of gold": Le Corbusier's system of architectural proportions based on the golden section.

monotype In printmaking, an impression made by simply pressing paper to a newly painted surface.

montage A French word for editing that stresses the positive aspects of connecting the shots to build a film.

mosaic A design or picture made by arranging small pieces of colored stone, glass, or ceramic.

mosque An Islamic place of worship, prayer, scripture reading, and preaching.

movement (1) The paths that lines create in a work of art for the eye to follow. (2) An essential characteristic of film art, including the activity of the actors and the changing position of the camera.

mural A painting on a wall or ceiling that becomes part of the architectural decoration.

museum An institution that collects and displays works of art, primarily to educate the public about art.

museum director The chief administrator and spokesperson of a museum, who sets the museum's policies and supervises its operations.

mythology Stories about the gods and goddesses, heroes and heroines of an ancient culture.

nave The central space in a basilica.

negative shapes Subsidiary shapes surrounding the dominant figures or objects in a painting.

neutral color A gray color produced when complements are mixed together in nearly equal proportions. Theoretically, mixing complements of full intensity should produce a black because one complementary color should totally absorb or subtract the wavelength of the other.

nonobjective art A work that reproduces no recognizable object in it.

nude An unclothed human figure in which the main emphasis is its beauty, grace, or ideal proportions.

oculus A circular opening at the top of a dome and sometimes in a wall.

oil A vehicle for painting; usually linseed oil.

optical color Color as the eye sees it, with all the subtleties of reflected colors, filtering atmosphere, colored lighting, and simultaneous contrasts.

orthogonals Lines in linear perspective that move away from the viewer and are genuinely perpendicular to the picture plane.

outsider art The work of self-taught artists who, isolated from mainstream artistic culture, supposedly create with innocence, spontaneity, and honesty.

overlapping A fundamental method of spatial projection in which something obscures part of something else considered to lie behind it.

pace In film editing, a rhythm or a tempo established by arranging shots to last on the screen about the same length of time throughout a sequence.

pan A camera movement in which the camera turns on its axis and sweeps horizontally across a scene.

paper A support for drawing and painting, normally made from matted rag fibers.

parchment The prepared skin of animals such as sheep, goats, or calves used as a drawing support.

pastels Pure pigments that are dry (not mixed with oil) and lightly bound together by a gum into chalk-like sticks for drawing.

patina The thin layer of brown or greenish oxidation on bronze when it is exposed to certain chemicals or to the weather.

patron An individual or group that encourages the arts and assists artists, often by making direct payments to artists or to artists' groups.

pediment The triangular gable at the end of a Greek or Roman temple.

pen and ink A tool filled with pigmented liquid for drawing and writing.

pencil A thin shaft of graphite and clay sheathed in wood and used as a drawing tool.

pendentive The curving triangular area underneath a dome and between the arches supporting a dome.

perceptual artists Artists who reproduce what they see before them.

performance art Works in which artists put themselves and their creative activity on display before an audience as a form of living art.

personification A human figure that stands for a virtue or some other abstract concept.

perspective See **linear perspective.**

petroglyph A drawing made by pecking or cutting a design into the stone face of a natural rock or cliff.

pictograph A visual image that represents a word or an idea.

picture plane The surface or imaginary window perpendicular to the line of vision on which the pictorial image appears to be inscribed.

pier A vertical support within a building; not a cylindrical column.

pigment The dry, powdery substance that produces a color for painting.

pilaster A flattened vertical support along the wall of a building, normally designed in one of the classical orders.

Pointillism Seurat's technique of painting in small dots of color.

porcelain Pottery produced by firing a highly refined clay mixed with kaolin at a very high temperature.

portrait A representation of a certain person.

position A convention for representing on a flat surface the location of an object in the third dimension; the higher up the object is within the flat image, the farther back in space it is understood to be.

post-and-beam system See **post-and-lintel system.**

post-and-lintel system A method of construction in which horizontal beams are placed across vertical supports.

pottery Fire-hardened vessels made of clay.

primary colors Colors that cannot be formed by mixing other colors and from which all the other colors can be formed. The primary colors are red, yellow, and blue.

principles of design Guidelines that artists follow to bring unity and focus to their vision. The principles of design include dominance, consistency with variety, rhythm, proportions, scale, and balance.

print Any impression onto a piece of paper made by ink applied to a plate, a slab, a block, or a stencil that in some form holds an image.

proportions Mathematical relationships or ratios that govern the measurements and placement of the lines, shapes, and masses of a work of art.

protest art Art that addresses political and social problems.

pyramid A massive tomb monument in ancient Egypt, in which four sloping sides meet at a point.

quill pen A drawing tool made from the wing feathers of large birds such as geese or swans or of smaller birds such as ravens or crows.

quilting The creation of a covering, stitched into a design with colored pieces of material.

real Actual as opposed to imagined existence.

realism According to straight photographers, the chief characteristic of photography because of the medium's ability to record a precise moment in time.

recto The right-hand page of a book or the front of a piece of paper.

reed pen A drawing tool cut from a hollow reed.

reflected light Light from an indirect source.

reinforced concrete Concrete in which steel rods are embedded and tied at their ends to the vertical supports to give the concrete the tensile strength of steel.

relief (1) Sculpture in which the back of the piece is not executed but is still attached to the block, slab, or wall. (2) Any printmaking process in which the image to be printed is raised from the surface of the plate or block.

religious art Images of the gods, goddesses, spirits, and beliefs of a people, which make present unseen characters and forces. Perhaps the earliest and most common category of art, it embodies humankind's deepest concerns.

rhythm A repetition of the visual elements in a work of art, in which they seem to flow to a steady beat across the picture plane or throughout a three-dimensional work.

right brain The theory that artistic activity takes place in the right half of the brain.

rotunda A circular room or building with cylindrical walls.

Salon The annual or biennial exhibition of the French Academy in Paris in the eighteenth and nineteenth centuries, originally held in the Salon d'Apollon of the Louvre.

Salon des Refusés The exhibition of works rejected from the French Academy's Salon in 1863.

scale The relationship between the artistic image and the object in reality that it imitates.

screen printing A form of printmaking in which ink is pushed through a stencil attached to a porous screen of silk, polyester, or other material.

scumbling Brushstrokes of paint dragged over, and only partially covering, the dry layer of paint underneath.

secondary colors The hues green, violet, and orange. They are called secondary because they can be created by mixing two primaries.

semiotics The study of the communication between the artist and the viewer through the medium of the artist's signs and symbols.

sentimental art Art in which the means used to arouse feelings are exaggerated and the emotions aroused do not represent a normal or proportionate reaction to the subject.

sepia A brown ink made from secretions of cuttlefish or squid.

sequence A portion of a film, normally lasting several minutes and consisting of a number of shots that are related to one another by some visual or conceptual coherence.

serigraphy Screen printing in which the screen is made of silk; also called silk screening.

sfumato A smoky appearance achieved through subtle transitions between values.

shade A color produced by the addition of black to make it darker; adding some of the complement to any color will also produce a shade of that color.

shape An area of the surface of a work of art that has a distinct form because it is bound by a contour line or because it has a different value, color, pattern, or texture.

shaped canvas A painting in which the traditional rectangular format has been manipulated, as though the shapes within the painting determine the shape of the format.

shot The basic unit of a film; one continuous rolling of the camera.

significance The combination and interaction of style and iconography that result in new ways of seeing.

silhouette A darkened outline representation of something.

silk screening A form of screen printing in which the screen is made of silk; also called serigraphy.

silverpoint The most common metalpoint used for drawing.

simultaneous contrast The ability of a color to induce in its neighbor the opposite in value and hue.

single-point perspective A linear-perspective projection in which the orthogonals meet at a single point, normally in the center of the composition and on the horizon line.

site specific A work of art designed for, and integrated into, a particular location.

soft ground A form of etching in which the acid-resistant asphaltum, mixed with petroleum jelly, remains soft and sticky so that a variety of materials and textured surfaces can be pressed into the ground in order to expose the metal plate underneath it.

solid wall construction A building technique in which the firm mass of the wall holds itself up and supports the roof or the upper floors.

space (1) The illusion of three-dimensional projection in a two-dimensional work. (2) The actual areas within architecture.

spatial relationship The appearance of close physical proximity established by connecting separate shots through film editing.

spectrum All the visible colors arranged by the size of their wavelengths, usually in a series of parallel bars of color.

steel cage construction A network of steel girders that forms an internal skeleton that supports a building.

still life Any deliberate grouping of small inanimate objects.

stoneware Pottery fired at a temperature higher than earthenware so that it becomes smoother and harder.

storyboard Sketches of all the individual shots in a film, giving a rough idea of its construction.

straight photography Photography produced under the conviction that the photographic print should reproduce what the photographer saw through the camera lens when the picture was taken. Straight photography claims to document reality with a minimum of manipulation.

studio craft The work of many contemporary craft artists who consider glass, clay, wood, fiber, or metal to be simply the means to create art.

study A drawing or painting in which the artist explores a part or an aspect of a work in order to resolve any problems in rendering that segment.

stupa A large hemispherical solid mound that may have originally contained relics of the Buddha.

style The formal properties of works of art and the ways artists use these properties; whatever answers the question "How is it done?"

subtractive sculpture A process of creating sculptural forms by taking away material from a block of something.

support The surface to which paint adheres.

suspension A construction technique in which a roadway, a floor, or a roof is held in place by a system of cables.

symbolic communication The transfer of a message through visual signs that have a rich, many-leveled, emotion-filled meaning similar to personal experience.

symmetry A balance achieved when the formal elements on one side resemble the formal elements on the other side, but reversed as in a mirrored image.

synaesthesia The theory that one sense organ in the body responds to the stimulus of another, as when a color evokes the sensation of a sound or a taste.

tapestry A wall covering woven into a pictorial design.

taste The appreciation of, and preference for, certain styles of art as a result of a person's background and education.

temporal relationship The appearance, established through film editing, that two or more shots are related in time. Such editing can expand or contract time.

tenebrism A strong and often dramatic contrast of light and dark; it emphasizes the space-creating property of chiaroscuro.

terra cotta Clay baked and made hard and permanent by firing it in a kiln.

tertiary (intermediate) colors Hues that are created by the mixture of a primary and a secondary.

texture A quality of the surface that calls attention to the physical presence of the material.

tilt In filmmaking, a camera movement in which the camera moves up or down in a sweeping motion.

tint A color produced by the addition of white to make it lighter.

tondo A circular-shaped work of art.

tracking A camera movement in which the camera is pulled on a dolly, normally on small tracks, while it is filming.

transept A space similar in its proportions to the nave but set perpendicular to the nave in a basilica.

triglyph A rectangular panel decorated with three vertical cuts, forming part of the frieze in the Doric order.

triptych A painting or relief consisting of three parts, which are usually hinged together.

trompe l'oeil Realism in art that nearly convinces the eye of the actuality of the objects represented.

truss Support beams of metal or wood designed with very stable and rigid triangular configurations.

tunnel vault A semicylindrical covering over an architectural space; also called a barrel vault.

Tuscan Doric A variant of the Greek Doric order. The Tuscan Doric normally has a base, and the shaft is not fluted.

tusche The greasy medium used to create an image on a lithographic stone.

two-point perspective A linear-perspective projection in which the parallel lines of objects, which are not perpendicular to the picture plane, meet at two separate vanishing points.

tympanum The area under an arch and over a doorway of a building.

typeface A particular design, size, and style of letters and numbers.

typography The visual appearance of letters and numbers.

ukiyo-e "Pictures of the floating world": Japanese woodblock prints from the eighteenth and nineteenth centuries that illustrate popular entertainments and views of daily life.

unity A cohesion, a wholeness, and a completeness of the visual elements in a work of art.

urban environment All the visible physical conditions in an urban area; a landscape of buildings, roads, open spaces, and facilities that humans have built over the natural landscape.

urban planning The orderly arrangement and control of the growth and development of an urban environment on a rational basis.

utilitas The Latin word for suitability, appropriateness, and practicality; one of Vitruvius's principles of architecture.

value The amount of light reflected from the surface of an object; the name for the relative lightness or darkness of some area.

vanishing point The position on the horizon where the lines of a linear-perspective projection meet.

vehicle The liquid that suspends pigments and causes them to adhere to a surface.

vellum Very fine calf skin or lamb skin prepared as a drawing support.

venustas The Latin word for beauty or the artistic expression of architecture; one of Vitruvius's principles of architecture. In ancient times, *venustas* was embodied in proportions.

verso The left-hand page of a book or the back of a piece of paper.

video art (1) Videotaped documentaries, events, interviews, and performances. (2) Video images electronically manipulated in a free and creative manner nearly impossible with ordinary film. The videotape can be colored, distorted, fragmented, combined, and abstracted.

visual relationship The appearance, established through film editing, that the lines, color, light, movement, or any part of the mise en scène of one shot is similar to—or thoroughly different from—that of the next shot.

voids The empty spaces between the masses of sculpture.

warm colors Hues that are near red on the color wheel.

warm–cool color contrast A juxtaposition that produces a spatial effect because cool colors tend to recede and warm colors tend to project forward.

wash Ink diluted with water and applied with a brush to produce values.

watercolor A transparent painting medium whose vehicle is water and gum arabic (a thickener derived from the acacia tree).

wipe A type of film editing in which a line moving across the screen removes one shot while introducing another behind it.

wood engraving A relief method of printmaking using end-grain blocks of wood on which white lines are normally cut out by the printmaker.

woodcut A form of relief printing in which a design is drawn on a wooden block, and then the part of the block that is not to be printed is cut away with woodcarvers' tools such as knives, gouges, and chisels.

ziggurat A massive Sumerian temple that rises in increasingly smaller stages, which are accessed by ramps.

zoom An apparent camera movement caused by smoothly and rapidly changing the focal length of the camera's lens so that the camera seems to rush toward something on the screen.

Bibliography

Twenty-One Top Museum Web Sites

Art Institute of Chicago
www.artic.edu/aic
Berkeley Art Museum and Pacific Film Archive
www.bampfa.berkeley.edu
Brooklyn Museum of Art
www.brooklynmuseum.org
Cleveland Museum of Art
www.clemusart.com
George Eastman House International Museum of Photography and Film
www.eastmanhouse.org
High Museum of Art, Atlanta
www.high.org
J. Paul Getty Museum
www.getty.edu
Los Angeles County Museum of Art
www.lacma.org
Metropolitan Museum of Art, New York
www.metmuseum.org
Milwaukee Art Museum
www.mam.org
Minneapolis Institute of Arts
www.artsmia.org
Museum of Contemporary Art, Chicago
www.mcachicago.org
Museum of Fine Arts, Boston
www.mfa.org
Museum of Modern Art, New York
www.moma.org
National Gallery of Art, Washington, D.C.
www.nga.gov
Nelson-Atkins Museum of Art, Kansas City
www.nelson-atkins.org
Philadelphia Museum of Art
www.philamuseum.org
San Francisco Museum of Modern Art
www.sfmoma.org
Walters Art Museum, Baltimore
www.thewalters.org
Whitney Museum, New York
www.whitney.org
Yale Center for British Art
www.yale.edu/ycba

General References

Atkins, Robert. *Artspeak: A Guide to Contemporary Ideas, Movements, and Buzzwords*. New York: Abbeville, 1990.

Chilvers, Ian. *The Oxford Dictionary of Art*. London: Oxford University Press, 2004.

Fleming, John, Hugh Honour, and Nikolaus Pevsner. *The Penguin Dictionary of Architecture and Landscape Architecture*. New York: Penguin, 1998.

Holt, Elizabeth G. *A Documentary History of Art*. 2 vols. Garden City, NY: Doubleday Anchor, 1957.

_____. *From the Classicists to the Impressionists: A Documentary History of Art and Architecture in the Nineteenth Century*. Garden City, NY: Doubleday Anchor, 1966.

_____. *The Triumph of Art for the Public: The Emerging Role of Exhibitions and Critics*. Garden City, NY: Doubleday Anchor, 1979.

_____. *The Art of All Nations, 1850–1873: The Emerging Role of Exhibitions and Critics*. Garden City, NY: Doubleday Anchor, 1981.

Lucie-Smith, Edward. *The Thames & Hudson Dictionary of Art Terms*. New York: Thames & Hudson, 2004.

Mayer, Ralph. *The HarperCollins Dictionary of Art Terms and Techniques*. New York: HarperPerennial, 1991.

Piper, David, ed. *The Random House Dictionary of Art and Artists*. New York: Random House, 1988.

Turner, Jane, ed. *The Dictionary of Art*. 34 vols. New York: Grove's Dictionaries, 1996– .

Chapter 1: What Is Art?

Alperson, Philip, ed. *The Philosophy of the Visual Arts*. New York: Oxford University Press, 1992.

Chemeche, George. *Ibeji: The Cult of Yoruba Twins*. Milan: 5 Continents Editions, 2003.

Davies, Stephen. *Definitions of Art*. Ithaca, NY: Cornell University Press, 1991.

Edwards, Betty. *Drawing on the Right Side of the Brain*. Los Angeles: Tarcher, 1989.

Hall, Michael D., and Eugene W. Metcalf, Jr., eds. *The Artist Outsider: Creativity and the Boundaries of Culture.* Washington, DC: Smithsonian Institution Press, 1994.

Hammacher, A. M., and Renilde Hammacher. *Van Gogh: A Documentary Biography.* New York: Macmillan, 1982.

Thompson, Robert Farris. "Yoruba Artistic Criticism." *The Traditional Artist in African Societies,* edited by Warren L. d'Azevedo. Bloomington: Indiana University Press, 1973.

Vogel, Susan. *African Aesthetics.* New York: Center for African Art, 1986.

Chapter 2: Subjects and Their Uses in Art

Elsen, Albert E. *Purposes of Art.* New York: Holt, Rinehart & Winston, 1981.

Furst, Peter T., and Jill L. Furst. *North American Indian Art.* New York: Rizzoli, 1982.

Gibson, Walter. *Hieronymous Bosch.* New York: Oxford University Press, 1973.

Hall, James. *Dictionary of Subjects and Symbols in Art.* New York: Harper & Row, 1979.

_____. *Illustrated Dictionary of Symbols in Eastern and Western Art.* New York: IconEditions, 1994.

Impelluso, Lucia. *Gods and Heroes in Art.* Los Angeles: J. Paul Getty Museum, 2002.

Roberts, Helene E. *Encyclopedia of Comparative Iconography: Themes Depicted in Works of Art.* 2 vols. Chicago: Fitzroy Dearborn, 1998.

Critical Analysis

Barter, Judith A. *Mary Cassatt: Modern Woman.* New York: Art Institute of Chicago/Abrams, 1998.

Mathews, Nancy Mowll. *Mary Cassatt: A Life.* New York: Villard, 1994.

Chapter 3: Line, Shape, and Mass

Carmean, E. A., Jr. *Helen Frankenthaler: A Paintings Retrospective.* New York: Abrams, 1989.

Richardson, John A., Floyd W. Coleman, and Michael J. Smith. *Basic Design: Systems, Elements, Applications.* Englewood Cliffs, NJ: Prentice Hall, 1984.

Chapter 4: Light and Color

Albers, Josef. *Interaction of Color.* New Haven, CT: Yale University Press, 1975.

Birren, Faber. *History of Color in Painting.* New York: Reinhold, 1965.

Hope, Augustine, and Margaret Walch. *The Color Compendium.* New York: Van Nostrand Reinhold, 1990.

Itten, Johannes. *The Art of Color.* New York: Van Nostrand Reinhold, 1973.

Weber, Nicholas F. *Josef Albers: A Retrospective.* New York: Solomon R. Guggenheim Foundation, 1988.

Chapter 5: Surface and Space

Dunning, William. *Changing Images of Pictorial Space: A History of Spatial Illusion in Painting.* Syracuse, NY: Syracuse University Press, 1991.

Gill, Robert W. *Basic Perspective.* London: Thames & Hudson, 1980.

Hilton, Timothy. Picasso. New York: Thames & Hudson, 1989.

Chapter 6: Principles of Design

Hibbard, Howard. *Michelangelo.* Cambridge, MA: Harper & Row, 1985.

Lauer, David A., and Stephen Pentak. *Design Basics.* Fort Worth: Harcourt, 1995.

Maier, Manfred. *Basic Principles of Design.* 4 vols. New York: Van Nostrand Reinhold, 1977.

Pile, John F. *Design: Purpose, Form and Meaning.* New York: Norton, 1982.

Chapter 7: Drawing

Chaet, Bernard. *The Art of Drawing.* New York: Holt, Rinehart & Winston, 1978.

Hale, Robert Beverly. *Drawing Lessons from the Great Masters.* New York: Watson-Guptill, 1989.

Lingwood, James. *Vija Celmins.* London: Institute of Contemporary Arts, 1996.

Mendelowitz, Daniel. *Drawing.* New York: Holt, Rinehart & Winston, 1967.

Rawson, Philip. *Drawing.* London and New York: Oxford University Press, 1969.

Tannenbaum, Judith. *Vija Celmins.* Philadelphia: Institute of Contemporary Art, University of Pennsylvania, 1992.

Chapter 8: Printmaking

Castleman, Riva. *Jasper Johns: A Print Retrospective.* New York: New York Graphic Society, 1986.

_____. *Prints of the Twentieth Century.* New York: Thames & Hudson, 1988.

Hults, Linda C. *The Print in the Western World: An Introductory History*. Madison: University of Wisconsin Press, 1996.

Peterdi, Gabor. *Printmaking: Methods Old and New*. New York: Macmillan, 1980.

Ross, John, Clare Romano, and Tim Ross. *The Complete Printmaker*. New York: Macmillan/Free Press, 1990.

Tallman, Susan. *The Contemporary Print: From Pre-Pop to Postmodern*. New York: Thames & Hudson, 1996.

Chapter 9: Painting

Anfam, David A. *Techniques of the Great Masters of Art*. Secaucus, NJ: Chartwell, 1985.

Auping, Michael. *Susan Rothenberg: Paintings and Drawings*. New York: Rizzoli, 1992.

Chaet, Bernard. *An Artist's Notebook*. New York: Holt, Rinehart & Winston, 1979.

Gair, Angela. *Artist's Manual*. San Francisco: Chronicle, 1996.

Mayer, Ralph. *The Artist's Handbook of Materials and Techniques*. New York: Viking, 1991.

Spalter, Anne Morgan. *The Computer in the Visual Arts*. Reading, MA: Addison-Wesley, 1999.

Chapter 10: Photography

Kirsh, Andrea. *Carrie Mae Weems*. Washington, DC: National Museum of Women in the Arts, 1993.

Newhall, Beaumont. *The History of Photography: From 1839 to the Present Day*. New York: Museum of Modern Art, 1982.

Rosenblum, Naomi. *A World History of Photography*. New York: Abbeville, 1997.

Smith, Joshua P. *The Photography of Invention: American Pictures of the 1980s*. Washington, DC: National Museum of American Art; Cambridge, MA: MIT Press, 1989.

Warren, Bruce. *Photography*. Albany, NY: Delmar, 2001.

Chapter 11: Film

Bordwell, David. *Film Art: An Introduction*. New York: McGraw-Hill, 1997.

Mast, Gerald. *A Short History of the Movies*. New York: Macmillan, 1992.

Monaco, James. *How to Read a Film*. New York: Oxford University Press, 2000.

Russell, Carolyn R. *The Films of Joel and Ethan Coen*. Jefferson, NC: McFarland, 2001.

Chapter 12: Sculpture

Beardsley, John. *Earthworks and Beyond*. New York: Abbeville, 1998.

Goldberg, RoseLee. *Live Art Since 1960*. New York: Abrams, 1998.

Levine, Gemma. *With Henry Moore: The Artist at Work*. New York: Times Books, 1978.

Rawson, Philip. *Sculpture*. Philadelphia: University of Pennsylvania Press, 1997.

Rubin, David S. *Petah Coyne*. Cleveland: Cleveland Center for Contemporary Art, 1992.

Wittkower, Rudolph. *Sculpture: Processes and Principles*. New York: Harper & Row, 1977.

Chapter 13: Applications of Design

Davis, Virginia I. *Crafts: A Basic Survey*. Dubuque, IA: W. C. Brown, 1989.

Dormer, Peter. *The Meaning of Modern Design*. New York: Thames & Hudson, 1990.

_____. *Design Since 1945*. New York: Thames & Hudson, 1993.

Franz, Susanne K. *Contemporary Glass: A World Survey from the Corning Museum of Glass*. New York: Abrams, 1989.

Heskett, John. *Industrial Design*. New York: Oxford University Press, 1980.

_____. *Toothpicks and Logos: Design in Everyday Life*. New York: Oxford University Press, 2002.

Klein, Dan. *Glass: A Contemporary Art*. New York: Rizzoli, 1989.

Lucie-Smith, Edward. *The Story of Craft*. Ithaca, NY: Cornell University Press, 1981.

Rawson, Philip. *Ceramics*. Philadelphia: University of Pennsylvania Press, 1984.

Retzer, John P., and Florence H. Retzer. *Fiber Revolution*. Milwaukee: Milwaukee Art Museum, 1986.

Chapter 14: Architecture

Frampton, Kenneth. *Modern Architecture: A Critical History*. New York: Thames & Hudson, 1992.

Salvadori, Mario. *Why Buildings Stand Up*. New York: Norton, 1990.

Vitruvius. *The Ten Books on Architecture*. New York: Dover, 1960.

Chapter 15: The Ancient and Medieval World

Hartt, Frederick. *Art: A History of Painting, Sculpture, Architecture*. Englewood Cliffs, NJ: Prentice Hall, 1993.

Honour, Hugh, and John Fleming. *The Visual Arts: A History.* New York: Abrams, 1999.

Janson, H. W. *History of Art.* New York: Abrams, 2001.

Kleiner, Fred S., Christin J. Mamiya, and Richard G. Tansey. *Gardner's Art Through the Ages.* Belmont, CA: Wadsworth/Thomson, 2005.

Lee, Sherman E. *A History of Far Eastern Art.* New York: Abrams, 1994.

Stewart, Andrew. *Greek Sculpture: An Exploration.* New Haven, CT: Yale University Press, 1990.

Stokstad, Marilyn. *Medieval Art.* Boulder, CO: Westview, 2004.

Sullivan, Michael. *The Arts of China.* Berkeley and Los Angeles: University of California Press, 1999.

Chapter 16: Expanding Horizons of World Art

Cutler, Charles. *Northern Painting: From Pucelle to Bruegel.* New York: Holt, Rinehart & Winston, 1968.

Hartt, Frederick. *History of Italian Renaissance Art.* New York: Abrams, 2003.

Held, Julius, and Donald Posner. *17th and 18th Century Art: Baroque Painting, Sculpture, Architecture.* New York: Abrams, 1971.

Hibbard, Howard. *Caravaggio.* New York: Harper & Row, 1983.

Kemp, Martin. *Leonardo da Vinci: The Marvelous Works of Nature and Man.* Cambridge, MA: Harvard University Press, 1981.

Miller, Mary Ellen. *The Art of Mesoamerica: From Olmec to Aztec.* New York: Thames & Hudson, 2001.

Murray, Peter. *The Architecture of the Italian Renaissance.* New York: Schocken, 1986.

Rosenblum, Robert, and H. W. Janson. *19th-Century Art.* New York: Abrams, 1984.

Willett, Frank. *African Art.* New York: Thames & Hudson, 2003.

Chapter 17: The Early Modern World: 1860–1940

Arnason, H. Harvard. *History of Modern Art: Painting, Sculpture, Architecture, Photography.* New York, Abrams, 1998.

Chipp, Herschel B. *Theories of Modern Art.* Berkeley and Los Angeles: University of California Press, 1996.

Dempsey, Amy. *Art in the Modern Era: A Guide to Styles, Schools & Movements 1860 to the Present.* New York: Abrams, 2002.

Hunter, Sam, and John M. Jacobs. *Modern Art: Painting, Sculpture, Architecture.* New York: Abrams, 1992.

Levine, Neil. *The Architecture of Frank Lloyd Wright.* Princeton, NJ: Princeton University Press, 1996.

Wright, Frank Lloyd. *The Natural House.* New York: Mentor, 1963.

Chapter 18: The Modern World: Since 1940

Archer, Michael. *Art Since 1960.* New York: Thames & Hudson, 2002.

Chadwick, Whitney. *Women, Art, and Society.* New York: Thames & Hudson, 1996.

Frank, Peter, and Michael McKenzie. *New, Used, and Improved: Art for the Eighties.* New York: Abbeville, 1987.

Hoffman, Katherine. *Explorations: The Visual Arts Since 1945.* New York: HarperCollins, 1991.

Lippard, Lucy R. *Mixed Blessings: New Art in a Multicultural World.* New York: New Press/Norton, 2000.

Lucie-Smith, Edward. *Art in the Seventies.* Ithaca, NY: Cornell University Press, 1980.

O'Connor, Francis V., and Eugene V. Thaw. *Jackson Pollock: A Catalogue Raisonne of Paintings, Drawings, and Other Works.* New Haven, CT: Yale University Press, 1978.

Rush, Michael. *Video Art.* London: Thames & Hudson, 2003.

Thompson, Jerry L., and Susan Vogel. *Closeup: Lessons in the Art of Seeing African Sculpture.* New York: Center for African Art, 1990.

Chapter 19: The Art World

Goldstein, Malcolm. *Landscape with Figures: A History of Art Dealing in the United States.* New York: Oxford University Press, 2000.

Marquis, Alice Goldfarb. *The Art Biz: The Covert World of Collectors, Dealers, Auction Houses, Museums, and Critics.* Chicago: Contemporary, 1991.

Index

All references are to page numbers.

Numbers in **boldface** indicate an illustration on that page.

The names of artists with work appearing in the text have been set in capital type.

ABAKANOWICZ, MAGDALENA
 Backs, 108–109, **108**
ABBOTT, BERENICE
 Exchange Place, New York City,
 213, **213**
ABC logo, 286, **286**
About Architecture (Vitruvius),
 296–299
Abstract art, 51–55, **54, 55**
Abstract Expressionism, 444–448,
 444, 445, 446, 447, 472
Abu Temple statuettes, 326–327,
 327
The Academy of Drawing (Houasse),
 4, **4**
Accents, color, 97
ACCONCI, VITO
 Theme Song, 200–201, **201**
Acropolis, Athens, 298, **298,**
 334–335, **335.** *See also*
 Parthenon
Acrylic paints, 196, **196, 197**
Action Painting, 444
Adam and Eve (Dürer), 171, **172**
ADAMS, ANSEL
 Mount Williamson–Clearing Storm,
 213–214, **214**
Adaptive reuse, 316–317
Additive sculpture, 250
Adjacent colors, 93–94, **94**
ADLER, DANKMAR
 Wainwright Building, 298–299,
 298
Advertising, 282–287, **285, 286, 287**
Advice on Landscape Painting (Kuo
 Hsi), 372
Aesthetics, definition of, 3
Aesthetic theories of art, 3–7
 Aristotelian mimesis, 4–5
 Platonic, 6
 Yoruban, 7
African art
 Bansoa, 135, **135**

African art *(continued)*
 Benin, 132–133, **133,** 379–380,
 380, 480, **481**
 Bushongo, 433, **433**
 early-twentieth-century, 432–433,
 433
 hieratic representation in,
 132–133, **133**
 Mali, 34–36, **35**
 map of historical cultures, **380**
 Nok, 433, **433**
 portraiture, 43
 Soninke, **95,** 96
 symmetrical balance in, 135, **135**
 Tallensi architecture, **294,** 295
 timeline, **366–367**
 Yoruba, 7, **7,** 433
After Piet Mondrian (Levine), 459,
 459
Agriculture, beginning of, 325–326,
 325
AIDS Memorial Quilt, 49–50, **50**
Aisles, **293,** 348
The Alba Madonna (Raphael), 63–64,
 64, 68, 76, 109
 life study for, 147–148, **147**
 study for, 143–144, **143,** 147
ALBERS, JOSEF, 98–99
 at the Bauhaus, 438
 Homage to the Square, 98, **99,**
 105
 The Interaction of Color, 97, **97,** 98
 photograph of, **98**
ALBERTI, LEON BATTISTA
 facade of Santa Maria Novella,
 Florence, 129–130, **130**
 De re aedificatoria, 129–130
 De statua, 250
Alla prima technique, 195
Allegory, 39, **39**
Allegory of Painting (Carriera),
 156–157, **157**
Alternative spaces, 475
Ambulatories, **293,** 349, **349,** 353,
 353
American art
 abstract, 51, 54, **54**
 allegorical, 39, **39**
 Arts and Crafts movement,
 277–278, **277**
 automobiles and, 313–314, **314**

American art *(continued)*
 film, 226
 genre, 41–42, **41**
 government support for, 475, 478,
 480
 historic preservation of, 316–317,
 316, 317
 Impressionist, 57–58, **57, 58**
 landscapes, 45–46, **46,** 48, 49
 map of historic sites, **379**
 movement in, 60, **60**
 murals, 187–188, **187**
 narrative, 28, 29
 Neoclassical architecture,
 406–407, **406**
 nudes, 42–43, **43**
 portraiture, 43, **43**
 pottery, 276, **276**
 religious, 36, **37**
 Romantic, 409–410, **409**
 shaped canvases, 76–77, **77**
 suburban housing, 314–316, **314,
 315**
Amida Butsa, the Great Buddha, 245,
 245
Amiens Cathedral, France, 357–359,
 357, 360
Analogous colors, 93–94, **94**
Anatomy notebook (Leonardo da
 Vinci), 384, **385**
Ancient art, 323–367
 Chinese, Early, 330–331, **331**
 Chinese Empire, 346–347,
 346
 Egyptian, 112, **113,** 327–329, **328,
 329**
 Greek, 334–341 (*See also* Greek
 art)
 map of ancient world, **325**
 Minoan, 331–334, **331, 332,
 333**
 Roman, 341–346 (*See also* Roman
 art)
 Stone Age, 323–326, **323, 324,
 325**
 Sumerian, 326–327, **326, 327**
 timeline of, **366–367**
ANDERSON, LAURIE
 Songs and Stories from Moby Dick,
 261, **261**
 United States, 261

507